THE HORRIBLE GIFT

Race in the Atlantic World, 1700–1900

✳ The Horrible Gift of ✳

FREEDOM

Atlantic Slavery and the
Representation of Emancipation

MARCUS WOOD

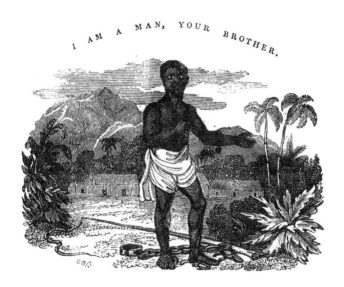

I AM A MAN, YOUR BROTHER.

The University of Georgia Press | Athens and London

A Sarah Mills Hodge Fund Publication

This publication is made possible, in part, through a grant from the Hodge
Foundation in memory of its founder, Sarah Mills Hodge, who devoted her life
to the relief and education of African Americans in Savannah, Georgia.

Designed by April Leidig-Higgins
Set in Garamond Premier Pro by Copperline Book Services, Inc.
Printed and bound by Sheridan Books

The paper in this book meets the guidelines for permanence and durability
of the Committee on Production Guidelines for Book Longevity
of the Council on Library Resources.

Printed in the United States of America

10 11 12 13 14 C 5 4 3 2 1

10 11 12 13 14 P 5 4 3 2 1

Library of Congress Cataloging-in-Publication Data
Wood, Marcus.
The horrible gift of freedom : Atlantic slavery and the
representation of emancipation / Marcus Wood.
p. cm. — (Race in the Atlantic world, 1700–1900)
Includes bibliographical references and index.
ISBN-13: 978-0-8203-3426-4 (hardcover : alk. paper)
ISBN-10: 0-8203-3426-X (hardcover : alk. paper)
ISBN-13: 978-0-8203-3427-1 (pbk. : alk. paper)
ISBN-10: 0-8203-3427-8 (pbk. : alk. paper)
1. Slavery in art. 2. Liberty in art. 3. Slaves — Emancipation.
4. Race relations. I. Title.
N8243.S576W663 2010
704.9'493268 — dc22 2009026743

British Library Cataloging-in-Publication Data available

To the living memory of Frantz Fanon
and for the two Ediths

CONTENTS

IN 2000 *Blind Memory: Visual Representations of Slavery in England and America, 1780–1865* was published. On page 8 of the introduction to this book I explained why I had decided to ignore a series of important areas within the visual archive of Atlantic slavery. When it came to the art generated by successive pieces of emancipation legislation, I wrote this material off in the following words:

> The implementation of an abolition myth was an inexorable cultural process, and by the middle of the 1820s the memory of the slave trade had become primarily the memory of its glorious abolition. A similar pattern followed for the abolition of plantation and domestic slavery in the British Caribbean in 1833, North America in 1863 and 1865 and Brazil in 1888. . . . In an important sense the waves of iconography generated in Europe and the Americas by successive emancipation moments do not visually represent slavery or its memory at all. They might more accurately be designated a spasmodic white ejection, a mythic and colouristically inverted analogue to the ink of the squid.

My conviction ran deep and I kept away from, and refused to think about, this material for the next six years. Now I have written a whole book about emancipation propagandas. I want to briefly explain how what might be described as an extended ironic appendix to *Blind Memory* came about. In 2005 and 2006 a series of invitations arrived from radically different quarters asking me to write about visual art and the 1807 act abolishing the British slave trade. All of the conferences I spoke in, and the publications I contributed to, were commissioned as part of the celebrations to mark the bicentennial of the 1807 act. I didn't want to contribute to any blanket laudation of this event as a great British achievement. I do not believe, in my heart, that 1807 in 2007 should ever have been constructed as a cause for national self-advertisement, and more especially as a space to produce self-praise masquerading as sentimental self-abasement. I agreed to write many articles and book chapters because I hoped that they might allow me to set out my reservations and suspicions concerning the bicentennial and how Britain had remembered slavery through the myth of emancipation. The more I looked at the materials the more I realized the dangers of my previous approach. I certainly did

not fundamentally alter my views, but I had no idea of the ingenuity, and frequently the poisonous beauty, with which the memory of slavery was lovingly repainted by the dominant cultures of the slave diaspora. In the natural world venomous things frequently advertise their nature with a flamboyant beauty, and then nonvenomous things copy them. Similar mimetic patterns and parodic procedures might be plotted in relation to the emancipation propagandas generated in Europe and the Americas.

As I wrote I couldn't ignore the fact that a lot had happened between 2000 and 2007, and that Britain and North America had been involved in the mass fabrication of some new emancipation moments. This book is consequently an attempt to understand the old propagandas, in the conviction that they have real implications for how the violent imposition of liberation continues to be marketed. The Euro-American slave powers may have metamorphosed into late capitalist states that refuse to acknowledge the continuity of slavery systems operated through debt bondage and associated forms of coerced labor. Britain and North America may also officially deny imperial or economic ambitions in relation to the oil-rich nations of the Arab world, or the raw materials of sub-Saharan Africa, or the labor-resources in the sweatshops of Asia. And yet when invasions happen, and concomitant forms of mass abuse emerge as the inevitable outfall, the perpetrators require explanatory rhetorics and disguises. Whether they were made in 1807, 1833, 1848, 1863, or 1888, the emancipation propagandas need to be studied closely. They provided the basic symbolic vocabularies by which the relevant governments remade the history of slavery through investment in an ultimate fantasy of imposed liberation.

This fantasy remains potent and alive. For example, the recent liberation of Iraq, particularly in its initial euphoric stages, was marketed in propaganda that drew directly upon the rhetoric already evolved in the context of the official celebration of the abolition of Atlantic slavery. The question of who claims to own liberty in the media remains a rather important one. Iraq is very educative when considering the longevity of "the horrible gift of freedom." The terms in which the propaganda of George W. Bush's and Tony Blair's publicity regimes seized the ownership of freedom, and the terms in which they claimed to give freedom out to the formerly enslaved population of Iraq, are chillingly familiar when set in the context of the Anglo-American archives of emancipation. Atlantic slavery was a globally organized socioeconomic process of abuse operating on massive geographic, industrial, and temporal scales. Yet each of the major European Atlantic slave powers culturally reencoded the memory of the slavery systems in prolonged and almost identical explo-

sions of cultural celebration. The mass production of justificatory publicities that peddled the gift of freedom has proved hugely effective again and again. We forget at our peril that this emancipation archive constitutes a set of blueprints that can be used by any powerful nation-state when it wishes to paint over the horrible things it has done in the brilliant brush strokes of the gift of freedom.

ACKNOWLEDGMENTS

THE HORRIBLE GIFT OF FREEDOM had a germinal moment. I was teaching a course on slavery and cultural memory to undergraduates at Johns Hopkins University while I was at the History Department in 2003 as the Hinkley Professor. We spent a week looking at the text of the 1807 act abolishing the British slave trade and comparing what this document said with a series of interpretations of it in popular textbook histories of Britain. It was at this point that I decided that a book needed to be written that could explain what lay behind the unbridgeable gap between the fact of the original text and the fictions that were generated around it. So I would like to thank the students in that class, and my colleagues at Hopkins, particularly John Russell-Wood, Richard Kagan, Pier Larson, and Phil Morgan, who helped me in different ways.

When I returned to England, the ideas in this book developed out of successive MA courses I taught at Sussex University focused on emancipation fiction. Several of the students who took these courses have become friends and have gone on to do doctoral work that has fed into this project. I thank the following students and colleagues, in particular, Anita Rupprecht, Philip Kaisary, Prithi Kanakamedala, Lillian Lopez, Stephanie Newell, Minoli Salgado, Geoff Quilley, Denise de Caires Narain, Trevor Burnard, and Saul de Bow (who introduced me to Lars Von Trier's *Manderlay*). Sussex as an institution has, as ever, been sympathetic to and supportive of my intense research needs. I thank Lindsay Smith and Steve Burman especially for smoothing my path.

The book really began to take final shape under the pressure of events in which I was involved in 2007. In January I traveled to Brazil, and my experiences and research gave me some powerful insights into the oddness, negativity, and perversities of European perspectives on the memory of slavery. I thank Carol Menezes, Julio Bandeira, and Roberto da Matta for their hospitality and help. Back in Britain I attended a mass of events and conferences that exposed me to much of the material and many of the ideas examined in the second half of this book. I can't list every event and person that shaped the work during this period, but the following people really changed things for me.

Zoe Whiteley was important, for setting up the wonderful conference, *From Cane Field to Teacup*, and curating the *Uncomfortable Truths* exhibition at the Victoria and Albert Museum. She took a lot of time out to lead me around the show and explain in detail its rationale. Similarly Temi Odumosu carefully guided me round the fascinating small show she curated at the Hunterian Museum, *A Visible Difference: Skin, Race and Identity 1720–1820*. John Oldfield, and his colleagues at the University of South Hampton invited me to be a plenary speaker at the conference *Imagining Transatlantic Slavery*. Discussions here and afterward with Cora Kaplan, Moira Ferguson, Diran Adebeyo, Elizabeth Kowalski-Wallace, Vincent Carretta, and Catherine Hall were important. Catherine also invited me to show my film work on slavery at her colonial history seminar, University College London, an experience that also impacted on my writing significantly. I am indebted to Jim Walvin, in many ways over many years, but in this context because he invited me to contribute to the catalogue for the parliamentary exhibition *The British Slave Trade: Abolition, Parliament and People*. He also introduced me to the curator and organizer of the exhibition, Melanie Unwin. Melanie then invited me to become involved in witnessing and documenting the installation of the show in the Palace of Westminster. Not only did this allow me intimate access to Thomas Clarkson's remarkable chest, but the days I spent ensconced in the exhibition pod also gave me invaluable insights into how the British state was approaching 2007. These insights fed directly into my understanding of the memorial service in Westminster Abbey, and my long analysis of that event in the present work.

The Wilberforce House Museum, and the Wilberforce Institute, in Hull resurfaced a number of times and in a number of ways in my research. I would like to thank everyone who has worked, and continues to work with me there, but David Richardson and Vanessa Salter were particularly valuable. David's work remains precious to anyone working on the inheritance of slavery, but was so significant in 2007, because he deals with the facts of the slave trade in ways that enable the likes of me to think about the fantasies. Vanessa gave a lot of time and thought to explaining to me exactly how and why the Wilberforce Museum was transformed for 2007 into what is now one of the most thought-provoking slavery museums in the world. Northwestern University invited me to give a plenary at their seminal conference *Out of Sight: New World Slavery and the Visual Imagination*, and in this paper I tried out some central ideas for my book. The British Museum and Neil McGregor deserve gratitude for organizing and inviting me to their tremendous memorial day *Resistance and*

Remembrance: 1807–2007 on Sunday, March 25, 2007. The intellectuals, artists, and students who exhibited and performed in the museum's great hall that day contributed at many levels to my project. Cheryl Finley performed a particularly memorable spontaneous performance, converting her identity bracelets into shackles. Helen Weinstein and Jane Moody of the University of York invited me to try out many of my emergent ideas about the 2007 events *in medias res* as part of York's *Slavery and Anti-Slavery: Open Lectures*. Similarly I tried out my ideas in keynote speeches and film screenings at the University of Dundee at two conferences in 2007, and Peter Kitson, Abigail Ward, Alan Rice, Jackie Kay, and Caryl Phillips have all influenced my thought and writing in different ways at these events. Madge Dresser was helpful in keeping me abreast of what happened in Bristol, and clarifying details of earlier artwork she had been involved with on the memory of the middle passage. The Museum of the Docklands not only set up "Sugar and Slavery," an important new permanent gallery dealing with London, trade, and slavery, but held an intense postmortem conference in 2008, which put many things in harsh perspective. I am grateful to the director David Spence for allowing me to film and be part of the event.

Outside the institution there were a number of art centers, community centers, and arts events that I was invited to that had a big impact on how I understood 2007. Eva Langret, then a curator at Gallery 198, was instrumental in setting up the exhibition and lecture series *Blind Memories*, loosely focused on my earlier work, events that gave me several new ideas. Mark Sealey of Autograph talked to me at length about my work and articulated his reservations about what was happening in 2007 and allowed me to see what he was doing in terms of a set of countercultural moves at Rivington Place, Shoreditch's radically creative powerhouse. He also introduced me to Kevin Bales. Paul Gilroy and Weyman Bennett performed a similar corrective task when they got up and talked so honestly at the Socialist Worker's Party public meeting *200 Years Since the Abolition of the Slave Trade: Who Really Ended Slavery?* Revisiting my films of that event has constantly kept me on guard as I wrote. I thank Linda Singh of Ealing Council and the YAA Carnival Village, for their original takes on slavery and commemoration. The remarkable photographs that Fatima Carvalho took of the YAA Commemorative Walk past the houses of Parliament make several appearances in my book. John Phillips of the London Print Studio and Angela Piddock, Head Teacher of the Wilberforce House Primary School, have a special place in my heart. First, because they organized the astonishing performance piece focused on the *Plan*

of the Slave Ship Brookes involving the entire school, and second, because they explained how and why the whole extraordinary thing had worked.

The single event in 2007 that had the biggest effect on shifting my perspectives and making me think in entirely new ways was the inspired conference, or perhaps *happening* is a better description, *The Bloody Writing Is Forever Torn*, which took place in Accra and El Mina in Ghana in August 2007. This was a genuinely unique gathering of academics, writers, artists, and activists from across the entire slave diaspora. The intensity and variety of the exchanges generated here was in my experience unique. What I learned changed not only the final structure of my book but my fundamental intellectual models for thinking about Africa, slavery, and freedom. I cannot enumerate everyone who influenced my thought in those incandescent few days, but my fellow panel members Catherine Molineux, Charles Fosdick, Karen Racine, and Rosanne S. Adderley need mentioning, as do Manu Herbstein, Christopher Brown, Seymour Drescher, and Vincent Brown. After the conference I was lucky enough to travel around sites connected with the memory of slavery in Ghana, Togo, and Benin, in the company of the people who had made the conference possible: Ron Hoffman, Sally Mason, and Emmanuel Akyeampong. The experiences and conversations I had with them, and with fellow traveling companions Phil and Barbara Morgan and Beninese historian Elisée Soumonni, again affected my understanding in subtle ways that markedly changed the way I reapproached what happened in Britain in 2007. I want to thank Emmanuel in particular for taking me aside, and explaining to me, as an Englishman, exactly what the British did to the Ashanti in Kumasi. The University of Georgia Press's Derek Krissoff has been a quizzical, enthusiastic, and sensible collaborator from the moment he became part of this project. I thank him.

The second half of this book was written, and all of the final editorial and revision work was undertaken, during my tenure as a Senior Leverhulme Fellow 2007–2009. I am profoundly grateful to the Leverhulme Foundation for supporting my work and giving me the chance to get this book completed.

Finally, there is a short list of people who have recently talked to me about my work and my life in ways that are impossible to explain but are vitally important. These friends are Richard Misek, Stephen Farthing, Benita Parry, Zahava Doering, and Dillwyn Smith.

THE HORRIBLE GIFT OF FREEDOM

"The Horrible Gift of Freedom"

An Odd Title?

Latin *liber* is "free," not a slave. Conduct is *liberalis* when it becomes a free
man. . . . Liberal has now lost this meaning. . . .Sometimes so many people
grab at the coveted word for so many different groups or factions, that,
while it is spoiled for its original purpose, none of the grabbers achieve
secure possession. . . . We cannot stop the verbicides. The most we
can do is not to imitate them. — C. S. Lewis, *Studies in Words*

If the commodity moves to turn a profit, where does the gift move?
The gift moves towards the empty place. . . . If a gift is not treated as such,
if one form of property is converted into another, something
horrible will happen. — Lewis Hyde, *The Gift*

FUNNY GAMES have been played with freedom and its definitions and with
slavery and its definitions. These games began in the period when Britain
constituted a dominant presence within the Atlantic slave systems and have
continued up until the present day. When Thomas Hobbes, John Locke, John
Stuart Mill, Edmund Burke, or Tom Paine wrote, it seemed, if not easy, then
at least quite a manageable intellectual task to define liberty and slavery in
relation to how human societies should work. Given that the words *freedom*
and *gift* appear prominently in this book's title, it is necessary to define these
terms at the beginning, to explain the processes that led to their destabiliza-
tion, and to explore why, when united, they constitute a "horrible" concept.
I should start by making it clear that *The Horrible Gift of Freedom* is not a
study that is centrally concerned with slavery and philosophical theories of
freedom or liberty.[1] Although at points *The Horrible Gift of Freedom* needs
to engage with the vast questions of how freedom relates to knowledge, to

reason, to coercion, and to choice, I do not attempt to frame the discussion of slavery within such purely philosophical terms in the main body of this book. I am not attempting either to historicize or to resolve the question of the re-lation of individual freedom within the slavery systems to the debates over positive and negative freedom. For those who would wish to enter this now rather tired old space, the places of departure are Isaiah Berlin's essays "Two Concepts of Liberty" and "From Hope and Fear Set Free" and the artificially circumscribed arguments that these limited ideas have since generated on the Left and the Right.[2]

The central concern of this book is, rather, with a series of justificatory, indeed self-serving, rhetorics that take liberty and dress it up as a gift in the various costumes created, at different times and in different places, by the "emancipation moment."[3] In this sense the book concerns a body of texts and works of art that together constitute an extended archive of liberation fantasy. Such fantasies represent liberation or emancipation as an enforced donation from the empowered possessors of freedom to the unfree and disempowered slave. From the viewpoint of the giver the slave has no choice about the terms of this gift, about when, where, or how it is imposed, or about whether to ac-cept it or not. As this book explains, various slave revolutionaries within the diaspora and various anti-imperial and postcolonial theorists, most effectually Frantz Fanon, have sought to deny the terms of this imposition. The events generated across Britain by the 2007 bicentennial of the act of Parliament abolishing the British slave trade would suggest that the terms of their denial have been, and will continue to be, resisted.

"IT'S THE THOUGHT THAT COUNTS": GIVING, TAKING, BINDING, AND COMMODIFYING THE PRICELESS GIFT OF FREEDOM

> Woody Allen used to tell a joke at the end of his standup routine: he would take a watch from his pocket, check the time and then say, "It's an old family heirloom, my grandfather sold it to me on his deathbed." The joke works because market exchange will always seem inappropriate on the threshold. — Lewis Hyde, *The Gift*

Gift is a key word — but a very slippery word — in the title of this book. *Gift* might not seem a very hard word to define; in *Chambers Dictionary* it has two primary meanings as a noun, and they are short and sharp: "A thing given; a quality bestowed by nature." But certain things, freedom being one of them,

cannot be given, and freedom in the context of slavery and emancipation consequently has a difficult, maybe impossible relation to these two definitions of *gift*. The impossibility is exposed in the following question: How can freedom be given, either individually or collectively, if it already exists as nature's gift to all? The first half of Jean-Jacques Rousseau's famous maxim "Mankind is born free, yet everywhere is in chains" assumes that freedom exists universally among humankind, fulfilling the second definition, "a quality bestowed by nature."[4] And if this aphorism of Rousseau's is assumed to embody a timeless truth and to reveal freedom as a quality all humans naturally take on at the moment when a fetus passes beyond the point when it can be legally aborted, then it cannot be given by one human to another, although it can be taken away. If freedom as nature's gift has been violently removed from certain people, it can only be returned to those who have been robbed of it. Such a process of restoring stolen property is not the same as the process of bestowing a gift. And yet, again and again across the Atlantic slave diaspora the ex-slave powers, turned liberators, decided to fictionalize freedom as a pristine gift that was in their power, or the power of their allegorical figures, to bestow upon the victims of their abuse in a successive series of emancipation moments.[5] When the slave powers or their apologists put this cultural mechanism in place, they established a paradox of perfect perversity. It is the unnatural coupling, the impossible equation, of an imagined emancipation with the reality of the inherited trauma of Atlantic slavery that justifies the compounding of the words *freedom* and *horrible* in the title of this book.

Gifts are, in fact, remarkably complicated phenomena; they are socially contingent and how they relate to power, reciprocity, indebtedness, gratitude, exploitation, reception, value, and commodification depend on when, why, and how they are given. There is, in fact, very little serious analytical work on the social history of gift exchange. Lewis Hyde, in *The Gift: Imagination and the Erotic Life of Property*, states simply that "we still lack a comprehensive theory of gifts."[6] Neither Hyde's book nor Marcel Mauss's *The Gift*, to which Hyde is in places profoundly indebted, is in fact centrally concerned with thinking about how humans may function as gifts when they are themselves turned into commodities. Neither do they think about how freedom may be perverted into a gift when the slave commodities are turned back into humans through the legal transmutation of an act of abolition.[7] Their work does, however, present a number of ideas that have enormous implications for this book.

As much of this book is about the visual encoding of the emancipation

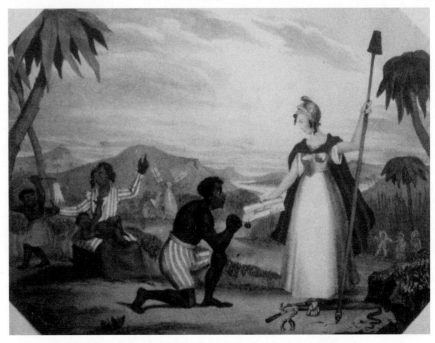

FIG. 1.1. *Freedom*, British, hand-colored copper engraving, 1834.

moment and the gift of freedom, it is pertinent to think from the outset about
the languages used to encode freedom and the gift as images. I will take two
iconic British prints that present the instant when the slave was theoretically
gifted freedom in 1833. In the first (fig. 1.1), a document inscribed "freedom" is
physically passed from the matriarchal Britannia to the kneeling and eternally
grateful slave.[8] This represents an example of gift transfer that is suspended
between the types of contaminated gifts that Hyde exclusively excises from
his study and the sort of positive gifts he does want to talk about. Hyde rejects
all discussion of "gifts given in spite or fear . . . those gifts we accept out of ser-
vility or obligation" and privileges the true gift, "the gift we long for, the gift
that when it comes speaks commandingly to the soul and irresistibly moves
us."[9] The gift of freedom, because it is a paradox and because it exists in radi-
cally different states in the minds of the giver and the receiver, can cover both
of these options in multiple ways, and that explains why it is both necessary
and in some ways impossible to write this book.

 In this print the slave appears, in the very experience of liberation, as utterly
servile and obligated, yet in the vision of those who created the print freedom

is seen to speak to the soul of the slave as an irresistible and inspirational force. Stretching out beyond this there exists an interpretative void that engulfs the irrecoverable thoughts and feelings of the hundreds of thousands of real slaves who had to live out the liberator's fantasy. This multitude experienced the performative reality of this choreographed redemptive moment and then passed through this threshold gift and straight out into the horrors of the apprentice systems. There appears to be an absolute caesura between what this print tells us the gift of freedom meant and what the slaves in fact experienced. In the ideological world of Hyde and Mauss, gifts, when they work, are all about circulation, reciprocity, trust, and mutual respect: "Gifts bespeak relationship. As long as the emotional tie is recognised as the point of the gift, both the donor and the recipient will be careful to structure the exchange so that it does not jeopardize their mutual affection."[10] But the gift of freedom does not operate according to circulatory or cyclic models of exchange; there is no ebb and flow, and the slave has no say in the structuring of the exchange relationship. Consequently, the gift of freedom is end stopped, it is a one-way traffic, it is all give and no take, it is a stillborn deliverance, and, as the print makes perfectly clear, it is above all a statement of power.

The second print (fig. 1.2) depicting the gift of freedom shows a slave family euphorically enjoying their gift and takes the discussion of gifts and thresholds of experience a step further. Britannia, the donator of freedom, is physically absent from this scene, but the effects of her gift send the entire family group into an ecstatic set of theatrical gestures. The father opens his arms toward a tree, upon which the act of emancipation is pinned, while his wife joyfully tosses a child in the air. Their little girl kneels, gathering dirt in her hands to throw into a grave that their little boy is digging with a great shovel in order to bury the broken chains and shackles that lie on the ground around them. In realistic terms the print seems ludicrously excessive. Why would the child actually dig a grave and bury the physical symbols of enslavement at such a moment? It makes a lot more sense, however, if we look at the print *Giving Food Over the Coffin* (fig. 1.3), a late eighteenth-century depiction of a common British ritual in rural areas.[11] The print shows a scene on the threshold of the house of a recently deceased and powerful member of a community. The dead person's coffin forms a barrier between the haves and the have-nots. In this scenario the rich mourning family passes gifts of food and money over the coffin to the poor, and the poor would have been expected to reciprocate with thanks, reverence, obedience, and the blessing of the deceased as that person moved from the realm of the living to that of the dead. Finally, the whole

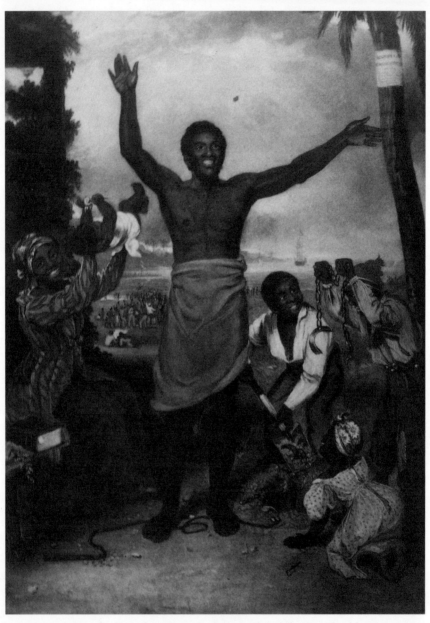

FIG. 1.2. David Lucas after Alexander Rippingdale, *The Friends of the Negro*, London, hand-colored aquatint, 1836.

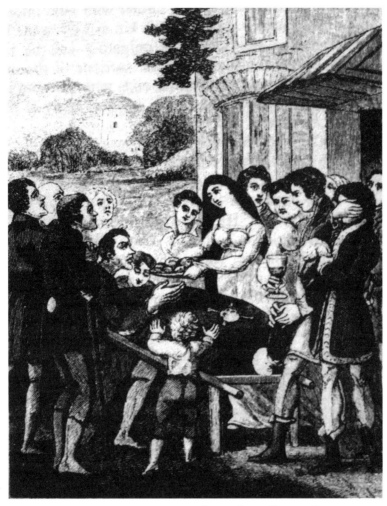

FIG. 1.3. Anon., *Giving Food Over the Coffin*, British,
copper engraving, c. 1800.

exhibition was constructed to cement existing power structures between the
dominant dead and the subservient living, and the gift passed over the cof-
fin is the adhesive that sticks the two together. One might see precisely the
same dynamic unknowingly lived out not merely in the emancipation prints
of 1807 or 1833–34 but in the memorial service enacted over the burial of the
slave trade in Westminster Abbey in 2007.[12]

But to return to the print, the composition uncannily anticipates and em-
bodies the main elements within the later emancipation prints. A beautiful
female hands over the gift to a subservient male, who accepts it upon bended

knee in the classic pose of the liberated slave.[13] A deeply grateful and presumably starving and consequently joyful child reaches out toward the platter, at the same time indicating the death that has enabled the gift. Hyde uses this image as a crucial demonstration of the concept of the "threshold gift," a public gift used to "mark the passage from one place or state to another," and elaborates:

> Threshold gifts belong to a wider group we might call "gifts of passage." I have adapted these terms from Arnold Van Gennep's classic work *The Rights of Passage*. Van Gennep divides rites of passage into three groups: rights of separation, rights of transition, and rites of incorporation. He also calls these "preliminal," "liminal," and "postliminal rites."[14]

These threshold gifts manifest themselves in all human societies at different levels of intensity, and we live with them today: gifts to the tooth fairy, the ceremonies of the baby shower, graduation, christening, marriage, birth, and death all commonly involve ritualized gift exchange. Hyde asserts: "Threshold gifts mark the time of, or act as the actual agents of, individual transformation." And this certainly describes at one level the immensely powerful tradition of ritualized exchange that the abolition mythologies would buy into. If the emancipation prints are read through this theoretical approach, then the threshold gift is freedom and it enables the passage of the slave from the preliminal state of bondage, through the liminal emancipation moment, and out into the postliminal state of liberty.[15] The death of slavery is the birth of liberty; a double threshold is crossed, which is enacted via the semiotics of Christian apotheosis and salvation and enshrined within the rhetorics of the emancipation moment. It is pleasant to appropriate the transformative powers of the threshold gift, to fantasize the easy metamorphosis of a human being from a state of ruined slavery into one of harmonized liberty, and to symbolize this fantasy in the form of a magical gift. Yet there is a fudge here, because the transformative gift was never there for the giver to bestow in the first place. And as we will see when we come to consider Frantz Fanon's take on the gift of freedom, the slave recipient was not necessarily prepared to accept the corrupted gift on the giver's terms and sometimes not on any terms.[16]

MARKETING THE PRICE OF THE GIFT OF FREEDOM

A man ought to be a friend to his friend and repay a gift with a gift. People
should meet smiles with smiles and lies with treachery. — *The Havamal*

Hyde establishes an important distinction between a gift and a commodity.[17] He states: "A commodity has value and a gift does not. A gift has worth. I

am obviously using these terms in a particular sense. I mean 'worth' to refer to those things we prize and yet say 'you can't put a price on it.'" In Hyde's analysis a person can, of course, purchase a gift with money, but in the act of giving the gift enters an emotional and reciprocal area of exchange where financial considerations are suddenly irrelevant or obsolete. The process is crudely summed up in the cliché "it's the thought that counts." This phrase, normally used to evade a sense of disappointment on the receiver's part when a thing of little money value has been given, essentializes the idea that the process of mutual interchange involved in the act of gifting something transforms the thing gifted into something beyond mere physicality and economic exchange value. It is in this context that Atlantic slavery deals strangely with the human gift relationship, and presents interactions between gifts and commodification that seem to outstrip the terms of Hyde's paradigms for giving and receiving.

Atlantic slavery was, of course, a process that at every stage — from initial enslavement via kidnap or barter, to sale on the African slave coast, to the transportation of the middle passage, to resale within the Americas and the Caribbean — was intent on putting a very precise economic value on human life and human freedom, which are traditionally two of those things upon which "you can't put a price." When humans are enslaved and turned into chattel in the marketplace, a price tag is placed on their existence and on their potential freedom. Within slave systems freedom consequently is forced to leave the terms of Rousseau's thought and enters the marketplace. The slave codes laid out a property law specifying that "the part follows the womb," which is to say children were quite explicitly not born free but born into slavery. When the freedom that the slave codes legally took away is given back, it consequently has a quite specific value in the capitalist money market. The price of the gift of freedom was consequently known to all slaveholders and to all abolitionists, and in this sense constituted a paradoxical phenomenon. The most spectacular cultural manifestation of this peculiar perversion of the gift-exchange nexus within the moral sphere lay in the celebrated 20 million pounds sterling (something around 1.5 billion pounds sterling by today's rates) that the British people, via the British government, paid to the planters of the British Caribbean in 1834 to purchase, in theory, the freedom of the British colonial slave populations.[18] This national donation constitutes one of the most peculiar gifts ever purchased. It was a wholly one-sided transaction shifting money from the British government into the banks of the slaveholders in exchange for the freedom of the slaves. In all the gift exchanges described by Mauss in *The Gift*, the act of giving involves a social contract between two

parties based in reciprocity and respect.[19] The purchase of freedom by the British government shattered such a social relation and cut the slave out of the equation. The powerful gave to the powerful; the powerless were not relevant to the transaction. The slave populations merely existed as the catalyst that enabled the British people to demonstrate their enlightenment by spending money. The idea that any of the money should have gone to the slaves was never mooted, and yet somehow the slaves were to remain forever in the British people's debt once they parted with all that cash. What that money paid for was an infinite sense of British moral superiority, and that sense was still very much in evidence as Britain celebrated in 2007.

Yet despite acute unease in some abolition circles, in propaganda terms the purchase of freedom was a triumph. The massive international impact that the redemption payment of 1833 had on the perception of Britain, and on Britain's perception of itself, in the latter half of the nineteenth century is hard to exaggerate.[20] What happened to this vast sum, and how it was reinvested in the industrial infrastructures of Britain and its empire after 1833 are severely under-researched issues. But what interests me here is that this ostentatiously visible lump sum was made to purchase something as abstract as freedom. To see the extraordinary functioning of the famed 20 million pounds sterling upon the national consciousness, consider the following outburst by William Makepeace Thackeray. He has just seen the Royal Academy exhibition of 1842 and is attempting to persuade his readers that the British government should buy a painting. *The Slave Trade* by Frenchman François-Auguste Biard depicted, with exaggerated sentimentalism, the examination, branding, and sale of slave bodies on the west coast of Africa. Thackeray thunders: "You British government who have *given* twenty million to the freeing of this hapless people, *give* yet a couple of thousand more to the French painter and don't let his work go out of the country now that it is here" (my emphasis). And the painting didn't leave Britain, but was duly purchased by the Anti-Slavery Society for Thomas Fowell Buxton and quite fittingly ended up on the main staircase of the Wilberforce House Museum in Hull.[21] For Thackeray this art object showing slave trauma should become a gift to the nation. Thackeray exuberantly claims that this depiction of the sale of slaves is worth precisely one ten-thousandth of the price set on the slave populations of the British Caribbean. There seems to be a world out there where the price of the slave body, the price of a painting describing the torture of slave bodies (specifically branding in order to define economic ownership of a body), and the evaluation (through medical examination) and sale of slave bodies can be precisely

calibrated. What sort of an infernal marketplace is Thackeray taking us into? This is a dreadful question to try and address, and I do not want to pursue that morally vertiginous line of speculation now. The relevant point here is how confidently Thackeray speaks to the commodification of freedom as a gift with a market value; he has found a work of art almost miraculously fit for the purpose. Thackeray's terms are quite precise; the British government gave a certain sum of money to purchase freedom for the slave. That is how the British saw, and for the most part still see, this blood money. It exists as a way of paying off the debt of the traumatic inheritance of slavery. In the hard terms of the economics of the marketplace the money was really paid to the owners of the slaves, as compensation for their material loss when the emancipation act turned their bodies from legal property into legally free people. But what should have been a moral transaction involving the return of something that had been stolen has become an economic transaction whereby wealth is used to purchase the moral high ground. This payment was, in fact, a brutal demonstration of the manner in which gifts and giving had lost their elevated status. What we see is a full-blown demonstration of what E. E. Evans-Pritchard described as "the substitution of a rational economic system for a system in which exchange of goods was not a mechanical but a moral transaction."[22]

The redemption payment of 20 million pounds sterling did not, however, come out of a vacuum. In order to comprehend what happened in 1833 it is necessary to understand what took place before 1807, in the decades when antislavery became established as an international movement. In this context the ideological intervention of Christopher Brown's work must be introduced.[23] Brown's *Moral Capital: Foundations of British Abolitionism* does many things that change perceptions of how abolition developed as a mass movement, but maybe the most vital is encoded in the first two words of his title. Capital and morality are fused in a single concept, and the fusion occurs, not in the reified and disinterested realm of a glorious humanitarian philanthropy, but in a British moral, economic, and intellectual world on the rebound from the effects of losing the American War of Independence.

The main drift of Brown's thesis sees British abolition in its first, "glorious" phase as developing out of a desire to regain the moral foundations for a theory of British imperialism that had been deeply shaken by the events and publications unleashed by the war with the American colonies. By making the abolition of the slave trade the key element in the restructuring of British attitudes to reform, Britain made a massive investment in moral capital.

Brown reaches out beyond questions of money (capital) to consider how class theory, revolutionary theory, and imperial theory interacted with, and were embattled over, the marketing of ideals (moral capital). Given that *The Horrible Gift of Freedom* is, among other things, a survey of the grosser propagandistic manifestations of moral capital in the context of the emancipation moment, Brown's work is of importance.[24] At the end of his book Brown glances at the manner in which the British inheritance of antislavery was used to underpin later nineteenth-century imperial depredations in Africa. Once the British had invested in, indeed patented, antislavery and emancipation as their own special brands of moral capital, then they could be appended to any activity. If British imperial activity in Africa was "antislavery," then anything and everything could be justified around it. An early and perfect embodiment of this transformation of a perceived superior morality into a sordid physical capital was the 1834 redemption payment.

The final moral price to be paid for the gift of freedom was, and is, rather dreadful. In acknowledging the market price of a slave, and the price to be paid for the cancellation of the legal status of the slave as property, the British government and the British people acknowledged that to them freedom had a market value; you could put a price on its head, and it could be bought and sold. Kevin Bales has recently demonstrated that as far as the marketplace is concerned this remains the case, the only difference being that the price of freedom has gone down considerably in the twenty-first century and slaves are now, if you know where to shop, as cheap as chips.[25] The concomitant price of freedom for any would-be liberators has presumably declined in proportion and is now cheap at the price. The present is undoubtedly a good time to enter the market and to invest in the horrible gift of freedom. There now seems a tragically hollow ring in Marcel Mauss's optimistic assertions regarding the gift and the place of morality in the marketplace:

> It is our good fortune that all is not yet couched in terms of purchase and sale. Things have values which are emotional as well as material; indeed in some cases the values are entirely emotional. Our morality is not solely commercial.[26]

When the noble Mauss, a deeply learned and genuinely wise man, wrote these optimistic lines in 1925, it seemed possible to him that a benevolent form of philanthropic capitalism would develop capable of maintaining the respectful and cyclic gift relationships of the older societies he had studied. That was before he, as a Jew, had to live through World War II, a process that drove him

literally mad.[27] Today he would see a marketplace for human flesh in which our morality is indeed wholly commercial. The British government ministers who brokered the flat cash payment of 20 million pounds sterling for the ownership of the freedom of entire slave populations would have understood the logic of the situation perfectly.

THE MYTHIC LEGACY OF EMANCIPATION AND
WHY FANONIAN SKEPTICISM MATTERS

The black must, whether he wants to or not, wear the costume that the
white has made for him. — Frantz Fanon, *Peau noire masques blancs*

The Horrible Gift of Freedom is a meditation upon the generation, operations, and limitations of the cultural materials, especially the visual materials, generated around the successive laws abolishing slavery primarily in England and North America.[28] The majority of the discussion takes the form of detailed close readings of cultural artifacts generated around emancipation decrees and their subsequent cultural construction up to the recent bursting of memorial pressures around slavery in 2007. All the close readings should, however, be placed in relation to the exposition of a stunning and neglected analysis of the metaphorics of slave liberation conducted by Frantz Fanon. I have chosen to anchor this introduction with an extended contextualizing discussion of Fanon's thesis because it constitutes a stern, precise, and rare counterthesis to the official, or state-manufactured, mythologies that came to enshrine the successive emancipation dates in the public consciousness, black and white. It is a central contention of this book that when it comes to the official and popular memory of slavery these mythologies exert a continuing and distorting pressure. The bicentennial celebrations of the 1807 antislavery bill across the black diaspora, celebrations that were marked by a particularly bizarre intensity in Britain, provide an ideal site for a cultural autopsy of these official sites of memory.

That the visual propaganda that narrativized the memory of abolition should be so monumentally clear, when the judicial and societal forces leading to the passage and reception of emancipation legislation were not, is a point of central interest in my analysis. When the Slave Trade Abolition Bill of 1807 was finally passed it was a complicated piece of legislation that generated a series of equally complicated reactions, not only in England but also in France and America. Here I will only provide the main outlines of this con-

tested response, which in any case has been anatomized with unique clarity and intellectual rigor by David Brion Davis.[29] One thing, however, which has not been sufficiently considered is the sinister and obfuscatory language and content of the document presented in the House of Commons on March 25, 1807, namely, "An Act for the Abolition of the Slave Trade."[30] As an object this mighty parchment scroll emerged as a central fetishistic object in 2007 in the British media coverage of the 1807 bicentennial, climaxing with its display in the palace of Westminster. The object was stroked and fondled at different times in different places before various cameras by a series of celebrities, including William Hague, Melvyn Bragg, and Kwame Kwei-Armah.[31] Yet if one takes the trouble to read in full the dense, indeed today almost impenetrable, legal jargon in which this act was composed it emerges as a grim nit-picking document. Its main concerns have nothing to do with the rights of the emancipated blacks. The text is really concerned to define the manner in which the black body can continue to be exploited. The vast majority of the document is focused upon the legal and pecuniary outfall of closing down the trade. At least a third of the text deals with the manner in which the complex insurance system, which this high-risk trade had engendered, is to be dismantled. Even more space concerns the rights of the members of the British military who manage to capture contraband slaves from ships that continue to trade illegally. Or, to put it more plainly, it sets out a blueprint for the profits, or to use the technical term *head money*, to be made by state-sanctioned British bounty hunters working on the slave patrol ships. And there is clearly a vast amount of money to be made for both the bounty hunters and the king, who gets his cut on every captured slave. There is consequently a section setting out the draconian penalties facing those attempting to claim they have captured slaves when they have not. The law will see all false claims as "Felony," the penalty for cooking the books is "death . . . without benefit of clergy." The law also carefully sets out what is to be done with the slaves once they are in British possession. Adult males are clearly marked for enlistment/impressments in the British army and navy and will fight British imperial wars. The act states that none of these coerced soldiers or sailors will have any entitlement to pension rights. Women and child slaves are immediately bound within an apprenticeship (in other words, debt-bondage labor) for a period of fourteen years. The act is at no point celebratory about the arrival of liberty; indeed, the words *freedom* and *liberty* are not mentioned. What we have is a revealing take on the emancipation moment: a mean-spirited and highly efficient plan for the continued exploitation of the African body as both commodity and resource within the new landscape established by abolition.

Despite the grim realities that the act advised and sanctioned, abolition of the British slave trade emerged as a pristine fiction and united both evangelical and establishment Anglican communities in a euphoric and celebratory response. According to this interpretational model, the 1807 bill was a triumph of Christian enlightenment and had sorted out the good Christian citizen from the bad. The idealizing intensity of this response led directly to an increase in missionary activity, both in the British sugar colonies and in Africa.[32] It also led to an increased protective interest in the activities of British missionaries abroad, which could be fanned into martyrological intensity if news of their persecution in the slave colonies percolated back to the metropol.[33] Yet from the start there were quizzical and even cynical responses to the British ascent of the moral high ground in 1807. These responses came not only from France (as one would expect in the midst of the Napoleonic wars, with San Domingo lost) and America (still in moral turmoil over the glaring contradiction that could allow the Constitution and Declaration of Independence to exist alongside the continuation of slavery in many states) but also from England. Representatives of the planter lobby were still vociferous in their defense of the oldest and most traditional form of human exploitation, and the thesis that slaves were very thoroughly protected under a benevolent slave-owning patriarchy remained an ideological staple.[34] English radical intellectuals (ranging from the bizarrely unstable William Cobbett to the hauteur of William Hazlitt) often stood strangely close to planter responses in their instinct that the lot of the British laborer might be unfavorably compared with that of the plantation slave. Radicals across a wide spectrum had a deep-seated and long-lasting suspicion of Clapham Sect evangelicalism and of William Wilberforce in particular. A variety of arguments, ranging in sophistication, basically promoted the thesis that abolitionism had always been a moral smoke screen designed to bamboozle the British public. According to this line of argument, abolitionism was not a sudden moral awakening, but a sinister propaganda strategy directing attention away from successive waves of repressive domestic legislation that had policed and circumscribed the thought and behavior of the emergent English working class.[35]

And yet the crucial fact is that this very real complexity surrounding the passage and reception of the bill evaporated before the clear-cut Manichaean outlines of the official art, high and low, which enshrined the 1807 bill as a cultural myth. What concerns me in this book is, first, the narrative clarity of the myth from its originatory moment in 1807 and, second, the manner in which it evaded change as it was transferred through time and space from Britain to North America, Spain, France, and finally Brazil. The visual rheto-

rics that greeted the 1807 bill established some terribly convincing and very joyful lies. The prints, statues, paintings, and plates that circulated alongside explanatory texts fantasized slavery with an effusive but evasive clarity. This book insists on asking to what extent we are now in a position to move beyond, or even to sidestep, this heart-warming fiction.

At the core of the myth is one enormous idea, the idea that a government that has presided over the development and maintenance of colonial slavery can at a certain point decide to abolish it and to give freedom to the slave. It is this conviction that an absolute transformation has occurred, from a state of complete bondage to a state of perfect liberation, and that this transformation is in the gift of the colonizing, or slaveholding, power, which lies at the heart of the visual propagandas of the emancipation moment. When it comes to the symbolic construction of this gift of freedom, its visualization is always the same. Glorious white patriarchal philanthropists (Thomas Clarkson, William Wilberforce, William Lloyd Garrison, Abraham Lincoln, Victor Schoelcher, Count Rio Branco, and Joaquim Nabuco), men who are somehow morally superior beings, who are saints, who are warriors for our lost ideals, men who are liberators, the moral "big daddies," the protectors of passive and powerless innocence, combine with a variety of female abstract personifications — Justice, Liberty, Britannia, Columbia, Brasilia — to break the chains of the slaves. In response, the slaves kneel in pious gratitude, thanking their new heaven-born masters and mistresses in the sky, or the slaves dance ecstatically, frenetically, like infants on a sugar rush at a party.

Historians and theorists (social, cultural, economic, political, and radical) have done a massive amount of work over the past thirty years to explain how very different the realities of slavery and abolition were from the optimistic and redemptive myths of the abolition moment that I have just essentialized.[36] There has also been a significant groundswell of scholarship devoted to thinking about how black agency continually manifested itself within the abolition archive and within the wider slavery archive. Scholarship has emerged suggesting that we take seriously the notion of an "enslaved enlightenment," a body of thought developed by blacks who worked from within the system to create a critique of Atlantic slavery.[37] Celeste Bernier's *African American Visual Arts from Slavery to the Present*, although largely concerned with more recent African American visual cultures, is the most recent and convincing work to argue that a whole series of early and often enslaved black artists produced layered critiques of the visual vocabularies of white hegemony. Artistic practitioners, including Dave the Potter, James Ball, Harriet Powers, Edmonia Lewis, and

Harry Tanner, made art in a remarkable variety of visual forms (ceramics, textiles, metallurgy, prints, sculpture, painting) that sought to demonstrate at a surprisingly early date that "black is beautiful, not only to white audiences familiar with dehumanizing caricatures but also to black viewers, many of whom internalized white racist standards."[38] In some academic circles there has, then, undeniably been important and intellectually passionate development, and the conclusion to this book discusses how these trends need to be developed. But if one steps back and considers the bigger cultural picture on both sides of the Atlantic it seems that in the popular imagination not that much has changed.[39] It is surely a sad truth that for the majority of the British and American (not to mention French and Brazilian) media the history of the Atlantic slave trade, when on various emancipation anniversaries they bother to think about it at all, is still overshadowed by the history of its "glorious abolition." One could indeed argue that the very fact that across Britain the 1807/2007 bicentenary attracted the concerted attention that it did, that it led to such a plethora of commemorative activity, is a testimony to the efficacy with which the celebratory cultural myths have done their job. It is attractive to believe, especially if you move in the intellectual circles of Atlantic studies and diaspora studies, that we have moved on, that big and difficult questions are being asked about the nature of white guilt and white memory. I have serious doubts about the extent to which the official state-backed memorial reconstructions of Atlantic slavery have gone beyond, or desire to go beyond, or will ever go beyond the original myths in which the emancipation moment of 1807 was enshrined. The solid, and it seems immovable, memorial blocks that were wheeled into place in 1807 remain in place. The Lord Wilberforce is still the head of Anti-Slavery International. The new headquarters of Anti-Slavery International was named Thomas Clarkson House and consecrated to the man who has gone down in history as having given his life to the cause of breaking the slave's chains. President Abraham Lincoln is still "the Great Emancipator," and the black slave on the emancipation monument in Washington eternally kneels humble, prostrate, and undressed before Lincoln's massively clothed bronze figure. The French are still, in their statues, their tourism, and above all their stamps, devoted to the myth of Victor Schoelcher. Joaquim Nabuco is still the face of abolition in Brazil. The price to be paid for commitment to these fictions is, in short, that when it comes to the official memory of slavery the slaves are still iconically imprisoned within the visual rhetorics of disempowerment, stereotypification, and passivity so brilliantly designed by British abolitionists in the late eighteenth century. The

Society for Effecting the Abolition of the British Slave Trade first abstracted and then sold the emotional plight of "our sable Brothers" to a skeptical but intensely sentimental British public. The rules they set up for the interpretational and cultural control of black bodies still maintain the tremendous power of a familiarity that has become invisible in its ubiquity.

EMANCIPATION ART, FANON, AND THE BUTCHERY OF FREEDOM

Live in slavery in the spirit of a free man [*eleutheron*]
and you will be free. — Menander

Meditating upon the sheer power that the myth of the emancipation moment exerts over the black, and white, imagination, Frantz Fanon wrote the following bizarre words:

> Thirty years ago, a Black of the most beautiful shade, was having rampant intercourse with a "sizzling" blond, and at the moment of orgasm he screamed out "Long Live Schoelcher!" ... It was Victor Schoelcher who made the Third Republic pass the law abolishing slavery.[40]

For Fanon that black man's orgasmic roar, "Long Live Schoelcher" (which might be translated more ironically, and maybe precisely, as "Schoelcher Lives!"), exists against the backdrop of several statues showing black enslaved youth, clothed to various degrees, standing next to the overcoated figures of Victor Schoelcher. They are late nineteenth- and early twentieth-century developments of a body of imagery perfected by the British and celebrating white philanthropists, at the moment of black release from bondage, as "the friends of the slave." The imprisoned black consciousness that Fanon thrusts before his readers in sexualized caricature has consequently been created to critique a vast semiotic inheritance that saturated, and saturates, black Atlantic popular culture. I want to open inductively with an English example that reveals Fanon's profound understanding of the constrictions and erasures that are operated by the visual art generated by emancipation.

In Britain Charles James Fox, William Wilberforce, Granville Sharp, and Thomas Clarkson all appeared in text and image as "the friends of the slave." Fox's monument in Westminster Abbey (fig. 1.4) is a good example of the manner in which European memorial and emancipation sculpture encoded the black body. Fox had certainly been a consistent "champion of freedom," whether it was for the rights of American and then French revolutionaries,

English radical laborers, Catholics, or slaves. He died days before the Slave Trade Abolition Bill went through Parliament, and made a suitably grand deathbed statement about how this measure was the one thing that allowed him to "consider my life well spent."[41] The monument that Richard West-macott made for Westminster Abbey nearly a decade later shows Fox in a classical toga, as a latter-day Roman senator, gazing heavenward at the moment of death. He is embraced by a beautiful female figure of Liberty, while a tragically smitten female figure of Peace has collapsed over his feet and ankles. On the ground near the foot of the great statesman's couch, and physically separated from him and the females, is the kneeling figure of a liberated black male slave. This slave is a precise three-dimensional adaptation of the enslaved black famously shown on the seal of the Society for Effecting the Abolition of the Slave Trade, who in 1789 was infamously allowed to ask, "Am I not a man and a brother?" (see fig. 2.3). The only major alterations are that the chains and shackles around the wrists of the original figure are gone and the black physiognomy is now sculpted according to European norms of facial beauty rather than according to the distorted race stereotypes of the original seal.[42] What I want to emphasize here, in the context of Fanon, is that even though this black has been given his freedom and has had his chains physically removed, he is still imprisoned within the posture and gestures that the abolitionists invented and that white society considered the most acceptable official icon of the Atlantic slave. The black slave has been given a strange form of freedom, and is now frozen forever within a gratitude that imprisons him.

ABOLITION'S CATCH-22: THE GIFT OF FREEDOM

Schoelcher, the veteran abolitionist and confirmed scientific racist referred to by Fanon, had been responsible for overseeing massive shifts in French colonial policy. His liberal politics had complicated implications for the French-Caribbean and French ambitions in Africa. His republican assimilationist ideals led Schoelcher to construct the legislation resulting in the 1848 law abolishing French colonial slavery. Yet the very same attitudes and political skills simultaneously allowed him to mastermind the annexation of Algeria by France at precisely the same moment.[43] He died at age eighty-nine, leaving behind the French Afro-Caribbean inheritance that would shape the life and thought of Fanon. Soon after Schoelcher's death, the colonies in which he had worked set up memorials (fig. 1.5).[44] In Louis-Ernest Barrias's 1896 statue there is a definite homoerotic charge. The lithe black youth in his loincloth is

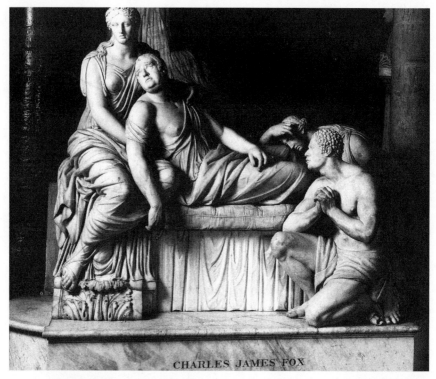

CHARLES JAMES FOX

FIG. 1.4. Richard Westmacott, *Memorial to Charles James Fox*, marble sculpture, 1815.

beautiful, with his slender legs, his almost female belly reminiscent of a Lucas Cranach Venus, and his hands covering his heart but caressing his nipple. The old patriarch wears an overcoat and his arm is raised. He seems to be telling the young black to grow into his freedom, to go off and enjoy himself. Yet as we will see, Fanon's savage satire is all about refusing the freedom that Schoelcher, like so many other sculpted white emancipators, lays on youthful black masculinity with, seemingly, such an easy innocence.[45]

Fanon hated these statues of colonial heroes that littered the capital of Martinique. He saw in them the stultifying symbols of "a motionless, Manichaeistic world, a world of statues, . . . a world which is sure of itself, which crushes with its stones the blacks flayed by whips."[46] What Fanon is saying is that under the terms of this contract of liberation the black man's expression of freedom will always be intimately bound to this original moment of controlled white donation: "white France caressing the frizzy hair of this fine negro whose chains have just been broken."[47] For Fanon each of these statues,

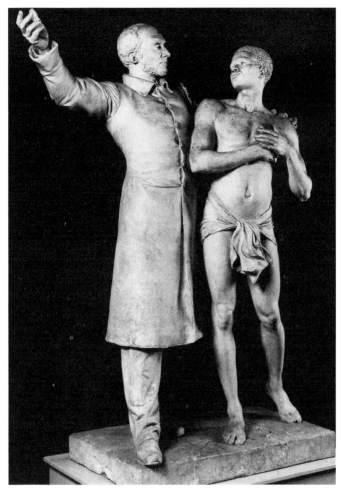

FIG. 1.5. Louis-Ernest Barrias, *Victor Schoelcher*, plaster statue, 1896.

and each image that shows a black with a white man's hand on his shoulder telling him to walk out into the life of a free man, is a semiotic trick.

Within such images is an encoded expression of the continuation of slavery. The black man is theoretically free; he can even enjoy carnal relations with white women. But whatever he does, and wherever he does it, he can never get Schoelcher out of his mind. That statue of Schoelcher, exhibiting on the one side a light, superior, and casual embrace, on the other a mighty raised arm embodying the "gift of freedom," is a haunting image. Like a nightmare it pervades, it saturates liberated black existence; it floods black conscious-

ness with its knowing superfluity. Even at the most intimate moment of adult life, the moment when life is created and human physicality and spirituality glimpse the possibility of a complete liberation through union with another, Schoelcher is still there with his hand on the shoulder of the beautiful black youth. Under what might be termed a white sentence of freedom the black eternally performs for the amusement of the white patriarchal voyeur. "Long Live Schoelcher!" indeed. The rest of this book, which is primarily an attempt to see with new eyes the representation of black freedom by white cultures, might also be construed as an extended attempt to do justice to Fanon's tremendous insight. As a first step, however, it is necessary to explain in greater detail how Fanon's strangely neglected theory works.

FANON SEEING THROUGH HEGEL AND
SEEING HEGEL FOR WHAT HE IS

> The weight of history does not decide even one of my actions. I am my
> own foundation. And it is by reaching out beyond the historical given,
> the instrumental, that I shall inaugurate the cycle of my liberty. The
> bad luck, the crucial accident, the calamity, for the man of colour,
> is that he was enslaved. — Fanon, *Peau noire masques blancs*

At one of the most charged points in *Black Skin White Masks* Fanon uncovers the metaphorics of slave liberation as they work through the officially sanctioned arts of emancipation.[48] He shows us how, again and again, in an instant white metropolitan government commanded the slave power to cast an official, formalized, in some ways abstracted cultural construction of freedom upon the slave population. Fanon searches deeply into the appalling moral *aporia* lying within the myth that freedom can ever be given by any master to any slave. Fanon's insights enable us to see the tumultuous artistic production erected around the myths of white freedom within the slave diaspora as a deeply damaging control fantasy.

Fanon produces a transformative engagement with the power dynamics disguised and encoded within the archive generated by the emancipation moment. His thesis is carefully worked out of a shockingly novel, and starkly satiric, construction of Georg Wilhelm Friedrich Hegel's master/slave dialectic. Fanon transforms the terms of the discussion by approaching the implications of the Hegelian theory from the perspective of emancipation. Fanon's analysis deserves a core position within the ever-growing body of work dedicated to

thinking about how Hegel's meditation on the limits of power and enslavement might be related to the Atlantic diaspora.[49]

Before looking at what exactly Fanon does with Hegel it is crucial to gesture toward a wider sociohistorical Hegelian context, because Fanon is clearly aware of Hegel's views on race and the manner in which they saturate his philosophy. Hegel had specific ideas about black Africans, and his thought in this area is primitive and clearly circumscribed by contemporary dogma on race. As far as Hegel was concerned, Africa and Africans were shut out of the terms of the master/slave dialectic and indeed the concerns of Hegelian philosophy generally. For Hegel Africans constituted a lower, animal form of life. He explicitly describes their consciousness as comparable to that of the dog, and consequently they are creatures not capable of the basic spiritual self-consciousness, let alone the intellectual development, required in order to embark on the Hegelian quest toward the enlightenment or the realization of the "freedom of the spirit."[50] The position is set out with a brutal clarity in the fascinating discussion of "Africa" in the *Philosophy of World History.*[51] This analysis has proved a rather unpleasant choke pear for elevated Hegelian philosophical scholarship. It must, however, be frankly admitted that Hegel emerges as a clumsy cultural analyst, who exhibits a crude but wholly conventional set of assumptions about Africans. The perusal of a handful of popular history and travel books on sub-Saharan Africa provided Hegel with the materials for an extended and generalizing account of the African continent. His establishment of a "Geographical Basis" for the analysis of human societies recycles, with an ignorant enthusiasm, the full range of stereotypes generated by contemporary European racist fantasies of the "Dark Continent."

Given Europe's and America's intellectual and economic investment in Hegel, it *is not* surprising that philosophical scholarship has sidestepped this material or insisted that it can only be comprehended within the larger mysteries of the Hegelian schema. It *is* surprising, however, that postcolonial and diaspora theory has not considered the implications of this extended race diatribe (a crazily, indeed comically, exaggerated catalogue of atavistic blood lust and homicidal excess) in terms of where it places the African in relation to the master/slave dialectic.[52] Nor should this aspect of Hegel's thought be written off as a philosophical footnote; these accounts of Africa had wide currency within artistic circles up to the mid-twentieth century. When Fanon was developing his ideas about freedom in the context of the inheritance of Atlantic slavery Hegel cast his Negrophobe shadow widely. The decision of the young doctor from Martinique to launch an assault upon a central Hege-

lian concept must be seen in this wider context. It is, for example, fascinating that Hegel's account of Dahomey was the direct source for Edith Sitwell's weird long poem "Gold Coast Customs." Her most extreme, hallucinatory, and orgiastic accounts of purported West African cannibalism, infanticide, and sexual excess are supported with long footnote quotations from Hegel. The poem merits detailed analysis in terms of its racial pathology and the extrapolations of Hegel's history into the linguistic mold of modernism, but one example will have to suffice. Sitwell approaches African women and the myth of the Dahomeyan Amazon army (which she appears to think existed in the Ashanti kingdom in Ghana, not in Benin) in the following lines:

> And her soul, the cannibal
> Amazon's mart,
> Where in squealing light
> And clotted black night
> On the monkey-skin black and white striped dust they
> Cackle and bray
> To the murdered day,
>
> And the Amazon queen
> With a bone-black face
> Wears a mask with an apeskin beard; she grinds
> Her male child's bones in a mortar, binds
> Him for food and the people buy.[53]

African women are presented as murderous, antimaternal, and animalized savages, who cackle like hens, bray like donkeys, wear ape-like beards, and not only kill and eat their children, but market their dead flesh as well. This is a gendered world of race stereotypes turned upside down, where ferocious African females outdo their male counterparts in inhuman primitivism — where on earth did a nice lady from Bloomsbury get such terrifying ideas? Sitwell was not in the habit of adding footnotes to her poems.[54] In this poem, however, she seems at some level uneasy about the intense violence and unnaturalness of the world she has fantasized. At each point of imagined African excess she justifies or defends herself by quoting extended paragraphs from Hegel. In this example Sitwell cites the opening two lines from the passage above in her footnotes to the poems and then gives her source text for the whole passage as follows:

"Tradition alleges that in former times a state composed of women made it-self famous by its conquests: it was a state at whose head was a woman. She is said to have pounded her own son in a mortar and to have had the blood of pounded children constantly at hand. She is said to have driven away or put to death all the males, and commanded the death of all male children. These furies destroyed everything in the neighbourhood and were driven to con-stant plunderings because they did not cultivate the land." Hegel's *Philosophy of History*, Chapter on Africa[55]

This gives a good idea of the sort of history we are dealing with; it is pure make-believe. There are no facts. The mythic representation of aberrant and abhorrent African womanhood comes out of "former times" (what times ex-actly?) where "Tradition alleges" (which Tradition?) an evil queen existed who "is said" (by whom? when? where?) to have done all sorts of awful things. The fact that Sitwell sought, and granted herself, imaginative authority to create these race fantasies by battening onto Hegel suggests that Hegel's brutish take on Africa was very far from harmless stupidity. It is vital to note that extreme caricatures of Africans as inhuman were part of the common currency of Eu-ropean high culture from the mid-nineteenth to the mid-twentieth centuries. And the attitudes embedded in the tradition live on with an avid refinement in Bruce Chatwin's 1980 novella *The Viceroy of Ouidah*. The poets of the Negritude movement were intensely aware of the racial extremities saturat-ing European art and intellectual life. Aimé Césaire and René Depestre de-lighted in sending this tradition up in parodically exaggerated descriptions of cannibalistic, tom-tom-beating, sexually rabid blacks.[56] Fanon contributes to this satiric body of work in hilarious ways at many points in *Black Skin White Masks*, particularly in the scathing and uproarious opening pages of his fifth chapter, "The Lived Experience of Blackness."[57] Yet when it came to dealing with Hegel and slavery, he withdrew from such an "eye for an eye, tooth for a tooth" exchange.

Rather than go at Hegel head-on as a primitive racist, Fanon has a far more ingenious strategy that involves destabilizing the master/slave dialectic through reference to the realities of postcolonial politics. In the second sec-tion of the seventh chapter of *Black Skin White Masks*, entitled "The Negro and Hegel," Fanon confronts the celebrated formulation of the master/slave dialectic.[58] He initially summarizes the conflictual dynamic set out by Hegel in order to explain how a consciousness develops its humanity, its sense of

self. Fanon summarizes that it is only through struggle, a struggle even to the point of death, with the consciousness of another (the master) that the consciousness of the slave can attain a sense of its own being, a sense of being in reality free. In Hegel's world of macho spirituality an independent consciousness can only be forged through what is basically a duel. Hegel provides what might be described as a "no pain, no gain" theory of spiritual birth: "The individual who has not staked his life may, no doubt, be recognised as a *person*, but he has not attained the truth of this recognition as an independent person."[59] Fanon's crucial insight is to take Hegel's abstract model into the specific racialized power dynamics of the slave diaspora.

For Hegel's crucial struggle into a heightened state of free consciousness recognition of "the one" by "the other" is essential. In order for the struggle between master and slave to take place the mutual recognition of difference must occur. But what, Fanon asks, if you exist in a crazy world where the master, with no warning, decides to pull the rug out from under the feet of the master/slave dialectic by saying, "I abolish slavery"? Suddenly the master gives you your freedom for nothing, whether you want it or not, and there is nothing to be done about this filthy gift. Fanon sums it up with a very strange "black" sense of humor:

> Historically, the Negro, unnecessarily dunked into servitude, was then liberated by the master. He [the Negro] did not experience a sustained struggle for liberty. Out of slavery, the Negro erupted into the privileged space where he found the masters. Just like the servants who, once a year, are permitted to dance in the drawing room, the negro reaches out for a crutch. The Negro hasn't become a master. When there are no longer slaves, there are no longer masters.[60]

Fanon reveals the cunning robbery at the heart of the decree of emancipation. At a stroke slavery is abolished, and so slave and master suddenly cease to exist. In Hegelian terms this means that there is suddenly no "other" whose destruction will enable the spiritual birth of the slave, and this means that the slave is forever locked out of the possibility of fighting for his or her freedom. The black slave can only celebrate under license, and in that image of the servant dancing in the drawing room Fanon gestures toward the colossal archive of emancipation art that depicts the liberated black capering (often dressed in extraordinary mimicry of polite white fashions) while white Benevolence gazes on with a controlling amusement.

White imposition of the abolition of slavery suddenly shuts down the iconic

possibility of slave revolution, slave rebellion, the slave as freedom fighter. And in a final piece of white devilry the master has been magically transformed, with a sudden bang, into a refulgent benefactor, bestowing that very thing which, according to the logic of the Hegelian dialectic, could never be given — freedom. It is of course a sleight of hand, moral smoke and mirrors, an abolition dodge, which suddenly generates myriad cultural fictions. There they are in the massed crowds, in the statuary and friezes erected in city squares and town halls, in every commemorative newspaper showing the slave kissing this or that white hand, the "liberator frozen/congealed within his whitewashed stone liberation" ("libérateur figé dans sa libération de pierre blanchie").[61] All this art of emancipation plays out endless variations in which the jubilantly submissive slave jumps for joy while the shackles fall, and in which the kneeling slave expresses unending gratitude. Suddenly slavery has gone, and the memory of slavery has been replaced in a flash by a space of celebration and thanks that insists on the fiction of an enforced equality of black and white.

Fanon shares with Aimé Césaire deep insights into how this violently imposed fiction of freedom really works:

> One day a good white Master who had a lot of influence said to his pals: "Let us be civilised with the blacks. . . ." Then the white masters argued among themselves, because all the same it was hard, but they decided to elevate the machine-animal-men to the supreme rank of *men. Not one piece of French soil will support slavery any longer.* From outside the blacks became aware of the upheaval. The black man became agitated. Values that had not been created by his actions, values that had not resulted from the pulsing of his blood, had come to dance in coloured circles around him.[62]

Fanon describes a perpetual process of daylight robbery. Freedom has been stolen from the blacks in the original act of enslavement. Then, in the very act of giving freedom back, it is stolen away for a second time, for there can now never be any process of cleansing revolutionary violence. Fanon sees in this process of deception a tragic legacy, the removal of the possibility of revolutionary black consciousness and its replacement with a black frustration and confusion so intense as to be pathological:

> The liberation of the black slaves produced psychoses and sudden deaths. It's a novelty that one doesn't hear twice in a lifetime. The Black contented himself with thanking the White and you find the most brutal proof of that fact in the imposing number of statues disseminated in France and right across the

colonies representing white France caressing the crinkly hair of the noble black whose chains have been broken. "Say thank you to the man" the mother says to her son . . . but we know that often the little boy dreams of shouting out another word — more resounding, more dismal.[63]

Fanon, with the prescience of a true artist, creates an articulate space, poised between silence and furious utterance. What is the little boy dying to scream in the place of silence? Maybe he doesn't even know, because all he has is a sense that he has been robbed blind. This is not a fantasy, but a commentary on a whole genre of artworks produced in the form of prints, paintings, and statues. Fanon refuses to see this inheritance from the perspective of the white paternalistic forces that generated it, but forces his reader to come at it with a new set of eyes, the eyes of the ex-slave tortured by the gift of liberty.

The great emancipation swindle is set up in order to refuse the ex-slave's consciousness both the historical memory of the trauma of slavery and the enabling presence of an antagonistic white patriarchy: "When it finally happens and the Black looks at the White with ferocity, the White says to him: 'My brother there is no difference between us.' Of course the Negro *knows* that there is a difference. He *desires* it. He wishes that the White would turn on him and shout: 'Filthy Nigger!' "[64] Fanon sees in the mythology of emancipation the foundations of today's benign liberal racisms. Such racisms have found in the easy fictions of equality, parity, and sameness a way of avoiding any real engagement with the difficult aspects of the inheritance of Atlantic slavery. In this sleek but savage equation the gift of liberty is also the gift of invisibility. We are in the territory so majestically mapped in Ralph Ellison's *Invisible Man*, and yet that territory was first suggested, maybe even first invented, in the successive waves of emancipation propaganda that flooded Europe and the Americas from 1807 to 1888. Fanon argues that the slave power, even at the moment of its dissolution, set a terrible mechanism in place that forever compromised and destabilized black access to a pure rebellious hatred. In this sense the amassed cultural archive of the emancipation moment is a dark and destructive phenomenon. In the piles of broken chains, in the endlessly repeated smiles of dancing blacks, and in the refulgent masses of myriad female allegorical embodiments of Liberty, Justice, Freedom, Britannia, Columbia, and Brasilia we do not have something merely misleading, merely sentimentally mistaken. What Fanon demands that we see in the organization of this vast and extended fantasy, so consistent across the slave-Atlantic, is nothing less than a brilliantly constructed aesthetic system for the control

of white guilt and black suffering and for the disguise of white culpability and black outrage.

Fanon ends with an incensed lament on cultural belatedness: "The former, the eternal slave requires that his humanity be questioned, he needs a wrestling match, a brawl. But it is too late."[65] And yet, like Aimé Césaire before him, Fanon, although he has seen through this white fiction of black belatedness, will simply not let it go at that. In the final page of his rewriting of Hegel, in the context of the enforced inheritance of abolition, Fanon enters both prophetic and parodic modes and creates a tragico-satiric interpretation of emancipation art. It is a triumphantly bitter finale in which Fanon first enacts the ecstatic outbreak of cleansing revolutionary blood lust that emancipation had robbed the blacks of. He then, however, shifts from this vision straight into an ironic assault upon those very forms of white state art built to shut out the possibility of remembering a slave revolution:

> "The twelve million black voices" wailed against the curtain of the sky. And the curtain, torn from end to end, the tooth marks standing out clearly, lodged in the belly of interdiction, collapsed like a burst balloon. On the field of battle, its four corners marked out by scores of Blacks suspended by the testicles, bit by bit, a monument is taking shape that promises to be majestic. And at the top of the monument, I can already perceive a White and a Black *holding hands*.[66]

Just when we feel certain that the monument to this fantastic spectacle of failed black rebellion will be a barbaric exhibition of sexually tortured black bodies, Fanon has the last laugh. Fanon steps in as hands-on satirist and erects a fantastic monument both to black suffering and to white complacency. The official vision of a false and effortless black and white equality was enacted in thousands of emancipation monuments, statues, dinner services, and engravings. In this sense Fanon both sets up, and simultaneously sends up, a body of work that has remained remarkably consistent in its symbolic essentials across the entire slave diaspora from 1807 onward. Fanon instructs us to see, rising above the real bodies of black men strung up by the balls, something far more vicious — the benign lie of the emancipation moment. What Fanon exposes is the inability of white European and American cultures to understand that freedom, in a terribly real sense, was never something they had the power to give the slave populations they had created. As a result, freedom is something they, the masters, the mistresses, and their current descendents, will never themselves enjoy, because they simply cannot comprehend what it means.

PONTECORVO'S *BURN!* AN ART OF EMANCIPATION
BEYOND THE GIFT OF FREEDOM

Soldier: But then after a while maybe they will free you.
José Dolores: It does not work like that friend. If a man gives
you freedom it is not freedom. Freedom is something you
alone must take. Do you understand?
Soldier: No.
— *Burn!* screenplay Gillo Pontecorvo Franco Solinas

I want to end this chapter by suggesting that Fanon's thought may be ap-
plied both positively and negatively. Fanon's analysis pins down the ingenious
limitations of the vision of freedom that the ex-slave societies produced. The
myth of the emancipation moment was their official rhetorical response to
the unbearable horror of Atlantic slavery, their way, our way, of dressing up
the obscenity of what had been done. Yet he also points a new way forward
and insists that there may be other interpretative traditions and options that
challenge the negative orthodoxies, the knowing cowardice, underlying white
emancipation art. I open this section with a quotation from the dialogue be-
tween an anonymous soldier and the leader of a nineteenth-century slave rev-
olution in the fictional Caribbean island of Queimada. The words occur at
the climax of *Burn!* Gillo Pontecorvo's unforgiving and beautiful film of the
late 1960s that analyzes slave insurrection and white mercantile hypocrisy in
the Atlantic diaspora.[67] The leader of the slave revolutionaries, José Dolores,
speaks these lines when he is finally captured. Led in bonds, he turns to one
of his black guards, himself an ex-slave, and talks about his fate and why he
would rather die than be given liberty by his captors, who are terrified that
Dolores's execution will make him into a martyr.[68] The final twenty minutes
of the film focus on the machinations of Dolores's captors and his insistence
upon dying to keep the theory of freedom alive. He dies, not as a Christian
martyr but as a slave revolutionary, because that is his only moral choice. He
wants to die in order to defend the right to achieve an abstract, yet completely
real, freedom, rather than have the lie of white physical freedom foisted upon
him.

The debate on freedom is primarily conducted through the interrelation-
ship and dialogue of Dolores and the political entrepreneur Sir William
Walker. Sir William, played with great subtlety by Marlon Brando, is the man
who in the first half of the film is shown to mentor Dolores, indeed to create
him, as a slave revolutionary.[69] Sir William then returns to Queimada in the

second half of the film as an employee of the European powers in order to defeat and capture his revolutionary protégé when the politics of empire and the sugar markets have shifted.

The final point that Pontecorvo makes in the film is not that Dolores always fights for the dispossessed (which he does) or that he possesses a beautiful and incorruptible soul that enables him to die a truly heroic death in the cause of black liberty (which he does). The final point is directed at white Europe and its inability, for all its power and intellectual subtlety, to understand what freedom means. Sir William, with all his jaded Machiavellian brilliance and strategic nous, cannot understand why Dolores refuses to cut and run when given the chance. In the final ten minutes of the film the colonizers attempt every ingenious ploy in order to get Dolores to agree to leave the Caribbean a free and rich man. He laughs at the offers. Unable to bear the impending execution of his erstwhile friend, and at the eleventh hour as the gallows are being set up, Sir William sneaks into Dolores's quarters, cuts him free, and tells him to run. There are, quite literally, no strings attached this time, and as the silent Dolores refuses to accept this proffered liberation Sir William must live out the vast bewilderment of the colonizer when finally faced with the rejection of his power to liberate. What we see is nothing less than the stillbirth of the horrible gift of freedom. The dialogue, or in fact a monologue, punctuated by increasing silences of almost Becketian desperation, runs as follows:

> Sir William: Come on you are free. José you are free, free. Don't you understand? Why, what good does it do? What meaning does it have José? Is it a revenge of some sort? What sort of a revenge is it if you are dead? I don't know José, it just seems madness. Why?[70]

So very many questions from a man supposedly in a position of absolute authority and intellectual superiority, who up to this point has had all the answers. Where does this obsessive insecurity originate? While the Sir Williams of this world may like to think they understand Dolores's actions, what they never have understood and still do not understand is his magnificent silence. Sir William believes he is making an offer that cannot be refused. Of course, Dolores says nothing; he doesn't need to. Sir William's tragedy, and that of any individual who believes he can simply hand out liberty to the oppressed, is that he cannot enter into a moral and political space that denies any validity, indeed any existence, to his proffered gift of freedom. Sir William, like the Anglo-American abolitionists and the generations of historiographers who

have culturally enshrined them, cannot see that there are certain things that it is beyond the power of any human, and most especially a politician, to endow another human with. The final thing about a gift is that it can always be rejected. Sir William tells Dolores that he is a man and a brother and sets him free; Dolores knows that what he is offered is not freedom but a lie. Pontecorvo uses film to shatter the white myth of the emancipation moment.

The terrific message of Fanon, refined and developed within the aesthetics of film by Pontecorvo, is one that, if read properly, allows us to approach the hidden rhetorical codes of all emancipation propagandas with new eyes. Thinking back through 2007, into the 1807 bill and the visual propaganda it both fed off and generated, it is vital that we look upon the tired moral chicanery of these images with altered vision. The final time we see Dolores in *Burn!* is utterly uplifting. This big strong black man, led to his execution, with the gallows rising above him in the background, is laughing. He stares back over his shoulder, and in true freedom, at the dumbfounded Sir William in a bold parody of a wondrous moment of acting that Brando had earlier performed in *On the Waterfront*. Pontecorvo shows us a radically different vision of black liberty from that offered in the Abolition Seal and the body of art it enabled. In an aesthetic context the choice of violent death, a real political martyrdom, at the hands of the colonizer proves the final semiotic antidote to the stultifying gift of freedom. The proud capacity of the slaves to die in the cause of celebrating true liberty was something that both the masters and the abolitionists found too frightening to encompass, let alone celebrate, in art. In the end it was this fear of black moral and martyrological superiority — the terror of Zumbi and Palmares, of the revolt of the Mâles in Salvador Bahia, of Nanny and the Maroons who never gave up in the Cockpit country of Jamaica, of the fires that burned thousands of white bodies black on the great North Plain of San Domingo in 1791 — which generated the bizarre narrative falsehoods, the white witchcraft, buried in the celebratory art of the emancipation moment.

FINAL ARTICLE

It is forbidden to use the word Freedom
Which will be expunged from every dictionary
And it will instantaneously be taken from
The lying quagmires of the mouth
Henceforth freedom will be something living and transparent

Like a fire or a river, like a grain of corn
And its home will always be within the heart of man
— Thiago de Mello, *Estatutos do Homem*

It is fitting that this chapter should move to its conclusion with the poetic manifesto of Thiago de Mello, writing under the shadow of the Brazilian dictatorship as it really began to show its teeth in the late 1960s, because he is right to warn the world not to let freedom become too easily enshrined in texts.[71] If the politicians, their speech-writers and propagandists, or the historians think that they can control it, then it is not freedom anymore. The wrong people will claim an impossible ownership and will know how to manipulate their strange creature. Freedom, when it exists, does not have to define itself, and it cannot be given; it is either present or absent — like life, or love, or beauty.

This book works, of necessity, around an old-fashioned binarism, and for the most part considers freedom very strictly in relation to slavery. This is not the result of a deliberate methodological narrowness or revisionism, or of a desire to excise black agency, but is the result of a simple fact: the emancipation moment is, in theory, a moment in which slavery and freedom are thrown, naked and face to face, into stark confrontation. In most of the abolition fictions I deal with, freedom, as soon as it is released upon slavery, is seen to annihilate it, and what the prints, paintings, statues, and writings describe is a process that is analogous to a sort of human rights harrowing of hell. It is the ultimate purpose of this book to suggest just exactly *what* is involved in supporting such a transformative myth of abolition. Slavery and the traumatic experiences and memorial sediments slowly laid down by it of course never did, and never have, and never will just disappear in a blinding flash of light. It matters tremendously how cultures create and then invest in emancipation fictions. If we deny and shut out a proper space for remembering and mourning the horror generated by an iniquitous system of mass abuse, then what happens is that the horror comes back to haunt us. What is the right way of remembering or commemorating slavery? The massed events of 2007, and my participation in many of them, took me further than ever from a sense that I might ever know an answer to this question. All I would say is that the more I have worked on slavery, the more I have found myself staring at the sea. In 2007 I traveled the Atlantic triangle the other way round. I sat in a café in Salvador Bahia, yards from the shell of what had been the greatest slave market in the world, I ate chips on a bench while the Mersey flowed out of Liverpool,

and I stood in the early morning mist as the fishermen of El Mina, Ghana, prepared their surf canoes. And on each occasion I watched the Atlantic waters moving, cold salt water still suffused with the particles of the flesh, blood, and bones of slave bodies, which dissolved in the great ocean, particles that have moved in their repeated diurnal round now for centuries, a solution that is rich and strange indeed. I also thought of C. S. Lewis's beautiful insight into the true meaning of liberty, when he goes back to Ovid's tremendous vision of the sea as "free water," commenting: "The sea, in Ovid, as opposed to rivers, is the plain or freer (*liberioris*) water."[72] If we require a symbol for the great emancipator, maybe it should be the ocean.

The Arts and Craft of Freedom

Picturing Liberty and the Free Slave

The natural liberty of man is to be free from any superior power
on earth and not to be under the will or legislative authority
of man but to have only the law of Nature for his rule.
— John Locke, *Of Civil Government*, Book 2, cap. 4 (1690)

Civil freedom is not, as many have endeavoured to persuade you, a
thing that lies hid in the depth of abstruse science. It is a blessing and
a benefit and not an abstract speculation. . . . It is not only a private
blessing, but the vital spring and energy of the state itself, which
has just as much life and vigour as there is liberty in it.
— Edmund Burke, *Letter to the Sheriffs of Bristol* (1777)

IN 1853 a juvenile theater was published in London entitled *Green's Characters in Uncle Tom's Cabin* (figs. 2.1 and 2.2).[1] This consisted of two pasteboard sheets that were crammed with figures. In fact, only one of the characters had appeared in Stowe's novel, and this was the figure of Uncle Tom, who had undergone extreme mutation since his first appearance in print. He is now a blackface grotesque, with an enormous caricatured head. He is represented twice and doubly disempowered — once as a sad figure, standing downcast, about to be whipped, and once as a capering, dancing figure who has just been made free. All the other characters are taken from English pantomime and harlequinade — Columbine, Dandy Jem, and Lucy Neal. The majority of figures are abstract personifications. The slave power is represented by Old Monopoly, while Britain is extravagantly embodied in the figures of Liberty, Freedom, the Genius of Freedom, Britannia, and many fairies.

In the middle of the second card (fig. 2.2) is a magnificent and ornate

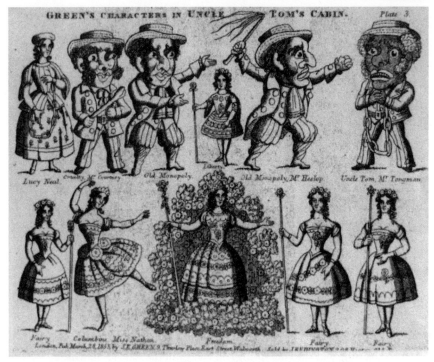

FIG. 2.1. *Green's Characters in Uncle Tom's Cabin*, plate 1, Child's Toy
Theatre, London, J. K. Green, engraving on pasteboard, 1853.

barge. Seated in the center is Britannia, replete with lion, trident, and a shield
bearing the Union Jack. Above her is the inscription "England the Land of
Liberty." The sea stretches out behind her and a small ship in full sail floats
upon it, representing a British antislavery patrol. Britannia is surrounded by
beautiful young females in elaborate crinolines labeled "Freedom" (the large
figure in a sea of blossoms, bottom center, fig 2.1), the "Genius of Freedom"
(the figure bottom right, fig. 2.2), and "Liberty" (a little girl carrying a staff
topped with flowers, directly above the top of Freedom's head, fig. 2.1). No
matter what sense a child tried to make out of this assemblage, the agenda is
clear. America is the land of slavery, populated by two elements: the brutal
slave power, Old Monopoly, and the slave, Uncle Tom. Tom is a miserable,
cringing victim under American slavery, but an ecstatic dancing buffoon
under the intoxicating effects of English liberty. England is embodied by the
powerful Amazonian Britannia, with her antislavery navy and accompanied
by the beautiful allegorical figures of Freedom and Liberty. England, freedom,

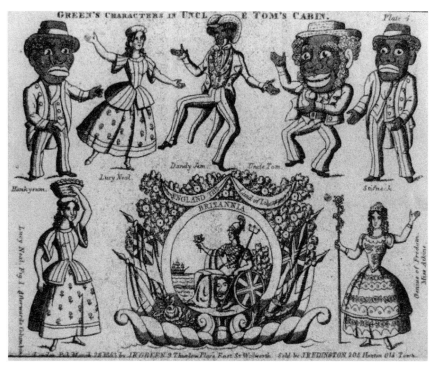

FIG. 2.2. *Green's Characters in Uncle Tom's Cabin*, plate 2, Child's Toy Theatre, London, J. K. Green, engraving on pasteboard, 1853.

and liberty are eternally inseparable and are the binary opposites of America and the mercenary slave power it contains. This powerful and crudely allegorized distillation of Britain's construction of itself and its slave history is, in its own way, quite simply perfect. Throughout the second half of the nineteenth century Britain had an utter confidence that when it came to Atlantic slavery and the concept of freedom, it had its own international monopoly. Britannia was Liberty.

THE FOLLOWING discussion concerns how English and American allegorizations of Freedom and Liberty evolved, and addresses a series of obvious but difficult questions. What does Freedom look like? How old is it? How many faces, how many forms, does Liberty have? Is it a man or a woman? How, in terms of representation and mimesis, should a slave be allowed to know, to see, to express, let alone to possess the strange property of freedom? When it comes to the iconographies developed to represent Liberty within the context

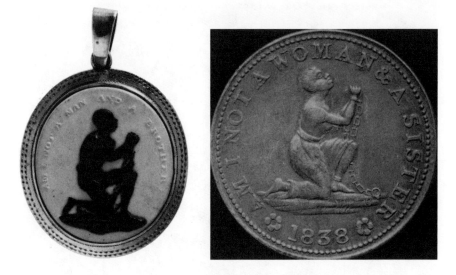

FIG. 2.3. (*Left*) William Hackwood for Josiah Wedgwood, *Am I not a man and a brother?* jasperware, seal of the Society for Effecting the Abolition of the Slave Trade, 1787.

FIG. 2.4. (*Right*) *Am I not a woman and a sister?* bronze Hard Times Token, 1838.

of emancipation and the Atlantic slave diaspora there are two very important sites of dominant and contested representation. The first is the figure of Liberty, and this chapter asks how, why, when, and where it was decided to make Liberty into a demure young lady. The second involves the representation of the slave body at the moment the gift of freedom was laid upon it. There were, in this context, two interpretative poles. The first consisted of active celebration, the second of passive acceptance. Yet, of all the representational options the most influential and widely circulated and adapted image across the slave diaspora was the design that the Society for Effecting the Abolition of the Slave Trade (SEAST) created as its seal in 1789 (figs. 2.3 and 2.4). This showed the body of a kneeling male, and later female slave, asking respectively, "Am I not a man and a brother?" "Am I not a woman and a sister?" Even when supposedly freed, the slave body inevitably seemed to maintain this configuration in the official artistic sites of emancipation. In the ensuing analysis I take each of these symbolic watersheds as a test case and consider how and when they came into general graphic currency. The discussion then extends to think about why these images remain so dominant in the visual cultures that attempt to describe abolition and emancipation.

WHY IS LIBERTY SUCH A PROPER LADY?

In the early 1850s, clearly influenced to some degree by the rush of prints, newspaper articles, and pamphlets that greeted the Fugitive Slave Law with outrage in the Northern states of America, William Cullen Bryant, who was at this date, with the possible exceptions of Henry Wadsworth Longfellow and John Greenleaf Whittier, America's most widely read and deeply loved poet, pondered upon the symbolic codes that had been evolved to celebrate emancipation:

> Oh FREEDOM! Thou art not, as poets dream,
> A fair young girl, with light and delicate limbs,
> And wavy tresses gushing from the cap
> With which the Roman master crowned his slave
> When he took off the gyves. A bearded man,
> Armed to the teeth art thou; one mailed hand
> Grasps the broad shield and one the sword; thy brow
> Glorious in beauty though it be, is scarred
> With tokens of old wars; thy massive limbs
> Are strong with struggling. Power at thee has launched
> His bolts, and with his lightnings smitten thee;
> They could not quench the life thou hast from Heaven.
> Merciless power has dug thy dungeon deep
> And his swart armourers, by a thousand fires
> Have forged thy chain; yet, while he deems thee bound,
> The links are shivered, and the prison walls
> Fall outward; terribly thou springest forth,
> As springs the flame above the burning pile,
> And shoutest to the nations, who return
> Thy shoutings, while the pale oppressor flies.[2]

Bryant asks a very good question: Why had Liberty been popularly constructed in poetry and art during living memory as a lissom, young, and very white "lovely girl" in a scarlet cap? Bryant is now an almost completely forgotten poet, but he takes on a very powerful symbolic inheritance here. He tries to dismantle the iconographic idea of Liberty that had become so central to the rhetoric of international abolition. When Bryant wrote his plea for an alternative vision of Liberty, a beautiful young woman, clothed in classical white toga and cloak and wearing the Phrygian or liberty cap, had become a

universal symbol of freedom within the semiotics of Anglo-American eman-
cipation. Sometimes in English prints she was accompanied by Justice and
Britannia; in American prints, by Columbia. Sometimes, as will become ap-
parent, Liberty even morphed into the figures of Britannia or Columbia, sym-
bolically merging the abstract theory of Freedom with the politically concrete
symbols of national identity. Liberty and nationhood underwent a sinister
cultural transfusion. And whenever emancipation legislation was passed in
the Atlantic slave diaspora, it was officially greeted with variations on the fig-
ure of this transcendent matriarch standing above, or sitting before, a group
of grateful and kneeling black slave bodies.

 It is worth asking why this figure had become so ubiquitous. Why hadn't
Bryant's male figure, patriarchal, massive, powerful, ancient, and beautiful in
his very ugliness, become the preferred symbolic option? Bryant also sets out
freedom as a force that exists through its antagonistic relation to an absolute
and abusive power, a power that through its "swart labourers" enchains all its
subjects, in other words, the slave power. It wasn't as if leading painters and
printmakers during the early stages of the French Revolution hadn't tried out
an ambitious variety of iconographic options, both contemporary and classi-
cal, which accreted the symbol of Liberty, the *bonnet rouge*, to forceful male
figureheads.[3] When and where did this female figure of Liberty, and her cap
that could sometimes take on a graphic life of its own, originate? Liberty and
freedom are often defined and indeed visualized by setting them against their
opposites, slavery and oppression. As abstract personifications these ideas have
been floating in and out of slavery literature and art from a very early date.
David Brion Davis has suggested that Roman manumission ceremonies in
many ways established basic frameworks, indeed the crucial ideological pa-
rameters, for subsequent cultural constructions of the passage of an individual
from slavery to freedom.[4] If this insight is of value, then it forces the semioti-
cian of emancipation back into a consideration of classical approaches to, and
representations of, liberation law and ceremony. This is becoming an increas-
ingly complicated and contested field of scholarly inquiry.

THE CLASSICAL LEGACY OF THE *BONNET ROUGE*

The most authoritative recent essay to set out the judicial and cultural con-
texts operating upon classical manumission emphasizes that we are dealing
with a set of social phenomena that developed slowly but radically over time,
were unstable, and were frequently open to satire and criticism. What might

be termed the politics of classical manumission takes one into all sorts of areas dealing with gender rights, the rights of children and the laws of inheritance, and the different construction of domestic and agricultural slaves. As M. I. Finley explained with brilliant precision as long ago as 1980, debates around manumission and the extent to which slavery ever formally ended within the Roman Empire constitute intellectual and historical minefields.[5] Reading the work of recent scholars, it becomes painfully evident that it might not be possible to use classical manumission as a relevant historical tool with which to unpack the cultural codes that slaveholding societies in the late eighteenth and nineteenth centuries were to evolve in the Americas and Europe for representing the freeing of African slaves.[6] Manumission operated in Greek and then far more directly in Roman societies in ways that intimately integrated slavery systems into the societies in which they flourished. Manumission is not organically, historically, or semiotically easily equated with abolition, or with late eighteenth- and nineteenth-century abolition movements, which seem to have no precise equivalents in Greece or Rome. Roman manumission absorbed the former slave into the host society with a completeness that does not fit easily with our post-eighteenth-century view of slavery and freedom.[7] Emancipation declarations within the Atlantic slave diaspora set up bondage and liberation as two oppositional states transformatively worked through by the catalyst of abolition. In the classical world manumission was a stage involving the incorporation of the newly liberated slave into a new stronger and more equal social role within a slaveholding society. Classical manumission operated within slave-based societies which, despite the carefully conditioned liberation of certain individuals, would continue to operate as slave societies. No matter what the Atlantic slave systems would borrow and adapt from classical manumission when encoding their liberation legislation, they believed that they were enacting a process of utter social change. This sense that the moment of national emancipation created two societal states — a fallen state of bondage before and a transmogrified state of universal liberty after — creates an unbridgeable moral and imaginative gap between classical visualization of manumission and enlightenment visualization of emancipation. The subsequent development of a visual language that might encode Atlantic slave abolition, from the mid- to late nineteenth century, draws in confusing ways upon the full and contradictory iconographic inheritance of slave liberation.

There is no point here laboring through the endless social, economic, and political aspects of Roman society which, classical historians have carefully explained, separated Greek and Roman approaches to slavery from those of

the Atlantic diaspora.[8] One big point, however, which has a major bearing on the following discussion, is that neither Greece nor Rome ended slavery at a symbolic moment through an act of legislation accompanied by an orchestrated program of propaganda founded in the celebration of the emancipator's moral enlightenment. Roman slavery was never formally ended with one explosive legislative outburst, but seems to have drifted into a sort of social, economic, and definitional soup, whereby the former distinctions between slave and free laboring agrarian poor became completely confused.[9] Consequently, Greece and Rome provide no precise historical anticipations of the 1807 and 1833 emancipation laws of Britain, or of those of 1863 in America and 1888 in Brazil. What *is* interesting, however, from the perspective of the subsequent artistic renditions of emancipation, is the extent to which a visually encoded manumission ritual had evolved. This ritual provided some remarkably powerful and translatable symbolic elements that later abolition could parody and exploit. There are few sociophilosophical analyses by classical authors of how manumission ceremonies work, but that of Dionysius of Halicarnassus (c. 60–10 BC) is useful for my purposes. Dionysius's account of manumission is, in fact, a satiric elegy concerned to explain how the ancient and noble traditions of manumission have become degraded as individual slaveholders seek to exploit the glamor attached to the gift of freedom for personal aggrandizement:

> Most of them [the slaves] were given their freedom as a reward for good conduct, and this was the best way of becoming independent of your owner. A small number bought their freedom with money they had earned by working dutifully and honestly. But this is not the situation today: things are in a state of such confusion and the fine traditions of the Roman State are ignored and disgraced to such an extent, that people now buy their freedom (and immediately become Romans) with money which they have acquired through brigandage and robbery and prostitution and similar disreputable activities. Slaves who have advised and supported their owners in poisonings and murders and crimes against the gods or the community receive their freedom from them as a reward; and others, so that they can draw the monthly dole of corn provided by the State or any other grant for poor citizens which leading politicians may be handing out, and then bring it to the persons who have given them their freedom; and others again as a result of their owners' frivolity or silly desire for popularity. I personally know people who conceded freedom to all their slaves after their own deaths so that as corpses they would be acclaimed good

men, and so that there would be lots of people wearing the felt liberty-caps on their heads to follow their biers in the funeral procession; and according to what was said by those who knew, some of those in the processions were criminals who had just been freed from prison and had done things worthy of ten thousand deaths.[10]

The fascinating thing here is that there is clearly a celebratory status attached to the act of manumission, a celebrity that powerful individuals would even cynically pursue beyond the grave. It seems that the fame and respect that would accrue to that long list of figures who stand in statues and paintings next to figures of a be-capped Liberty, giving freedom to the slave (Charles James Fox, William Wilberforce, and Thomas Clarkson in England; the Compte de Mirabeau, Gillaume-Thomas Raynal, and Victor Schoelcher in France; William Lloyd Garrison and Abraham Lincoln in the United States; and Count Rio Branco, Joachim Nabuco, and Princess Isabella in Brazil) could also be acquired by ancient Romans.[11] What is revealing here is the detail that the funeral cortege would be formally accompanied by a crowd of freed slaves wearing that uniform of manumission, the liberty cap. From the beginning it seems this badge was more a public declaration of the generosity and abstract goodness of the master than an unconstricted celebration of the absolute freedom of former slaves. In this sense manumission in its symbolic manifestation might indeed underpin the propagandas of emancipation in the Atlantic slave diaspora. No matter how different Roman approaches to manumission might have been in practice from those of New World slave systems, the cap of liberty, operating at a purely symbolic level, registers each freed slave as the enlightened achievement of a former master. The slave is not quite his own master yet, but in terms of the struggle over ownership of freedom as a behavioral ideal, the freed slave is an ideal icon, a badge, of the master's generosity. It would appear, then, that it was the quest for moral visibility on the part of Roman slaveholding politicians that enabled the horrible gift of freedom to develop as a paradigm within the theater of Roman gesture politics.

To my knowledge only one Roman image of a manumission ceremony featuring slaves wearing liberty caps, and in the act of being freed by a master, exists.[12] In this stone fragment (fig. 2.5) we see a master and two slaves. The master holds a rod in his right hand that he waves over the head of a slave in a loincloth who kneels at his feet. The slave appears to be about to kiss the master's foot, a universal gesture of worshipful submission reserved in art for slaves, servants, and the vanquished in battle pleading for mercy. In his right

hand the master carries a rolled-up scroll. A second slave on the left, also in a loincloth, shakes with his extended right hand the extended right hand of another figure who exists beyond the picture plane, presumably a second master or official, whose body has been broken off from the rest of the fragment and is now lost. The scene relates closely to the legal and simultaneously ceremonial conditions necessary for manumission: "So-and-so is not a free man unless he has been set free by entry in the census roll [*censu*], or by touching with the rod [*vindicta*], or by will [*testamento*]."[13] It would seem in this example that both the first two conditions of liberation are being formally enacted in the fragment. There may be a further gesture of liberation in the clasped hand of the standing slave, for contact between the body and the master accompanied by an announcement that he was now free, literally "out of hand," was customary: "A slave is said to be manumitted, when his owner holds that slave's head or some other part of his body and says 'I want this man to be free' and takes his hand away from him [literally, 'lets him go out of his hand']."[14] Both slaves wear conical cloth caps that anticipate with great precision the accessory that will feature in subsequent late eighteenth- and nineteenth-century abolition propagandas. In the Roman ceremony the liberty cap, or *pileus libertatis*, actually served a practical function in that it covered the head of the newly freed slave, obscuring the shaven or closely cropped head that was a sign of servitude and keeping the head warm while the hair grew. The cap consequently became a sign of not only freedom but of Roman citizenship.[15] This knowing bestowal of the *pileus libertatis*, the liberty cap, was the single most significant rhetorical bequest that Roman slavery would provide for the resources of the Atlantic slave systems once they decided to own the rights to marketing the freedom of their slaves.

THE CONTINUING PROGRESS OF THE *BONNET ROUGE*, TOSSED IN THE RENAISSANCE, TURNED IN THE ENLIGHTENMENT

The cultural signification of the *pileus* and its journey into modern European cultures and thence into abolition rhetoric is horribly complicated. The cap's association with a liberty pole is first recorded in connection with Saturninus's taking of the Roman Capitol in 263. He was reported to have placed the *pileus* on the end of his spear and held it up so that all slaves could understand his promise to free them. With the revival of classical learning in the sixteenth century, the cap entered modern European art and was included as a symbol of liberation together with a discussion of its connection to the ceremony of

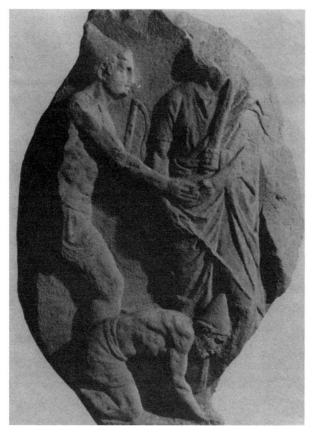

FIG. 2.5. *A Roman Manumission Ceremony*, Musée royal
de Mariemont, Belgium, carved relief, n.d. Courtesy
of Musée royal de Mariemont.

manumission in the most influential iconographic compendium of the Re-
naissance, Cesare Repa's *Iconologia* of 1593.[16] Its inclusion in this text ensured
its place within the central image bank of Western art. Through the course
of the late seventeenth and eighteenth centuries, the cap came to symbolize
freedom from political tyranny and was taken up in a variety of insurrection-
ary contexts. As early as 1675 in Brittany, it was worn in the aptly named
"Revolt of Red Caps" by rioters protesting unjust taxation.[17] On the brink of
the French Revolution, Augustin Dupre produced a commemorative medal
for the American Revolution in 1783, which showed a female figure of Lib-
erty and, behind her head, a "bonnet de la liberté" on a pole. The cap was
also worn by some of the American revolutionaries with the motto "Liberty

or Death" embroidered upon it. There is no evidence, however, that the cap was at any point associated with the freeing of slaves by either side during the American war.[18]

It was in the context of the French Revolution that the cap, or *bonnet rouge*, was to become ubiquitous with many aspects of revolutionary thought, including the liberation of colonial slaves. The *bonnet rouge* was adopted as the headgear of the Sans-Culottes, and all members of the Revolutionary Assemblies sported it. The icon exploded across popular graphic culture in revolutionary France and the early 1790s.[19] Yet for obvious reasons, the cap came to have very different meanings in French and British iconography, the former primarily positive and the latter primarily negative. How these came to inflect the use of the image in the context of slave liberation is consequently a conflicted and contradictory affair.

In the early 1790s, there was revolutionary optimism, in fact, jubilation, surrounding the liberation of blacks in the French slave colonies. An alternative iconography was developed that explicitly countered the compromises and imprisoning passivity of the English emancipation models and that restored the liberty cap to the free slave, as it had to the free citizen, on terms of absolute equality. To take one clear example, high-quality stipple engravings were produced by the master engraver Jean-Louis Darcis to celebrate the notion of black liberation (fig. 2.6).[20] In these facing profile portraits black physiognomies are presented with a notable lack of caricature, and black equality is signified by the addition of the liberty cap. This badge of universal revolutionary brotherhood made all wearers *citoyens*, and it is straightforwardly given to both the male and the female slave. It is significant, however, that the cap is added in a rather charming fringed variant to the woman, who also wears great pearl earrings and a pearl necklace decorated apparently with a bulky African charm. Both figures are simply clothed and physically perfect, with strong arm muscles; their hair grows naturally, but not excessively, and is not straightened. There is no white emancipation symbolism cluttering up the background or foreground. There is not a white female embodiment of Liberty in sight. The absolute equality of the figures comes out in the fact that they are both given the identical exclamation "Moi libre aussi," which is hard to translate; the French *moi* in this context does not carry the meaning "me" or even quite "myself," but is more of an assertive but shared "I," something that doesn't really exist in English and only really existed in France with precisely this inference then and there. But the biggest impact comes from the fact that this is an assertion of individual, shared, and universal freedom. The control-

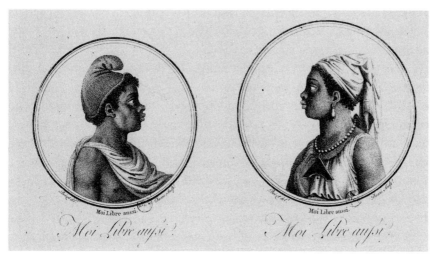

FIG. 2.6. Jean-Louis Darcis, *Moi libre aussi*, male and female busts, stipple engravings on copper, 1792. Courtesy of Bibliothèque nationale de France.

ling temerity of the initial French translation of the English abolition motto "Ne suis-je un homme? Un frère?" (Am I not a man and a brother?) is gone. These blacks are sharing in the liberation moment that the Revolution made briefly available to blacks and whites alike, and they are asserting their right as *citoyens* to be a part of this moment. A plethora of related prints celebrating black equality circulated and many carried longer and more forthright statements of equality that went even further in their shattering of the subservient terms of the famous English abolition aphorism. For example, François Bonneville's matching pair of engravings stated "Moi égal à toi / Coleur est rien / le Coeur est tout / n'est tous pas mon frère?" (I am your equal / color means nothing / the heart is everything / are you not my brother?) and "En Liberté comme toi / La République franse d'accord avec la Nature / l'ont voulu: ne suis-je pas ta Soeur" (Enjoying Liberty like you / the French Republic in harmony with Nature / has desired this, am I not your sister?).[21]

The power of this sign is underlined when one remembers that precisely the same inclusive gesture was hilariously extended to Louis XVI in an act of terrific graphic superimposition. When the revolutionaries invaded the Tuilleries Louis XVI was famously forced to don a *bonnet rouge* and publicly to drink to the health of the people.[22] In an inspired gesture that ironically fused satire and commemoration the plates for the official engraved royal portraits were taken in and reworked (fig. 2.7).[23] The royal visage remains unaltered;

the only addition is that a Phrygian bonnet has been stuck on the king's head. This may initially seem a coarse and degrading gesture motivated by a desire to drag proud aristocracy down to the level of the people, but viewed another way it is a radical gesture which, at a stroke, dissolves the Manichean extremes required in the master/slave relationship. The king is raised by the people to the dignity of their own level. This is a wonderful gesture, the implication being that as an absolute monarch the king was enslaved by the situation of absolute power that surrounded his every thought and action. In becoming a *citoyen* he had now, like the Jacobin masses in Paris or like the blacks in San Domingo, gained the privileges of both freedom and an ideal human community. What a beautiful new thought: that the gift of freedom might be given by the people to their former king.

These noble interpretations of black freedom and radically produced or reduced monarchical equality existed at a magic historical moment. The cap of liberty was liberally distributed across the printed ephemera of the Revolution. It was appended to or hung above the engraved busts of the heroes who stormed the Bastille, and thenceforth became the revolutionary icon all other popular revolutionaries had to strive to merit. It was fastened on the heads and accoutrements of the jacks, queens, and kings in newly designed packs of revolutionary playing cards, and was even retroactively encrusted onto classical deities. Hercules had to give up his traditional lion's pelt for a liberty cap and appear as "Le Patriot Hercule," wearing a modesty veil and a liberty cap and little else as he tackled "l'Hydre" of antirevolution.[24]

Yet when thinking about its iconic relation to blacks, slavery, and freedom, it was not simply that the image became ubiquitous, indeed promiscuous, within the print ephemera thrown up by the Revolution. This was also the brief period in the 1790s when the most sophisticated artists in Paris were able to produce images of colonial blacks that seem almost completely uninflected by the lenses of stereotypification and patronization that were subsequently exuded, when not ruthlessly superinscribed, by abolition and scientific racism. The same force that produced the engravings of the be-capped ex-slave male and female also generated Marie-Guillemine Benoist's powerful, simple, and loving image of a young black woman or the stirring revolutionary hauteur of Anne-Louis Girodet's portrait of Jean-Baptiste Belley.[25] Benoist's 1800 *Portrait d'une négresse* (plate 1), presenting a monumental and anonymous free black woman, takes up the image of the liberty cap with great visual tact. This black subject, who had come over to France as a "servant" at the very moment when universal freedom still operated as an ideal and before the cynical reim-

FIG. 2.7. *Louis seize*, hand-colored stipple engraving, reworked copperplate of 1775, after Joseph Boze, 1792. Courtesy of Bibliothèque nationale de France.

position of slavery in the French colonies in 1802, remains a unique expression of black liberty rendered by a white artist. This woman, with a swan-like neck borrowed from Botticelli's Venus and a gaze that is sad, serious, powerful, intimate, trusting, maybe disdainful, and finally indescribable in its vibrating levels of emotion, demands the participation of the viewer. Her humanity is manifested with a complex force which, it could be postulated, no other portrait of a black person painted by a white person has ever achieved. The formal refinement of the palette and the limited use of accessories is almost

draconian. The single gold earring and the scarlet sash, glimpsed in three tiny fragments around the black arm and simple white shift and almost as thin as a hair ribbon, provide the only inference of exoticism. William Wordsworth, at almost the same date, turned his avaricious gaze at a lone black woman dressed in Caribbean style and saw "gaudy in array, / A Negro woman like a lady gay."[26] Benoist approaches her subject very differently. The touches of color are not gaudy but disciplined and political. The red sash is not merely decorative, for along with the soft, almost gunmetal blue silk drape over the chair and the crisp white linen cap and shift there is a clever but most delicate evocation of the revolutionary *tricoleur*. The white headdress gives the woman an inevitable identification with the figure of Liberty. Indeed, it is striking to compare her cap of liberty with that of the female in the Darcis engraving, blatantly propagandistic though the latter is, for they share many qualities. Both seem improvised out of a piece of square white fabric, with one of the corners hanging down. While the black male in the engraving clearly wears a dark-colored bonnet, presumably the *bonnet rouge*, the black woman's head-gear is white, or at least unshaded. In both cases it seems that the black female has improvised a cap of liberty out of the traditional headgear of the madras turban, and in this sense the cap of liberty has been given an African tinge. Both the black woman in the engraving and Benoist's *négresse* are magnificent figures of Liberty, simultaneously physically alive young black females and abstract personifications who exist in proud contradistinction to the white young girl who was to supplant them in the emancipation propagandas of Europe and the Americas.

LIBERTY CAPS AND SLAVE BODIES: WHY DID THEY GET TOGETHER?

To answer this question it is necessary to stay focused upon a crucial icono-graphic shift. The above examples demonstrate that in classical manumission, and in the first wave of French revolutionary propaganda developed out of this tradition, it is the liberated slave who wears the liberty cap. Conversely, in the emancipation propagandas that have come down to us from Britain, North America, and finally Brazil, the cap has been removed from the slave and given to the white female emblem of freedom. In all the English, Ameri-can, and Brazilian prints, paintings, and sculptures from 1807 on, which show the emancipation moment, the figure of Liberty wears the cap or carries it upon a spear; the slave is no longer entitled to wear it. This infallible process

of substitution, or semiotic re-dressing, whereby the badge of freedom is re-
moved from the slave head and placed on that of a white female abstraction,
is hugely significant. Could it be that at some deep level of the cultural uncon-
scious each of these slaveholding societies found it inadmissible to envisage
the slave as the absolute possessor of an abstract liberty? Liberty must remain
the property of the dominant white society; whether it abolishes slavery or
not, freedom will always remain its gift and perched symbolically on top of a
female figure's abundant tresses.

In fairness, however, it should be stressed that other forces might have con-
tributed to a reluctance on the part of British abolitionists to place the *bonnet
rouge* on the head of a slave. The liberty cap had gone through a series of ideo-
logical transformations during the 1790s outside France. As the French war
evolved, the Revolution was constructed in British graphic satire increasingly
through the fantasies of "The Terror," a body of imagery saturated with blood
lust, cannibalism, and general outrageousness.[27] The Jacobins and their god-
dess Liberty and perhaps more significantly their English sympathizers were
increasingly to be identified by the addition of the cap. Fox in the late 1790s
was hardly presented in single-sheet satires without this necessary appendage,
as he got up to all sorts of imagined revolutionary crimes.[28] James Gillray's
extreme Terror fantasies, typified by the series *Promised Horrors of the French
Invasion*, associate the cap with the worst forms of human cruelty and perver-
sity. The apotheosis of the liberty cap as the badge of British proto-Jacobinism
is the print *Patriotic Regeneration — Viz. Parliament Reformed a la Françoise*
(fig. 2.8).[29] Here the leading opposition politicians all wear the liberty cap,
and are trying and condemning to death the martyr Pitt the Younger. Fox
appears twice, as the judge in the top left and as the kneeling figure in the
center. Wearing a liberty cap, he attempts to prove the value of French liberty
by placing a huge red weight, inscribed "Liberty" and made in the form of
yet another vast *bonnet rouge*, in the scales. The cap, however, is incapable of
weighing down the British crown, which fills the other side of the scales. All
the members of the audience, composed of degenerate radical revolutionaries,
wear red caps. Significantly, Gillray has presented all their faces as swarthy or
dark. There seems to be an allusion here to extreme revolutionary violence
and negritude, perhaps to the San Domingo revolutionaries. Gillray became
far more explicit about the association of French liberty, the *bonnet rouge*,
and the black Jacobins in the print *Icarus* (plate 2) of 1800.[30] Here the radical
sympathizer Sir Francis Burdett is shown rising toward a black Jacobin sun,
while a miniature revolutionary black appears as Apollo in a chariot drawn

FIG. 2.8. James Gillray, *Patriotic Regeneration — Viz. Parliament Reformed a la Françoise*, hand-colored etching on copper plate, 1795.

by asses. His grossly caricatured face makes him appear apelike; he has a tail and he wears a *bonnet rouge* converted into the cap and bells of the fool. Tied to Burdett's ankle is a cannon barrel and the decapitated head of the prince regent, crowned with grapes signifying his drunkenness. The cannon fires more grapes, a pun on grape shot. Icarus/Burdett shits out clouds of tiny French revolutionary flags. These fall down to a group of black Jacobins, presumably the slave rebels of San Domingo. They leap joyfully and their simian faces grimace with glee; each is wearing an outsized *bonnet rouge*. Gillray's print is evidence of the manner in which the liberty cap had been fused in the popular British imagination not merely with the idea of Parisian Jacobinism, but with the image of the slave rebel running riot.

The effect of the waves of propaganda directed at French aspirations to freedom in the 1790s was huge and long lasting. The figure of Gallic Liberté developed into a form of antifemininity, and the cap of liberty became universally associated in British minds with her imagined depravity.[31] It would consequently have been a somewhat ambiguous, not to say dangerous, gesture to place the Phrygian cap on slave heads in the art that greeted the Slave Trade

FIG. 2.9. Joseph Collyer, *Abolition of the Slave Trade,*
copper engraving, after Henry Moses, 1808.

Abolition Bill in 1807. While the figure of Liberty may have been discreetly
allowed to maintain the Phrygian cap in the context of later abolition art, the
image would always carry the taint of a crazy French revolutionary excess.

It is consequently intriguing to see the manner in which English and then
American prints gingerly skirted around the extent to which Liberty should
be inevitably conjoined with her notorious French iconographic Siamese twin
when it came to giving slaves their freedom. One of the most elaborate al-
legorical prints brought out to commemorate the 1807 abolition bill shows
how the *bonnet rouge* is being edged out of the picture.[32] In the forthrightly
entitled *Abolition of the Slave Trade* (fig. 2.9), the scene is dominated by the
triumvirate of powerful female personifications Justice and Wisdom (on each

FIG. 2.10. *Freedom*, British, hand-colored copper engraving, 1834.

flank) and Britannia (in the center). Britannia wears an elaborate military helmet, not a cap of liberty; the cap is hung in space, on the top of her spear, physically separated from the figures and compositionally isolated. The cap seems on the verge of losing its form; it falls in a series of serrated folds, rather like a jellyfish, and its fluid form moves down into the enormous banner that dwarfs it. The banner carries the British crown and the emblazoned caption "Slavery Abolished."

This process of marginalizing the cap and allowing Britannia to dominate the ceremony of emancipation was taken further in subsequent prints. In the simply titled *Freedom* (fig. 2.10), brought out to celebrate the 1833 abolition act for the British slave colonies, it is noticeable that the slaves wear no headgear, while the figure who dominates the scene and gives the slave his freedom, although to an extent a hybrid, is now a lot more Britannia than she is Liberty. She wears an armored helmet upon her head, which is metallic blue and in no sense a liberty cap. Although she carries a spear of liberty, the cap is given an atypical shape, more like a flower pot, and it is now tiny and is stuck up in the top right-hand corner of the composition, suspended in midair, as far from the black slave's head as is possible within the terms of the composition.

FIG. 2.11. "The American Flag, A New National Lyric," sheet music cover, lithograph, 1862. Courtesy of Library of Congress, Prints and Photographs Division, reproduction number LC-USZ62-17725.

One sees a similar drift into ambivalence and occlusion with American approaches to the symbolic expression of liberty when slavery and emancipation are added to the mix. Representations of America combining Liberty and the flag often have an unproblematic relation to the liberty cap. A typical example would be the cover of an 1862 Union piece of sheet music, "The American Flag, A New National Lyric" (fig. 2.11).[33] Here Liberty proudly wears the *bonnet rouge*, while the pole from which the stars and stripes stream is also topped by another smaller version. There could hardly be a more straightforward account of the symbolic transference of the figure of Liberty from the context of the French Revolution to that of Union nationalism in the middle of the American Civil War. As soon, however, as the issue of slavery enters the equation, the famous cap generates more trepidation. The history of the

design for a statue of *Lady Freedom* to be placed on permanent exhibition in Washington is in this sense an exemplary little narrative. In 1855 the sculptor Thomas Crawford produced a design for an *Armed Liberty* who was wearing a traditional liberty cap. At this date the future president of the Confederacy, Jefferson Davis, was secretary of war. He was uneasy over the associations that the symbol might have with slave liberation and blocked the design. When the statue was finally erected on top of the dome of the Capitol in 1863, at almost the same moment as Lincoln's Emancipation Proclamation was signed, Liberty wore an elaborate native American feather headdress and the liberty cap was gone.[34]

A remarkably elaborate Civil War allegory deposited with the Library of Congress in January 1863 approached the liberty cap in an equally circumspect manner. *The Triumph* (fig. 2.12) is a carefully constructed apocalyptic vision that shows the forces of the enlightened Union saving the slave and destroying the massed forces of the Cotton Kingdom, symbolized by an alligator-headed monstrosity whose body is a cotton bale. The figures of Humanity, Justice, and Christianity are flanked by the American heroes George Washington, Thomas Jefferson, et al.[35] Humanity, resting upon the back of a giant American eagle and cradling a white infant, reaches down into the Southern darkness and extends her hand to a manacled and imploring slave. Rising vertically above the composition and in a line precisely above the passive slave is the figure of Liberty. She carries an enormous Union flag, but like the figure on the Capitol is not given a liberty cap, but sports an elaborate native American eagle feather headdress. In her left hand, however, she carries a liberty pole with a small cap of liberty perched on top of it. Again it would seem that the conjunction of slave emancipation with the liberty cap was a dynamic and challenging association for the Northern propagandists, and the icon has been marginalized. The slave is not allowed revolutionary agency in this print, but remains a shackled victim imploring salvation and awaiting the intervention of the combined allegorical and historical forces of the Union.

The extent to which the liberty cap remained a dangerously negative symbol in the context of slave emancipation comes out with a terrible force in American antiabolition satire produced during the Civil War, *Northern Coat of Arms* (fig. 2.13).[36] The dark side of this inheritance was taken up in American graphic satire, which sought to feed off the old narrative elision whereby abolition ideology was conjoined with that of Jacobin revolutionary anarchy. The lesson of San Domingo was the locus in which Jacobin blood lust and the sadistic excesses of slave insurrection had been seen to meet, creating a

FIG. 2.12. *The Triumph*, lithograph, 1862. Courtesy of Library of Congress, Prints and Photographs Division, reproduction number LC-USZ62-68236.

lethal cocktail that had long been vilified by English and American authors. *Northern Coat of Arms* remains a deeply disturbing print. Produced in the Northern states in 1864 and questioning the price paid for freeing the slaves, the design continues to carry the full force of the race paranoia that the Haitian slave revolution had generated.[37] This brutally simplistic but clever design draws on a series of well-established graphic satiric traditions, the whole message finally revolving around the negative troping of the cap of liberty. The title to the print draws upon heraldic reference, itself a satiric concept given the antiaristocratic ideologies of both the American and French Revolutions. This particular Northern coat of arms is a liberty cap, somewhat resembling an enormous fungus, its stem consisting of two black ankles and its roots two splayed and very flat black feet. The flat foot of the Negro was a central element in the rhetoric of racism evolved out of the Civil War, and found its apotheosis in the revolting and overtly fetishistic descriptions of black feet and footprints in Thomas Dixon Jr.'s *The Clansman*.[38] The print also relates to the primitive folk/graphic device for representing "nobody." This popular graphic satiric tradition consisted of presenting, or rather destroying, one's enemy through taking away his or her corporeality.[39] The object of hatred is destroyed and literally made into "nobody" by showing the person as a head on two feet or legs, with no body intervening. *Northern Coat of Arms* takes this tradition a step further by removing not just the body but also the head, which is replaced by an enormous *bonnet rouge*. Given the undeniable resemblance of the cap to the glans penis, there may even be a more appalling and obscene level at which the print operates as a commentary on white male ithyphallic Negrophobia. The black man becomes two enormous flat feet, his legs the shaft that supports the cap of his huge member. This print exists at a ghastly semiotic extreme in relation to the earlier French prints that used the cap to celebrate black equality.

SEMIOTIC GHOSTS AND THE GIFT OF FREEDOM: THE LONG SHADOW OF THE ABOLITION SEAL

> He would speak of a cruel deed ... with a furtive disapproval which
> suggested to us a doubt in his own mind as to whether he had a right to
> think or to feel, and presented to us the curious psychological spectacle of
> a mind enslaved long after the shackles had been struck from the limbs of its
> possessor. Whether the sacred name of liberty ever set his soul aglow with a
> generous fire ... I do not know. — Charles Chesnutt, *Dave's Neckliss*

NORTHERN COAT OF ARMS.

FIG. 2.13. *Northern Coat of Arms*, lithograph, 1864.
Courtesy of Library of Congress, Prints and Photographs
Division, reproduction number LC-USZ62-19673.

Here are two pieces of mail that tell a tale.[40] In 1980 the Atlanta Postal Services in Georgia brought out a first day cover to mark the production of a 15 cent stamp celebrating Martin Luther King Jr. (fig. 2.14). On the top right of the envelope was the stamp itself. The top half carried a full-face portrait of King, with white-collared shirt and black tie. The bottom half carried an illustrated scene of African Americans in a civil rights march. Yet the whole of the left-hand side of the envelope was dominated by a massive reproduction of the early nineteenth-century seal of the Society for Effecting the Abolition of the Slave Trade. At least four times the size of the stamp, the enchained kneeling black slave reaches out toward the floating head of King, asking, "Am I not a man and a brother?" From time to time I receive correspondence from the Wilberforce House Museum (fig. 2.15). The envelopes are always embellished with one or more white stickers showing a crude photographic reproduction of the figure of a kneeling black male, shackled at the wrists, hands extended

FIG. 2.14. FDC, 15 cent stamp celebrating Martin Luther King Jr., Atlanta Postal Services, Georgia, photolithograph, 1980. Reprinted by arrangement with the Heirs to the Estate of Martin Luther King Jr., c/o Writers House as agent for the proprietor, New York, NY. Copyright 1963 Martin Luther King Jr. Copyright renewed 1991 Coretta Scott King.

Dr Marcus Wood
University of Sussex at Brighton
School of English + American Studies
Art Building
Farmer
BRIGHTON
BN1 9QT

do not bend

FIG. 2.15. *Am I not a man and a brother?* envelope with Wilberforce House logo sticker.

out before him as if in prayer, wearing a white loincloth. He kneels under the caption "Wilberforce House Hull Est. 1906 Britain's First Slavery Museum." The figure is an adapted version of the same image that appeared chaining Martin Luther King Jr. to black disempowerment. What can be learned from the fact that the civil rights movement can still be enchained to this climactic vision of black passivity developed by the white imagination? What does it mean that this figure is still considered the appropriate factotum of a slavery museum dedicated to a white abolition leader? What does it mean that this figure is still endlessly cut up, reproduced, or morphed into a variety of other figures in illustrations, graphic satires, and advertisements?

As we have seen, Frantz Fanon explained that at the rhetorical heart of white emancipation propaganda was its assumption that freedom remain the gift of the white. This was his great insight, because once you understand this, then it doesn't really matter whether the colonial imagination that talks of black freedom claims to be proslavery or abolitionist. The controlling mechanisms were put in place from the outset of abolition as a Euro-American phenomenon and have remained monolithic. I am going to use the Abolition Seal, and the history of its adaptations through time and place, as a proof of this assertion. The famous seal combined image and word with ruthless economy to create a most Fanonian impasse for the emergence of a free black subject.

It is no exaggeration to say that this little icon provided a distillation of the rationale for the entire body of visual art that was to be generated under the pressures of a series of emancipation moments within the Atlantic slave diaspora. The Abolition Seal is a semiotic nexus, a net for containing the black male and female. In England, France, North America, and Brazil, from 1807 to 1888 successive emancipation moments generated successive waves of emancipation statues, paintings, envelopes, letter seals, mezzotints, stipple engravings, woodcuts, samplers, cups, saucers, and plates. These objects, with their often elaborate allegories of freedom, have one constant ingredient. They invariably carry images of slave men, women, and children who, although emancipated and no longer enchained, still replicate with ominous precision the precise posture of the supplicant black who asked in 1789, "Am I not a man and a brother?" and a little later in the version produced showing a female slave, "Am I not a woman and a sister?"[41]

The image places the viewer in a one-on-one relation with the slave body; the caption gives the power of instant manumission to the viewer. David Brion Davis has posited that "the idea of emancipation was profoundly influenced

by the model of manumitting individual slaves."[42] He further argues that manumission constituted a rite of passage in the same way that a birth, death, marriage, or baptism did. If one applies this brilliant insight to the Abolition Seal and its motto, then the crucial element must be that it is the viewer who is given absolute power over this intimate rite of passage. What the Abolition Seal bestowed on the white viewer was the power to manumit.

In many ways the Abolition Seal was the first great piece of liberation propaganda to generate an international, indeed intercontinental, impact upon the slave diaspora. Its instant, ubiquitous, and, judging from the stationery of Wilberforce House, continuing success, may be explained by the manner in which it encoded an entire antiliberation philosophy. Within the racial dynamic of this print the white power to say yes (which of course implicitly tenders an antithesis, the right to say no) is the necessary precondition by which the possibility of black freedom is allowed to be introduced. This image with its accompanying aphorism laid down the ground rules for how white abolitionists liked to envision their power over prospective emancipated blacks. Kneeling, supplicant, and still enchained, the slave must ask for the right to possess a gender and a human status.

LIBERTY AND THE CONFLICTED EVOLUTION
OF THE ABOLITION SEAL

> What is Freedom? Ye can tell
> That which Slavery is too well,
> For its very name has grown
> To an echo of your own.
> — Percy Bysshe Shelley, *The Masque of Anarchy*

When it came to developing a white-controlled semiotics for the configuration of liberty within the emancipation moment, the body of the freed slave posed a tricky problem.[43] Emancipation as a large-scale phenomenon in the Atlantic diaspora did not first arrive in 1807, or 1833, or any of the later watershed dates across Europe and the Americas. It first came in two contexts, both of which had the effect of generating a deeply confused set of symbols and art narratives: the first was the American war of independence, the second was the Haitian war of independence. As early as 1775, the British began to implement a policy of liberating any black slave who would fight with them or work with them against the rebel colonies. The first three hundred slaves who joined up

with the British army became the Royal Ethiopian Regiment. The first widely used abolition motto was not "Am I not a man and a brother?" but the rather more forthright words "Liberty to Slaves," which the British had embroidered on the uniforms of this first black regiment of free slaves some fifteen years before the creation of the Abolition Seal.[44] As the war progressed, British hypocrisy, uneasiness, and confusion over the policy of liberating slaves through enlistment became increasingly manifest. At the end of the war, the cessation of hostilities between white English and white American was not carried over to blacks, no matter what national identity they embraced. The slave population was treated with casual duplicity by the defeated British. Their ex-slave army was broken up amid confused negotiations with the victorious colonists, who wanted their property returned. Some black soldiers ended up back in enslavement. A group of about three thousand were evacuated en masse to found a new colony of freed blacks in Nova Scotia. Given the moral miasma surrounding this monumental failure of British nerve and American moral vision, it is not surprising that neither the victorious colonists, with their proslavery agenda, nor the British, still a mighty slave power in the Caribbean, felt obliged to generate propaganda celebrating this first emancipation moment within the slave diaspora.[45]

It should be clear even from the necessarily scanty overview set out above that the War of Independence, and the celebration of the gift of liberty within the graphic culture of North America, were likely to generate some bizarre semiotic crosscurrents. The black slave body was figured in circuitous and obfuscatory ways. Of course, the first extended graphic works to deal with the process of bestowing freedom on Americans forced to endure the yoke of colonialism depicted not blacks but whites and native Americans. As early as 1766, North America had developed an elaborate iconography relating to the gift of freedom from Britain. The crucial point is that this tradition shut out the black slave body. The first recorded political engraving to come out of the colonies is an elaborate representation in four panels of the obelisk that was erected on Boston common to celebrate the repeal of the British Stamp Act. The 1766 print, *A View of the Obelisk erected under Liberty-Tree in Boston* (fig. 2.16), sets out the four narrative allegories that adorned each facet of a giant ithyphallic and illuminated monument.[46] Presiding over each of the narrative panels are quadruple portraits of British aristocrats, royals, and politicians deemed to be the dispensers of liberty to the colonies. Throughout the panels the colonies are represented symbolically as a native American, with a skirt of foliage and a bow and arrow. In the second of the panels this figure kneels in

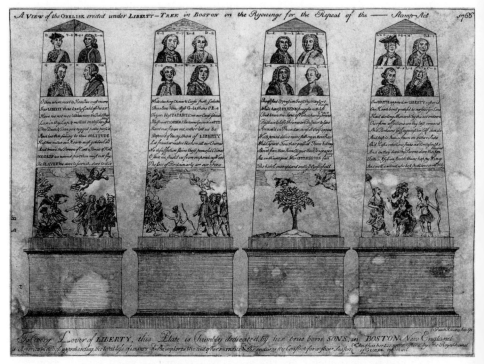

FIG. 2.16. *A View of the Obelisk erected under Liberty-Tree in Boston,*
copper engraving, 1766. Courtesy of Library of Congress, Prints and
Photographs Division, reproduction number LC-USZ62-22385.

supplication before British figures who stood out against the stamp tax and
implores protection from the enemies of liberty. The gesture of supplication
anticipates that of the slave in the Abolition Seal, yet the African American
slave body is conspicuous throughout this design by its absence.

The final panel in the print shows the symbolic native American now
standing upright with bow still in hand, being greeted by the figures of Lib-
erty and Britannia. In other words, the emblematic figures who were to popu-
late the abolition prints produced in their thousands in England to mark the
1807 slave trade bill (prints that then provided the basis for endless adapta-
tions in subsequent emancipation propaganda) had already been developed in
the context of the War of Independence. Few prints representing American
liberation seem to have survived, but those that have maintain the essential
symbolic elements of this early design. So, for example, prints evolved out of
the elaborate allegoric representation of the War of Independence by British
artist Robert Edge Pine continue to show the liberated America as a suppli-

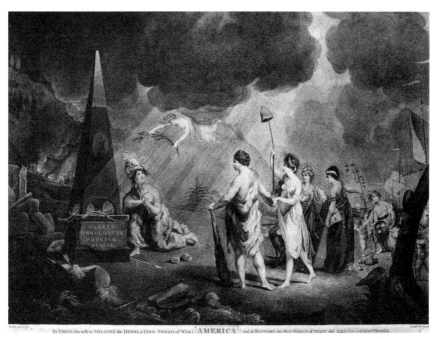

FIG. 2.17. *America: To Those Who Wish To Sheathe the Desolating Sword of War*,
copper engraving, 1781. Courtesy of Library of Congress, Prints and
Photographs Division, reproduction number LC-USZ62-15366.

cant native American female. In the 1781 engraving *America: To Those Who
Wish To Sheathe the Desolating Sword of War* (fig. 2.17), she kneels, barefoot,
wrapped in furs, with her left breast exposed, hands clasped in supplication.
The allegorical figures of Liberty, Concord, and Plenty approach her, while
the refulgent figure of Peace breaks through the clouds of war and descends
from the sky holding an olive branch. Again, this figure of America closely
anticipates the posture and attitude that were to be projected onto both male
and female slave bodies initially in the designs of the Abolition Seal.[47]

It is a sad fact that when it came to celebrations of the 1807 Slave Trade
Abolition Bill in American visual art black freedom was, in fact, savagely
ridiculed within print satire. Blacks do not seem present in North American
political graphics on the subject until 1808, and fascinatingly then they appear
in crude racist satires from the North ridiculing the black commemoration
of American abolition of the slave trade. This was traditionally celebrated
by free black communities in the Northern states on July 14, although the
date of abolition of the trade was actually January 1, 1808. Black abolition-

ists immediately became the butt of white ridicule, which manifested itself
in a tradition of racist satires known to historians of the American prints
as the "Bobalition" series. "Bobalition" (a supposed black dialect corruption
of *abolition*) prints endlessly reworked the notion that any black attempt to
talk about or formally celebrate emancipation would be ridiculous. In this
example, *Reply to Bobalition of Slavery* (fig. 2.18), the blacks are shown as po-
litically ignorant fashion victims. The text is couched in the ancient satiric
form of a letter from a country bumpkin to an urban sophisticate, but the
diction of both figures is an out-of-control black dialectal parody of white
libertarian rhetoric. There is a dark irony in the fact that these "Bobalition"
prints dominate early white representations of black freedom in political sat-
ire. To summarize: if one looks at the overall patterns of the representation of
emancipation in early American graphic art, it seems that slaves were kept out
of prints celebrating the end of the War of Independence. When blacks did
attempt to mark the American passage of the Slave Trade Abolition Bill, they
were mercilessly mocked. This tradition of mockery, which began in 1808,
reached a new level of intensity in 1832–33, perhaps coinciding with American
free black responses to British abolition.[48]

The fluctuating responses of the French nation to its involvement in slave
trading and the existence of its San Domingo plantations were to generate a
fascinating body of visual material in Paris from 1789 up until English aboli-
tion of the trade in 1807. The French context for the figure of the kneeling
slave in emancipation prints is complicated. The French revolutionary intel-
ligentsia were exposed to the first great wave of English abolition propaganda
from its originatory point in 1789, when a young Thomas Clarkson visited
the newly formed Amis des Noirs in Paris. He was equipped with substantial
packages of visual propaganda, including copies of the *Plan* of the slave ship
Brookes and versions of the Abolition Seal. His accounts, and those of people
exposed to the materials he brought, indicate the impact of this material.[49]
The Amis des Noirs were apparently behind an attempt to mass-produce
copies of the Wedgwood medallion of the Abolition Seal for French distri-
bution. This immediately aroused the horror of French administrators, who
pressured the Sèvres porcelain factory into abandoning the scheme on the
grounds that the medallions, now suitably inscribed "Ne suis-je un homme?
Un frère?" would, if sent to the French colonies, foment instant rebellion.[50]

Yet it would be a mistake to assume that French designs using the figure
of the kneeling slave were solely developed out of the English design. French
travel literature of the mid-eighteenth century contained images that seem to
anticipate, with some precision, the emancipation prints that incorporated

FIG. 2.18. *Reply to Bobalition of Slavery*, wood engraving and letterpress, 1819.
Courtesy of Library of Congress, Prints and Photographs Division,
reproduction number LC-USZ62-40669.

the image of the kneeling slave from the English Abolition Seal. Take, for
example, the upper plate from J.-A. Chambon's *Le Commerce de l'Amérique
par Marseille* (fig. 2.19). The image would appear to represent a benevolent
eighteenth-century gentleman either commiserating with a slave or embrac-
ing him, telling him what freedom means. In this sense it seems an early pre-
cursor of that body of public sculpture that was to culminate in the Lincoln
Monument in Washington. In fact, the image carried an entirely different set

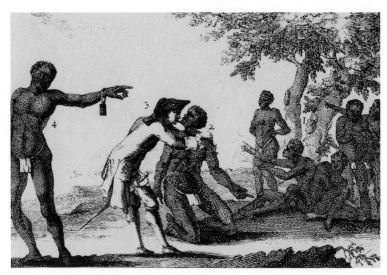

FIG. 2.19. Untitled plate from J.-A. Chambon's *Le Commerce
de l'Amérique par Marseille*, copper engraving, 1764.

of meanings and occurred in an objective account of French colonial trade
practices produced in 1764. At this date there was very little public sense,
in France or in England, that there was anything morally suspect about the
Guinea trade. What appears to be a tender embrace and a kiss, however, is
nothing of the sort. The explanatory text attached to the number 3 within the
engraving reads: "An Englishman licking a Negro's chin to ascertain his age,
& to determine from the taste of his sweat if he is sick."[51] This clearly at one
level has nothing to do with abolition philosophy. And yet it is surely trou-
bling that, in the manner in which white domination is exhibited as enforced
intimacy, the print does share a lot with the subsequent emancipation prints
and statues showing white standing males embracing kneeling black males in
order to thrust freedom upon them.

In fact, the earliest graftings of the figure of the kneeling black into vi-
sual representations of black liberation tended to introduce a white female
as the emancipator, not a male, and came not out of Britain but France and
the newly self-liberated United States. So as early as 1789 the frontispiece to
Benjamin Sigismond Frossard's *La Cause des esclaves nègres* (fig. 2.20), which
argued in abstract political terms for the abolition of the slave trade, showed
a crowned female personification of France bestowing liberty upon a group
of kneeling slaves, all of whom seem still locked in the supplicatory position

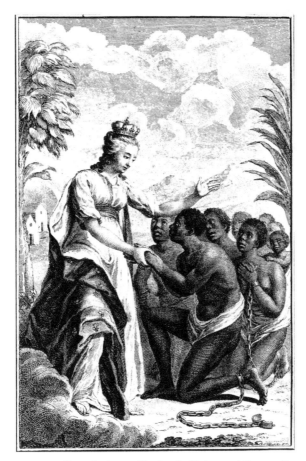

FIG. 2.20. Frontispiece to Benjamin Sigismond Frossard's
La Cause des esclaves nègres, copper engraving, 1789.

of the black in the Abolition Seal. The male figure in strict profile in the
foreground is quite precisely replicated from the Wedgwood medallion, and
although unchained his clasped hands are now locked in place by the grasping
white hand of the standing female liberator. One year later Samuel Jennings
began work on a large allegory for the Library Company of Philadelphia, *Lib-
erty Displaying the Arts and Sciences* (fig. 2.21). This big oil painting exists in a
tense relationship to libertarian rhetoric coming out of revolutionary France.
Liberty has a pole topped with a cap of liberty propped on her arm, and in
the background there is a group of blacks dancing around a tree of liberty. Yet
this untrammelled black celebration of freedom is set off against the bottom
right-hand corner of the painting, where a group of blacks kneel in submissive

FIG. 2.21. Samuel Jennings, *Liberty Displaying the Arts and Sciences*,
Library Company of Philadelphia, oil on canvas, 1792.
Courtesy of the Library Company of Philadelphia.

homage to Liberty. The kneeling black infant is, in this example, the figure
who most precisely maintains the posture and gesture of clasped outstretched
hands from the Abolition Seal. Again, while the visible chains are gone, the
slave body is still imprisoned.

Jennings's image was to provide a lasting formula when it came to the
prints produced to celebrate British abolition in 1807 and 1833. A good ex-
ample is the elaborate engraving entitled *Freedom* (fig. 2.10), which we have
already examined in the context of the liberty cap. This engraving, mass-
produced in both finely colored and black-and-white versions in 1833, takes
up the central elements developed by Jennings. Here Britannia carries a spear
with the liberty cap on top of it. She stands on a discarded whip and shackles,
and hands a sealed scroll inscribed with the single word "freedom" to a male
slave, who perfectly replicates the figure from the original Abolition Seal. As
in Jennings's design, this static, respectful figure exists as a counterbalance
to the groups of happy, dancing slaves, middle ground left and middle back-

FIG. 2.22. Frontispiece to James Montgomery, "The West Indies," in
Poems in Commemoration of the Slave Trade, copper engraving, 1809.

ground right. When the slave trade was abolished in Britain in 1807 a great
majority of the commemorative prints played out variants on this symbolic
tradition, choosing to show the black still kneeling in the position of the seal
before abstract personifications of Liberty, Justice, and Britannia. The plate
(fig. 2.22) accompanying James Montgomery's celebratory poem "The West
Indies" included in the lavish 1809 volume *Poems in Commemoration of the
Slave Trade* is a good example of the genre and may stand for literally dozens
of other prints and paintings. Britannia, physically raised on a stone platform
above the level of a slave family, consisting of husband, wife, child, and grand-
father, extends her hand to the young male, who is still locked in the familiar

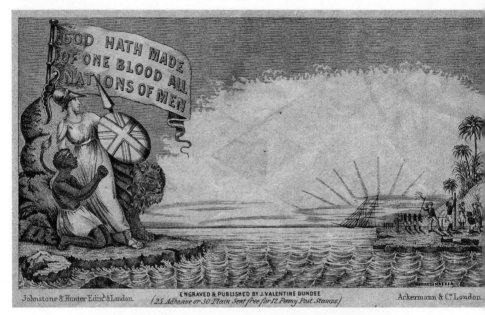

FIG. 2.23. *God Hath Made of One Blood All Nations of Men*,
abolition envelope, copper engraving, 1834.

posture. The British lion slumbers behind her, and Justice, carrying scales but
no sword, floats above the group.

When the campaign to abolish slavery in the British colonies gathered
steam in the mid-1820s, the British abolitionists mass-produced stationery
that made wide use of the figure from the Abolition Seal. So, for example,
this envelope (fig. 2.23) uses the old symbolic structures to make a striking
claim for the different statuses of Liberty on the British mainland and in
the colonies. In this engraving the left-hand part of the composition shows
Britannia with raised shield and spear protecting a supplicating black locked
in the inevitable posture, although supposedly manifesting the fact that he is
free because on British soil. The slogan "Am I not a man and a brother?" has
been changed to the biblical quotation "God hath made of one blood all na-
tions of men."[52] In the background across the sea are miniature scenes show-
ing planter atrocities against slaves. A British slave patrol ship, irradiated by
lines of divine sanction, sails across the horizon line.

The image was so ubiquitous that it was circulating as printed ephemera in
contexts where its relation to an original abolition context is difficult to deter-
mine. Take, for example, the following elaborate dinner invitation to the Lon-

don Guildhall in 1824 (fig. 2.24). The dinner was given by the Lord Mayor of London and his sheriffs and was attended by Britain's leading big business-men. The invitation that they had been sent demonstrates how abolition of the slave trade had been enshrined at the heart of an economic mythology that showed Britannia as essentially compassionate though unstoppable. Bri-tannia rises triumphant above the whole scene, extending shield and trident with her right hand and gesturing toward her heaped imperial wealth with her left. This wealth is represented by an enormous cornucopia, which spills its produce out before kneeling black and white infants. The white infant confidently turns his back on the National Matriarch, and clasps a large globe with his right hand. Immediately above the white hand and globe stretches the Thames, with St. Paul's rising on its far bank. The black infant is seen in three-quarter profile from the back. He gazes in supplication and awe at the figures of Britannia and Justice, who reclines on a mighty sword to Britannia's lower right. He adopts precisely the same posture as the slave in the Abolition Seal. With nearly one million slaves still laboring in the British sugar colonies, the status of this black child is ambiguous. Is this little black boy a freed slave, triumphantly liberated by the bill of 1807, or a slave awaiting his freedom in the British Caribbean, or even an African child waiting and watching as Britannia expands relentlessly into Africa? He may be all of these things, but if we set him against the iconography that greeted the abolition of slavery in 1807 he seems firmly contained within the parameters of popular graphic imagination. He is exactly what the British business community hoped he would be: grateful, supplicatory, undemanding, and passive.

The adaptations and variants of the black male and female from the Aboli-tion Seal were to continue to proliferate within a great variety of abolition vi-sual propaganda on both sides of the Atlantic up to and beyond 1865. Yet it is important to note that the image also generated another adaptive tributary in popular art dealing with the expression of freedom. In British graphic culture the earliest adaptation of the Abolition Seal within debates around eman-cipation involved what was to become a classic proslavery gesture of iconic substitution. In 1789, just at the moment when the Abolition Seal in the form of a Wedgwood medallion had gained wide popular currency, a primitive and anonymous satiric etching appeared entitled *Abolition of the Slave Trade, or The Man the Master* (fig. 2.25). A white man, kneeling in the posture of the black from the Abolition Seal and naked except for a bizarrely elaborate loincloth, screams in pain. A black in gentleman's attire grabs the white man's long, unkempt hair with one hand and holds aloft in the other a large length

FIG. 2.24. Dinner invitation to Guildhall, copper engraving, 1824.

of thick sugarcane. This print, and its fellows, were based on a sort of graphic scare-mongering that refused the reassuring visual rhetoric of British abolition. A whole string of subsequent prints would use the iconography of the seal to suggest that the suffering of the white laboring classes in Britain was being overlooked at the expense of sympathy for the colonial slave. So, for example, William Hone and George Cruikshank's notorious parodic medal (fig. 2.26) brought out in response to the Peterloo Massacre in Manchester in 1819 took up the inheritance of the Abolition Seal in complicated ways. Although this powerful work undoubtedly brings into dramatic focus the plight of northern textile workers, it does so at the expense of the absent black.[53]

It is ironic that it was, among British radicals, the wonderful proto-feminist firebrand Elizabeth Heyrick who provided one of the only reinterpretations of the Abolition Seal to place an autonomous black slave at the center.[54] Heyrick's pamphlet *Immediate, not Gradual Abolition* carried a frontispiece (fig. 2.27) showing a confident, upstanding black man, with arm outstretched in the gesture (as we have seen from the Schoelcher statue) customarily reserved for the white emancipator. The slave stands in a tropical landscape before a plantation with a long whip and shackles on the ground at his feet. Below him is the tremendous sentence "I am a man, your brother," which in one daring move decimates the interrogative double negative of the original slogan. By substituting "your brother" for "a brother" this powerful phrase enforces intimacy between black and white. It is most significant that it was a radical female consciousness that finally swept away the sinister shroud of negativity in which the statement of black equality had been so comfortably shrouded for three decades. Yet despite Heyrick's valiant attempts to transform both the word and image of the Abolition Seal, the original remained the most long-lived and effective package allowing white audiences to imagine freed slaves.

In this context the words were as important as the image, and it is consequently worth dwelling on the precise terms of a formula that so perfectly encapsulated the conditions under which black freedom was allowed to ask for its right to be. In any context there is a vast amount at stake in the simple inversion of the two words *I* and *am*. "I am" proclaims its vitality; "Am I?" asks to be assured that it is alive. The slave is asking what is for the white audience a real question, and one that influential white intellectuals in Britain were still answering in the negative in the mid-nineteenth century. Take, for example, the brutally frank Negrophobia of William Makepeace Thackeray, who, touring the United States as the Civil War was about to explode, medi-

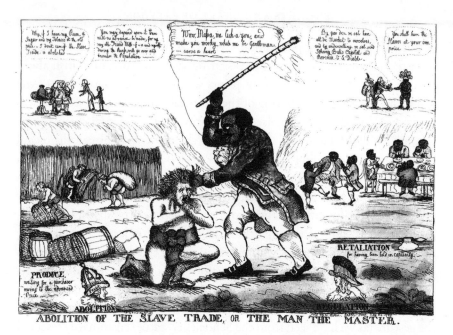

FIG. 2.25. *Abolition of the Slave Trade, or The Man the Master*, etching, 1789.

FIG. 2.26.
George Cruikshank,
Peterloo Medal, wood
engraving, 1819.

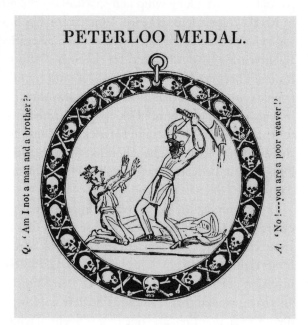

IMMEDIATE,

NOT GRADUAL

ABOLITION;

OR,

AN INQUIRY

INTO THE SHORTEST, SAFEST, AND MOST EFFECTUAL MEANS OF GETTING RID OF

𝔚𝔢𝔰𝔱=𝔍𝔫𝔡𝔦𝔞𝔫 𝔖𝔩𝔞𝔳𝔢𝔯𝔶.

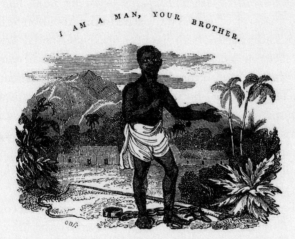

I AM A MAN, YOUR BROTHER.

" He hath made of one blood all nations of men."—*Acts* xvii. 26.

LONDON:

Printed by R. Clay, Devonshire-street, Bishopsgate.

SOLD BY

F. WESTLEY, 10, STATIONERS' COURT; & S. BURTON, 156, LEADENHALL STREET;

AND BY ALL BOOKSELLERS AND NEWSMEN.

[*Price Twopence, or* 1s. 6d. *per dozen.*]

FIG. 2.27. *I am a Man, your Brother*, title page to Elizabeth Heyrick's *Immediate, not Gradual Abolition*, wood engraving, 1825.

tated upon the status of the black slave: "They are not my men and brethren, these strange people with retreating foreheads, and with great obtruding lips and jaws.... Sambo is not my man and brother."[55] When it comes to thinking through the basics of his relation to black people, Thackeray's racism instinctively takes cover in and asserts its legitimacy by going back to the terms of the renowned question on the Abolition Seal. For Thackeray, this is not a rhetorical question, but a real question that can only be answered with an emphatic negative.

Throughout the middle decades of the nineteenth century there remained a graphic tradition that pictured the emancipated slave in terms of degraded victimhood. This tradition generated some of the most extreme and negative variations on the imagery of the Abolition Seal. Take, for example, a lithograph from the early 1830s, *An Emancipated Negro* (fig. 2.28). The figure is a compositional masterpiece. It is as if the slave in the Abolition Seal has been raised from his knees and his body has been attenuated and dried out. This moving black skeleton operates compositionally on a powerful diagonal running from the foot in the bottom left corner to the desperate fingertips in the top right. The profile is a horrible example of the stylistic distortions of nineteenth-century racialism — vast fleshy lips, concave nose, and colossal mandible. This black figure is a sneering development of the kneeling slave from the Abolition Seal. Armed, liberated from his chains, this figure no longer asks us to identify him as human. His language has been reduced to an atavistic level, where thought and action are fused. As he shouts out "Food" rather than "Freedom," he simultaneously sees and pursues the concept that controls him. This emancipated slave has no interest in whether we see him as a man or a brother; his entire existence has been reduced to avoiding starvation. Of course, the implicit message buried within that grotesque race stereotyping is precisely that enunciated so brutally by Thackeray. This specimen is not a man and a brother, and therefore his liberation was a game not worth the candle.

PUNCH AND THE CHAOTIC LEGACY OF THE ABOLITION SEAL

"Am I not a man and a brother?" was not a question that went away. England in postemancipation phase would not let go of either the image or the aphorism on its most notorious abolition emblem. The seal provided unending opportunities for attacking both British politicians and foreign governments

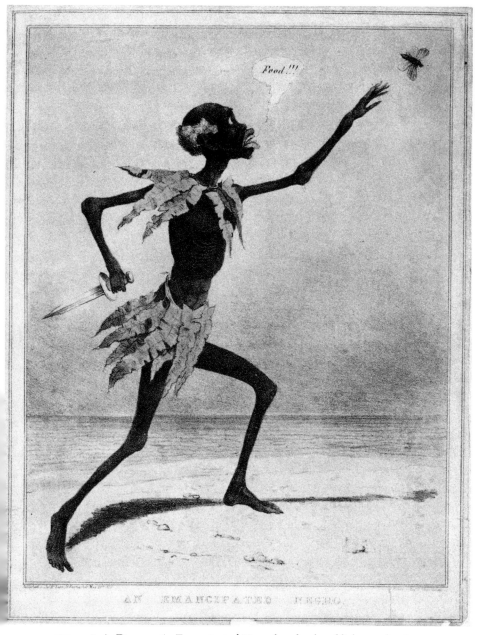

FIG. 2.28. A. Ducote, *An Emancipated Negro*, hand-colored lithograph, 1833.

over a variety of human rights agendas, of which the continuation of slavery
was only one. The icon was evolved out of the spirit of busy but sentimen-
tal evangelical philanthropy at the end of the eighteenth century, but it was
reared and culturally embedded within Anglo-American graphic discourses
in the later nineteenth. There is not space here to run through the myriad
adaptations of the seal in the popular illustrated journalism of nineteenth-
century Europe and America. Indeed, the topic would furnish material for a
fascinating comparative study. I will conclude this meditation on the image
by taking some readings from that barometer of the opinions of the Victorian
prospering classes, *Punch, or the London Charivari*. Isolating just a few of the
more spectacular single-page feature prints that followed 1833, one gets some
idea of the adaptability of this image and of how it had become a cultural
shorthand for thinking about, or rather ingeniously avoiding, the genuine
suffering of colonized peoples.

When in 1848 Lord Brougham, secretary of the Anti-Slavery Society, failed
to turn up at the anniversary meeting to commemorate the emancipation
bill at Exeter Hall, *Punch* saw a terrible dereliction of duty. The print they
produced to mark their feelings (fig. 2.29) shows how, early on, the memory of
British slavery had now been officially enshrined within the successive dates
of its abolition. If slavery continued as an evil, then it was one perpetrated by
other corrupt nations who had not followed Britain's lead in ending it. The
abolition of slavery was consequently a sacred site, the grand memorial site
at which a national evil was overwritten by a national triumph. Brougham
in tartan trews and a topper thumbs his nose at *Punch*'s readers as he shuns
Exeter Hall in favor of a meeting of the Privy Council. He leaves behind him,
still frozen in the posture and chains of the original 1788 seal, the supplicating
black, who continues to ask, "Am I not a man and a brother?" The implication
is that to Brougham he is not a man and a brother, but to the decent reader
he is, in principle anyway. The anniversary of abolition is not just an occasion
to remember past suffering, but for the British to praise themselves at the
expense of others and to crack down on the continued slavery activities of
the Americans, Spanish, Brazilians, French, and Portuguese. In shunning his
responsibilities Brougham is neglecting a national treasure, the abolition in-
heritance of Wilberforce and Clarkson. The seal of the SEAST in this context
instantaneously calls up the entire inherited weight of British abolition, but
has lost its impact as an emblem specifically designed to raise national con-
sciousness of a terrible national failing. The print testifies to the manner in
which the propaganda of the SEAST could become, after the British abolition

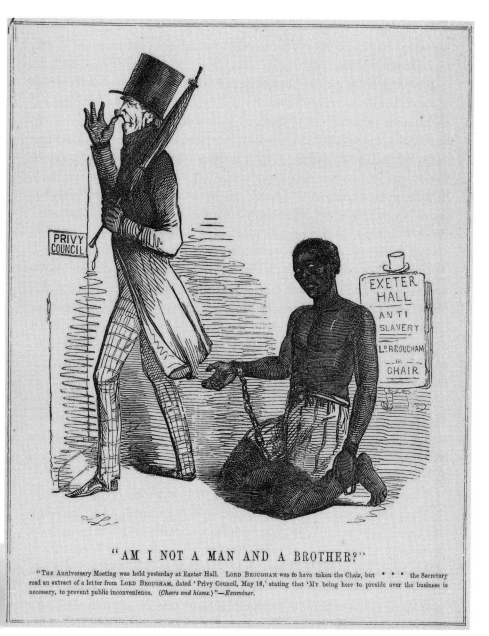

"AM I NOT A MAN AND A BROTHER?"

"The Anniversary Meeting was held yesterday at Exeter Hall. Lord Brougham was to have taken the Chair, but * * * the Secretary read an extract of a letter from Lord Brougham, dated 'Privy Council, May 16,' stating that 'My being here to preside over the business is necessary, to prevent public inconvenience. (*Cheers and hisses.*)"—*Examiner.*

FIG. 2.29. "Am I Not a Man and a Brother?" *Punch*, wood engraving, 1848.

legislation had been passed, the iconographic jewel in the crown of British moral triumphalism.

British gloating over its moral superiority was to reach remarkable levels of self-inflation when *Punch* came to mull over the American Civil War and the continuation of slavery.[56] But even before this the inheritance of abolition propaganda was often called upon when Anglo-British political tensions emerged. So in 1856 the tension between the Franklin Pierce administration and Britain over shipping and trade agreements, which at one point held the distant prospect of a naval war, was characterized in the following print, "Come, Jonathan, Why Should We Fight —'Am I Not a Man and a Brother?'" (fig. 2.30) A robust figure of John Bull with sword and pistol in his belt stretches out his hand to a stringy, distrustful figure in stars-and-stripes-flared-trousers smoking a cheroot. This is brother Jonathan, or the United States, and the crucial detail in his representation is that a slave whip sticks out from his tail coat pocket. In this scenario John Bull outrageously takes on the persona of persecuted slave, while the implication is clearly that as long as the United States tolerates slavery within the Union, there is no hope that it will be able to understand the humanitarian and egalitarian motives of Great Britain. What is fascinating here is that abolition, symbolized by the SEAST seal, seems to lie behind the entire moral platform of Britain. The moral transformation symbolized initially in the abolition campaigning, and then the fact of successive abolition legislation, is the one thing that completely separates an enlightened British constitutional monarchy from a darkly compromised American slave Union.

When in November 1858 it was rumored that France had designs to reopen the slave trade and to get an officially unwilling Portugal to join in, *Punch* met events with another full-page print featuring the words and image from the SEAST seal (fig. 2.31). In "Poor Consolation" an overdressed French officer stands over a cowering black slave and a Portuguese male. Both figures kneel and are enchained and look out sadly as the Parisian states, "Courage mon ami; 'Am I not a man and a brother?'" Things have clearly shifted about a bit. Now it no longer needs to be asked or asserted whether the black man is a human or not. The question has been ironically recast in the mouth of the cocky Frenchman, and the answer *Punch*'s readers are expected to give is, "No, you are not a man and a brother, you are a bloody Frenchman." The short article accompanying the print makes it apparent that the French, while they may lead European fashions in dance and clothing, should not be allowed to see the reimposition of the slave trade as merely another fad:

COME, JONATHAN, WHY SHOULD WE FIGHT—"AM I NOT A MAN, AND A BROTHER?"

FIG. 2.30. "Come, Jonathan, Why Should We Fight —'Am I Not a Man and a Brother?'" *Punch*, wood engraving, 1856.

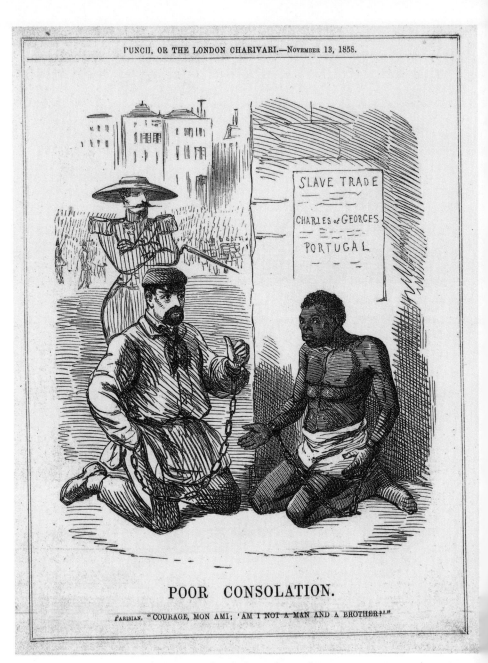

FIG. 2.31. "Poor Consolation," *Punch*, wood engraving, 1858.

France has determined to resume the slave-trade: let Europe accept the slave trade as no longer piracy. Because France is allowed to impose quadrilles on the human race, the Imperial government believes that it has only to compel her to dance in fetters to oblige all nations to load themselves in chains and caper after her.[57]

Again, the underlying agenda is that Britain as the guardian of antislavery globally is also the global guardian of morality. By owning abolition Britain owns international human rights, and in this sense emancipation propaganda has started to evolve a colossal remit.

The final irony, however, was that, as the century progressed *Punch* was to use the SEAST seal in a series of condemnatory scenarios that looked straight back to proslavery propaganda first originated in the context of late eighteenth- and early nineteenth-century opposition to abolition. So, for example, British economic and missionary colonization of Africa was set against the suffering of British children laboring in the factories. The central device within the 1865 satire "Telescopic Philanthropy" was yet another play on the SEAST seal (fig. 2.32). Britannia stands at the dock looking through a telescope while starving, ragged children covered in industrial smut ask, "Please 'm, ain't we black enough to be cared for?" Extreme Negrophobes, most notoriously William Cobbett and then Thomas Carlyle, had been making more or less the same argument for decades. There was a long-standing tradition that united both political Right and Left and that saw abolition as nothing more than a piece of political chicanery designed to obfuscate the suffering of the emergent industrialized poor at home. The antislavery seal, as is evidenced in the discussion above, had been ironically appropriated by Hone and Cruikshank to plead the case of the industrial weavers at the time of Peterloo. *Punch*'s print was accompanied by a poem that makes explicit the extent to which the image upholds the earlier radical satires, while it also exists in parodic dialogue with the SEAST seal and its inheritance:

> Ain't I black enough to be cared for?
> I'm not a black nigger, 'tis true,
> As armies and fleets is prepared for,
> And missionaries is sent to.
> But I'm black as dirt can well make me,
> And, if by the look of my skin,

> You'd nigh for a blackamoor take me
> I'm not so much lighter within.
>
> ... We're wery much like one another,
> We are, arter all's said and done.
> If he is a man and a brother,
> Why ain't I a boy and a son?[58]

The children in this print relate in telling ways to the enchained and abstracted passivity of their black graphic progenitor. They are not physically chained; their confinement comes through the exhaustion and sickness of poverty and overwork. They do not seek affirmation of their free or human status but the attention of their distracted mother. Here a domestic human rights agenda is argued through an implicit racism, while the whole thing is enshrined within the metaphorics of parenthood and the family. The disguised accusation is that if Britannia is capable of achieving freedom for her black slave populations, how can she stand distractedly by while her white infants are starved and worked to death in the factories? And yet as ever in this sort of work the rights of white infants cannot be claimed without suggesting that the rights of the slave were never quite as important.

It is appropriate that the last full-page satire that *Punch* devoted to the SEAST seal involved a remarkably revisionist and full-blooded attempt to defend the rights of the dispossessed white Jamaican planter class in the wake of the disastrous Eyre Affair. As knowledge of the full horrors of the aftermath and the excessive violence used to put the "rebellion" down seeped into the public sphere, sympathy for the Jamaican planters began to drain despite Governor Eyre's vindication within the British courts.[59] *Punch* didn't care for the way things were going and in "The Jamaica Question" (fig. 2.33) once again drew on the hidden powers of the SEAST seal to try and turn things around.

Here a black fieldhand walks off hand in hand with a British government functionary while a bemused planter reaches out and exclaims, "Am not *I* a man and a brother too, Mr. Stiggins?" And so it seems within the strange currency of graphic propaganda meaning has finally been rubbed smooth and original political context has all but disappeared. With a feeling that the gesture is wholly appropriate, the most famous aphorism ever devised by sentimental British philanthropy to protect the humanity of the abstracted slave is put into the mouth of the white colonizer. The argument is a simple one precisely mirrored in many contemporary tracts, most notoriously Carlyle's "On the Nigger Question?" and is elaborated again in verse:

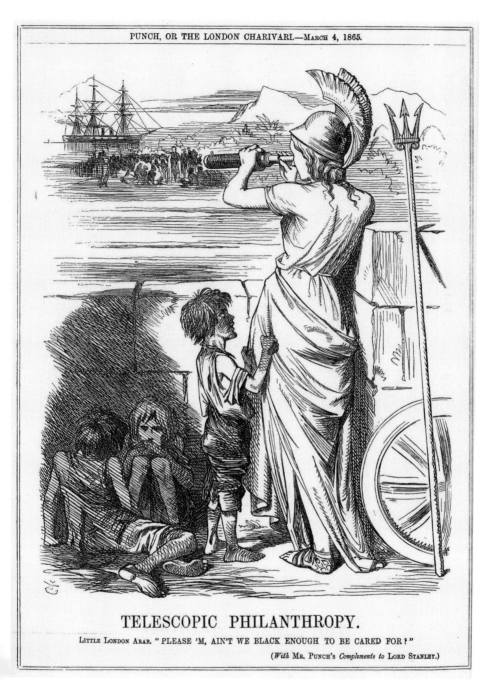

TELESCOPIC PHILANTHROPY.

Little London Arab. "PLEASE 'M, AIN'T WE BLACK ENOUGH TO BE CARED FOR?"

(*With* Mr. Punch's *Compliments to* Lord Stanley.)

FIG. 2.32. "Telescopic Philanthropy," *Punch*, wood engraving, 1865.

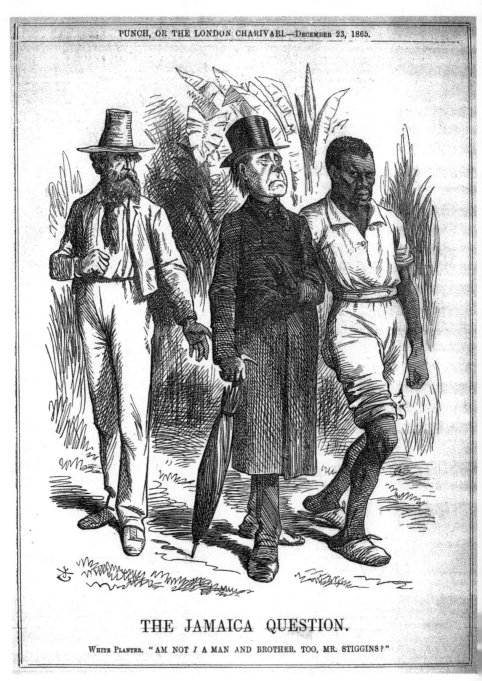

THE JAMAICA QUESTION.

White Planter. "AM NOT *I* A MAN AND BROTHER, TOO, MR. STIGGINS?"

FIG. 2.33. "The Jamaica Question," *Punch*, wood engraving, 1863.

> Does human kindness drain its cup
> For black and whitey-brown,
> That still you cry the darkey up
> And bawl the planter down?
>
> ... Then lay your suit of sables by,
> Black predilections smother,
> And listen to the *white-man's* cry —
> Am not *I* man and brother?[60]

When it comes to owning and exploiting the brand names, logos, and slogans developed in the name of abolition, the British seem to have a peculiar gift for imaginative laxity. And when it comes to looking at the recirculation of the Abolition Seal, the whirligig of time does seem to have brought in some uncommon revenges and will no doubt bring in many more.

3

Pragmatic Popular Propagations
of the Emancipation Moment

Freedom, like love, must be conquered for ourselves afresh every day.
The battle for Freedom is never done; that field is never quiet. Beside
the obvious and professional foes — the dictators, slave-owners, despots,
profiteers, inquisitors, and censors — we can dimly discern innumerable
hosts that work against freedom as white ants which labour always
in the darkness of galleries morticed by their own spittle — the
scandal-mongers, the cowards of habit, the devotees of
authority, and the semi-animate Robots of routine.
— Henry Nevinson, *England's Voice of Freedom*

HOW DID AND HOW DO the slave powers remember slavery, and how central did 1807 remain to these processes prior to the 2007 bicentenary? As indicated in the first chapter and the conclusion to this book, the 1807 act was a compromised, corrupt, and confused piece of legislation.[1] Substantial British capital continued to finance shipping across the Atlantic slave systems, while abuses over the head money for Africans claimed at sea and over the conscription of soldier-slaves meant that British involvement in the international slave trade was very far from over in 1807.[2] The central subject of this book is not, however, what really happened after 1807, but what the British people wanted to believe had happened. This chapter consequently takes several areas of popular cultural production, from school textbooks and coffee-table history books to after-dinner speeches, popular prints, and emancipation theatricals, in order to think about how emancipation was encoded for a mass market.

1807 IN THE CLASSROOM: TEXTBOOK EMANCIPATION

History textbooks, and particularly school textbooks, with their mandate for stupendous abbreviation and their tendency to lay out platitudes with economy, can be helpful when it comes to gauging the popular ingestion, and subsequent digestion, of big cultural myths. Slavery never got very much room in British school histories before 1950, and the room that the subject did get was mainly reserved for the abolitionists. And yet for those who believe in significant silence this can make things all the more interesting. In the following four accounts of the history of British slavery and its cessation from widely used textbooks spread over a period of nearly a century, certain constants clearly emerge. Here is David Hume's account in 1875:

> A little before the dismissal of Lord Grenville the abolition of the slave trade had been carried. That question had now been twenty years in agitation. A society had been formed for its promotion of which Mr. Granville Sharpe was Chairman and of which Mr. William Wilberforce and Mr. Clarkson were distinguished members. The inhuman traffic had been denounced by several authors, but it required the zeal and enthusiasm of the evangelical party, which had sprung up of late years, to effect its abolition. The society adopted every means by newspaper articles, pamphlets, speeches et. c to influence the public mind on the subject. Pitt approved the cause and a board of the Privy Council had been formed to consider the state of the African trade; but the commercial interests of the country offered a great impediment, and all that could be obtained at first was a mitigation of the horrors of the middle passage.[3]

For Hume the bill's importance was primarily as a demonstration of the force of evangelical moral vision and of the potency of the British media as a propaganda tool. By this date the slaves have been all but airbrushed out of the picture and a bland euphemistic linguistic currency is firmly established to deal with mass trauma. We have "the inhuman traffic" (which is, in fact, an all too human traffic) and "the horrors of the middle passage," an abstract phrase that by naming horror with such a casual generality has cleverly avoided any imaginative engagement with human suffering. Perhaps most sinister of all is the presence of William Pitt the Younger, who, we are told bluntly, "approved the cause." Of course, Pitt did initially approve it, as long as Wilberforce acted as the front man, but he then reneged and by the end of British involvement in the San Domingo revolution he had revealed himself as a politician capable

of almost anything when it came to playing with slavery policy.[4] But standard school history textbooks came to name him alongside the sacred abolition triumvirate of Sharp, Wilberforce, and Thomas Clarkson. Poor Charles James Fox, who did at one point genuinely turn to the opposition of slavery and the slave trade and who stuck to the position, makes no appearance.[5]

At the turn of the century Osmond Airy, the hugely successful manufacturer of school histories, produced a breakneck account of the place of slavery in British history that reduces the whole business to a business. He is only interested in a few facts and figures:

> In 1788 began the slave trade agitation. Granville Sharp, Clarkson, Wilberforce, and Macaulay exposed its appalling horrors. In 1804 the House of Commons agreed to prohibit the traffic for a time, but this did not pass the Lords. The victory was not won until 1807 when the trade was declared illegal; the emancipation of negroes throughout British territory was not completed until 1833.[6]

Wilberforce, Clarkson, and Sharp remain at the center of the picture, with Zachary Macaulay added, and they are framed by the dates 1788, 1807, and 1833. Slavery's dateline runs from the establishment of the Society for Effecting the Abolition of the British Slave Trade, to the Slave Trade Abolition Bill, which leads seamlessly into the Colonial Slave Bill, which is seen to bring slavery to an abrupt end. A fatal belief in fantastic finalities is the price history pays for the fetishization of inception and cessation dates.

By the time we get to George Macaulay Trevelyan, who composed a nervy national history that attempted to maintain the confidence of empire in interwar Europe, the story has developed. Wilberforce has emerged as a benevolent superhero:

> It was a turning-point in the history of the world when William Wilberforce and his friends succeeded in arousing the conscience of the British people to stop the slave trade in 1807, and to abolish slavery in the Empire in 1833, just before the development of the interior of Africa by the European races began. If slavery and the slave trade had continued through the nineteenth Century, armed with the new weapons of the Industrial Revolution and of modern science, the tropics would have become a vast slave farm for white exploitation, and the European races in their own homes would have been degraded by the diseases of slave-civilization of which the old Roman Empire had died.[7]

In this essentialized discourse Wilberforce, like some antislavery cuckoo in the nest, has turfed out his competitors, and the whole pantheon of abolition

leaders exist simply as the "friends" of the Pittite Member of Parliament for Hull. While they have disappeared, the bill itself has been magnified and is now not just a piece of maritime trade legislation, couched in the most impenetrable legal jargon, but a "turning point in the history of the world." The thesis justifying this elevation is a revealing one. The 1807 act, we are told, led to the 1833 act and the 1833 act miraculously happened just as Europe was about to spring into the African continent. Trevelyan's thesis is that 1807 and 1833 saved Africa (which is revealingly constructed as an entirely "tropical" continent) from becoming a "vast slave farm for white exploitation." The history recited here contends, in a voice of high reason, that Wilberforce single-handedly prevented Africa from being enslaved by Europe.

The brilliance of this rhetoric lies in the way it shuts out historical truth by positing that truth as a rejected fiction. The grammatical formula "If X had not happened, then Y would have happened" assumes that Y has not happened. But if X constitutes the two abolition bills of 1807 and 1833 and Y is the conversion of Africa into a "vast slave farm for white exploitation," we seem to be dealing with a rampant piece of logic chopping. In reality is it not the case that Africa, wherever it was overrun by European capitalist interests in the second half the nineteenth century, did convert into a vast resource of slave labor for the whites? Slave codes did not exist and slavery was not legislatively acknowledged, but as every young fieldworker for Anti-Slavery International knows, capitalism, wage-slavery, and debt-bondage prefer neither to define nor to advertise themselves; indeed, they remain the forms of exploitation that dare not speak their names.[8] The final rhetorical flourish puts Wilberforce in an even more peculiar position. Trevelyan finishes off with an ingenious final argument, the main gist of which is that the primary benefit of the abolition bills lay not in saving the slaves nor in preventing the establishment of Africa as a slave continent, but in the way they prevented Britain from drowning in a slough of colonial excess. Creating a bizarre theory of trickle-down morality, Trevelyan contends that had slavery continued and had Britain enslaved Africa, then the resultant wealth would have paralyzed and corrupted the British and the empire would have sunk in its own rottenness, run, apparently, by latter-day Neros and Caligulas. Wilberforce, an active and vicious campaigner against all forms of domestic vice among the lower orders and an inveterate enemy of the rights of the poor to enjoy themselves, would undoubtedly have been delighted at this latest construction of his moral force.

It may seem hard to take Trevelyan's hyperbolic construction of Wilberforce and 1807 seriously, yet it has remained disconcertingly powerful. The

myth that abolition agitation and the victory of 1807 was a defining moment
in the awakening of British, indeed world, moral consciousness continued to
lie, in both senses of the word, at the heart of school histories. The leading
imperial theorists of the twentieth century would summarize the relevance of
1807 in familiar language:

> [The law abolishing the slave trade] had made an effective entry into that
> vast field covered by the relations between the white and coloured peoples of
> the British Empire. . . . The "Saints" by single minded devotion to one cause,
> through the dark days of war, anti-Jacobinism, unpopularity and personal
> abuse, had achieved the first and hardest step towards the destruction of an evil
> seemingly indestructible, had awakened the conscience of the British people
> and planted a humanitarian tradition in the heart of British politics.[9]

In this scenario, 1807 becomes the benchmark for defining the British instinct
for imperial benevolence and paternalistic philanthropy. The theory of impe-
rial trusteeship, which was so dominant throughout the nineteenth century
and which is now so strangely neglected by historians of empire and post-
colonial theorists alike, found its point of departure in the 1807 bill.[10] This
was the moment the British proved themselves capable of loving colonization
— when they admitted that with the creation of an imperial family came the
responsibilities of parenthood for patriarch and matriarch alike.

The basic structure for this version of events has not only remained intact,
but if anything has bourgeoned into even more bizarre forms of sentimental
excess. That most popular of current popular historians, Simon Schama, en-
grafted his loquaciousness onto the tall tale of the 1807 act as recently as 2005.
Schama warns in "Endings Beginnings," the preciously entitled epilogue to
Rough Crossings: Britain, the Slaves, and the American Revolution, that "his-
tories never end, they merely pause their prose. Their stories . . . are, if they are
truthful, untidy affairs resistant to windings up and sortings-out."[11] Yet there
is nothing untidy or truthful about his potted account of the 1807 slave trade
act, which "winds things up" and "sorts things out" in a manner that would
not have ruffled the feathers of Trevelyan and that would have delighted the
most extreme celebrant of British imperial trusteeship at the turn of the nine-
teenth century:

> Introducing a "Bill for the Abolition of the Slave Trade" in the House of Lords,
> Lord Grenville proclaimed that its enactment would be "one of the most glo-
> rious acts that had ever been undertaken by any assembly of any nation in

the world." In the Commons, with the bill's passage a certainty, the Solicitor general contrasted the guilty conscience of Napoleon Bonaparte as he retired to bed, with Wilberforce "in the bosom of his happy and delighted family" sleeping with a perfect conscience in the knowledge that he had preserved the lives of millions of his fellow creatures. . . . On the 25th March George III gave the royal assent. After the 1st of January 1808 it would be unlawful for any British ship to carry slaves, nor could any be landed in other ships in the dominion of the British Empire.[12]

As far as I can determine, this was written in all seriousness and is not intended as parodic satire. The voice of moral jingoism appears to be perfectly intact. We are invited to continue to see Britain's investment in the slave trade as relevant quite simply because it enabled the British to create an act claiming to end it, "one of the most glorious acts that has ever been undertaken." We are invited to invest in a falsehood, namely, that after 1808 it would be impossible for any ship to carry slaves "in the dominions of the British Empire." We are invited to indulge in an almost hysterical paternalistic fantasy that shuts out slave culture and slave experience and to envision Wilberforce, and his "perfect conscience," absurdly reclining "in the bosom of his happy and delighted family." And we are invited to take the fantasy further and envision Wilberforce, as he falls back in self-congratulation, dreaming about how he, personally and in a rather God-like way, has actually given life to "millions" of black "creatures." And the final insult is that we are invited to frame this fantasy within one of the time-honored pastimes of atavistic British nationalism, namely, Napoleon-bashing. That these words (written according to the self-pleasuring back cover of *Rough Crossings* by "the leading historian of our times" and flogged to an all too gullible reading public by Schama's vast publicity machine) could pretend to be a serious account of the 1807 slave trade act was a fact that did not augur well for what was to happen around slavery and commemoration in 2007.

MORAL MELODRAMAS:
EMANCIPATION AS DOMESTIC THEATER

The year 1807 engendered a wave of writings, engravings, paintings, and sculptures that projected a colossal protectionist mythology embedded in an unquestionable and unquenchable benevolence. In colored engravings, on plates and party invitations, enormous maternal allegoric figures of Britannia and British Justice embraced their liberated black children, while refulgent sun-

shine decimated the clouds hanging over the dark monster of slavery.[13] Now
that the slave trade was abolished it needed to be built up as the quintessence
of evil. If Britain's moral crusade against the "execrable traffic," the "inhuman
traffic," was to have real stature, then the slave trade needed to be a satanic foe
worth fighting. Suddenly the slave trade needed to emerge as something worse
than the abolitionist's worst nightmare, an incubus of colonial wickedness. In
the harsh glare of the abolition moment everything became polarized. If you
got rid of the black slave trade at a stroke, then what you were left with was a
glorious British navy, dedicated to protecting the slave and developing British
imperial trade interests globally, under a self-righteous banner of liberation
in a moral world that was whiter than white. No wonder Britain grounded
its new myths of good and bad imperial practice in such jaw-breakingly crude
imagery. No wonder Britain publicized these fictions with such ferocity. No
wonder that they remained so firmly implanted within the popular culture
and education of the nation.

From the moment the clocks struck twelve on August 1, 1834, the myth
was in place that freedom had been mystically given. Fifty-four years later, in
1888, the year of the Golden Law finally claiming to abolish slavery in Bra-
zil, the prince of Wales, newly instituted as chief patron of the British and
Foreign Anti-Slavery Society, addressed a packed audience in the guildhall
of the city of London at the Anti-Slavery Jubilee. He told the story as it had
been told for a half century and as it was to be told for another half century.
The substance of the speech consisted of a simplistic reduction into prose of
the massed propagandas that had enshrined the myth of the emancipation
moment. The tale is now a cyclical one. Everything begins and ends with
Clarkson, Wilberforce, and 1807:

> Principally owing to the indefatigable exertions of the undaunted Thomas
> Clarkson and his great Parliamentary coadjutor William Wilberforce, the
> Slave-trade and the untold horrors of the middle passage were, as far as Great
> Britain was concerned, put an end to in the year 1807. The majority, therefore,
> of the Slaves in the West Indian Islands who received the benefit of the Eman-
> cipation Act were descendents of those Africans who had been originally torn
> from the forests of Africa. Speaking of the proclamation of the emancipation
> of the Slaves in the colonies, Mr. Buxton said: "Throughout the colonies the
> churches and chapels had been thrown open, and the Slaves had crowded into
> them on the evening of the 31st July 1834. As the hour of midnight approached
> they fell upon their knees, and awaited the solemn moment, all hushed, silent

and prepared. When twelve o'clock sounded from the chapel bells they sprang upon their feet, and through every island rang glad sounds of thanksgiving to the father of all, for the chains were broken and the Slaves were free."[14]

The prince concluded his oration with these words: "The negroes in the West Indies look back to the 1st of August 1834, as the Birthday of their race. The emancipation Act which on that day came into force spoke the doom of slavery all round the world."[15] For Cardinal Manning, who spoke immediately after the prince, the inheritance of slavery was a triumphant and sacred trust inherited from Britain's liberty-loving ancestors: "I know no people on the face of the earth bound by such strict obligations to give freedom to men as we are. We are bound by the liberty which is an heirloom from our ancestors; the liberty of our own land in which Slavery became extinct and serfdom could not survive; on the coast of England, if a slave set his foot, he is free. 'The Slave cannot breathe in England' for the first vital draught of English air makes him free."[16] The publication ends with an interview with the secretary of the Anti-Slavery Society, C. H. Allen, in which he completes the symbolic landscape of the emancipation moment by presenting slavery through the metaphoric language of disease and monstrosity again so familiar from the print culture of the 1830s:

> "August 1st 1834 was a great day for England and for humanity," said Mr. Allen, "and the popular rejoicings which took place on that occasion are among the most vivid recollections of my boyhood. Slavery was a terrible reality to us in those days, a monster, the horror and the shame of which was keenly felt by the nation. . . . Slavery is to Englishmen a thing with which they have no personal concern. Its moral leprosy does not cleave to our garments, and we are therefore supposed to be free from any necessity to bestir ourselves in the matter. We paid £ 20,000,000. We liberated our slaves. That was our share. Let other nations follow our example. We have done enough."[17]

Those final four staccato sentences sum up with a chilling economy what had become the orthodox British assumption of the moral high ground. The position is complacent, unreasoning, and, as far as the British were and to a disconcerting extent still are concerned, impregnable.

The huge British investment in the redemptive capacities of the 1807 and 1833 emancipation legislation paid transatlantic dividends. This emerges clearly in the following words, which show the compromised legislation of the 1833 act reconstructed with transcendental enthusiasm by the Anglophile

Ralph Waldo Emerson as "an event singular in the history of civilisation; a day of reason; of the clear light; of that which makes us better than a flock of birds and beasts; a day, which gave the immense fortification of a fact, — of gross history — to ethical abstraction."[18] Of course the facts were in reality rather different for the apprentices, and their historical situation completely gross. Yet this did not stop a full-fledged set of American celebratory variants on the English abolition acts emerging in the East Coast states in the twenty-five years running up to the Civil War.[19]

Moving back to England and moving on another fifty years, we find that the redemptive philosophy of moral improvement is still in place. A fine example of how completely white abolitionists had become the custodians of the myth of black freedom within popular education is a book by the vastly popular didactic children's author C. D. Michael, *The Slave and His Champions*. The cover (fig. 3.1) is a little masterpiece articulating the manner in which the slave exists as no more than a convenient mechanism for the celebration of white philanthropy. The title sets out a central equation balancing "the slave and his champions," and defines the slave in relation to the powerful white men who take up his (not her) cause. This equation is graphically set out with great ingenuity on the cover. A bust portrait of Wilberforce enclosed in a roundel stares out from the soft blue background, straight at us. The capital *S* of the word *slave* is extended in a curlicue that reaches into the soft panel of Wilberforce's portrait and physically connects the slave with his most celebrated champion. Below this we are given another graphic demonstration of how the slave and his champion work together. The three figures in a doorway have been adapted from one of the central abolition narratives showing a white male abolitionist giving freedom to a slave by physically confronting the slave power. Granville Sharp is shown in the Mansion House laying his hand on the shoulder of the slave owner, Mr. Kerr, and accusing him of assault on the body of Jonathan Strong, the cowering young black man depicted on the far right. The slave as helpless victim is saved by the white emancipator, and following Sharp's intervention the text tells us: "Jonathan followed his champion out of the court a free man —'no one daring to touch him.' "[20] Freedom is something bestowed by white champions to black victims. As if the point needed further emphasis, the spine of the book again carries the title, but this time the words "The slave and his champions" have replaced the words "Am I not a man and a brother?" and float directly above a representation of the chained black male slave from the iconic abolition committee seal.

FIG. 3.1. Book cover, C. D. Michael's *The Slave and His Champions*, n.d.

COFFEE-TABLE EMANCIPATION:
POPULAR HISTORIES AND ABOLITION

The propagandas generated by abolition showed great inventiveness in my-
thologizing the extinction of the institution — the Dragon of slavery slayed
by the St. George of Abolition, the Medusa of slavery, the Gorgon of slavery,
the monster of slavery, done in. And the moment the monster that had im-
prisoned the innocent and passive slaves died they were free. Slave families, all
of them children, especially the adults, dance, sing, and play again as the sun
breaks through the clouds, in the imagery of hundreds of thousands of paint-
ings, prints, envelopes, letterheads, dinner plates, cups, bowls, and saucers.[21] It
is a powerful myth because everyone wants to believe in it — the abused and
the abusers and their ancestors — and they have a lot invested in wanting to
move on. The huge advantage of the myth of the abolition moment is that it
not only allows for the possibility of moving on, but it allows for the extrac-
tion of a potent draft of sentimental positivism.

 The British Slave Trade and Public Memory by Elizabeth Kowaleski Wal-
lace is a fascinating book when considering the extent to which British society
has started to enter a new and more quizzical stage in the historicizing of its
slavery history. The author is an American academic, who is a specialist in
English literature but who is also very aware of the advantages and disadvan-
tages of her outsider status.[22] The picture her work paints overall gives a very
healthy and dynamic account of the major advances in work on the memory of
Atlantic slavery over the past three decades. She runs through the work of Stu-
art Hall, Paul Gilroy, Jim Walvin, F. O. Shylon, and myself, and she considers
the impact of postcolonial theory on the reforming of literary canons for the
eighteenth and nineteenth centuries. What emerges is an optimistic account
of a huge narrative and indeed epistemological shift away from the silences and
erasures of earlier British history that had evaded the dark and complicated
inheritances of slavery. While I admire her book and her optimism, I feel that
it is symptomatic of the work of historians and theorists of the diaspora in
that it fails to acknowledge the extent to which the official memory of slavery
within British popular culture is still dominated by those primitive celebra-
tory myths. Slavery was never simply an absence or a cultural embarrassment,
but a negative that could be magically changed into a positive.

 This is a complicated affair because there is a pressure on blacks as well as
on whites to become involved in the cultural processes of celebration and the
erasure of the past.[23] The tragic disguises that result from these still largely

unacknowledged pressures have been simply outlined in the context of U.S. emancipation by W. E. B. Du Bois:

> Away back in the days of bondage they [the slaves] thought to see in one divine event the end of all doubt and disappointment; few men ever worshipped Freedom with half such unquestioning faith as did the American Negro for two centuries. To him, so far as he thought and dreamed, slavery was indeed the sum of all villainies, the cause of all sorrow, the root of all prejudice; Emancipation was the key to a promised land of sweeter beauty than ever stretched before the eyes of wearied Israelites.[24]

What Du Bois articulates as the central redemptive myth of the preemancipation slave consciousness is identical in every way with the mythology of the emancipation moment so heartily espoused by the white evangelical Anglo-American patriarchs who engineered the myths of the gift of freedom. Slave societies have an immense amount invested in this myth, precisely because it is a myth that strangely, at one level, cuts across race.

It would be safe to assume that in time the inadequacy of this attempt to disguise a moral failing of such vast proportions would have to come out, and yet the myth of the emancipation moment has proved remarkably difficult to erode. How does a nation remember en masse? What constitutes the popular memory of slavery in Britain today — does it exist in its monuments, its museums, its popular history books? As a test case I recently went through a bestselling popular history book entitled *On This Day: The History of the World in 366 Days*. This coffee-table history takes eight thousand key historical events and sets them against each other on the days on which they occurred, jumbling chronology to startling effect. The basic premise is a clever one in a flashy kind of way. The book attempts to be serious and open-minded in including a healthy gender mix and ethnographic and geographical elements that allow space for the histories of colonization and the subsequent struggles within the "developing world." When it comes, however, to the history of Atlantic slavery, and indeed the institutions of slavery globally, the framework is completely and inflexibly developed out of the myth of the emancipation moment. Abolition is passed on like some Olympic torch of freedom from date to date and from country to country. This moment does not merely define an imagined end of slavery, but comes to represent, within this version of popular history, the very institution itself. It is not merely a case of "in my end is my beginning" but "in my end is my beginning, middle, and end." So the page for March 25 includes a chronological table that reads:

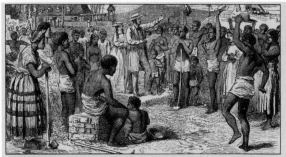

BRITONS NEVER NEVER SHALL HAVE SLAVES

1833 In a momentous move, Britain has finally ended its 400-year involvement in slavery. The act passed by parliament today frees all slaves in the nation's territories after a five- to seven-year apprenticeship. A sum of £20 million ($37 million) has been earmarked to compensate slave-owners. Today's news marks a victory for the Anti-Slavery Society (formed in 1823) and their parliamentary leader, Thomas Fowell Buxton, who have campaigned hard for this amendment. It also completes the work begun some 40 years ago by William Wilberforce. Wilberforce's bill abolishing the slave trade was eventually passed in 1807, after a series of setbacks to its progress since its inception in 1789. The new bill is expected to put fresh heart into the abolition campaign in the United States.

AUGUST 1

1714 George Louis, Elector of Hanover, accedes to the British throne as George I on the death of Queen Anne.

1774 British chemist Sir Joseph Priestley announces that he has discovered oxygen.

1778 The first savings bank opens in Hamburg, Germany.

1798 Nelson attacks and annihilates the French fleet at Aboukir Bay, cutting off Napoleon's supply route to his army in Egypt.

1831 The new London Bridge is opened by William IV and Queen Adelaide.

1834 Death of Robert Morrison, the first English missionary to go to China and translator of the Bible into Chinese.

1914 Germany declares war on Russia.

1950 Australian prime minister Sir Robert Gordon Menzies promises to send troops to South Korea to join US forces in repelling the invasion by North Korea.

FIG. 3.2. "Britons Never Never Shall Have Slaves," in *On This Day: The History of the World in 366 Days*, 1992. Text and design © Octopus Publishing Group, 1992, 2004.

"1807 Influenced by the philanthropic MP William Wilberforce, the British parliament abolishes the slave trade." No more and no less, Britain abolishes the slave trade because William Wilberforce wants them to. The entry for August 1 carries an illustrated article with the banner headline "Britons Never Never Shall Have Slaves" (fig. 3.2). The copy reads:

> 1833 In a momentous move, Britain has finally ended its 400 year involvement with slavery. The act passed by parliament today frees all slaves in the nation's territories after a five- to seven-year apprenticeship. A sum of £20 million ($37 million) has been earmarked to compensate slave-owners. Today's news marks a victory for the Anti-Slavery society (formed 1823) and their parliamentary leader, Thomas Fowell Buxton, who have campaigned hard for this amendment. It also completes the work begun some 40 years ago by William Wilber

force. Wilberforce's bill abolishing the slave trade was eventually passed in 1807, after a series of setbacks to its progress since its inception in 1789. The new bill is expected to put fresh heart into the abolition campaign in the United States.[25]

Text and image work seamlessly together to perpetuate the established myths of the emancipation moment. A woodcut from an unspecified source shows a white plantation owner, accompanied by his wife, reading out a proclamation and extending freedom to the surrounding group of field slaves by the gesture of extending his left arm and hand. This is the time-honored gesture accreted to all patriarchs, the fathers of the people, when they are in the act of giving.[26] The slaves operate according to the two time-honored behavioral codes, namely, passive gratitude and extreme terpsichorean jubilation. So the majority of blacks are shown, mainly dressed in loincloths, standing passively by, some leaning on their hoes, in a state of deep reflection. Yet isolated in the right foreground one male slave is shown breaking into spontaneous dance, his clenched left fist raised.[27] This is clearly an old woodcut, made for the press in England to commemorate abolition. Although the text is not old, the terms of its thought are still drenched in the mythology developed to fictionalize abolition in imperial England in the nineteenth century. Britain is an abstract personification that has acted decisively to end slavery and has paid down a magnificent sum of capital to buy the slaves their freedom. This "20 million" was endlessly cited as the proof of British benevolence, and even at this date remains the price of freedom.[28] The message is perpetuated that having spent four centuries wandering more and more deeply into the moral quagmire of Atlantic slavery, the British could buy their way out of it in an instant. The narrative then switches from the payment to lock itself into a rehearsal of the history of slavery as the history of abolition. Emancipation is a victory, not for the slaves, but for the Anti-Slavery Society and its nominated leader. Buxton in his turn is seen to exist only as the latest historical tool of Wilberforce, "completing the work" of this earlier mythic mentor. And the judicial pedigree of the emancipation bill is also set out, with the 1807 slave trade act standing in the background. The future is also involved in this emancipatory chain reaction, for the 1833 bill will prefigure abolition in America. The terms in which this is set are interesting, however, for again it is not the slaves who are of primary importance, but the reinvigoration of the white American abolitionists, who will now have been given "new heart." This little panel demonstrates with what extraordinary precision the master narrative of the

AMERICAN SLAVES "MUST BE UNCHAINED"

JANUARY 1

New Year's Day

1863 As civil war rages in America, President Abraham Lincoln today declared freedom for all slaves in the southern states that have rebelled against his government. In Washington huge crowds of emancipated slaves celebrated the announcement, which honours a pledge made by the President before the war began. "The old South must be destroyed and replaced by new propositions and new ideas," said Lincoln in a speech. But his order does not apply to slaves in border states fighting on the Union side against the South, nor does it affect slaves in southern areas already under Union control – and, of course, the rebel Confederates will not act on Lincoln's order. What the proclamation does show is that the Civil War is really being fought to end slavery. The issue has dominated the election campaign, with Democrats claiming that the Northern states will be overrun with "semi-savages". Meanwhile, all-black army units are being formed to fight the South.

44 BC Julius Caesar, founder of the Roman Empire, introduces the Julian calendar.

1538 German and Swiss states introduce the Gregorian calendar.

1804 After an 11-year slave rebellion against France, Haiti declares its independence, becoming the first Latin-American state to gain its freedom.

1901 The Commonwealth of Australia is established with Edmund Barton as the country's first prime minister.

1958 The European Economic Community, an alliance between France, Italy, West Germany, Belgium, Holland and Luxembourg, comes into being.

1961 The British farthing ceases to be legal tender.

1965 British footballer Stanley Matthews becomes the first professional footballer to be knighted.

1990 A week after the death of the Ceaucescu, Romania

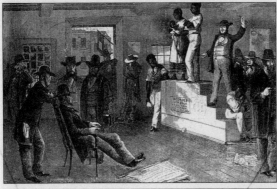

FIG. 3.3. "American Slaves 'Must Be Unchained,'" in *On This Day: The History of the World in 366 Days*, 1992. Text and design © Octopus Publishing Group, 1992, 2004.

British gift of freedom has been passed down through print culture. This story is seemingly impervious to interpretative change.

When the book comes to dealing with American slavery, the story continues. The entry for January 1 consists of a panel with the title "American Slaves 'Must Be Unchained'" (fig. 3.3). Below this is a period woodcut showing a slave family on the auction block, and this time the copy reads:

> 1863 As civil war rages in America, President Abraham Lincoln today declared freedom for all slaves in the southern states that have rebelled against his government. In Washington huge crowds of emancipated slaves celebrated the announcement, which honours a pledge made by the President before the war began. "The old South must be destroyed and replaced by new propositions

and new ideas," said Lincoln in a speech. But his order does not apply to slaves in border states fighting on the Union side against the South, nor does it affect slaves in southern areas already under Union control — and, of course, the rebel Confederates will not act on Lincoln's order. What the proclamation does show is that the Civil War is really being fought to end slavery. The issue has dominated the election campaign, with Democrats claiming that the Northern states will be overrun with "semi-savages." Meanwhile, all-black army units are being formed to fight the South.[29]

This text gives a strange version of the truth, but one that is consistent with the North's retroactive justificatory and explanatory fictions, focused as they were on a belated appropriation of emancipation mythology. The truth is that the first Emancipation Proclamation was a compromised mess, that Lincoln had always prevaricated over the slavery issue and would at any stage have sold the blacks down the river if it meant salvaging the Union.[30] The ultimate irony is that the proclamation was not a declaration of fact but one of intent, because the slaves declared free were those within the rebellious states still at war. There was no chance that the rebel states were going to suddenly free their property. It took Sherman's March to the Sea for that. Emancipation was only enshrined in law and reality across the nation with the passage of the Thirteenth Amendment in 1865. The Civil War was by no means a war that was fought "in order to end slavery." Lincoln's "pledge," which is quoted, is deliberately vague; it is written in canny lawyer's language, referring to "new propositions and new ideas," but makes no explicit mention of slavery and abolition at all. Throughout the war there was profound reluctance to arm and use black regiments, and when they were used they were subject to profound and continued race prejudice.[31] But the present overview does not bring any of this out. In fact, historical verisimilitude is not a priority. The slaves are freed, huge crowds of them celebrate in the nation's capital, the war is fought to kill off slavery, and blacks are embraced to become the agents of their own emancipation. Perhaps strangest of all is the choice of an abolition wood engraving depicting slaves on the auction block. Why is one of the iconic images of slave disempowerment chosen as the most appropriate sign to celebrate black liberation? This is not just a casual approach to the relation between word and image, but a conflicted one. It is as if the book wants to remember slaves as forever disempowered property, no matter what the legal documents bringing freedom are supposed to have said. History, or at least this type of popular historiography, moves around famous figures and anniversaries. It likes definite beginnings and ends; the reality of slave experience is not of interest.

If today's popular histories of empire prove one thing it is that the abolitionist custodians of the memory of slavery did their work very thoroughly. It is so much less trouble to look at things the traditional way, and anyway it seems to be the case that this is what people want to hear, so why not let them have the old lies? And there is never any shortage of journalists ready to dress up the same old story and call it "revisionist" or "neo-con" colonial history. Listen to Niall Ferguson, like some sort of historiographical telly-chef, serving up piping hot historical comfort food and repeating the time-honored tall tales of abolition triumph in terms that are reassuringly stupid: "In 1807 the slave trade was abolished. . . . Thanks to the work of zealous activists armed only with pens, paper and moral indignation, Britain had turned against slavery. . . . One victory led to another for once the slave trade had been abolished slavery itself could only wither. . . . By 1833 the last resistance had crumbled. Slavery itself was made illegal in British territory; the helots of slavery were emancipated, their owners compensated with the proceeds of a special government loan. . . . The memorial to the Clapham Sect on Holy Trinity Church's east wall salutes Macaulay and his friends who 'rested not until the curse of slavery was swept away from all parts of the British dominions.' "[32] And a good thing, too, what a joyous little narrative British involvement in slavery enabled, and how kind of Ferguson to pass this feel-good fanfaronade on to us in such a pristine state. This prose is crass, not merely in the English sense, but in both the primary French senses of the word.[33] Not merely G. R. Mellor, but Lord McCauley himself would have given this mendacious melange the nod. C. L. R. James and Eric Williams might as well never have written a word. The poor old black Marxists fall powerless before the full glory of the British emancipation moment and the Clapham Sect is linguistically embalmed in full-blown Schamanisms.

Eric Williams's wonderful *Capitalism and Slavery* was the first sophisticated book-length polemic to suggest that slavery might be constructed historically as something more than a moral monster, the chief relevance of which was to serve as an inspiration for the Christian philanthropy of the Clapham Sect. Williams's thesis was met with a barrage of outraged and sometimes paranoid responses. One of the most comprehensive and then popular replies came in the form of G. R. Mellor's *British Imperial Trusteeship*, a book that demonstrates at great length and with thoroughness exactly how intact the Clarksonian narrative fiction remained.[34] In his intelligent and clean style Mellor, as a prose stylist and intellectual, has a good deal to teach today's pumped-up and media-savvy apologists of empire.

MAGIC MOMENTS, MIDNIGHT'S CHILDREN, AND MISSIONARIES:
THE EMANCIPATION MOMENT AS PERFORMANCE ART

In Barbadoes then as to their blacks or negroes, I desired them to
endeavour to train them up in the fear of God, as well them that were
bought with their money as them that were born in their families that all
might come to the knowledge of the Lord. — George Fox

The monster is dying, The monster is dead! — The Right Reverend
William Knibb, at his emancipation ceremony

When we try to remember slavery through the visual archive it generated at
the moments of its supposed disappearance, we forget performance art at our
peril.[35] The theater of abolition went into full swing during successive emanci-
pation moments. The narratives, tableaux, and symbolic structures generated
were terribly powerful, and they were to succeed in their historical makeover.
There is nothing politicians and functionaries like more than to knock bad
news on the head, to get the job done, to draw a line under it, and to move
on. But Atlantic slavery constituted a very big, and a very protracted, piece of
bad news and required special methods if it was to be absolved, or dissolved,
as history. When one set of humans from one continent systematically abuses
another set of humans from another continent in such vast numbers for such
a long time and in such complicated ways as they did during the course of the
Atlantic slave trade, what publicity methods allow a nation to move on?

July 31, 1838, was the day before eight hundred thousand ex-slave appren-
tices in the British sugar colonies of the Caribbean were finally, officially, set
free. The hated apprentice systems were to be disbanded and slavery, at last,
was declared dead and gone. History, even as it happened, was constructed
as pure political theater. When the midnight hour approached, the Baptist
missionary and abolitionist zealot William Knibb prepared a ceremony of
celebration in his church in Kingston, Jamaica. On the garlanded and flower-
bedecked walls hung large engraved portraits of Thomas Clarkson and Wil-
liam Wilberforce. Below their white faces and black jackets, laid out on a
table, was a real polished wooden coffin with an inscribed plate reading "Co-
lonial Slavery died July 31st 1838, aged 276 years."[36] On top of the coffin lay a
spiked iron slave punishment collar, slave chains, and a whip. As the moment
of jubilee approached, the congregation of whites and blacks sang:

The death blow is struck see the monster is dying,
He cannot survive till the dawn streaks the sky;

In one single hour he will prostrate be lying,
Come shout o'er the grave where so soon he will lie.[37]

This is technically disastrous verse, even by the standards of the most de-
volved mid nineteenth-century narrative balladry; the drumming dactyls are
reiterative and metrically clotted. Yet there is an ironic potency in the repeti-
tion of "lying" and "lie," as if the very act of attempting this excessive descrip-
tion of death must inevitably lay bare, must name, the essential mendacity
under-"lying" the entire project. Knibb standing in his pulpit pointed at the
church clock as the second hand approached twelve, chanting, "The monster
is dying," then as the clock struck twelve, like a child killing the bogeyman
through incantation, he cried, "The monster is dead." Ecstatic rejoicing shook
the building. Knibb recounted: "The winds of freedom appeared to have been
set loose. The very building shook at the strange yet sacred joy." Then the con-
gregation quietened and in solemn procession bore the coffin out to a freshly
dug grave in the playground of the church school. The coffin was lowered and
the grave filled in.

Knibb's parodic death and burial of slavery shows with a pristine and al-
most pathetic brutality the extent to which abolition dates are not about the
memory of slavery but about killing off the memory of slavery and putting
something very different in its place. I discussed in the first chapter the power
of the threshold gift in preindustrial societies. A threshold gift is something
given symbolically at the point where life changes radically (puberty, mar-
riage, and so on), or more powerfully at the point where life appears (births
and birthdays) or in the space where death usurps life (funerals). Knibb's cer-
emonials are very ingenious because he here invents the gift of freedom as a
threshold gift. Freedom becomes a gift given to the slaves by the masters over
the dead body of slavery. The ingenuity lies in the creation of an apocalyptic
ending, where no ending in reality occurs. Slavery never did die in 1807, 1833,
or 1838, but to mark its fictional dissolution by the appropriation of something
as atavistic and pure as the gift over the coffin is to create a powerful commu-
nal ceremony.[38] Knibb's ceremony clearly sums up the desperate desire on the
part of British abolitionists and government alike to erase slavery as a social
and political reality, to replace history with myth. Yet how many times does a
history have to be killed off?

For all Knibb's ecstasy, and the finality of his metaphoric burial, there was
the peculiar fact that this death of slavery was *in fact* reliving something that
had happened before. These ex-slaves in Knibb's church might have been for-

given a certain sense of déjà vu; they were experiencing, indeed performing, something akin to an abolition Groundhog Day. Slavery had, of course, been declared dead, and these apprentice-slaves had been publicly, vocally, ceremonially, politically, metaphorically, symbolically, and finally set free five years before. Slavery had categorically and legislatively died on August 1, 1833, although Knibb's antics would suggest that the rumors of its death did seem to have been rather exaggerated. If you were a slave in the British Caribbean in the high summer of 1833, you had lived a lie, for forms of freedom had proved elusive and the reality of slavery surprisingly resilient. As slaves became apprentices and slave labor became indentured labor, slaves had found out the hard way that euphemism could be a cruel deceiver whose job it was to make it very hard to see what was in a name. How many times could slavery die, how many times could it be buried, and where did its body go to? The answer would seem to be that it dies precisely as many times as it is in the interest of the slave power to consider it convenient to kill it yet again with the gift of freedom. And then again, what of the slave body, the slave experience? Where did it fit into this almighty mythological mess?

If we go back to Knibb's carefully controlled ceremony, there is little space within it for the slave body. The spectacle is overseen by the engraved visages of the two patron saints, indeed the two talismanic martyrs, of British abolition — Wilberforce and Clarkson. The coffin does not hold the body of a slave or a metaphoric embodiment of slave memory and trauma, but a monstrous abstract personification, an animalized and alienated construction of slavery as an ideal of evil. The slaves have no presence and agency within the terms of this ceremony. The slaves had been the victims of this cruel and remorseless monster, yet their victimhood is shut out of the historical charade, and is remembered here only in the form of the implements of torture that the monster slavery used. While there is no slave body there are the empty chains, and a collar, and the static whip — relics belonging to the slave power, relics within which lies locked a terrible but silenced history of pain, humiliation, despair, fury, and disbelief. How strange that there is this reluctance, at the very point of her or his deliverance, to show the body of the tortured slave.

Within the performative world of the Reverend Knibb slave thought and slave cultures are not allowed a presence, a life, while paradoxically, slavery as a personified national sin has an immediate biography, a birth date and a death date. Like some grisly folkloric fallen tyrant, a sort of diasporic dragon, slavery seems to have lived out its garish cruelties, and now lies there, a spectacle of terror, wonder, disbelief, and relief. Slavery is nicely and finally separated

from white human agency and from black suffering; it is hideous, animal, evil, other, quite specifically something else and something dead. There are no gray areas in this fiction; there is no sense that this monster of slavery was once rather a different figure. In day-to-day reality slavery was not a monster; it was horribly normal, it lived on quietly, a healthy normal unremarkable life force at the heart of the British economic nexus binding metropol and colony. How ironic, then, that it is not finally the body of the slave that is constructed as other, but the very machinery of the white slave power.

Without the myth of emancipation slavery poses a big problem, a problem Britain is only just starting to wake up to. The challenge that confronted successive slave powers within Europe and the Americas was how to fit slavery into their memorial archives. Surely something so intricately involved in the variegated abuse of power at such a variety of social levels could not fit comfortably or positively into a nation's collective memory. The brilliant strategy at the heart of immediate reactions to abolition was positivism. Slavery is posited as a sort of insane *reductio ad absurdum* of Christ's redemptive equation: "joy shall be in Heaven over one sinner that repenteth more than over ninety and nine just persons" (Luke 15:7). The thesis that slavery is ultimately a cause for celebration because it brought about abolition was an evangelical truism, a truism fully and elegantly elaborated by Thomas Clarkson. His *History of the Rise, Progress, and Accomplishment of the Abolition of the African Slave Trade by the British Parliament* established in the most spectacular and watertight manner the terms in which slavery was to be remembered by the white British culture that had profited so vastly from it.[39] The title sets out the limits of re-memory; the history of slavery is now the history of its abolition. It is not the English slave trade that is abolished but the African one, and its demise is finally the achievement of the British democratic Parliament. Clarkson sees the 1807 bill as a Christian triumph:

> Among the evils, corrected or subdued, either by the general influence of Christianity on the minds of men, or by particular associations of Christians, the African slave trade appears to me to have occupied the foremost place. The abolition of it, therefore, of which it has devolved upon me to write the history, should be accounted as one of the greatest blessings, and, as such, should be one of the most copious sources of our joy. Indeed I know of no evil, the removal of which should excite in us a higher degree of pleasure. Are not our feelings usually affected according to the situation or the magnitude, or the importance of these? Are they not more or less elevated as the evil under our contemplation

has been more or less productive of guilt. Are they not more or less elevated, again, as we have found it more or less considerable in extent? Our sensations will undoubtedly be in proportion to such circumstances, or our joy to the appreciation or mensuration of the evil which has been removed.[40]

This is a rather cumbersome and reiterative way of saying that the more you sin, the more joy you bring when you repent of that sin. If the slave trade was uniquely bad in the eyes of God, the most horrific evil in the history of humanity, then its abolition must be commensurate in terms of the joy it brings. This redemptive oppositionality was to remain the central thesis behind subsequent British approaches to the history of the trade.

Britain's involvement in the slave trade at the very moment of its abolition, its recantation, its repentance, becomes a force for ecstatic celebration. Within this redemptive cycle slavery operates as a semiotic closed circuit, and the logic runs on the following loop: only Britannia could have created the monster slavery, and only Britannia could have destroyed it. In this topsy-turvy world sin exists as the necessary foodstuff of redemption. Within the vision of the evangelicals who masterminded the mythologization of the 1807 abolition bill, the amount of moral good required to repent and to abolish the sin of slavery precisely equalled the degree of moral evil that had been required to implement and conduct the trade during the previous three centuries. Seen this way slavery and abolition form a perfect balance, a sort of moral enactment of the principle of double-entry bookkeeping where profit and loss result in zero. Of course, colonial and metropolitan cultures had been saturated by the real social, psychological, and pathological outfall of slavery in ways that evaded the evangelicals' redemptive formula and that could never be killed off, shut down, or buried. And yet the awful truth is that it was the job of the fictions, narratives, ceremonies, and propagandas that greeted abolition to pretend that the terrible memorial inheritance of slavery simply did not exist. Seen from this direction, the myth of the emancipation moment is firmly embedded in the philosophy of "never apologize, never explain." The lethal efficiency with which the propagandas of the emancipation moment policed the reconstructive framework of the memory of slavery within Britain remains one of the wonders of cultural mythography. When it came to the creation of memorabilia, the memory of slavery morphed suddenly into a bizarre hagiography. It became obvious that slavery had fortunately existed in order that a band of altruistic white Christians could labor intently, and suffer intensely, in order to give freedom to millions of innocent victims. These latter-day St.

Georges worked directly for an evangelical God. They fought and killed the monster of slavery, and the slaves were only relevant in the degree to which they could express their gratitude through applause and devotion to God. Wilberforce's God, Parliament's God, and the Jamaican missionaries' God were one and the same.

Knibb's ceremony is above all a desperate desire for closure. A good clean end was what was required, something akin to an execution or at least a massive thrombosis. The last thing either the abolitionists or the slave power, or the British Parliament, or the disinterested general reader wanted to see was inconclusiveness, a mess, a continuing wound that got reinfected and would not heal. Slavery had to be shown to drop dead in Britain and throughout its colonial possessions. If slavery were imagined to linger on, then it had to be on foreign soil.

TRACKING THE LACK OF CHANGES: THE TRANSMISSION OF SOME ICONIC LOWEST COMMON DENOMINATORS

The earlier parts of this chapter demonstrate how the fictionalized death of slavery and the simultaneous birth of regenerated British imperial liberty were culturally encoded and enacted across a great variety of forms.[41] Yet when it came to the creation of a body of propaganda that was capable of carrying this message across the globe and being reinvented in diverse slaving cultures and environments, graphic art was peculiarly powerful. I want to end this chapter by explaining how the most influential abolition prints worked, and consequently why they traveled so well.

Within popular graphic art an extreme example of the processes of effacement and reinscription to which I have been alluding is the technically gorgeous engraving that Joseph Collyer developed out of the Henry Moses painting *Abolition of the Slave Trade* (fig. 3.4). This plate was produced in June 1808 as an official commemorative work celebrating the passage of the 1807 bill, and was distributed in large numbers both as a black-and-white and as a hand-tinted colored engraving. The engraving is worth analyzing in detail because it so perfectly lays down the ground rules for the visual rhetoric of emancipation. The crucial question is, what has become of the slaves in this version of events? The British may have dominated the Atlantic slave trade for over a century and shipped an estimated combined total of six to eight million slaves from Bristol, Liverpool, and London during this period, but where are

FIG. 3.4. Joseph Collyer, *Abolition of the Slave Trade*,
copper engraving, after Henry Moses, 1808.

those black bodies now? The print gives us a fleshy white female threesome, an abolition trium-feminate, who oversee the nativity of a new national fiction. The print is weighed down with massive amounts of text listing the evils of slavery; the names of the politicians who voted to pass the bill; and the deeds and achievements of William Wilberforce, the politician who has come to be seen as the saintly popular face of abolition. That popular face is indeed the only portrait likeness within the print, and yet it is a most carefully calculated representational reality.

Wilberforce, although he was alive and well when the print was made, is not presented as a flesh-and-blood human presence. We are not invited to look upon a man, but upon a simulacrum, a stone likeness that gazes back down at us, a marble bust on a plinth with a cold, contented smile. The processes of Wilberforce's official sanctification (or is it deification?) are put in place at the very instant of abolition. He has been moved from man to myth, his flesh and blood have already been subsumed into the stark and sterile white marble of official neoclassical statuary. He is a cold neo-Roman monument, beyond reproach, beyond reality, and beyond the reach of the slaves. At a stroke the memory of slavery has become the memory of William Wilberforce's heroic battle for the abolition of slavery. What should be two discrete narrative entities have been elided. Wilberforce in body and reputation has undergone a process of total albinification; he is almost literally whiter than white, and was to remain so within the Atlantic slavery archive, right down to the present century. All shadows and gray areas have evaporated in this tumultuously bright vision of abolition.[42] Indeed, the entire upper third of this print is bathed in a divine radiance, its rays exploding out from a center focused on Britannia's liberty cap and the British crown that flies conspicuously on her banner. These rays drive off the heavy, dark clouds (presumably symbolizing Britain's slavery inheritance) in order to illuminate the bust of Wilberforce.

The brutal truth is that there is not a single black body in this composition; the official history has conveniently eased black corporeality right out of the picture. If the slave body is present, it is by allusion, indeed, by an allusiveness that suggests presence via traumatic absence. There are three details that invite us to fill in this massive cultural aporia and to bring the slave body back to cultural life. The first is the presence of the ship sailing through the picture plane middle left and nearly obliterated by the banner entitled "Standard of Slavery." Yet even here the presence is ambiguous. Is this ship supposed to represent a departing slaver? It may be, but then again, it is placed behind the figure of Justice with her sword and scales, the symbol of judicial fairness

placed above every British court. This may imply that this boat is one of the new Royal Navy patrol vessels, now cruising the Atlantic in the wake of the 1807 bill. As the nineteenth century progressed these antislave trade patrol vessels were to occupy a central position in Britain's morally self-aggrandizing narrative of the history of slavery.

The second detail that indisputably gestures toward the traumatized slave body lies beneath the substantial paw of the British lion and beneath Britannia's feet. Snaking around her sandals is a pile of chains and shackles, the restraints applied predominantly to male slaves on the middle passage. But then again it is relevant to ask how, precisely, do these objects represent the slave body? At their primary level of meaning these objects do not describe the limbs they once encased, but the minds of the traders and torturers who operated the Atlantic slave system. The chains and fetters, hand-forged in Manchester and Birmingham, represent the economic vision of the ship owners and the sailors who ran the trade. If they represent the slaves at all, it is only as the dehumanized victims of the trade. Surely these objects are intended to symbolize white depravity, the mindset of the slave traders rather than the suffering of the slaves. The debased position of these objects supports this reading. Britannia is not supposed to be seen to be trampling, figuratively, upon the bodies of slaves or their traumatic memory, but upon the greed and corruption that generated British dominance of the Atlantic slave trade.

The third detail that may allude to the slave body is the tiny death-head, hung with leg irons and chains, which floats at the top of the broken slave standard as a macabre factotum. Yet again this is not a straightforward sign. The slave is presented as dead and gone, as a deceased victim, and, finally, not as black living flesh and skin but as white bone. This is the only detail in the print that does portray part of a black body, and it presents a head, of unidentified gender, as a doomed fragment. This little death-head hangs there as a precise spatial counterpoint to the head opposite it, a white head with soft hair, a head with a neck and a body, a head set above a tailored coat and a cravat, a head that carries the face of Wilberforce, and a head that is, by volume, about ten times the size of the slave skull.

The message of this print is all too clear. Henceforth the history of slavery will make way for the history of abolition. The history of abolition is a white-evolved historical fiction in which the slave is given the gift of freedom by a beneficent patriarchy and by a noble nation. The heroes of the emancipation moment are the white leaders of the abolition movement, men on a mission, martyrs to their cause, who must now be worshipped as the incarnation of a

higher moral calling. The idea that the slave might have had any input into the processes of his or her own liberation, the concept of slave agency, finds no place in this remarkably effective allegory, an allegory that is also a statement of national moral abrogation. This print sets out a crushing agenda for what slaving nations will choose to forget and what they will choose to embody in fantasy, when they have to confront the memory of slavery at the moment of its official demolition.

When the abolition of slavery in the British sugar colonies was declared in August 1834, the event was met with ecstasy. Having practiced the process of occupying the moral high ground once in 1807, new strategies were developed that celebrated white philanthropy ever more extravagantly and that disempowered and misrepresented the black ever more effectively. Of course, the official abolition of slavery in 1834 was a convenient blanket fiction. On the ground in the colonies things were rather different. Emancipation in reality inaugurated the hated apprentice system whereby slaves had to continue to work for their masters without pay for five years. Knowing that they still had five years in which to exploit their ex-slave labor force and the full power of the military and judiciary to support their policies, the majority of slaveholders exploited their nominally ex-slave workers with a terrible thoroughness. One apprentice in Jamaica, James Williams, summed the situation up with a terrifying purity: "Apprentices get a deal more punishment now than they did when they was slaves; the master take spite, and do all he can to hurt them before the free come; — I have heard my master say: 'Those English devils say we to be free, but if we is to free, he will pretty well weaken we, before the six and the four years done; we shall be no use to ourselves afterwards.' "[43] Within the year shocking reports began to circulate in the Commons and led Lord Macaulay to draft a grim assault on the failings of the system and the dubious nature of the much vaunted abolition.[44] But the plight of the slaves under the apprentice system never caught the English popular imagination, and certainly not that of the legislature, in the way that abolition had done.[45] The reason, of course, is obvious. Once a nation has made a down payment on its own myth of abolition (in this case, a literal cash down payment of 20 million pounds sterling) and once it has been consumed by its own myth of liberation, no nation wants to or indeed may possess the moral capacity to see beyond the veil of self-aggrandizement. The slaves have been given the gift of freedom; they have been moved culturally en masse from bondage to liberty. Consequently, in the imagination of the people who made emancipation prints and wrote emancipation poetry, the people who marketed the gift of freedom, the slave at a certain level would never be free.

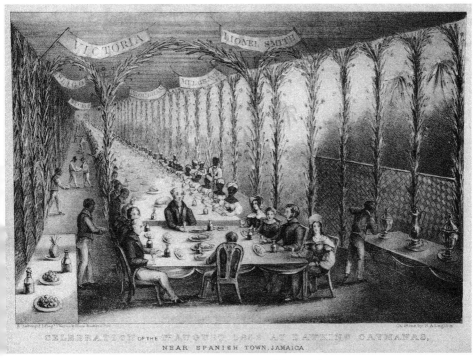

FIG. 3.5. R. A. Leighton, *Celebration of the I'st of August 1838 at Dawkins Caymanas*, lithograph, after William Ramsey, 1838.

The massive deceptions that clothe the propaganda of the emancipation moment come out clearly if we look forward thirty years beyond the 1807 act and five years beyond the 1833 act to an image entitled *Celebration of the I'st of August 1838 at Dawkins Caymanas* (fig. 3.5). This elaborate lithograph depicts the celebration of the anniversary of emancipation on the occasion of the final abolition of the apprentice system in Jamaica. I have just alluded to the terrible reality of life for slaves in the wake of the 1833 act, yet this design is carefully constructed to insist that the apprentice systems produced an ideal slave population who are now ready and waiting to enter a world of white-controlled freedom. This 1838 lithograph was developed out of a drawing by William Ramsay, a witness of the event. His drawing was then sent to London, where it was carefully refined by R. A. Leighton into a propaganda print. The image unambiguously celebrates black gratitude for the abolition of slavery and the apprentice system, while simultaneously enforcing the idea that in terms of power relations and the harmonious cultivation of sugar, nothing has really changed.[46] The image is an extreme control fantasy. The governor of Jamaica,

the white planter, with his family and entourage, including the overseer and the local clergyman, dominate the foreground, where they sit at a square table that is separated from the slaves' table.[47] The latter disappears into the back of the picture along a perspective line of infinity, as if there is no end to the ordered ranks of anonymous ex-slaves. Black servants decorously wait on the masters from sideboards loaded with food and silver vessels for wine and spirits. The entire scene is bordered by a series of arches that have been composed out of coconut branches and sugarcane leaves.

While the whites sit relaxed, with males, females, infants, and adults promiscuously intermixed, the supposed ex-slaves, or apprentices, are all adult and have been rigorously divided along gender lines; the women and men are all dressed in identical pristine uniforms. The implication is that things go on precisely as they did under slavery: the cane flourishes and still forms the background or framing device for the whole of life; the ex-slaves are submissive, contented, and well disciplined, turning out in their Sunday best for the feast day. The overseer is still the overseer, the master and mistress are still in control, and the planter family is still the unit around which all domestic power turns, while "his Excellency the Governor," the representative of British imperial dominion, oversees all. Floating in space above the whole scene is a series of banners bearing names of the queen and of the English politicians involved in seeing through the abolition bill and the implementation of the brutal apprentice system. The accompanying text explains that these are both political and sacred names, British implementation of abolition being specifically sanctioned by a Higher Power, namely, the parliamentary representatives of a very white, English, and imperial God: "The inside was fitted up in a style . . . chaste and elegant, being . . . adorned with flags of various coloured silk bearing in gold and silver letters the names of the illustrious living characters who under God achieved the glorious triumph the assembly met to celebrate."

The print, and indeed the event it depicts, was a carefully orchestrated fantasy designed to reassure white British audiences that all goes on efficiently in the colonies and that emancipation is only a term, not a social revolution. The accompanying prose account observes that when the governor's coach arrived, the apprentices spontaneously insisted on taking the places of the horses and drawing the grand visitors to the banquet: "a body of the most Athletic of the late apprentices surrounded the Carriage . . . and, removed the horses and dragged them [his Excellency and suite] along to the scene of interesting conviviality in the midst of volleys of enthusiastic huzzas." "Athletic" slave flesh and horse flesh are, despite the gift of liberty, still locked within that sinister

equality that saw them advertised alongside each other in auction notices during the days of slavery.

The fiction that this print embodies takes the controlling mechanisms of British emancipatory rhetoric to a point of perfection. Black resentment, violence, traumatic memory, sexuality, and above all agency are ruthlessly locked out of this version of events. Controlled, yet contented, happy to choose a state of continued servitude, this black laboring population not only suggests that it will continue to produce sugar, but implies that it was always happy under a benevolent white patriarchy.

In this sense the print relates to another very prominent graphic tradition. Up to, and beyond abolition, popular propaganda continued to engender the myth that the slave's lot might well be preferable to that of the free black or indeed the free white laborer in Britain. This myth was potent in the thought and writing not only of proslavery figures, but was a common refrain among radicals and socialists. The notion that slaves in the sugar colonies were contented and protected while white laborers were barbarically exploited within the nascent capitalist systems of British domestic labor was reiterated throughout the nineteenth century. It was a constant theme in the work of such popular social critics as William Cobbett, Henry Hetherington, and Thomas Carlyle.[48] A particularly effective articulation of the position in graphic satire is the print *Cocker's Solution of the Slave Question* (fig. 3.6), brought out in 1831, when popular debates around emancipation were at their height and when Chartist agitation for labor reform in British factories was a prominent domestic issue. The print is dialogic, setting up two equations. The well-to-do soldier is faced off against the starving white factory operative, and this pairing is seen to provide a perfect counterbalance to the affluent slave family, who are in turn set off against the diseased and starving "free Negro," who afflicted with elephantiasis addresses the black slave, with unintended and cruel irony, as "massa." The highly Carlyleian argument here is that it is all too easy to become a very real victim of liberty within a free market economy, and that the old-style plantation is an infinitely preferable state for the black.[49]

TRACING OLD WORLDS IN NEW WORLDS: EMANCIPATION IMAGERY IN THE AMERICAS

Popular print culture is notoriously conservative. The basic symbols and satiric devices employed in liberation propagandas, and related satires, have remained remarkably consistent from their first mass distribution during

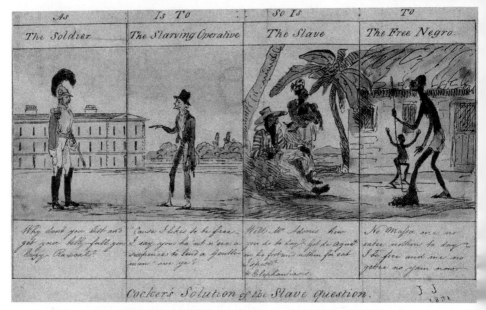

FIG. 3.6. *Cocker's Solution of the Slave Question*, hand-colored etching, 1831.

the pamphlet wars of the Reformation. When it comes to the articulation of freedom and slavery, the examples of the figures of Liberty and of the kneeling slave from the Abolition Seal, discussed above, indicate the monolithic manner in which symbolic languages are translated through time and place across the slave diaspora. A similar pattern emerges with regard to the basic semiotic building bricks of the emancipation prints, and I want to turn to a few American examples that demonstrate the purity with which the English models of 1807, 1833, and 1838 were absorbed into the American and then Brazilian contexts of 1863, 1865, and 1888.

One of the most complete assemblages of the major ingredients of British abolition propaganda within the American context occurred in the 1862 lithograph *The Triumph* (fig. 2.12), a print I have already examined in some detail within the context of the development of the figure Liberty and the liberty cap.[50] The print is also related to the European abolition propagandas in presenting the slave power, or "King Cotton," in the form of a monster. This composite creation has a body made of a cotton bale with daggers, whip, and pistols stuck under its ropes. The creature's head and claws resemble those of a swamp alligator, while the ruff and ermine that it wears are a swipe at the monarchy. There were many satires that presented the secessionist South in

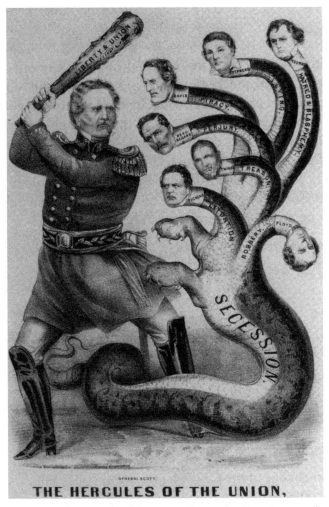

FIG. 3.7. *The Hercules of the Union Slaying the Great Dragon of Secession*, lithograph, 1861. Courtesy of Library of Congress, Prints and Photographs Division, reproduction number LC-USZ62-40070.

the forms of various types of monster. One of the most intriguing, in terms of the way it took up European symbolic traditions generated by the French Revolution, is *The Hercules of the Union Slaying the Great Dragon of Secession* (fig. 3.7).[51] This design draws on a long tradition of European prints that had depicted Liberty in the form of a Herculean force beating down the monster of the Hydra. The American version is, however, an ingenious hybrid that also draws upon the association in evangelical thought between the slave

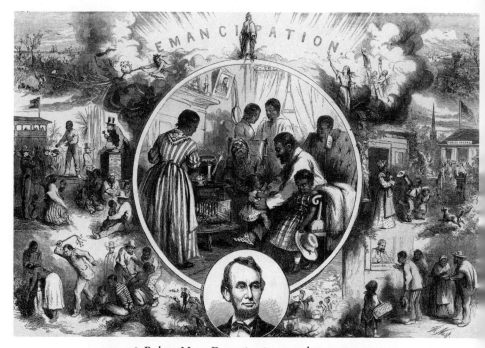

FIG. 3.8. Robert Nast, *Emancipation*, wood engraving, 1855.
Courtesy of Library of Congress, Prints and Photographs
Division, reproduction number LC-USZ62-2573.

power and the beast from the Revelation of St. John. The number of heads possessed by Hydra was certainly not consistent in classical texts, varying from one hundred in Diodorus to fifty in Simonides and a more modest nine in Apollodorus and a host of other authors.[52] This hybrid Hydra possesses seven, and is consequently related directly to the dragon of Apocalypse with seven heads. The association is further enforced by the inscription of the word "Blasphemy" on the head representing Confederate Secretary of State Robert Toombs. The designer has taken things a step further and cleverly incorporated the seven heads into a secessionist reworking of the seven deadly sins.

While the American prints tend to animalize, demonize, and abstract slavery, they also exhibit a propensity to represent emancipation through a more illustrational and even documentary approach to the depiction of the slave body (fig. 3.8). Robert Nast's immense wood engraving *Emancipation* brought out in 1855 exemplifies the formal tensions between the older symbolic approaches to slavery and freedom and the new, more realistic conventions of

contemporary journalism, purporting to show the realities of life for South-
ern blacks. The engraving contains the full allegorical range inherited from
the earlier English prints. Emancipation appears in an illuminated sky, with
the figure of Freedom, right in the center of the title word. Justice, bearing
scales and an olive branch, stands to the right directly below the *n* of "Eman-
cipation," while two soldiers bearing a Union flag cheer. To the left slavery,
personified as a hideous Medusa-like hag with snake hair, flees from the light
and grabs a lead holding the multiple heads of a Cerberus. Together these
monstrous figures personify slavery, and a series of lightning bolts reaches out
to the left-hand panels that show stock scenes of abuse within plantation life.
Runaways cower in a field (top left), a family is sold on the auction block (cen-
ter), and a topless female is whipped while a topless male is branded (bottom
left). These melodramatic vignettes are counterbalanced by a correspondingly
reassuring set of fantasies of free slave life after emancipation on the right.
Delighted slave children run out from a public school, while below them
ex-slaves queue to collect payment from the Freedmen's Bureau. These com-
plex narrative compartments all revolve around a large central roundel that
shows a free black family enjoying the pleasures of emancipation. The scene
is closely adapted out of the illustrations showing Uncle Tom's family in their
cabin during the opening scenes of *Uncle Tom's Cabin*. Two light-skinned
and attractive young lovers who are adapted from depictions of George and
Eliza Harris stand by a window. A portrait of Lincoln hangs on the wall and
overlooks the scene, while a second portrait of Lincoln is inset in a smaller
roundel at center bottom. The basic formulas, whereby freedom and slavery
are shown as abstract personifications while blacks are shown as either passive
victims or obedient and grateful creatures, are meticulously observed. The
containment of the free black population within such reassuring fantasies
reached a graphic climax with the deluge of prints that greeted the passage
of the Fifteenth Amendment in 1870. These rigorously compartmentalized
designs imprison their black subjects within a rhetoric where obedience and
dutiful gratitude are the gifts of freedom.

The efficacy of these designs and the well-oiled fictions they promulgated
found its final celebration within the diaspora with the passage of the Golden
Law in Brazil in 1888. The narrative and symbolic conventions of the Anglo-
American tradition were transferred with a remarkable thoroughness, and it
may well be the very familiarity of these designs that has misled historians of
Brazilian abolition into assuming that it operated according to the ideological

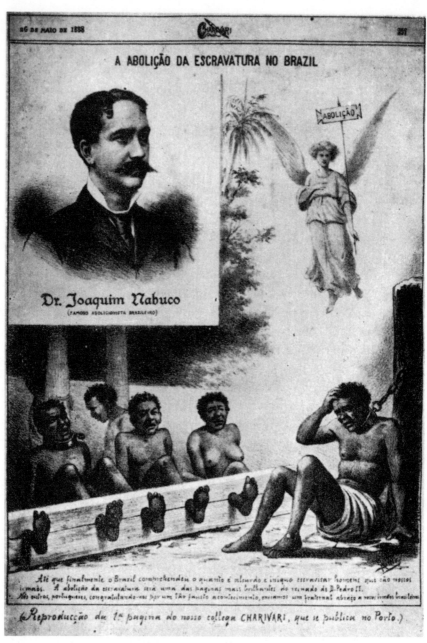

FIG. 3.9. Angelo Agostini, "A Abolição da Escravatura no Brazil,"
Revista Illustrada, lithograph, 1888.

frameworks of the Anglo-American abolition movements. Given the entirely different conditions and history of emancipation in Brazil, these images are astonishing in their distance from reality. A typical example can be found in the leading graphic satiric journal of Rio, *Revista Illustrada* (fig. 3.9).[53] Male and female slaves with collars and chains around their necks sit immobilized and in agony in the stocks. Above them floats a winged female figure bearing a spear labeled "Abolition"; to her left is a large and realistically executed portrait of Count Joachim Nabuco, the abolitionist author and intellectual spearhead of the parliamentary agitation for slave emancipation. The slaves are pitiful victims, abolition is a lovely and abstract female vision, and freedom is brought about by the activity of a white aristocratic champion of the slave. The narrative building blocks put in place by Thomas Clarkson and the Clapham Sect could not have been more meticulously transferred.

4

No-go Areas and the Emancipation Moment
Running-Dancing-Revolting Slaves

IT SHOULD BE apparent by now that the propagandistic legacy of the emancipation moment (as orchestrated by the slave powers and their occasionally innocent apologists, the abolitionists) projected sophisticated agendas for the containment and packaging of the slave body in the context of freedom. Yet it must never be forgotten that this propagandistic legacy was not invincible, and that against all odds the history of Atlantic slavery is also a history of prolonged, unceasing, ingenious, and effective slave resistance. This chapter consequently forms a sort of coda to the rest of the book in taking up slave agency. The slave's individual assumption of freedom and slave enjoyment of freedom through artistic forms of expression are considered in terms of how they posed problems for the white imaginary. Resistance could take many forms, both passive and active, and several of these forms relate directly to self-emancipation. It is the purpose of the following discussion to think about several ways in which slaves could liberate themselves and express freedom. These subject areas, which were largely closed down by the white-generated slavery archive, nevertheless did generate intriguing literary and iconographic treatments.

The first subject I want to consider is slave flight, or more accurately, self-liberation through escape. The discussion is focused on treatments of this subject outside the mainstream slave narrative. The second area briefly considered is revolt or insurrection, both during the middle passage and on the plantation. The third and most problematic theme is the possibility of a momentary and transcendent escape from slavery through intense cultural expression, in other words, through art. I consequently end the chapter by analyzing the slave's reappropriation of dance as a method of self-empowerment so intense as to allow the enslaved mind to enter a state beyond slavery.

RUNNING AWAY WITH THE STORY: FUGITIVE SLAVES
AND THE EXPRESSION OF LIBERTY

They make a rout about *universal* liberty, without considering
that all that is to be valued, or indeed can be enjoyed by
individuals, is *private* liberty. — Samuel Johnson

All slave narratives are, of their essence, texts that work around and toward the emancipation moment.[1] They are texts about slavery in relation to the possibility of gaining individual freedom, or in Dr. Johnson's terms, *"private liberty."* Consequently, the majority of slave narratives are only too aware that freedom can only be experienced as a variegated set of social possibilities once the narrator has passed beyond the physical point when liberty has been claimed, through escape, as a geographical and physical reality. The narratives deal with the growth and articulation of an intimate, personalized notion of what the possibilities of a liberated existence might be within a mind educated, matured, and possibly terminally compromised within a slave system. An ex-slave consciousness subsequently operating in various environments designated as "free" may see these environments in terrifying ways.[2] The slave narratives consequently occupy a complicated space, both within the emancipation archive of Atlantic slavery and within the American nineteenth-century literary landscape generally. This complexity has to do both with the establishment and subsequent development of the slave narrative as a form in its own right and with the manner in which the publishing industries and the expectations of their audiences developed from the late eighteenth century through to the Emancipation Proclamation.

Consequently, the manner in which slave narratives relate emancipation is contradictory and unstable. Freedom can mean very different things within slave narratives depending on when and where they were written, who oversaw their publication, and how capable the author was of resisting conformity to the triumphalist rhetorical traditions governing Anglo-American celebrations of the exodus. To put the matter bluntly, the cultural environment into which the 1791 New York edition of Olaudah Equiano's *Interesting Narrative* was released was unrecognizably different from that which received *The Story of Mattie J. Jackson* in 1865 or *A Narrative of the experience, adventures and escape of Richard J. Potter* in 1866.[3] When Equiano wrote in England in the late 1780s, the slave narrative as a form did not exist; he was making up the rules and defining the literary terms of his achievement as he went along. In this sense the entire text is a multivalent approach to various ways of un-

derstanding what freedom of thought and action might constitute within the slave diaspora.[4] As far as models were concerned Equiano was writing backward, staring into the glow of traditions we now lack the general cultural background to be able to associate easily with slave narrative. Equiano's book was in genre terms something of a mixed bag, part spiritual autobiography, part travel narrative, part economic treatise. Equiano wrote primarily for an English readership which, for the first time, was just becoming aware of abolition as a social and moral issue. There was also a philosophical and social context for thinking about the whole concept of freedom that was immediately inflected by Enlightenment thought and by the impact that the liberationist agendas of the philosophes had had upon the development of the American and French revolutions.

The ex-slaves who wrote their autobiographical accounts in the years immediately following the American Civil War were writing in a very different and far more limited intellectual environment. Unlike the exploratory, unpredictable, and brilliantly uncertain Equiano, they were writing celebratory testimonies that, in a sense, retroactively justified the Civil War as a "war against slavery." Jackson's and Potter's texts were part of a late glut of slave narratives that presented slave experience as the traumatic basis upon which the North had fought and won.[5] Their narratives were received and digested by an enthusiastic and largely sympathetic Northern readership that had been exposed to an ever increasing flow of slave narratives in the three decades leading up to the outbreak of war.[6] This audience was also all too willing to accommodate formulaic and celebratory slave narratives into the explosion of publications that the North unleashed in the wake of the Emancipation Proclamation. In this sense slave narrative became increasingly an expression of white liberationist fantasies, a way of whitewashing the memory of Southern slavery, the complicity of the North in the continuation of slavery, and the appallingly violent and traumatic conditions, for both black and white, through which emancipation finally emerged. The central point here is that freedom within the context of Atlantic slavery and the story of the runaway had become packaged by 1865 in a manner in which it had not in the early 1790s. And yet if the slave narratives were conditioned in terms of their ideology, then radical developments in publishing meant that they possessed new and expansive formal elements.

From 1760 to 1865 North American slaves and ex-slaves, often working closely with white editors and collaborators, wrote autobiographical texts that remain a distinctive body of traumatic evidence. These texts are founded in a

unique integrity and examine the fictional options for analyzing and celebrating freedom and self-liberation. There is no other major Atlantic slaveholding area within the diaspora, and no other abolition movement, that may lay claim to the creation of a body of narratives by ex-slaves so sustained, so variegated, and so widely read as that of North America.[7] In this sense they constitute a distinct archive for the examination of the emancipation moment. In the Northern free states of America for three-quarters of a century a new and increasingly significant literary form emerged that, whatever its shortcomings, was devoted to examining the possibility of freedom within the ex-slave consciousness. The evolution of the slave narratives occurred against the backdrop of a series of unprecedented developments in communications and of quite literally revolutionary developments in the definition of personal freedom. Abolition, and the fictions of liberation that it promulgated in the course of its various Euro-American fluctuations, remained a global propaganda movement umbilically connected to a publishing revolution, which was, in its turn, one aspect of an intercontinental industrial revolution.

The North American slave narratives are personal testimonies. They are, no matter how intrusive or damaging the editorial procedures, accounts of the manner in which the traumatic experience of slavery impacted on the consciousness of individual slaves. But because of the environment in which they were published in the Northern free states the slave narratives as a genre were involved in a complicated dialogue with the literary glamour and saleability of trauma. Closely related to this, and central to the orchestration of emotion within the narratives, was the excessive joy, or even *jouissance*, which was fictionally released by the experience of writing down and writing out the experience of becoming free, or very differently, being set free. The ways in which all slave narratives approached the experiences of freedom as excess, an excess closely related to traumatic suffering and to pleasure, also lock them into a complicated dialogue with Anglo-American traditions of Protestant martyrdom. Slave narratives were marketed as dealing with the suffering of innocent victims who had remained pure of heart and in this sense were integrated into a responsive market for evangelical martyrological confession. The central archive and the magisterial touchstone of Protestant martyrology, on both sides of the Atlantic, was the *Actes and Monuments* of John Foxe. Better known in its popular abbreviated forms as *Foxe's Book of Martyrs*, this text remained a classic entertainment for pious Northerners (many abolitionists) in the first half of the nineteenth century.[8] In this context it is also highly significant that white abolitionists on both sides of the Atlantic had continually

narrativized their activities and experiences in terms of an extreme martyro-
logical rhetoric. The slave narratives fitted alongside the texts by and about
English and American abolitionists who had been constructed as martyrs.
These ranged from John Newton and William Cowper in England to the
American abolitionists William Lloyd Garrison, Elizah Lovejoy, Jonathan
Walker, and, most climactically, John Brown.[9] All these figures generated
biographical cults that foregrounded martyrdom as the inevitable experience
of any individual consciousness that denied the legitimacy of slavery in every
aspect of human culture — whether economic, social, moral, religious, or be-
havioral. The slave narratives did not, however, function as pure martyrology.
Because of the development of a variety of popular forms of fictional enter-
tainment founded in teleological narrative, of which the novel was hugely
the most influential, they were also conscious works of literature inevitably
operating within an evolving and ever more competitive set of publishing
environments. In this sense they were designed to make the slave-martyr's
quest for freedom into entertainment of a sort that could easily slide into the
conventions of the novel.[10]

Slave narrative interacted with American and British publishing environ-
ments in diverse ways. Although initially released as works of propaganda for
the American antislavery campaign, as the nineteenth century progressed the
slave narratives came to have appeal as works of entertainment, sentimental-
ity, and melodrama, suspended between fact and fiction and relating to, or
interacting with, other publishing forms. In this sense their very success as
a form had made them precarious; the more popular they became the more
they flirted with, and might be absorbed into, already extant popular genres
outside the literatures of antislavery. Sheet music, the collections of nigger
minstrelsy, gallows literature, travel books, and after 1852 the "Tom Shows"
were all forms capable of sucking in slave narratives and of then spitting them
out in devolved and racially inflected forms that all but destroyed their es-
sence.[11] And yet this formal promiscuity had been both an advantage and a
danger from the very inception of the slave narrative proper.[12]

Because of the strange pressures inevitably generated by their recent absorp-
tion into the North American literary canon, the slave narratives have tended
to be read in formal isolation. It must, however, never be forgotten that they
were successful because they appealed to a series of popular markets, new and
old, which were not always strictly related to abolition and which came at
personal freedom in diverse ways. Their strategies were very different from
those sanctioned by abolition thought, let alone the bizarre agendas of those

who now police course structures in literature departments in North America and Europe. It is quite possible that much of the success of Harriet Jacobs's *Incidents in the Life of a Slave Girl* lay in the way in which it related to the emerging market for pornographic literatures.[13] With its constant sexual tension, with its narrative suspension of the act of rape, as Harriet negotiates her precarious life around the predatory advances of the infatuated yet cunningly sinister master, it is a text that edges toward and yet skirts around the borders of the pornographic. Much of the lasting appeal of Jacobs's book lies in the way it deals with intimate domestic relations within a context of complete patriarchal empowerment and female slave disempowerment. In other words, the narrative is centered upon the classic power dynamic underlying virtually all sadomasochistic bondage pornography. Abolition publications, and graphic satires in particular, which dealt with the sexual abuse of young slave women inevitably moved into a variety of areas connected with the rapidly expanding markets for pornography and for sadistic and flagellatory material in particular. The extent to which slave narratives might often be constituted pornography is a sensitive and consequently radically under-researched area. In this context it should be remembered that Sigmund Freud and Richard von Krafft-Ebing both observed that several of their patients experienced their first sexual fantasies while reading flagellation scenes in *Uncle Tom's Cabin*.[14]

How stable is the tradition or the form of the Afro-American slave narrative, in any case, how stable is the vision of freedom it offers us, compared, say, with the white-evolved rhetorics surrounding the passage of abolition laws? When does the narrative of escape and emancipation manage to free itself from the propagandistic agenda that originally generated it and then continued to sustain it? The politics surrounding the American and English editions of particularly successful slave narratives are now too complicated to engage with in this book. It is now impossible to recover the degree to which an ex-slave, working within the power dynamics and political agendas of Northern abolition, was ever allowed total control over the production of her or his text. The canonical texts have in any case been thoroughly investigated in these contexts by William Andrews and several subsequent scholars, while the most celebrated of the slave narratives have each now generated a critical literature of their own.[15] What I want to do here, in the wake of Andrews, is to think about a series of marginal and problematic areas that construct the concept of freedom liminally in relation to the canonical core of the slave narrative proper. The first is the runaway slave advertisement as a compromised and fragmented archive of liberation, a subject that I only gesture toward in

the present context. The second is the construction of the emancipation mo-
ment within the mythology of the Underground Railroad (URR). I focus my
discussion on an extended analysis of a single text, William Still's *The Un-
derground Railroad*. I do this for a number of reasons: first, because it has
not been done before; second, because of the text's remarkable deployment
of visual imagery; third, because of the weird extremities and subtleties of
Still's rhetorical methods. And finally I would stress the timing of this book;
its chronology places it in a particularly charged space for this study, for Still
published his masterwork after the end of the Civil War and after the passage
of the Fifteenth Amendment.

SELF-EMANCIPATION AND RECOVERABILITY:
THE RUNAWAY ADVERTISEMENTS

The ultimate act of slave emancipation before the Civil War was, of course,
the repossession of the self through the act of running away. This is a tre-
mendously important fact when set against the fantasies of the emancipation
moment. The slave narratives provided one cultural space for the retrospective
reinvention of the act of running away. As has been indicated, the levels at
which the official testimony and mythologization of the act of self-liberation
were policed can often make the slave narratives compromised. The policing
could come in many forms, ranging from direct authorial intervention to the
more inchoate pressures of conforming to narrative and market conventions
and even audience expectations. It is consequently worth speculating on the
limits of slave narrative, and upon whether there might be other parts of the
slavery archive that give alternative ways of reinventing slave escape.

Uncle Tom's Cabin is by no means unique among the bestsellers of Ameri-
can antislavery in raising questions about what the limits of slave narrative
should now be taken to be. Consider, for example, the case of *American Slav-
ery as it is: Testimony of a Thousand Witnesses*, published in 1839. This book-
length publication was the brainchild of Theodore Dwight Weld and Ange-
lina and Sarah Grimké. As abolitionists became more confrontational and
extreme in their approach to slavery, the polemical base of abolition shifted
from arguments of moral suasion to atrocity literature that confronted the
physical, sexual, and psychological torments of Southern slavery full on.
American Slavery as it is was the watershed publication in this respect. The
volume enjoyed mass circulation on both sides of the Atlantic and was the
single most widely disseminated antislavery text after Harriet Beecher Stowe's
Uncle Tom's Cabin. American Slavery as it is was a hugely ambitious text that

took the unprecedented approach of condemning slavery by almost exclusive quotation from slave owners themselves. The testimony takes the form of advertisements and articles concerning slave life published in the Southern press. The volume was arranged with a set of prefatory "Personal Narratives" by slaveholders or ex-slaveholders, "embodying in the main, the results of their own observation in the midst of slavery." Yet these white narratives of slavery were integrated with seemingly unending inventories relating to the description of slave flight and, underlying this as an inevitable counterpoint, slave abuse. The lists of slave punishment and torture were made up of a carefully ordered collage of advertisements.

Each of these texts constitutes a miniature slave narrative, at one level noting through identificatory marks the former abuse of the slave but also advertising the slave's bid for freedom. The direct and endlessly repeated formula, whereby horrific acts of violence upon the body of the slave lead directly to the attempt to gain individual freedom through flight, constitutes one of the most uncompromised expressions of emancipation within the Atlantic slavery archive. Of all those who endured slavery, and all those who managed to escape, only a tiny percentage ever published their stories as full-fledged personal narratives. Most slave lives went unrecorded; most slave suffering and most slave philosophy on the subject of freedom remained and remains unrecoverable. In this sense the carefully organized lists of advertisements put together by Weld and the Grimkés constitute a grim, minimal, and deeply moving set of micro narratives articulating the price of freedom. Here are just three from a single page of this almost unbearably intense text:

> Ranaway, a negro named Arthur, has a considerable *scar* across his breast and *each arm* made by a knife; loves to talk much of the *goodness of God*.

> Ranaway a negro girl called Mary, has a small scar over her eye, *has a good many teeth missing*, the letter A *is branded on her cheek and forehead*.

> Was committed to jail, a negro man, says his name is Josiah, his back very much scarred with the whip, *and branded on the thigh and the hip, in three or four places* thus (J.M.) the *rim of his right ear has been cut or bit off*.[16]

These are terrible little manifestos of liberation that operate through tremendous narrative compression. In the first two examples the stark opening word *ranaway* goes off like a gunshot, to be followed by the arbitrary list of identifying marks and occasionally behavioral characteristics. These inventories, which set down the signs of casual yet extreme abuse with such forensic calm, reach out into an aporia that lies at the center of the emancipation moment

and its articulation within abolition literatures. For every Frederick Douglass and Harriet Jacobs there are hundreds of thousands of silent, absent lifestories where mutilated people attempt to get away from persecution against all the odds and often fail with terrible personal consequences. The slave advertisements are enormously significant for these fragmentary glimpses, in which "Arthur," "Mary," "Josiah," and countless others have their names and distinguishing features registered minimally in print for the first and the only time. They constitute a different approach to the emancipation moment, a neglected archive that exists entwined around the core of abolition propaganda. It is now time to think what to do with, and indeed how to read, these problematic texts that come at freedom in such unexpected ways. The narrative shards and testimonial nuggets scattered throughout the diasporic press, and then subversively reconstituted within the bestsellers of Anglo-American abolition — be it Thomas Clarkson's *Negro Slavery*, Samuel Taylor Coleridge's *Table Talk and Omniana*, Weld and the Grimkés' *American Slavery as it is*, Stowe's *Key to Uncle Tom's Cabin*, or Charles Dickens's *American Notes* — are hard little histories testifying to the assumption of individual liberty.[17] The runaway advertisements were created by the slave power and record the slave body only in terms of the signs of cruelty and abnormality inscribed upon it, signs made relevant or visible by the sudden absence of that body. It has often been asked, in the context of Holocaust memory and the display of relics, if it is right to remember the bodies of the victims through the language and eyes of the perpetrators.[18] Given that the only cultural relic that survives as a testimony to so many enslaved people's desire to express their freedom lies in the fragmented form of these advertisements, surely it is right to follow Weld's *American Slavery as it is* into the testimonial gray zone it creates.

Weld's text is finally an agglomeration of abuse, a bizarre collage-like extension of *Foxe's Book of Martyrs* cut and pasted out of advertising and popular journalism and written at a point when the realization of abolition seemed unlikely. In this sense *American Slavery* presents the emancipation moment as something fragile, precarious, and not yet realized. When the Civil War ended and freedom was officially enshrined in the Emancipation Proclamation and the rapid passage of the Fifteenth Amendment, slave liberation was packaged in popular art and publications in predictable ways. Freedom emerged as the familiar gift, given by the liberator to the enslaved.[19] And yet there were black authors and propagandists who attempted to go against the grain and to produce texts that foregrounded freedom as something the slave actively seized rather than passively received. One monumental text that attempted to place

black agency center stage was William Still's eight-hundred-page compendium *The Underground Railroad*. Still's book was published by subscription in 1872 with an elaborate title: *The Underground Railroad, A Record of Facts Authentic Narratives Letters & c. Narrating the Hardships, Hair-breadth Escapes and Death Struggles of the Slaves in their efforts for Freedom as relayed By themselves and others or witnessed by the author together with sketches of some of the largest stockholders and most liberal aiders and advisers of the Road.*[20] The title page indicates the complicated manner in which Still's mighty text locates itself vis-à-vis publishing markets and literary genres. While it is claimed to be first and foremost a "record of facts" in the form of "authentic narratives," these narratives are advertised in the language of sensationalism and melodramatic adventure—"Hair-breadth escapes" and "Death Struggles." In genre terms the narratives are described both as autobiographies (stories "relayed" verbatim by the "slaves themselves") and as processes of "witnessing" on Still's part. The final part of the title parodies the commercial language of big business to advertise the abolitionists and philanthropists who supported the URR. Still has, in fact, created a variegated compilation that interweaves a series of different styles and forms — including letters, poetry, travel literature, spiritual autobiography, trial literature, economic history, the novel, belles lettres, humor, and advertisement — to politicized and often highly ironic ends.[21] What results is a powerful and unstable text that both contributes to and yet questions the narrative orthodoxies within the white fictions that had attempted to appropriate freedom.

WILLIAM STILL AND THE SUBVERSIVE CRITIQUE OF EMANCIPATION FANTASY

The Underground Railroad is ingenious in terms of the way it flirts with the conventional narrative dynamics with which abolition constructed the emancipation of the slave. For example, the book has a formally conventional frame, in that it opens and closes with explicit hagiographic and Christological tributes to white abolitionists involved in the URR. After the prefatory apparatus, the work opens with the story of the white abolitionist Seth Concklin. The opening two sentences could not make the foundations of the book's emancipatory fictions within the frame of white martyrology any clearer:

> In the long list of names who have suffered and died in the cause of freedom, not one, perhaps, could be found whose efforts to redeem a poor family of slaves were more Christ like than Seth Concklin's; whose noble and daring spirit has

been so long completely shrouded in mystery. Except John Brown, it is a ques-
tion, whether his rival could be found with respect to boldness, disinterested-
ness and willingness to be sacrificed for the deliverance of the oppressed.[22]

These are the martyrological parameters, or parentheses, against which all
must be measured: the sacrifice of Christ and the sacrifice of John Brown
at Harpers Ferry. The landscape of freedom has radically altered since 1860,
and it seems that the Civil War has completely exonerated Brown, who now
carries no taint of maniacal enthusiasm or violent excess but is freedom's true
martyr. Still seems to be supporting the liberationist orthodoxies of abolition,
and to be suggesting that while the slave, in attempting to escape, always acts
out of self-interest, the white free abolitionist works in a spirit of selflessness or
spiritual disinterest. The latter part of the book appears to uphold this agenda.
The last quarter of the volume consists of an extensive series of biographies of
the leading abolitionists involved in harboring or helping fugitive slaves. As
such, this part of the book conforms quite precisely to earlier British volumes
that remembered slavery in terms of a series of fêted and mainly white "heroes
of abolition" and "friends of the slave."[23]

It would, however, be a mistake to see this conventional structure, so sub-
servient to the fantastic glorification of white abolition, as the defining nar-
rative stance. Still was black and wrote a history, arguably the first history in
point of fact, that is primarily focused on celebrating black volition, black
agency, and indeed black violence in the pursuit of freedom.[24] While undeni-
ably respectful to mainstream abolition, this aspect of the book is very much a
shell covering a far more challenging and semiotically destabilizing text. Thus
the activities and attitude of the white abolitionists, in feeling duty-bound to
give freedom to the slave, sit uneasily with the sense that all these slaves forc-
ibly seized their liberty because it was something that was always theirs.

The narratives are pieced together out of letters, personal testimonies
by witnesses, including the slaves, biographical reminiscences, newspaper
articles, and inserted literary quotations. The more extreme or spectacular
modes of escape are accompanied by wood engravings, and several of these
have been made from photographs especially composed by Still to commemo-
rate specific subjects and modes of escape.[25] The text is not arranged in any
straightforwardly chronological way beyond the fact that the escapes are set
within the time frame of the passage of the Fugitive Slave Law (FSL) in 1850
and the final outbreak of war in 1861. In this sense the book makes a power-
ful and constantly reiterated connection between the FSL and the Civil War.

The narratives of escape — some long and involved, some barely a sentence in length, some dealing with well-known ex-slave celebrities, the majority with obscure and unknown slaves of all ages and both sexes — create the effect of an unending sea of black resistance breaking in narrative wave after wave upon the reader. There is consequently a sort of mesmeric power exerted by the re-iterative percussion of the main body of the text. The slaves just keep coming, there is no stopping them, and Still exhibits great skill in orchestrating and modulating the speed of their narratives and the flow of their numbers. There are only a certain number of ways in which a slave body can escape, and consequently a series of internal dialogues are set up within the text when a certain mode of escape is attempted by a series of different slaves at different times and in different places. How carefully Still manipulates these patterns within this vast gallimaufry of a book is a subject that merits closer attention. Within the terms of this study I just want to take a single example of the sort of inner synergies and tensions that Still sets up: slave escapes involving the packaging of slaves as freight. The main concern of the analysis is to reveal how thoroughly Still interrogates white paradigms for the expression of lib-erty within this one narrative space.

I will begin the analysis with a narrative that not only involves boxes and boxing, but which also powerfully reappropriates the slave advertisement. Throughout his text Still shows great guile and inventiveness when it comes to taking on the negative associations of the runaway advertisements. As we have seen, whether the slave advertisements were employed without irony by the Southern slaveholders or with irony to express the outrage of the aboli-tionists, the documents still had the effect of presenting the slave as disem-powered and victimized. Still boldly takes on this inheritance and overturns it in several narratives.

In the following example, the story of Lear Green's escape, he expands and subverts a genuine slave advertisement by incorporating it into an elaborate resurrection narrative based in an actual case of emboxment. In a sense he brings Lear back to fictional life, from her burial alive within the textual tomb of the slave advertisement that once encapsulated her. He begins her narrative with a bold verbatim quotation of the entire text of the original puff:

ESCAPING IN A CHEST.

$150 REWARD. Ran away from the subscriber, on Sunday night, 27th inst., my NEGRO GIRL, Lear Green, about 18 years of age, black complexion, round-featured, good-looking and ordinary size; she had on and with her when she

left, a tan-colored silk bonnet, a dark plaid silk dress, a light mouslin delaine, also one watered silk cape and one tan colored cape. I have reason to be confident she was persuaded off by a negro man named Wm. Adams, black, quick spoken, 5 feet 10 inches high, a large scar on one side of his face, running down in a ridge by the corner of his mouth, about 4 inches long, barber by trade, but works mostly about taverns, opening oysters, &c. He has been missing about a week; he had been heard to say he was going to marry the above girl and ship to New York, where it is said his mother resides. The above reward will be paid if said girl is taken out of the State of Maryland and delivered to me; or fifty dollars if taken in the State of Maryland. JAMES NOBLE, No. 153 Broadway, Baltimore.[26]

Still begins his textual reconstitution by then subjecting the quotation to a critique of style and content:

LEAR GREEN, so particularly advertised in the "Baltimore Sun" by "James Noble," won for herself a strong claim to a high place among the heroic women of the nineteenth century. In regard to description and age the advertisement is tolerably accurate, although her master might have added, that her countenance was one of peculiar modesty and grace. Instead of being "black," she was of a "dark-brown color." Of her bondage she made the following statement: She was owned by "James Noble, a Butter Dealer" of Baltimore. . . . In this situation a young man by the name of William Adams proposed marriage to her. This offer she was inclined to accept, but disliked the idea of being encumbered with the chains of slavery and the duties of a family at the same time. After a full consultation with her mother and also her intended upon the matter, she decided that she must be free in order to fill the station of a wife and mother. For a time dangers and difficulties in the way of escape seemed utterly to set at defiance all hope of success. Whilst every pulse was beating strong for liberty, only one chance seemed to be left, the trial of which required as much courage as it would to endure the cutting off the right arm or plucking out the right eye.[27]

The assault is deftly organized. Still opens with a direct correction of factual details in the advertisement. Almost as if he is teaching the slave catcher his advertising trade, he changes the color adjective from the inaccurate *black* to *dark-brown*. But from this unemotional factual base the prose rapidly spills out into the construction of a potentially tragic love story featuring a heroic and virtuous young couple. The language of the slave advertisement is displaced by that of the Romantic novella, only to slip quite suddenly into a

different sermonic register. In fact, the final sentence constitutes an ingenious biblical commentary both on the strength of Lear's desire for freedom and on the purity of her motives. The courageous but horrifically violent imagery, involving the plucking out of the right eye and the severing of the arm, is developed out of Christ's reinterpretation of the fifth commandment, "Thou shalt not commit adultery," in the Sermon on the Mount. Christ, drawing on the Oriental belief in the lustful eye, warns his disciples that if you have looked lustfully on a woman, you have already committed adultery in your heart.[28] The solution he suggests is to pluck out the offending eye, or cut off the offending hand, if you have moved from thought to action: "that one of thy members shall perish and not that thy whole body should be cast into hell" (Matthew 5:30). So why is Still inserting a bizarre reinvention of these difficult and seemingly irrelevant scriptural ideas here? Given that Lear has been open to white lust in the adulterate slave South, and that she has fallen in love with a black slave whom she desires to marry, Still is making a complicated point about her love of freedom, her sexual love, and her love of virtue. She has survived the lustful gaze of the slave power and yet maintained her purity intact, and this moral victory is presented as being as majestic as the physical trials she will now endure to secure bodily freedom. Her desire for freedom is thus constructed not merely as a desire to escape bodily from slavery into freedom, but as a desire to move into an environment where her emotional and sexual purity will, for the first time, mean something. Of course, the final satiric kick contained within this reconstituted biblical language comes from the way it reaches back into the bodily abuse that slaves suffered and that was used to identify them in slave advertisements. Slave owners *were* frequently knocking, whipping, and plucking eyes out from slave bodies, and slave limbs *were* cut and severed. Yet, as Still's redeployment of Christ's extreme imagery powerfully asserts, the slaveholders who committed these acts of brutality were not concerned with correcting, but with extending, their own lustful and sadistic nature and practice.

The narrative continues by making a second move from descriptive realism into a more mythic space, where Lear and her box are finally set up as a memorial *tableau vivant*, and yet this symbolic account constantly relates back to the reality of the box with Lear inside it, which is printed at the head of the narrative (fig. 4.1):

> An old chest of substantial make, such as sailors commonly use, was procured.
> A quilt, a pillow, and a few articles of raiment, with a small quantity of food
> and a bottle of water were put in it, and Lear placed therein; strong ropes

were fastened around the chest and she was safely stowed amongst the ordinary freight.... After she had passed eighteen hours in the chest, the steamer arrived at the wharf in Philadelphia, and in due time the living freight was brought off.... Subsequently chest and freight were removed to the residence of the writer, in whose family she remained several days under the protection and care of the Vigilance Committee. Such hungering and thirsting for liberty, as was evinced by Lear Green, made the efforts of the most ardent friends, who were in the habit of aiding fugitives, seem feeble in the extreme. Of all the heroes in Canada, or out of it, who have purchased their liberty by downright bravery, through perils the most hazardous, none deserve more praise than Lear Green.... The chest in which Lear escaped has been preserved by the writer as a rare trophy, and her photograph taken, while in the chest, is an excellent likeness of her and, at the same time, a fitting memorial.[29]

The narrative begins with a detailed and realistic account of the details of the journey, but ends as a bold assault on the memorial fictions of white abolitionists. Still explicitly attempts to minimize, indeed to negate, the activities of the latter. Despite the amount of this text given over to the celebration of white contributors to the URR Still sets their efforts in comparative perspective. Measured against the heroism of this one young black woman, the sum total of their contribution is written off with the wonderfully dismissive colloquialism: "feeble in the extreme."

Having this woman and her box in his house, Still also takes the opportunity to use the most up-to-date visual technology, photography, to have her journey and escape transformed into an icon. The photograph is then engraved for reproduction within his book and mass-produced for public consumption. Still claims for this icon both a real and an ideal status; he has created an "excellent likeness," a true-to-life portrait, but also a lasting icon to the young woman's heroism, "a memorial." Still does not merely drop the image into the text, but directs his audience on how to interpret, or read it, emblematically. It is evidence, a historical record, but it is also a perpetual reminder that the achievement and courage of this disempowered woman will always dwarf the moral claims "of even the most ardent friends" of the slave. In other words, the image finally concerns the process whereby Lear liberated herself and asserted her right to freedom.

It is worth looking closely at how this icon of a free black woman has been constructed. The visual memorial of Lear plays brilliant games with space and light in order to create an image encompassing both Lear's free and enslaved

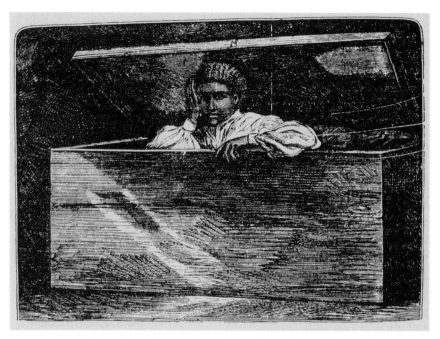

FIG. 4.1. "Lear Green Escaping in a Chest," plate from William Still's
The Underground Railroad, wood engraving, 1872.

states. Dressed in a simple white blouse, she rests her head on her right hand
and gazes straight out at the viewer, while her left hand rests on the front edge
of the box. Her calm and relaxed demeanor appears remarkable in the context
of the spatial oppression and sepulchral gloom that the rest of the composi-
tion evokes. It needs to be remembered that this image was evolved out of the
fusion of a studio photograph and a commercial wood engraving of that pho-
tograph, and it combines elements from both these forms to extraordinary
effect. The composition for the original photograph was ingeniously set up to
maximize a sense of claustrophobia. The box was photographed in close-up
and consequently fills up the picture space almost completely, thrusting the
viewer right up against Lear. The camera was also placed at a low angle. The
effect of this deliberately constructed point of view is to put the viewer on an
intimate or equal footing with Lear; we are almost on the floor with her. This
combination of proximity and abasement makes the coffin-like chest appear
heavy, monumental, and oppressive.

The feeling of being interred or buried alive is also ingeniously enhanced

by the construction of the engraving. Lear and the box are surrounded by an intensely cross-hatched background of deep shadow, while the whole composition has been framed within another boxlike margin. Lear's box, surrounded by gloom, pushes out to the edges of the picture plane, but is itself constricted and boxed in by the picture frame, and this gives a sort of pressure cooker feel to the design. The sense of stifling enclosure is brilliantly enhanced by the double shaft of sunlight breaking across the wood grain on the front of the chest. This is descriptively ambiguous, emphasizing darkness and horror by suggesting a world of light and space outside the picture. The illuminating shaft of light, conventionally used to describe divine oversight, the protective eye of God, in religious painting, has been tactfully introduced. The two illuminated bars are a naturalistic detail, but they are also emblematic and typological. The strips of sunlight are a refulgent, a tumultuous expression of freedom, of the transformed state into which Lear emerges. They are also an allusion to Still's earlier claim that Lear was protected by a divine and benign providence, that God was intimately concerned with the processes of her suffering and liberation: "That the silent prayers of this oppressed young woman . . . were momentarily ascending to the ear of the good God above, there can be no question."[30]

Looking at Still's text as a whole there are yet deeper and more complicated narrative and cultural dialogues to which this newly forged abolition emblem contributes. This wood engraving of a young female slave emerging from a box, seizing free life from the living death of slavery, is also an image that exists in dialogue, not to say competition, with another image bank and another narrative in Still's text. Still created Lear's icon in order to take on the narrative legacy of one Henry "Box" Brown.

LIBERTY PACKAGES: BOX-MEN, BOX-WOMEN, AND STILL'S GREAT CHAIN OF SUFFERING

When Still was composing his masterpiece, Henry "Box" Brown had already provided a central and celebrated transatlantic metaphor for the expression of the emancipation moment as one of ecstatic fulfillment for the escaped slave.[31] Brown's emergence from his packing case had become an image beloved of white abolitionists in terms of the way it showed slavery as a living death from which the liberated victim could escape (fig. 4.2). Brown had become a celebrated abolition icon. Jumping out from the coffin-like box, singing psalms as a body of white philanthropists embraced him, Brown's image conformed at

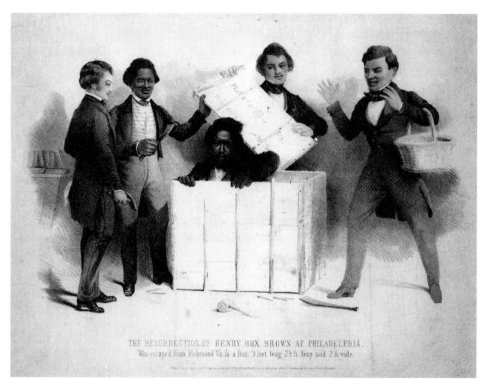

THE RESURRECTION OF HENRY BOX BROWN AT PHILADELPHIA.
Who escaped from Richmond Va. in a Box. 3 feet long 2½ ft. deep and 2 ft. wide.

FIG. 4.2. *The Resurrection of Henry Box Brown at Philadelphia*, lithograph, 1850.

one level quite comfortably with the major demands of the sanctioned rhetoric of emancipation. The Manichean construction of South and North, of slave power and land of freedom, of immoral darkness and moral refulgence was spectacularly upheld in the symbolism of Brown's narrative, at least up until the moment of his escape. What Brown was to become, and indeed to make of himself when he went to England, and how he was to slip first into disrepute and finally out of sight, were not parts of the narrative that fitted easily with the posthumous white fantasy of abolition.[32] The image of the liberation of Henry "Box" Brown was reproduced in innumerable forms in the popular press and within the visual print cultures of England and America.[33]

The two narratives of his life that Henry "Box" Brown produced, first in North America under the direct supervision of a white abolition clergyman and then later in England, where he had a much freer hand, possess remarkable differences. Brown discovered the confidence and creativity to tell aspects of his life in very different registers and forms in his later account.[34] In

many ways one might say he reinvented a language of freedom in the later text, which had clearly been dampened down in the earlier text in accordance with a set of white abolition priorities. For example, the climactic moment in Brown's narrative is the escaped slave's Lazarus-like emergence from the packing case in which he was shipped to freedom. In the later English edition this moment of rebirth is accompanied by Brown's own rough-and-ready satiric ballad productions and by his rearrangement of the psalms as ecstatically reiterative chants in the style of plantation song. Brown soon came to see textual representation of the event, no matter how untamed and enthusiastic the language used to describe his emergence, as inadequate. His rebirth into freedom from the grave of slavery became more purely performative, and Brown, as he lectured in England, would on occasion have himself transported from destination to destination in his packing case. He would then spring out of the box on stage, drawing the audience into what would now be termed the "lived experience" of his ordeal and subsequent joy. Through his performance art Brown discovered a unique way of repossessing his moment of liberation and of then sharing it with an audience.[35]

Brown had been presented as uniquely daring, but also as a universal example of the slave redeemed by the noble activity of abolitionists, and this is largely how he has been remembered today. In this context it is fascinating that Still's book, although it deals fully with Brown's escape, also seeks to question and contextualize this controversial figure. Brown, as the ideal creation of white abolition publicity, is presented as overselling his case and as losing his humanity in a show of vanity. When it comes to the presentation of slave escape and liberation through the processes of packing, shipment, and unpacking, Still clearly had his own agenda and was keen to establish a new hierarchy that did not place Henry "Box" Brown at its apex.

Still opens his long account of Brown by reproducing a woodcut representation of his moment of liberation (fig. 4.3). This small wood engraving has been adapted out of the celebrated and technically refined large-sheet lithograph produced by the Boston abolitionists in 1850 to celebrate Brown's escape. Still keeps the original title *The Resurrection of Henry Box Brown*, but the image is now part of a diptych existing in visual dialogue with the potent design of Lear Green's moment of emergence.[36] The designs are radically different. Whereas Lear is seen close up from below eye level, the point of view in the Brown print is above and from a distance. Whereas Lear is surrounded by gloom and imprisoned in a frame, Brown is outdoors in bright light and there is no framing device shutting him inside the picture. Whereas Lear is

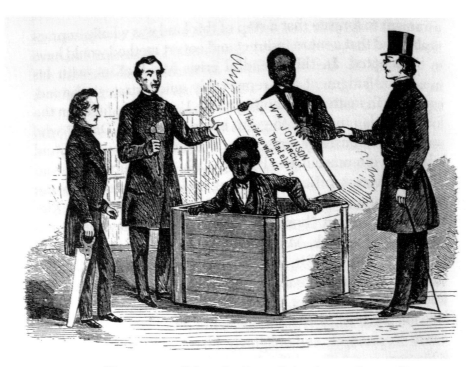

FIG. 4.3. "Resurrection of Henry Box Brown," plate from William Still's
The Underground Railroad, wood engraving, 1872.

a single woman, alone, unaided, and sitting calmly, Brown is surrounded by
male attenders, who help him out as he raises himself up.

Still's text makes his take on Brown increasingly clear. Still initially lauds
him, stating: "the name of Henry Box Brown has been echoed over the land
for a number of years, and the simple facts connected with his marvellous
escape from slavery in a box published widely through the medium of anti-
slavery papers. . . . Brown was a man of invention as well as a hero."[37] Yet im-
mediately after this Still sounds a note of caution, stating "that very little is
generally known in relation to this case." Still then gets stuck into the task of
cutting the Brown myth down to size: "his case is no more remarkable than
many others. Indeed, neither before nor after escaping did he suffer one-half
what many others have experienced."[38] Compared with other "box-men" and
"box-women" Brown is presented as having the luxury of ordering his own
box: "The size of the box and how it was to be made to fit him most com-
fortably, was of his own ordering. Two feet eight inches deep, two feet wide,

and three feet long were the exact dimensions of the box, lined with baize."[39] Brown is already presented, in terms of suffering, as vastly below his boxed competitors, none of whom enjoyed the luxury of a bespoken container lined with soft "baize." Still then switches the majority of the rest of the narrative to a white perspective, before Brown's resurrection. Still focuses on the activities and expectations of McKim, the abolitionist who is to receive the box in Philadelphia. After Brown's release, the narration switches to a detailed study of the untold sufferings of S. A. Smith, the white man who packaged Brown up, in the South. Attempting a follow-up to Brown's escape, this time packaging up two slaves, the plan was betrayed and traced back to Smith, who was then imprisoned. The implication is that Smith has to pay a terrible price for Brown's liberty, and that the real martyr to freedom's cause was not the black slave but the white friend of the slave.

Brown himself is almost entirely shut out of his own story, despite the fact that Still had two very different published versions of *The Narrative of Henry Box Brown* to draw on. When Brown does finally appear in the scene of the resurrection, it is described with notable brevity:

> All was quiet. The door had been safely locked. The proceedings commenced. Mr. McKim rapped quietly on the lid of the box and called out, "All right!" Instantly came the answer from within, "All right, sir!" The witnesses will never forget that moment. Saw and hatchet quickly had the five hickory hoops cut and the lid off, and the marvellous resurrection of Brown ensued. Rising up in his box, he reached out his hand saying, "How do you do, gentlemen?" The little assemblage hardly knew what to think or do at the moment. He was about as wet as if he had come up out of the Delaware. Very soon he remarked that, before leaving Richmond he had selected for his arrival-hymn (if he lived) the Psalm beginning with these words: "I waited patiently for the Lord, and He heard my prayer." And most touchingly did he sing the Psalm, much to his own relief as well as to the delight of his small audience. He was then christened Henry Box Brown.[40]

It is revealing that the first words he is shown speaking are those attributed to him by the white editor of the first edition of his narrative, the polite and subservient "All right sir!" rather than the forthright "All right" of his own later version. It is also revealing that the ecstatic gospel rendering of the psalm that Brown reprinted in the later editions of his narrative is reduced to a "touching" song, which serves to "delight his small [white] audience" rather than

sum up his ecstatic emotions at the moment of realizing his liberty. Brown is finally "christened" by those who have saved him; his life as a free man, and his reborn status, are officially conferred in a parodic Christian ritual by the abolitionists. When it comes to showing his life of liberty, the prose constantly hints that Brown is rather spoiled and that he is inordinately pleased with himself: "Clothing and creature comforts were furnished in abundance. . . . Brown promenaded the yard flushed with victory [he] then took his departure for Boston, evidently feeling quite conscious of the wonderful feat he had performed."[41]

In this revisionist history Brown is marginalized and his myth reduced. But it is not only in the direct relation of Brown's own story that it is possible to detect an overall set of strategies for how Still wants to reappropriate the symbolic meanings of the box within the redemptive mythology of resurrection. The narrative tentacles stretch out in a variety of directions and invariably drag Brown's self-mythology down.

The first time Brown is mentioned in the text is in relation not to his escape but to Smith's ordeals. There is also an emphasis on the fact that Brown was only one in a production line of such escapes masterminded by Smith:

> Here too come the overwhelming claims of S. A. Smith, who at the sad cost to himself of many of the best years of his life in the Richmond penitentiary, boxed up Henry Box Brown and others in Richmond, and committed them to Adams' Express office, to be carried in this most extraordinary manner to freedom.[42]

Viewed from this angle, Brown emerges as less spectacular and less unique, and also as the beneficiary of yet another white martyr of abolition. The first boxed escape described in the main text, although in real time it occurred six years after Henry "Box" Brown, comes well before Brown's in the text and in many ways steals his fire. The escape is presented in headlinese and even appropriates Brown's famous descriptive epithet of "Box": "William Peel, Alias William Box Peel Jones. Arrived per Erricson Line of Steamers, Wrapped in Straw and Boxed Up, April, 1859."[43] Peel's ordeal is presented according to both folkloric and biblical narrative patterns. The pain suffered during the journey is reconstructed using a structure of triplicate ordeals:

> The limit of the box not admitting of straightening himself out he was taken with the cramp on the road, suffered indescribable misery, and had his faith taxed to the utmost, — indeed was brought to the very verge of "screaming

aloud" ere relief came. However, he controlled himself though only for a short season, for before a great while an excessive faintness came over him. Here nature became quite exhausted. He thought he must "die;" but his time had not yet come. After a severe struggle he revived, but only to encounter a third ordeal no less painful than the one through which he had just passed. Next a very "cold chil" came over him, which seemed almost to freeze the very blood in his veins and gave him intense agony, from which he only found relief on awaking, having actually fallen asleep in that condition. Finally, however, he arrived at Philadelphia, on a steamer, Sabbath morning.[44]

The narrative structure is intricate, each of the ordeals itself broken down into a subset of three. So the initial cramp leads to "misery," which leads to a near loss of faith; then his fainting fit leads to exhaustion and then immediately terror of death; and finally comes the "cold chil" that seems to freeze the blood and cause a final agony. At this point divine intervention allows him to sleep the sleep of the blessed and innocent. The narrative is rounded off by stressing that he arrives at safety and freedom on the Sabbath, and so the whole ordeal becomes a religious one, indeed, a narrative riff on the harrowing of hell. The moment of release is described in terms that flirt with the imagery of apotheosis and the whole revolves around the cycle of martyrdom, entombment, and resurrection, the typological prefiguration of Christ in Lazarus being extended to the slave body: "The box is opened, the straw removed, and the poor fellow is loosed; and is rejoicing, I will venture to say, as mortal never did rejoice, who had not been in similar peril. The trial in the box lasted just seventeen hours before victory was achieved."[45] The account of the escape ends by quoting a letter from the man who saved William "Box" Peel Jones. This epistolary account is encoded within the secret parabolic language of the URR and ends by reinventing Jones within the dynamics of Old Testament liberation narrative:

> His good friend returned to Baltimore the same day the box man started for the North, and immediately dispatched through the post the following brief letter, worded in Underground Rail Road parables:
>
> BALTIMORE APRIL 16, 1859.
>
> W. STILL: — Dear brother I have taken the opportunity of writing you these few lines to inform you that I am well and hoping these few lines may find you enjoying the same good blessing please to write me word at what time was it when Israel went to Jerico I am very anxious to hear for thare is a mighty host

will pass over and you and I my brother will sing hally luja I shall notify you when the great catastrophe shal take place No more at the present but remain your brother N. L. J.[46]

Within the URR encoding Jones has been converted into Israel, and his passage from Baltimore into Philadelphia is equated with the pass-over of the tribes of Israel (the "mighty host") under Joshua, who "passed over" Jordan into the plains of Jericho. This event, the fitting end of the exodus, takes place immediately following the destruction of Pharaoh's army in the Red Sea and the death of Moses. This climactic liberation narrative was perhaps the most important chain of events within the slave culture's revolutionary rereading of Old Testament teleology, and as such was comprehensible to black slave and white abolitionist alike.[47] Yet again, however, Jones is allowed to preempt a key element within the narrative layering of Henry "Box" Brown and to detract from Brown's primacy.

The next mention of Brown is straightforwardly competitive and concerns another escape by steamer. The idea that slavery is a living hell is here literalized as the escaping slaves are placed almost within a fiery furnace that clearly evokes the burning lake of hell:[48]

JAMES MERCER, WM. H. GILLIAM, AND JOHN CLAYTON.
STOWED AWAY IN A HOT BERTH.

This arrival came by Steamer. But they neither came in State-room nor as Cabin, Steerage, or Deck passengers. A certain space, not far from the boiler, where the heat and coal dust were almost intolerable, the colored steward on the boat in answer to an appeal from these unhappy bondmen, could point to no other place for concealment but this. Nor was he at all certain that they could endure the intense heat of that place. It admitted of no other posture than lying flat down, wholly shut out from the light, and nearly in the same predicament in regard to the air. Here, however, was a chance of throwing off the yoke, even if it cost them their lives. They considered and resolved to try it at all hazards. Henry Box Brown's sufferings were nothing, compared to what these men submitted to during the entire journey.[49]

The passage fuses infernal imagery with that of the middle passage. The constricted space, polluted air, and enforced physical position all call to mind the descriptions of slaves during the Atlantic voyage. Here, however, the torture is willingly chosen by the slave in order to achieve freedom. In this sense the

narrative powerfully appropriates, even while it overturns, one of the most emotive bodies of imagery within the abolition archive. The enforced passivity and the namelessness of the slaves who endured the middle passage is replaced by a volitional suffering by two individuals who have names and personal histories. When they finally emerge from the boat, Still conjures up a vision of two men who have actually been driven out of their own humanity by their ordeal: "From the thick coating of coal dust, and the effect of the rain added thereto, all traces of natural appearance were entirely obliterated, and they looked frightful in the extreme. But they had placed their lives in mortal peril for freedom."[50] This is visionary writing: the thirst for freedom is presented as something for which the slave must have the courage not merely to suffer, but for which she or he must be prepared to undergo mutation into a state outside nature.

And yet the final tribute to these men comes at the expense of Henry "Box" Brown. The manner in which Brown is usurped, or in fact destroyed, in that final sentence suggests an intensely competitive approach on the part of Still. It is not good enough that Mercer and Clayton suffered, it is essential that these sufferings are seen to reduce the traumatic agonies of Brown to "nothing." Logically the extremity of this view is absurd. Why is there no room for Brown's pain alongside that of Mercer and Clayton? Why does Still want to write Brown's pain out of memory?

There is, in fact, an overarching pressure that Still places upon these narratives. It seems that the quality of freedom within this world of slave escapes relates directly to the intensity and duration of physical suffering. In this sense freedom replaces true faith within Still's martyrological hermeneutics. The power of liberty exists in direct correlation to how close to death the escapee approached. Consequently, their status as free beings can be calibrated on what might be termed a great chain of suffering. Within each form of escape, whether it is being boxed up, cross-dressing, using a horse, going by foot, swimming, rowing, and so on, each individual is to be measured in terms of the degree to which he or she approached death. The martyr must be prepared to die for his or her faith, and because religious faith has been replaced by the secular concept of liberty, a concept so iconically enshrined with the Declaration of Independence and the Constitution, the slave must show how far he or she is prepared to suffer for this ideal.

As far as Still is concerned Henry "Box" Brown did not undergo enough physical ordeals to place him high up on the chain. The comparative dynamic comes out even more clearly in the following account, where a pregnant fe-

male escapee is used to show Brown's inadequacy. The account is worth quoting at length because it lays out with great precision the rigorous framework that allows Still to calibrate the precise value of each moment of release into freedom. The passage also shows what an artist of the emancipation moment Still could be:

WOMAN ESCAPING IN A BOX, 1857.

SHE WAS SPEECHLESS.

In the winter of 1857 a young woman, who had just turned her majority, was boxed up in Baltimore by one who stood to her in the relation of a companion, a young man, who had the box conveyed as freight to the depot in Baltimore, consigned to Philadelphia. Nearly all one night it remained at the depot with the living agony in it, and after being turned upside down more than once, the next day about ten o'clock it reached Philadelphia. Her companion coming on in advance of the box, arranged with a hackman, George Custus, to attend to having it brought from the depot to a designated house, Mrs. Myers', 412 S. 7th street, where the resurrection was to take place. . . . The secret had been intrusted to Mrs. M. by the young companion of the woman. A feeling of horror came over the aged woman, who had been thus suddenly entrusted with such responsibility. A few doors from her lived an old friend of the same religious faith with herself, well known as a brave woman, and a friend of the slave, Mrs. Ash, the undertaker or shrouder, whom every body knew among the colored people. Mrs. Myers felt that it would not be wise to move in the matter of this resurrection without the presence of the undertaker. Accordingly, she called Mrs. Ash in. Even her own family was excluded from witnessing the scene. The two aged women chose to be alone in that fearful moment, shuddering at the thought that a corpse might meet their gaze instead of a living creature. However, they mustered courage and pried off the lid. A woman was discovered in the straw but no sign of life was perceptible. Their fears seemed fulfilled. "Surely she is dead," thought the witnesses. "Get up, my child," spake one of the women. With scarcely life enough to move the straw covering, she, nevertheless, did now show signs of life, but to a very faint degree. She could not speak, but being assisted arose. She was straightway aided up stairs, not yet uttering a word. After a short while she said, "I feel so deadly weak." She was then asked if she would not have some water or nourishment, which she declined. Before a great while, however, she was prevailed upon to take a cup of tea. She then went to bed, and there remained all day, speaking but a very little during that time. The second day she gained strength and was

able to talk much better, but not with ease. The third day she began to come to herself and talk quite freely. She tried to describe her sufferings and fears while in the box, but in vain. In the midst of her severest agonies her chief fear was, that she would be discovered and carried back to Slavery. She had a pair of scissors with her, and in order to procure fresh air she had made a hole in the box, but it was very slight. How she ever managed to breathe and maintain her existence, being in the condition of becoming a mother, it was hard to comprehend. In this instance the utmost endurance was put to the test. She was obviously nearer death than Henry Box Brown, or any of the other box or chest cases that ever came under the notice of the Committee.[51]

In this account Still is determinedly explicit about the equation of liberty and Christological resurrection. The emergence from the box is anticipated from the first as a resurrection. The final scene of the young woman emerging and coming back to life delicately plays around the narrative and details of the beautiful description of the miracle of Jesus raising Lazarus in John 11. Although the woman is not dressed in a shroud, Still is careful to point out that the scene occurs with an undertaker, termed a "shrouder," present. The terror, horror, and inward doubt of the two old women is a tremendous substitution for the similar emotions of Christ, who does not approach the miracle of raising Lazarus back to life with either confidence or joy, but with agony. John describes how Christ "groaned in the spirit," "wept," and finally "groaned in himself" at the prospect that the miracle might be beyond his power, and that he may indeed have lost Lazarus. The old ladies are similarly shown "shuddering at the thought that a corpse might meet their gaze instead of a living creature." The sequence of events from the young slave's presumed death ("Surely she is dead") to the calm but irrational certainty of one of the women, who suddenly announces with simple faith, "Get up my child," draws on the full majesty of the biblical original. Christ, forced to confront the certainty of Lazarus's death, so bluntly summarized by Martha's statement, "Lord, by this time he stinketh," quite simply, and again with inspired irrationality, exclaims, "Lazarus, come forth." Lazarus's three days in the tomb are of course highly significant as a prolepsis for Christ's own entombment. Transposed to a joltingly realistic domestic setting, replete with beds, glasses of water, and cups of tea, Still again makes a bold transposition. The slow awakening of the woman's senses is set out over three days, so that on the third day she rises again.

Where the text is most pregnant, however, is in the way it closes certain thoughts and experiences off from the narrator and consequently the reader.

While the white abolitionist witnesses are desperate to hear the experience of suffering, to feed off its fictionalization, the woman cannot translate the trauma into words. "She tried to describe her sufferings and fears while in the box, but in vain." In this "vain" attempt to articulate her pain, this nameless woman stands in contradistinction to Brown, who was able to elaborate with such endless invention, and Still implies "vanity," his own ordeals. It is the silence with which she greets the horror of her experience that seems to confer on her an elevated status. While she is aided up the staircase she remains incapable of "uttering a word," but these are symbolic steps, each one of which is taking her farther and farther away from the publicized ordeal of Brown. Her silence is a significant one and again reaches back to the biblical model. Lazarus is raised from the dead but famously says nothing, and it was this provocative silence that was to lead Robert Browning to write one of his greatest speculative poems confronting the question of death as liberation.[52] Lazarus's embodiment as a living proof of Christ's miraculous powers also puts him in a perilous situation in the future. Lazarus becomes a marked man, and in this sense he stands as representative of all runaway slaves who have undergone the miraculous rebirth into freedom at the hands of the abolitionists.

Still's brilliance in developing the physical details of an escape into a complex rhetorical web drawing in biblical metaphor and elements of Gothic fiction comes out in multiple instances where he deals with boxing up or enshrouding. In the following he elaborates on slavery as a living death, or burial alive, with some mercurial metaphoric maneuvers:

> BLOOD FLOWED FREELY.
>
> ABRAM GALLOWAY AND RICHARD EDEN, TWO PASSENGERS SECRETED IN
> A VESSEL LOADED WITH SPIRITS OF TURPENTINE. SHROUDS PREPARED
> TO PREVENT BEING SMOKED TO DEATH.[53]

This narrative concerned the escape of two slaves from North Carolina to Philadelphia on board a trading vessel. Again, Still creates a complicated fusion of biblical narrative and chains of imagery, this time conjoining the resurrection narratives of Lazarus and Christ with imagery of infernal torment. Still also uses paradox as a fictional shock tactic. The shroud, normally associated with death and the embalming of the corpse, is here miraculously changed into a source for the preservation of life. The manner in which this idea is developed is ingenious:

> The captain of the ship is sympathetic they learned when the vessel would start, and that she was loaded with tar, rosin, and spirits of turpentine, amongst

which the captain was to secrete them. But here came the difficulty. In order that slaves might not be secreted in vessels, the slave-holders of North Carolina had procured the enactment of a law requiring all vessels coming North to be smoked. . . . To escape this dilemma, the inventive genius of Abram and Richard soon devised a safe-guard against the smoke. This safe-guard consisted in silk oil cloth shrouds, made large, with drawing strings, which, when pulled over their heads, might be drawn very tightly around their waists, whilst the process of smoking might be in operation.[54]

The ship is simultaneously the means of escape and the space of torment. The reference to tar and turpentine is intriguing from the perspective of one of the most celebrated plantation folktales. The "tar-baby" is of course constructed out of tar and turpentine by Brer Fox, and there may be a level at which Still is alluding to this powerful myth of black entrapment but final liberation.[55] Yet there is no doubt that the primary associations in the narrative are biblical. The suffering takes on an infernal quality, for hell, biblically configured as a lake of fire and brimstone, is here a space of smoke and turpentine.[56] The symbolic associations of hooding are also taken on and reinvented. The silk hood placed over the head primarily carried associations of hanging, as the criminal was customarily hooded by the hangman before execution. Here the voluntary hooding is a source of survival and continued life, a way of cheating death, or of evading recapture and reenslavement, which is a metaphoric form of death. Having set up this smoking scenario, Still then deftly swerves away, presenting a new form of suffering that is even weirder and more lurid:

They were ready to run the risk of being smoked to death; but as good luck would have it, the law was not carried into effect in this instance, so that the "smell of smoke was not upon them." The effect of the turpentine, however, of the nature of which they were totally ignorant, was worse, if possible, than the smoke would have been. The blood was literally drawn from them at every pore in frightful quantities. But as heroes of the bravest type they resolved to continue steadfast as long as a pulse continued to beat, and thus they finally conquered.[57]

Again, the metaphorics of suffering are very complicated. The effect of the fumes of turpentine is to suck the blood out of the victim's skin. The image is a device for describing the operations of slavery, which sucks out the slave's life or bleeds the slave victim to death. The suffering is also figured in martyrological terms as a test; if the slaves can survive this ordeal, then they will

emerge as brave heroes worthy of experiencing the freedom they have won. As with the case of Lear Green, the description ends by focusing on the material relics of the ordeal, which are fetishized much as the remains of saints and martyrs are kept and then displayed within the reliquaries of the medieval cathedrals:

> The invigorating northern air and the kind treatment of the Vigilance Committee acted like a charm upon them, and they improved very rapidly from their exhaustive and heavy loss of blood. Desiring to retain some memorial of them, a member of the Committee begged one of their silk shrouds, and likewise procured an artist to take the photograph of one of them; which keepsakes have been valued very highly.[58]

Here the imagery gets even denser. A tight-fitting silk shroud that is discarded while new life rises out of it at one level alludes to the metamorphosis of the worm into the butterfly. Silk is, of course, literally the cocoon of a certain form of moth, and consequently the allusion is very witty. But there is an even more forceful set of narrative associations at work. This shroud takes us again specifically into the terrain of Christological resurrection. Undoubtedly the most celebrated religious relic in the world is the shroud of Turin, the grave cloth in which the body of Christ was claimed to have been embalmed after the crucifixion and through which his resurrected body passed. In demanding to keep one of the slave shrouds the abolitionists confer upon it the status of both material evidence of the miracle of escape and holy icon of freedom. The final registering of this object, and its passage into the abolition community as a shared image, is only possible through the exploitation of the latest reproductive technology, photography.

Still has a quite remarkable capacity for inventing a new semiotics of liberation. The objects used in unusual escapes, and which hid and protected the vulnerable bodies of slaves, male and female, are endowed with a mystical force. These objects, and the imagery in which their simulacra are circulated around the North, constitute a new way of expressing the slave experience of gaining freedom. They have a narrative autonomy that exists beside yet separate from the abstract personifications of freedom which, as we have seen, had previously been so extensively used by the abolitionists to represent the emancipation moment. The soiled, begrimed, oiled, sweat-stained, blood-soaked, and finally discarded silk sack in which the black body suffered stands in powerful counterpoint to the refulgent image of a white female figure of Liberty, with which Still's readers were so familiar.

THE FINAL POINT to stress about Still's book is just how marvelously alternative its narrative strategies and images were and are. Still's book is a brilliant intervention into debates over liberty, emancipation, and slavery because it has so many ingenious strategies for countering the suffocating orthodoxy of white celebratory approaches to slave emancipation. Still is at his most effective when he throws the idea of freedom out into new performative contexts. He is not content to see emancipation as an end in itself, as the death of slavery in a flash of blinding light and a moment of innocent rebirth.

His book as an entity deserves far more detailed analysis than I can give it here, but I want to conclude with a famous illustration of how far he is prepared to go in challenging white complacency over the limits of freedom. I refer to the hilarious set piece when he stages the head-on collision of white academic control of the aestheticization of slavery with the furious humor of a set of free blacks. Toward the end of his text Still describes how the escaped slaves William Wells Brown and William and Ellen Craft, who are by this point celebrities in Britain, create a form of performance art in England as they confront white notions of freedom. The ex-slaves are shown playing outrageous games with the black slave, the white slave, the free white male and female, and the slave power. Still quotes from a wonderful letter written in England and sent to William Lloyd Garrison. The letter opens by satirizing the pretensions of the Great Exhibition and America's participation in it:

> "FUGITIVE SLAVES AT THE GREAT EXHIBITION."
> Fortunately, we have, at the present moment, in the British Metropolis, some specimens of what were once American "chattels personal," in the persons of William and Ellen Craft, and William W. Brown, and their friends resolved that they should be exhibited under the world's huge glass case, in order that the world might form its opinion of the alleged mental inferiority of the African race, and their fitness or unfitness for freedom.[59]

The Crystal Palace is transformed into a domed global specimen case, and the specimens on display for their humanity are three fugitive slave celebrities, all of whom have gained notoriety through the publication of their narratives. The crucial point here is that they may be in one sense liberated, but Anglo-American society still needs to make its mind up as to whether blacks were or ever will be fit for freedom. In this sense freedom is initially set up as something possessed by the white, which can be given or crucially withheld from the black, even after physical freedom has been attained. The description continues by setting the scene, as the ex-slaves visit the exhibition with

the celebrated abolitionist George Thompson and his family. Thompson's attractive young daughter is paired off with Wells Brown, whose companion she remains for the day. The whole party then heads for the American pavilion in order to examine and discuss the most sensational of the American exhibits, Hiram Powers's gleaming white marble statue *The Greek Slave* (fig. 4.4). This piece of sadomasochistic soft-core pornography had been a sensational hit on both sides of the Atlantic. It presented white female slavery in terms that combined sentimentalism, voyeurism, and outrage in precisely the desirable measures. The statue is really designed for a male audience and takes us into a world of classic porno-fantasy. We are invited to eye up the assets of the nubile and demure young woman on the auction block and, under the cloak of a protective moral outrage, do what we like with her or to her. The work of an American sculptor, *The Greek Slave* had already become the subject of ironic comment in Britain. While its beauty was not questioned by Victorian Britain, the ethics behind it were. *Punch* had produced a satiric commentary, including a woodcut entitled *The Virginian Slave*, which presented an alternative sculptural vision of a half naked, but equally nubile young black woman (fig. 4.5).[60] The suggestion was that before it started making grand aesthetic statements about the nature of enslavement, America needed to look into its own back yard. Thompson's party entered this charged arena, and William Wells Brown decided to take the debate several stages further:

> Wm. Wells Brown took "Punch's Virginia Slave" and deposited it within the enclosure by the "Greek Slave," saying audibly, "As an American fugitive slave, I place this 'Virginia Slave' by the side of the 'Greek Slave,' as its most fitting companion." Not a word, or reply, or remonstrance from Yankee or Southerner. We had not, however, proceeded many steps from the place before the "Virginia Slave" was removed. We returned to the statue, and stood near the American by whom it had been taken up, to give him an opportunity of making any remarks he chose upon the matter. Whatever were his feelings, his policy was to keep his lips closed. If he had felt that the act was wrongful, would he not have appealed to the sense of justice of the British bystanders, who are always ready to resist an insult offered to a foreigner in this country? If it was an insult, why not resent it, as became high-spirited Americans? But no; the chivalry of the South tamely allowed itself to be plucked by the beard; the garrulity of the North permitted itself to be silenced by three fugitive slaves. . . . We promenaded the Exhibition between six and seven hours, and visited nearly every portion of the vast edifice. Among the thousands whom we met in

our perambulations, who dreamed of any impropriety in a gentleman of character and standing, like Mr. McDonnell, walking arm-in-arm with a colored woman; or an elegant and accomplished young lady, like Miss Thompson, (daughter of the Hon. George Thompson, M. C.), becoming the promenading companion of a colored man? Did the English peers or peeresses? Not the most aristocratic among them. Did the representatives of any other country have their notions of propriety shocked by the matter? None but Americans. To see the arm of a beautiful English young lady passed through that of "a nigger," taking ices and other refreshments with him, upon terms of the most perfect equality, certainly was enough to "rile," and evidently did "rile" the slave-holders who beheld it; but there was no help for it. Even the New York Broadway bullies would not have dared to utter a word of insult, much less lift a finger against Wm. Wells Brown, when walking with his fair companion in the World's Exhibition. It was a circumstance not to be forgotten by these Southern Bloodhounds. Probably, for the first time in their lives, they felt themselves thoroughly muzzled; they dared not even to bark, much less bite. Like the meanest curs, they had to sneak through the Crystal Palace, unnoticed and uncared for; while the victims who had been rescued from their jaws, were warmly greeted by visitors from all of the country.[61]

As with so many of the set piece narratives in *The Underground Railroad*, this piece mixes performance with real life, high art with low art, and art with life. A black ex-slave takes himself, and a wood engraving that an English satirist had made in response to an American statue, and brings all three elements into frantic interaction. He chooses to enact this union in the most intensely cosmopolitan and socially charged space of public performance on the planet—the Crystal Palace. He juxtaposes two visions that white America had tried very hard to keep apart, and in doing so galvanizes white Americans into action. And yet as the passage progresses, it is not the dialogues and juxtapositions of conventional aesthetics that are held out as important but the performance of life itself. Having made his melodramatic political performance, Wells Brown continues to walk the exhibition halls in physical contact with a beautiful young white woman. Finally, it is this act, and the very different *inactivities* of the English and American spectators, which are held out as the really significant performances. This is both an angry and a remarkably moving examination of what freedom might actually mean. What we are being told is that debates on slavery and freedom are not finally very relevant if conducted solely within an isolated aesthetic environment. Freedom emerges as

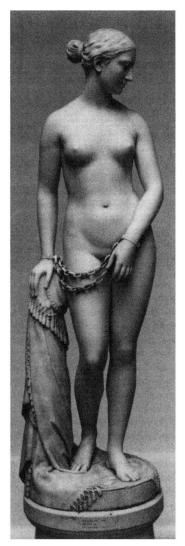

THE VIRGINIAN SLAVE.

INTENDED AS A COMPANION TO POWER'S "GREEK SLAVE"

FIG. 4.4. (*Left*) Hiram Powers, *The Greek Slave*, marble, modeled 1841–43, carved 1846, 66 × 19 × 17 inches. In the collection of the Corcoran Gallery of Art, Washington, D.C. Gift of William Wilson Corcoran.

FIG. 4.5. (*Right*) "The Virginian Slave," *Punch*, wood engraving, 1851.

organic, as a living thing, and it can only exist if the conditions for its life are created. The lack of prejudice (albeit rather idealistically constructed) within the British audience is the primary element, the oxygen, of liberty. If English people see nothing special about a white woman and a black man walking together, that is because they have evolved a way of looking where there is nothing special to see. Let's hope that's what they continue to see.

THE BIG EMANCIPATION TABOO: SLAVE REBELLION AND THE ICONOGRAPHY OF FREEDOM

> Hereditary bondsman! Know ye not
> Who would be free themselves must strike the blow?
> By their right arms the conquest must be wrought.
> — Byron, *Childe Harold's Pilgrimage*, lxxvi

There are certain areas of slave behavior and thought that the controlling mechanisms of emancipation propaganda are not keen to engage with. Perhaps the most significant of these taboo subject areas is slave revolt and revolution. Slaves had emancipated themselves from the earliest days of institutionalized plantation slavery in the Americas. Escaped slave communities developed in a great variety of contexts, and every major slaveholding culture had to deal with organized slave rebellion at some point in its existence. And yet, to look at the visual archive of the Atlantic diaspora, and at the art generated by emancipation in particular, very little of this activity is registered at any level or at any time.

Liberation through Execution: Slave Narrative and the Subversion of Gallows Literature

The oldest and still one of the most popular areas of mass publication — gallows literature — provides a space for thinking about how popular forms of publishing relating to criminality could be used to drown out or erase slave insurrection as an expression of slave liberation. The slave narrative is locked from the outset into this morbid, sensational, and sentimental subgenre. Last dying confessions, harangues from the gibbet, revelations of horror and atrocity from notorious criminals lying in their cells or standing beneath the gallows had been a staple of the English and indeed European chapbook and ballad market since the Elizabethan period.[62] The eighteenth and nineteenth centuries may have seen revolutions in printing technology, but the public's

thirst for this material in any and every form remained unquenchable and conservative. Show trials maintained their central position as sites for political contestation and debates over personal liberty. Trials were frequently exploited by political radicals, as in the case of the renowned treason trials of 1794 in London.[63] Criminal execution remained a space of public entertainment and personal liberation; the criminal was allowed, through the form of a published confession or final speech, to have the last word.[64] In this sense gallows confessions were a form capable of empowering and indeed biographically establishing the previously disempowered. Slave violence and insurrection were subjects largely written out of the liberation narratives that abolition publicized. Of course, on occasions when black slaves or free blacks committed violent crimes and were sentenced to public execution, their narratives were inevitably absorbed into the genre of the gallows confession. Ironically, the murder of a master or mistress could suddenly allow a slave to operate in a performative space that was egalitarian, in the sense that black on white murder was a crime of such enormity as to be colorblind. How individuals were then capable of bending and manipulating their newly acquired celebrity into expressions of black resistance is an under-researched question. The expression of slave resistance through homicide, and indeed infanticide, provides a particularly disturbing archive of the emancipation moment.

As early as 1795, the links between slave narrative, homicide, and gallows literature were established with the publication of the broadside the *Dying Confession of Pomp a Negro Man*.[65] Pomp was a slave in Massachusetts who murdered his master and was hanged. Yet his confession is a fascinating document that pits Pomp's own account against that of a white amanuensis who had a heavy controlling editorial hand. Pomp tells of his torture and harassment under a brutal master, and also refers to fits of mental instability and invisible voices calling upon him to kill. Pomp finally presents himself as cleansed and brought nearer to God by his justifiable homicide — in other words, the slave acts as a divine instrument, his violence is a revolutionary gesture sanctioned by God in opposition to a wicked system and its wicked representative. Pomp consequently emerges as a shadow consciousness in this text who sees the necessity of murdering his master in much the same terms as Hamlet sees the necessity for murdering Claudius. The editor Jonathan Plummer is blind to this aspect of Pomp's account and can see no moral or liberationist motive for the attack, only religious fanaticism. In Pomp's lack of contrition for the killing Plummer further indicates that a slave consciousness is characterized by hopeless and animalistic amorality. This text highlights

the complicated interpretative environment into which such early liberation slave narratives were released. *The Confessions of Nat Turner* is the most notorious text to combine slave narrative, liberation theology, and the popular confessional form of the criminal's "last dying testament."

The Confessions of Nat Turner is consequently an endlessly fascinating text. While it constitutes at one level a fine representative example of the evil murderer's death cell confession, it is also an idealistic account of a slave revolution founded upon religious ideas, and finally a black insurrectionary emancipation declaration, although a very different one from that signed by Abraham Lincoln in 1863. The *Confessions* is an ambiguous text, a slave narrative that had lasting impact as both a proslavery and antislavery testimony. Turner's *Confessions* takes the tensions between a passionate black narrator and a white auditor and amanuensis to the breaking point. It is the meeting point for a traumatic struggle between a slave's attempt to document a successful insurrection and the slave power's attempts to counter and erase that narrative through a policing application of legal and religious rhetoric. The text was supposedly dictated to Thomas Gray, himself a slaveholder, who was Turner's court-appointed lawyer but also his confessor and ironically both his literary "editor" and censor.[66] Gray explains his own motives to have been "the gratification of public curiosity" and his rapidly produced pamphlet seems to have fulfilled this function, selling a reputed fifty thousand copies within weeks of publication. In fact, a pamphlet account of the Southampton massacre had already been rushed out.[67]

Nine days before Turner was finally captured, Samuel Warner had produced the luridly entitled *Authentic and Impartial Narrative of the Tragical Scene which was Witnessed in Southampton . . . when Fifty-five of its inhabitants (mostly women and children) were inhumanly MASSACRED BY THE BLACKS.* Despite its title this account of the narrative was a passionate antislavery diatribe. What makes the earlier and now almost forgotten text dangerous to abolition, and indeed to the subsequent constructions of Turner, is its central concern with the extreme violence of slave insurrections, especially when successful. Warner conjures up the specter of the slave revolution in Haiti at some length, and Nat Turner is linked with Jean-Jacques Dessalines, reputedly the bloodiest of the slave generals during the massacre of the whites in revolutionary San Domingo.[68] The pamphlet ends with a passionate plea for America to "burst asunder the chains of bondage and set the captive free!" or the mayhem created by "General Nat" will emerge as merely the first outbreak in a full-fledged slave revolution.[69] Yet Warner's message was not one that the

popular fictions generated around the Turner insurrection were ever going to embrace.

As an interpreter of Turner Gray was much more in tune with the version of events the public demanded. As an editor/author Gray carefully constructed a text that had no interest in exploiting the antislavery potential within the story of Turner's life. From Gray's perspective the *Confessions* is an attempt both to entertain the public and to allay the mass hysteria traveling through the slave South in the wake of the massacre. Gray's narrative interventions are fundamentally in line with those of Jonathan Plummer in his relegation of Pomp to the role of fanatical deviant. Gray tries to construct Turner as a religious maniac, explicitly an "enthusiast" in the millennial sense. As such Turner is set up as a being who is outside normal human consciousness, slave or free. In constructing the Turner myth in this manner, Gray both initiated and concurred with the hysterical accounts of the Southern press. Yet enough of Turner's own thought, language, and narrative artistry remains embedded within the text to allow for alternative constructions of the agitator as freedom fighter. He can be read as a political revolutionary, a religious martyr, and even as a Christological substitute, as in the following famous exchange with Gray: "Ques. And do you not consider yourself mistaken now? Ans. And was not Christ crucified."[70]

A huge amount of discussion has arisen around exactly what truth lies buried in the *Confessions*, but what I want to emphasize in the context of slave narrative, the expression of freedom through a philosophy of violent rebellion, and the functioning of the antislavery marketplace is the fortuitous promiscuity of the *Confessions*. It is narratively and formally a completely unstable text that enjoyed a most heterogeneous appeal. It is also a text that reentered mainstream abolition publicity through a back door once the initial hysteria had quieted down. In the early 1850s Harriet Beecher Stowe's follow-up to *Uncle Tom's Cabin*, entitled *Dred: A Tale of the Great Dismal Swamp*, was absorbed into the popular publishing market.[71] The eponymous Dred is Stowe's Northern evangelical reinvention of Nat Turner as ex-slave prophet, but he is a peculiar construct — partly a flamboyant, but aspiring, guerrilla, partly an enthusiastic sentimentalist, partly a great ape living in the trees. Dred is a creation who steers completely clear of Turner's revolutionary program, which demanded the logical and planned extermination of all whites, regardless of age or sex. And yet the early editions of Stowe's second antislavery bestseller did carry as an appendix an almost complete reprinting of Gray's *Confessions*. As Stowe's text went into multiple editions, not to mention dramatic adapta-

tions, on both sides of the Atlantic, we might speculate as to how many readers thought about the terrible ironies that result from setting the *Confessions* within the same covers as *Dred*. As I have intimated, slave narratives are not always discrete or containable elements within a white-dominated marketplace, but they do possess cultural possibilities for the expression of freedom that are not countenanced within the other mainstream abolition publicity.

The Children Eating Saturn: White Propagandistic
Responses to Black Revolutionary Violence

A survey of the entire range of graphic representations of slavery in the nineteenth century reveals that it was only very rarely, and then only in the work of satirists, that an alternative vision emerged, suggesting that blacks might feel fury about their abuse under slavery and that they might want to express this fury. George Cruikshank's peculiar 1818 etching *Every dog has his day — or black Devils amusing themselves with a white Negro Driver* comes at the subject with a typically neurotic ambiguity (fig. 4.6).[72] Produced at the height of his engagement with the English Ultra-Radical movement for parliamentary reform, it is a good example of the anxieties generated around this theme of black insurrectionary violence. Here the naked white overseer is presented as a parodic religious martyr, burned at the stake, while the slaves are presented as deformed and diminutive devils. The association of blackness with the diabolic was by this stage deeply engrained in popular culture. The black faces involve elements of extreme Negrophobe caricature: they all possess massively exaggerated lips, and those shown in profile have exaggerated jaws, flat noses, and low foreheads. Yet the figures do not constitute straightforward racial satire; they are so deformed as to slip out of the realm of black caricature and into some other realm of animalistic or demonic fantasy. Comic, trivial, devolved denizens of a fantastic world, they are more like imps or sprites than actual slave revolutionaries operating in a real world of social grievance. It might be said that this print is in one way typical, in that white artists throughout the nineteenth century seemed incapable of producing visual art that dealt seriously with the subject of black revolutionary violence.

There were, of course, a huge number of violent revolutionary and insurrectionary outbursts during the course of Atlantic slavery. Yet the number of pieces of art showing slave rebellion/revolution/insurrection, whether during the middle passage or within the context of plantation or urban slave society, are few in number. When such material was generated it was almost always produced not by abolitionists, but by the slavery apologists as a horrifying

FIG. 4.6. George Cruikshank, *Every dog has his day — or black Devils amusing themselves with a white negro driver*, hand-colored etching, 1818.

warning. The Haitian slave revolution, the Nat Turner rebellion in Virginia, and the revolt of the Mâles in Salvador Bahia each generated focused atrocity literatures. Viewed in one way these are the forbidden visual archives of the emancipation moment. Produced by whites for whites, these works were almost inevitably designed to shock the spectator into a horror of black bestiality, not to promote a heroic image of black liberationist endeavor. Black insurrectionary violence was presented as proof that blacks were uncivilized and incapable of comprehending what liberty meant. The treatment of slave uprising aboard vessels during the middle passage is equally circumscribed. It is, to

my knowledge, only with the exceptional case of the *Amistad* revolt, that white abolitionists developed what was at least in part a celebratory visual rhetoric around slave ship rebellion. This was partly because the slave revolutionaries lived in, and interacted with, North American society for an extended period. It was also because the Africans possessed an exceptionally charismatic and physically beautiful leader, Cinque, who could be easily absorbed into extant tropes for the representation of the African prince. In this sense Cinque became appropriated as a mid-nineteenth-century Oroonoko, whether he liked it or not. The majority of earlier depictions of slave ship insurrections show the slaves either as violent murderers or as doomed victims, leaping to death in the sea.[73] Of course there was a narrative option here to celebrate an ultimate liberationist gesture by the slave. Slaves frequently committed suicide by drowning in order to escape the horror of the middle passage. This is an extreme way of gaining freedom and, as many slaves believed, regaining life with one's ancestors in Africa. Yet to my knowledge the subject was never taken up as the basis for a celebratory work of art in any visual medium.

When it came to the visual representation of slave revolution on land, the negative tropes applied were even more unified in their negativity. The popular art that suddenly appeared as the details of Turner's rebellion became known is appalled and appalling, and presents the revolutionaries according to a set of negative stereotypes (fig. 4.7). These people are cowardly, villainous, murderous, and animalistic. J. D. Torrey chose to present Nat and his followers plotting the rebellion. They are surrounded by darkness, in a gloomy and gothic forest clearing. They look trepidacious but ferocious; they sit, crouch, and slink.[74] The most widely distributed visual account of the revolt was the formally crude but narratively ingenious single-sheet woodcut *The Nat Turner Revolt* (fig. 4.8). This consisted of two panels, the upper and larger one showing a series of violent narrative vignettes. Each illustrates a specific murderous attack on white victims, and as such they can be read singly, or from left to right, as a progressive account of the atrocities. The inhumanity and unfairness of the slaves are privileged. A kneeling mother and her three children cower before Nat as he stands relaxed, axe in hand, staring out at the viewer and inviting us to contemplate what he is about to do to these innocent white females. In the central scene two insurrectionaries with large pointed knives poised massacre a youthful and elegantly attired young man. He falls back and again we are invited to complete the murderous violence that these slaves are about to commit. In the third scene a white older male fights back as

FIG. 4.7. J. D. Torrey, *Nat Turner Talking with his Confederates,*
copper engraving, n.d.

FIG. 4.8. *The Nat Turner Revolt,* wood engraving, 1831.

he engages Turner, who raises his axe. Behind the white man's shoulder stands a mother cradling an infant. The implication is that this man is fighting to protect his wife and child, that he is fighting for their lives. The idea that the insurrection represented a justified act of revolutionary violence, designed to incite a general slave revolution and predicated upon a sense of profound injustice and abuse, does not get a look in. The print is designed to terrify, but also to reassure. In the bottom panel a counternarrative is set up. The state militia is shown pursuing Turner and his accomplices, who flee into a wood. The slaves have now been literally reduced in size, and as tiny figures with their backs turned toward us they are shown doing what slaves who want their freedom do best — running away. This propaganda exists in another symbolic world from that produced in the North to mythologize John Brown's Harpers Ferry raid and Brown's subsequent execution. Brown's execution was to be converted in a series of monumental and idealizing canvasses into one of the seminal emancipatory moments of North American abolition. But it is crucial that Brown dies giving, or trying to give, the blacks their freedom. Again, it is white patriarchy that is in the position to deliver freedom, and black subjecthood will benefit from the selfless gift.

When it came to the Haitian revolution and popular visual representation, there was a similar reluctance on both sides of the Atlantic to present black revolutionary activity as anything except animalistic blood lust. The bestselling illustrated contemporary account of the Haitian revolution in England was Marcus Rainsford's *An Historical Account of the Black Empire of Hayti* (fig. 4.9). Appearing in 1805 a scant few months after Haiti declared itself an independent republic, this publication is certainly not committed to the celebration of black liberty as an ideal or the blacks as revolutionaries. The engravings in this volume concentrate on scenes of extreme depredation; blacks are presented as barbaric, vengeful fiends, stringing up and mutilating elegantly uniformed whites. In this plate, entitled *Revenge taken by the Black Army* and copied from what claims to be an eyewitness visual account by Rainsford in the form of a pencil drawing, the blacks appear as thuggish sadists.[75] They have gone to the trouble of setting up formal gibbets right across the fertile plains of this rolling tropical landscape. The white victim has a privileged position, hanging in the center of the picture plane, performing a desperate dance of death in midair. The blacks are a group of torturers adapted from the representational codes of European martyrology. Again, the primary narrative thrust behind this material is not about the celebration of

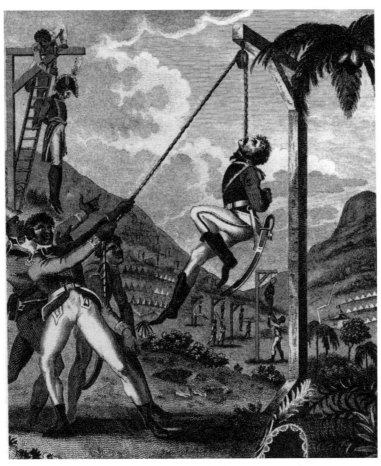

FIG. 4.9. Plate from Marcus Rainsford's *An Historical Account of the Black Empire of Hayti*, copper engraving, 1805.

black achievement, military ingenuity, or courage. The message is that if you give blacks their freedom, or worse still, if they take it themselves, they will use their freedom enthusiastically to torture and murder their former masters. Rainsford's book, in fact, produced visual analogues for the graphic atrocity literatures that had deluged Paris, London, and major cities on the East Coast of America in the early 1790s. The irony is that he was still producing such material in 1805.[76] Similar interpretations, indeed slave insurrection in general, constituted the abolitionists' worst nightmare. Standard representations of the frenzied violence of the Haitian slave revolutionaries was used

across the slave diaspora for the next hundred years.[77] The visual propaganda that came out of the slave revolution decimated the abolitionist ideal of the slave, an ideal nicely summed up in the abolitionist poet William Cowper's unintentionally ironic aphorism: "Now lambs and negroes both are harmless things." The black revolutionaries were certainly not harmless things; they violently took their liberty and so were excised from the loop of the horrible gift of freedom and were excluded from the visual nexus of the official version of the emancipation moment.

AN AESTHETICALLY POISONED CHALICE: SLAVE DANCING AND THE CELEBRATION OF FREEDOM

There is a vital field that my discussion of the representation of freedom in the context of Atlantic slavery has so far steered clear of. I refer to the artistic activity of the slaves themselves within their state of enslavement. It is only recently that scholarship has considered the possibility of uncovering the cultural expression of slaves in the ceramics, architecture, music, food, clothing, sculpture, and dances they evolved and created.[78] I haven't the space, or the expertise, to attempt to do justice to the subject here, but I want to approach one aspect of slave dancing as a test case. The point of the following discussion is to show how, despite the corrupting pressures of white authority and the distorting effects of white iconography, slaves could to an extent free themselves through the practice of art.

When analyzing the symbolic language of the emancipation prints they are frequently locked into unsettling conversations with their peculiar inheritance. Slaves are basically shown in two attitudes, either static, kneeling, and respectful, or capering, celebratory, and jubilant. I have already shown the extent to which the famous image of the Abolition Seal casts a shadow across the kneeling figures. The dominance of this submissive posture suggests the extent to which, even in their moment of liberation, white artists could not allow them to break out of the confinement of the visual traditions in which the white imaginary had locked them. When it comes to the representation of dancing slaves, the imagistic tradition is even more problematic. Slave dance provides a focal point for thinking about the extreme tensions that exist between the expressive potential of slave art and the containing and disempowering imperatives of abolition rhetoric. What this discussion finally revolves around is the fraught question of how or indeed if it is possible to express complete freedom within a state of enslavement.

Dancing on Deck: The Middle Passage and the Dance of Death

Throughout the duration of the Atlantic slave trade the cultural inheritance of slave dancing carried some appalling associations. By the turn of the nineteenth century, slave dancing already had an established and very bleak set of meanings within slave literatures. The evidence that Thomas Clarkson set before the British Parliament on the first reading of the slave trade bill introduced many examples of how slaves during the middle passage were taken from below decks and forced to dance on deck. Sometimes still shackled and often forced to move to the rhythms of European folk music played by the sailors, the slaves were urged to jump about, to exercise their muscles and lungs, before returning to the stench and constriction of the slave quarters.[79] Frequently it was a dismal affair. Shackled slaves "were ordered to stand up and make what motion they could," and were whipped when they could not.[80] Yet this utilitarian aspect of slave dancing could also merge with the aesthetic, in the sense that the sailors, often bored and brutalized themselves, sought entertainment, and apparently sometimes sexual gratification, from watching the terpsichorean movements of their prisoners. At times the slave dancing on the quarter-deck must have provided the slaves with the chance of expressing something of their sorrow and grief, albeit in a horribly contaminated performative environment. Apparently the women slaves on some slave ships accompanied their dancing with African instruments.[81] At times some slaves must even have found relief or joy in the experience, which may now be an even more difficult idea to come to terms with.

Dancing was, indeed is, central to West African cultures and as a means of emotional expression carries over a variegated field with a sophistication that European dance has never approached. The full range of human feelings — love, joy, ecstasy, religious inspiration, pity, horror, sorrow, aggression, fear — and the most important ceremonial occasions relating to the threshold moments of life — harvest and fertility rituals, puberty rituals, weddings, funerals, births, wars — found communal expression though dance.[82] In some ways, maybe akin to the aesthetic perversion of Auschwitz, with its unbelievable slave orchestra performing Beethoven, slave dancing during the middle passage possesses a quality of obscenity. These terrible scenes of coerced artistic movement are unrecoverable; the weird mixtures of thought and feeling they evoked in the victims cannot be imagined. Visual interpretations were, however, produced as part of the atrocity literatures of the abolitionists. In the most widely reproduced of these images, a plate that first appeared in Amé-

dée Gréhan's *France Maritime* (fig. 4.10), three male slaves are forced to caper before the assembled ship's crew on the deck, urged on with the whip.[83] The blacks emerge as pathetic, deranged, and terrified, as powerless performers voyeuristically exploited by their white audience. It is almost too sad to think that the profound beauty and artistic complexity of African dance cultures and their attendant musical forms of percussive counterpoint were first widely experienced by European audiences in such a barbaric context. But what this inheritance meant when it came to emancipation imagery was that a dark pall was spread over what should have been a spontaneous expression of joy. All representations of slave dancing seem to fall to a greater or lesser degree under the long shadow cast by the middle passage. I want to think about the expression of freedom and the act of dancing by giving a reading of probably the most widely interpreted and forceful image produced in North America depicting a slave dance on a plantation.

Dance and Devolution: The Minstrel Tradition and Abolition

At a basic level the representation of dancing plantation slaves was, from the late eighteenth century on, heavily inflected by the association of the popular theatrical practices of "nigger" minstrelsy. White actors in blackface and black actors, often themselves blacked-up, would perform high-energy dance routines developed out of the Jim Crow repertoire.[84] These images of the black as happy, laughing, and dancing figures related closely to the myths that proslavery had evolved to show both how naturally lighthearted the blacks were and how close to animals they were in their spirit. White interpretation of black dance has been aesthetically hampered, not to say voyeuristically inflected, by the fact that the centrality of pelvic movement to many African dance forms can only be seen as lewd or sexualized. Edward Thorpe sums up a vast cultural chasm over the aesthetics of dance:

> In black dance the pelvic region is the epicentre of all movement. . . . In most dances performed by white races . . . the torso is held comparatively erect if not rigid and so again and again, throughout the centuries, western observers, from missionaries to sea captains, anthropologists to consular officials, have referred to the tribal dances of West Africa as "lewd," "libidinous," "lascivious," "disgusting" and "hideous," imposing their own pre-determined ideas of what constitutes a socially acceptable vocabulary of movement on to an alien culture.[85]

There is an inexhaustible archive of paintings and engravings that show plantation entertainments in the Caribbean, North America, and Brazil where

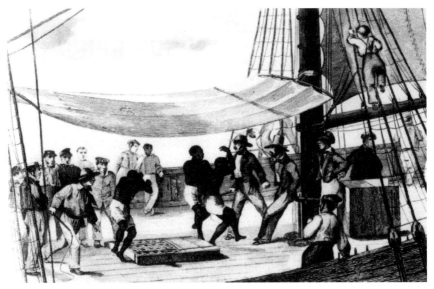

FIG. 4.10. "Slaves dancing on deck during the Middle Passage," from
Amédée Gréhan's *France Maritime*, copper engraving, 1855.

frenzied sexuality is the only element open to the white gaze.[86] The literatures
of slavery are similarly saturated with descriptions of the lewd and comic ex-
aggeration of African dance, ranging from James Grainger's *Sugar Cane* to
Charles Dickens's *American Notes*. Stowe's *Uncle Tom's Cabin*, from its open-
ing pages, develops an expansive discourse around black dancing, which is
invariably the portal to crudely comic narrative effects.[87] These reach their
explosive apogee in the description of Topsy's first dance when St. Clair in-
troduces the black infant to Miss Ophelia. Topsy was subsequently developed
within global culture in both the visual and performing arts as a trope for the
essentially comic excess of black dance.[88] Stowe's text, when it became popular
in England, was also adapted in ways that fused black dance and emancipation
in a predictably patronizing narrative. The climactic scene of emancipation
near the end of Stowe's text, when the young master liberates his slaves, was
taken up in the most influential English illustrated edition. George Cruik-
shank imagined the collective slave response in a wood engraving (fig. 4.11).[89]
As the slaves are handed over their manumission papers, they go into convul-
sions and begin grinning and jigging about. Yet for Cruikshank, any black
expression of pleasure leads to this impromptu leaping. Compare the figure
of the black slave on the left, who dances in anticipation of being handed his

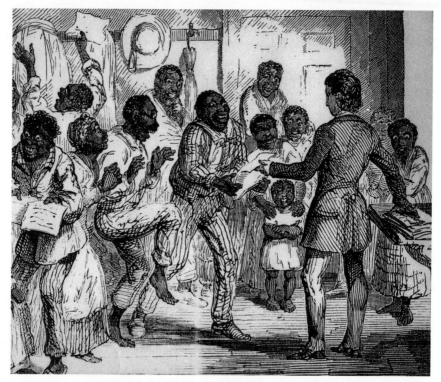

FIG. 4.11. George Cruikshank, "He appeared among them with a bundle of papers,"
plate for *Uncle Tom's Cabin*, wood engraving, 1852.

papers, and the depiction of Tom (fig. 4.12) at the opening of his novel, as he
holds his daughter up before a youthful George Shelby and as his other chil-
dren frisk and pirouette about him. Cruikshank does not describe any form
of dance in particular but a sort of generic hopping about, which is supposed
to describe the instinctive high spirits of the childlike blacks.

When emancipation propagandas came to celebrate slavery abolition,
whether in England, North America, or Brazil, black dance was habitually
portrayed in ways that came out of the poplar traditions of minstrelsy. Very
little visual art was produced that showed itself capable of resisting these re-
ductionist tropes and that could record the beauty and significance of slave
dance forms.

One reason for this lies in the fact that if one attempts to move beyond
the emancipation art very little scholarship has focused on this area. Even
the meticulous work of Philip Morgan has turned up little evidence, and he

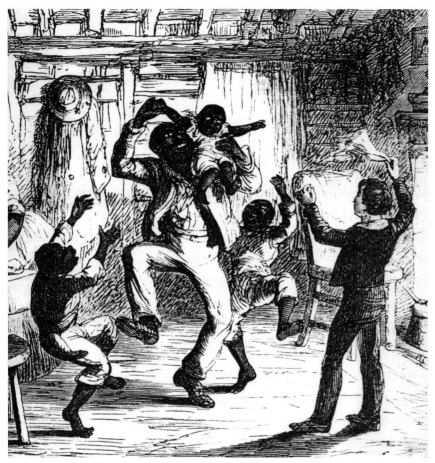

FIG. 4.12. George Cruikshank, "Ain't she a peart young'un?"
plate for *Uncle Tom's Cabin*, wood engraving, 1852.

stresses finally how this performative, and frequently satiric, aspect of slave life has left a depressingly thin archive.[90] It is, however, increasingly certain that African dance on the plantations was mainly hybrid, and that the slaves habitually merged two or more African dance forms into their performances. Morgan also stresses the manner in which dance could put slaves in touch with remembered African traditions to the extent that in exceptional cases the dance generated such a powerful collective memory of the homeland that slaves would perform impromptu enactments of a form of exodus, maybe African, maybe Christian, dancing en masse into rivers or the sea. At least one group of slaves drowned themselves in this final emancipatory gesture.

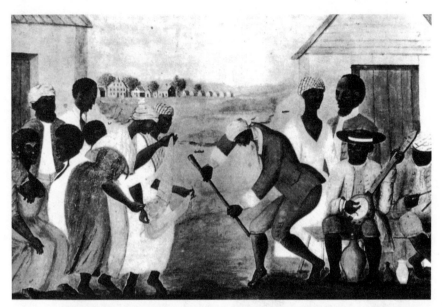

FIG. 4.13. *The Old Plantation*, watercolor, c. 1800. Abby Aldrich Rockefeller Folk Art Museum, The Colonial Williamsburg Foundation, Williamsburg, Va.

Given the scarcity of evidence, the renowned eighteenth-century water-color *The Old Plantation* (fig. 4.13) is a seminal image when it comes to interpreting slave dance and the response of slave societies to this phenomenon. The image has generated some wildly variant interpretations within slavery studies, and I am going to make my own contribution.[91] Whatever the precise dance form recorded here, the image does convey intensity, high seriousness, and the synesthetic intensity of the event. Dancers and musicians, including the seated woman far left who beats out the rhythm on her knees, are all completely engrossed in the power of the moment. Surely this is a work that describes a space of freedom that has been created within slavery via black performance. In this sense the image might be seen to stand in powerful opposition to the mass of representations that trivialize, misrepresent, or mock slave dance.

Within the formal terms of this painting, freedom is expressed through the extreme application of spatial conventions. The dancers and spectators, and indeed we as viewers, are forced to cohabit in a remarkably shallow space in the foreground. The dancers teeter right on the edge of the picture, as if they are going to fall out of it and start dancing with us. This feeling of privi-

leged proximity to controlled energy is increased by the representation of the
dancers' feet. All three figures are up on their toes, almost swaying in and out
of the picture plane, pressed right up against our sight. The slave cabins oper-
ate, left and right, as sheer planes, locking the performers into their dancing
area, as if it is a proscenium stage set. The middle ground is then taken up by
the bend of the river, which flows through the right arm, face, and body of
the dancing male, and then sweeps away behind him and the vertical of the
slave hut on the right. The river is a classic linking device used in the middle
ground in landscape painting from Claude Lorrain on to guide the eye away
into the distance in a gentle manner. In the distance are the main plantation
buildings, with the Big House sitting up on the left of the horizon line. The
bold propinquity of these titanic dancing figures is finally exaggerated by the
two tiny boats that float on the river. When you show dancing slaves and
boats, you are encoding objects in ways that are far from innocent. Surely
those two tiny boats, and the water they float upon, force questions about how
these people came to be where they are, and about what they are thinking and
feeling in relation to their homeland. Will this be one of those days when the
yearning for Africa and the ancestors becomes just too hard to bear? Will the
slaves "become so wrought up that utterly oblivious to the dangers involved,
they would grasp their bundles of personal effects, swing them on to their
shoulders, and setting their faces towards Africa, would move down into the
water singing as they marched"?[92] This intimate little watercolor constitutes
one of the great articulations of the spirit of liberty. Look into this intense
creation and you realize that slaves could create performative environments
which, however briefly, shut down the oppressive physical and emotional con-
trolling mechanisms of the slave power.

Morgan's *Slave Counterpoint* remains a great book because it raised, and to
a large extent answered, a whole series of questions about the mental as well
as behavioral limits of slavery and freedom within the plantation systems of
North America. The meticulous micro histories so patiently unearthed in this
book make us ask, again and again, what the limits of freedom, and indeed of
coercive power, may be within the highly varied conditions of systems of slave
labor. The book avoids the oppositions, and stark contrasts, of Manichean
slave history, in order to take us into a much more difficult intellectual and
moral terrain. One of the really difficult questions that the book approaches
concerns the extent to which freedom can be enjoyed as a mental state within
the legal and physical state of enslavement. In this context I find the graphic

redeployment of one of the central figures from *The Old Plantation* through-
out the text of *Slave Counterpoint* fascinating.

Whoever designed the cover for *Slave Counterpoint* (fig. 4.14) decided to
cut the memorable black male figure out of the watercolor and then set him,
duplicated, in reverse on the cover. The dancing black man, with those enor-
mous thighs, tensed and serpentine, and the white bandanna on his head, now
faces himself. The staffs of the two dancing figures form a framing device for
the book's subtitle, while the earth floor he dances on in the original has been
taken away. The two figures now seem to dance in a much more precarious
space, each one on the edge of a precipice, which they both look down into.
What they see floating in the precipice is the name of the author, in red type,
enclosed by thin black lines in a white coffin-like box. It is hard to tell how
this space functions. Has the author become the ground beneath the slaves'
feet, or a grave upon which they dance? The original watercolor operates mul-
tiple effects of counterpoint. The two females are set off against the male in a
complicated series of visual dialogues, and similarly the old man playing the
banjo performs in relation to the clapping woman on the right. The two little
boats float in relation to each other, and the slaves in the background and
the two slave cabins in the foreground exist in a geometrical relation to each
other and in a relation of domestic power to the dancers. On the book cover
all this complexity has been pared down to the symmetrical counterbalance
of the digitally cloned male figure. This male dancer then goes through a
series of subsequent transformations that make him into a totally dominant
figure within the covers of text. The dancing man appears in isolation with
the words "Slave Counterpoint" on the first page, then immediately reappears
with the subtitle on the second page, and the third page, where the counter-
balanced effect of the cover is given yet another variation (fig. 4.15). He also
appears in splendid isolation three other times, as a large device on the title
pages to each of parts I, II, and III. The reproduction and isolation of this
figure within the design of *Slave Counterpoint* raises questions in relation to
representations of slave autonomy. What does the dancing slave mean in each
of these new reproductive contexts, and how does he relate to the smaller ver-
sion of himself within the reproduction of the whole picture in the main text
of the book? Why has he been so obsessively reproduced?

My answer to this question would relate to the idea that this figure ex-
presses a special form of independence, which Morgan's book is both deeply
interested in and finally a moving testament to. The image embodies an al-
most unimaginable achievement, a human who has ascended, or transcended,

FIG. 4.14. (*Left*) Book cover, from *Slave Counterpoint: Black Culture in the Eighteenth-Century Chesapeake and Lowcountry* by Philip D. Morgan. Published for the Omohundro Institute of Early American History and Culture. Copyright © 1998 by the University of North Carolina Press. Used by permission of the publisher. Cover art used by permission of Abby Aldrich Rockefeller Folk Art Museum, The Colonial Williamsburg Foundation, Williamsburg, Va.

FIG. 4.15. (*Below*) Title page, from *Slave Counterpoint: Black Culture in the Eighteenth-Century Chesapeake and Lowcountry* by Philip D. Morgan. Published for the Omohundro Institute of Early American History and Culture. Copyright © 1998 by the University of North Carolina Press. Used by permission of the publisher.

to a state of physical and mental freedom even though he is within a legal state of enslavement. This man, massive but delicate and nimble, seems to exist in a truly inspired space that the slave community has enabled through performance. This slave's brief exhibition of liberated self-sufficiency exists as a moment out of time — in the beautiful phrase of W. B. Yeats, "the dancer becomes the dance." Indeed, one is tempted to think of this figure existing in a state of heightened consciousness, that charged calm that Yeats describes in the second stanza of "The Long Legged Fly." At the center of Yeats's great meditation on the transforming power of creative consciousness, or inspiration, exists an ideal dancing woman whose "feet / practice a tinker shuffle / picked up on the street." The Irish poet's transhistorical dancer exists in the same artistic space as this timeless, and tumultuously solipsistic, dancing black man. The tremendous power that this figure possesses finally comes out of the fact that he has invented a precarious freedom for himself by embracing that essential manifestation of the African artistic soul, communal dance. In his elegant power, paradoxical public performance, and intense self-involvement, this dancing slave refutes the entire visual tradition showing black male slaves as juddering and capering Jim Crow or blackface minstrels. His tremendous artistic oblivion stands in aesthetic opposition to the frenzied gesturalism that the white gaze imposed on the black dancer. This man has not been given a legislated freedom by the slave power, which has then sent him into parodic spasm. He has, in fact, created freedom through the confident adaptation of African culture.

Dancing is of course a fascinating cultural crossroads within the slave diaspora. Within the hybrid religions of Voodoo in Haiti, Santeria in Cuba, Obea in Jamaica, or Candomblé, Umbanda, Macumba, or Xamba in Brazil, dancing provided the performative space in which the world of the sprits and the world of the slaves could unite. It provided a space beyond the reality of slavery, a magical space where anything was possible. The dance is still the driving force at the living heart of the slave diaspora, whether it's the Jongo of the Serrina Favella in Rio, where the old teachers still speak in Yoruba, or the Afro-Indian forms of the Maracatu in the rural villages and towns of Pernambuco, or the beautiful cycles of the Ciranda as it is still danced on the island of Itamaracá. This dancing man connects across time and space with these living African slave evolved traditions. He does not kneel passively with Bible in hand, but even more significantly he does not contort himself in ecstatic gratitude for the entertainment of whites. He creates an art of movement on his own terms and in his own time. Still inside slavery he creates and expresses

an intimate, personal, yet communal assertion of liberty. If there can be joy, freedom of expression, and even *jouissance* within a state of enslavement, then this image describes that paradox. Above all, this figure tells us that freedom can never be given by anyone to anyone, because it is an essential possession of every human soul. The inherited tragedy we live with today lies in the fact that slavery exerted an infinite ingenuity in order to try and disguise or erode this truth.

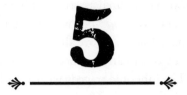

5

Stamping Out the Memory of Slavery

The 2007 Commemoratives and Philatelic Approaches to Bondage and Freedom

The child looks to far off Liberia through an inverted opera-glass:
there it lies behind its little strip of sea with its palms, just as the stamps
show it. With Vasco de Gama he sails around a triangle which is as
isoscelean as hope and whose colours change with the weather.
A travel brochure for the Cape of Good Hope. — Walter Benjamin,
"The Stamp Shop," *One Way Street*

Commemoratives . . . have come to stay, and it is now fully
appreciated that their propaganda value far outweighs their philatelic
significance. — L. N. and M. Williams, *The Postage Stamp*

Despite its small size and relatively discreet support (letter or parcel),
the stamp probably has a more concentrated ideological density
per square centimetre than any other pictorial form.
— David Scott, *European Stamp Design*

THE DECISION to produce a full set of stamps in 2007 in commemoration of the bicentenary of the abolition of the Slave Trade Act situated the official British recollection of Atlantic slavery within a quite unique and many-layered popular graphic space. The six commemorative stamps, released and circulated in a staggering variety of adaptive forms, were without doubt the most widely viewed and widely disseminated visual art connected with the slave trade ever to be produced.[1] They have been seen by both sexes and all ages, they have penetrated every continent, and, given the prevalence of electronic messaging for most of the world's population, they have been sent to many of the most undeveloped parts of the globe, where email and the cell

phone have yet to arrive. Yet what message do these stamps carry about slavery? As Walter Benjamin's words suggest, stamps have the tendency to provide crude fantasies of complicated truths. One stamp can easily boil the Atlantic triangle and the origins of imperialism in the Americas down to something simple, attractive, and colorful. This chapter is devoted to the idea that these British commemoratives, though small, are not unimportant, both in themselves and in the history of stamp production that supports them. In fact, they are some of the most important graphic art ever made about slavery. The processes of their production, distribution, and interpretation reveal an enormous amount about how, in 2007, Britain desired to have its role in the Atlantic slave trade popularly enshrined in text and image. These stamps did not exist in a vacuum, but are related to a whole series of traditions, some of them philatelic, some of them to do with national mythology and with the politics of empire. There has been almost no serious scholarly work on the relation of stamp production to the visual representation of slavery. This is curious, bearing in mind the fact that a great number of stamps have been produced in Europe, Asia, Africa, the Caribbean, and the Americas relating and responding to the memory of the slave systems and their various emancipation moments. The following discussion consequently uses the six slave trade abolition stamps released in Britain on March 22, 2007, as the central focus for an extended meditation on how the memory of slavery is and has been manifested in the cultures of philately.[2]

Stamps exist within a unique environment for popular art. They are miniatures, constructed using the highest production standards available, yet they are mass-produced in millions, they travel the globe, and they communicate across gender, age, and educational barriers. Stamps are for the most part produced by powerful nationalized businesses representing powerful nation-states that want to market themselves via their postal services in specific ways. The ubiquity, availability, and geographical promiscuity of stamps mean that they possess a communicative potential that in terms of scale and diversity is unrivaled by any other form of printed visual propaganda, or indeed printed image. Each stamp is a self-contained entity, frequently emblematic in its combination of a symbolic image and an aphoristic text, yet it also has the potential to combine in myriad forms with a series of related printed forms.[3] The formal variety of distributive combinations escalated hugely in the second half of the twentieth century due to the nature of the international postal systems, the development of modern transport systems, and the now considerable economic pressures of the collector market.[4] Stamps do not usually operate in

isolation. Stamps combine with other stamps: if they are commemoratives, they may be issued as part of a thematically organized group, but they are also a type of paper currency and so can form sometimes random and sometimes planned combinations on envelopes. Stamps also combine with postmarks and cancellation marks, and many of the latter carry their own starkly emblematic texts and images. First day covers (FDCs) deliberately combine the above elements upon specially customized envelopes. These envelopes often carry elaborate visual material and extensive text intended to interact with the other elements of the cover. FDCs are created with great care by design teams usually employed by postal systems, but sometimes operating independently. The FDCs might be seen to constitute mass-produced collages, and sometimes montages, capable of marketing national political agendas in semiotically subtle and appealing ways.[5]

The British slave trade stamps need to be seen as part of a tradition of stamp production. British commemorative stamps constitute a semiotic environment that has always been and remains heartily and unapologetically celebratory. What these billions of little colored pieces of paper celebrate, if they are viewed in their entirety, is a notion of nationhood, of what lies at the heart of Britishness.[6] Britishness, when it comes to philately and commemoration, fits into a series of fairly predictable criteria: British political and military heroes, British achievers in science and the arts, British flora, British fauna, British monuments, British architecture, British art, British customs, British ceremony, British sport, and, preeminent among these criteria since the inception of the stamp, the British monarchy.[7]

Commemorative stamps are, in fact, a recent philatelic invention, only developed over the past fifty years in Britain. For the first century of their existence, and of course beginning with the iconic "penny black," all British stamps simply carried an engraved representation of the head of the reigning monarch.[8] Once commemorative issues, which in visual terms departed from this norm, became standard, the royal family still remained a central feature. Elizabeth's coronation, royal weddings, royal jubilees, and royal deaths led to many commemorative issues during the second half of the twentieth century.[9] Perhaps the most dramatic and intriguing, in terms of its reflection of a national mood far from promonarchy, was the full set of mourning stamps in commemoration of Princess Diana in 1998.[10]

Looking beyond the monarchy, the bulk of the remainder of British commemorative issues may be described as thematically organized. Sets are devoted to animals, fish, insects, plants, buildings, the professions, famous art-

ists and authors, and, of course, the only annually repeated commemorative issue, the Christmas stamp, which became a national institution from 1966.[11] There remains one final large category, the anniversary stamp, and it is into this category that the bicentennial of the abolition of the slave trade stamps fit, although they overlap with other categories. It is worth dwelling on this large and significant philatelic subset because it has always been mysteriously unresolved, not to say random. The anniversary, in fact, constitutes the most unregulated and surprising element within commemorative stamp issues. The more one looks into Britain's commemorative issues, the only truth to cling to is that enunciated by the magnificently dry Williams brothers in the epigraph to this chapter, who voice an eternal truth when they state that the primary end of all commemoratives is propaganda. And yet while these sets of stamps have a definite agenda to do with celebrating national achievement, and indeed with defining national identity, how they do it, and what they do it to, are not so easily understood. Yet it is important to try to understand this elaborate imagistic terrain in order to decode why the slavery stamps were made the way they were and how they are now interpreted.[12]

Surveying the entire field in *Stanley Gibbons Great Britain Stamp Catalogue*, it is baffling to try and work out the criteria behind the issuing of full commemorative sets. Avoiding the plethora of sets devoted to living Royals and to communications and postal themes, what determines the choice of the rest? Subjects, objects, celebrity, infamy, dates marking special days, centuries, half centuries, quarter centuries, good luck, bad luck — to the casual observer the Royal Mail's obscure, even mystical, selective processes have no rhyme or reason. When thinking about Britain's domination of the slave trade and how six stamps might remember this immense crime, it is worth setting out the philatelic domain they enter and asking what deep forces unite the following: "10th International Congress of Botany" (1964), "Battle of Britain 25th Anniversary" (1965), "Battle of Hastings 900th Anniversary" (1966), "900th Anniversary of Westminster Abbey" (1966), "Birth Bi-Centenary of J. M. W. Turner painter" (1975), "150th Anniversary of Public Railways" (1975), "500th Anniversary of British Printing" (1976), "Centenary of Wild Bird Protection Act" (1980), "500th Anniversary of College of Arms" (1984), "Centenary of the Greenwich Meridian" (1984), "50th Anniversary of British Council" (1984), "300th Anniversary of the *Principia Mathematica* of Sir Isaac Newton" (1987), "Haley's Comet, Appearance of" (1986), "Civil War 350th Anniversary" / "Bicentenary of Linnaean Society" (1988), "400th Anniversary of Spanish Armada" (1988), "150th Anniversary of Royal Microscopial Society" (1989), "150th

Anniversary of the Royal Society for the Prevention of Cruelty to Animals" (1990), "Ninth World Congress of Roses" (1991), "150th Anniversary of Dinosaur's Identification by Owen," "Sherlock Holmes Centenary of the Publication of *The Final Problem*" (1993), "Dickens 150th Anniversary of Publication of *A Christmas Carol*" (1993), "Death Centenary of Alfred Lord Tennyson" (1993), "50th Anniversary of D-Day" (1994), "Reconstruction of Shakespeare's Globe Theatre" (1995), "Centenary of Rugby League" (1995), "Cinema Centenary" (1996), "50th Anniversary of Children's Television" (1996), "50th Anniversary of Wetlands and Wildfowl Trust" (1996), "Henry VIII'th 450th Anniversary of Death of" (1997) (featuring formal portraits of the king and the six female victims of his abuse), "650th Anniversary of the Order of the Garter" (1998) nicely paired with "Comedians" (1998) (featuring Gerald Scarf's caricatures of five people wedded to the comedic — Tommy Cooper, Les Dawson, Peter Cook, Joyce Grenfell, Eric Morecombe) . . . Only taking some random examples up to the end of the last millennium, this is still a very strange list.[13] The whole gallimaufry reeks of the chaos of committees, of sets of people with many opinions and no real ideas, of powerful time-servers who know what they want and how to get it. Bearing this in mind, how perfect for 1807 and the official response to Britain and the abolition of the slave trade that we should get a set of commemorative stamps. The actual company that the stamps keep in 2007 is equally random and strange, but is worth listing because it gives some idea of the extraordinary proliferation of commemoratives and FDCs in the twenty-first century. The list graphically illustrates the huge shifts in production and marketing that now underpin commemoratives and that formed the immediate environment for the design and marketing of the slave trade stamps.

The slave trade series operates in an altered philatelic world that since 2000 has become increasingly dynamic, eclectic, energized, and, dare one say, democratic, and which is radically different from that of even ten years ago. Stamp issues for 2007 run as follows. In January "The Beatles" set came out for the fortieth anniversary of the *Sergeant Pepper's Lonely Hearts Club* album, and was coupled with the "Definitive Love Booklet"; in February "Sea Life of the British Coast" was paired with "The Sky at Night," the latter commemorating the fiftieth anniversary of the indefatigable and ancient astronomer Patrick Moore's television program. March paired the slave trade series with "The World of Invention" and "Country Stamps." April saw "Celebrating England"; May, "Beside the Seaside" and "Wembley Stadium" (marking the long overdue opening of the national football stadium); and June, the fortieth

anniversary of "Machins." In July came the triplets "Motor Racing Grand Prix," marking the British Grand Prix; the "Centenary of Scouting" series; and the "Harry Potter Books," marking the publication of J. K. Rowling's *Harry Potter and the Deathly Hallows*, the final book in the bizarrely successful series. The stamp series consisted of seven first-class stamps, each carrying one of the book covers. September gave us "Endangered Species — Birds" and "British Military Uniforms"; October, the "60th Wedding Anniversary of HM the Queen"; and November, the Christmas series and a "Lest We Forget" series, focused on World War I. What is noticeable from this series is that the monarchy is now only a marginal element in an arrangement that mixes new and old and that appears to prioritize popular, or "low"-culture, entertainment, female achievement, ecological issues, human rights, and sports.

It can be concluded, then, that the slave trade series exists within, and as part of, a competitive marketplace that sells British culture and achievement with opportunism and confidence. The presence of slavery within this strange national shop window may well reflect a new self-confidence and the feeling that there is now almost no subject that cannot be marketed as part of the national heritage. Yet the unremittingly positive nature of commemoratives sits strangely beside the memory of a national Shoah, until it is recognized that it is the myth of the abolition of the slave trade, and not the trauma or guilt of this system of mass exploitation, which the stamps are dedicated to.[14]

THERE AIN'T MUCH BLACK IN THE POSTAL SACK:
EMPIRE AND SLAVERY IN BRITISH STAMPS BEFORE 2007

When thinking about the aesthetic or historical meaning of the slave trade stamps, another good question to ask is where they lie in relation to the representation of slavery, or the victims of empire, or even the representation of ethnic minorities in earlier British stamps? And moving beyond a national context it is relevant to take in the global philatelic history relating to slavery, abolition, and commemoration with which the British stamps are in dialogue. It is an irony of history that when Britain was at the height of its imperial pomp under Victoria, and in a mood to celebrate just about any aspect of empire in garish visuals, the Royal Mail did not issue commemorative stamps of any sort. When the new color photolithography was transmogrifying British imperial achievement on a global scale, in magazines, newspapers, product advertising, and indeed every area of commercial and noncommercial graphic reproduction, including envelopes and stationery, British stamps remained as

conservative as British bank notes, and merely showed the bust of the queen in one merry, and several dismal, colors. Indeed, it was only with the British Empire exhibition of 1924 that a stamp was produced featuring any imperial iconography. In this very early commemorative stamp George V is shown in profile before a British imperial lion, which stands bottom left of the royal gaze, with its four legs planted inelegantly but massively, as if to say it is here to stay.[15] The next stamp that might be said to incorporate elements relating to Britain and its maritime empire is the 1951 "H.M.S Victory" half crown stamp brought out as part of the six stamps to appear in connection with the Festival of Britain.[16] This time George VI, again in starkly familiar postage portrait profile, gazes straight out at a roundel showing the famous flagship in full sail on the high seas. The reference is primarily to Horatio Nelson's heroic encounter with the French and only implicitly concerns the British navy's intimate engagement with the slave trade both before and after 1807. It should not be forgotten that a significant percentage of the sailors in Nelson's warships were black.

In 1955, seven years before Jamaican independence, the Colonial Postal Service issued four stamps to mark the tricentenary of British rule over the island (fig. 5.1). These stamps included the first representation of the emancipation moment in philately and, taken as a group, constitute a precise commentary on how the colony's brutal slave past was to be remembered within the sanctioned symbolism of empire. All four stamps carry a vertical panel taking up about a quarter of the surface area and showing Elizabeth's newly crowned head facing left to right on the 2 d and 3 d stamps and right to left on the 2 ½ d and 6 d stamps. The 2 d stamp has an olive green frame, with a caption "Man-o-war at Port Royal"; it shows a British fighting ship from the period of the Napoleonic wars in full sail swinging out across the harbor. The primary references here are similar to those of the British 1951 "H.M.S. Victory" stamp, in that they celebrate British military prowess in the early nineteenth century. There is also a possibility that the boat might relate to the British antislavery patrols that were cruising off the coasts of the British slave islands after 1808. This is of course not a slave ship, and the stamp emphasizes in miniature the larger processes of amnesia and selective memory that had dominated the construction of the British navy's role in colonial history throughout the nineteenth and the first half of the twentieth centuries.

The 2 ½ d and 3 d stamps, entitled "Old Montego Bay" and "Old Kingston," also shut out any explicit allusion to slavery. The former shows Montego Bay as an idyllic landscape scene, arranged according to the spatial formula

FIG. 5.1. GB Royal Mail, commemorative 2 d, 3 d, 2 ½ d, and
6 d stamps, "1655 Jamaica 1955," 1962.

evolved by Claude Lorrain and perfected by J. M. W. Turner. Indeed, it might
as easily describe a view from the Kentish or Sussex coasts as a tropical bay
on a slave island. The latter depicts an equally idealized scene, this time re-
inventing downtown Kingston as a calm and prosperous urban center. Only
the presence of unattended dogs and pigs on the street suggests that this is
not London at the turn of the nineteenth century. The figure on the right
foreground appears to have a black face beneath the kerchief she wears on her
head, and, given the date, would presumably have been a slave. But the design
is primarily devoted to showing off the stately buildings and elegant white
couples who promenade the streets. It is only the 6 d stamp that makes any
explicit reference to Jamaica and slavery, carrying the caption "Abolition of
Slavery proclaimed 1838." Printed in black within a dramatic scarlet frame, it
portrays a scene adapted from a nineteenth-century engraving showing mas-
sive but orderly crowds assembled outside the governor's palace. The fore-
ground is dominated by the governor's carriage, which moves out from right
to left, while above the coach and horses a massive flag showing the royal coat
of arms hangs in the sky.[17] Taken as a group these stamps enact with a fault-
less economy and didactic purity the workings of the horrible gift of freedom.
The memory of slavery is erased from the national history of Jamaica, to be

reinscribed as the memory of emancipation. There is, however, an ironic reference, probably unconscious, to the darker sides of the reality of abolition. It is revealing that the date chosen to celebrate abolition is not 1833 (the date celebrated in Britain, as marking the cessation the slave systems) but 1838, when the apprentice systems were finally ended in the colonies.

With the exception of the Jamaican 1955 commemoratives, British stamps maintained a minimal engagement with the slave diaspora in the remainder of the twentieth century. It was not until 1962 that the first British stamps introducing race and the inheritance of empire appeared. They came as a part of the Freedom from Hunger series, and were designed by arguably the most refined aesthetic intelligences involved in British postwar stamp design.[18] Michael and Sylvia Goaman were commissioned to produce a large variety of stamps, mainly for the British colonies between 1953 and 1980, and the 2 ½ d stamp from this series is a good example of their graphic sophistication (fig. 5.2).[19] The stamp is entitled "Campaign Emblem and Family" and has a pink background. The "campaign emblem" is three ears of corn standing up in proud ithyphallic display, like some weird John Barleycorn variant on the crucifixion, a slightly taller central ear of corn standing above its suffering fellows. Beneath the stalks are the "family." A mother and father in long fabric gowns, vaguely African west coast in design or possibly some sort of sarong, stand with left and right arms bent to form chevrons, which simultaneously function as leaves on the corn stalks. Both adult figures are completely symmetrical, their raised right arms held above the heads of two stylized children who stand beneath right and left. While the family hold hands, their outstretched arms, hanging in triplicate, again carry unavoidable associations of the crucifixion. The two slightly lower right arms unite dead center above the head of a standing infant child. The faces of all figures are represented by tiny black circles, like overfed full-stops.

This is a powerful design, flirting with the abstraction of the human form to make a point about the anonymity of the suffering and starving poor and about their martyrdom. The effacement of the victims, in the sense that these "people," drawn as basic stick figures with blob heads, have no identity apart from being racially other (i.e., nonwhite) and nationally other (i.e., non-English) creates an effect open to different interpretations. The viewer might be challenged and invited to question his or her own prejudice (starving blacks "all look the same to me"); or the viewer might be seen as inevitably complicit, forced by the very act of viewing to accept the terms of human representation on offer (starving blacks "all look the same to me"). There is a further

FIG. 5.2. GB Royal Mail, commemorative 2 ½ d stamp,
"Freedom from Hunger," 1962.

irony in the fact that the words are constructed allographically using a strik-
ing "typewriter" typeface to make a cage surrounding the group of figures
and corn ears. What sort of freedom is on offer here, where a white society
creates a design that gives black people no faces and sees their identity defined
through their assimilation into a cereal crop? The black family becomes food
for thought, and as such merely a product for Western meditative consump-
tion. This design, in its refusal to sentimentalize or to become naturalistically
descriptive, moves in the same aesthetic domain as the famous *Plan* of the
slave ship *Brookes*. We are confronted with the British capacity to formalize,
essentialize, and objectify human suffering in order to put it on display as a
subject for empathy. Yet as the queen in all her photorealist glory — young,
enthusiastic, and bejewelled — stares obliquely out at us, but keeps an eye on
the starving of what was then termed the "third world," it is difficult not to
see powerful satire at work in this potent little brew.

The next engagement with blacks, the slave diaspora, and Britishness came
in 1965, when two sets of stamps approached the black British subject in very
different ways. The Salvation Army centenary issue carries a black officer
on its one ⅙ d stamp (fig. 5.3).[20] The design, entitled "Three Salvationists,"
consists of an extended horizontal rectangle in the form of a vividly printed
diptych. On the right, printed in white on a scarlet panel, is the price and the
queen's head. Printed in a larger almost square panel taking up the center and
right is a panel with a light yellow background and a threadlike scarlet bor-
der. This features a white male and a white female on the right of the panel.

FIG. 5.3. GB Royal Mail, commemorative ⅙ d stamp, "Salvation Army Centenary" / "Three Salvationists," 1965.

Separated from them by a flag on a pole is a standing black male, his face represented as a solid dark brown triangle with no features or profile, his right hand by a brown circular blob. Despite his anonymity, this generic man of color seems to gesture toward interracial unity in the British Commonwealth. Yet the formal arrangement of the figures, which falls distinctly into black and white compartments, aggressively demarcated by the flag, seems to work against such an impulse and enact a philatelic apartheid. It is no coincidence that the bust of the queen is kept, in spatial terms, as far away from the black man as possible.

The same year saw two commemorative stamps for the "Commonwealth Arts Festival" (fig. 5.4). The 6 d stamp, "Trinidad Carnival Dancers," is the first British stamp focused on the Commonwealth to show black diasporic culture in action.[21] This is consequently the first British stamp to engage directly in the inheritance of British slave-evolved cultures. The design is supposed to show dancers in full carnival costume, against a thick cadmium orange background, with the price and the queen's head printed in white on the right margin. Two diminutive women with elaborate hairstyles and costumes flank a man, who daintily steps toward the viewer bearing a headdress consisting of two gigantic straw fish that he supports on a wooden pole. The headdress dominates the design, dwarfing the human figures, and is accurately observed from carnival costume.[22] The figures are printed in stylized heavy black outline, a bit like designs of Balinese shadow puppets. On the right the queen continues to gaze implacably and ambiguously out in three-

FIG. 5.4. GB Royal Mail, commemorative 6 d stamp, "Commonwealth
Arts Festival" / "Trinidad Carnival Dancers," 1965.

quarter profile. The stamp was the companion to a ⅙ d stamp, which was
entitled "Canadian Folk Dancers" and which is very similar to the Trinidad
design, apart from the giant fish, which have disappeared, and the use of a soft
violet background color instead of the vibrant tropical orange.[23] The pairing
makes apparent the extent to which Trinidadian culture has been reduced to
a generic tourist display, a package that can be laid alongside Canadian folk
dancing, or no doubt English Morris dancing.

In 1974 the Turner bicentenary commemorative issue provided a real op-
portunity to think about Britain's dark engagement with the slave trade. Yet
the designers bypassed the opportunity, not choosing to use "The Slave Ship"
as the basis for a stamp, choosing instead "Peace Burial At Sea," "Snowstorm,
Steamer off a Harbour's Mouth," "The Arsenal — Venice," and "St. Lau-
rent."[24] The last time a black face appeared on an English stamp before the
2007 slave trade issue was in the 1981 "Scout Movement" 26 pence stamp for
the "Youth Organisations" set.[25] This shows an upstanding black youth hold-
ing the flag of his scout troop, while a much younger and smaller cub-scout
stands beside him in a cap, making the scout salute. The message is very much
that blacks in the ex-slave colonies salute the flag and stand by British cultural
traditions of discipline and clean living. The scouts, and indeed the Royal
Mail, allow the black youth to be nearly as British as the British.

The first set of stamps nominally devoted to black diasporic culture and its
manifestation in Britain appeared in 1998, a quartet of 20, 26, 43, and 63 pence
stamps under the title "Europa Festivals Notting Hill Carnival" (fig. 5.5).[26]

FIG. 5.5. GB Royal Mail, commemorative 20 p, 26 p, 43 p, and 63 p stamps, "Europa Festivals Notting Hill Carnival," 1998.

These consist of brilliantly colored and blurred details taken from photographs of costumed figures in the carnival parade. The titles claim that the images concentrate exclusively on women and children; human figures are in fact hard to decipher, faces emerging as small dark brown blurs drenched in flaring feathers and textiles. The carnival and the black people who have created it exist as bright fields of color, full of gyrating excess. The black presence has been reduced to two race stereotypes, exotic costume and exotic dancing. The specific cultural operations of the carnival, its Trinidadian base, and the keen political edge of the themed carnival schools, which often confront the memory of Atlantic slavery directly, are refined out of these designs. The tense, intense, and sometimes incensed relationship with that British institution, to be branded "institutionally racist" in the Stephen Lawrence Report in 2000, namely, the Metropolitan Police, also gets no manifestation in these stamps. The special first day issue postmarks designed to accompany this set consisted of a pair of disembodied caricatured black hands, slapping a pair of bongo drums.[27] The only recognizable human being in all these stamps is of

course the queen, with her ubiquitous portrait hanging top right. And it was on this note that the inheritance of the black slave and ex-slave subject within the British stamp ended until the issue of the slavery stamps. Given the high cultural profile of British abolitionists when it came to remembering slavery, it is also significant that no British abolitionists had been presented on British stamps prior to the 2007 commemoratives.[28]

WHAT MIGHT HAVE BEEN AND THE STATUS QUO: SOME DESIGN OPTIONS FOR THE 2007 SLAVERY STAMPS

Bearing in mind these contexts, what does the current set of six stamps devoted to the date on which the British House of Commons decided to end the slave trade tell us about how the Royal Mail has decided to approach the memory of slavery? The first thing to note, and the key fact to hold on to, is that what these stamps commemorate is not slavery, but quite precisely its opposite, the anniversary of the abolition of the British slave trade. Had these stamps been made even ten years ago, it is most unlikely that a black face would have appeared among the "heroes of abolition." The Royal Mail design committee did well in including not merely Olaudah Equiano, but Ignatius Sancho, among the six portrait heads that constitute the complete set of stamps. It might be argued that when it came to the 1807 abolition act Equiano and Sancho were the only serious candidates among British blacks. The pair have indeed gained a remarkable cultural visibility over the past decade, both men having had their writings produced as Penguin Classics and both having had one-man exhibitions devoted to them in major British galleries.[29] It is, however, a great shame that the series could find no place for the female black slave presence. Given the inclusion of Sancho, who was only tangentially connected to abolition activism and who was never a part of the great abolition publicity drive in the late 1780s, it is pertinent to ask why Phyllis Wheatley could not also have been included, ousting one of the three white males from the series? She was a British subject until the American Revolution, and she did travel to London and had her poems published there. The other four figures who were finally selected are Granville Sharp, Thomas Clarkson, William Wilberforce, and Hannah More. Yet once the decision had been made to organize the stamps around a series of portrait busts of the "friends of abolition," the interpretative options had been radically curtailed. The only decisions left to be made were which individuals should be placed at the top of the abolition league table, and then which images of the selected

final six, from their multiple portraits, should be used and what the back-
grounds should consist of.

Why did the powers that be, and the designer Howard Brown, take such a
conservative tack, when so many of their other commemorative sets of stamps
take far more creative approaches to memory and image? To speculate on
what might have been, there were surely many possible ways of getting a little
closer to the memory of slavery. One approach might have been to dedicate
the set to commemorating famous slave insurrections on British ships; there
were certainly enough of them. Then again, why not put black resistance in
a more potent context and have the stamps bear the images of black insur-
rectionary leaders from across the slave diaspora—Nanny of the Maroons,
Sam Sharpe, Vincent Ogé, Nat Turner, Toussaint l'Ouverture, Zumbi, the
Mâles of Salvador, and so on, all of them fine products of the European slave
trade and quite appropriate.[30] This would have engaged with the slave trade in
terms of a much grander historical sweep, and would have moved away from a
narrow nationalist agenda devoted to self-aggrandizement. Another solution
could have been to illustrate six scenes of the torture and abuse of slaves on
British slave ships, taken from the evidence laid before the British Parliament
by Thomas Clarkson. A striking set would have resulted if the torture imple-
ments used on slaves on British ships (shackles, whips, chains, collars, muzzles,
thumbscrews, the *speculum oris* for force feeding) had been placed in stark en-
graved designs, just as they appeared in Clarkson's publications.[31] Of course,
there would need to be the price on the left and the queen's profile top right,
but the designs would still have maintained a stark elegance, while the text
of the official descriptive details might then have a satiric charge. In fact, the
stark representation of slave torture implements was the preferred design op-
tion when Mauritius produced a stamp on February 1, 2001, commemorating
the "End of Slavery and Indentured Labour" (fig. 5.6). The FDC envelope car-
ries stark engraved images of shackles and whips, which contrasts violently
with the image on the stamp showing two freed slaves climbing stairs, with
arms raised and casting aside their shackles, as they move from the darkness
to the light.

If this option appeared too grim to the British designers, there were more
cheerful ones. For example, what about reproducing six of the most outstand-
ingly beautiful objects to have been made with slave money for the consump-
tion of slave produce? There are dozens of contenders in the Victoria and
Albert's collections of snuffboxes, tea and coffee sets, glasses, pipes, cigarette
holders and cases, and dinner services. Such a set of images would have the

FIG. 5.6. FDC Mauritius, "End of Slavery and Indentured Labor," February 1, 2001.

advantage of pleasing viewers of varying persuasions. For those convinced that good things came out of slavery, the designs would carry the message that, bad though it was, at least the slave fortunes were spent on making lovely things for rich white people to enjoy using. For those with a more skeptical take on slavery matters, the designs would be a space to ponder what our society might do with the fact that it remains saturated with gorgeous objects and buildings created out of the filthy money generated by the "Guinea trade." Or what about stamps exhibiting the trade items themselves, two from England (textiles, guns), two from Africa (hardwood, slaves), and two from the slave Caribbean (tobacco, sugar) to show how the "triangular trade" worked?[32] This approach would have the advantage of picturing the slave trade purely in economic terms, which was how British law viewed it both before and after its abolition.[33] Another confrontational option would have been portraits of six mainland Africans from the major regions to suffer the depredations of the trade. Such designs would aim to make an audience meditate upon the beauty and uniqueness of the millions of people British ancestors abused so completely for so long. Or what about the names and pictures of some of the members of the House of Commons who voted against the bill when it was passed, to show just how strong the opposition remained and to name and shame these proslavery scoundrels at long last? Or what about turning attention on the slave power? The stamps could have given portraits of six proslavery apologists, together with infamous aphorisms connected with them. The result would have been a sort of abolition rogues' gallery featuring Cap-

tain John Kimber, John Newton in his early days, Banastre Tarleton, James Boswell, Edward Long, William Pitt the Younger once he decided to try and reenslave San Domingo, and so on. A more complicated narrative could be set up by showing the heads of respectable slave torturers involved in the slave trade with the specific implements connected to them in the background. So Newton's bust-length portrait could be set up with the thumbscrews he used on infant slaves as a backdrop, or Kimber's portrait would be offset against the cat o' nine tails he ordered to be used to beat an adolescent African slave girl to death.

Although my list of projected designs appears to be taking on an increasingly dark satiric bent, such speculation serves a serious end. Turning from what we might have got and looking at what we did get, it is devastatingly clear that in the end these stamps were never designed with the intention of really confronting the disturbing memory of what the British slave trade means. It would be good to know what guidelines were set out for the designer Howard Brown when he got the commission for these stamps. Was he given carte blanche, or was he instructed that these stamps were designed to repress doubts and to repeat reassuring stereotypes? Was he told that the positive action of the abolitionists and the cult of personality generated around them had to be the focus, and that his stamps must be designed to stop us from thinking too deeply about the horror of the slave trade, and to make us focus on the celebration of a fiction? The fiction the stamps celebrate is that of the emancipation moment, and they do this by continuing to invest in the myth of the "heroes of abolition." Despite the fact that the first-class stamp makes a claim to racial equality, shared as it is by Equiano and Wilberforce, white patriarchy still dominates the set. The series is heavily weighted by the inclusion of three white males, although now they support a pyramid with two black males in the middle and one white female to crown it.

One gets a good sense of how things broke down when it came to marketing and celebrating the stamps in the group photograph that the official websites of Hull City Council, Wilberforce House Museum, and the Wilberforce Institute for the Study of Slavery and Emancipation carried to celebrate the issue of the stamps on March 22. This shows a gigantic enlargement of the Wilberforce stamp being "presented to the Lord Mayor of Hull, Cllr Trevor Larsen, on behalf of the Wilberforce house and the city of Hull."[34] The accompanying text tells the reader that the first-class slavery stamp is devoted to Wilberforce and that the "idea was first petitioned to the Royal Mail by Hull and Humber Chamber of Commerce" because they "wanted to create a

lasting legacy for the city." No mention is made of the fact that Wilberforce, in fact, shared the first-class stamp with black ex-slave Olaudah Equiano. This is a revealing photograph that communicates the fetishistic hold that the little abolitionist still exerts over the memory of British slavery. Four grinning white males in suits and ties dominate the composition; one younger female stands out in the right margin. There are no black people, male or female, in sight. Wilberforce's head, a great deal larger than life, floats in the middle of the composition, and each of the figures delicately holds, indeed touches or touches up, the iconic image, which is now framed on all sides with adoring white fingers. The distinguished councillor's white hair blends into the white marble of a statue rising above him in the background. This is Wilberforce's statue, standing in the courtyard of Wilberforce House and gazing down with patriarchal satisfaction at Wilberforce's own engraved face on the giant stamp.

QUESTIONS OF GENDER AND RACE EQUALITY IN THE 2007 SLAVE TRADE COMMEMORATIVES

The privileging of Wilberforce in the Hull stamp launch invites the question whether these stamps do, in fact, present a level imagistic playing field and a further question: If each stamp is analyzed in all its constituent elements, are the chosen abolitionists treated equally? The stamps consist of six figures who have been paired off into three couples according to value. The first pair unites Equiano and Wilberforce (plates 3 and 4), and one wonders what both men would have thought about being inscribed as equal "1st," and printed in millions upon millions of alternate couplings in the first-class sheets of stamps that went out to post offices across Britain. Sharp and Clarkson shared the 50 pence stamp (plates 5 and 6), and the 72 pence stamp forms a mixed-race union between Ignatius Sancho and Hannah More (plates 7 and 8). Looking closely at the stamps, it is significant that the portrait heads are taken from very different artistic sources. The heads of the two black males and the white female are reproduced from contemporary copper plate engravings, in black and white. The heads of the three white males have been taken from oil paintings, and consequently have a smooth quality, effects of realism, and a subtle range of mid-tones that the engraved images lack. In terms of the values attached to fine art images by connoisseurs and art historians, formal oil portraiture exists in an elevated class, indeed, a different aesthetic world, from the humble engraving. Given that there exist high-quality portraits in oil paint on

canvas of Equiano, Sancho, and More, it is relevant to ponder why the deci-
sion to use engravings was taken and whether there is more to it than meets
the eye. The monochrome in which the portrait busts are reproduced creates
problems in terms of the accurate description of skin color. It is noticeable
that both the portraits of Equiano and Sancho have been reproduced from
stipple engravings, a preferred technique when it came to the representation of
nonwhite skin types.[35] This method of intaglio involved making tiny circular
holes in the copper plate of slightly different depths with a specially adapted
burin or hammer, and was capable of a far more subtle range of halftones than
the line engraving used for More's head, but is still well below the subtleties of
oil painting used for Sharp, Clarkson, and Wilberforce. Given these technical
divisions, indeed, aesthetic hierarchies, around and between black and white,
male and female, the portraits consequently have a tense relation with equal-
ity, both racial and sexual.

There are many other peculiarities in the descriptive details of the stamps
that beg questions around color, power, and representation. For example, the
small gold bust of the queen in profile, which appears on all six stamps, faces
left to right and is placed top left in the black male portraits, while she faces
right to left and is placed top right in the four stamps featuring whites. The
conventional position for the queen's head is top right, so what governed this
eccentric rearrangement when the two black faces entered the frame? An-
other element to think about is that the blacks sport late eighteenth-century
English clothing and hairstyles; their jackets, shirts, cravats, and straightened
hair mimic the appearance of the three white males. Does this indicate that
the blacks exist happily in white society, that they have bettered themselves, or
are the stamps telling us that then and now we can only see blacks when they
behave and dress like whites, and for whites, when they toe the line and invest
in mimicry? Do these black portraits tell us that ex-slaves can only survive by
rejecting their own culture and memory in favor of an assumed Britishness, a
sort of sartorial equivalent of the extreme gentlemanly sentiment that domi-
nates Sancho's epistolary style? Hannah More emerges as slightly larger than
the five men; indeed, the big bonnet she wears and her enormous lace collar
make her appear slightly larger than life. More and Equiano are the only two
figures who are completely full-face and who stare straight out at the viewer.
Again, it is not clear whether this gesture elevates or disempowers the black
man and the white woman.

What primarily differentiates the stamps in terms of both color and ex-
ternal narrative is the background accreted to each figure. Each stamp has a

colored backdrop containing text and imagery considered appropriate to the subject. Wilberforce, Sharp, More, and Clarkson are each attached to a piece of abolition propaganda they were involved with. Yet only the Wilberforce stamp appears unproblematic; in the other three it is difficult to see what message is now being given to the millions of people who will be licking and sticking down these little paper narratives. It is relevant to question what agendas governed the designer's decisions when it came to creating color-coordinated backgrounds bursting with significant words and pictures for these miniature assemblages.

The Wilberforce stamp makes a straightforward connection between Wilberforce and his dealings in Parliament on behalf of the slave trade. One of the most spectacular manifestations of the popular base of abolition feeling were mass petitions. Antislavery societies across the country went out collecting signatures supporting the immediate abolition of the slave trade.[36] The sheets of signatures were sewn together and these vast paper constructs presented to Parliament. Wilberforce delivered some of these documents and talked about the power of the petitions in his speeches. It consequently makes a lot of sense to show one of the explosive broadside advertisements advocating petitioning as a backdrop to Wilberforce's portrait. The text may carry the somewhat bellicose assertion that Britons and their government freed Europe and must now free Africa, but as a whole the message of the stamp is coherent. The same cannot be said of the rest of the series.

In More's case the images behind her head, printed in a very soft olive green, constitute most of the central section from a bordered wood engraving that dominated the front page to her illustrated ballad *The Sorrows of Yamba, or The Negro Woman's Lamentation*.[37] The scene illustrates the key moment in this brutal and primitive missionary narrative when the slave turns from suicide to God. Both text and image are significant in that they are the only point at which these stamps deal directly with gender, religion, and slavery. It is consequently worth considering in some detail how this poem relates to the stamp and to the whole series. Yamba is an African woman from the Gold Coast (modern-day Ghana), and in the first half of the poem she is kidnapped by slave stealers, taken from her children, forced to endure the middle passage, and sold into the plantations of St. Lucia. Too miserable to live, she tries to commit suicide but is persuaded not to by an "English Missionary good." The second half of the poem swings between dire warnings to the slave owners of what God will do if they do not mend their ways, and lavish praise to God for the boon of Christianity and the hope it offers the slave. More's stern evan-

gelicalism may have represented the moral status quo at the heart of Clapham
Sect abolition when she wrote, but now it is hard to see the poem and its il-
lustrations as anything but a perverse peon to the powers of state Christianity
to overcome the sins of slavery. Once she has been converted, then slavery and
Yamba's traumatic experience within it take on a strange new set of linea-
ments. In a bizarre appropriation of martyrological zeal, Yamba even goes so
far as formally to bless her enslavement because of the opportunities it gives
her to mimic Christ's suffering: "I will bless my cruel capture, / (Hence I've
known a saviour's name) / All my Grief is turn'd to Rapture, / And I half for-
get the blame."[38] This is an attitude toward slavery, Christianity, and freedom
that would have been attractive not only to abolitionists but to slaveholders.
The more blame that ends up being forgotten the better. A slave who can see
freedom only in terms of a higher servitude to God, and who thanks God for
her suffering because it brings her closer to Christ's agony, is not going to be a
threat on the plantation, or anywhere else for that matter. And, indeed, after
her conversion Yamba is shown not as free, but as better able to endure her
sufferings within slavery. The poem is, in fact, rather sinister in its champion-
ing of the redemptive potential of the slave state. Slavery has given Yamba
an infinite experience of suffering; Christianity has given Yamba the gifts of
meekness, endurance, and infinite patience, so that she is "True of heart and
meek and lowly." In fact, from More's perspective Yamba is in a privileged
position. She suffers horribly and is completely innocent; the only thing she
has to do to be saved is lie back and enjoy her abuse. The message is succinctly
summarized: "all her pain and woe / Brought the captive home to God."[39]

I have gone into the coercive operations of Christianity within More's
poem in some detail because it is precisely the moment of Christian conver-
sion that is pictured on the stamp. Walking purposefully to the right and
into More's head is the English missionary. In the original he carries a vast
Bible in his right hand, which on the stamp has already been carried inside
More's cranium. His arm is locked into that of Yamba, whom he tugs away
from the sea. The nearly naked Yamba, wearing only a white loincloth, at-
tempts to break away, but stares back into the face of the man of God. How
are we supposed to read this now? More's big white earnest face stares out at
us, protected from the outside world by the enormous fortifications of her
lace-saturated head and neck wear. Meanwhile, a stern little clergyman tries
to drag a reluctant naked black slave woman away from suicide and inside the
formidable abolitionist's head. Yamba also incidentally possesses the only pair
of black breasts on display in British stamps. The words "The negro woman's

FIG. 5.7. GB Royal Mail, commemorative presentation pack, set of six
"Abolition of the Slave Trade 1807" stamps, 2007.

lamentation" float in front of Queen Elizabeth II's golden profile, but it is
hard to know what to do with this lamentation now.

The use of abolition propaganda in the stamp devoted to Thomas Clark-
son is, once it is considered in detail, no more straightforward than that of
More. Clarkson is surrounded by prostrate slave bodies, contained in the prow
of the slave ship *Brookes*, now reproduced in miniature from the famous aboli-
tion broadside. Historically there are solid reasons for linking Clarkson and
this image. He was instrumental in gathering the information that led to the
construction of this famous *Plan*.[40] He was also responsible for the mass dis-
tribution of the design, and personally gave out hundreds of copies in revolu-
tionary France when he visited Paris in 1789.[41] As is apparent from my analysis
of the mass of projects devoted to reinterpreting or just reproducing the *Plan*,
this design remains the most cut up, recirculated, and reproductively abused
image of the middle passage ever created. Yet despite its myriad and protean
remanifestations, what this *Plan* now means is, as we have seen, not so easy
to determine. The *Plan* was appropriated in multiple ways by the Royal Mail
and also forms the central design element in the special collector's package in
which the "Mint" editions of the abolition stamp set were sold (fig. 5.7).[42]

The front page of these display folders sets the six stamps on a chocolate
brown background on the bottom half, while a long folding flap carries the
image of the whole length of the middle deck from the *Plan* printed in light
olive green, with the words "Royal Mail Mint Stamps Abolition of the Slave

Trade" printed over it in burnt sienna. Underneath the word *slave* is a thick blood-red rectangle, which blots out a bloc of slave bodies beneath. Is this supposed to be blood, the pain of memory, a sanguine underlining, or merely an insensitive designer's caprice? The *Plan* consequently dominates the entire design, and the space in which all the stamps are read. It is a controlling symbol that states implacably that the manner in which the slave body was packaged for abolition in 1788 remains unchanged in 2007. The effect of repeating a fragment of the design in a new color behind Clarkson's head on his stamp enforces this message. Here the tip of the middle deck edges across the stamp, like a bizarre yellow ochre turban, floating behind the round face of Clarkson. The tip of the prow of the boat nestles up against the small golden profile of Queen Elizabeth. There could be no clearer articulation of how the slave body, and the experience of slave suffering, exists literally as a backdrop framing the earnest reality of Clarksonian philanthropy. As ever, it is the face of abolition that has substance, personality, biography, a cultural presence, while the slave body remains anonymous, passive, a collective and nameless *absent* presence.

On the matching 50 pence stamp, Granville Sharp is given an even more complicated background. Again, the slave ship is the central motif, but the extent to which black experience and suffering is given a voice is again questionable. In this stamp two elements make up the backdrop. The first is a reproduction in black of the manuscript minutes of the first meeting of the Anti-Slavery Society, May 22, 1787. The handwriting runs backward and forward, behind, and through Sharp's head, and includes the signatory list of founding members and the information that Sharp became the first leader of the society. Floating above Sharp and sailing into his wig, printed in a uniform cobalt blue, is a slave ship. Tiny slave bodies fall over the prow into the white horsehair wig of Sharp. Up in the far right-hand corner a tiny gold cameo silhouette portrait of the queen stares out at the boat. It is perhaps impossible to know how to interpret this odd assemblage of imagery. Sharp was, of course, the figure who first popularized the infamous story of the slave ship *Zong*. The captain of the ship threw a large number of living slaves overboard because he could then claim for their loss due to an insurance loophole.[43] Sharp brought the atrocity to public notice during the trial involving the insurers, the captain, and the ship owners. This scene of slave bodies going overboard in the stamp is apparently a reference to the *Zong* atrocity, and yet the ship itself is not the *Zong*. The image has been taken from a book illustration produced decades after Sharp's death in 1851, nearly a half century

after the abolition of the British slave trade. William Fox's *A Brief History of the Missions on the West Coast of Africa* included this image as an account of a slave insurrection.[44] Slave insurrection seems to have been introduced inadvertently in order to illustrate something very different if not precisely opposite: the calculated mass murder of slaves for financial gain. The sloppy manner in which slave trauma is introduced here is certainly troubling, but what may be more significant is the manner in which this opportunistic and inappropriate introduction of slave ship insurrection serves to underline the extent to which this subject was largely excised from discussions of the slave trade in 2007.

When it comes to the representation of the two black heads, it is noticeable that the backgrounds in both cases do not confront the slave trade or abolition propaganda directly, but take a much more oblique approach connected to trade and travel. Ignatius Sancho is set against a background consisting of a detail from his own trade card. The card has had a radical makeover, however, and is no longer in its original black, but is printed in magenta, indeed, a color not far from Barbie pink. Why Sancho, and indeed Equiano, are given such "girly" colors, while the whites all get tasteful greens, ochres, and blues is anyone's guess. It is well to remember that the one color none of the gangsters wants to be given in the notorious code-naming sequence in Quentin Tarantino's *Reservoir Dogs* is pink. Would Sancho have shared Steve Buscemi's articulate outrage at being forced to wear the title "Mr. Pink"? The design shows a white gentleman in a three-corner hat, leaning on a long staff and shaking the hand of a native American wearing a feather headdress and skirt and bearing a feather wand. The pair seem to be finalizing a deal. To the left of Sancho's profile is a large pulley and a bale of tobacco inscribed "Sancho's Best Trinidad." The idea seems to allude to Sancho's activities as a tradesman in London once he had left his job as a butler. This may certainly be a justifiable decision, but why not reproduce a key passage from the published letters for which Sancho is now chiefly remembered?[45] An excerpt from the famous letter to Laurence Sterne, urging the great satirist to put his talents into attacking the slave trade, would surely have presented Sancho in a more dignified and empowered way.[46] The relevance of the native American is hard to work out. There were no native Caribs left in Trinidad by the time Sancho was buying his tobacco; the "Indian" appears to have been wafted over from a Virginia trade advertisement.[47] Is the stamp supposed to be a comment on the trade links uniting the ex-slave, the white dealer, and the American colonial subject? Are we supposed to think about Sancho as a dealer, or as a piece of

colonial merchandise himself, or as a former piece of colonial merchandise who now trades in the produce of empire? The relationship between portrait head and advertising background sends out very mixed messages, but it is clear that unlike the four white abolitionists Sancho is not attached to a key piece of abolition text that he generated himself.

Equally bemusing is the choice of color and background design for Equiano. Here we are given an antique map set out in tasteful violet; it is described as a "Triangular Trade Map" in the official paperwork attached to the first day issue. There is no explanation why no text from Equiano's superb autobiography the *Interesting Narrative* is included.[48] Equiano's head has been placed in the middle of the Atlantic, while Spain, France, and Europe are just top right of his hair. His cheek nestles against Brazil, North America floats above left of his forehead, and Africa lies at the back of his head. Again, one can only speculate on the significance of all this: Is Equiano dominating or dominated by this now literally "black Atlantic," is he lost at sea or lost in translation, does the map allude to his hybrid status as neither European, American, or African? It is finally anyone's guess, but what is certain is that while the designers felt confident about linking the white abolitionists to the slave body and to antislavery propaganda, they had a different agenda with the black males. Sancho and Equiano are described in terms of their links to merchandise and to sea travel; the slave body and black autonomous authorship are kept well out of the background effects.

THE PICK 'N' MIX MARKETING OF MISERY:
FDCS AND TRAUMA COLLAGE

So far in this discussion the stamps have been considered as discrete items, operating as single visual units, or in the form of "se tenant" pairs, as the official Royal Mail websites market them, meaning that each pair is multiply conjoined on the Royal Mail's whole printed sheets. Yet when it comes to posting these things, and to the FDCs in particular, one enters a far less stable and controllable visual world. The postage stamps are not left intact, but are linked to a second level of visual discourse that is far less stable, namely, the cancellation postmarks. Commemoratives normally bear the stamp of the Philatelic Bureau of Edinburgh, but under special circumstances occasionally they carry a postmark of a place thematically linked with the subject of the stamps. The Royal Mail went overboard with regard to cancellation marks and the bicentennial, and in fact developed no less than sixteen spherical or

oval cancellation designs for the slave stamps, all of them related to the place of issue of the various FDCs. Each of these issue locations is related in one way or another to the slave trade.[49] These small monochrome stamps operate beneath the semiotic radar that policed the production of the colored stamps. They are far more crudely emblematic than their elaborately constructed colored cousins, but because they operated in a less celebrated public space they give a different, one might dare to say, truer idea of the agenda behind the Royal Mail's approach to 2007. As a body the cancellations that carry visual imagery conform to a stark set of criteria that are unremittingly conservative. Chains, slave shackles, slave ships, the portrait of Wilberforce, and disempowered and passive representations of the stereotyped slave body proliferate and indeed totally dominate the designs.

Throughout the designs there is also a laxness, indeed sloppiness, around how words and images are being used. Of the twelve postmarks that carry images no less than six (those for Whitney, Garrison Close, Parliament Square, the Hyde Park Slave Trade memorial, and two of the five Hull postmarks) simply carry images of chains or chains attached to wrist or ankle shackles. The images for Hull and Parliament Square show a length of chain with an open shackle at each end (fig. 5.11, detail, top left). The shackles may be open, but the extent to which they speak of slave freedom is questionable. The chains and metal cuffs wait there, ever open, ready to close again on the slave body. One of the Hull postmarks, entitled "The Wilberforce Arms, Hull," simply carries a black head in profile silhouette. In this a Negroid face, presumably lifted or adapted from a pub sign, is caricatured and carries a massive lower jaw and flattened nose. But probably the most revealing is the "Deans Yard" postmark, which reproduces the notorious image from the Abolition Seal showing the slave kneeling in supplication and begging the question "Am I not a man and a brother?" (fig. 5.11, detail, right).[50] This insulting slogan, with no accompanying illustration, is also baldly reproduced in the "Balls Park" postmark. It is fascinating that while this notorious symbolic enactment of white supremacy and black disempowerment is meticulously kept out of the commemorative stamp designs, it seeps back into the memorial equation via the symbolic hinterland of the cancellation stamp. While Equiano and Sancho are allowed a major presence in the stamps, no recognizable or individualized black is allowed into the cancellations. Indeed, the only figure graced with an individual portrait across the whole range of postmarks is, inevitably, Wilberforce, who stares confidently out from his writing desk in the "Freeman Street Birmingham" design (fig. 5.10, top left). On the evidence of these

cancellations abolition is the sole achievement of the Member of Parliament from Hull while the slave body remains as abstracted and devolved as it was two hundred years before.

While the designers were on their imagistic best behavior when it came to designing the stamps, one feels that the true state of affairs comes out more clearly in the cancellations, when the Royal Mail and its designers are caught with their bicentennial trousers down. It may seem overly critical, even mean and carping, to pick on these details, but I would suggest that these postmarks emerge as finally more significant than the stamps. What these postmarks mean, how we come to read them, is by no means a straightforward affair. They were, in fact, only used across the country on the first day of issue on March 22, but their use was by no means entirely arbitrary or innocent. Looking at philatelic sites specializing in the merchandising of FDCs it becomes apparent that this plethora of postmarks led to something little short of a feeding frenzy for collectors who could pick and choose their own combinations of cancels in advance. The Norvic company, for example, advertised on its website under the headline "Special Postmarks" the following: "Postmarks available for the day of issue are shown below. . . . These cannot be obtained after 22nd March and must be ordered from us by 20 March." There is then a controlled collectors' market for FDCs in which any of the postmarks can be consciously imposed, or literally stamped, upon the faces of the commemorative issue.

The first day issue envelopes also pass beyond the control of the Royal Mail in other ways. Take, for example, the "Norvic Exclusive First Day Cover" (fig. 5.8), produced in an exquisite limited edition. This envelope is completely different from the Royal Mail's. Its entire left side shows the Clarkson Memorial, in Wisbech, Cambridgeshire. On the original monument there are sandstone plaques beneath Clarkson's statue showing Sharp and Wilberforce. In a revealing move the Norvic design reproduces these plaques in foreshortened view to bottom left and right of Clarkson's be-robed white marble figure. In a single gesture the holy trinity of white abolitionists has been resurrected and now dominates the stamp designs. Reading across the envelope left to right the stamps have been so arranged that Clarkson, Sharp, and Wilberforce now stand together. This reversal of the first-class stamp with the 50 pence stamp means that Equiano is now isolated out on the right, and Sancho and More hang below. Not only does this double representation of the three white males on monument and stamp suddenly prioritize them, but Clarkson has clearly been raised above everyone. This takes us straight back into the recent squabbles

over who is the *Übermensch* or *Übermeister* of the campaign to abolish the slave trade. Wilberforce's Hull may have got five of the sixteen postmarks, but here the Norvic designers have ousted him and instituted Clarkson. The two circular postmarks that link the six stamps are both the Wisbech Clarkson design, which states: "Wisbech Cambs. Capital of the Fens, Birthplace of campaigner Thomas Clarkson." Clarkson now lords it over all comers as, in the words of the *Daily Telegraph*, "The Man who broke their chains." Inside the FDC envelope is a memorial card that reproduces on its left side a photograph of Clarkson's memorial plaque in Westminster Abbey and a lengthy biographical text on Clarkson. This again enforces the trinitarian link with Wilberforce and Sharp, and significantly the text does not mention the two black ex-slaves, or the white woman, who feature on three of the six stamps on the FDC envelope.

Norvic's philatelic inclination to reaffirm the history of the Slave Trade Abolition Act as the history of Clarkson's and Wilberforce's combined efforts is demonstrated in their issuing of two customized "maximum cards" as part of their commemorative stamp package. The cards bear no relation to the official cards, which the Royal Mail issued in sets of six, reproducing each of the stamps as a postcard. The Norvic "maximum card" devoted to Clarkson reproduces a 1967 black-and-white photograph of the Clarkson memorial in Wisbech (fig. 5.9). The 50 pence Clarkson stamp is placed in the clear sky to the left, with the Wisbech cancellation stamp below. The only piece of color in this assemblage is the prow of the *Brookes* from the *Plan*, which now floats out toward the tip of the Clarkson monument. The Wilberforce card is in color and shows a wax effigy of Wilberforce sitting in his study in his house in Hull, a candle, quill, and large tome before him, and an oil painting of a liberated slave hanging above him (fig. 5.10). The Wilberforce first-class stamp has been placed top left, with the "Freeman Street Birmingham" cancellation mark below it. This cancellation features a line-drawn portrait of Wilberforce set in a circular text. This card enacts retroactive celebration of abolition specifically through the worship of Wilberforce as fetish, and is a bricolage that incorporates no less than three bust portraits of the cult abolitionist. The backward-looking nature of this creation is enforced by the fact that the wax-work, and the room in which it is placed, no longer exist. The card is a photograph of a certain room in the old Wilberforce museum in Hull.[51] Ironically, the 2007 bicentennial had opened up massive lottery funding and Hull applied for a substantial grant to refurbish the Wilberforce museum. One major aspect of the redevelopment was to take the museum away from

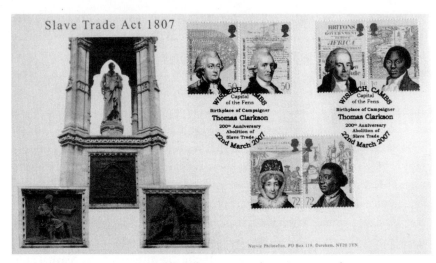

FIG. 5.8. GB Royal Mail, Norvic Exclusive FDC, set of six
"Abolition of the Slave Trade 1807" stamps, 2007.

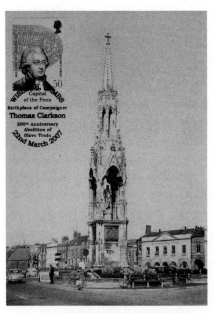

FIG. 5.9. GB Royal Mail, Norvic Exclusive
FDC "Clarkson Maximum Postcard,"
March 2007.

FIG. 5.10. GB Royal Mail, Norvic Exclusive
FDC "Wilberforce Maximum Postcard,"
March 2007.

an exclusive focus on Wilberforce and to place slavery and abolition in wider discursive contexts. The waxwork, and the room in which it was displayed, were removed as part of the new setup, yet they ironically live on within the philatelic archive and still circulate globally.

The FDCs of the slave trade series have also been incorporated into specific fund-raising initiatives related to 2007. The most arresting, yet confusing, of these is the Bletchley Park Post Office FDC (plate 9), the envelope designed by artist Paul Ayre. This sets the six stamps in a horizontal line in three pairs of two on the top half of the envelope against a blood-red background. Below these floating heads with their parti-colored backgrounds is an undulating mass of black human silhouettes standing out against the ensanguined sky. In the bottom right-hand corner printed in crimson and white over the black bodies are the words "Memorial 2007 [crimson] Remembering Enslaved Africans and their descendents 1807–2007 [white]." One thousand of these designs were printed as a fundraiser for the projected Hyde Park memorial garden, designed to "Remember enslaved Africans and their Descendants." The official sales blurb states: "The cancel is the chain motif from the Fund's logo, with the Hyde Park address of the memorial garden. A very dramatic cover to grace any collection or as a 'talking point.'"[52] This statement wonderfully captures the uncertain space that the stamps now occupy. Sent out in a limited edition especially designed for a philatelic market, they may "grace any collection," but there is also a shady awareness that the stamps, in their dramatic new setting, may relate to bigger political questions, or "talking points," although what exactly these points may be is left deliberately vague. The official marketing publication of Bletchley Park, *Stampex*, is similarly guarded. Tempering enthusiasm with a hint of reservation, it states that Ayre "has produced a fabulous design.... It really looks fantastic and we think the most dramatic but at the same time sensitive treatment of an emotional subject."[53] Drama and sensitivity are claimed as the desirable ingredients when it comes to treating this "emotional subject," but it is not clear whether this subject is abolition of the slave trade or the horror of the trade itself.

The design certainly has an immediate graphic impact. The saturated crimson sky reaches out to the aesthetic memory of Turner's great masterpiece *Slavers Throwing Overboard the Dead and Dying*. Turner painted a blood-red sunset as a backdrop to the slave trade atrocity he depicted. The gorgeous natural display hangs over the event and magically conjoins emotions of horror, guilt, outrage, violence, lamentation, and beauty. How we are to read Ayre's red sky is equally open to debate. Certainly horror, violence,

and guilt hang above the black crowd, but the impact of this sky is compli-
cated, maybe contaminated, by the white stamps, with their detailed pastel
backgrounds and formal gray portraits of the outsized abolitionists. Not only
is the impact of the flat plane of crimson firmament broken up, but the sud-
denly gigantic portrait heads on the stamps now hang above and dominate the
miniature faceless black masses below them. There is an inevitable message
suggesting that the abolitionists are more important, and more memorable,
than the nameless victims they float above and look down upon. It is also
hard to determine what these little black figures mean, why they are there, or
what they are doing. On close inspection the silhouettes all seem to be adult
males of the same size, dressed in trousers and long-sleeved tops. The figures
are not set on a straight horizontal but in a gentle curve; where exactly they
are and what they are standing on, whether the land or the deck of a ship, is
not clear. The heads of the slaves are represented as irregular circles; each one
is shown resting on a small curved bar, which represents a slave collar. There
is a small gap between each head, collar, and body, with thin red lines of the
background bleeding through, and this has the effect of making the heads and
collars look detached from the bodies; the heads float in space as if decapitated
by the collars. This gently seething crowd of headless black bodies growing
up out of a solid mass of blackness suggests collective victimhood, suffering,
and exploitation, but does not give this human merchandise any personality,
voice, dignity, or individuality. The relationship of the crowd of victims to
their floating liberators is further complicated by the operation of the cancel-
lation postmarks. These are carefully printed so that they just impinge on the
perforation marks of the three pairs of stamps, but do not interfere with the
stamp designs. Printed in the same matte black as the slave bodies, the cancels
are suspended in space above them, and their most distinctive feature is a
length of chain hanging vertically down from the bottom of the lace cravats
of Equiano, Sancho, and Clarkson. It is finally impossible to know what to do
with this design and the ambiguities it creates, yet it does seem locked into the
semiotic traditions that celebrated the "heroes of abolition" at the expense of
the individuality and trauma of the slave.

 These envelopes and the plethora of cancellation stamps indicate the extent
to which an insatiable collectors' market means that in terms of circulation
and reception these stamps are not a stable territory but are cut up, collaged,
overstamped, and encrusted onto a whole set of visual contexts. Even more
fascinating is what happens when FDCs are sent out into the real world of the
international mail. With a typically eccentric visionary precision, Walter Ben-

jamin ruminated on the disturbing, anarchic, and even sexually deviant effects of postmarks, observing: "The post mark is the night side of stamps. . . . No sadistic fantasy can equal the black practice that covers faces with weals and cleaves the land of entire continents like an earthquake. And the perverse pleasure in contrasting this violated stamp-body with its white lace-trimmed tulle dress, the serrated border."[54] The violent juxtapositions and seismic shifts Benjamin refers to are spectacularly in evidence in the following envelope, a FDC posted out to one Mr. Ismail Peermamode in Mauritius (fig. 5.11). How should this chaotic ensemble be interpreted? Part of the slave ship *Brookes* noses out across the rust-red capitals stating "ABOLITION OF THE SLAVE TRADE," while two designs showing shackles, the "Garrison Close" and "Parliament Square" postmarks, now float above the boat. Above everything is a bottle-green bust of Queen Elizabeth from the 2 pence stamp and a cobalt blue airmail sticker. Bottom right is the Mauritian bicentennial stamp, which shows two young male ex-slaves stripped to the waist, with fine physiques. They walk hand in hand up a set of stone steps into the refulgent light of freedom, their free arms raised. Their demonstration of liberty is now rather complicated, not to say compromised, by the fact that they gaze straight up at the weird symbolic crossbreed that has been created through the conjunction of the Equiano stamp and the "Dean's Yard" postmark that has been punched over it. Equiano is no longer a free citizen, but seems still to be asking us if he is a man and a brother. Of course, when it comes to this effervescent piece of popular assemblage nothing was planned, but what comes over very strongly is the dangerously negative capability of the postmarks to contaminate any other imagery they are placed in contact with. Equiano on his own, or even conjoined to his first-class partner Wilberforce, means something very different from Equiano tangled up with the figure from the Abolition Seal. For me this envelope says a vast amount about how little in fact the underlying agendas concerning the memory of slavery have really moved on in the two hundred years separating 1807 from 2007. Every one of those FDCs sent across the globe on March 22, 2007, bears quite literally the multiple stamps of this fact.

SLAVERY AND EMANCIPATION IN GLOBAL PHILATELIC PERSPECTIVE

When it comes to putting the British stamps in some sort of final perspective, it is above all their graphic conservatism, their subordination to cults of personality and the great man theory of history, that stands out. The stamps

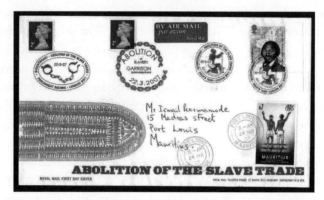

FIG. 5.11. FDC of "Abolition of the Slave Trade 2007," posted to
Mr. Ismail Peermamode in Mauritius, 2008, with Mauritian stamp,
British and Mauritian cancellations, and airmail sticker, 2007.

appear unique, and indeed rather daring, if set against British commemorative issues, but when set in global perspective they form the latest addition to a complicated set of dialogues that involve the entire Atlantic slave diaspora. Many nations in Africa, the Americas, Europe, and Asia, from the 1930s to the present, had brought out stamps to commemorate different aspects of slavery and a variety of abolition anniversaries. The most significant sets came out of Goree, Mauritius, Sierra Leone, Dahomey, Togo, Ghana, Jamaica, St. Lucia, Martinique, Haiti, Barbados, Trinidad and Tobago, Anguilla, the British Virgin Islands, Uruguay, Brazil, Surinam, North America, Belgium, and France. Several of these come at slavery from very different and often more radical perspectives than the British set.

Graphic Conservatism:
The Long Shadow of the Emancipation Moment

Several African and Caribbean nations, which had been British colonies, produced sets of stamps relating to independence or to anniversaries of slavery abolition at relatively early dates. The earliest stamps to commemorate an abolition anniversary were the Sierra Leone 1933 centennial series.[55] Of the eight stamps, three of them approach different elements of the slavery inheritance. The 2 shilling stamp had a caption that commented in a tone of apparently amused disdain, "An old Slaver's resort," showing a distant view of a slave trading fort. The 3 pence stamp (fig. 5.12) carried the inscription "Centenary of the abolition of slavery and of the death of William Wilberforce," nicely encapsulating how abolition and Wilberforce still existed in perfect symbolic

equilibrium in the official colonial reading of abolition. The accompanying image shows a beautiful mulatta girl in *profil perdu*, with an enormous Carmen Miranda–style basket of fruit on her head. The basket seems to be a sort of neo-realistic cornucopia expressing the full fruits of the Wilberforcian gift of freedom. The 2 pence stamp (fig. 5.13) carried a tripart caption labeling a tripart image. On the left and right the "Law Courts Freetown" and "Government House" are conventional administrative buildings, while in the center the "Old Slave Market" consists of a large tree. Given that the central meeting place for discussion and trading in west coast African villages is commonly a sacred tree, the implication seems to be that while law and order are configured in white colonial buildings slave trading is part of African culture.

The most explicit of the series in terms of its engagement with the details of emancipation was the 1 pence stamp (fig. 5.14). Running across the top of the stamp is the title "Sierra Leone" with the juxtaposed dates 1833 and 1933 below it. The stamp was printed in two colors; a soft rust-red background depicted a palm tree and a beach with breaking waves, presumably the African slave coast. In the center of the vertical design stands an African male printed in black, wearing a white robe tied off the shoulder in the typical manner of West African male dress. He raises his arms, while a chain with an unrealistically enormous ball attached has fallen from his left wrist and a chain attached to a double shackle from his right. This image has come straight from the emancipation prints of 1833, without mediation or alteration, and it perpetuates designs that froze emancipation in the white European imaginary. The slave is a passive figure who has freedom magically thrust upon him. He has a human body, but is shown as a powerless innocent, looking heavenward, arms rising in cruciform extension. He wears a pure white robe symbolizing baptismal rebirth or the purity of virginity.[56] Conversely, the slave power is represented symbolically in the form of a series of vast restraints, and the powers of antislavery or emancipation are represented mystically. At the relevant moment the iron fetters spontaneously shatter under the vast invisible forces of white moral regeneration. Abolition appears, or rather manifests itself, as an irresistible force coming, like some variant of the Holy Spirit, from we know not where, to put down the forces of darkness. And yet the decorative borders to this stamp tell another tale, for the chains, far from disappearing, in broken fragments run down the left and right margins in an orderly pattern, with a ball motif resting at the center. The chains, floating in the margin, in their vertical symmetry have a sinister effect, suggesting that they lie there in perpetual potential to recapture the slave body as their property.

FIG. 5.12. (*Top left*) Sierra Leone, 3 d stamp, "Centenary of the abolition of slavery and of the death of William Wilberforce," 1933.

FIG. 5.13. (*Top right*) Sierra Leone, 2 d stamp, "Law Courts Freetown," "Government House," "Old Slave Market," 1933.

FIG. 5.14. (*Right*) Sierra Leone, 1 d stamp, "Sierra Leone 1833–1933," 1933.

The extent to which the basic abolition paradigms exhibited in this first slavery commemorative have maintained their power into the new millennium comes out with shocking completeness in the FDC that Thailand brought out in 2005 to celebrate its centenary of abolition (fig. 5.15). This carries a stamp that reproduces the mural painted on the roof of the Royal Throne Hall showing King Rama V bestowing freedom on his kneeling subjects.[57] The design could have been precisely adapted out of designs showing William Wilberforce in England, or Abraham Lincoln in America, or Victor Schoelcher in the French colonies, or Count Rio Branco in Brazil, bestowing freedom on the slaves.[58] Below left the postmark shows a kneeling, praying male slave, surrounded by a border of chains. The far left of the design depicts two giant chain links and a third broken link, which hangs above a sepia

FIG. 5.15. Thailand, FDC centenary of abolition, mural of Royal Throne Hall showing King Rama V bestowing freedom on his kneeling subjects, 2005.

soft-focus detail of a group photograph of a set of seated partially clothed and naked Thai adults, presumably slaves. The horrible gift of freedom could not be expressed with a greater semiotic concision.

When Ghana claimed independence on March 6, 1957, a full set of nine stamps was produced.[59] All of these carry the head of the young Elizabeth either in the top right or left corner, with each denomination printed in a different color, along with a central narrative design relating to Ghanaian culture or history. This set is most revealing in that it is ambiguous in relation to Ghana's participation in the slave trade. In this sense the stamps anticipate the stance Ghana was to adopt in 2007 when called upon both to celebrate its independence and to commemorate the bicentenary of the 1807 Slave Trade Abolition Act.[60] The slave trade did terrible damage to Ghana, yet the country was complicit in, not to say highly successful at, the trade. Although none of the stamps directly address Ghana's role in the Atlantic slave trade, two of them do come at the subject obliquely. The 5 shilling stamp carries an image of canoes, or as they are described, "surf boats," coming up the beach through the waves. The little boats are crowded with African figures. While these boats are still used as fishing boats today, they are the same craft that were

FIG. 5.16. Ghana, commemorative independence 1 d issue,
"Christiansborg Castle" (side view of the castle printed in indigo), 1957.

used to run the slaves out from the slave forts, through the shark-infested surf,
to the waiting slave ships.

The 1 pence stamp (fig. 5.16) represents Christiansborg Castle, which is
viewed from a low angle through what appears to be a field of weeds. As with
the surf boats this is an ambiguous image that strangely embodies the combi-
nation of pride and unease with which Ghana's great coastal trading forts and
castles are viewed. The castle itself had a remarkable history that compresses
Ghana's complicated colonial coastal history. The first building took place
in 1661, when the Danish Commander Joos Cramer bought a land site from
the Africans. In 1679 the castle was overrun in a mutiny and then sold by
the victorious mutineers to the Portuguese, but in 1683 they sold it back to
the Danes. In 1693 the fort was taken by the Akwamu chief Assameni, who
then sold it back to the Danes a year later although he kept the keys. The
castle then became the center for Danish trading and the main conduit for
the Danish slave trade throughout the eighteenth century; it continued to
play a role in the smuggling of slaves during the first half of the nineteenth
century. It was expanded and developed on a terrific scale into a complex of
buildings that rivaled the other two great castles on the slave coast of Ghana,
Cape Coast, and Elmina. It was only in 1850 that the British finally gained
possession of the fort, which they bought from the Danes, together with their
four other coastal forts for 10,000 pounds. Over the next century the castle,

like the other great coastal forts and castles of the Gold Coast, fell into ruin; it was only in the 1950s that there was a concerted effort to restore them to their former grand state. Christiansborg in fact became, and remains, the official seat of the government of the republic of Ghana.[61]

This brief account of the remarkably fluctuating fortunes of this castle indicates how difficult it is to reduce its significance to a single idea or its role in slave trading to a single nation. The castle stood for Danish, Portuguese, and then British colonial activity. It was a symbol of the eighteenth-century slave trade, yet it also stood for African agency and the successful guerrilla tactics of Assameni. By the mid-1950s, the castle had been marked as the headquarters for the new Ghanaian republic and hence was a symbol of the birth of the new nation. In this context it is crucial to remember that to Ghanaians the great slave forts on their coast do not carry the exclusively negative and traumatic associations that they have come to hold for African American and British tourists.[62] While slavery tourism is now well established around these sites, for the Ghanaians their great coastal castles are not seen primarily as sites of shame and sorrow but as symbols of their preeminence as traders and businessmen. The coat of arms of Ghana still carries the image of a coastal fort, and the major castles are commonly chosen as coffin designs.[63] Ghanaians actually choose to be buried in elaborate wooden models of these castles, because they see them as symbols of national pride and power. The representation of the fort on the 1 pence stamp must consequently be seen to carry the full admixture of these associations. The entire set of stamps suggests the manner in which the memories of colonialism and the slave trade saturate Ghanaian historical memory in twisted and bittersweet ways. The slave coast of Africa, even in its stamps, approaches the memory of slavery in a very different manner from that of the Caribbean and the Americas.

Chains are ubiquitous to a great number of the abolition commemoratives coming out of the diaspora. One of the most uncompromising applications came with the 1963 U.S. 5 cent stamp, commemorating the centennial of the Emancipation Proclamation (figs. 5.17, 5.18, top right). Against a ultramarine background three chain links are shown, one of them snapped clean through. This has the virtue of emblematic simplicity, and equates the idea of the emancipation moment to the snapping of a chain. Yet the clarity of the American stamp is radically undercut on the FDCs on which it appeared. The original 1963 FDC (fig. 5.17) carried the stamp top right, but the entire left of the envelope was given over to an elaborate recasting of the broken chain under the shadow of Lincoln's gift of emancipation. Here a length of

chain with broken link floats up into an elaborate framed oil painting with the title *President Lincoln and his Cabinet discuss the Emancipation Proclamation*. Five seated and three standing white patriarchs are shown deliberating the document that will give freedom to the slave population. Slavery is quite clearly something the Great Emancipator and his inner circle first articulate and formally inscribe in private among themselves before they go public and bestow it upon the slave victim, who is significant in this design by his or her total absence. This ultraconservative take on slave emancipation in North America is repeated in subsequent FDC commemorations of the Emancipation Proclamation.[64] So on January 1, 1986, Mort Kunstler, an illustrator specializing in kitsch reimaginings of theatrical key moments in the Union's history, produced an FDC as part of his Epic Events in American History series (fig. 5.18). The reprinted 1963 stamp was placed top right, now next to a 22 cent stamp, showing the Capitol building and the Stars and Stripes. A Washington postmark cancelled the two stamps. The whole left-hand part of the envelope is filled with a horribly wooden reconstruction of Lincoln in the act of signing the sacred document. The fetishized pen and ink wells, which are now in various museums, are clearly shown, and below the title "THE EMANCIPATION PROCLAMATION" in scarlet capitals is the statement that "it expressed Lincoln's firm stand against slavery." It hardly needs to be added that this is, given Lincoln's notorious shilly-shallying over slavery and the Union, rather wishful thinking. We are also informed by the narrative on the back of the envelope that "in the minds and hearts of men everywhere it is as the 'Great Emancipator' that Lincoln is still remembered." This FDC is useful in demonstrating the processes whereby the abstract power of the original stamp is commandeered and utterly reduced when incorporated as an element to decorate the myth of Lincolnian emancipation mythology.

One of the strangest philatelic manifestations of the long shadow Lincoln casts over the iconography of emancipation is to be found in the remarkable FDC for the stamps that the newly established republic of Togo issued in 1963 to commemorate both John F. Kennedy's assassination and the one hundredth anniversary of the abolition of slavery in North America (fig. 5.19). The 1, 25, 50, and 100 franc stamps were printed with blue, pink, bronze, and gold backgrounds, respectively, and each carried the same text and imagery. They show a crude portrait of Lincoln's head on the right and then a broken chain and shackle floating above a miniature map of Africa. Set diagonally across the latter is the inscription "En memoire de John F. Kennedy" and at the bottom "Centenaire de L'Emancipation de l'esclavage." Then the left of

FIG. 5.17. United States, FDC of 5 cent stamp commemorating the centennial of the Emancipation Proclamation, 1963.

FIG. 5.18. United States, commemorative FDC reissue of 1963 5 cent stamp commemorating the centennial of the Emancipation Proclamation, Epic Events in American History series, Lincoln signing Emancipation Proclamation, 1986.

FIG. 5.19. Togo, 1, 25, 50, and 100 franc stamps, FDC, commemorating both
John F. Kennedy's assassination and the one hundredth anniversary of
the abolition of slavery in North America, 1963.

the cover is taken up with a large portrait photograph of Kennedy enclosed
within a black border. It is thought provoking to see the two assassinated
presidents resurrected in a memorial stamp design dedicated to the memory
of slavery in one of Africa's newest republics. This FDC is a tribute to the effec-
tiveness with which the American emancipation moment had been globally
marketed for a hundred years through the iconography of Lincoln.

The slave body is not entirely shut out of North American stamps, yet
tends to be contained and codified in conservative ways. The most predict-
able and yet extreme example of these tendencies is the 3 cent stamp brought
out to mark the seventy-fifth anniversary of the Thirteenth Amendment to
the Constitution (fig. 5.20). Printed in austere, not to say funereal black and
deep purple, this stamp simply reproduces an engraved representation of the
1876 Thomas Ball *Emancipation* statue in Washington, D.C. Lincoln, in an
overcoat and suit, extends his arm above a kneeling slave, who, even though
his shackles are broken, adopts the position of the prostrate enchained captive
in the British Abolition Seal.[65] The inheritance of nineteenth-century codes
for the representation of the passive and eternally grateful slave, still frozen
within the posture of the British Abolition Society Seal, appears to be com-
pletely intact in the mid-twentieth century.

Slavery is directly manifested through the depiction of one heroic male
ex-slave on one American stamp, the 25 cent stamp of 1987, which features a

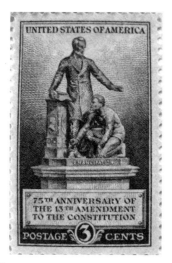

FIG. 5.20. United States, 3 cent stamp commemorating the seventy-fifth anniversary of the Thirteenth Amendment to the Constitution, 1940.

portrait bust of Frederick Douglass (fig. 5.21). It is, however, intriguing that this stamp depicts that most photogenic of ex-slaves as a bushy-haired and bushy-bearded patriarch decked out in a tuxedo, complete with black bow tie. Like Equiano and Sancho on the British 2007 stamps, Douglass is dressed up formally in the dominant white male fashions of the day and consequently made formidably respectable. Douglass has been printed in a roseate brown, and the image, although adapted from Mathew Brady's famous daguerreotype portrait, has been crudely engraved.[66] This has the effect of dissolving the unique force of Douglass's renowned stare and of placing him in some sort of nineteenth-century illustrational limbo. He doesn't look like a radical black intellectual, but like any cozy old establishment figure, albeit with a touch of Uncle Remus about him. Douglass has been made safe. The message of this stamp seems to be that inside every black radical a white politician is dying to get out, and that Douglass was always really a white patriarch in disguise.[67]

Although the slave presence did not become forcefully manifested on many individual North American stamps there was an impressive 13 cent stamp printed in 1961 as part of the Black Heritage USA series to mark the 140th birthday of Harriet Tubman. The top half of the design (fig. 5.22, top right) depicts a full-face portrait of Tubman wearing a dramatic purple headscarf against a manganese blue sky. The bottom third shows a wagon with fugitive slaves, driven by Tubman (fig. 5.22). There was also a spectacular

FIG. 5.21. United States, 25 cent stamp,
Frederick Douglass commemorative, 1987.

FDC that focused in more extended fashion on the Underground Railroad
and Tubman's part in engineering mass slave escape. Four of the Tubman
stamps are top right, while the envelope design left and center shows a snowy
landscape and in the distance a group of escaped slaves trekking northward
in a wagon. Harriet stands and is shown half-length in three-quarter profile
in the foreground. She wears a military-style overcoat, and a headscarf tied
African-style. She gazes out seriously beyond the viewer, watching for pur-
suers. She holds a rifle barrel in both hands before her, the butt of the rifle
planted on the ground. The image has been adapted directly out of the dra-
matic woodcut frontispiece to Sarah H. Bradford's 1869 *Sciences in the Life
of Harriet Tubman*. The text reads "Honoring Harriet Tubman 1821–1913
Abolitionist — Nurse — Escaped Slave. She guided more than 300 slaves to
freedom." She is armed, vigilant, aggressive, and heroic, and significantly she is
not defined merely as an abolitionist, but as having a profession and as having
actually freed herself. This is a unique example of an American female ex-slave
celebrated as a forceful, engaged, and successful political activist.

"Hoorah for Schoelcher":
Philatelic Hero Worship of the Gallic Wilberforce

This discussion of slavery in stamps has been considering the extent to which
philatelic design is locked into the imagery of the late eighteenth- and early
nineteenth-century graphic archive of the emancipation moment. In this con-

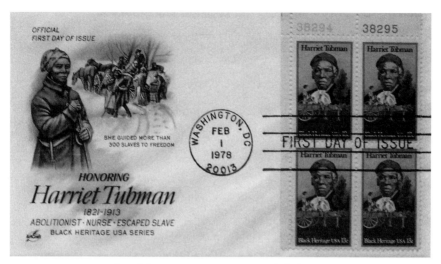

FIG. 5.22. United States, 13 cent stamp, FDC "Black Heritage USA,"
the 140th birthday of Harriet Tubman, 1961.

text the fixation of France and its Caribbean colonies on the figure of Victor
Schoelcher is educative. The French construction of this male emancipatory
icon emerges as even more intense and overpowering than archival transmog-
rifications of Wilberforce in Britain or Lincoln in North America.

Intriguingly, the valorization of Schoelcher in French philately came in
through the side door via Britain. During the Nazi occupation of France, Brit-
ish propagandists put a lot of thought and energy into how to celebrate the
free French colonies during a period when France itself was powerless to do so.
The French artist and illustrator Edmund Dulac had lived and made his repu-
tation in England, taking English citizenship in 1912. He had been involved in
producing a series of brilliant designs for English stamps in the 1930s. In 1940
Charles de Gaulle, in exile in Britain, personally approached Dulac to design
stamps and banknotes for the free French colonies. Dulac produced many sets
during the early 1940s, including a full range of nineteen stamps for Marti-
nique (fig. 5. 23).[68] Each value of stamp is printed in a different color but they
all carry a portrait head of Schoelcher against a view through a tropical grove.
The scene beyond the grove consists of the port of Fort de France, with tall
ships sitting in the harbor. The viewer is left to make the connection between
the head of Schoelcher and the ending of the trafficking in slaves. The slave
bodies themselves are completely absent from the design, but it nevertheless
combines clarity and discretion with a certain force.

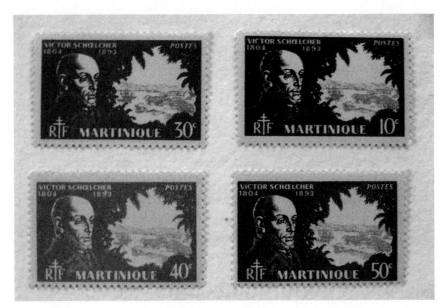

FIG. 5.23. GB, Schoelcher commemoratives, produced for
the Free French in Martinique, 1943.

In 1957 Schoelcher's portrait appeared in white outline on a crimson 18
franc stamp (fig. 5.24). The stamp explicitly celebrated Schoelcher as the man
who created the 1848 Abolition Decree. The FDC contains an elaborate il-
lustrative panel on the left side that shows two male slaves naked to the waist
and wearing white skirts. One stands, the other kneels, and both have out-
stretched arms trailing broken chains and shackles. They reach out with ges-
tures that combine abject gratitude and celebration toward a towering bust of
Schoelcher, while he stares out with noble unconcern beyond the slaves into
the distance. The design is completely locked into that vision of the gift of
freedom that dominates the multiple emancipation statues depicting Schoel-
cher across the Francophone black Atlantic. It was this body of work, and
its associated mythologies of black submission and white valorization, which
led Frantz Fanon into such incandescent satire at the white emancipator's
expense.[69]

The 150th anniversary of the act abolishing slavery in the French colonies
generated some peculiar designs and took Schoelcher mania to a new level.
The 3 franc definitive stamp produced for general use did attempt to shift
attention to black agency, yet carried a strangely caricatured portrait head of
Toussaint l'Ouverture wearing a tricornered military hat carrying a tricolor

FIG. 5.24. France, 18 franc stamp, Schoelcher commemorative, 1957.

rosette (fig. 5.25, top middle). The stamp designers had worked the image up out of the French late eighteenth-century engraving of François-Séraphin Delpeck and Antoine Maurin. This was beautifully engraved and showed Toussaint in full French general's military uniform, yet presented his facial features in Negrophobe caricature.[70] The mandible is massively exaggerated, and the chin and lower lip are huge. The stamp was widely commented on in the French press, which seemed blind to the denigratory nature of the portrait the stamp carried.[71] The image contrasted markedly and unfavorably with the heroic images of Toussaint and other black revolutionary leaders that came out of Haiti over an extended period.[72]

As well as the stamp the anniversary also generated a host of elaborate official philatelic productions, where Schoelcher ruled the roost. By far the most spectacular was the limited edition contribution to the grand series Célébrités de la France (fig. 5.25).[73] This long-running series of exotic productions is consecrated to the greatest celebrities of the French nation and Schoelcher appears as number 254. This spectacular object, more like an official certificate than an FDC, represents a high water mark in the kitsch-memorabilia developed to market a white male abolition patriarch. A finely woven textile of silver-dyed silk was laid onto thin card, forming the backing for a quite remarkable assemblage. A rich metallic-crimson margin was then embossed onto the silk, in letter-press, using refined lead cast intaglio ornamentation. Within the margin the bottom half of the design consists of an exquisite enlarged portrait of

FIG. 5.25. France, FDC Schoelcher whole sheet commemorative for
the 150th anniversary of the act abolishing slavery in the French
colonies, "Célébrités de la France" number 254, 1998.

Schoelcher, in three-quarter profile, facing left to right, the image having been
adapted from a nineteenth-century portrait engraving. The portrait bust is
printed in a subtle light burnt sienna ink, which softly floats on the absorbent
silk backing. Below the portrait is the forthright inscription "1804 — Victor
Schoelcher — 1893 L'abolition de l'esclavage" in the same ink. The dates are
not those of abolition and its anniversary but of Schoelcher's birth and death,
as if he alone embodies the whole memory and experience of French Atlantic
slavery and its abolition.

The top half of the design within the margin then consists of five perfectly
positioned 3 franc commemorative postage stamps, each carrying the bizarrely

caricatured head of Toussaint l'Ouverture already commented upon. Each of
these stamps is then printed over by circular cancellation stamps, each cancel-
lation stamp featuring another portrait head of Schoelcher, again in three-
quarter profile but this time facing left to right. The inscription of each can-
cellation is different; one is from Paris, and the other four from the French
capitals of the slave colonies, "Fort de France," "Basse Terre," "Cayenne," and
"St. Denis." The effect of the whole is to present the vast head of Schoelcher
crowned with a sort of floating halo of his own noble portrait, which encom-
passes every French slave colony and which also quite literally cancels out the
tiny portrait images of Toussaint. This is the apotheosis of abolition patriarchy
in perfection and demonstrates with a terrible thoroughness the continuing
and terrific manner in which the official memory of slavery in France is domi-
nated by the myth of one abolitionist shibboleth. The irate satire of Frantz
Fanon seems powerless to impact upon such lush memorial national self-
indulgence.

The official FDC for the 150th anniversary was a good deal more ambigu-
ous (fig. 5.26). This consisted of a standard white envelope, which had a glossy
embossed design printed in black and blue over white on its left-hand side.
The blue background depicts Europe, Africa, and the Americas against lines
of longitude and latitude in the top third. In the bottom right-hand corner a
black slave, with caricatured bone-white lips and shackles that stand out like
starched shirt cuffs, reaches upward with his bare black arms outspread. Float-
ing between these arms is the buoyant portrait head of Schoelcher. This bald
head, with wing collar, floats out across the Pacific Ocean, looking grim and
very decapitated, or like some crazy beach ball that the slave is either catching
or tossing in the air. The design is hard to read, but presumably the slave is try-
ing to grab and embrace the disembodied head of his savior Schoelcher. The
rest of the envelope carries a double cancel showing the head of Schoelcher,
this time in three-quarter profile; floating above the second cancel in the top
right corner is the commemorative 3 franc abolition stamp. This shows a cari-
catured profile portrait of a black head, sporting a Napoleonic-style tricor-
nered hat and a tricolor cockade, with a red fabric, presumably a flag, floating
in the background. The date 1998 has been drawn on the middle right margin
so as to resemble a length of chain. The figure, with flattened nose and huge
lips, is, as mentioned above, presumably a grotesque representation of Tous-
saint l'Ouverture.

It is hard to determine intention in this peculiar admixture, but whether
it meant to or not, this FDC assaults conventional abolitionist celebrations of

FIG. 5.26. France, standard FDC Schoelcher commemorative for the 150th
anniversary of the act abolishing slavery in the French colonies, 1998.

the emancipation moment. The link between the liberated black and the por-
trait of Toussaint, both looking out left in profile, and the idea that the free
black is using the detached head of the white patriarch as a plaything, suggest
a complicated take on the expression of slave freedom. But one thing seems
certain: in their stamps, as in their culture, the French find it hard to celebrate
Toussaint as a great leader. Ever since the French army tricked Toussaint into
capture, and Napoleon could not find it in his heart to reply to Toussaint
l'Ouverture's desperate letters from his prison in the Jura, French officialdom
has not found Toussaint an easy figure to deal with in its public art.

French stamps have, however, honored other radical slave figures less cele-
brated than Toussaint, at least outside the Francophone Caribbean. In May
2002 the French Postal Service brought out a commemorative slavery issue
devoted to the black revolutionary hero and martyr Louis Delgrès (fig. 5.27).
The FDC envelope carried the statement "He preferred death to the chains of
slavery which he wished to break" below a portrait bust of Delgrès and two
hands breaking a huge chain. The commemoration of Delgrès on a French
stamp is an unusual gesture of French cultural solidarity with a black activist.
Yet Delgrès was by no means a straightforward revolutionary hero, but a com-
plex figure, caught up in the shifting politics of the Revolution, who had to
work from within the system. He had a short but fascinating life. Born a black
in Martinique, he fought for the French against the English in the American
wars, was captured, sent to England, exchanged, and found himself in Gua-

deloupe in 1799. By 1801 he was fighting the black revolutionaries in Guadeloupe as aide-de-camp to General Jean-Baptiste de Raymond Lacrosse, and was soon made a colonel. Yet once he understood that Lacrosse intended to reimplement slavery in the colony, Napoleon Bonaparte having reintroduced slavery by law to the French colonies in 1802, Delgrès refused to continue to fight the slaves. He holed up in his defenses in the mountain fortress of Basse Terre until it was blown apart by the attacking army on May 28, 1802. Slavery was reestablished in Guadeloupe on July 16. Delgrès is consequently a contradictory figure. He ended up becoming a victim of political manipulation but finally would not betray the blacks. As early as 1870 he was proclaimed "the last defender of black Freedom in Guadeloupe" in an uplifting article in the *Larousse Encyclopaedia*. This article, together with a beautiful tributary proclamation by the Haitian general Jean-Jacques Dessalines in 1804, when Haiti became independent two years after Delgrès's death, served as the inspiration for a major poem by Aimé Césaire.[74] This typically dense hymn of praise uses the name of Delgrès in an incantatory manner, similar to, but more intense than, the way Toussaint operates, when imprisoned in the mountain fortress of the Jura, in the famous lines from "Notebook of a Return to the Native Land."[75] It is above all Delgrès's patience and his ability to look head-on at inevitable destruction that moves Césaire:

> and I sing of Delgrès, who, obstinately endured on the ramparts
> for three days contemplating the elevated blue of dreams
> projected out of the sleep of the people
> for three days supporting, supporting, in the fragile structure of his arms
> our sky of crushed pollen[76]

In this context the design of the rare full-sheet FDC devoted to Delgrès (fig. 5.28), produced as one of the coveted *Collection Historiques du Timbre-Poste Français*, is significant. This has the stamp and the official first day cancellation mark showing the fort of Basse Terre. The bottom third of the sheet is dominated by an elaborate architectural drawing of Delgrès's last retreat seen in aerial view, as if Delgrès's spirit floats above the scene of his simultaneous destruction and apotheosis.

The next commemorative brush of the French Postal Service with slavery came in May 2006 and marked the official recognition by France that Atlantic slavery, throughout its practice from the fifteenth to the nineteenth centuries, was a crime against humanity. The stamp issue, however, bears the title "Mémoires de l'esclavage et de son abolition" and consequently confusingly

FIG. 5.27. France, standard FDC, Louis Delgrès commemorative, 2002.

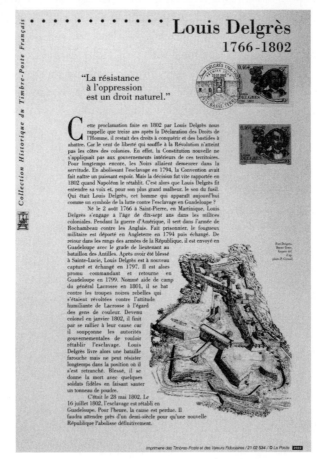

FIG. 5.28. France, full sheet FDC, Louis Delgrès, *Collection Historiques du Timbre-Poste Français*, 2002.

FIG. 5.29. France, FDC, *Mémoires de l'esclavage et de son abolition*, 2006.

fuses the official acknowledgment of crime with a celebration of abolition (fig. 5.29). The FDC encompassed this confusion in visual terms. The left-hand side carried, within an elaborate gold frame, a realistic portrait of an attractive young black male against a map of the African coast, with a length of chain floating down the right-hand side. Top right carried the official stamp, which depicts a caricatured angry-looking mulatto male wearing what appears to be a yellow wife-beater T-shirt.[77] His face leers out from under the brim of a large-brimmed straw sun hat. A large, heavy length of chain is fastened to each side of the brim of the hat; the length on the right has broken. Below this figure are two circular Paris cancellation marks, each bearing the portrait bust of Victor Schoelcher. The messages here seem very mixed. One of the blacks looks intelligent and admirable, while the other looks malignant and retarded. The presence of Schoelcher hanging between them is disconcerting and hard to interpret, yet again it seems that the traumatic inheritance of slavery cannot be gestured toward without including the moral and narrative counterweight of a redemptive myth of abolition. As the title suggests, the memory of slavery is inevitably bound up with the fantasy of emancipation.

The most spectacular response to the 2006 commemoration was a full-page FDC "Mémoires de l'esclavage et de son abolition," designed for the deluxe "Collection Historique" (fig. 5.30). This FDC makes the absorption of tragic black memory within the white celebratory imaginary very explicit,

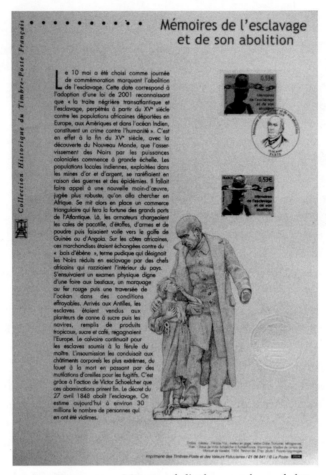

FIG. 5.30. France, FDC, *Mémoires de l'esclavage et de son abolition,*
Schoelcher, "Collection Historique," 2006.

and shows Schoelcher at his most resplendent and ascendant. Here the por-
trait of the attractive young male black is absent. The top right of the design
has the 0.53 euro stamp, again conjoined to the Schoelcher postmark. But
this time the celebration of Schoelcher is far more fully blown. Below the
slavery stamps and dominating the entire design is a stipple reproduction of
Jean Joseph Marquet de Vasselot's 1902 statue of Schoelcher in Fort de France
Martinique.[78] This piece of brazen sentimentality has been stippled in brown
ink, and shows Schoelcher not exactly dressed for the tropics, in an overcoat
with a frock coat underneath, bending down to embrace a small slave girl
in a ragged dress. Broken shackles hang from her right wrist and left ankle,

and she gazes lovingly up at her emancipator; her left hand is on her heart, or breast, and she blows him a kiss. It was these Schoelcher monuments that ignited Fanon's terrible fury at what he saw as an obscene deception. As we have seen, for Fanon these statues constituted a brutal encoding of the horrible gift of freedom foisted on the colonial blacks by a knowing white power center.[79] The loving reproduction of this imagery in the official response to the admission that Atlantic slavery constituted a crime against humanity would have elicited some bitter humor, but little surprise, from Fanon.

Although French stamps confronting the memory of slavery through emancipation are thoroughly dominated by the figure of Schoelcher, the 1980 UNESCO 1.20 franc stamp did break with the tradition (fig. 5.31). The stamp was devoted to the memory not of a figure, but a traumatic architectural site, the Maison des Esclaves in Gorée, Senegal. The stamp is unusual in being a European confrontation with the culturally and historically much neglected Senegalese slave trade.[80] Printed in a soft reddish brown and a powder blue, the stamp contains no figures, but two spiral stone staircases that flank a doorway leading out into the light. This is a stylized depiction of a slave dungeon, leading out to the proverbial gate of no return for the slave. The stamp has a certain restraint, and its stripped-down depiction of a single horrible space is effective. Yet the FDC compromised this effectiveness by placing the stamp top right of an envelope dominated on its left side by a narrative scene of extreme melodrama. Printed crudely in a garish manganese blue with red, the design shows three naked slaves in the foreground adopting various stock poses of despair. In the middle ground a rowing boat laden with slave cargo heads out toward a slave ship in the background. The image is a horribly crude adaptation of part of the lower portion of an exquisite copper plate engraving in J.-A. Chambon's *Le Commerce de l'Amérique par Marseille . . .* of 1764, a practical treatise on French slave trading on the west coast of Africa and in the Caribbean.[81] In this reduced version the slave body emerges as passive and despairing. Although no abolitionist enters to oversee this scenario, the slave is nevertheless constructed as an eternal victim, a figure whose only justification for existence seems to be to elicit white sentimental fantasy. Although released in 1980, the vision was implanted unchanged from an empathetic tableau created more than two hundred years earlier.

It needs to be stressed, however, that the way emancipation was registered through the postal services in the ex-slave colonies of France could be a great deal more challenging and radical than the mainland. Although France itself made no stamp to commemorate the 150th anniversary of its département and

FIG. 5.31. UNESCO, 1.20 franc stamp FDC "Maison
des Esclaves," Gorée, Senegal, 1980.

former slave colony of Réunion, a confrontational prepaid 20 gram airmail
envelope was produced in the island in 1998 (fig. 5.32). The top right corner
carries two allegorical portraits of the figure of Liberté, together with the in-
scription "Liberté, Egalité, Fraternité." The entire left side of the envelope is
taken up with a large black-and-white reproduction of an 1853 lithograph by
A. M. Potémont showing a liberated (*affranchi*) black woman. The inscription
explains that it is taken from the "Archives départmentales de la Réunion."
The woman has real presence and is shown half figure and three-quarter pro-
file, wearing a simple cotton dress. She folds her forearms gingerly across each
other, and seems to rub her wrists as if they are in pain, as if they have just been
released from shackles. She has cropped hair, and stares out and away from
the viewer with an enigmatic, maybe angry, gaze. Her mouth is set and she
has an arresting countenance. Her face is marked with a vertical tattoo in the
form of a dotted line that passes down over the center of her forehead and out
to the end of her nose. This is a finely drawn portrait of a powerful black in-
dividual, and there is no hint of caricature or stereotypification about it. The
image consequently forces the viewer to think about this free black subject as
a psychological entity. She so clearly carries a tragic inheritance of slavery in
her hardened features and complicated expression. The facial markings on
the woman carry an equally complicated message. They indicate that she is

FIG. 5.32. Réunion, prepaid 20 gram airmail commemorative envelope,
150th anniversary of slave abolition, 1998.

probably first-generation African, shipped to the French colony as an adult,
well after the French abolition of the slave trade had officially been declared.

Revolutionary Energies and Capital Ironies:
Experiments with Stamps in the Slave Diaspora

As the preceding analysis amply demonstrates, North American and Euro-
pean philatelic responses to the memory of slavery and the slave trade emerge
as controlled and controlling. Almost all these stamps, although the majority
of them are recent, are depressingly locked within the descriptive paradigms
evolved in the eighteenth and nineteenth centuries to control the image of the
traumatized slave body. As this book argues at length, these conventions were
developed in order to remember slavery and the slave trade primarily through
fantasies of white-controlled emancipation. Bearing this in mind I want to
conclude this discussion by developing a line of thought suggested by the
portrait on the Réunion envelope, and by suggesting that the commemora-
tive stamps coming out of the slave diaspora are prepared to question, to take
chances with, and even to overturn the visual inheritance of the emancipation
moment in bold and confrontational ways.

In December 1803 the French colony of San Domingo, which a mere ten
years before had housed the greatest sugar-producing slave factories in the
world, proclaimed itself the republic of Haiti. Haiti, whatever it became in the

FIG. 5.33. Haiti, "Centennaire de FIG. 5.34. Haiti, "Centennaire de
l'independence" Toussaint, 1904. l'independence" Dessalines, 1904.

sad later nineteenth, sadder twentieth, and apparently irredeemably saddest
twenty-first centuries, remains proof positive that at the right time and given
the right conditions an entire slave population could take back their own free-
dom on their own terms. Haiti's unique and almost mystical status as the birth-
place of black slave liberty was also reflected in its commemorative stamps.

It is fitting, given that Haiti achieved the first genuine emancipation mo-
ment within the Atlantic slave diaspora, that it should also generate the first
centennial stamp issue devoted to that subject. In 1904 Haiti brought out
a full set of stamps from 1 to 50 centimes to celebrate the "centennaire de
l'independence." These were beautifully engraved dual-color stamps printed
in two strikes (figs. 5.33 and 5.34). The framing device on all stamps is printed
in a single subtle color, and consists of two young female figures representing
Liberty — one a classical figure in a toga, the other a half-naked indigenous
Indian raising laurel branches. In the bottom center is Haiti's coat of arms,
showing a drum, two cannons pointing right and left, crossed national flags
with their famous motto "Liberty or Death," and in the center a palm tree
topped with the liberty cap. The center of the stamp is printed in black in
a second strike and carries a small oval portrait of one of the major military
leaders of the slave revolution. The 1 and 2 centimes stamps have portraits
of Toussaint; the 7 and 10 centime, Dessalines; and the 20 and 50 centime,

Alexander Pétion, who had become the right-hand man of Dessalines during the latter stages of the war. Each portrait bust shows the figure in full military uniform. Toussaint and Dessalines wear elaborate three-corner hats with plumes. They appear as any other national heroes, on any other European stamp commemorating the Napoleonic wars. Is this presentation empowering or disempowering? The effect of the stamps is to show the black slave leaders of the revolutionary war as people who have naturally replaced the figureheads of the slave power, and who now accept their laurels calmly and with confidence. They emerge in victory as not merely the equals but as the superiors of the French they fought.

To commemorate the 150th anniversary of independence a new and radically uplifting stamp was created (fig. 5.35). It shows a black officer leaping from the horse that has been shot from under him, and with sword upraised, urging his following men into the attack. It carries the caption "Capois le mort 18 Novembre 1803." This represents one of the legendary moments of black military heroism during the gruesome latter stages of the revolutionary war. The legendary scene was narrated with typical brio by C. L. R. James in *The Black Jacobins*:

> Clairveaux the Mulatto was in charge and with him was Capois Death, a Negro officer, so called on account of his bravery. From early morning the national army attacked. In the early afternoon under a crossfire of musketry and artillery Capois led an assault on the blockhouses of Breda and Champlain shouting "Forward! Forward!" The French were strongly entrenched and drove off the blacks again and again only to see them return to the attack with undiminished ardour. A bullet knocked down Capois' horse, boiling with rage he scrambled up, and making a gesture of contempt with his sword he continued to advance. "Forward! Forward!" The French who had fought on so many fields had never seen fighting like this. From all sides came a storm of shouts "Bravo! Bravo!" There was a roll of drums. The French ceased fire. A French horseman rode out and advanced to the bridge. He brought a message from Rochambeau [the French field commander] "The Captain in Chief sends his admiring complements to the officer who has just covered himself in glory."[82]

The battle proved a turning point. Immediately afterward Rochambeau held a council of war and planned the outline for French withdrawal from San Domingo. Within two months Dessalines, Clairveaux, Henry Christophe, and Pétion had drawn up the Declaration of Independence. It is highly significant that 150 years later it was this example of almost insane black brav-

FIG. 5.35. Haiti, 150th anniversary
of independence, *Capois le mort 18
Novembre 1803*, 1954.

FIG. 5.36. Haiti, 3 gourdes stamp
commemorating the bicentennial of
Toussaint's death and of Haitian
independence, 2003.

ery and ferocity in the battle for liberty that would be chosen to symbolize
Haitian independence. This emphasis on black military heroism continued
into the bicentennial of Toussaint's death, and of Haitian independence in
2003. Toussaint appeared on the 3 gourdes stamp riding into battle on a white
charger, in full military uniform (fig. 5.36). The design was adapted out of a fa-
mous early nineteenth-century engraved portrait.[83] The black leader proudly
usurps the position otherwise exclusively reserved in European portraiture for
white monarchs, aristocrats, generals, and, of course, Napoleon himself.

Haitian commemoratives evince an undeviating desire to celebrate black
heroism and agency in the battle for liberation. In this context it is worth
pointing out how positively Toussaint was to be constructed in stamps com-
ing out of other parts of the Caribbean and the slave coast of Francophone
Africa. In 1953, to mark the 150th anniversary of the death of Toussaint the
republic of Dahomey, Benin, brought out a spectacular set of stamps with
a variety of embossed FDCs. It is claimed on the stamps that Toussaint was
a "descendant des Rois d'Allada (Dahomey)" and that his ancestors hailed
from just outside Cotonou (fig. 5.37). A crude but enormous statue was erected
to him in a small park in Cotonou, which celebrates him with exactly the
same straightforward boldness and adulation that we see in the stamps.[84]
The stamps further describe Toussaint as "General Haitien Revolutionary,

FIG. 5.37. Benin, FDC, 150th anniversary of the death of Toussaint, 1953.

Homme d'etat Liberateur et Martyr." He stands on the three stamps in three-quarter profile, wearing a military uniform and reading out an emancipation proclamation. It is highly significant that it was a new African "république" that should choose to celebrate its independence by calling up the memory of Toussaint and the black Jacobins, and by claiming blood kinship with the great revolutionary general.

This African positivism over Toussaint was to be taken up with even more fervency half a century later in Cuba, when a really uplifting FDC marked the bicentenary of the outbreak of the Haitian revolution. The stamp gives a heroic three-quarter profile portrait of Toussaint in his full general's uniform. His features are powerful and idealized, depicted in a socialist realist style borrowed from Soviet art. The postmark presents the famous equestrian portrait of Toussaint, already discussed in the context of the Haitian 3 gourde stamp. The most sensational aspect of the stamp is the narrative scene in the big roundel on the left. This shows black slaves butchering white planters in the foreground. In the middle ground and background the sugar plantations of the great plain of the north go up in flames. This stamp boldly fuses Toussaint's iconic image with an explicit depiction of extreme slave revolutionary violence. It took the extraordinary confidence of Fidel's postrevolutionary Cuba to make this image. It goes without saying that to date no European or North American stamps have properly celebrated Toussaint in such a manner. Cuban stamps and FDCs show a continued commitment to investigating ideas

of rebellion, revolution, and violence in the context of slavery. In 2003 the fiftieth anniversary of the National Museum was marked with a stamp and commemorative FDC postcard showing Carlos Herníquez's 1938 masterpiece *El Rapto de les Mulattas*. This powerful painting fuses the dynamic approach to the representation of animals in Franz Marc's art with the style of the Mexican revolutionary muralists Jose Clemente Orozco and David Alfaro Siqueiros. It shows the violent sexual abuse of two mulatto women by armed soldiers, and so combines themes of imperial rapacity with the extreme mistreatment of the woman slave. The memory of slave trauma looks forward to the idea of eventual revolutionary reaction.

The earliest stamp I have so far discovered that deals head-on with the Atlantic slave trade and human rights in Latin America is the 1954 Colombian 5 centavos stamp (fig. 5.38).[85] This was produced to mark the tricentenary of the death of San Pedro Claver (1580–1654), known in Colombia as "Apostol de los negros" because of his concern over the treatment of slaves. Claver devoted his life as a priest in Cartagena to preaching to and tending the slaves who arrived in the thousands from Angola and the Congo. He was a classic Catholic missionary, giving his life over to converting and nursing the Africans. As a figure he combines patriarchalism and humility; part of the colonial project he is also in conflict with it, and the stamp reflects these tensions.[86] Printed on an ivory background in a sensuous deep red ochre, this dramatic stamp shows Claver standing on the beach, greeting a coffle of newly arrived slaves. He has two young black assistants, who carry baskets of bread that are offered to the desperate captives. The design is theatrical, as Claver moves in horizontally from the left-hand side of the composition and the slave coffle takes up the right. The slaves in wooden yokes are whipped in a vertical line out of the ship's boat, through the sea, along the sand, and out under the viewer's nose. The bottom left corner of the design is taken up with an enlarged and foreshortened black head, cut off at the bottom of the nose. The middle ground shows another ship's boat driving slaves through the shallows to another part of the beach, while in the background the slave ship floats in sinister isolation on the horizon. The print certainly romanticizes the benevolence of the saint. Yet Claver was unusual in registering that the most traumatic experience for transported slaves lay in arriving in a completely foreign land and culture. Not only did he insist on meeting new slave cargoes, but he offered on-the-spot medical help to the most sick, and even more imaginatively he sought to allay their fears of the unknown.[87] Knowing of the terror slaves often had because they believed they would be eaten on arrival, he sought to explain exactly

FIG. 5.38. Colombia, 5 centavo stamp commemorating the
tricentenary of the death of San Pedro Claver, 1954.

what would happen to them. It is this unusual empathy that the stamp seeks
to communicate. The stamp may present the blacks as bound, but they are
athletic, beautiful, and individualized, and do not appear as helpless, name-
less, passive victims. The image encourages a view of the slaves as strong hu-
mans, some of whom did develop their own modes of survival in the terrible
New World of the plantation.

A spectacularly celebratory take on slavery in Latin America is the remark-
able FDC of July 26, 1976, which Uruguay brought out to commemorate the
150th anniversary of abolition. This stamp explores the conventional imagery
of slave restraint by setting it within a layered and quizzical iconographic en-
vironment. The envelope (fig. 5.39) carries three discrete designs that work
off each other in dramatic ways. On the left is a large roundel containing a
black-and-white design suggesting the scene has been viewed through a fish-
eye lens. The design shows a kneeling slave in the background, whose lead-
ing foot stands on a broken chain link. The chain leads up to a giant black
hand that hangs in the foreground, the wrist still fettered. On the right of the
design is another roundel, again printed in black and white. This is the first
day cancel stamp, and shows another slave hand, fingers spread wide, while
the chain on either side of the fettered wrist is shattered. This vigorous hand

FIG. 5.39. Uruguay, FDC commemorating the 150th anniversary of abolition, 1976.

operates in dialogue with the limply hanging hand opposite, and expresses energy and volition as it reaches up into the brilliantly colored rectangular 30 cent stamp above it. This design is a miniature reproduction of one of the Candomblé paintings by the Uruguayan artist Pedro Figari. Figari, after a career as a lawyer, devoted himself to painting late in life. He is known for his energized scenes of black street life, painted using a vibrant palette and a deliberately reduced naive style of draftsmanship. His most renowned canvases were devoted to celebrating the culture of poor black urban Uruguay and the native form of Candomblé dancing in particular. His paintings portray black freedom and creativity in a style that is itself liberated from the European ones Figari first studied and mimicked.[88] The black outlined index finger of the outstretched fettered hand just touches the edge of the vibrant miniature reproduction of the Figari painting. This is an ingenious parody of one of the most celebrated pieces of gestural rhetoric in the European artistic canon, Michelangelo's God creating Adam in the Sistine Chapel. Here God has been replaced by the dancing, drinking, and singing crowd of low-life blacks, while the newly created Adam is represented by the hand of the liberated slave. This design has found a potent way of overcoming the negative associations of chains and fetters, and douses the guilt-ridden and fatalistic iconography of abolition in the vibrant confidence of a black artist in the diaspora.

Dutch Surinam produced a number of stamps and FDCs in connection

FIG. 5.40. Dutch Surinam, 50, 100, and 120 cent stamps, FDC
commemorating the 150th anniversary of abolition, 1988.

with abolition anniversaries. In 1963 a 10 and a 20 cent stamp marked the
centenary of abolition. Identical designs apart from a scarlet and white back-
ground and an olive green and white background, these stamps both feature
a central motif of three black chain links, the central link fractured. This
simple, abstract, and direct design relates closely to the U.S. 5 cent emancipa-
tion centennial stamp, which also appeared in 1963.[89] A more elaborate and
confrontational set of stamps appeared in 1988 to mark the 150th anniversary
of slavery abolition. The FDC (fig. 5.40) shows two black clenched fists float-
ing midair on the left side, with heavy iron fetters with dangling broken chain
links on each wrist. This motif is repeated on each of the commemorative
stamps, where the fists are placed in miniature top right and left. Then each
of the three stamps carries an image below the fists. On the 50 cent stamp is
the Abaisa monument, dedicated to the Maroons; on the 110 cent stamp, the
monument to Kwakoe, the great slave Maroon revolutionary; and on the 120
cent stamp, the house of the indefatigable anti-imperialist author and activist
Cornelis Gerard Anton de Kom. The stamps are consequently dedicated to
the memorials of slave resistance and anticolonialism in Surinam. The Kwa-
koe statue also forms the image at the center of the cancellation stamp, which
links the mythic Maroon revolutionary with de Kom. de Kom, whose father
had been a slave, died in exile in a German concentration camp in 1945, but
had devoted his colorful life to fighting for the rights of the ex-slave popula-

tions of Surinam.[90] This FDC is a montage that coherently celebrates Surinam's
black revolutionary activists and finds no place for the white emancipator.

Brazil constitutes a particularly fascinating case in terms of the way its
representation of slavery in stamps has developed over the course of the past
half century. Up until the end of the 1960s, the history of slavery in Brazilian
stamps was represented according to Eurocentric conventions. The memory
of slavery meant the memory of prominent abolitionists and predominantly
white abolitionists. In 1946 a 40 centavo stamp was produced for the cente-
nary of the birth of Princess Isabella, a figure indissolubly linked with the pas-
sage of the Golden Law of 1888, which she signed in her father, Dom Pedro's,
absence. This was a simple, indeed somber stamp, reminiscent of the English
"penny black." The year 1947 saw the production of a 40 centavo stamp to
commemorate the centenary of Castro Alves, "the poet of the slaves." Printed
in soft green, this stamp shows a portrait head of the poet rising up through
and breaking a giant ankle shackle. In 1949, the centenary of the birth of
Joaquim Nabuco, the leader of the Brazilian abolition movement in its final
stages and the greatest antislavery author Brazil produced, was marked with
the production of a 3.80 cruzeiro stamp. This consists simply of a bust por-
trait of Nabuco in his senatorial robes. In 1953 the centenary of the birth
of José do Patrocinio, the great mulatto abolition author and activist nick-
named "the Tigre of abolition," was commemorated with a 60 centavo stamp
(fig. 5.41).[91] This carries an engraved reproduction of a famous nineteenth-
century oil painting, now in the abolition collection in Petropolis, which
shows a full-length portrait of Patrocinio clutching a quill and piece of paper,
while a winged figure of Liberty floats above him and whispers in his ear. It is
a highly significant image in that it was the first Brazilian stamp to carry the
image of a mulatto and to celebrate an African Brazilian as proactive in bring-
ing about the end of the slave system.[92] The year 1969 commemorated the
150th anniversary of the birth of Count Rio Branco with a 5 centavo stamp.
This three-quarter-length portrait depicts the Count in a relaxed pose, lean-
ing on the back of a quilted chair in a luxurious interior. Taken as a group, all
of these stamps are conservative. The slave agency and the traumatic memory
of slavery are kept out in favor of celebrating the personal anniversaries of
aristocratic individuals who supported the abolition cause to greater or lesser
degrees. It is only in the figure of Patrocinio that a man of color who also held
radical political beliefs is introduced, and even then he is presented as the
extension of a white female allegorization of liberty.

After the fall of the military dictatorship, however, things changed dra-

FIG. 5.41. Brazil, 60 centavo stamp commemorating the
centenary of the birth of José do Patrocinio, 1953.

matically, and Brazil has shown a consistent ability to revisit its slavery past
in ways that are prepared to celebrate black resistance and, most unusually,
slave creativity as manifested in art and sculpture.[93] In 1980 a set of six designs
came out as 5 cruzeiro stamps entitled "Homenagem a Antonio Francisco
Lisboa — O Aleijadinho" and devoted to the celebration of the art of the crip-
pled mulatto slave sculptor (fig. 5.42). Over the past fifty years Aleijadinho has
been recognized as unquestionably the most ambitious and refined sculptural
genius of the Brazilian Baroque.[94] Yet it is equally relevant that the sculptor
has also been seen as a profound and acerbic satirist, using caricature and
distortion to produce disguised attacks on the Brazilian slaveholding elite.[95]
Each stamp carries a monochrome detail of one of Aleijadinho's decorative
wooden panels and then a larger full-color detail of his representations of
Christ's passion. The stamps are unique in celebrating the achievements of a
slave artist.

Another set of stamps was produced in 1984 which, although more conven-
tional in their imagery, are again impressive in terms of the political focus they
possess. Two stamps were brought out to commemorate the "centenário dos
abolicionistas precursores." One stamp was devoted to Ceará and the other

FIG. 5.42. Brazil, set of six 5 cruzeiro commemoratives, "Homenagem a Antonio Francisco Lisboa — O Aleijadinho," 1980.

to the Amazonas. The former (fig. 5.43) shows two upraised black hands, one displaying a broken shackle, in the foreground. In the background is a sailing boat typical of those used by the Fortaleza boatmen, or *jangadeiros*. The significance of this is that the first state in Brazil to abolish slavery was Ceará, in March 1884. The sudden abolition frenzy in the state came to a head in the port of Fortaleza when the boatmen refused to carry slaves out of the port for sale down south. The remarkable events in Ceará then galvanized the Amazonas to mount their own abolition campaign, and the state followed suit with lightning speed, abolishing slavery in May 1884. The Amazonas stamp carries a picture of the upper half of a male slave torso, with arms raised and broken shackles on each wrist, while the Amazon River flows in the background, framed by the green of the rainforest. It is fairly well known in Brazil that slavery was abolished nationally through the Golden Law of May 1888. It is not generally known that two key states had made this event inevitable by abolishing slavery independently four years before. These stamps consequently celebrate an obscure yet crucial set of events in Brazilian antislavery history.[96]

FIG. 5.43. Brazil, commemorative, "Centenário dos
abolicionistas precursores," Ceará, 1984.

The year 1988 itself was marked with the production of two fascinating
stamps designed by Darlan Rosa. The 20 cruzeiro stamp (fig. 5.44) carries a
miniature reproduction of the illuminated copy of the Golden Law that Prin-
cess Isabella signed. Floating above this is the schematic representation of the
jewel-encrusted pen that the princess had used to sign the law, the original of
which is kept in the Royal Museum in Petropolis. Yet the pen has been drawn
to resemble a giant fern leaf, and within it are four black figures, who raise
their arms to express their joy. This stamp is intriguing in that it draws on the
established iconography of the abolition moment but incorporates elements
relating to the land and the people that develop the stereotypes. There was
also a 50 cruzeiro stamp (fig. 5.45) that takes the form of an ambitious compo-
sition that fuses cartography with fantasy. The stamp shows the slave coast of
West Africa, in cadmium yellow in the top third, and then the ocean beneath,
but ghosted onto the ocean is a second map showing the outlines of Brazil and
Africa with a dotted white line indicating where the slaves were taken from
East and West Africa and where they arrived in Brazil. Then floating in the
center of the stamp, above the maps, is an above view of a highly stylized slave
ship. Its brown prow points out into the Atlantic Ocean. There are brilliantly
colored sails, and each contains representations of African gods, accompanied
by symbols and figures. All of these are powerfully depicted in the style of Af-
rican art, and they act as a powerful assertion that the slaves were not merely
an economic element in a trade, but that they brought their own culture and
beliefs from Africa into Brazil. This stamp clearly marks the new confidence
with which Brazil, by the late 1980s, was prepared to celebrate the African
elements within Brazilian culture as something vibrant and valuable.

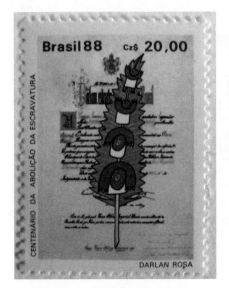 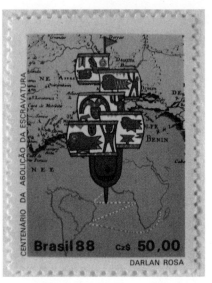

FIG. 5.44. Brazil, 20 cruzeiro commemorative stamp, centenary of the Golden Law, 1988.

FIG. 5.45. Brazil, 50 cruzeiro commemorative stamp, centenary of the Golden Law, 1988.

Equally impressive in terms of a celebratory approach to slave culture is the brilliantly colored commemorative stamp that was produced in 1995 entitled "300 Anos da Morte de Zumbi dos Palmares" (plate 10). The legendary, indeed mythical figure of Zumbi, the great Maroon slave revolutionary who was the chief of the Palmares Quilombo, is boldly celebrated.[97] Palmares successfully resisted the Luso-Brazilian slave power for decades before its brutal annihilation in 1695. The heroic resistance and death of Zumbi immediately passed into folklore, and remains a potent focus for black pride and resistance in Brazil to this day. The stamp presents Zumbi, who stands alone, and three followers, armed with long spears and striking various fighting poses. They are, however, all presented as relatively light-skinned, ranging from light brown through yellow to white. It is only in an inset panel top left that a black face appears, which is represented in a highly stylized way, reminiscent of an African mask. This dominant black face may be intended to represent Zumbi or one of the African deities he and his followers were reported to have worshipped. Below the mask is a map of the northeast coast of Brazil, setting out the geographical location of Palmares. The whole design is a powerful statement of black agency and of the potency of slave culture and religion. The imagery celebrates the abilities of slaves to escape, organize themselves,

and then fight to preserve their liberty. There are no other stamps produced within the slave diaspora to date that have dared to celebrate black revolutionary violence in such an undiluted and joyful manner.

The confrontational approaches to the memory of slavery, and the confidence in celebrating diasporic black culture on its own terms, which emerge in the Uruguayan and Brazilian stamps, are elements that also dominate the slavery stamps produced in the British Caribbean in the postindependence period. It is appropriate that this analysis of the cultural memory of slavery in stamp culture should conclude with a range of stamps that demand very different responses from those of the British commemoratives. Of the many sets of Caribbean stamps that came out in 1984 to mark the 150th anniversary of emancipation, several confronted the conventional Eurocentric take on the emancipation moment.

Anguilla produced eight stamps showing prominent abolitionists but included in their ranks Oluadah Equiano and Henry Christophe, and this at a time when Equiano was still an obscure figure known only to a small coterie of slavery historians. St. Vincent produced a set of four stamps in which a portrait of Wilberforce is set against the reality of slave abuse in the form of three plantation scenes.[98] Trinidad and Tobago produced a remarkably powerful set of four stamps that manage to compress a complicated shift in the historiography of slavery and abolition into four remarkable narrative panels. The 35 cent stamp (fig. 5.46) shows a slave ship on the open sea. The foreground portrays an enormous heap of chains and shackles that appears to float upon the waves. The ship is not an eighteenth-century slave ship but a later sleeker vessel. These very fast clipper ships were used in the later nineteenth century, once the trade had been officially abolished, to run illegal slave cargoes past the slavery patrols. The stamp consequently brings attention to the fact that despite the claims that the slave trade was abolished in 1807, a black market flourished well after this. The floating chains in the foreground are also a powerful detail and hearken back to one of the most lambasted features of Turner's great painting *Slavers Throwing Overboard the Dead and Dying*. When the painting appeared, with its foreground filled with chains and shackles pushed above the waves by the desperate limbs of the drowning slaves, it was ridiculed by several reviewers for its lack of realism.[99] The stamp reproduces this ghastly detail and the facts that dead slaves were known to have been cast overboard, still in their shackles. The 55 cent stamp develops the theme of the middle passage, its background reproducing a period map depicting in the form of a scarlet acute triangle the route ships sailed on the

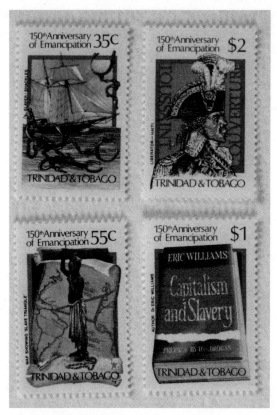

FIG. 5.46. Trinidad and Tobago, 35 cent, 55 cent, 1 dollar, and 2 dollar stamps commemorating the 150th anniversary of the abolition of slavery, 1984.

notorious "triangular trade." Floating above the map in a shallow space is an image of a semi-naked adolescent slave child enchained to a vast block of timber that the victim carries upon his head. It was common for runaways to be tethered to such bulky weights both as a punishment and as a practical impediment to further escape attempts. The stamp consequently fuses two narrative styles: a diagrammatic representation of the trade with a descriptive and realistic account of the practical results of that trade in human torture and suffering. The 1 dollar stamp simply displays a copy of Eric Williams's groundbreaking study *Capitalism and Slavery*, the first book to present the thesis that abolition was not the result of altruism but political expediency, once the European slave powers found out that it was no longer a profitable labor system.[100] The fourth stamp consists of an idealized portrait of Toussaint l'Ouverture, in a spectacular military hat. The implication of this image

is that the slaves of the Caribbean did not always have to wait to be given their freedom, but could decide violently to seize it. As a group the stamps move from images of loss and disempowerment, via a black Caribbean critique of the established history of abolition, into a triumphant celebration of slave agency. The approach could hardly be further from that adapted by the British stamps in 2007.

The four stamps produced in St. Lucia in 1984 are perhaps the most powerful of all and constitute the only sustained philatelic attempt to portray slavery as a business and to depict the daily life of the slave as part of a vast industrial process (fig. 5.47). All four stamps are printed in black on a plain straw-colored background. Each shows a detail from a period copper engraving showing slaves at work. The 10 cent design depicts three slaves working as coopers, making barrels to store the rum and sugar. The 35 cent portrays slaves washing and baking bread on an open fire in a yard, while an overseer with crossed arms stands in the background. The 55 cent scene shows the slaves making rope, or possibly ropes of tobacco for storage. The 5 dollar stamp presents slaves hanging up leaves, probably tobacco, to dry, while another tends a cooking pot. The vertically arranged designs, drawn with an almost forensic precision, express above all an intense sense of industry. There is no communication between the little slave bodies. All the figures are engrossed in their activities, heads bent industriously down. Not one figure looks out of the picture plane or away from its task; even the tiny naked child in the third design stretches upward, in mimicry of its mother, and tries to hang up a leaf. The stamps also play cleverly with internal and external spaces. The first and fourth stamps (10 cent and 5 dollar) give close-up views, from right under the thatched canopies where the slaves labor. The central two designs (35 cent and 55 cent) have pulled out, giving wide-angled views of the entire yard of the *engenho*. The effect is claustrophobic, or agoraphobic. Whether the viewer stands in close or pulls back, there is no free space, nowhere to hide, nowhere to rest. We seem to have an enclosed, ordered world of eternal labor, a sort of *perpetuum mobile* of nascent capitalism where human personality and identity are swallowed up in the larger processes of production. Even the unremitting yellow background color, reminiscent of the dried leaves and husks of the cane "trash," evokes a world where everything is subordinated to the slave crop and its refinement.

These stamps use period imagery and the mechanically cut lines of the professional copper engraving to produce a powerful commentary on what slavery was and what it meant to abolish it. In narrative and conceptual terms,

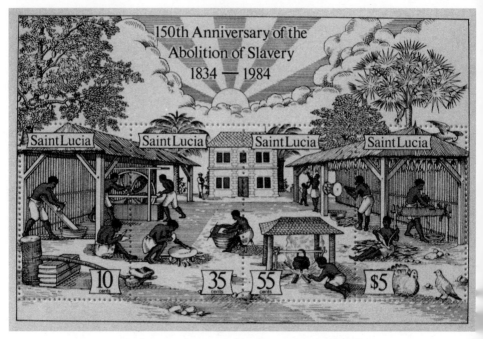

FIG. 5.47. St. Lucia, FDC, 10 cent, 35 cent, 55 cent, and 5 dollar stamps commemorating the 150th anniversary of the abolition of slavery, 1984.

these designs work in a different semiotic world from the 2007 bicentennial stamps. We are not presented with abolition, but with slavery as it was, a cycle of unpaid, unending labor devoted to the production of one thing: profit. There are no "heroes of abolition" on show in this world, just the sense that such a horrible system of dehumanizing coercion had to go. It is above all the lack of sentimentality in these little industrial vignettes, the manner in which they reflect the matter-of-fact values of the employers, and the laborious anonymity of the slaves that make the series so effective.

A similar emphasis on industrial process can also be seen in the commemorative stamp brought out by Antigua and Barbuda to celebrate their 150th anniversary of slavery abolition. The FDC issue of this 5 dollar stamp (fig. 5.48) simply reproduces a period watercolor depicting the "Carting and loading of sugar hogsheads Willoughby Bay." The image is produced in the style typical of late eighteenth-century topographical watercolor drawings. The foreground shows two black figures on a beach rolling a substantial hogshead of sugar toward a rowing boat, which is manned by two more blacks. Mules bring in more sugar barrels in the middle ground, while off on the horizon

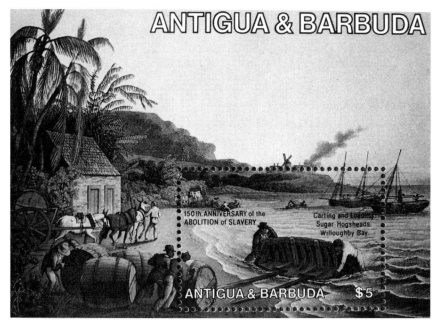

FIG. 5.48. Antigua and Barbuda, 5 dollar stamp commemorating
the 150th anniversary of abolition of slavery, 1984.

the refinery sends a trail of smoke up into the soft blue sky. The palette, in a
narrow range of gentle browns, greens, and ochres, nicely corresponds to the
calm and businesslike activity described. Slavery emerges as the labor element
underpinning a stable, well-run process of manufacture. The irony of replac-
ing the slave ship with a rowboat to be filled not with slave bodies, but sugar,
the product for which the slave bodies were sacrificed, is effective. Again, we
are dealing with a design that seems to criticize the attitudes and values of the
slaveholders by describing the very normality of the business of slavery. There
is no retreat into any of the easy options: the histrionics of the emancipation
moment, the celebration of the white "heroes of abolition," and even the rep-
resentation of slave torture are all avoided for a scene that terrifies through its
calm industriousness.

Wilberforce versus Bussa

It appears to be the case that the agendas and creative attitudes at work in the
postal systems of the slave diaspora differ from those of the Royal Mail when
it comes to the processes of commemorating the memory of slavery. I want
to end this meditation on philately and slavery by taking us full circle from

1807 to 2007 and considering the materials that the General Post Office in Bridgetown, Barbados, generated to mark the bicentennial. Five stamps were issued and two FDCs. The stamps take a sophisticated approach to 1807 and its extended effects on memory. Rather than a narrow focus, which exclusively prioritizes individual abolitionists active in the late eighteenth century, the Barbados stamps attempt to place the slave trade in a much wider set of contexts. The stamps suggest a number of different ways of seeing how problematic it is to represent the memory of slavery through images at all. Although familiar primary materials, which had been adapted in the British stamps, are also used here, the Barbadian adaptations have ironic and subversive qualities.

The notorious engraving of prostrate slave bodies from the famous *Plan* of the *Brookes* is extensively used in the Barbadian stamps, as it was in the British marketing of the stamps, but the effects are radically different. Both the Barbadian FDCs make extensive use of the slave figures from the central section of the *Brookes*. The first FDC was for the 3 dollar stamp (plate 11). The stamp exists as a perforated vertical rectangle, isolating a slave ship and cut out from an eighteenth-century engraving that is printed as an extensive surround to the stamp proper. The engraved image of the departure of a slave ship from the West African coast has been extracted from a plate from J.-A. Chambon's *Le Commerce de l'Amérique par Marseille* of 1764, a matter-of-fact treatise concerning French trade in the colonies. The area selected for the Barbadian 3 dollar stamp (fig. 5.49) consists of the entire bottom section from the two-tier engraving. The stamp embodies a transgressive approach to the slavery archive on the part of the Barbadian designers, and the choice and manipulation of source material is worthy of further thought. The plates were engraved in the workshop of Jean-Michel Moreau and are at the top end of the French print market. The rendition of skin tones on the black bodies, the evanescent shades of gray in the clouds, and the delicate tracery of the ship's rigging all testify to this being a quality product from the golden age of French copperplate book illustration. Both parts of the original print worked very closely with a tight explanatory text, which ran as follows:

> 1. Negroes on sale in a public market. 2. Negro slave examined before being purchased. 3. An Englishman licking a Negro's chin to ascertain his age, & to determine from the taste of his sweat if he is sick. 4. Negro slave with the brand of slavery on his arm. 5. Slave ship lying in the harbour waiting for the trading to be completed. 6. Chaloupe loaded with newly purchased slaves transporting them to the ship. 7. Negroes on the shore wailing and crying at the sight of their loved ones and friends being embarked.[101]

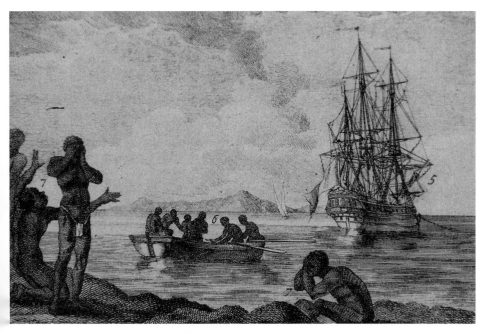

FIG. 5.49. Untitled plate for J.-A. Chambon's *Le Commerce
de l'Amérique par Marseille*, copper engraving, 1764.

In this great narrative arc, every element of the arrangement leads out to the
slave ship, which is both the end of one form of life and the beginning of
something new and terrible, a cultural rebirth embodied in the tall ship that
floats calmly and beautifully on the still sea.

It is as a result of this remarkable crispness of line, and sensitivity of tech-
nique, that the selected image translated so well to the miniaturized format of
the stamp. The two plates, which read logically as a diptych whose narrative
is to be interpreted from left to right, give a starkly condensed story of the
series of events. The prints mark how a slave passed through the various pro-
cesses of market display: physical inspection, purchase, branding, and finally
transportation out to the slave ship by rowboat. Earlier in this book there is
a partial reading of one detail of this narrative in the discussion of the top
half of the plate in the context of graphic anticipations of the kneeling slave
in the Abolition Seal.[102] In many ways the second part of the print is far more
compositionally refined and emotionally powerful than the cluttered, almost
claustrophobic, upper panel. Yet in making the decision to cut the second sec-
tion from its context, a powerful set of narrative interrelations is excised. The
whole plate in its original state used gestures and margins with great dramatic

power. Crammed up against the left margin and standing out against a nearly clear background, a tall, athletic, and almost naked black male slave points with extended arm dramatically across the foreground. He points out above the heads of the cowering, gesticulating group of slaves for sale below a tree in the right, over the head of the elaborately clothed English ship's doctor who licks a slave's chin, and out to the second print. The first thing he is pointing at is the group of weeping slaves watching their friends and family being taken out in the rowing boat. But what he finally points toward is the slave ship, the open sea, and the full horror of the middle passage in anticipation.

The design is marked by a brilliant compression of the main group of slaves to the extreme near foreground. They are squeezed right up to, indeed, the figure on the left is forced out of, the picture frame, as if trying to get away from the horror of what is happening. The spatial arrangement of the seascape is done with almost Claude-ian elegance. The rowing boat easily takes the eye into, and then across, the middle ground, and then out toward the slave ship and the low horizon line. Yet the rowing boat also maintains a relationship with the slaves still on land. All of these figures move within an acute triangle working along a diagonal from the bottom left-hand corner to the middle of the left vertical margin, the hypotenuse running from the bottom corner precisely though the heads of the three despairing slaves who clutch their heads, one sitting on the shore, one in the boat, one standing on shore. The slave ship, in contrast, floats in majestic isolation, the bottom of the hull geometrically lying on the golden section of this particular rectangle. The ship dominates two-thirds of the space of the print, although physically it takes up rather less than 10 percent of the surface area. Pointing out to sea, this lovely boat seems to have so much space and peace compared to the hectic, naked, degraded, and miserable black human bodies that crowd the first scene and the bottom left wedge of the second.

The sense of space and light around the slave ship, which conveys the promise of European commercial calmness and authority, is the element that the Barbados design takes up and assaults with great effect. Chambon's plate is now given a different set of margins, a space beyond the picture plane that dramatically describes the savagery underlying the slave trade. In this new frame that unruffled sky and sea are sawn in two by a series of fragmented sections of the slave bodies reproduced from the celebrated *Plan* of the *Brookes*. The seascape in which the slave ship floats is consequently attacked from all sides by the sliced-up bodies of slaves. The four dark margins around the French image have a jerking unevenness, and they cut into and threaten the whole

design like an obscene razor wire constructed out of human body parts. The sky above the ship drifts up into a line of shackled, inverted slave legs, which seem to be raining down from the heavens.

The adaptation of the Chambon image is, however, only one element in a complicated montage of effects on the FDC. The official envelope for the FDCs also reproduces a section of the *Brookes Plan*, the bodies this time printed slightly larger than the original and in a faint gray. These floating bodies exist in relation to both the Chambon image and the circular cancellation stamps, which carry the image of an ankle shackle and chain open at one end. The FDC consequently integrates three quite distinct late eighteenth-century graphic styles: the detached power of the wood-engraved *Brookes Plan*, the illustrational finesse of the elaborate French copperplate engraving, and the emblematic simplicity of the shackles. Slave bodies and fragments of slave bodies consequently appear stacked up in distinct spatial and stylistic layers, which then interact with each other in disturbing ways, fracturing and displacing any continuous sense of space and time. The slave ship is a delicate and seemingly unpopulated structure and the perforations for the stamp deliberately cut it out from its context, suggesting an incomplete frame within a frame. Yet this attempted isolation merely serves to emphasize the cacophony of suffering bodies that surround the ship, and invites the viewer to make the move of entering and imaginatively populating the boat. The slave bodies in the canoe that is being rowed out to the slave ship also relate directly to the prostrate bodies in the margins.

Again, the viewer is given an invitation to flesh out the narrative cycle, the implied message being that the weeping bodies on the shore will soon be safely packaged on the slave ship. The fact that the ghostly and enlarged forms of the prostrate slaves on the envelope exist, in spatial terms, as a final plane beneath all the other elements of the design is metaphorically potent. The sea on which the boat floats, so clear and untroubled in the engraving, when viewed from the wider perspective of the envelope, becomes literally saturated in slave bodies or the ghosts of slave bodies. The idea that the Atlantic Ocean, into which so many slave bodies were cast and into which so many slaves voluntarily leaped, can be seen as a beautiful and eternal monument to the middle passage has been explored in a variety of artistic contexts. Turner's great painting *Slavers Throwing Overboard the Dead and Dying* constitutes the most profound exploration of the narrative limits of the idea that the sea might be understood as both a tomb and a monument to the middle passage. The Barbadian 3 dollar FDC provides a new and rather elegant aesthetic

solution as to how this vast memorial concept can be embodied in imagery. The effect of the whole design is both elaborate and subdued, and cleverly extenuates the tendency of the original *Plan* of the *Brookes* to reduce human bodies into abstract geometrical configurations. The color scheme is cold and mournful. The layers of slave bodies have something tidal about them, as they drift in and out of each other in their shifting patterns of blues, purples, and grays. The design looks intricate, fragile, and as precious as a bank note. The slave bodies have become both beautiful water spirits and stamped merchandise.[103]

The design talks back to the past in a variety of ways and can also be seen to function as a reinscription in 2007 of the abolitionists' merchandising of 1807 in their stationery. The British antislavery societies mass-produced writing paper and envelopes in the early nineteenth century (fig. 2.23 above). These were finely engraved and printed in a distinctive pale blue, strangely reminiscent of the color scheme of the Barbados envelopes. The earlier propaganda envelopes presented a closed and revised narrative of Britain's involvement in the slave trade.[104] They carried an elaborate allegorical design that showed Britannia protecting the slave in the foreground on the British mainland, while over the water in the wicked colonies slaves are shown being tortured on a Caribbean island. The ocean is dominated by a British antislave trade patrol; cruising the horizon line, it irradiates divine light. This celebratory and sanitized rewriting of history is confounded by the Barbados FDC. Slave torture is no longer something Britain abhors at a distance; the British navy is no longer a refulgent ideal, forever fighting for the freedom of the slave on the high seas, but is firmly replaced in its original position at the heart of the business, engineering the "abominable traffic" with cruel efficiency.

The second FDC (plate 12), produced for the four remaining lower-value commemorative stamps, is also complicated in terms of the interventions it stages with the *Brookes*. The envelope is identical to that used for the 3 dollar stamp, but the four stamps carry radically different messages and take the imagery of the slave bodies from the *Brookes* out into a series of challenging graphic contexts. While the British commemorative stamps adopted a narrow focus that exclusively prioritized individual abolitionists active in the late eighteenth century, the Barbados stamps attempt to place the slave trade in a much wider set of contexts.

Only one of the stamps makes reference to a white abolitionist — the 1 dollar stamp, which is very close in design to the British first-class Wilberforce stamp. A bust of Wilberforce, reproduced from a portrait engraving, domi-

nates the design against a background that reproduces a section from the text of the Slave Trade Abolition Act. Yet this Barbadian Wilberforce does not sit easily at the head of a pantheon of other abolitionists. He is surrounded by stamps that are devoted to approaching 1807 through the memory and experience of the slaves. The 10 cent stamp shows the agonistic figure of a slave breaking free, raising his fists that trail broken chains. The slave rises up out of a horizontal black bar at the bottom of the stamp. This compositional device, of having a lone figure rise out into the picture plane from a solid horizontal, is adapted from Francisco José de Goya's wonderful painting of the Colossus.[105] The black figure consequently appears enormous and dominant. The slave figure has been taken from the central figure on the 1985 emancipation statue unveiled in Bridgetown to commemorate the 1816 slave revolution in Barbados. The name Bussa is printed below this figure on the stamp.

Bussa was the legendary black guerrilla leader who led a force of four hundred slave revolutionaries against the British troops. He was killed in battle but his followers fought on to the death chanting his name. Although the statue was not specifically intended to be a portrait of Bussa, Barbadians call it the Bussa statue and the stamp has followed this popular appropriation. Bussa is a rather different abolitionist from Wilberforce. Like Zumbi, the legendary leader of the Palmares Quilombo in Brazil, Bussa lives beyond the confines of historiography, the archive, and the database.[106] He is more an idea, an incarnation of the spirit of black resistance and autonomy, than a historical entity. Bussa stands over 1807 as a manifestation of the black will to resist enslavement, and of the desire actively to seize, rather than be gifted, freedom.

The 175 cent stamp constitutes a different but equally challenging approach to 1807. The horizontal design consists of a diptych made up of two photographs showing the interior (in sepia) and an exterior (in black and white) of a slave hut. This stark reminder of the basic living conditions of the plantation slave operates in a different visual register. The hut is a photograph of one of the replica slave huts that form the Chattel Village recently rebuilt on the grounds of Tyrol Cot, an old plantation and the residence of Sir Grantley Adams, first prime minister of Barbados. The style of documentary realism, the lack of humans in the pictures, and the stark juxtaposition of inside and outside spaces give the image an air of anthropological detachment. The year 1807 and the slave trade are taken out of the hands of British abolition and off the high seas and placed into an intimate domestic space of deprivation. This work forces recognition of the fact that when the slave trade was finally abolished by Britain the damage had already been done and millions of Afri-

cans now lived in terrible conditions on foreign plantations. The image also forces confrontation with the reality that while the slave trade was abolished, at least on paper, slavery in the colonies was not.

This thought leads naturally on to the 2 dollar stamp, a pen and wash design showing ex-slaves celebrating abolition. The abolition they celebrate is not, however, that of the slave trade in 1807, or even colonial slavery in 1833, but the end of the coercive and hated apprentice system in 1838. For five years after the 1833 abolition act the supposedly free ex-slaves had suffered, and thousands of them had been worked to death, under a system of coerced labor and brutal punishment. In practice the apprentice system was worse than slavery because the newly compensated ex-slave owners had no incentive to do anything but work their new "free" labor force to death before the terms of the apprentice system expired. It is consequently highly significant that it is this date, when seventy thousand survivors of the slave and apprentice systems finally assumed something approaching real freedom and swamped Bridgetown, which the Barbadian government chose to commemorate. Again, what this stamp insists upon is the complicated and compromised history that in reality surrounded the reluctant and flawed British approach to emancipation.

As a group, then, these stamps interrogate the stereotypes set up around the celebration of the abolition moment, and demand that slave agency and slave labor be integrated into the discussion. The presence of Wilberforce in this assemblage is a generous gesture on the part of the Barbadian government, but also asks several difficult questions. Wilberforce is now a problematic element within a world otherwise populated by slave bodies and slave agency. The four stamps consequently interact violently, as images, with the floating bodies of the slaves grafted in from the *Brookes* and acting as a backdrop. Wilberforce floating above the abstracted bodies of the slaves might imply that the little abolitionist from Hull liked to consider the slaves as idealized icons of suffering that he could emote over from his estranged and privileged position as an English aristocrat. The presence of the poverty of the slave hut, the heroism of Bussa, and the violent joy of the crowds celebrating the cessation of the apprentice system deny the vision of perfect slave passivity encoded in the *Brookes*, and endow the slaves with life, liberty, and the capacity to pursue happiness.

Supine in Perpetuity

The *Description* of the *Brookes* in 2007

IT WAS inevitable when the 2007 bicentennial arrived that the key elements within the visual archive of slavery would be drawn upon, reproduced, recirculated, reinvented, recombined, reappraised, reactivated, and for the most part reduced. There is a sort of visual shorthand now used in popular treatments of slavery and the slave trade to essentialize its memory. These short cuts, these instant-access ways, into the archival savings account of slave trauma are as follows: the Abolition Seal, in its male ("Am I not a man and a brother?") and in its female ("Am I not a woman and a sister?") forms; the male and female runaway slave motifs; and the horrific image generated during the American Civil War of the slave Gordon's whipped back, corrugated with keloid scarring. Beyond these individual icons there is the collective body of imagery consisting of the tools used by the slave power to terrify and abuse its property, consisting of yokes, whips, paddles, brands, collars, chains, shackles, the *speculum oris*, and thumbscrews.[1] And finally above and beyond all of these popular images, in terms of its ubiquitous dismemberment and endless recycling, is the *Plan* or *Description* of the slave ship *Brookes*.[2] Surveying the representational archive tapped into in 2007 it is evident that all of these icons were shuffled, redealt, played out, and played to death.

I have fairly continuously talked about these key sites of representation at great length, in different places, in different ways over the past twenty years. The year 2007 made me wonder if I had anything more to say about them, if they still have any cultural value, or if they have been worn into smooth meaninglessness through the unending processes of recirculation. Owing to their enormous volume it is not possible to survey, let alone to analyze in de-

tail, even the core materials that recycled, quoted, or parodied the key images of the earlier visual archive. The following discussion is consequently going to be restricted to the analysis of the reconfigurations of a single image, the notorious broadside wood engraving of the *Brookes*.

CUTTING AND PASTING THE *BROOKES* IN 2007: THE LIMITS OF CULTURAL RECIRCULATION

The *Description* was reworked in 2007 in a remarkable number of ways, some of them intensely creative, some of them conservative, some of them effective, and some of them dangerously close to irresponsible. In thinking about what happened to this image and why it happened, a great deal can be learned about the dominant cultural agendas that conditioned the visual archive that 2007 generated. There are different semiotic subdivisions covering how the *Description* was recirculated and marketed that require clarification at the outset. First, there were a plethora of straightforward reproductions of the image, where it was used as a shorthand for what a slave ship looked like and how it was packed. These can be categorized as uninflected, or relatively uninflected, quotation. There are literally thousands of examples. I will describe three that give some idea of the range of processes that this simple mimicry involved.

First, there are the media quotations, where any article or television documentary dealing with the subjects of abolition or the slave trade flash the image of the *Brookes* as a sort of instant contextual filler. A typical example is the following (fig. 6.1), where the Plymouth Committee version of the *Description* is stuck in, without any comment whatsoever, as a visual backdrop to a Jackie Kay article demanding that Scotland acknowledge its part in Atlantic slavery.[3]

Second, there is the *Brookes* as trauma fashion accessory (fig. 6.2). I saw the image on this young man's T-shirt in the forecourt of Cape Coast castle, Ghana, in August 2007. He ran a tourist stall outside the slave dungeons, and when I photographed him he was in the process of trying to persuade a group of American academics attending the bicentennial slavery conference *The Bloody Writing is Forever Torn* to buy his slave trade kitsch. He wouldn't, however, sell me this shirt, because he had received it from a friend in New York, but he said he was a designer and could get some made for me. I was impressed by his typically Ghanaian entrepreneurial flair and ordered ten. This textile again simply reprints, three times over, the key section of the middle deck of the *Brookes*, this time as an instantaneous shorthand for the "slavery holocaust."

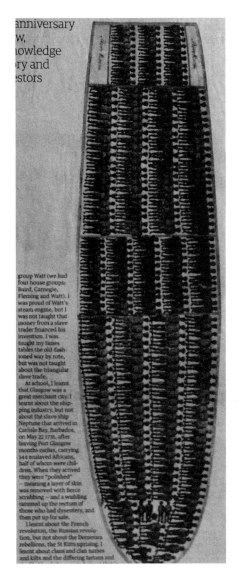

group Watt (we had four house groups: Baird, Carnegie, Fleming and Watt). I was proud of Watt's steam engine, but I was not taught that money from a slave trader financed his invention. I was taught my times tables the old-fashioned way by rote, but was not taught about the triangular slave trade.

At school, I learnt that Glasgow was a great merchant city. I learnt about the shipping industry, but not about the slave ship Neptune that arrived in Carlisle Bay, Barbados, on May 22 1731, after leaving Port Glasgow months earlier, carrying 144 enslaved Africans, half of whom were children. When they arrived they were "polished" — meaning a layer of skin was removed with fierce scrubbing — and a wadding rammed up the rectum of those who had dysentery, and them put up for sale.

I learnt about the French revolution, the Russian revolution, but not about the Demerara rebellions, the St Kitts uprising. I learnt about clans and clan names and kilts and the differing tartans and

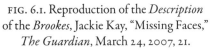

FIG. 6.1. Reproduction of the *Description* of the *Brookes*, Jackie Kay, "Missing Faces," *The Guardian*, March 24, 2007, 21.

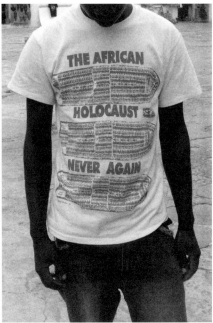

FIG. 6.2. Reproduction of the *Description* of the *Brookes*, Cape Coast Castle, Ghana, silk screen onto cotton T-shirt, 2007.

FIG. 6.3. (*Right*) Reproduction of the Wilberforce model with the *Description* of the *Brookes* pasted onto decks, London, 2007.

FIG. 6.4. (*Below*) Designer's plan for Case in House of Commons exhibition, *The British Slave Trade: Abolition, Parliament and the People*, detail, London, 2007.

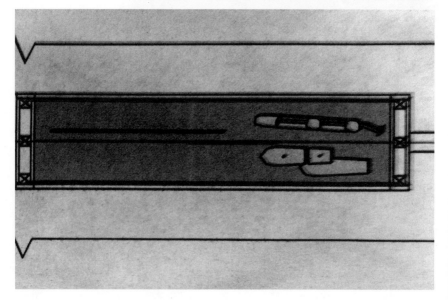

Third, there are the uses of the image as historical background in popular educational contexts: traveling exhibitions and museum displays. The exhibition mounted on behalf of the British government in the Palace of Westminster to commemorate the bicentennial furnishes a rich example. This time the *Description* of the *Brookes* was logically related to its place in parliamentary history. A case displayed the original engraving as a backdrop to a reproduction of the miniature scale model of the *Brookes* that William Wilberforce had ordered to be constructed (fig. 6.3). The bodies from the engraving were pasted down on the decks of the model, and the *Description* was consequently developed from two to three dimensions. Wilberforce then used this model as a visual aid and had it passed around the chamber during slavery debates.[4] Yet the museum case in which the plan and the model appeared also contained other elements that greatly complicated their reception.

In the Commons exhibition the *Description* and the scale model of the boat were exhibited beside a bulky African slave yoke, about seven feet long, borrowed from Anti-Slavery International. This assemblage was carefully planned months before by the design team responsible for hanging the show. Their little architectural plans show the yoke, the slave ship, and the original *Description*, reduced to a series of side views and elevations. The graphic conventions used to render the slave ship *Brookes* diagrammatically in space have now been reapplied and take the *Description* into a new abstract space where its original content is lost. Viewed from above (fig. 6.4), the *Description* becomes a simple line, while the yoke and the ship keep their outlines as objects. Occupying real space in a way that a sheet of paper does not, are they therefore more real than the *Description*? This display, and its diagrammatic configuration, dramatically force us to confront the artificiality, the decided unreality, of the *Description*.[5]

These adaptations and visual quotations of the *Brookes*, whether in the form of the T-shirt, the model boat, or the diagram of the display case, underline the extent to which the *Brookes* has now entered that fluid semiotic terrain reserved for a very few images that enjoy, or must endure, global currency. It lies, in all senses of the word, alongside Edvard Munch's *The Scream* or the photograph by Alberto Dias of the bearded Che Guevara wearing his beret with a single star on it, as an ever open parodic resource.[6] The ubiquity, the promiscuity, of the image of the slave ship forces us to ask whether it still has any power to shock, or if it does retain any meaning, what exactly this meaning is. The very familiarity of the image appears to have given it a reassuring rather than a horrific effect. Cultures throughout the Atlantic diaspora are

now, it seems, only too happy to accept this idealized vision of a slave deck as the standard version of events. Although the *Brookes* image was made to look so palpably unrealistic, it paradoxically seems to represent the truth, or at least a truth.

<div style="text-align:center">

BURNT-OUT CASES? HIGH-ART
APPROPRIATIONS OF THE *BROOKES*

</div>

And so we get to my second adaptive territory, namely, the radical reworkings by artists who do not merely quote the image, intact, in slightly altered contexts, but who dive in in an attempt to shake it about, reinvent it, parody it, and generally wrestle it, no holds barred, to the death. I will start with the most trumpeted of the high-profile adaptations. The Beninese artist Romuald Hazoumé had worked for eight years and completed in 2005 *La Bouche du Roi*. Named after an ancient slave port on the coast of Benin, the work was exhibited in, and bought by, the British Museum in 2007. Over the past decade the British Museum has become increasingly interested in the importation of sub-Saharan African artists and in buying their work. The new permanent African galleries in the north basement of the museum mix beautiful Beninese and Ghanaian sculpture from Africa's precolonial past. Much of this work was, of course, looted under conditions of extreme violence and political cynicism as a central element in the colonial conquest of "British Africa." Gorgeous bronze reliefs and sculptures from Benin are exhibited in the same spaces as recently purchased contemporary forms of African sculpture, including furniture and insects made out of gun parts or African gods made out of soft drink cans. Neil McGregor, the politically canny and economically wired museum politico who took over directorship of the British Museum in 2002, saw the chance of taking these initiatives a good deal further in the context of the 2007 celebrations.[7] The visually spectacular Hazoumé, an extrovert who will launch into wonderful extempore performances explaining his work to anyone, anywhere, at any time, was targeted by the British Museum and also by the Victoria and Albert Museum.[8] As 2007 progressed he became the jewel in the crown of England's museological links with the slave coast of Africa. Throughout the British Museum's open day Hazoumé was a nonstop road show, a one-man band, the pied piper of traumatic memory. After a two-hour opening performance in the space of his own show, he moved around the British Museum's Great Court in his beautiful Beninese clothing, followed by flocks of visitors. He was a charismatic figure, making extraordinary speeches

suggesting huge and unexpected links between Africa's traumatic slavery past and Benin's present political and economic woes. And right at the center of attention was his work, *La Bouche du Roi*, still feeding off the power of that remarkable eighteenth-century print. Hazoumé's installation was a typically bold, a typically postmodern, postcolonial amalgam of new and old technologies, of the virtual, the actual, and the neo-mimetic. But was it any good, did it finally go beyond the power of its source and model in any significant way?

The piece as exhibited at the British Museum combined a video running on a loop with an installation laid out on the floor in which the sawn-off tops of plastic gasoline containers had been arranged, more or less, to mimic the aerial view of the middle section of the *Description* of the *Brookes*. Some of the tops were personalized by the attachment of small symbolic and fetish objects. These consisted of beads associated with African deities, dolls symbolizing death, and so on, the idea being that each mask would then have a personalized identity and some relation to the African culture so starkly absent from the original *Description* (fig. 6.5).[9] Other elements were included that related to transatlantic trading: cowry shells, tobacco, glass bottles (standing in for ships' masts), mirrors, and an ancient rifle. As mentioned, the work was acquired by the British Museum, but this was only the first stage in an unprecedented program of artistic mass marketing. After its exhibition at the British Museum, *La Bouche du Roi* was to be gathered up and sent on a grand parade. Every gasoline can, mirror, bottle, glass bead, shell, gun, and fetish, and, of course, the bucket of tobacco, urine, excrement, and alcohol (constantly remixed?), went on a grand parade, a sort of recolonizing-postcolonial walkabout. With the aid of substantial funding from the National Lottery, the Arts Council of England, and the board of the trustees of the British Museum, *La Bouche du Roi* was to be ceaselessly taken apart and put back together as it was toured nationally to major arts venues over a period of two years.[10] When a piece of work gets this sort of exposure and official rubber stamping, when so many different major museums sing from the same hymn sheet, then it is legitimate to ask exactly why this has happened and what it means. Why was *La Bouche* made the way it was made? Why did the great and the wise of British museological culture see it as so desirable? What set off this particular curatorial feeding frenzy, and at the end of the day did Hazoumé cut the mustard? Is *La Bouche du Roi* all it was cracked up to be?

There was a sea of publicity in which this particular take on the *Description* of the *Brookes* was launched and now floats. I haven't time to go into much of the vast advertising campaign generated around this work, but I do want to

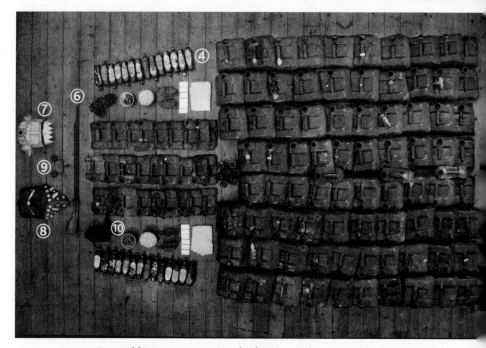

FIG. 6.5. Romuald Hazoumé, *La Bouche du Roi*, exhibit at the British Museum, London, plastic, glass, wood, metal, tobacco, human feces, alcohol, and human urine, 2007. Photo © 2009 Artists Rights Society (ARS), New York / ADAGP, Paris

consider the British Museum's flagship poster (fig. 6.6), because this formed the basis for most of the subsequent advertising imagery. The poster did very strange things to the original *Description*. The middle section of the 1789 London broadside version of the print is excised. It is then printed over black in what might be described as an extreme off-white, or a light gray. In other words, the slave deck has been turned black and the slave bodies off-white. They float barely visible, like fungus spores or an intricate pattern of cigarette ash, above an aerial photograph of Hazoumé's installation. The two images have been scaled to match. Why have the black bodies from the original print been albinified while Hazoumé's gasoline can lids exist against a dark yellow hardwood floor in a range of deep browns and grays? Is this supposed to be a comment on how the slave bodies were imagined by a white abolition committee and engraved by a white artist with the inference that they are therefore not really black, while Hazoumé's appropriation of the slaves is really black in comparison?

Coming at the *Brookes* as an image that has been manipulated and rein-

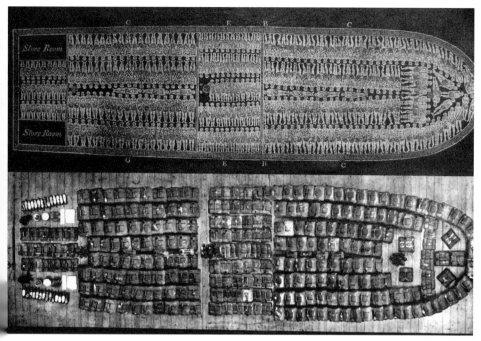

FIG. 6.6. British Museum publicity poster for
Romuald Hazoumé, *La Bouche du Roi*, March 2007.

vented without cessation from the moment of its production over two centu-
ries ago, it is hard to see in *La Bouche* anything but yet another predictable
variation in a long line of relatively straightforward adaptive moves by instal-
lation artists and performers. The *Description* of the slave ship has been more
adapted and played with than any other image generated by Atlantic slavery,
and my feeling is that it may be all played out, that it may be on the point of
cultural exhaustion. What sort of icon can hold up after such unremitting
processes of recirculation? There must come a point when the semiotic well
runs dry, when the stuffing is knocked out of it and we can't see the wood
for the trees, or the slaves for the banana boxes, bottles of blood, tar fetishes,
animal skulls, excrement, or gasoline cans. There must come a time when it is
pointless to rock that particular boat any more. For me that point came when
I stood in the theatrical gloom, something like the light of the ghost train
tunnel at a fairground, bathed in the exotic odors created by Hazoumé as an
olfactory cocktail to accompany his installation. As I breathed in the fumes
and looked at the pile of rubbish on the floor, a terrible feeling of pointless-

ness, of ennui, came over me. Was I witness to the moment when that strange and oddly perfect eighteenth-century print of an imagined slave ship was simply incapable of bearing the weight of yet another set of borrowed robes?

Kevin Bales, the modern antislavery campaigner and author of the hugely significant book on modern forms of slavery *Disposable People: New Slavery in the Global Economy*, gave a lecture at the South Bank Centre in March 2007. He talked about the 2007 bicentennial and the activities of the first abolitionists in relation to the bourgeoning forms of slavery that exist in the world today.[11] It was an uneasy talk because he was attempting to set up certain parallels between contemporary antislavery activism and the organization, ideals, and activities of the original Society for Effecting the Abolition of the Slave Trade. At a certain point he threw a slide of the *Brookes* up on the wall, and his commentary was all about how we have now lost the power to be shocked the way an eighteenth-century audience would have been shocked by this image. At the end of the talk Mark Sealey, the inspirational force behind Rivington Place, and Autograph ABP, and a black photographer and intellectual who refused to have anything to do with straightforward celebrations of 2007, asked Bales a question. Why did he think contemporary antislavery activists were unable to come up with an image that could generate a powerful message equivalent to that of the *Description* of the *Brookes*? Why, with all our new technologies, arts sponsorship, human rights organizations, and NGOs had we not produced any single image that instantly conveyed the idea of slavery and the certainty that slavery was evil the way the *Description* of the *Brookes* seemed to? Bales's response was telling, in that rather than counter the assertion, he completely agreed that no visual work had been produced since the *Brookes* that came anywhere near its power.[12]

Over the past decade I have seen banana boxes set out as a full-scale enactment of the *Brookes* in Bristol (fig. 6.7), bottles filled with blood as the *Brookes* in Hamburg, kangaroo skulls as the *Brookes* in Australia, tarred and feathered objects on a bed of feathers as the slave bodies in London. In 2005 Lancaster finally made a public monument to its neglected, indeed almost buried, role in the slave trade, commissioning a public sculpture. Kevin Dalton-Johnson produced a schematic sculpture focused on black loss and suffering and the power of trade. Yet when it came to representing the slave bodies, he still fell back on setting a reproduction of the *Description* of the *Brookes* in a transparent acrylic block.[13] I saw three Brazilian artists draw a full-scale parody of the *Brookes*, where they substituted the slave bodies for crudely drawn sexual imagery, on the sands on Copacabana. Then the sea, that same Atlantic in

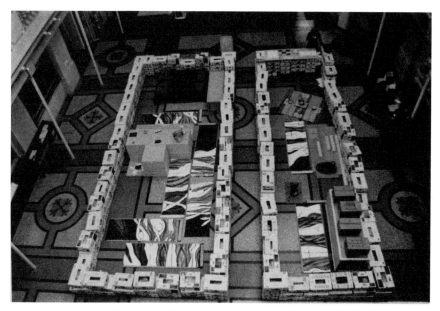

FIG. 6.7. Peter Baidoo, *Slave Ship*, installation, banana boxes and mixed media, Cargo exhibition, Bristol City Museums and Galleries, 1999.

which so many millions of slave bodies still lie dissolved, came and washed the image away. Should these parodic interventions be graded? Are some of them better than others, do some work and some fail, do they all operate in the same gestural ballpark? For over ten years now a black British artist, Paul Hope, has been patiently working his way through a response to the *Brookes*.[14] The piece is entitled *Jam Packed Berth Place* (fig. 6.8), a title that for a start suggests that Hope has located himself rather differently from the other satiric variants out there. The work consists of reimposing, or ghosting in, one set of imagined black bodies upon another, and at that level is not a million miles from Hazoumé. Yet the type of imposition involved is, I think, more interesting and more intellectually lean. Hope's comical golliwogs float in and out of the tragic black manikins of the original, which are left as in a palimpsest. There is no attempt to obliterate his source.

Within the adaptive history of race stereotypes evolved in Britain and across the diaspora, in order to simultaneously bind down and ridicule the image of the black, and particularly the black male, the golliwog holds a central and notorious position. That the golliwog still possesses a massively charged status as a racist symbol within British culture was spectacularly demonstrated as this book went to press. Early in 2009 the "Golli-gate" scandal engulfed the Brit-

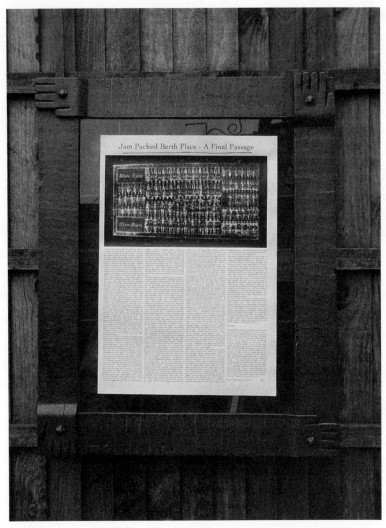

FIG. 6.8. Paul Hope, *Jam Packed Berth Place*, paper, photolithographic paper-stickers, cast iron, and mixed media, 2006.

ish media. Carol Thatcher, ex–Prime Minister Margaret Thatcher's daughter, is a minor broadcasting celebrity in Britain. As Thatcher sat in the greenroom chatting after appearing on a talk show, she was overheard referring to an unnamed tennis player at the Australian Open (almost certainly Frenchman Jo-Wilfried Tsonga) as a golliwog, or more precisely, as having hair like a golliwog's. Immediately the story became headline news across every medium, and at every level, of the British media. Thatcher was fired from her job at the BBC, and every media hack wrote a self-serving story about what golliwogs meant to them.[15] Yet why did Hope alight on the Robertson's golliwog in particular? Robertson's is of course a famous jam-manufacturing company, and its strawberry jam and marmalade were staples most English people over age forty grew up with.[16] Jam is a wonderfully rich metaphoric substance to throw into the mix of the slave ship. Jam could not be made without sugar, and sugar is of course the precious export that drove the Atlantic slave trade. Jam is sweet and luxurious, but it also suggests human blood and guts. Motorway police and ambulance drivers talk about "scraping the jam off the tarmac." And I don't know if it's appropriate to mention here that Hope, before he made *Jam Packed Berth Place*, had had hands-on experience in his job as a highway patrolman seeing the very worst things that high-speed car crashes can do to human bodies.[17] But whether the artist's biography inspired the visual pun or not, the holds of slave ships were responsible for the production of vast amounts of such horrendous human jam.

If we go back to the original *Description*, it was printed as a broadside, and at least half of the space was given over to a closely printed descriptive text. This gives appalling eyewitness accounts of the degeneration of the black slave body into human jam. Thomas Clarkson quotes from Alexander Falconbridge's *Account of the Slave Trade*. When talking of conditions on the slave decks, he begins by approaching the impossibility of description: "When attacked with fluxes their situation is scarcely to be described." He then continues: "Some wet and blowing weather having occasioned the port holes to be shut and the grating to be covered fluxes and fevers among the negroes ensued. While they were in this situation, my profession requiring it, I frequently went down among them till at length their apartments became so extremely hot, as to be only sufferable for a very short time. But the excessive heat was not the only thing that rendered their situation intolerable. The deck, that is, the floor of their rooms was so covered with the blood and mucus which had proceeded from them in consequence of the flux, that it resembled a slaughter house. It

is not in the power of human imagination to picture to itself a situation more dreadful and disgusting."[18] Here we have human bodies boiled down through disease into an obscene jammy effluvia. And of course this filth and suffering are unrecoverable and indescribable in literal terms, which is exactly why the hands-off and clinical descriptive method of the *Description* is so effective. The *Description* finds no room for this slaughterhouse vision; it will not go in that direction, will not take on the challenge that "it is not in the power of human imagination" to show something so dreadful. What Hope does, in throwing his golliwog badges into the mix, is to raise this specter of black human disintegration and white human unconcern, and crucially, at the same time he avoids any attempt at descriptive realism. Hope, in isolating the Robertson's golliwog, lighted upon an image brilliantly suited to set up a dialogue with the original design. It is the outrageous whimsicality of Hope's gesture of substitution that is so effective. His solution is a very dark humor that links the literal jam of the Robertson's golliwog with the quite inconceivable fact that the slave bodies decomposed into a very different sort of condiment.

I stress that it is the ability to avoid the incorporation of any realistic descriptive element that makes Hope's work artistically successful and that maintains the spirit of the original, which in its clarity and cleanness is so completely unreal. When it came to approaching the reality of the filth and the decay of the slave decks, Hazoumé's solution was to mix up a literal cocktail that combined slave trade products and human waste products. We were told that he flavored his exhibit by mixing up human feces and urine with tobacco, spices, and alcohol to produce a heady brew that conjoined the suffering of the slaves with the products that their suffering was being sacrificed to.[19] Yet what finally is the status of this smell? What does it do or mean? Why use real human waste products, and whose products are they anyway? Did Hazoumé use his own excretion, or another black person's, or a white person's, or a male's or a female's, or a child's? We are never told. If he used his own, then was he claiming for himself the agonized body of the slave, or was it an act of bizarre insult through mimicry, the artist pissing on the memory of slavery as the white slave power had, or was he placing himself alongside all those Western artists who have played so lovingly and profitably with their own excretion as art object — Piero Manzoni's canned coprolites, Andy Warhol's "piss-paintings," and so on and so forth — I won't run through the sorry litany here. Surely we have the right to ask, finally, what on earth is the relation of the excrement Hazoumé used to the real filth on the slave decks?

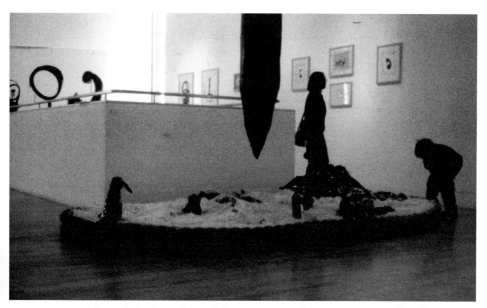

FIG. 6.9. Marcus Wood, *High Tar Babies*, entrance exhibition space, Royal College of Art, London, duck feathers, rope, roofing bitumen, and mixed media, 2001.

Ironically, the only people who really suffered as a result of this installation were the poor, and mainly black, museum guards, forced to sit there breathing in the shit for hours on end. I asked the victims what they thought about their predicament. One was genuinely grieved, and claimed to have developed a bad throat; several laughed and said they had just gotten used to it after a while.

The last thing I want to do is to try and take the moral high ground here when it comes to Britain's involvement in Atlantic slavery. There isn't a lot of moral high ground going around. But I do think there are right ways and wrong ways of coming at the memory of the middle passage, and that we need to be clear about how much abuse the *Description* of the *Brookes* can take. And so I should make a confession at this point. *Maxima mea culpa*: I contributed to the horrible flotsam and jetsam that the *Brookes* now tows along with it. In 2001, I built a parodic installation of the *Brookes* under the title *High Tar Babies* (fig. 6.9) and exhibited it in London in the Henry Moore galleries of the Royal College of Art. I laid out a genuine eighteenth-century ship's hawser in the shape of the *Brookes*. I filled the pool of space within the rope, the symbolic slave deck, with white duck down, and then put my substituted version of the slaves' bodies upon this soft bed. They were a motley crew of tar babies,

fetish objects created by a series of artist collaborators and then dipped in tar. And then I hung a giant eight-foot slug, stuffed with bone-white feathers and painted with tar, above my version of the slave deck of the *Brookes* — a new captain of industry, a new kind of deity, overlooking the destiny of the slaves.[20] What do I think about it now? Well, as with Hazoumé's work, it's easy enough to construct a knowing defense of it, talking about how I questioned gender roles, animal and human rights, or the nature of testimony, or broke up, while being in dialogue with, the rigor of the original. But now I realize, as with Hazoumé's work, there was too much going on; it was too big and too noisy and too confused, and it was certainly as big a failure as *La Bouche du Roi*, if not as widely publicized a failure. I am not questioning the good intentions behind *La Bouche du Roi* or its undoubted seriousness, any more than I question my own seriousness in 2001. What I do question is the ability of either installation to develop the information encoded in the original *Description* in any new or powerful direction, or, in other words, the effectiveness of either work as art or propaganda in 2007. As Kevin Bales's silence and bafflement explained, it is very hard to go beyond the terms of the original *Description* in any powerful way. The games that most state-funded art has played with the *Description* merely encode a current communicative impotence.

YOUTHFUL DISCRETION, THE *BROOKES*, REVIVIFICATION, AND THE HUMILITY OF THE PHOTOCOPY

As I walked down the staircase of the great court in the British Museum at the launch party, and away from *La Bouche du Roi* on that anniversary day in March, I came across a stall run by the Youth Concern Global Network. They were exhibiting a series of works produced by young people in Southwark as part of the Youth Bicentenary Project, entitled *Following the Trail 2007 and Beyond*. Among these visual experiments, lying in piles on a trestle-table were modest sheets of A4 photocopies, and many of these played around with the *Brookes* image. All were satiric but humorous. There was a map of Britain with the slave bodies cut and pasted onto it; another of Southwark, the borough where this organization is based.[21] The graphic gesture of substitution is ambiguous. Do these images say that this is how white people in Britain of Southwark still see black people today, that their slave origins cannot be overcome? Does it say that this is in reality how black people still exist, that disempowerment, prejudice, or debt bondage keeps them as slaves? Is it about

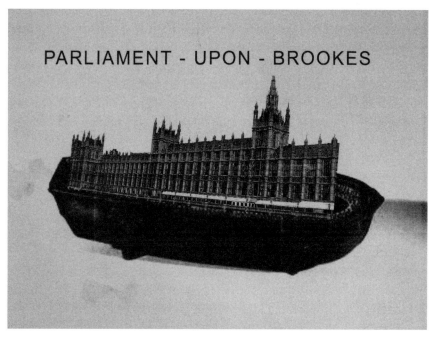

FIG. 6.10. "Parliament-upon-Brookes," collaboration by Youth Concern Global
Network, *Following the Trail 2007 and Beyond*, London, photocopy montage, 2007.

the survival of Africans, their abilities to have endured and triumphed over
the oppression of Atlantic slavery? Other images showed key buildings of cul-
tural and institutional power thrust into the actual *Brookes*. The miniature of
the boat that Wilberforce had made to pass around the House of Commons
(fig. 6.10), in order to demonstrate to politicians how many slaves could be
legally packed into the *Brookes*, now takes on an extra cargo, the House of
Commons or Buckingham Palace. These are complicated images, powerful
photomontages that place three-dimensional representations of buildings on
top of, literally crushing, the lifeless flat black bodies of the original *Descrip-
tion*, which Wilberforce then had cut out and pasted down. The final joke is
surely that with this big piece of iconic real estate on board the boat is going
to go down, slaves, politicians, kings, and queens sharing the same watery
grave. The image is also telling us to watch out in 2007 when *the powers that
be* briefly want to celebrate the abolition of slavery, because they will want a
piece of the action, they will want to climb on board. Here they have amus-
ingly and literally done so, but they don't fit, they don't belong.

Visually the most complicated of all these images was an interpretation

created by the young Ghanaian Earnest Gyasi, which carries the simple title *Identity* (fig. 6.11). Here the middle slave deck of the *Description* is reproduced on the left. On the right it is reproduced again but the central section and the stern of the print have had photomontage applied. A figure in a hoodie is repeated six times vertically down the center and twice horizontally in the stern. The figure has clenched fists crossed over and pressed into its chest, like hard breasts. The space within the hood is black, and floating in front of it is a question mark. The question is not so easy to answer. We are challenged to say who lies within the hood; that black space might hold a white face, a male or a female chav (poor white trash from the South End of England, who typically adopts the fashion and values of West Coast American rap). The irony of course is that white urban youngsters have taken up the hoodie from its origins in urban black street-wear because it's a good look and hides faces from CCTV cameras, but are they being culturally recolonized by black ghetto culture, or are they mimicking it because it is exciting to do so? The graphic simplicity of the image works; the repeated interlocking forms of the hoods suggest shackles. In the modesty of its scale and in the elegance of its layout it seems in tune with its source. These are not the stark, crude chains on display in the cases of slavery museums but the mind-forged manacles that centuries of slavery imposed on the minds of blacks and whites alike. As a way of linking modern attitudes and modern life in the diaspora with the memory of slavery as frozen in the stark formalism of the *Brookes*, this image succeeds.

JOHN CANOE AND THE SLAVE SHIP *BROOKES*

The Carnival Village Yaa Centre, Maida Vale, London, organized a parade on October 6, 2007, which set out from Tothill Street and went past the Houses of Parliament to Whitehall Place. The London-Afro-Caribbean walk, or in fact masquerade, was dedicated "to the ancestors who died on the middle passage and to the Long Black presence in Britain since the beginning of the slave trade." Many of the dancers wore vast carnival headdresses evolved out of the traditions of festive masquerade in Trinidad and Jamaica. Dressed in a variety of intense blues, and gliding in and out of the center of the parade, was a woman who carried a huge boat on her head (fig. 6.12). When I asked her what her costume meant, she explained that it was both the *Windrush* and the *Brookes*; it was both the sadness and suffering of the initial middle passage and a commitment to the triumphant survival of the descendents of slaves and their arrival in Britain via a second middle passage, after the independence of

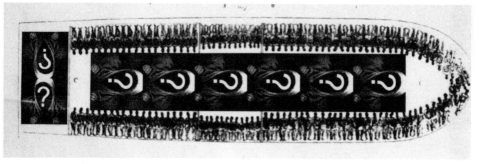

FIG. 6.11. Earnest Gyasi, "Identity," produced for *Following the Trail 2007 and Beyond*, London, photocopy montage, 2007.

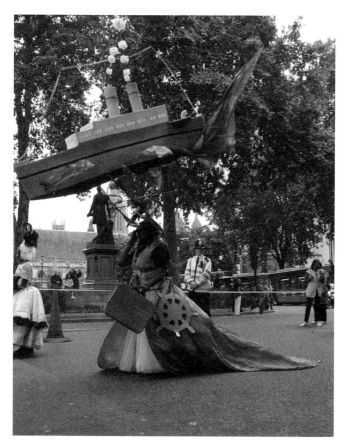

FIG. 6.12. *Empire Windrush and Brookes*, YAA Carnival Village Parade, carnival headdress, wire, papier mache, acrylic paint, synthetic textiles, and mixed media, October 6, 2007.

the ex-slave colonies. The little black boat that hung over the papier mache sculpture of the larger boat constituted both a literal lifeboat and the *Brookes*. This was a sculptural realization of the memory of the slave ship carried on, and carrying on, from the Caribbean into Britain.

The power of this sculpture emanates from the manner in which it demands that the *Brookes* be seen from a variety of diasporic performative contexts. The formal design of the headdress is, in fact, locked into a set of imagistic devices that had been evolved over centuries within Antillean carnival art. The recent international exhibition of a set of colored lithographs that Isaac Mendes Belisario produced in the early 1830s representing the central figures of the Jamaican slave masquerades has generated intense interest in a figure known as John Canoe or Jonkonnu.[22] In the eighteenth and nineteenth centuries Jamaican slaves were, during certain holiday periods, allowed to orchestrate elaborate street performances. Those that took place as part of the Christmas festivities were often dominated by a central figure known variously as Jaw Bone, or John House Canoe, parading an elaborate headdress in the form of a house, or a houseboat, or a canoe containing certain ritual objects. There is a lot of speculation among ethnographers as to precisely which parts of West Africa and which African rituals these houseboat headdresses evolved out of. Headdresses incorporating boats are common among the Ijo, Ibo, Ibibio, Agoni, and Yoruba peoples of the Niger Delta. Carved masks with human faces surmounted by houses exist among the Ibibio and Nagoni of Nigeria. In Yoruba a boat-shaped object known as the *inle eleri* (the house on your head) was used to represent the protection and blessing of the surrounding world. Also within Yoruba ceremony a canoe form, carved in miniature, formed the base for headdress of priests during funeral ceremonies in the ancient Beninese capital of Dahomey. The boats were filled with ritual objects dedicated to the deceased. The laden canoe represented the worldly wealth of the deceased but also his journey across from this world to the world of the ancestors.[23] Precisely how and why the houseboats were developed in Jamaican slave and ex-slave cultures is a complicated and still unresolved question. The houseboat headdresses are still related to ancestor worship, and form a link between the living and dead, while the gesture of raising the boat above the head shows respect, elevating all that the ancestors symbolically embody above the day-to-day events of the living. The canoe in both coastal West Africa and the Antilles also relates to the life of the fisherman, and symbolically to the fecundity of the seas in providing the whole community with its

food and wealth. But the surf canoes also inevitably form another and darker pan-African link. They were the vessels that carried the slaves out through the shark-infested waters to the slave ships and that took the slaves into their new diasporian homes after the middle passage was over.[24]

When it comes to interpreting the boat, I saw dancing before the House of Commons in October 2007 that these wider Afro-Caribbean cultural origins are vital. The *Windrush* is transformed before our eyes from a rather tatty transatlantic liner, now embodied in papier mache, to a magical vessel protecting the traveling Afro-Caribbean populations in their journey from the New World to the Old. The *Windrush* simultaneously exists as a symbolic vessel respectfully uniting these travelers with their African ancestors through the magical medium of water.[25]

It must also, however, be remembered that these boat-headdresses are essentially diasporic, and while drawing on elements of an African past, developed within the popular culture of the slave colonies, they also inject hybridized elements relating to European tradition and maritime history. There is a startling visual record of an Afro-Caribbean black parading in the streets of central London as early as 1815, bearing an elaborate boat headdress that anticipates the later costume with some precision (fig. 6.13). The artist, John Thomas Smith, published a book with the amply self-descriptive title *Vagabondia: or, Anecdotes of Mendicant Wanderers through the Streets of London, with Portraits of the most remarkable drawn from life.* One striking etching entitled *Joseph Johnson* shows a disabled but well-dressed black man, sporting fashionable sideburns. He holds out a wide-brimmed hat for donations and supports himself on a crutch and walking stick. He bears a finely detailed miniature model of a British tall ship, in full sail, called the *Nelson*. Clearly this boat alludes immediately to the famous British admiral, and Johnson aimed his spectacular display at British patriotism and pride in the naval domination that had enabled the defeat of Napoleonic France. Yet seven years after the abolition of the British slave trade the boat must also recall Britain's involvement in that commerce, and resonates with memories of the *Brookes* and the little model of that ship that Wilberforce passed around the House of Commons in order to force British politicians to think about the reality of the trade.[26] It seems that the mendicant vagabond Joseph Johnson is playing the same sorts of ironic semiotic games with hybridity and the crossing of maritime thresholds as well as with nautical imagery and the metaphorics of the Atlantic Ocean, which are to resurface in the parade before the British

Parliament in 2007. And looking at both headdresses there is a sense that the bleak graphic perfection of the *Brookes* has been overturned by joyful reinvention, metaphoric revivification, and sheer imagination.

"THERE WAS A VERY BRIEF SHUDDER": WILBERFORCE PRIMARY SCHOOL AND THE LONDON PRINT STUDIO GET INTO THE *BROOKES*

The most logistically complex, and ideologically ambitious, attempt to readdress the inheritance of the *Brookes* in 2007 grew out of a collaboration between the London Print Studio in Harrow Road and the Wilberforce Primary School, North Westminster. In late November 2007 an invitation card went out entitled "The Print That Turned the World?" (plate 13). One side carried a truncated representation of the middle section of the *Description* of the slave ship *Brookes*, reproducing the dark brown and ivory yellow of the original with the text printed above. The other side of the card had the title printed the other way up, so it had to be turned upside down to be read, and the card consequently literalized the statement of the text through a visual pun. This section carried an image, repeating the slave deck, but populated this time by a parti-colored and multiracial assemblage of real people in casual dress. They are mainly children and lie on their backs on a dark blue background, mimicking the pattern of the slave bodies from the original *Description* with some precision, but not with absolute adherence to detail.

What does this juxtaposition, this reversible, upend-able diptych, tell us, and where did it come from? In fact, it represented both an exhibition dedicated to interrogating the design at the London Print Studio and the climax of a piece of performance art involving several hundred children and a few adults. Throughout the early part of the winter term of 2007 the children from Wilberforce Primary School had been invited to participate in a variety of workshops and classroom activity sessions focused on thinking about the image of the *Brookes*. They had written, spoken, and made art about what it would have meant to experience the middle passage. Particular emphasis was given to getting the children to think about what it would mean to be suddenly taken from the protection of parents and home and forced to cohabit with strangers in conditions of incredible suffering.

The re-creation of the *Brookes* slave deck had been rehearsed and approached gradually over weeks. As one part of the preparation each class had been provided with large pieces of blue tarpaulin that were laid out on the

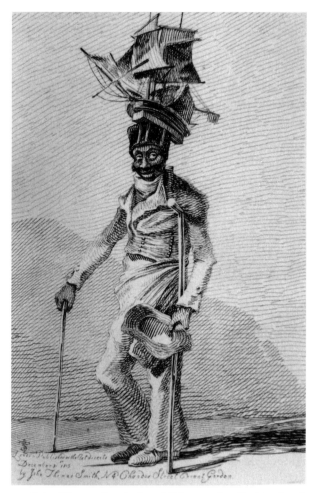

FIG. 6.13. John Thomas Smith, *Joseph Johnson*, plate for *Vagabondia; or, Anecdotes of Mendicant Wanderers through the Streets of London, with Portraits of the most remarkable drawn from life*, copper engraving, 1815.

ground and all the children, teachers, and school-assistants were invited to lie down and register their outlines in white (much in the manner of a murder-scene crime-victim representation) (plate 14). These subsequently became *their* individual spaces on the deck of the slave ship, spaces that they would get to know, to inhabit. In late September 2007 all the tarpaulins were laid out in the school playground, and together formed a life-sized enlargement of the spatial representation of the middle section of the *Description* of the *Brookes*. John Phillips, the organizer of the event and director of the London

Print Studio, described in an interview how the event was organized and what he witnessed. I quote the interview at some length because it gives an idea of the different forces and creative pressures that generated the performance, and because in retrospect I think this was one of the more effective and imaginatively subtle utilizations of the *Brookes* image in 2007. There was clearly a confidence on the part of the artists and the teachers that somehow the children's imaginative input could be trusted in a way that the adult imagination might not. Was it right to encourage children to go through a series of immersive exercises to imagine what it was like to experience the middle passage? Is it right to have a drama exercise where a child imagines what it was like to have to excrete on the slave ship? Should a professional storyteller have prepared them for the experience of lying down on the imagined slave deck? Did the games with contemporary media techniques for reporting in trauma zones allow the children to create little personal narratives that really contributed to the slavery archive? In answer to these questions I must say that I remain uneasy in relation to some of the emotionally immersive aspects of the event, yet what all these prefatory episodes gave rise to was surely worth the price of whatever dodgy empathetic distortions occurred along the way. The children's partial imaginative immersion into some aspects of the memory of the middle passage provided the emotional groundwork for the creation of what was finally a spontaneous and magical moment out of time:

> MARCUS WOOD: Can you talk me through the genesis and origin of the performance, why that school?
>
> JOHN PHILLIPS: It was Wilberforce School, and we had already done several projects with them.
>
> MW: But not on slavery?
>
> JP: Not on slavery issues, but we've worked on quite sustained projects with them. We had a teacher's evening with them here, and I was talking about some sort of response to the image of the *Brookes* slave ship. And we were talking about it and three of us think that we all had the idea that we could do it with the school kids and the ship at the same time.
>
> [Laughter]
>
> JP: That's the wonderful thing about deciding whose idea it really was.
>
> MW: Well of course the original *Description* was designed by committee so you are keeping that collaborative tradition going.
>
> JP: So I think it was just one of those ideas where everyone said, we have to do it with the kids.

MW: Complicated though, politically, given that you cannot recover, ever, the trauma that went on through any single slave's mind when they were on the middle passage, to decide that you are going to allow children to lie down and mimic that process.

JP: The lying down and mimicking was the end of a much longer process. Because we didn't just march in and take a photo. The School worked with the kids the term before on projects on slavery. We also made a large jigsaw puzzle in which everyone had drawn out where they were going to lie. And so they were allocated their own space in their own class. And so that process of coming in and working out where your space was going to be was part of the teaching that went on when the teachers would talk about what the conditions would have been like. I remember one teacher while the kids were coming in and drawing their images of where they would be, she did the most fabulous piece of drama about wanting to pee. Which did bring home the terror of not even knowing how you could go to the loo. So the staff really did, across the whole school, an enormous amount of work about what slavery was and on what the "middle passage" was as experience. And then the day that we did the photo shoot we had a story teller who told a story to all of the kids, in the hall, that was related to slavery, and that was related to loss.

MW: When you say story teller was this in the tradition of African oral story telling?

JP: Yeah. We also embedded reporters in the classes so some people were photographers, and so some kids were reporters and asked the other kids what it would be that they would miss most if suddenly someone picked you up now and took you away, what would you want what would you miss. Those kinds of ways of engaging them.

MW: This was a whole day workshop?

JP: This was in the morning and then we laid everyone out on the ground, on the large jigsaw and photographed it from high up in the school. And it probably took half an hour for everyone to come down and to lay-out.

MW: And were they given instructions about lying down as they lay in their allocated space, were they told how to behave, did they have to remain motionless?

JP: They had to lie down, but I mean they were on a slave ship you know.

MW: But on a slave ship if you look at the two or three eyewitness images they bear no relation to the *Brookes*, people weren't just lying down and there weren't just slaves, they were stuck in among barrels, bits of ivory,

anything the traders had got their hands on, the whole thing could be a
chaos, and often they weren't chained up because you couldn't it was just
too much of a mess in there. So in a way the *Brookes* is an idealisation, it's
like the perfect slave ship.

JP: Well I'll show you the images of the kids, they are fabulous [plate 15].
We got them all to lay out and there was probably no more than thirty
seconds in which the whole, in which a whole, wave of silence went across
it. I was up in a top window and I felt it, and other people described it. It
must have been very short but you were just hit by a huge emotion, that
people had been brought together, and they had made something that, it
wasn't just an image, they had learned from it, they had related to it, I feel
most strongly that . . .

MW: It sounds like there was some higher force that took over.

JP: There was a very brief shudder. And I think that was collective.

MW: Could you just tell what the racial mix was?

JP: Oh it's pretty wide. Because this used to be a strong Afro-Caribbean
community but increasingly you've got a large Bangladeshi community,
Kosovo community, so it's very, very mixed. One of the reasons that we
touched on slavery today is because it's not entirely removed from some
of those kids' experience, or people disappearing through wars or people
coming as "illegal immigrants" in container lorries and working in sweat
shops. And so while we paid homage to the Triangle we also wanted to
raise issues about contemporary slavery and global slavery.

MW: And when they all lay down they weren't programmed to have a minute
of silence?

JP: No it just happened. There was a self-imposed, a self-generating
moment.[27]

The children lay down with their teachers and day helpers, in the bright sun-
light, in their allocated spaces, and for a brief few magical moments the *De-
scription* of the slave ship came into a new form of life. Listening to eyewitness
accounts, and looking at the video footage of the event, it is clear that there
was movement from chaos, to a twittering sort of order, and then into a deep
calm, before the whole piece dissolved back into the ludic disorder of the play-
ground. As they took up their allotted places on this imaginary slave deck, all
behaved differently. Some interacted, some turned from their neighbors, some
cuddled each other, as if looking for comfort, some giggled, and then quite
suddenly that uncanny silence descended. If the performance had been made

using adults, if it had attempted precise mimicry of the near nudity, or total nudity, of the originals, or if it had incorporated shackles or attempted precisely to mimic the *Description*, the whole thing would have been another invasive, unacceptable, and self-conscious sham. As it is, bizarrely, in the purity of its unpretentiousness and in its shabby innocence, the whole thing seems to have worked, miraculously, beautifully, and one of my main regrets in 2007 is that I missed it. When performance started to become fashionable in the mid-1960s, spontaneous "Happenings" were always going on. Almost immediately the whole idea of "Happenings" was soon ridiculed, sometimes quite brilliantly, as in Tony Hancock's *The Rebel*. "Happenings" are now deeply unfashionable, and all too soon they carried an aura of silliness; performance artists now have to brand what they do very differently. I get the feeling that this *Brookes* performance, at its climax, really was something of an old-style "Happening."[28]

The performance was, however, only the first element in a layered interpretation of the *Brookes*. Back at the London Print Studio an elaborate exhibition was put together that sought to interrogate the *Brookes* in many ways.[29] There is not space here to do justice to the show, which was of course its own justification and explanation. There are, however, some elements I would like to record, because they provided quite original critiques of the *Brookes* image within the context of the Western visual archive of slavery. A facsimile of the original copper plate used to print the *Description* was made by scanning it, and then transferring the reproduction photographically onto a copper plate. The copper plate was then bitten, and the image made as an intaglio print on cheap newsprint, in order to mimic its original mass distribution as a single-sheet broadside. The trimmed print was then pinned in splendid isolation onto a vast gallery wall, and lit by a single spot of light. The original moment of production was thus scrupulously respected, but the mode of display also made a powerful point about the tiny scale, and indeed the graphic modesty, of the original in relation to the gargantuan responses the image has generated in the contemporary art world.

HONEST EYES, INNOCENT EYES, AND PUTTING A FACE ON THE *BROOKES*

The rest of the show attempted to create a set of charged visual dialogues with this original, each of which also stood as an autonomous work of art. I will again quote Phillips because he talks with great insight about the genesis of the first major element in the dialogue:

MW: One of the reasons I am interested in it [the *Brookes* image] is that it is still one of the most popular images in terms of what people think conditions on the middle passage were like. Have you got any ideas as to why you think it has remained so popular?

JP: I think it's a cliché and I don't think it's an image people think of really in relation to the middle passage. I think it's an image that people think of in relation to slavery generally so it's almost a graphic device which you can substitute for the term "slavery." It's a logo and what I wanted to do was critique it as much as celebrate it. And one of the things that struck me about the early images created around slavery was the lack of empathy with the individuals. And we were thinking about how empathy is the one thing that allows people to understand each other, and if it's lacking then we can permit terrible things to happen to each other. And so while this is an image which is against slavery it is also an image which lacks any empathy. There is no individual slave, these are simply blank figures and what we wanted to do was bring empathy to it and that's why we worked with the school and with the teachers, and put real people in the place.

MW: But isn't there a sense in which because of its very blankness it forces the viewer to project into it, to inject empathy into it? And in this sense it's paradoxically, essentially, empathetic.

JP: Well no. It encourages empathy within a system. I'll tell you what I mean about empathy, and the black subject. I came across a drawing by [Albrecht] Dürer [plate 16], the silverpoint drawing of a black girl, and because it's in the Uffizi it was going to be difficult to borrow. But I thought it was very rare because it's an image of a slave as a real person, and we lack these images.

MW: I agree. There are very, very few, a few more in the eighteenth century, the early period of the French Revolution generated some great ones, Marie Benoist, again a portrait of a young black woman made with great compassion and yet honesty. I agree empathy is the word. But the remarkable thing about this image is that it is so much earlier.

JP: So much earlier. And what fascinated me about this was the ambiguity of age, Dürer tells us that she was twenty, we know her name, Katerina, she averts her gaze, she won't look directly at him. There's a youthfulness in her face, and yet a terrible ageing, that carries so much experience within it. And he captures that.

MW: He's drawing her as a person, not a black person.

JP: Yes. But he's drawing her with a recognition of her experiences as a slave,

because those experiences are written in her face, and he's such a great draftsman. And so I re-drew her on a greatly enlarged scale, and I had a relationship with her through Dürer.

MW: So you drew this?

JP: Yes, if you looked at the Dürer it would be made up entirely of an intricate network of cross hatched lines, which I just couldn't do. So I redrew her in pencil and then blew her up. And that went across one of the exhibition panels. We treated her like a celebrity. If you imagine that Dürer's drawing is about three inches square, I enlarged her, as if she were a celebrity for today, poster size. We wanted to get across that intimate face, and then layer on to her as a symbol, all sorts of things which didn't have anything to do with her. Because what Dürer did was to look closely at her as a person, but when we look at her image what we do is to impose all our associations on to her.

MW: And that's where the texts came in?

JP: Yes, these are hand written texts which vary from the second millennium BC of a Pharaoh ordering concubines, to someone who has been enslaved at the turn of the twenty-first century.

MW: I love the way those eyes come through, so you didn't dare write across Katerina's eye balls?

JP: No.[30]

There is a series of sophisticated moves here that ask difficult questions about how, now, white audiences in the developed world are able to look at black people with an innocent eye. No eye is entirely innocent, of course, but the eye of Dürer is not contaminated by the waves of racist iconography that have infected the twenty-first century artist or audience when it comes to the representation of the black body, male or female. The fact that this black woman is fully clothed, the fact her breasts are not depicted, the fact that she has her head covered, the fact that her features are so West African but not in the least caricatured are all significant facts. Dürer's empathy is maybe artistic sympathy: he seeks factuality and accuracy; there is no sensationalism, no voyeurism, and no distortion in his response. He is trying to draw as keenly as possible the subject before him, and in the honesty of his act of recording her full humanity emerges. There is something humble and very significant in Phillips's decision that he could not photograph this image, that he had to copy it, to pay homage to it in the full knowledge that his technical skill as a draftsman was so vastly below Dürer's. The humility of the gesture, yet

the commitment to understanding through mimesis and the arduousness of copying in pencil the scale of Dürer's vision, is deeply moving. And then in the next stage the image is assaulted. The modern world's technology gets hold of it and destroys its intimacy; the copy of Dürer's original is photographed and supersized. A variety of hands and words literally defaces the calm black woman, as an elegantly choreographed graffiti assaults her from every direction with the imposed memories of slavery and the slave trade. This is a very glyphic, a very cryptic violence, and yet, even though this was not consciously planned, no one who wrote upon this lovely face could finally bring themselves to violate it. Each of the performers' pens stopped short of cutting into or over her eyes and mouth. It is as if they had finally to turn away from the violence of sacrifice. She is not blinded, silenced, overwritten, and buried by the cacophony of voices and texts. Her giant eye, the window of her soul, now isolated as if in bizarre parody of the eyes of the beloved that eighteenth-century lovers carried on ivory in miniatures about their necks, still looks out at our eyes and asks us how innocent they have remained.

INVERTED OREOS, REAL WIGGERS, AND THE FANTASTIC NATURE OF PIGMENTS

Phillips complemented this interrogation of black female slave identity in the context of the *Brookes* with an equally powerful piece confronting male identity (plate 17). The work is again best initially approached through the artist's own explanation:

> MW: There's so much we can never know because the archive we are dealing with is a white generated one. Does that worry you? Is what you're doing about trying to get under that archive's skin?
>
> JP: I'll show you the piece we put in the middle of the show, which in a literal sense tries to get under its skin. It's also a critique of the question: why should a white artist try to deal with this subject?
>
> [unrolls the image (plate 17)]
>
> MW: Wow, explain!
>
> JP: Pygmalion. The idea that statues can come to life. Reification, the making of people into objects. The Golem, the figure that you make that should be for your own good but comes to destroy you. The idea that the black story is never quite told. So we have an image that looks like a Greek sculpture which has turned its back on you, yet what is revealed are the

Greek words, which were the great classical justification of slavery, taken directly from Aristotle's *Politics*, and revealed in the colour of the skin of the person, so the letters are the skin colour, and yet the apparent marble has been painted on, painted over.

MW: And the palms of the hands are a black person's hands, but the palms of the hands are paler than the rest of the black body. Very clever. And this was shot from a black model with white make up on.

JP: Yes. One of the things about its composition was I used a model and shot it from three slightly different angles. The camera was straight on, looked up at the head and then down at the feet. And I digitally stitched those three together, because I wanted to create something so that you don't know why it is disturbing, but even the construction of the body is disturbing.

MW: It's a tremendous image because turning its back on you immediately introduces that voyeuristic thing, and because he's on the auction block you want to see what you are getting for your money. It puts the viewer in a very compromised position.

JP: It plays on the ship and the anonymity but it is also trying to make a human.

MW: But it's also the end of the middle passage, what happened when the slaves ended their sea journey, and they were auctioned, that was the first experience of the New World. It levers the flat horizontal figure up and puts it on the auction block.

JP: The other contextual thing in terms of where the image came from was, in the research I came across the idea that the foreign slaves in the market in Rome were identified by covering their feet and the bottom part of their legs in chalk. I just had this image in my head of the Roman market place where people were almost being turned into statues.

MW: And of course there's whiteness and Englishness in the Roman market, the "non Angles, sed Angeli" comment, which a Roman Emperor said seeing a group of English slaves, the idea that the blond haired super white English were the most prized slaves in the late Roman Empire, a real exotic import.[31]

This image does resonate so powerfully with the *Brookes*, hanging in the original show, like a little monochrome postage stamp in its puddle of light a few meters away. In its whiteness this image gives us the fact of blackness. Africa staged only one big international slavery conference around 2007, and

it was held in Elmina, in Ghana, in a resort overlooking the great slave-trading castle.[32] After a series of papers on race and representation that had focused on the black body and white processes of graphic stereotyping, a young African man stood up, waved a blank sheet of paper at the audience, and shouted: "No body in this room is as white as this sheet of paper!"[33] His point was that in their exclusive focus on an idealized and assumed black body the white professors who had delivered their papers had wholly overlooked the fantasy of whiteness. No "white" people are actually white, white the way a sheet of paper is, white the way this painted black man is perfectly, evenly, white. And in the same way no black people are that uniform blackness of the slaves printed in black ink on the *Description* of the *Brookes*. There is, in fact, a further irony in that the original African bodies would have been printed with black ink made from ivory. Ivory black was made from a powder ground in with linseed oil. The powder got its name because it came from burning ivory, which gave an immensely dense charcoal.[34] The pure white of an African elephant's tusk was transformed through fire into the deepest of blacks, and then smeared across copper and wiped with a cloth to make a set of tiny black bodies. The relation of the painted black man to the print of the *Brookes*, with its printed black bodies, is consequently a highly charged one.

This very human albinified black man, with his love handles and his slightly ungainly posture, standing just a little bit larger than life, stands in for every one of those little black men on the *Brookes*. They lie on their backs, which we cannot see; all we can see of this man is his back, forming the base for that originatory inscription. He turns away from us: Is he turned toward some audience who appraise him, and who will buy him? Or are we that audience, whom he has refused to face? Or is he turning because we commanded him to, because we want to examine every inch of the property we can now buy? Again, it is the modesty and respect within the image that is effective around issues of power, black masculinity, and white male sexual angst. This is a black man, turned white on the outside, but the image denies access to the sexualized black male. A frontal image would have been so very different, a shocking and finally rather amusing satire on white penis envy. The white man would finally have got his hands on the black member and turned it white. But in this image the black penis is out of bounds. The black penis that obsesses white photographers from early ethnographic and postcard photography, to the knowing smutty-ness of Gian Paolo Barbieri or the more aesthetically intelligent excesses of Robert Mapplethorpe is excised from the picture.[35]

TRANSPARENT LIES AND HOLDING A MIRROR UP TO NATURE: THE *BROOKES* IN THE SHOP WINDOW

And then all of these images were bounced off, and from the street were seen through, a nine-foot re-creation of the playground performance (plate 18). The slave deck and the surrounding sea become clear as glass, and the children and their teacher, digitally cut out and pasted down, float in space. This space reaches back into the idealized order of the *Brookes* and out into the uncontrollable chaos of the Harrow Road. Families with prams and babies, families of the children who made the performance and who exist in its photographic rearrangement on that long high-street window, come and go. Looking at this show it seems certain that we, the ex-slave trading cultures, have got nowhere near to exhausting the aesthetic possibilities encased within that modest little copper engraving the *Description of the Slave Ship Brookes*.

The Horrible Gift of Freedom and
the 1807/2007 Bicentennial

Naomi McLean-Daley (a.k.a. Ms. Dynamite):
Can you tell me what does being a Maroon mean to you?

Colonel Frank Lumsden (Leader of the Charles Town Maroons):
After eighty five years of armed conflict a small group of Africans
made the greatest power on Earth sign for the first time in its history
a peace treaty, this as far as I am concerned remains Jamaica's greatest
achievement, and being Maroon is something of vital importance
because FREEDOM is why I live the way I live.

But I have done. For those who have power to cramp Liberty have gone so
far as to resent even the liberty of complaining, although a man upon the
rack was never known to be refused the liberty of roaring as loud
as he thought fit. — Jonathan Swift, *The Drapier's Letters*

ON THOSE RARE occasions when the machinery of popular culture within
Great Britain has, since 1807, been concentratedly directed at the subject of
Atlantic slavery, more often than not this has involved contemplation not of
the history of slavery but of the myths of its abolition. In this sense it was not
surprising that the most sustained confrontation with the subject of slavery
in modern British history occurred in 2007. The bicentenary of the act abol-
ishing the British slave trade generated a staggering amount of government
funding and publicity. This chapter is given over to considering how this phe-
nomenon should be interpreted. It is not an easy task to approach the memo-
rial inheritance of the 2007 bicentenary because it rapidly spun out of control;
indeed, it became increasingly hysterical as the precise commemorative date
approached. It is difficult to explain to anyone who was not in Great Brit-

ain during these months how intense the celebrations were. I felt I had been sucked into a media sensation, and was functioning like an expert witness called to perform, and suddenly required to comment on a terrible terrorist event, a natural disaster, or a gargantuan sex scandal. There was apparently no limit to the number of sites and web pages 2007 generated and now encompasses, no way of attempting an overview of what it came to mean in museums, schools, universities, the heritage industries, newspapers, television, film, and the avenues of official and unofficial merchandising. Each performance, march, procession, church service, exhibition opening, broadcast, and article, each announcement by politicians, academics, artists, lawyers, social workers, students, schoolchildren, television announcers, pundits, celebrities and would-be celebrities, ex-slaves, ex-slaveholders, singers, footballers, cooks, and musicians led to a web page, more web pages, website-links, and spin-offs in chat-rooms and blogs. This bubbling archive, this informational cacophony, is now quite impossible to deal with analytically, because it is impossible to decide what the limits were and are, where to enter and where to leave, what to put in and what to take out, what has value and what does not. Consequently, what I have done in this chapter is to isolate what I saw as some of the key cultural moments of display, performance, and textual production. I have isolated things that I feel gave particularly vivid insights into what the horrible gift of freedom had come to mean in Britain in 2007.

THE DEAN, THE DUKE, HIS WIFE, AND THE MAAFA: TOYIN AGBETU AND "ENGLISH NAZIS" IN WESTMINSTER ABBEY

One of the high points in the media coverage of 1807/2007 was Lola Young's long article entitled "The Truth in Chains," which came out in *The Guardian* on March 15, 2007, on the brink of the bicentennial carnival week.[1] This constituted a brilliantly compressed, but not reduced account of the different forces swirling within the culture wars and inheritance debates thrown up by the anniversary. Young clearly outlined how interest groups with axes to grind and chips on their shoulders could only see the opportunity of hijacking the event. She saw through, with a weary wisdom, the maneuverings of New Labour, as it attempted once again to fool all of the people all of the time. Here we had an insider, while naming no names, explaining why the safely impotent hypocrisies of Blair and his official anniversary front man, John Prescott, Member of Parliament for Hull, were so inevitable. There is no space

to summarize her excellent general take on things here, but I do want to excise two of the central truths she enunciated because they inflect so much of what happened generally. First, she said, "Africa is still a blank space in most European people's consciousnesses"; "One downside of the commemorations," she noted, "is that the emphasis on enslavement reinforces the belief that there was no African history before European domination." This fact, and it is a fact, has terribly destructive effects on how slavery is perceived throughout the Atlantic diaspora. And second, she concluded simply that "in popular public consciousness William Wilberforce ended slavery."[2] Sad but true, and she observed: "A damaging side effect of the focus on white people's role in abolition is that Africans are represented as being passive in the face of oppression." I think that the considered intervention of Toyin Agbetu when he so boldly and sanely confronted the self-serving basis of the Westminster Abbey memorial service commemorating the 200th anniversary of the abolition of the slave trade was an attempt to get black resistance registered.[3] And I for one would have welcomed a much bigger emphasis on slave agency and slave revolution in all its forms during 2007, and the more extreme the better. Yet, isolated though it was, the intervention of Agbetu was significant in many ways, especially in the light of the cultural responses it elicited. Agbetu had the courage to stand up on a world stage and to launch into an extreme critique of the horrible gift of freedom in its most pompous and self-pleasuring manifestation. It is consequently worth considering this event and its cultural outfall in some detail.

When it came to the official commemoration of the 1807 bicentennial, Westminster held center stage. When all was said and done the commemorative service in Westminster Abbey on the morning of Tuesday, March 27, 2007, was a compromised, dull, yet highly fetishistic affair. It would have been quietly passed over and quickly forgotten were it not for Agbetu's prolonged act of intervention that managed to transform the meaning and memory of this national service. For some Agbetu was a hero and spokesman for black consciousness, for others he was a public menace and a symbol of postcolonial ethnic ingratitude. In the main the ceremony, following predictable patterns of authoritarian symbolic display and ceremonial narrative, could have been commemorating just about anything. It was only the importation of some black faces and the almost comic tokenism of the inevitable African drummers and elephant tusk horns that provided some ethnic window dressing for what was otherwise a typical "Establishment" Anglican Church memorial service. Agbetu has announced since that he did not go into the Abbey with

the premeditated intention of making a scene, but that as he saw with increasing incredulity the basic wrongness of the event, a sense of outrage seized him: "I don't call it a protest," he explains. "I prefer the word 'objection.' Protest has that connotation of banners, T-shirts, something pre-meditated. I'm not saying what I did wasn't political, but it was a much more natural response, I saw something I felt was wrong and I objected to it."[4] Agbetu's objection, his critical reaction to proceedings, has been largely misinterpreted. He has been presented as either a radical madman or a self-serving extremist who was rocking the boat because he wanted to get his fifteen minutes of fame and knew that he would subsequently be able to cash in on it.[5] And yet, from his perspective, the service appeared a disgraceful insult. I want to try and contextualize his actions by running through what he was exposed to up to the moment when his sense of outrage forced him to act. The violent collision of Agbetu's vision and that of the state forces that planned and executed the service (backed by the BBC on its best behavior) constitutes one of those moments when the veil is lifted and truth can be glimpsed.

Looking at the form and content of the service in a relatively retrospective calm, it is easy to see why Agbetu, and many African and black British viewers, felt that it constituted an insult to the descendents of slaves. The ceremony does seem to have been designed to evade certain areas of the memory of slavery in favor of a set of established narratives focused on abolitionists.[6] The service involved a series of unfortunate elements. First, there was a patronizing approach to black people, which reduced their presence and participation in the service to a passive tokenism. Second, there was recourse to various redemptive and celebratory religious formulas that had been long established to act as a moral camouflage to disguise British perpetration of specific crimes against humanity. And third, there was an inordinate investment in the myth of Wilberforce as the savior of the slave. The service, as originally planned, was a typically pompous and unctuous spectacle. It is significant that Agbetu's intervention was required to literally wake Gordon Brown up from a deep doze.[7] All in all, the service demonstrated that the pillars of the establishment — monarchy, church, and state — had learned, or had wanted to learn, very little from the radical shifts that have impacted on Britain's interpretation of its role in the Atlantic slave systems over the past three decades.

The television coverage was carefully packaged from well before the start of the service proper. There was a half hour prologue, and in our IT-obsessed age this was also broadcast on monitors across the Abbey. This is significant because it meant that Agbetu would have been exposed to this prefatory ap-

paratus as he waited for the service to begin. The prologue was carefully con-
structed apparently to give black Britain a voice, albeit those of two aspiring
cultural celebrities. George Alegaia and Kwame Kwei-Armah had been put in
harness by the powers that be to talk with suitable gravitas and respect for the
British people of color. Armah was to appear in multiple media guises during
2007 as the respectable and acceptable face of the black British/Caribbean
memory of slavery.[8] He also wrote a number of articles in the media, includ-
ing a powerful confessional piece explaining why he had changed his name
from Ian Roberts, his birth name. Much of this piece was about black uneasi-
ness over the 2007 bicentennial, and argued that middle-class British blacks
still needed, in Bob Marley's famous lyric, to "emancipate" themselves "from
mental slavery."[9]

The prologue was concerned to gift wrap the actual service with a reassur-
ing set of narratives briefly gesturing toward African suffering, but finally
placing white abolitionists, and inevitably Wilberforce in particular, firmly
center stage. Armah's role was to be the voice of Africa, or at least a voice in
Africa. He narrated a bizarrely telescoped five-minute account of the Atlantic
slave trade that included scenes of him wandering through a West African
market and standing in the slave dungeons of Cape Coast Castle Ghana, tell-
ing us in hushed cliché: "It's really heavy on the spirit, it must have been hell
on earth."[10] When Alegaia couldn't think of what to say during a hiatus later
on, he inaugurated an exchange in which it was hard not to see the hint of
a mischievous satiric response to his co-presenter: "Alegaia: Kwame, you're a
playwright, you make things up, but watching you there was nothing make
believe about your reaction in that dungeon? Armah: No George, it was very
heavy on my spirit to be in that dark, dank place."[11] Kwame's performance
climaxed, just before the queen's entry, with a tableaux of him seated in the
archive reading room, Palace of Westminster, worshipping the abolition act
itself (fig. 7.1).[12] He had now been dressed up in a dark suit and in white cotton
gloves, primarily to protect the document, and Armah or his director should
have been alert to the unfortunate associations of these props. They had the
ludicrous effect of recalling the white-gloved hands of minstrel performers.
Armah gripped and stroked the rolled scroll of the act with his right glove,
and with his left glove gave a bizarre thumbs-up gesture as he enthusiastically
announced: "So this is it. The act that banned the slave trade that saved the
lives of millions of Africans."

Moving closer to the service, a series of brief historical accounts of leading

FIG. 7.1. "Kwame Kwei-Armagh stroking the Abolition of the Slave Trade Act," Archive Reading Room, Palace of Westminster, still from BBC broadcast, 2007.

abolitionists dominated the presentation. The former Trades Union Congress leader, now Lord Morris of Handsworth, gave a very potted history of Granville Sharp and the Jonathan Strong and James Sommerset cases. This included a eulogizing and falsely optimistic interpretation of the Mansfield decision.[13] On the grounds that Sharp "worked closely with" Olaudah Equiano, Morris's piece moved seamlessly into the presentation of Arthur Torrington, president of the Equiano Society, who talked about Equiano again in the most reductive and abbreviated terms. Armah responded to this by announcing, "I mean, Equiano was the pop star of the day, I mean, it's amazing when you think about it!"[14] Equiano surely deserved better than this. From here accounts were given of the central shadows who hung over the service, Clarkson and Wilberforce, whose joint descendents occupied several front pews. The Most Reverend and Right Honorable Dr. John Sentamu, archbishop of York, celebrated Clarkson. Pride of place was given to Wilberforce, Lady Davson lauding "the God-given vocation" of her "visionary forebear" in terms that the most fulsome Victorian tribute would have been pressed to surpass. The last word before the ceremony began was given to the dean of Westminster Abbey:

GEORGE ALEGAIA: Dean, just how important is this service today?

THE VERY REVEREND JOHN HALL, DEAN OF WESTMINSTER CATHEDRAL:
It's a chance for us to remember the extraordinary power of the abolition-
ists working two hundred years ago and what they achieved, so signifi-
cant, to reflect theologically on what they were fighting against and why
they needed to achieve what they did achieve and that culminates in the
Archbishop's sermon, and then to respond with an act of commitment
to ensure that we work together to make reparation and to avoid any-
thing of the same kind happening again.[15]

The dean had his strategies worked out ruthlessly. The first move was to
embed memory in the "extraordinary power of the abolitionists," not in the
reality of what the slaves were forced to endure or indeed in the extraordinary
force of the British slave power. The second move was to further embed that
memory of abolitionist activity within the context of the controlling thought
of the Anglican Church and its capacity to absolve all sin. And the final move
was to wipe away the sin and guilt of the inheritance of Atlantic slavery via a
spiritual "act of commitment." Kind words butter no parsnips, and this spiri-
tual act of reparation was a handy way of avoiding the debate over whether any
other more costly and usable form of repayment might be in order.

The radio coverage of the service avoided preambles and cut to the chase,
utilizing a voice-over in the classic style of BBC official reverence by front man
Nicholas Witchell. The radio coverage was in many ways more revealing than
that of the television because it required a constant commentary on events
and the description laid bare much of the agenda with which the BBC had
approached the event. Witchell's voice-over, which until Agbetu's appear-
ance was clearly read from a script, was initially focused on Wilberforce. The
service opened with the descendents of Wilberforce carrying various fetish
objects up the aisle to be laid on the high altar. Witchell solemnly intoned:
"Carrying a copy of the act of Parliament which in 1807 abolished the slave
trade William Wilberforce's great, great, great, great, great, grandson Daniel
Wilberforce."[16] This document was strangely balanced by three "black es-
corts" carrying a copy of Olaudah Equiano's *Autobiography*, on another holy
cushion with tassels. One wonders what the author of that famously ambigu-
ous text would have thought about the whole thing. The abolition relics were
then passed on to two authority figures of the established Church, who made
them into holy relics. Witchell explained: "At the high altar the copy of Equi-
ano's book and the copy of the act are received by the Arch Bishop of York

and the Dean who will place them on the altar."[17] And while they did this a black gospel choir, dressed all in black, respectfully sang "There Is a Balm in Gilead" in mournfully restrained tones. Then "Lady Davson a great, great, great grand-daughter of Wilberforce [read] from the first anti-slavery speech he made before the house of commons in 1789." It was not at all clear why all these members of the Wilberforce bloodline were crawling out of the wood-work and dominating proceedings. How did an accident of birth qualify these distant members of the abolition patriarch's family to speak for the nation on the issue of the Atlantic slave trade in 2007? In the previous months there had been ample evidence of the ambivalence, not to say open hostility, of many in Britain, and particularly of members of the black community, to what had been termed the "Wilberfest" approach to the bicentennial. The opening of the service was at best insensitive, at worst a calculated insult. The reading from Wilberforce's speech that had been selected made matters even worse. It opened with the remarkable statement: "I mean not to accuse anyone, but to take the shame upon myself."[18] Here was massive evangelical arrogance posing as humility and taking responsibility for what had happened from those who were really responsible.

What put Wilberforce in a position to absorb the entire shame of the At-lantic slave trade personally? The move might have made some sense in terms of political expediency and theological theory in 1788, but in 2007 it appears close to delusional. And again, why did he "mean not to accuse" those re-sponsible? In 1788 he wasn't going to win any friends by naming and shaming the guilty, but remarkably influential, parties. In 2007 things were, however, surely very different from 1807, and we should not have been invited to praise Wilberforce's approach. Surely those who had perpetrated, and more signifi-cantly enabled and protected the trade — the parliamentary proslavery lob-bies in the Commons and the Lords, the successive generations of monarchs, churchmen, absentee planters, bankers, merchants, shipwrights, as well as the sailors and slave-traders — should certainly have been dragged out of their historical obscurity and into the light.

The reading of Wilberforce's speech was followed by a black choir singing "Were You There When They Crucified My Lord?" — "a spiritual," Witchell explained, "which was a favourite of enslaved Africans."[19] It might or might not have been, but there were far more radical favorite spirituals of the slaves focused not on terror at our collective responsibility for having crucified the Son of God, but in black agency and violent rebellion against the slave power. There are many spirituals based on the celebration of God's wrathful destruc-

tion of the Egyptians (a symbol of the slave power) during the exodus. Why wasn't there a fiery rendition of "Oh Mary, Don't You Weep" with its triumphant assertion that "Pharaoh's army got drownded"?[20]

Armah then appeared again, this time in a splendid gold robe that far outshone the clerical costumes of the dean of Westminster and the archbishop of Canterbury. After his short reading, there followed music from the Freedom Two Hundred Chamber Orchestra, Witchell explaining that "the orchestra [had] been especially formed for these bicentennial events" and that "many of its members [were] of African descent."[21] The inference was clearly that those of African descent had been drafted in to be the face of race for a few days. Baroness Amos, who Gordon Brown has recently demonstrated is always a convenient option when a black face is needed in a tricky situation, then read a short passage from Luke: "Let the oppressed go free."[22] This was followed by the address delivered by the archbishop of Canterbury, the most Reverend Dr. Rowan Williams. He began: "In the name of the Father, the Son and the Holy Spirit Amen. Human beings are born free yet everywhere they are in chains. A great and inspiring slogan for progressive thinking in the last two centuries, yet the very act of this commemoration should make us question it."[23] There followed a woolly piece of nonsense, moving between past and present forms of enslavement. The analysis mushed all forms of slavery, past, present, and future, into one sludge. The final assertion of the speech was that original sin means "no we are not born free," but that we have to learn how to be free through Christ. "We need the spirit of the Lord on us and within us."[24] The record was stuck again on the old mantra, so beloved of the pious slave captain John Newton, that we are all enslaved to sin, "universal sin," "original sin," and that God is the final and the great Liberator. The abolitionists were presented as the servants of God, and poor Equiano was as ever requisitioned to the latest cause. This was followed by more tokenism and positive discrimination, a very brief excerpt from a symphony by the Chevalier de San George, a composer, Witchell noted, "who was known in his lifetime as 'the Black Mozart.'" In the same way that Europeans would dub Toussaint l'Ouverture the "Black Napoleon," and in a smaller way Kwame Kwei-Armah "the black David Hare," this musician could only be seen through an overpowering white mist of achievement. Why he couldn't just be "the Black Chevalier de San George" wasn't clear.[25] The service was then to climax with the confession and absolution. The dean began his absolution by stating: "All of us have sinned and fallen short of the glory of God, let us therefore confess our sins in penitence and faith to our gracious Father."[26]

The dean's command that the audience get down on their collective knees and beg forgiveness was for Toyin Agbetu the straw that broke the camel's back. It was at this point that he could contain his outrage no longer, and he strode into the middle of the aisle, the cameras all following him, assuming for a few seconds, because he seemed so sure of what he was doing, that he was part of the official proceedings. Agbetu raised his hands in a gesture of peace, but was lucky that he was not immediately dealt with by a police terrorist squad, who are trained to read such gestures as lethal. Often the raising followed by the lowering of the arms is the trigger gesture for a suicide bomber.[27] Yet once it was plain that Agbetu wanted to talk, and not to detonate himself, the security personnel were in a difficult position. They could hardly wrestle this articulate black man to the ground before the world's assembled press. The BBC cameramen clearly had silent instructions, however, for almost immediately after Agbetu began to speak the cameras were pointed skyward, at the vaulting of the Abbey, avoiding Agbetu as completely as if he had been a streaker exposing himself at the World Cup final. Witchell, however, was still broadcasting live on the radio and needed to keep saying something to drown out Agbetu (the sound system was not turned off) and to explain why what was supposed to happen was not happening. He presented Agbetu as a ranting protestor. The narration was as follows:

A protestor has stepped forward in the Sacrarium, he is being escorted to one side by Abbey officials the Dean is continuing. . . .

[Loud shouting as the Dean raises his voice and tries to continue, and Agbetu carries on his objections.]

As you can hear the protestor is still shouting, making his protest he has been taken to one side by officials but he is refusing to leave. [The passionate command of Agbetu rises above the general confusion shouting and then repeating "Let. Go. Of. Me."] The service has been interrupted by this protest, which took place not far from where the Queen and the Duke of Edinburgh are seated in the Sacrarium, the protestor stepped forward without warning and began shouting. . . . Still this man is making his protest, officials I think unwilling to use force to make him leave, he is now surrounded by half a dozen officials who are trying to persuade him to desist from this protest and to leave the abbey as you can hear he is insisting that there should be an official apology, he is saying that Britain should say sorry for what had happened, and still the officials are resisting using no more than a minimum of force, he is being gently pushed now towards the choir screen, and out into the nave, but

as you can hear he is still shouting his protest, the congregation is sitting in
silence while this episode continues the Queen and the Duke of Edinburgh
very aware, the whole abbey is aware of this protest, now this protestor is being
escorted along the full length of the nave towards the West door. He inter-
rupted what really was the most solemn part of the ceremony the confession
and absolution the Dean did however continue with it.[28]

But Witchell was not accurate. The dean had stopped long before Agbetu's
forced departure, and by now the entire ambience of the service had been radi-
cally altered. As one eyewitness described it to me, Agbetu had "brought the
whole thing down like a house of cards."[29] Agbetu's lengthy intervention did
achieve a basic change in the event. Suddenly it was no longer stage-managed,
a memorial closed-shop, but meant something different and rather moving.

Agbetu has explained his actions subsequently, and although some of his
attitudes are unhelpful in their extremity, the comparison of the English slave
traders to Nazis in particular, he does have a coherent position:

> The "Wilberfest" abolition commemoration had eradicated any mention of
> resistance, rebellion and revolution instigated by millions of African people.
> ... I stood up with my arms raised in a gesture of non-violence and said "Not in
> our name" to Dr. Rowan Williams who was attempting to lead the congrega-
> tion, which included a number of African people, to their knees to beg God's
> forgiveness for the slave trade. . . . I went to the Queen and told her that in the
> history of the Maafa the English are the Nazis, I then turned to Tony Blair
> and told him he ought to be ashamed for his behaviour, he quickly averted
> his gaze. The rest of what I said was directed to members of our community,
> I don't believe it was right for us to have remained in a venue in which the
> British Monarchy, Government and Church, all leading institutions of Afri-
> can enslavement during the Maafa, collectively refused to atone for their sins.
> Then a gang of men attempted to drag me out through the back door on my
> knees. I strongly asserted that I would be walking out of the front door, on my
> feet, as an African.[30]

Blog reactions explain very fully why Agbetu's intervention was necessary
and meant something. It is dangerous to give unreconstructed racist hostility
a space it does not deserve, but I want to quote a tiny sample of the vitupera-
tive outbursts that Agbetu's actions generated. Britain seeks to deny that it
contains a large white element that still believes that anyone black is not Brit-
ish, but from some other homeland, and that all ethnic minorities are privi-

leged to be on British soil and have no right to be uppity, let alone to insult the beloved queen. This "rivers of blood" element came into its own in the hours following the service. One "Martin" posted an "Open letter to Toyin Agbetu," which began:

> You are a public menace, and should get out of this country and go back to Africa on the first available flight. Your little publicity stunt in Westminster Abbey certainly got your name in the papers — although I have to say that if I, a 36 year old, 14 stone Glaswegian white man, tried the same trick the royal protection goons would probably have dropped me before I got out my chair and the pathologists would still be picking bullets out my corpse. But such is life. The police have to be very careful about accusations of racism; which is very probably why you were gently ushered out of Westminster Abbey still screaming abuse at the monarch instead of being frog-marched out in handcuffs with a bag over your head, which to my mind is what you deserved.[31]

This immediately generated a host of bloggers' replies, of which I quote the following as typical:

> Shotgun said . . . Nice one and prety [sic] much reflects my thoughts. Why are they here? Why don't they fuck off back to their motherland? Cunts all looking for a handout and handup [sic] and excuse as to why they are cunts. 3/29/2007 09:48:00 a.m.

> Anonymous said . . . What a marvellous bit of rhetoric about the shenanigans in Westminster Abbey from that prat! Slavery was abolished by the English but started (and continued) by the Arabs. Excellent — but lets himself down on comments about the British National Party. [This comment is in response to a section of the "Open Letter" where "Martin" had registered his disapproval of the BNP.] We want to build up not destroy this country. You never know, Nick [Griffin, leader of the BNP] might well go to church with the Queen, God bless her — even if she does sign away her Sovereignty in May 2009! 3/29/2007 09:51:00 a.m.

> crackers said . . . Toyin Agbetu. Before I apologise and sign over my house to your bretheren [sic], I would like you to take me through the history of Liberia from circa 1840. I want to understand the benefits of whitey beating his breast and making some financial sacrifice for past misdeeds. I want some evidence that the act of contrition and £7 trillion will help. Basically Tyin [sic] its [sic] people like you who are preventing Africans from standing on their own two

feet and getting their continent organised. You are looking in the wrong direc-
tion. Try the mirror.
3/29/2007 09:51:00 a.m.

Umbongo said . . . I don't blame Toyin for all this. If I had no talent except
for having black skin and a big mouth I'd do exactly the same. After all — as
Martin implies — Darcus Howe and Yasmin A-B (and even our very own Lee
Jasper) would be reduced to earning a (probably meagre [sic] but, at least, hon-
est) living if they didn't have the benefit of fashionable ethnicities.
3/29/2007 11:06:00 a.m.

R—— T—— said . . . People need to look very closely at those stirring up
trouble. You will notice that almost all have a direct or only slightly indirect
gain to be made from such trouble. They are filling their ricebowls [sic].
NO GRATITUDE SOME PEOPLE, WE EDUCATED THEM, CLOTHED THEM
AND STOPPED THEM EATING EACH OTHER
3/30/2007 02:00:00 p.m.[32]

Brutal unreconstructed racism is still endemic in British society, but it does
not exist in cultural isolation. What these ghastly responses establish is the
extent to which the most extreme white racists seek to attach themselves to
church and state. It is consequently the duty of church and state to set out posi-
tions over race, slavery, colonialism, and empire that make it impossible for the
extreme right to claim any form of identification with them. It would appear
in retrospect that the Westminster Abbey memorial service failed to do this.

A GOOD DAY TO EXHUME BAD NEWS: NEW LABOUR
AND SLAVERY AS A MARKETING OPPORTUNITY

The British government, then, under the leadership of Tony Blair, threw an
awful lot of money at a publicity drive surrounding the bicentenary.[33] Slavery,
indeed the international monopolization of the Atlantic slave trade, is not
something that any nation can easily celebrate, and yet it seemed that the
formation of a successful abolition campaign could exist in a triumphal zone
of its own.

Before looking at what was officially done at home, it is educative to glance
at how Britain operated abroad. West Africa was in reality largely excised
from the celebratory machinery erected around 2007. The major exception
in this regard was Ghana, partly because of British imperial involvement with

the country and partly because the fiftieth anniversary of Ghanaian inde-
pendence coincided with the bicentennial. There was consequently an onus
upon the British government to attempt to become involved with Ghana-
ian celebrations and to control the manner in which abolition and indepen-
dence were marketed and packaged. The British Council was put in charge of
marshalling the culture wars around the official Ghanaian commemorative
events, and it seems to have done a tremendously effective job of exporting
the "right" ideas and closing down the "wrong" ones.[34] To understand where
these notions of right and wrong come from, it is essential to see the British
Council for what it is and what it is not. It *is not* an independent body spread-
ing the best of British culture to a developing world. It *is* a propaganda wing of
the New Labour government. The British Council acted under strict criteria
set out in memorandums from the British Foreign and Commonwealth Of-
fice, and they were in their turn directly answerable to the secretary of state.
Officially Britain was presented within Ghana, and by complicit Ghanaians
working through the British Council, in a most favorable light. Yet there were
dissenting voices who uncovered the deeply troubling cultural manipulations
and complicities that allowed 2007 under the aegis of the British Council to
operate as a full-blown propaganda drive.

 Ghanaian Manu Herbstein devoted much time in 2007 to detailed detec-
tive work uncovering exactly how the British Council in Ghana spearheaded
a chillingly effective series of glamorous cultural events that prioritized one
version of history while completely silencing aspects of British colonial depre-
dation in Ghana over the past three centuries. At the big international confer-
ence *The Bloody Writing Is Forever Torn* in El Mina, Ghana, in August 2007,
Herbstein delivered "Silences: A Reflection upon How the Bicentenary of the
1807 Act for the Abolition of the Slave Trade Was Marked in Ghana," a bril-
liant and incendiary analysis of exactly what had been going on.[35] Herbstein
opened with a concise set of close readings of the absurd but corrupt advertis-
ing freebies that had been manufactured and given out en masse at British
Council events. This satiric opening was followed by a powerful core argu-
ment that has yet to find contradiction.[36] As far as Herbstein was concerned,
every key element in the British Council's celebration of 2007 was concerned
to silence British involvement in the slave trade in Ghana, and further to cam-
ouflage and erase all record of British military atrocity and imperial rape of
Ghana during the appalling actions of the early 1870s, and following decades.
The fact that celebratory performances by the British Council provided over-
flow seating on the very site of a major British atrocity, the destruction of

Edina, was only one of many disgraceful facts uncovered. Equally shocking was the demand by New Labour, via the British Foreign and Commonwealth Office, that all commemorative activity be restricted to coverage of the past two hundred years. By locking all events into a chronology after 1807 serious analysis of the period when Britain was actively involved in the slave trade was in effect prevented.

Herbstein was also troubled by the fact that all events were staged in El Mina. El Mina did not ship out English slaves, but was historically associated primarily with Portuguese, Dutch, and Danish slave trading. In fact, it was not El Mina, but Cape Coast Castle that was the center of the British slave trading on the Gold Coast. Yet when then Deputy Prime Minister John Prescott arrived to oversee official launches on February 14 and 15, 2007, even though he spent a morning in Cape Coast, his itinerary amazingly did not include a visit to Cape Coast Castle. Herbstein's meticulous work left, and leaves, absolutely no room for doubt that Britain had an agenda around the Ghanaian celebrations that was all about selective memory, the celebration of the gift of British freedom, and a total amnesia regarding Britain's inexcusable actions in Ghana in the late nineteenth century in successful pursuit of Ashanti gold. Although many of the Africans and Americans present were amazed and shocked at these revelations, and an electric and angry discussion was generated by his work, I have to say that I was not in the least surprised. I had already had to witness within Britain the lengths to which New Labour was prepared to go to put a positive spin on British involvement in the slave trade.

The official archive site, which by late 2006 informed the British public, and indeed the world, what New Labour was doing around the bicentenary greeted its audience with a banner headline and the following short explanation:

2007 BICENTENARY OF THE ABOLITION OF THE
SLAVE TRADE HONOURING THE PAST & LOOKING
TO THE FUTURE. NEW LABOUR.

Plans to mark the 200th anniversary of Parliament's abolition of the slave trade in the former British Empire today received the support of the Deputy Prime Minister, David Lammy (Culture Minister) and Paul Goggins (Race Equality Minister). Influential stakeholders were brought together by Ministers to create an Advisory Group, chaired by the Deputy Prime Minister, to discuss how best they could maximise their organisations' contributions to

the bicentenary. Speaking almost 200 years after William Wilberforce — one of his predecessors as MP for Hull — led the campaign to change the law and abolish slavery in the British Empire, Deputy Prime Minister John Prescott said: "William Wilberforce's achievement and the suffering of so many must be remembered in 2007. This anniversary is an opportunity to reflect on the struggles of the past, the progress we have made and also the challenges that remain. Today is just the beginning of what will be a fitting commemoration in cities and towns across the country on this momentous occasion."[37]

What these statements make clear is that for New Labour the 2007 bicentennial was the chance to reestablish national ownership of a much sought after brand, the "Liberty" brand. The official announcements on the bicentennial quoted in part above do tell us a lot about how then Deputy Prime Minister John Prescott's advisors desired to set up and exploit the occasion. Apparently this was definitely another type of "good day to bury bad news," and the bicentennial gave Britain a chance to "honour" the past, while moving on and "looking to the future." Given that the British domination of the transatlantic slave trade is hardly an honorable aspect of Britain's past then what is being honored in the past is not slavery, but abolition. In fact, it is not abolition but the leaders of abolition, and it is significant that the only name that made it across the centuries into John Prescott's generalizing statement was that of William Wilberforce. There might, however, be doubt about what exactly the determined diminutive moral crusader from Hull would have made of the amorous extramarital frolics, not to mention the bulimia, of the successor to his parliamentary seat.[38] The whole way in which this pitch of the bicentenary is set up concerns selling culture and exploiting cultural memory. The government's 2007 Bicentennial Advisory Committee was concerned to get "influential stakeholders" together in order to "maximise their organisation's contributions." What on earth constitutes a "stakeholder," let alone an "influential" one, is hard to imagine when we are considering the memory of the British slave trade. The rhetoric here is venal and just plain wrongheaded.

HEADING THE "APOLOGY DEBATE" OFF AT THE PASS

So much of the government response was about controlling the terms in which the bicentennial was to operate. Indeed, the bicentennial first entered popular media, and consequently public consciousness, when Blair attempted to put the apology debate to bed. The question of apology is a particularly

sensitive one in the context of the inheritance of the gift of freedom. The need for an abject apology does, after all, beg a question in that it suggests that the gift of freedom was in itself and of itself not enough to counterbalance the negative aspects of the slavery inheritance. The British press carried stories of Blair's expression of a near hysterical desire to have an apology for slavery as part of his much vaunted public "legacy." He therefore needed to get something out in the open before he stepped down. Baroness Amos carelessly flourished notes from a meeting with Blair when the question had cropped up, unaware that the cameras were lurking. As *The Guardian* reported: "Plans for Mr Blair's apology became public this month after Lady Amos showed notes from a meeting with the prime minister discussing whether to back a UN resolution on slavery tabled by Caribbean countries. The notes contained the phrases 'window closing, political pressure mounts, get it out of way' and 'do it before end of year.' The notes said the apology would be 'internationally recognised' and 'status enhancing.' "[39] In the event Blair fudged the issue when he, or his speech writers, produced a short statement in the unlikely location of the *New Nation*, which appeared on November 27, 2006.

The only sentence in the piece that was taken up generally in the media appeared in the third paragraph, and concerned the appropriate emotional and moral response that the government should adopt toward the question of British participation in the slave trade. Blair was widely quoted as stating: "Personally I believe the bicentenary offers us a chance . . . to express our deep sorrow that it [the slave trade] ever happened." That seamless grammatical conjunction of "personally" with "us" and "we" tells us a great deal about Blair's assumptions and posturing. Who is the "us" he refers to? Is it the New Labour ministry, the whole of his party, the entire electorate, all of humanity?

The piece progresses by constantly harping on the theme that everything is improving, everything is perfectible, that we all have potential we need to fulfill, and that under New Labour's management of the bicentennial we will fulfill our potential. Africa is talked about in the most absurdly generalizing terms. Rather than a vast and complex continent involving a whole series of evolving histories, cultures, and nationalisms, it is set out as a single beautiful site, with a single beautiful population, bursting with potential. The prose is frequently operating outside the laws of English grammar and so strictly speaking without any meaning. Take the following sentence: "Africa, of course, is a place of great beauty, fantastic diversity and a resilient and talented people with enormous potential." Africa, a vast continent, cannot be described as a single "place of great beauty," as if it were Kew Gardens or

Sarah Palin's notorious "country of Africa." The grammar does not function properly: What is happening with the main subject of the sentence once the population of Africa is introduced? What are the words trying to say, that "Africa, of course, is . . . a resilient and talented people," or is Blair really trying to say "Africans are a resilient and talented people" or that "Africa contains a resilient and talented people"? Even assuming this final option, how can the entire population of Africa be described as a single "people"? The level of patronizing ignorance behind this verbiage beggars belief. And yet it was this piece of nonsense that set the tone for, and dominated, the public discussion of British domination of the Atlantic slave trade in the months leading up to the bicentennial.

Many of the plethora of responses that the Blair article elicited seemed to be competing with the original in terms of their illogicality and total ignorance about Africa. On December 2 Charles Moore, a minor columnist for the *Daily Telegraph*, produced a piece that in its reductivism and logic chopping revealed all too clearly how morally abject establishment responses to the bicentennial could still be. It also revealed how much remains invested in the liberation theology of British abolition. He opened by saying that no British prime minister of today had anything to apologize for when it came to the slave trade, and supported the assertion with his comparative trump card. If Blair wanted to express "deep sorrow" for the slave trade, then shouldn't the chief rabbi express "deep sorrow" on behalf of all Jews for the crime of the crucifixion? The next move was to condemn Blair for being too sorrowful, because for Moore, as for so much of middle England, "the bicentenary should be a cause for celebration." The piece goes on to set up the Slave Trade Abolition Act as a typical piece of Anglo-Saxon reasonableness: "This tradition of improvement through argument and law is a very good one, and it is stronger in Anglo-Saxon countries than anywhere else. We should give thanks for it, even though the onward march of legislation is not the same as the onward march of liberty. It is rather shaming that the bicentenary next year will coincide with the ban on smoking in pubs and clubs."[40]

This risible piece of elementary debating, as the hack's roving mind moves from the "abolition" of the slave trade onto the deliberately trivial subject of the "abolition" of the normal British bloke's right to smoke a cigarette in the pub, demonstrates just how dangerous a sideshow the whole apology debate was. It allowed just about anybody the opportunity to weigh in with outraged statements about the magnificence of British philanthropy, the greatness of the British Empire, or denigratory comments concerning African responsibil-

ity and complicity in the slave trade. Surveying the mass of material this issue generated, it is now hard to see the so-called apology debate as anything except a convenient smoke screen designed to prevent serious discussion of what the slave trade had really meant to Britain, and what its inheritance might be.[41]

MS. DYNAMITE AS NANNY MAROON

This brings me to another set of questions we must now ask of the 2007 bicentennial. Why was abolition activity working toward the legislated gift of freedom given so much space and black slave agency so little? Why was the black body represented according to such outmoded stereotypes of passivity? Taking an overview of the major commemorative events supposedly describing Britain's participation in, and domination of, the Atlantic slave trade, it is depressing that the rhetoric formed predominantly revisionist and unchallenging patterns. The Anglocentrism of the majority of coverage also indicated many lost opportunities to widen the debate into different areas and contexts in the diaspora. There were exceptions, and some particularly fine work came out of the investigation of the economic and mercantile effects of the wealth generated by British involvement in the slave trade and Atlantic slavery. Michael Buerk fronted a deeply researched and cleverly structured tripartite series on Radio 4 entitled "Trade Routes."[42] From its dramatic opening in the All Souls College, Oxford, where the white marble figure of Christopher Codrington and his vast library were revealed to have been constructed out of blood money from his slave plantations, this series painstakingly looked at how British banking, the established church, and the industrial revolution all developed and prospered through the fortunes generated by Atlantic slavery.[43]

Yet the production of sustained, serious, and influential work dedicated to the celebration of slave agency in 2007 came from an unexpected and uplifting direction. The contribution of two remarkable British black women stood out, both of whom gave the myth of the gift of freedom an impressive kicking. Moira Stuart produced a spirited and intellectually focused documentary on the relation between slavery, abolition, and memory. This came to a straightforward, yet very necessary conclusion: "No, William Wilberforce did not abolish the slave trade."[44] Stuart talked to a variety of academics, chosen for their intellectual distance from naive and celebratory responses to the myths of abolition. She also got out of England, and her interviews in the British

Caribbean, and most intensely in Ghana in Cape Coast Castle, revealed that out there it was the slave heroes and heroines of black resistance upon whom cultural memory is focused. In a balanced and determined way Stuart produced a piece of television that finally revealed Wilberforce as irrelevant to the historical thought of the black slave diaspora.

Taking things further in this direction was Naomi McLean-Daley, better known as the rap and soul star Ms. Dynamite, who fronted a powerful piece of work on Nanny of the Maroons. This documentary didn't mention a single white abolitionist but was in search of a black diasporic legend, Nanny. The program was engaged, sensitive, and hungry to think through exactly what the distance between myth and history meant. Ms. Dynamite was up and down and all over Jamaica. Appearing on the great Dub poet Mutabaraka's radio chat show, she was skeptical when he mentioned that Nanny could "catch bullets in her bottom," but she soon saw what he was doing and they shared a moment of intense Jamaican irony. Nanny's bullet-ridden bottom is not a joke, but a point where white terror of a black myth meets black humor, and where Obeah and herbal medicine, not to mention cunning, enter the equation.[45] The program slowly expanded on this insight, namely, that it was the whites who wanted, who needed, to believe in Nanny's magic bottom, not the blacks. If there wasn't magic, how could the impenetrable British army be defeated? And one of the most impressive aspects of the interviews in this documentary lay in the way they showed that it wasn't simply the Maroon leaders who talk of Nanny in terms of the fear and magical aura she generated.

One of the most powerful interviews was between McLean-Daley and Commanding Officer Stephen Brown, a black officer in the Jamaica Defence Force. Impeccably turned out in black beret and combat uniform, he talked of the brilliance of the Maroon army's use of camouflage and guerrilla defense tactics, at a time when such things were unknown to the military powers of Europe. When asked about the relevance of Nanny's Obeah, or spiritual powers, his answer, as a soldier trained in the psychology of war, was fascinating:

For the guerrilla campaigns of the Maroons Nanny's prowess as an Obeah woman was the most important factor, it instilled fear in the British forces, she was reported to carry about her waist knives, and each knife, there were about eighty, had killed a British soldier, and she wore around her neck the teeth of some of the British soldiers that she had killed. So that fear of witchcraft, that fear of necromancy, was the Maroons' greatest weapon.[46]

There was a straightforward analysis of the fact that Nanny was fighting a slavery system that functioned by creating fear through the infliction of pain. What the whites were capable of doing, casually to their slaves, was presented as pathological, as insane. McLean-Daley went around a slavery gallery, and examined various objects of torture with local historian Cecil Gutsmore. Somehow the footage worked because of the purity of emotional response. McLean-Daley had clearly never before seen little shackles especially designed for slave children, or an iron gibbet for a grown man to rot to death in. She never actually cried on camera in this film; she is clearly one very tough but very sensitive young woman. But when she bit her lip and looked down, hearing of child torture, it was obvious that this young mother was going out into an experience beyond simple words or history. Moments like that cannot be faked, and McLean-Daley retrospectively underlined that the intensity of her reaction was not grounded in simple appropriative empathy with the black victim, but in her incredulity, her sense of the impossibility of ever entering the minds of the torturers. The documentary moved straight from this scene to an excruciating interview between McLean-Daley and David and Nicky Farqueson, present-day plantation owners and direct descendents of a great planter family in Jamaica. It was the almost complete mutual incomprehension between the interviewer and the interviewees that made this exchange of lasting value.

McLean-Daley's approach to Nanny as history was open. There are very few provable facts about Nanny, one or two references in archive materials, one entry relating to a land deed. Not only her birth and death dates, but her whole chronology is fluid. Rather than see this as problematic, McLean-Daley dived into the full richness of folklore, oral culture, song, and the present-day reverence toward Nanny that the Maroon villagers still express in every aspect of their life and art. There was also a consideration of the cultural marketing of Nanny in visual art. The signs and symbolism that have evolved around her are as fluid as her myth, and the discussion ranged from her image on Jamaican currency to the public sculpture produced in 1976 to mark the moment when Nanny was named Jamaica's first and, up to this point, only female national hero. There was also an extended interview with the African American artist Renée Cox. Cox's work explores black history and memory through photographic historico/autobiographical projections of a type not dissimilar from those of Cindy Sherman. In 2007 Cox produced a show devoted to the presentation of herself in multiple guises as Nanny, which was widely shown and discussed in the United States. Nanny clearly had a mythic

presence across the black slave diaspora of which the white custodians of the 2007 bicentennial in Britain were unaware.

What was particularly forceful in McLean-Daley's approach was her constant awareness that Nanny's final importance may lie in the way she provides an open site for energized, even violent female self-empowerment. Her final approach is, like Cox's, assimilative and appropriative. She summed up what Nanny had come to mean to her: "She stands for confidence, struggle, resistance, rebellion, not bowing down to someone's expectations, there's been times in the last week where I've learned little things about Nanny here or there and I've thought, oh gosh, that's just such a me thing to do, or a me thing to say, or a way that I personally think I would be, that there is a little rebel in me."[47] In brief, Nanny is that very rare thing, an embodiment of black female agency in the age of slavery. As such she is up there for grabs by every strong, creative young black woman in the Atlantic diaspora; she is a mythic role model. She holds a similar position as female revolutionary icon in Jamaica to that occupied by Zumbi as male revolutionary in Brazil, and yet she passed the British bicentennial by almost unnoticed. Small wonder that Toyin Agbetu shouted out in dismay in Westminster Abbey, "Not a mention of Nanny."

Yet Moira Stuart and Ms. Dynamite were whistling in the media wind. My sense of increasing tedium, and I suppose my feeling that we were largely cheated, in 2007, now that the dust has settled, result from the fact that in so many ways nothing has changed much in two hundred years. Basically, Britain's societal response to 2007 hid behind a date, and used 1807 as a monolith, or is it a shibboleth, to avoid thinking of the wider implications of the outfall of the slave trade right now. This avoidance had two major manifestations, both remarkably conservative in their processes. The first lay in an undue emphasis upon a celebratory approach to a supposed magical and chimerical moment of transformation. But that side of the memorial equation dealing with the celebration of the "heroes of abolition" was set off against an equal and opposite element, namely, the anonymous and passive representation of the slave body. Surveying all areas of popular display, within the media and within museum culture, the slave body appeared trapped within a series of visual motifs that prioritized slave inactivity, slave suffering, and slave anonymity. In drawing upon a body of visual material developed by the abolitionists in the late eighteenth and early nineteenth centuries, British popular visual culture in 2007 perpetuated a series of controlling stereotypes for the configuration of Atlantic slavery.[48]

OBJECTS, MUSEUMS, AND THE FREEDOM FETISH:
MUSEOLOGICAL APPROPRIATIONS OF 2007

The 2007 bicentennial inevitably forced confrontation with the difficult and probably irresolvable question of whether it is possible to represent the memory of the trauma of Atlantic slavery through museological display. Given the spur of a pot of National Lottery funding to compete for, just about every institution that put in a bid tried to reinvent itself or refurbish itself for the bicentennial. Liverpool and Bristol set up new permanent slavery displays; Hull had a complete makeover. The big London institutions made an attempt, and several museums decided to reassess their collections from perspectives questioning the privileging of economics and trade.

Of these attempts, the most impressive were the *Trade and Empire: Remembering Slavery* exhibition at the Whitworth in Manchester, the Natural History Museum's wonderful slavery colloquia, devoted to analyzing flora and fauna in their collections from the perspective of the slave trade, and the new permanent "Sugar and Slavery" Gallery in the Docklands Museum.[49] The latter constitutes one of the few new permanent museum displays to come out of 2007, and the only one in the capital, and is therefore of particular importance. The new gallery at the Docklands Museum was a project that had thought deeply about the problematics of providing effective solutions to the impossible task of representing the inheritance of the British slave trade. Much of the gallery thinks about how the wealth of the slave trade had transformed the life and culture of Britain, and attempts to question simple notions of white achievement, white guilt, and even white memory. While there is much to admire in the ambition of the curators who set it up, the gallery does, however, leave me with deep worries.[50]

The Importance of Being Wedderburn — or the Perils of Dressing Slaves in Borrowed Robes

London's Docklands Museum received fairly substantial lottery funding in 2005 in order to set up its permanent gallery.[51] This led to a set of spaces that utilize a variety of conventional, and many new and unconventional, display techniques in order not merely to present, but to interrogate, the public display of the London docks' involvement with slavery and trade. Some of the displays were ambitiously proactive and were designed to destabilize significant objects already held in the museum's collections. Several specially commissioned exhibits were involved in generating what might be called in Said-

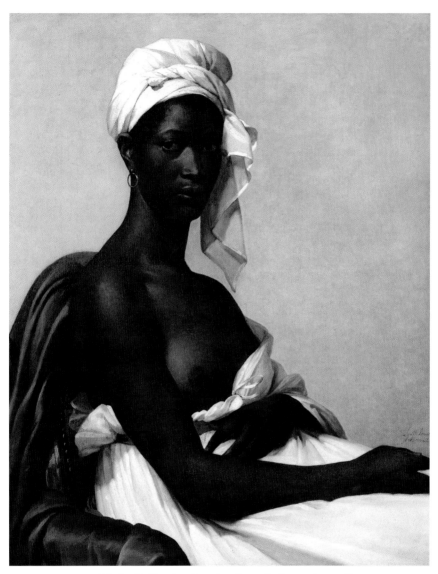

PLATE I. Marie-Guillemine Benoist, *Portrait d'une négresse*, Louvre, oil on canvas, 1800. The Bridgeman Art Library International.

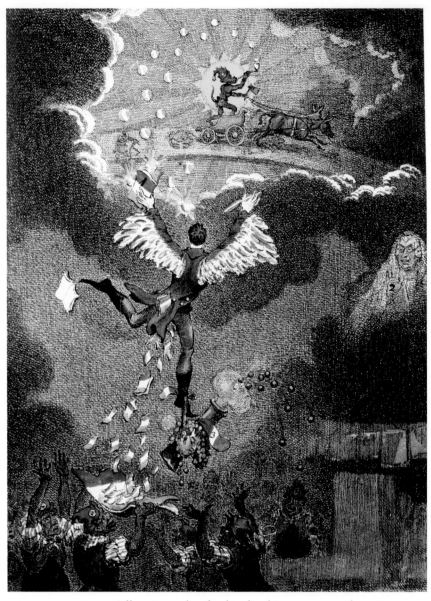

PLATE 2. James Gillray, *Icarus*, hand-colored etching on copper plate, 1800.

PLATE 3. GB Royal Mail, first-class commemorative stamp, "Abolition of the Slave Trade 1807 William Wilberforce," 2007.

PLATE 4. GB Royal Mail, first-class commemorative stamp, "Abolition of the Slave Trade 1807 Olaudah Equiano," 2007.

PLATE 5. GB Royal Mail, 50 p commemorative stamp, "Abolition of the Slave Trade 1807 Granville Sharp," 2007.

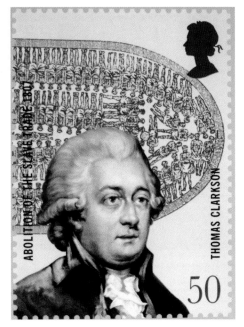

PLATE 6. GB Royal Mail, 50 p commemorative stamp, "Abolition of the Slave Trade 1807 Thomas Clarkson," 2007.

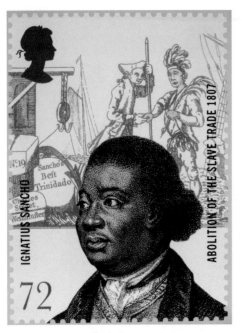

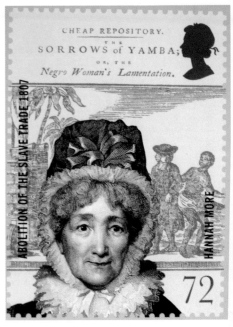

PLATE 7. GB Royal Mail, 72 p commemorative stamp, "Abolition of the Slave Trade 1807 Ignatius Sancho," 2007.

PLATE 8. GB Royal Mail, 72 p commemorative stamp, "Abolition of the Slave Trade 1807 Hannah More," 2007.

PLATE 9. GB Royal Mail, Bletchley Park FDC set of six stamps, "Abolition of the Slave Trade 1807," 2007.

PLATE 10. Brazil, 1.05 reis stamp commemorating
"300 Anos da Morte de Zumbi dos Palmares," 1995.

PLATE 11. Barbados, General Post Office, FDC for 3 dollar stamp, "Abolition of the Slave Trade Act," 2007.

PLATE 12. Barbados, General Post Office, FDC for set of 10 cent, 1 dollar, 175 cent, and 2 dollar stamps, "Abolition of the Slave Trade Act," 2007.

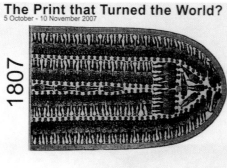

PLATE 13. "The Print That Turned the World?" invitation card, London Print Studio, November 2007. Courtesy of London Print Studio.

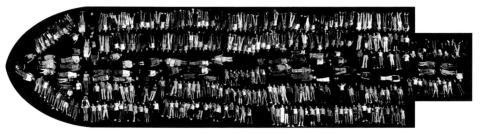

PLATE 14. Digitally remastered photograph of "Brookes Performance," Wilberforce Primary School, November 2007. Courtesy of London Print Studio.

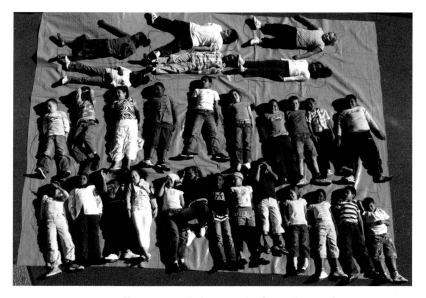

PLATE 15. Digitally remastered photograph of "Brookes Performance," Wilberforce Primary School, November 2007. Courtesy of London Print Studio.

PLATE 16. John Phillips, *Katerina*, pencil on paper, after
Albrecht Dürer, silver-point sketch book, 180 × 120 cm,
October 2007. Courtesy of London Print Studio.

PLATE 17. John Phillips, *Pygmalion*, studio photograph, October 2007. Courtesy of London Print Studio.

PLATE 18. London Print Studio, photograph of window display, Harrow Road, November 2007. Courtesy of London Print Studio.

PLATE 19. Kente cloth from Ghana, Clarkson's chest, n.d.
(Photograph Marcus Wood)

PLATE 20. Slave yoke, installation, Palace of Westminster, 2007.

PLATE 21. Haitian voodoo shrine, permanent slavery exhibit, Wilberforce
House Museum, Hull, installation, wood, metal, plastics, 2007.
Courtesy of Hull Museums. (Photograph Marcus Wood)

FIG. 7.2. Thomas Lawrence,
George Hibbert, oil on canvas, 1811.
© Museum of London

FIG. 7.3. Lloyd Gordon as Robert
Wedderburn, photomontage, 2007.
© Museum of London / Paul Howard

ian terms a "counterpoint" to dominant traditional white discourses. New
contexts rooted in slave life and resistance, and black life in Britain, were fed
in, but at times these semiotic hybrids led to questionable results. Typifying
the worthy but finally methodologically misguided approach was the decision
to attempt to destabilize a portrait of an eighteenth-century slave owner, by
commissioning a modern, or was it postmodern, parody of his portrait, which
featured a fantasized image of an early black activist.

Hanging next to each other at the conclusion of the "Sugar and Slavery"
Gallery in the Docklands Museum are two full-length portraits (figs. 7.2 and
7.3). On the left is an 1811 portrait of George Hibbert, the first chairman of
the West India Dock Company and leader of the proslavery lobby that fought
against the abolition of the slave trade. It is an academic portrait in oils. On
the right of him is a photomontage parody of the Hibbert portrait showing
a contemporary mulatto male, Lloyd Gordon, in the guise of the historical
figure of the incendiary radical revolutionary and black rights activist Robert
Wedderburn. Presumably the attempt was intended to raise Wedderburn up,
through the power of parody, or was it irony, to Hibbert's level and conse-

quently to give him an equal stature in history. The real effect is, however, ideologically suspect, the Wedderburn/Gordon fusion producing a freak icon ideologically stranded somewhere between Cindy Sherman and a fairground memento. One big problem relates to the manner in which power operates through form and technique. The portrait of Hibbert was produced according to the highest levels of mimesis then technically available to a top artist. It is a statement of ruthless mercantile power, a celebration of the wealth produced by the sugar plantations. The other image is a nonportrait of Wedderburn, who has been usurped by a photograph of someone else. This phoney Wedderburn has no status, no power, and above all no identity. He is only able to exist in mimicry of the white simulacrum that has spawned his shadowy existence. Wedderburn has been done up, in every sense of the phrase, in the costume of the slave trader and forced to adopt the same stance as the symbolic representative of all he hated and fought against. There is a total lack of respect for the real Wedderburn here. The bizarre contradictions that made up this wonderful man — fierceness, unruliness, irreligion, flamboyance, immorality, scurrility, magnificent anger, and outrageous impertinence — have disappeared.[52] The absurd substitutions — an African sword for a watch chain, floorboards for carpet, sugar casks for table and chairs, newspapers for a map of the West Indies, a cap of liberty for a silver basin — again only serve the purpose of emphasizing how catastrophically out of his aesthetic element the fantasy Wedderburn has been taken. This surely is a self-defeating gesture. The attempt to critique the slave power by dressing up its victims in its very own borrowed robes must of necessity close down and distort the voice of the oppressed.[53]

New Lamps for Old: Buxton's Table as Museological Palimpsest

Another prominent example that illustrates the dangers of trying to overturn the associations of an already extant exhibit is the Buxton table. At the center of the "Sugar and Slavery" Gallery is a large, round wooden hall, or library table, about seven feet in diameter, with inset drawers (fig. 7.4). It is a quality piece of joinery with classic Georgian lines that would grace any auction house. The polished top is completely plain, except for an engraved copper plaque set flush into its center. The table stands raised on a circular white dais and is sealed off from the public by eight stainless steel bollards and a crimson rope. Set among the illustrated plaques and sign boards with information about the history of slavery, abolition, rebellion, and sugar production, and surrounded by glass display cases filled with sugarloaf molds, machetes, coffee

and tea sets, coins, chains, samples of sugar, and so on, the table is dominant
and awkward. Its inclusion is explained by the text on the plaque:

> This table hallowed by intense labour and earnest desires now happily
> fulfilled was presented to the popular hospital in 1855 by Sir Edward N.
> Buxton Bart through M. Samuel Gurney, the founder of the hospital. It
> had been the property of Thomas Fowell Buxton M. P. and round it
> had sat with him at 57 Devonshire Street between 1823 and 1833
> William Wilberforce M.P.
> Zacharay McCaulay
> Dr. Lushington
> & others discussing & drafting the Bill for abolishing slavery in the
> British Dominion which received royal assent May 28th 1833.[54]

In other words, this is another abolition fetish object, worshipped in the same
manner that the Lincoln Emancipation inkwell and the pen that Princess
Isabella used to sign Brazil's Golden Law are worshipped in Washington and
Petropolis.[55] The table combines history and mystery in equal measure. It may
look like any old table but this property is drowned in significance and its
first-rate provenance, its abolition pedigree, sets it apart as an object. It was
owned by one famous male abolitionist, Buxton, and around it sat, like latter-
day knights of the round table, the heroes of British abolition, with the saintly
Wilberforce as their King Arthur. The final act abolishing British colonial
slavery was created on and around this piece of wood, and this fact makes
it quite literally sacred. The great abolitionists wrote upon it, rested their el-
bows on it, touched it; who knows, it might even have some Wilberforcian
DNA upon it. The table is consequently transmogrified before our eyes, and
turned quite literally into a sacred relic. "Hallowed" is a powerful word to
apply to anything, let alone a table. The seventh word of the Lord's Prayer,
hallowed means to make holy or sacred, in other words, or in the words of
Chambers Dictionary, to have been "set apart for a sacred use," to have been
"made perfect in a moral sense," to have "become saintly," to have "become
holy, or completely sound." This wood has been transformed by three things:
by "intense labour," by "earnest desires," and by the fulfillment of this wishful
working in the passage of the abolition act.

The memorial plaque was also mass-reproduced in photocopy sheets for
visitors to read, and in another paper version was stuck on the white dais
beneath the table. It is a text that gives an undiluted and high Victorian ac-
count of emancipation, a perfect articulation of the horrible gift of freedom.

FIG. 7.4. Buxton table, permanent exhibit, entrance to the "Sugar and Slavery" Gallery, Docklands Museum, London, 2007. (Photograph Marcus Wood)

Yet the table and its plaque exist within a state-of-the-art museum gallery that in many other ways has been designed with deep thought and sensitivity concerning issues around slavery, memory, and slave agency. Consequently, the table presented a problem; because the Docklands Museum had it, they had to show it. According to the terms of the bequest, the curators could not physically alter the table in any way. They couldn't take away the plaque and put on another, yet they did their very best to attempt to alter its memorial function. Their only option in terms of trying to break down the hagiographic glorification of white abolition patriarchy, and give the slaves a voice, lay in attempting to overwrite the text of the plaque (fig. 7.5). The solution the curators came up with was to draw up a list of the names of slaves who were either insurrectionary or involved in different ways in resistance or abolition activity. These names are then periodically projected across the surface of the table in an intense bunsen-burner blue light. In the museological gloom the names of Bussa, Cuffy, Samuel Sharpe, and so on float in vast lettering across

FIG. 7.5. Buxton table, with light show turned on, permanent exhibit, entrance to the "Sugar and Slavery" Gallery, Docklands Museum, London, 2007. (Photograph Marcus Wood)

the wooden table. They have a ghostly, shifting, ephemeral presence, which stands in marked contrast to the solid, unfaltering, and unalterable engraved words of the gleaming table and its glinting metal plaque. The effect seems to be to tell us that the slaves must be remembered but, compared with that huge disc of hardwood, they are fragile and insubstantial. The unfortunate effect is to present the slave names as showy yet ephemeral in comparison with the rock-solid and real history of the white abolitionists. Wilberforce and Buxton were there first and they will remain there after the light show goes out, when the museum closes each night. Despite the best intentions of the curators, the table remains what it is: a monolithic monument to the myth of the emancipation moment. The problem with this holy table is that it has the same dull clarity of purpose no matter how you try to dress it up, and in this sense it stands in stark contrast to the radical instabilities and unstable ironies of another of abolition's holy relics that lay at the heart of the 2007 commemorations: Thomas Clarkson's chest.

Expanding Thomas Clarkson's Chest and
the Speaking Volume of Objects

In January 2006 I received an official letter from the House of Commons inviting me to write for a special edition of *Parliamentary History* to be devoted to the exhibition about slavery and abolition to be held in the Palace of Westminster. The letter informed me that a centerpiece of the show would be a traveling chest belonging to the legendary abolitionist Thomas Clarkson. While this object is undeniably connected to one of the iconic figures of British abolition, it has the capacity to expand and even destabilize many aspects of that tradition. The more I meditate on the meanings of this chest, the more it emerges as a sort of abolition Pandora's box. When it comes to the memory of slavery, the cult of Clarkson's personality and the power of objects from his chest provides a fascinating nexus in terms of what he did, how he did it, and how he might be constructed now. The renowned display chest, the contents of which Clarkson amassed at his own personal expense, was used in a variety of contexts to publicize abolition from a series of didactic perspectives, and it rightly held center stage in Westminster Palace. The chest and its contents create a charged and contradictory cultural space that throws up a series of unanswered, and maybe unanswerable, questions about what the abolitionists thought they were doing and about how they should be remembered now.

The chest itself (fig. 7.6) is a perfectly plain rectangle of polished hardwood measuring twenty-eight by seventy-six by thirty-five and a half centimeters. It has two unembellished strong brass carrying handles. When closed this object has a certain monumental simplicity and is always going to carry intimations of mortality. Given its proportions, its starkness, and its lack of ornamentation, it is not unlike a miniature pauper's coffin, the sort of object in which the remains of a bastard baby might have been laid to rest. Yet the interior of the box has a highly elaborate, even warren-like structure (fig. 7.7). It is divided into four levels by trays. Each tray is a different depth and subdivided by thin wooden partitions into a series of compartments, many of the smaller ones covered by individual tight-fitting lids. Looking at the object today it carries a myriad of associations. Full of surprises it is a sort of conjuror's box of tricks, holding a lot more than it seems it could. Yet filled with its little covered boxes, each containing a different hidden treasure, it relates both to the gentleman's cabinet of curiosities and, at a more instinctive level, to the curious child's delight in forming and organizing collections of just about anything. At this level it shares something of the same aesthetic appeal as

the intense boxed displays developed by the pioneering American conceptual artist Joseph Cornell. The simple box, containing so many carefully stowed objects, is also reminiscent of the seaman's chest, the object synonymous with the nomadic existence of the mariner, constantly packing and unpacking his worldly goods. As a basic container in proportions and utter simplicity it is virtually identical to this seaman's chest from the 1850s. This chest (fig. 7.8), with its naive design of slave and master inside the lid, was used in the 1850s by a sailor illegally employed in the slave trade. Yet given its intricate internal structure and its timber construction, the chest might even carry a more universal message relating to maritime metaphorics. Viewed this way it is reminiscent of a merchant ship, loaded in its different decks with different international trade goods. In this sense it carries ironic echoes of the slave ship itself, echoes that become all the more potent if one considers exactly what Clarkson put into this container and how the various objects related to each other and spoke through him to an audience.

So what did Clarkson put in this box, when did he do so, and why did he do it? Initially the chest was an elaborate visual aid used to illustrate a certain theory of trade economics. Proslavery arguments had focused on the exclusive profitability of the slave trade with Africa and laid stress on the fact that this human traffic was Africa's only significant export market. Clarkson's box was filled with samples of manufactured goods, agricultural materials, and even art objects that were intended to display the full range of trade markets that Africa supported and that could be developed within Europe. The box in this sense was intended to demonstrate that slavery was not an inevitable or even necessary aspect of future European mercantile expansion within Africa. Clarkson was following the general practice of the Society for Effecting the Abolition of the Slave Trade (SEAST) in using a typically up-to-date and cutting-edge visual aid. His box is a both a moveable lecture kit and a beautifully choreographed traveling salesman's sample case.

The long eighteenth century was a period when bourgeoning international trade markets and increased spending power among the nascent middling classes in Britain led to the sudden influx of increasingly diverse materials into everyday English life. Hardwoods from India, Africa, and the Americas began to appear in a variety of decorative domestic contexts in Britain.[56] New types of exotic flowers and plants were starting to be seen in English gardens, and so a market for new types of seeds developed. Exotic objects from the expanding empire were brought back as gifts, collected, and kept in cabinets. Sample books, catalogues, the traveling salesman — phenomena now so

FIG. 7.6. (*Top*) Clarkson's chest, exterior view. (Photograph Marcus Wood)

FIG. 7.7. (*Bottom*) Clarkson's chest, interior view. (Photograph Marcus Wood)

FIG. 7.8. Painting on inside lid, seaman's chest, American, oil on board, c. 1850.

familiar — were beginning to develop around the increased production and consumption of foreign goods. Certain types of furniture were manufactured as exotic display items. Table tops and other flat surfaces showed off a full range of exotic woods and veneers, or marbles and semiprecious stones; they were permanent domestic inventories of colonial produce.[57] Clarkson's chest, taken around to lecture halls and public forums throughout the land, related very directly to these developing markets and spaces of material exchange. At a certain level Clarkson was acting as abolition's traveling salesman. That the collection of samples he used was constructed with great attention to detail, and with the intention of showing the variety of produce across different African regions, comes out in the detailed lists of materials and sources that Clarkson laid out in his *History*:

> In my attempts to add to my collection of specimens of African produce, I was favoured with a sample of gum ruber astringents, of cotton from the Gambia, of indigo and musk, of long pepper, of black pepper from Whidah, of ma-

hogany from Calabar, and of cloths of different colours made by the natives, which while they gave other proofs of the quality of their own cotton, gave proof also of the variety of their dyes.[58]

Mobile, condensed, constantly developing and evolving, and full of magical and mysterious little objects, Clarkson's chest was the perfect display item for the man selling abolition to a skeptical market. The most spectacular success of the chest's content in winning a convert came very early on and involved the biggest game of all, in the form of William Wilberforce. After an abortive first meeting with the young Member of Parliament for Hull, Clarkson, shy and awed by the slightly older man's spectacular political position, had failed even to raise the question of abolition. His second attempt involved setting up a fashionable dinner party at the house of the lanky Bennet Langton, a wealthy and deeply committed member of the tightly knit Quaker abolition community. It was at the dinner that Clarkson brought out his samples of African produce, which acted as a sort of intellectual aperitif to the main arguments about the horror of slave transportation. Wilberforce, who had already been sounded out by his friend the Prime Minister William Pitt, agreed to become the parliamentary spearhead of the SEAST.

The fine copper-engraved portrait of Clarkson in this exhibition, adapted from a painting by A. E. Chalon (fig. 7.9), is fascinating from the perspective of this legendary meeting.[59] Clarkson is shown seated in a simple chair. His posture is not relaxed but tense, as if braced for action and ready to stand, or even spring, up; he grips the chair arms, while his right hand holds a quill pen. To the top right of Clarkson's head is a marble bust of Granville Sharp standing on a mantlepiece, while farther along and half out of the picture frame is a bust of Wilberforce. The entire bottom right of the engraving is taken up with the elaborate display of Clarkson's chest and its contents. The chest stands open, and like some sort of rectangular cornucopia its contents of brightly striped textiles, knives, musical instruments, grains, seeds, and pods spills out over the carpet and over one of the labeled and minutely sectioned shelves that has been removed from the chest. Compositionally Wilberforce, Clarkson, and the chest are powerfully conjoined. Wilberforce forces his way into the scene, and a diagonal runs down from Wilberforce's gaze, through Clarkson's heart, and on to the chest. There could hardly be a more powerful statement of cause and effect, or of the power of material objects to effect political change.

FIG. 7.9. A. E. Chalon, *Thomas Clarkson*, copper engraving, c. 1835.

There are no records of how Clarkson talked about these objects to politicians, including William Pitt, or to abolitionists on his endless research and publicity trips across Britain. But he was clear about his motives and his commitment to thinking about African production seriously:

> I wished the [Privy] Council to see more of my African productions and manufactures, that they might really know what Africa was capable of affording instead of the Slave-trade, and that they might make a proper estimate of the genius and talents of the natives. The samples which I had collected had been obtained by great labour, and at no inconsiderable expense: for whenever I noticed that a vessel had arrived immediately from that continent, I never hesitated to go . . . even as far as Bristol, if I could pick up but a single new article.[60]

Looking at the content of the chest now, it is evident that Clarkson had some knowledge of African culture and of the relative levels of cultural significance

of the various items he included. There is, for example, a heavy emphasis upon weaving and textile manufacture. He included in his collection two fully threaded heddles and a breast beam from an Ashanti horizontal narrow band treadle loom, set up ready for weaving (fig. 7.10). He also included ten samples of woven Ashanti and Ewe cloth, including a gorgeous full man's wrapping cloth in blue and white (plate 19). The strips of cloth cover a wide range of patterns and include double, triple, and quadruple weave samples, thus exhibiting a fairly full range of colors and warp stripe designs. This heavy emphasis upon Ghanaian weaving would indicate that Clarkson understood, to some degree, the extraordinary power manifested by the Kente textiles of West Africa.[61] Ghanaians have a saying, "Kente is not just a cloth," and to the Ashanti and Ewe peoples of Ghana Kente was, and is, at the heart of their civilization. Ghanaian weaving is an art form still dominated by males; the gorgeous cloths they produce are intensely symbolic and different cloths relate to different cultural positions of power and to different ceremonies. It is difficult to explain the multivalent power of these cloths and the manner in which they are woven into the deepest and most significant aspects of the national life without going to Ghana. It was Kwame Nkrumah and the Ghanaian independence movement of the 1950s that made Kente a symbol of West African creativity and liberation on the world stage. Ghanaian traditional dress focused on Kente is now centrally associated with state ceremony and national identity. The gift of Kente cloths to visiting dignitaries and international statesmen has become *de rigeur*, especially since Jerry Rawlings's gift of a magnificent Kente wrapping cloth to President Bill Clinton.[62] Yet when Clarkson was putting his chest together there was widespread ignorance about both the quality and the symbolic power of these cloths. It is remarkable that Clarkson should have latched onto this expression of African pride, power, and creativity when he did. If one area of his remarkable collection of African productions overturns at a stroke Western-evolved imagery of black passivity, disempowerment, and cultural negation, it is this. The loom and the still brilliant pieces of weaving deny the rows of manikins that lie in the hold of the slave ship *Brookes*. Clarkson's cloths demanded that Europe turn to, and marvel at, African thought, African culture, and African creativity, decades before European modernism realized what it was missing and began to feed off African indigenous art.

The composite metaphorics of the chest become even more densely fascinating, not to say contradictory, when it is noted that when Clarkson took his case to the Privy Council he had added to its contents torture implements and

FIG. 7.10. Threaded heddles and a breast beam, Ashanti horizontal narrow
band treadle loom, Clarkson's chest, n.d. (Photograph Marcus Wood)

restraints used on the slaves. This was predictable fare, a stable of abolition
atrocity literature, and he had used and would use these items frequently in
his antislavery publications.[63] What changed the entire dynamic of this area of
the collection was the fact that he also included a large piece of rope, tied with
a specially enlarged monkey's-fist knot at the end (fig. 7.11).[64] This item related
to the abuse, not of slaves, but of British sailors, and Clarkson explained that
it was this type of rope whip that was often the cause of death by flogging.
Indeed, Clarkson's *History* gave an account of the murder of a ship's steward
called Peter Green aboard the *Alfred* with precisely just such an implement:

> The captain . . . beat him [Green] severely . . . and ordered his hands to bee
> made fast to some bolts on the starboard side of the ship and under the half
> deck, and then flogged him himself, using the lashes of the cat-of-nine-tails
> upon his back, and at one time, and the double walled knot at the end of it
> upon his head at another.[65]

Because of the inclusion of this British-made torture implement, which was
used on British as well as African bodies, the whole assemblage now estab-
lished a relationship between African trade, the British seamen, and the slave
cargoes they took from Africa to the Americas. This object suddenly places

FIG. 7.11. Cat-o'-nine-tails, with monkey's-fist knot bludgeon,
Clarkson's chest, n.d. (Photograph Marcus Wood)

notions of white and black freedom, and white and black trauma, into a difficult, mottled interpretative space. The same sea chests that would have been stowed below decks with the sailors and their hammocks on the way out had to be moved along with the sailors and their hammocks for the journey from Africa to the Caribbean. During the middle passage the lower decks were fitted out with shelves and filled with slaves; consequently, the common sailors had to vacate their former quarters on the slave decks and had to sleep on the open deck, gaining what rest and shelter they could. The movements of the bodies of slaves and sailors and the spaces and the sufferings they shared forge powerful links between them.

It is now forgotten that a good deal of the force of Clarkson's antislave trade propaganda was directed toward uncovering the suffering of white sailors during the middle passage. Abolitionists were attempting to dislodge a series of well-formed and almost mythic proslavery arguments anchored in the celebration of British naval excellence and the centrality of the slave trade to the achievement and continuance of that prowess.[66] The lynchpin of this position was the theory that the slave trade was the "nursery of British seaman-

ship." Much of the testimony of trauma in Clarkson's famous "Abstract" of the evidence presented to the House of Commons in the first antislave trade hearings concerned the excessive abuse of white sailors. The practice aboard the "Guinea traders" was shown as chaotic, abusive, sadistic, and fundamentally inefficient. There were numerous accounts of sailors mercilessly flogged to death for trivial or nonexistent offenses by out-of-control captains.[67] Clarkson's knotted flogging-rope is a difficult icon to deal with, but in some ways it symbolizes the world of leveling brutality on board the slavers, where human values were reduced to the consideration of profit margins, and where black slaves and white sailors alike were seen as elements in a single merchandising system.

Clarkson's chest embedded, warts and all, at the heart of the 2007 bicentennial emerged as a magnificent thing, a troubling thing, and finally a terribly important thing.[68] The whole crazy, contradictory, and compromised legacy of the middle passage might be seen to be embodied within it. This chest and its contents are a physical embodiment of the ambiguities at the heart of British abolition — its publicity strategies and its continuing legacy. As such the chest provides an open space for meditating upon the evolving relationship of Britain with its difficult slavery history. Its resonance and complexity as an object are all the more important in view of how the objectification of slavery operated in other museum displays. One way of putting into relief the exceptional and positive value of Clarkson's chest, as an object capable of getting beyond the simple binaries of slavery and freedom, torturer and tortured, is to consider it in relation to some of the objects that it was displayed beside.

Torture Implements as Memory Tools: Round Up the Usual Suspects

The objects of torture and restraint used upon slave bodies were inevitably endemic in the popular visual culture that 2007 generated, and were still seen as relatively unproblematic. But why were curators and historians still so reluctant to ask the basic question: What do these objects actually mean and do in relation to traumatic memory? When a giant slave yoke was displayed, a few feet from Clarkson's chest, inside the Palace of Westminster's slavery exhibition, it was hard to know how these pieces of wood talked to each other. Neither object appeared in a neutral context; their setting worked upon them, they were reified by the world of museology. Both emerged as desired, collectable, and valuable objects, and it is important to note that this is the case with all the torture implements shown in the world's slavery galleries. People compete to own and pay large sums of money at auction for yokes, branding

FIG. 7.12. Slave yoke, installation, Palace of Westminster, 2007.
(Photograph Marcus Wood)

irons, collars, thumbscrews, and shackles. Museums take the same infinite
care in preserving and displaying these purchases and loans as they do for
other archaeological, anthropological, or indeed artistic treasures. I saw the
processes of reification in operation when I witnessed the handling and un-
wrapping of both Clarkson's chest and the giant African slave yoke borrowed
from the collections of Antislavery International (fig. 7.12). I saw the yoke, all
wrapped up, carried in on the shoulders of two museum guards, in a bizarre
parody of a slave coffle. The yoke was then painstakingly released from its
layers of tissue paper and bubble wrap, literally cut out from its museological
swaddling bands by forensically sealed-off rubber-gloved hands using surgi-
cal scissors and scalpels. At one level it was obvious why the yoke was being
displayed. It was supposed to communicate what the 1807 slave trade bill had
freed the slaves from. This yoke was used by African slave traders, on African
slaves, as they were marched from the interior to the slave forts on the coast
in coffles. Such objects had been celebrated as objects of horror by Christian
abolitionists from Clarkson to Dr. Livingstone.[69] And yet this object, basically

FIG. 7.13. Activists march from Hull to Westminster, 2007.

a cut-down branch, is not as semiotically stable as it might seem. I watched the processes of this object's installation in the exhibition, and when the museum guards stood it on its end in a case it looked like a tree, which of course it once was (plate 20). And standing on the other side of its case, before they removed the covers, it cast beautiful autumnal shadows against the polythene skins that protected the Perspex windows that in turn protected it. What on earth did that crazy moment of beauty mean in relation to Britain's perpetration of the slave trade and its current attempts to come to terms with that inheritance? Then again, what was the relation of this yoke to what was going on outside?

As the slave yoke went up in its case, there were, bizarrely, other yokes on the move outside the Houses of Parliament (fig. 7.13). Marching down from Hull were worthy white families donning newly fashioned wooden slave yokes and sweatshirts saying "so sorry."[70] I don't want to return to the territory of the slavery apology debate now, but I do want to think briefly about how this yoke performance relates to martyrology and slave torture. The older male in this picture was part of the evangelical Christian group Lifeline. By the time they put on their restraints and marched in 2007 they had already been all over the globe for seven years apologizing for a variety of sins perpetrated against Africa by the so-called developed world, and mainly apologizing for slavery.

On March 25 the core activists set out on a twenty-four-day trudge down from Hull to Westminster, chained and yoked together. It was a symbolic act of atonement for the British sin of the slave trade and at Westminster they were to demand that Tony Blair on behalf of the British government go beyond his expression of "deep sorrow" to unambiguously saying sorry.[71] What concerns me about this gesture is not the misplaced motivation but the bondage aspect. What did this discomfort mean, what space did this pantomimic slave coffle function in? Did the participants feel that they were (through briefly submitting themselves to a little pain and mimicking what they imagined to be the physical conditions in which Africans were forced to march to the slave forts) somehow atoning for the suffering of the slaves? Did they feel that they could that easily discard their own liberty and enter the psychological territory of the enslaved? Maybe the whole thing was a resurgence of the old abolitionist quest to possess the agony of the slave. Maybe it was motivated by an overriding desire to appropriate, to get close to or into the experience of slavery. But such immersion therapy is finally not only unhealthy, but an insult to the memory of those who really did suffer. The performance forces us to speculate on what the limits for such empathetic theater might be. How far can such posturing go in its vain desire to gesture at the discarding of personal freedom in order to briefly wear the costume of the slave? Surely these marchers had only dipped their toes into the sea of suffering, surely it would mean more if they suffered more. Once you start out on the dubious road of reclaiming slave trauma through an outrageous mimicry, what are the limits and who sets them? If these people were serious, they needed to strip naked, they needed to be consumed by parasites, they needed to march without adequate food and water, they needed to be beaten and periodically raped, and when they couldn't go on, they needed to be left to die. These marchers and their make-believe coffle were not only objectionable but obscene. They marked a low point in the bicentennial. Because they believed the suffering of slaves could be so easily approached and so frivolously appropriated, they were utterly disrespectful to a particularly intense piece of traumatic historical memory. This was, in fact, no way to say you were sorry. Expiation does not come through an apology printed as a logo on a sweatshirt or through putting a log on your neck.

WILLIAM WILBERFORCE: A LITMUS TEST
FOR THE HORRIBLE GIFT OF FREEDOM

When it comes to the horrible gift of freedom and British memory, a single figure dominates the inheritance: William Wilberforce. His manifestations

during the bicentenary must be considered, if only to explain to the rest of the world how fixed prejudice remains when British culture comes to celebrate what Britain did with slavery. In fact, as will become apparent, some of the showpiece mass media productions that resulted were beyond the realms of parody. What 2007 was to mean, at the end of the day, in popular memory was always going to come down to the question of how Wilberforce was approached. Was he to be quietly passed over, or even erased from the picture, as, for example, in Ms. Dynamite's *Nanny Maroon* documentary, or was the inherited weight of Wilberforce fest-o-mania to prove irresistible?

A Makeover for the Little Master: Wilberforce Sent Downstairs

In terms of a site and a building enshrining the single figure most directly associated with the public myths of 1807, Wilberforce Museum in Hull was, and remains, of central importance. What happened here in 2007 was, in fact, both interesting and impressive. Hull emerged as a fascinating case of what the politics of finance could mean in 2007. Ideally placed to apply for a large slice of the mighty government funding pie, Wilberforce House was duly granted a substantial Heritage Lottery Fund award and funding from two other bodies that enabled a total makeover of the slavery museum for 2007.[72] John Oldfield and I have both written about the old museum and its shortcomings at some length.[73] The year 2007 saw the museum transformed; in short, it was turned into something quite new, and it was no longer a shrine to Wilberforce. He and his myth were not overlooked, but as a biographical entity he was moved downstairs to a small self-contained basement space. This consists of simple displays and a few cases that retain the old wax manikin, his court dress, and the other personal memorabilia. This freed up the bulk of the museum, which was completely redesigned and filled with new displays, all of which moved away from the hagiographic emphases of the old Wilberforce exhibits. The museum also dismantled the crudely appropriative displays showing slave victimhood in offensive ways, and replaced them with a series of far more provocative interactive and thoughtful displays.

The galleries were designed over two years and resulted from an intense consultative process that involved bringing in academic experts from across the slave diaspora, including the Caribbean and West Africa. Diane Patton, Jim Walvin, Hilary Beckles, Paul Lovejoy, Paul Edwards, Elisée Soumonni, and of course the Wilberforce Institute's own David Richardson all contributed, but there were also lengthy discussions with a community consultation group that had a substantial mix of blacks and Asians, an impressive achievement given that 97.7 percent of Hull's population is white. The primary aims

were to "re-align Wilberforce in history" and to attract "nine to . . . seventeen year old" schoolchildren to a museum that previously had almost no visitors.

Given the awkward space available and the constraints on making any major structural alteration in Britain to a Grade 2 listed building, the permanent galleries that have resulted are remarkably successful. The most powerful overriding element within the new museum relates to its determination to move away from the presentation of the slave as passive and the consideration of Atlantic slavery as culturally isolated. So, for example, the space where the old slave ship exhibit used to be, although still devoted to thinking about the middle passage, provides a series of more questioning approaches.

The visitor enters this space through a gallery that dramatically places Atlantic slavery in a context of global development, stressing that every major nation-state, from Egypt through Greece and Rome, developed slavery systems. Slavery itself is shown to be an ever-present element within human societies, while Atlantic slavery is shown to be different from all other forms of organized slave labor in terms of its scale and its proto-capitalist labor and economic structures. There are some particularly effective moves with regard to display. So, for example, there is a large glass case full of an enormous set of shackles. This seems predictable enough until one reads the label, which tells us that this particular set are iron age neck-shackles from Wales and that they are more than a thousand years old.[74] Suddenly the historical rug has been pulled out from under the viewer's feet. We are no longer looking at the inevitable abolitionist relics, which still so weigh down the visual rhetoric of the representation of slavery in the majority of other slavery museums, but at some very ancient British irons. These shackles are not only virtually identical to those used on the slave ships a thousand years later, but demonstrate that an internal slave trade was happening in Britain long before the Romans arrived and enslaved the English with total efficiency. The effect is shocking, much in the manner that Marlow's prologue to *Heart of Darkness* is shocking as he imagines what it would have been like for a Roman soldier to enter the unknown barbarity of ancient Britain for the first time. The terrifying implication is that Britain was and remains a place of depravity.

This is a fine introduction to the middle passage gallery itself. This is now largely empty, the displays restricted to wall panels and text. The famous *Plan of the Slave Ship Brookes* features, but has been developed again in a unique manner. As well as a copy of the renowned print there are three rectangular Perspex boxes outlined against the wall, each giving the precise spatial allocation for a man, a woman, and a child according to the measurements quoted

FIG. 7.14. Slave meal on the middle passage, permanent slavery exhibit, Wilberforce House Museum, Hull, installation, wood, metal, plastics, 2007. Courtesy of Hull Museums. (Photograph Marcus Wood)

on the *Plan*, from Dolben's Bill. This is simple and effective display. Visitors can stand against these frames and see just how tight the fit is, without going too far into the murky territory of total historical immersion. Interactive video displays have been set up giving accounts of the middle passage from a captain, a surgeon, a doctor, and a slave, or ex-slave in the form of Equiano's testimony. The intention is to show the slave ship as a collective social environment, or even temporary community, where white sailors, intimidated and disempowered to an extent themselves, had to interact with disempowered black slaves. The gallery effectively gets away from simplistic notions of the slave ship as a two-dimensional prison space, the verbal testimonies opening up and denying the rigid geometrics of the overfamiliar *Plan* of the *Brookes*. The only attempt at mimesis in terms of the conditions of the middle passage is in the form of a ladle and a bowl of food, set on top of a cask to represent a slave's average daily allowance of sustenance during the voyage (fig. 7.14). This is particularly well designed for schoolchildren, and makes them relate to the slave trade through their own experience of institutionalized feeding via school dinners. While avoiding melodramatic wallowing in the sheer inhumanity of the slave trade, the display modestly gets over the basic extremity of conditions from start to finish.

The most impressive room in the whole museum is that devoted to slave re-
bellion and resistance. Bussa, Sam Sharpe, Nanny of the Maroons, and Tous-
saint l'Ouverture are all given space, with Toussaint given the most coverage,
respecting his preeminent position across the black Atlantic diaspora. There
is also a very ingenious flow diagram that charts the forms of internal resis-
tance open to a slave living on a plantation and under constant surveillance
and various forms of oppression. With each abuse a series of behavioral op-
tions is set out, and the individual must plot her or his way through this moral
maze. The boldest move of all comes in the coverage of slave religion. It is rare
enough in slavery museums to see the diasporic hybrid religions developed by
the slaves represented at all. Hull decided on the unique move of re-creating
a full-fledged contemporary Haitian voodoo shrine (plate 21). Drawing upon
the expertise of Phil Cope, who traveled to Haiti to research and purchase the
objects on display, they have created a colorful, messy, fascinating synthesis
that feels authentic enough to give a sense of the creative ebb and flow that
typifies the practice of this type of diasporic hybrid religion. If the health
and safety officers had not prevented them from using the blood, feathers,
and flesh of real sacrifices, the shrine would have been even more spectacular
and powerful. As it is, Hull has achieved what remains to date the only re-
creation of the site of worship of a slave-evolved cult religion in Britain. This
is significant. We have for the first time a display that makes the point that the
religious culture of the slaves enabled social organization, artistic creativity,
and revolutionary action.

The final two rooms put slavery and Wilberforce in the context of con-
temporary concerns with racism and human rights. The terms of the debate
extend out into the existence of various forms of contemporary slavery from
charcoal burning in Brazil to East European sex slavery in Beverly, a few miles
from the museum. Taken for all in all the exhibition is remarkably ambitious,
and gets at least one quart into a pint pot. While the spirit of Wilberforce still
hovers around the place, he has been firmly and finally placed in a series of
other dominant perspectives. The extent to which he has been recontextual-
ized comes over emphatically in the fact that the room in which he was born
now houses the slave resistance and slave religion exhibits. One wonders what
he would have made of that.

Going Nowhere Fast: Wilberforce and Media "Bragg-adochio"

When it came to 2007 and the mass media, however, Wilberforce House
might just as well not have bothered. The radical realignments that the Wil-

berforce House Museum undertook found no echoes in the world of popular entertainment. For the producers with the big money, and for the mass audiences who ingested the fodder that the producer's directorial lackeys provided, the old mythologies proved immovable. Wilberforce remained a saintly untouchable entity. There is no doubt about what British and American audiences desired and required when it came to the representation of the "heroes of abolition." Inevitably, it was the continued focus and indeed development of the cults of personality erected around what is termed the great man theory of history that ensured the survival of the theory of the gift of freedom in 2007. It became obvious which way the wind was going to blow when the arts fixer and author of light fiction Melvyn Bragg decided to batten on to Wilberforce. Bragg's extended Radio 4 *In Our Time* tribute to Wilberforce was sent out just before the main wave of 2007 bicentennial programs flooded the airwaves. It should be explained to non-British readers that until 2010 Bragg had virtually dictatorial powers within arts broadcasting in Britain, and could do just about whatever he wanted.[75] Consequently, his Wilberforce broadcast was uncontested, widely advertised, given two prime time spots on one of the BBC's top radio channels, repeated several times, made available as a download through all available means, and sent out on the BBC's World Service. It was consequently aired to an audience of many millions across the globe. Bearing this in mind, it is worth reporting on what Bragg insisted on doing.

Bragg created a program that would have gone down very well across the empire in 1907, let alone 1807. *In Our Time* was an uninflected peon to a great white Englishman. Bragg was not shy about the absence of the slave from the whole production. Having told us that slavery in any case was really the responsibility of a motley crew of baddies, including "African Kings, Chiefs, Arabs and other European traders," he insisted that he and Radio 4 were proud to leave the slave out of this account: "my focus today, and I make no apology for it, is not the suffering of many but the vision and tenacity of one, of Wilberforce himself." He repeated, three times in slightly different ways, in increasingly Churchillian parody, that it was time to bring the great man theory of history back to the center, no questions asked: "I'm even more convinced that the great man theory of history now discredited all over the place needs to be resurrected sometimes, and in the case of Wilberforce it bears resurrection he was a great man . . . this Englishman. . . . He was indeed a great man in his time and I think for all time." The interviews in the program dragged in the two relevant North English political heavyweights. The first was William Hague (briefly leader of the British Conservative Party in the days of Tony Blair),

whose contribution was a barely disguised attempt to flog his forthcoming book, a revisionist prayer of thanks to Wilberforce who was remembered as a Conservative Member of Parliament for Hull. The second was John Prescott, then deputy prime minister and current Member of Parliament for Hull, who, still suffering from a series of recent media humiliations that climaxed in a pitiful sex scandal, sounded slurred. Prescott spoke, rather weirdly, about how Wilberforce represented the belligerent Northern male who had no truck with monarchy, authority, or the South.

Bragg dished up unadulterated nineteenth-century hagiography: Wilberforce's conviction was absolute, his religious zeal admirable, his suffering real, his achievement eternal. His first speech on the slave trade, Bragg explained, with no evidence to back up such a daft claim, "is still regarded as the greatest speech ever delivered at Westminster" and Bragg continued even more extravagantly to claim, again with no supporting evidence, that this was "a speech which has down the centuries inspired successive waves of individuals, Martin Luther King, Nelson Mandela and countless others seeking emancipation of many kinds." Quite simply, the story went, Wilberforce was, and has remained, a great man who freed the slaves because of his Christian morals and his personal courage. During the course of the broadcast a couple of dissenting academic voices were allowed to articulate civilized reservations. The most outrageous part of the program, however, was its brazen attempt to bury the great Caribbean historian Eric Williams because he had had the temerity to see Wilberforce as merely another compromised and not particularly effective politician. The most negative parts of Williams's assessment of Wilberforce were recited, so as to make them appear as a no-holds-barred *ad hominem* attack:

> Wilberforce with his effeminate face appears small in stature. There is a certain smugness about the man, his life, his religion. As a leader he was inept, addicted to moderation, compromise and delay. He deprecated extreme measures and feared popular adulation.[76]

Bragg, lacking the courage or intelligence to defame Williams for this presumed assault on the sacred cow of British abolition, then got in a hired hand to do his dirty work, and asked "the Trinidadian historian Dr. Peter Fraser to give me his thoughts on what Williams had written." Fraser did indeed give his opinion on Williams, which was and is quite frankly a disgrace. Williams is presented as an angry young man, intellectually out of his depth and completely out of step with the prevailing views of the black Caribbean. The

attack is written off with the following words: "Well in many ways the writing of a young man . . . I think the animus against Wilberforce in the quotation is very much Williams on his own." Bragg then asks a question so leading it would be tossed out of any court: "Is what's behind this view any sort of prevailing view among commentators and historians about Wilberforce in the Caribbean?" To which Fraser, only too willing to please his media master, replies: "I don't think so any more, I don't think it ever became a majority view." Moira Stuart, who unlike Bragg got on a plane and went to Jamaica to find out what the real islanders thought of Wilberforce, got a rather different story.

And right at the center of the program, even though it was a radio program, were the emancipation fetishes, the freedom monuments. Interviews were conducted, we were told, in front of the frothy Wilberforce monument in Westminster Abbey and the big white marble statue outside Wilberforce House. The huge ithyphallic Wilberforce column in Hull seemed to spur Bragg into a "mine's bigger than yours" column envy comparison with Nelson (fig. 7.15): "Alison Lewis has taken me into central Hull where the towering Wilberforce Monument has him dressed as a senator. . . . This monument looked mighty impressive from a hundred yards away, but standing underneath it it's even more so, you've got to think of something in the fashion and of the ambition of Nelson's Column in Trafalgar square, not as high but a great, great column, with the man himself in stone on the top." Finally Hague and Bragg penetrated Britain's parliamentary inner sanctum, the Palace of Westminster. Cloistered in the archive reading room, they were heard unrolling, stroking, fetishizing, the parchment of the 1807 Slave Trade Abolition Act. The radio audience heard the parchment sensuously rustle as they took it out. Hague read out part of one sentence, which stated that Britain's involvement in Atlantic slave trading was over forever because the king said so. It is easy to laugh and walk away, to write these gestures and oversimplifications off as typical media posturing by two men who like to feel they are the translators of high culture and serious thought for the swinish multitude. Yet this glorification of Wilberforce through the misrepresentation of the key piece of legislation with which he is associated is not trivial. As I pointed out at length in the first chapter, the 1807 act was not a clear statement of slave trade abolition.[77] It was a deliberately compromised and badly organized piece of legislation containing sinister prescriptions relating to the future human bounty captured by the British antislavery patrols. The act was also riddled with legal loopholes that allowed both foreign slaving nations and British shipping and commerce to

FIG. 7.15. Wilberforce Monument, Hull. (Photograph Marcus Wood)

continue to be physically involved in the trade for years. The terms of the act also allowed for concerted, ingenious, and economically mainstream British exploitation of the trade through various operations of business and venture capital.[78] Indeed, it required the passage of no less than eight major acts of Parliament between 1811 and 1830 to attempt to stop up the gaps.[79] What Bragg and Hague presented us with when they rubbed up against the parchment scroll was not half-truth but untruth.

Amazing Disgrace: Wilberforce in the White House

Reaching an even bigger global audience, and without doubt the single most influential piece of political propaganda to be generated by the 2007 bicentennial, the film *Amazing Grace* was released in March to commemorate the passing of the 1807 act. The film was generally a critical and public success

on both sides of the Atlantic — a fact I find rather terrifying, when one starts
to look at what we were actually being given. *Amazing Grace* was financed
by Philip Anschutz's Walden Media, in other words, by right-wing Ameri-
can money, and directed by Michael Apted, whose previous major success
was *Gorillas in the Mist*.[80] *Amazing Grace* does not merit serious comment
in aesthetic or historical terms. It makes countless basic errors of fact and
engineers wholly fictional scenarios, many of them involving the total mis-
representation of the life and politics of Olaudah Equiano, John Newton,
Thomas Clarkson, and of course poor old Wilberforce himself.[81] The film
had no interest in African slave experience; it had a narrow ideological agenda
set firmly on the glorification of Wilberforce, British abolitionists, and the
British tradition of parliamentary debate. *Amazing Grace* is, however, educa-
tive, because it was very pure in terms of the way it duplicated the mechanisms
evolved by the British to account for and disguise their role in the slave trade.
The memory of slavery was removed, or displaced, and then replaced, with
the memory of supersensitive and morally charged male abolitionists. Slavery
and the slave trade were reduced to the function of mere catalysts, allowing
a cast of junior and minor British luvvies — Rufus Sewell (Thomas Clark-
son), Ioan Gruffudd (Wilberforce), and Benedict Cumberbatch (Pitt the
Younger) — and some real heavyweight hams — foremost among them Sir
Michael Gambon (Charles James Fox) and Albert Finney (John Newton) —
to work themselves into appropriate emotional states as they celebrate their
status as "friends of the slave." As usual the sly Gambon managed to send
the whole thing up, without the director or producers apparently seeing what
he was up to. Olaudah Equiano, now erected as the eighteenth century's ce-
lebrity token black abolitionist, was represented by a token black actor, the
Senegalese Youssou N'Dour. N'Dour is, in fact, a fine musician, and had not
acted before, and it looked like it; his main function was to hang around the
whites with a long face.[82] It is comically fitting that his final appearance in the
film is as a gravestone. When the 1807 act passes we are treated to the sight
of a completely inebriated Thomas Clarkson (who is played as a long-haired
proto-hippy maverick by Sewell) lolling on Equiano's grave, swilling down
strong spirits and sloshing them onto Equiano's tomb as a sort of impromptu
Obeah or voodoo libation.

N'Dour's one short statement, supposedly spoken when the Clapham Sect
theatrically confronts Wilberforce with the horrors of the middle passage,
was the only moment in the film when slave experience was presented in any
sort of factual detail, even if the meeting itself never actually took place. The

FIG. 7.16. "Equiano bares his brand," frame grab,
Amazing Grace, DVD, Momentum Pictures, 2008.

FIG. 7.17. "Clarkson tortures himself," frame grab,
Amazing Grace, DVD, Momentum Pictures, 2008.

effect is somewhat spoiled when N'Dour rips open his shirt to reveal a vast latex branding scar on his chest (fig. 7.16). The makeup people were apparently given a blank check on this one, creating a fieldlike series of furrows and lacerations, his brand hanging there like an open rubber wound that appears never to have healed. Even here the black voice is finally drowned out of the scene by white fetishization of bondage and torture implements. The cameo is dominated not by N'Dour's brief comments but by his mighty scar and even more thoroughly by Sewell/Clarkson's theatrics (fig. 7.17). Sewell heaves a bulky carpet bag up onto the dinner table, and tips out the obligatory piles of chains and shackles. He proceeds to demonstrate their use by trying a few of them on for size, a bizarrely literal case of the abolitionist mimicking and thereby appropriating the suffering of the slave.

Slave trauma was otherwise barely touched upon, and when it was this was done in ways that abstracted torture and often removed the black body altogether. There is, for example, a silly scene where Wilberforce is imagined being shown around an empty slave ship by Equiano. There is of course no hard evidence that Wilberforce ever met Equiano, who is known to have been intimate with Thomas Hardy, the ultra-radical leader of the London Corresponding Society and the central figure in the notorious Treason Trials of 1794. Wilberforce would have loathed Equiano's politics. To be honest, given Equiano's political leanings and the shadow of San Domingo, Wilberforce would not have touched this particular black Londoner with a barge pole. As it was, Wilberforce throughout the late 1780s and the 1790s was the butt of obscene racist graphic satires that presented him frolicking amorously with enormous black women. In the film, however, they seem to be very good chums. Equiano points out the slave berths, and they both handle yet more piles of rusty chains. Ignoring the fact that again there is no evidence that Wilberforce physically ever went near a slave ship, the dirty hands research was in reality very much Clarkson's remit; the film's researchers and director were seemingly oblivious to the facts of the "triangular trade." Slave ships returning from the Americas almost exclusively carried colonial trade goods, not slave cargoes. The slave decks had their temporary fittings removed by the carpenters at the end of the middle passage to make way for the new cargo of sugar, tobacco, coffee, rice, or rum. In reality Wilberforce would have had no slave berths to emote over in this particular ship just docked in London. There is an equally daft set piece where Wilberforce is imagined haranguing a group of wealthy potential abolitionists from the stern of a slave ship (fig. 7.18). He stands before yet another mountain of rusty chains and shackles,

FIG. 7.18. "Wilberforce holds forth," frame grab,
Amazing Grace, DVD, Momentum Pictures, 2008.

this time heaped before him and spilling out over the ship's side. Gruffudd/
Wilberforce shouts at the audience to take in the full stench of the boat, and
literally inhale the torture of the slaves. Both Wilberforce's fictive audience
and the movie's cinema audience are consequently invited to remember the
slaves only through the instruments used to torture and restrain them and the
excrement and effluvia of their pestilential bodies.

As the above examples make plain, the slaves are, in fact, remembered pri-
marily through Gruffudd/Wilberforce's fetishistic relationship to objects as
presented in a series of overblown set pieces. The sacred paperwork constrain-
ing the horrible gift of freedom is not ignored. We see a coach roll up and a
stringy youth lugs a huge abolition petition, the size of a rolled-up carpet, into
the House of Commons. Wilberforce grabs it and, with ten-pin precision,
sends it spinning out down the bowling-alley-like center of the stage, to the
amazement of the assembled Members of Parliament (fig. 7.19). At one point
Clarkson visits the little abolitionist and on entering Wilberforce's office can't
see anyone, until the grinning and sprightly Wilberforce shocks him by jump-
ing out of a box (fig. 7.20). He then informs us that he has had the prop made
up to the specifications of a slave berth, so that he can lie inside it and imagine
that he is a slave. Who on earth dreamt this up? The writer, the director, the
carpenter? The vulgarity of the appropriative empathy on display here knows

no bounds.[83] Wilberforce, in fact, comes over as a sort of vast caricature of the man of sentiment, constantly trying to outbid everyone in terms of his capacity to enter into the suffering of "lesser" beings.

The film opens with a little animal rights lecture, as Wilberforce, his stomach acting up, passes by a pair of men beating up their fallen horse on the road. Despite the protestations of his friend, he strides out from his carriage and saves the beast, with a quiet word of advice. The giant ruffian who has been playing about the sorry nag with a riding crop desists as soon as his friend tells him that he is being spoken to by "Mr. Wilberforce," the abolitionist celebrity. Throughout the film Wilberforce is shown not as a political operator using Christianity as a tool of control, but as a lovable eccentric who keeps a menagerie of damaged hares, rats, and other cute little furry things about the house. This stuff would be harmless enough frippery, were it not for the deeply offensive underlying equations. While we see animals realistically portrayed as victims in this film, we never see any slaves up front. The only glimpses of slave abuse are presented in the form of fragmented drug hallucinations. The laudanum-ridden Wilberforce suddenly sees a shackled slave, made all golden with light filters, flickering in the firelight like the "ghost of Marley" (Jacob, that is, not Bob; fig. 7.21), or glimpses slave children again presented through gilded filters, burned in a sugar refinery. The equation of slave suffering and animal suffering is highly problematic; Cowper's line "Now lambs and negroes both are harmless things" comes to mind.[84] This equation is problematic because slaves were constantly compared with animals in their dumb victimhood by both proslavery and antislavery propagandists. That this sinister comparison should still be so unthinkingly introduced tells us a lot about the final agendas upon which *Amazing Grace* is based. We are still in a world where the man of sentiment feels for these exquisite victims with a degree of pain superior to theirs, and where he sucks in their suffering with a boundless moral generosity. Human rights and animal rights are insanely conflated via one pietistic and appropriative male imagination. Such sentimental pap is not harmless because it offers a delusional sop to audiences today. We are still primarily invited to remember the disaster of the slave trade through the hysterical responses of a single sympathetic white mind.

Ultimately the film was structured to use abolition as an emotional flypaper designed to trap us into falling in love with a sentimental fantasy of Wilberforce. In order for this to happen, abolition had to appear to be not merely inspiring but positively sexy. Enter the love interest in the form of Barbara Spooner/Romola Garai. In reality we don't know too much about

FIG. 7.19. "Wilberforce bowling the Petition," frame grab,
Amazing Grace, DVD, Momentum Pictures, 2008.

FIG. 7.20. "Wilberforce as Jack in the Box," frame grab,
Amazing Grace, DVD, Momentum Pictures, 2008.

FIG. 7.21. "Slave as the Ghost of Marley," frame grab,
Amazing Grace, DVD, Momentum Pictures, 2008.

Mrs. Wilberforce, except that Wilberforce's closest friends thought that she
was dull and socially unworthy of the match. In the film she starts out as quite
an independent and chirpy soul, initially displaying her social activism while
playing hard to get. But this is Hollywood, and it's only a few frames before
Ramai, in vast curling red wig, is seen heaving her mighty cleavage about in
the firelight before the confessional Wilberforce, who cannot keep his eyes
off her assets (fig. 7.22). In the eyes of this well-endowed young woman not
only Wilberforce's abolition struggles, but his terrible digestion and addic-
tion to a class A narcotic, make him intensely desirable. It's a sort of *Leaving
Las Vegas* in periwigs, with a happy ending. While for his part Gruffudd/
Wilberforce, as soon as he sees that his moral excellence, combined with his
diseased vulnerability, have gained him the affections of this hot and buxom
number, becomes a changed man. He throws the laudanum out of the window
and becomes not merely a reinvigorated abolitionist but a great inseminator,
fathering children left, right, and center. Indeed, as a result of this propagatory
fury poor Mrs. Wilberforce is thrust out of the film, and from here on in is re-
stricted to brief cameos where she floats around adoring and "pregnant" with

FIG. 7.22. "Wilberforce eyes his future assets," frame grab,
Amazing Grace, DVD, Momentum Pictures, 2008.

a cushion stuck up her frock. Absolute nonsense, but not harmless nonsense.
The ruthless marketing of the movie by the Christian Right in the United
States and in West Africa was anything but harmless.

The film gained mainly favorable reviews in England, although some black
voices were raised in fury. Lee Jasper, former race equalities advisor to Ken
Livingstone, underlined the extreme misrepresentations, stating bluntly:
"The film prettifies the tragedy, the horror and the brutality of the slave trade.
It seeks to give the impression that one man freed millions of slaves and ne-
gates the contributions of the enslaved Africans to their own freedom to a bit
part."[85] Yet like Peter Linebaugh in the United States, Jasper was whistling
in the wind. *Amazing Grace* was the version of slavery that in 2007 the An-
shutz publicity machine and the British government's cultural wing wanted
its audiences to witness. Consider, for example, that the climax of the Brit-
ish Council's celebrations of 1807/2007 in Ghana consisted of a premier of
Amazing Grace. If you look behind the scenes as Manu Herbstein did, this
really was a sinister affair with a whiff of Nuremberg triumphalism about
it. Fifteen hundred Ghanaians, mainly schoolchildren, were lured with the
bribes of free tickets and masses of free buttered popcorn, vanilla ice cream,
and American-style hot dogs, and herded into the National Theatre in Accra.

They watched the film and then were made to hold hands and to pray publicly "to change the world we live in and leave it a much better place than we met it." Herbstein summarizes:

> At the request of the British Council, Walden Media supplied the film free of charge and sent the reel direct from U.S. The net cost of the screening at the National Theatre was about £4,500. Walden Media explains its generosity thus: "Mr. Philip Anschutz's hope to bring about social impact through filmmaking could not have been more powerfully demonstrated through this momentous cultural moment."

Perhaps the final proof of the film's poisonous politics and corrupt morality lay in the manner in which it was ecstatically received by the religious Right in America.[86] Indeed, the *Daily Telegraph* back in Britain proudly reported the gratification of Wilberforce's ancestors on hearing that the American president was to attend a private screening at the White House: "Alice Beaumont, a direct descendant of Wilberforce, said she was thrilled by the support the film had received. 'I am delighted that Mr. Bush is seeing the film.'"[87]

And so, when all was said and done, this was what the 2007 bicentennial had come to mean. The horrible gift of freedom was alive and well, rubbing up against George W. Bush in the White House.

Conclusion

Freedmen in the New World carried an external sign of their
slave origin in their skin colour, even after many generations, with
negative economic, social, political and psychological consequences
of gravest magnitude. Ancient freedmen simply melted into the
total population within one or at the most two generations.
— M. I. Finley, *Ancient Slavery and Modern Ideology*

Among the Romans emancipation required one effort. The slave
when made free might mix with, without staining the blood of, his
master. But with us a second is needed unknown to history. When
freed he is to be removed beyond the reach of mixture.
— Thomas Jefferson, Query XIV, *Notes on the State of Virginia*

THE HORRIBLE GIFT OF FREEDOM was a depressing book to write. It is
draining to come to know that so much human knowledge, power, ingenuity,
and creativity should have gone, and continues to go, into the manufacture
and perpetuation of such enormous narrative falsehoods. When it comes to
Great Britain it is above all the sanctimoniousness with which the horrible
gift of freedom is purveyed as a cultural product that sickens. Anyone who has
spent time in the Atlantic slave diaspora outside Europe, for example, in Ja-
maica, or Trinidad, or in the great historic port towns on the northeast coast
of Brazil, knows that the ex-slave populations do not smother and deny their
memorial inheritance in sentimentality, guilt, or somber breast-beatings. The
problem in England is that there is still an ugly enjoyment in the ownership of
guilt. There is a feeling that it is enough for the white British establishment to
parade the specter of an easily assumed and rather superior sorrow, to shed a
bitter tear, and that this show of emotion is true and proper and just what the
slave's descendents deserve and want. As this book has amply demonstrated,
such theatricalized sadness also provides the support for its emotional coun-
terbalance, the celebration of the "heroes of abolition."

For the majority of white people in Europe and North America, slavery and
the slave trade are things that they are easily bored with, rarely think about,

and, given the choice, would rather not talk about. But there is a great deal more honesty in an openly expressed and cynical boredom than in pretending to an emotion that is not felt. The polarization of opinion over a national crime that involved the immoral consumption of generations of lives, along with all that luxury produce, is nicely summed up in Lewis Carroll's superb meditation on colonial exploitation and white guilt, the poem "The Walrus and the Carpenter." Taking a leaf from Isaiah Berlin's cheeky philosophical anthropomorphism and turning Foxes and Hedgehogs into something else, one could speculate that most British people are either Walruses or Carpenters when it comes to the memory of the slave trade. Either they don't want to hear about it, want to draw a line under it in order to move on, or they want to weep a bit about it and then move on. The poem can be read as a curious satire on Britain's involvement in the slave trade, and is indeed beautifully constructed as a parable to cover any form of abuse carried out by the patriarchy of a developed nation against an innocent population in a colony, or developing nation. Throughout the poem the Walrus and the Carpenter represent two attitudes toward exploitation: the pragmatism lathed in brutal irony of the latter and the cunning faux benevolence of the former. Having lured the young and innocent Oysters out with the promise of a walk, the sinister pair suddenly stops and consumes them. The reactions to the mass murder are very different, and a useful paradigm for thinking about 2007 and its outfall:

> "It seems a shame," the Walrus said,
> "To play them such a trick,
> After we've brought them out so far
> And made them trot so quick!"
> The Carpenter said nothing, but
> "The butter's spread too thick!"
>
> "I weep for you," the Walrus said
> "I deeply sympathize."
> With sobs and tears he sorted out
> Those of the largest size,
> Holding his pocket handkerchief
> Before his streaming eyes.
>
> "O Oysters" said the Carpenter
> "You've had a pleasant run!
> Shall we be trotting home again?"
> But answer came there none —

> And this was scarcely odd, because
> They'd eaten every one.[1]

Both attitudes are dishonest, and equally terrifying and amusing. The Carpenter, we would now say, is in denial, or is an Oyster-Holocaust-denier. While he perpetrates the crime he sidetracks his mind with the practicalities of the process of consumption ("The butter's spread too thick"), and then when the process of consumption is complete he pretends that it simply hasn't occurred and that the victims remain alive ("You've had a pleasant run! Shall we be trotting home again?"). The Walrus always terrified me far more as a child, because of the way he pretends to care. He first suggests guilt over the crime and the deception, although he uses euphemism with great aplomb; the mass murder becomes "a trick," and he dresses up guilt in cliché and supposition. "It seems a shame," he says, but is quite certain underneath that this is not how he really feels. From this position he then launches into full-blown sentimental empathy ("I weep for you, I deeply sympathize . . ."). I am assuming here that he is talking still to the Oysters, although he could of course be ironically weeping for the Carpenter's plight with the butter. Both readings are necessary if the full extent of his iniquity is to be understood. The one thing that is certain, given how Europe and America have behaved around the processes of colonization, is that the Oysters don't stand a chance. They never did, they never have, and they never will. While their literally dead silence at the poem's end is their true epitaph, what happened to them will always be drowned out in the tearful, noisy fantasy of the Walrus (let us call him the Archbishop) or the denial fantasy of the Carpenter (let us call him the Prime Minister). What both the Walruses and the Carpenters of this world do not want to see are their ideally passive victims, the Oysters, standing up for themselves, speaking truths, or making a scene. As Joe Strummer tells us, "You have the right not to be killed," but if you end up in the Oyster's position that right is not often respected, and the deaths are not reported.

I end this book knowing there are many other works to be made about slavery and freedom — books, paintings, and films that will break out of the vast shadow cast by 1807 and its ancillary diasporic anniversaries, which climaxed in the sorry spectacle of 2007. The history of Atlantic slavery needs to shift its emphases; it needs to think about how slaves expressed freedom within slavery, and to think about visual art that has emerged which, in different ways, was capable of sidestepping the policing mechanisms of white abolition art or was genuinely independent of them.[2] As the imagery of slaves dancing in Vir-

ginia, or the shocking celebratory portraiture of Marie-Guillemine Benoist, or Pontecorvo's *Burn*, or Fanon's desperate satire prove, there are triumphant interstices, still points of the turning world, where this may happen.[3] It is finally as important to privilege these magically open aesthetic moments as it is vigilantly to expose the corrupt and corrupting closure of the majority of emancipation art. There has also been an increasing effort to start sifting areas of the slavery archive for evidence of slave agency and forms of day-to-day resistance through cultural expression. And there are signs that this painstaking scholarship is growing.[4] But beyond this there is also the art of the slaves themselves, which we are starting to develop methods for uncovering, as we are developing languages to celebrate and understand what is being uncovered. Architecture, ceramics, metallurgy, dance, food, medicine, and above all music are emerging as key cultural sites in this regard. The pioneering work of Toyin Falola, Matt D. Childs, Niyi Afolabi, Akinwumi Ogundiran, and Gwendolyn Midlow Hall have been crucial in the past ten years in getting out a plethora of detailed and pioneering work by scholars working across several disciplines in Africa and the African diaspora that opens up such concerns.[5] There is also an increasingly strong backlash in some African American art and scholarship directed against West Africa. To take one striking example, Saidiya Hartman's remarkable book *Lose Your Mother*, which was ironically published in Britain in the direct aftermath of 2007, is a passionate cry of rejection. The book articulates a feeling that the slave coast of Africa can be less than welcoming to its rich African American children who return to the slave forts as trauma-tourists. Bearing all this in mind I want to end with some relatively optimistic musing.[6]

RIDDLE ME THIS: DAVE THE POTTER,
THROWING DOWN A CHALLENGE

> Riddles appear where there is an emphatic intention to elevate an
> artifact or an event that seems to contain nothing at all, or nothing out of
> the ordinary, to the plane of symbolic significance. Since mystery dwells
> at the heart of symbol, an attempt will be made to uncover a "mysterious"
> side to this artifact or event. — Walter Benjamin, "Riddle and Mystery"

Freedom did not always have to be expressed by slaves and their descendents at the moment of liberation or in antithetic relation to enslavement.[7] There is now mounting interest in the quiet yet infinitely subversive voices of slave

artisans, individuals whose creativity was sanctioned and marketed within the slave system for the master's profit. One figure to emerge in the past twenty years in this context is David Drake, known as "Dave the Potter" or less respectfully "Dave the Slave."[8] Seeing into the ironies of his position, as he was traded from owner to owner, understanding the symbolic richness of the objects he was making, of the trade he had mastered, and of the materials he was using, Dave inscribed peculiar statements often formulated in irregular rhyming couplets into his exceptionally large, heavy, and beautiful pots (fig. 8.1). These inscriptions possess the tremendous communicative openness of their roots in oral and ritualistic language.[9] They lie somewhere between William Blake's "Proverbs of Hell" from the *Marriage of Heaven and Hell*, the energetic colloquialism of the prescriptions in plantation proverbs, and the celebratory, performative, and satiric elements of African praise-poems.[10] Then again, they have the sharpness and economy of popular tradesmen's slogans, they are very close to the nineteenth-century "confectioner's mottos," the rhyming aphorisms that Walter Benjamin spotted hidden in gingerbread and sweets: "I have danced away / My weekly wage today," or "Here you little flirt / This apricot won't hurt."[11] In the following quotation I have taken the liberty of arranging several of Dave's inscriptions composed between 1840 and 1860 into one consecutive passage. Set in this manner Dave's thoughts talk to each other in strangely unsettling ways:

> Making this jar: I had all thoughts
> Lads & gentlemen: never out walks
> Ladies & gentlemens shoes
> Sell all you can & nothing you'll loose
> Dave belongs to Mr. Miles
> Wher the oven bakes & the pot biles
> I wonder where is all my relations
> Friendship to all — and every nation
> The forth of July is surely come
> to blow the fife — and beat the drum
> I saw a leopard & a lions face
> then I felt, the need of grace[12]

This is great satiric and indeed philosophical poetry; it is also witty, fun, and, like the best political satire, aphoristic and enigmatic. If one reads these lines carefully, they encode both a philosophy of freedom for the slave and a critique of the enclosed world not of the slaves but of the masters. The first line is an

astonishing assertion, raising the potter's art to the level of a universal act of creation. The biblical metaphor of God as a great potter, making humans out of the clay in his hands, clearly lies in the background, as does the symbolic significance of clay as mortality, in the sense that we all spring from the earth and will return to it.[13] There is also a sort of musing realism in the line, which invites speculation on the nature of the creative imagination. The pot is made in real time by a real slave, but the processes of its creation involve a timeless state of mind, in which the imagination of the artist is limitless, ranging over all thought and entering an all-encompassing stream of consciousness. Dave could be suggesting that in making his pot he enters a privileged becalmed state of mind something akin to that assumed by Michelangelo when making art in William Butler Yeats's "The Long Legged Fly." The two lines are built around the stark antiphonal structures typical of Dave's inscriptions, whereby each line is broken down into two distinct parts; the two lines are themselves disjunctive. This has the effect of forcing two sets of ideas, which apparently do not logically connect, into a violent conjunction where it is up to the reader to figure out the meaning. In this example the reader is invited to move from Dave's gargantuan claims concerning his own state of mind when working, to think about a privileged world, the audience's world, of "Lads and gentlemen," and then the statement "never out walks." Although in terms of the orthodox rules of grammar this last clause would refer to the main subject that immediately preceded it, the most likely construction is that the "never out walks" refers to Dave. The implication, then, is that while Dave is infinitely free inside his own head, his enslaved state as an artist for hire means that he, unlike the fine white folk, is never free to go out walking. The thought process described could be seen as an elegant variant upon Hamlet's renowned formulation on mental liberty. In his initial exchange with Rosencrantz and Guildenstern, Hamlet calls Denmark "a prison" and continues, "there is nothing either good or bad but thinking makes it so." In response to an accusation from Rosencrantz that it is Hamlet's mental "ambition" that makes him feel imprisoned, he states: "O God I could be bounded by a nutshell and count myself a king of infinite space, were it not that I have bad dreams." It seems that Dave, when making his pots, has good dreams, that he is a mental traveler with access to all thoughts, and in this sense his art does make him a "king of infinite space," even though his physical state within slavery makes him tightly confined. Using a language that is both intensely colloquial and abstract, Dave's inscription makes a deep point about the possibility that a slave's consciousness can liberate itself through the practice of art. Slavery's physical

FIG. 8.1. Dave the Potter, stoneware vessel, 1840. All rights reserved,
McKissick Museum, University of South Carolina.

conditions and the social death it enforces are terrible realities, and yet Dave
seems to suggest that when he is making a pot, they can be overreached.

The next couplet, read consecutively, develops the walking imagery through
reference to shoes, while the "Ladies and gentlemens" echoes the "Lads and
gentlemen." This inscription seems to be a command to some cobbler to sell
his wares, yet for a slave to talk about ladies' and gentlemen's shoes, in the
context of selling property, may carry a very different and more unsettling
message. Dave's "shoes" may have a wider symbolic meaning, and the slave
may be talking about how the slave owners put fashion and consumption
above all else. Viewed this way, the lines imply that the materiality of slave
owners means that they would have no qualms about selling a slave to keep
up appearances.

The third inscription may be a simple trade advertisement, informing an
imagined purchaser of this particular pot which slave made it and where the
maker can be found. But, again, context is everything and the images of the
baking oven and the boiling pot may have other meanings within a culture
where one human owns another. Is the baking oven a kiln, or is it the fires of

hell that will eternally bake Miles for his sin of slaveholding? Again, is the boiling pot a reassuring sign of domestic wholesomeness, or a metaphor for the furious slave potter, whose repressed anger at his state will boil over? The odd word *biles* would seem to be a neologism of Dave's that conflates the verb *boil* with the noun *bile*, the humor traditionally associated with anger, hence biliousness. Dave appears to have fashioned a richly evocative new verb form out of a noun, the verb *to bile* meaning to boil over with anger. Again the two lines on his friends and relations are open to bitterly ironic construction. For a slave to wonder where his relations are may be a sad, indeed, traumatized speculation; it may allude to lost family sold down the river or to an extended and ancestral family in Africa. The latter reading would give new emphasis to the second line and its demand for international friendship. An equally potent veiled accusation lies within the apparently celebratory inscription on the Fourth of July. As we have seen, the central British charge against America in terms of its moral hypocrisy lay in the citation of the Declaration of Independence with its claims about universal human rights and particularly liberty, while slavery was maintained within the Union.[14] For a slave to allude to the anniversary date of American declaration of liberty had, at one level, to contain implicit criticism. The inclusion of the qualifying "surely" supports a satiric reading. This sarcastic overemphasis implies opposition. The Fourth of July may have come, as a calendar date, but what it is supposed to embody in terms of universal liberty has not. The final inscription takes the language out into a different register. Here the language of religious enthusiasm is drawn upon and particularly that of the biblical book of Revelation (the Apocalypse). Four beasts with the face of a lion, and the face of a man on its right side, appear to the prophet Ezekiel (Ezekiel 1:10), and when John ascends to heaven in Revelation (4:7) he sees a lion as one of the four beasts. Yet it seems that in the specific combination of leopard and lion, in the form of a terrifying beast, Dave is alluding with some precision to the Beast of the Apocalypse in Revelation: "And I stood upon the sand of the sea, and saw a beast rise up out of the sea . . . and upon his heads the name of Blasphemy. And the beast I saw was like unto a leopard . . . and his mouth as the mouth of a lion: and the dragon gave him his power, and his seat, and great authority" (13:1–4). Within extreme evangelical abolition writings the Beast from Revelation had long been associated with the slave power, as constituting an empire hostile to God and his people. American abolition generated many graphic satires where the slave states, and later the secessionists, were configured in explicit terms as the Beast of the Apocalypse.[15] In biblical terms the big carnivores are also

reminders of the fall, when harmony was broken in the animal kingdom and when the lion no longer lay down with the lamb but fed upon it. While Dave is clearly drawing upon this biblical background, his words also have a more direct signification within plantation fable, where large carnivores represent the slave power.[16] In this sense Dave's cryptic utterance is open to the interpretation that slavery is a fallen world, and the slave can only be protected from its depredations by the divine gift of grace.

Dave's formulations are powerful because they are so open-ended, so troubling to authority. This whole book has been about how freedom, in the context of the crime of slavery, has been ingeniously marketed. Dave's poetry, written into clay, is about the expression of a free will within the confines of slavery. Dave's poetic pots embody a wholly magnificent kind of liberty, outside the prescriptions of the gift of freedom. C. S. Lewis tells us that the Greek word *eleutheros* means "free," defined specifically as not a slave, and that "the character of *eleutheros* (or *eleutherios*) is, of course, contrasted with that of the slave." Yet he goes on to ask what the character of the slave is, and concludes: "The true servile character is cheeky, shrewd, cunning, up for every trick, always with an eye open to the main chance, always determined to look after number one."[17] Lewis is talking of classical slavery, but he has given a precise description of Brer Rabbit, that talismanic demonstration of how the slave can work from within the system and maintain control though trickery. Yet Lewis's "true servile character" does not die out with the passage of emancipation legislation. This figure also relates closely to the ex-slave narrator Uncle Julius, who ironically probes the constructed realities of his Northern employers in the brilliant plantation fictions of Charles Chesnutt. This is also a part of the spirit of Dave's ambiguous aphorisms, as he acts as the conscience and provocateur of the slave power, with the inspired indirectness of a Shakespearian-style jester who sees into the tragic ambiguity of his compromised position. Lewis goes on to present a darker insight: "The slave always has an axe to grind. Hence the miserably betrayed Philoctetes in Sophocles' play says to the cunning Odysseus 'Oh you, you who never had a sound or free (*eleutheron*) thought in your mind!' Odysseus has done nothing without an ulterior motive."[18] Dave clearly has an axe to grind, but like Philoctetes it is he, and not his owners, who has true insight into what freedom may mean, and he can see forms of mental and behavioral un-freedom manifested in white society. He has clear insights into how many free thoughts his owners might be capable of. What Dave's work demonstrates is that slaves can possess pragmatic and humorous insights into what the prescriptions of slavery and the slave codes

might mean. It is finally this satiric humor that stands apart from the theories of the slave power and from the propaganda of the abolitionists. It is above all the irony and lack of closure in Dave's words that create his crucial imaginative independence.

Dave's words may finally lie close not only to the language of the proverb and biblical prophecy, but to that of the riddle. Riddles are about disguising truth in fiction, about secret truths and secret sharing, about the disempowered empowering themselves through disguise. The riddle is also the perfect form by which the slave can lay unacceptable truths before the master. As a form it is more powerful than direct accusation because it invites speculation and delayed reaction. The riddle is a sort of cultural time bomb, and makes the object of its humor a hostage to fortune and to time.

There is a vast, fragmentary, and hitherto neglected archive made up of the surviving and recoverable objects made by slaves across the Atlantic diaspora. This archive is hard for historians, archaeologists, literary theorists, and art-historians to categorize and to read if we stick with tried and trusted academic categorizations and prescriptions. Indeed, this emergent archive might be said to constitute an enormous and unsolved riddle. The time has come to turn from the white archives bred and overseen by the slave powers in their manifestation as abolitionists. The time has come to unearth, and to contemplate deeply, the body of slave art and slave satire into which Dave's work leads us.

"THE DEVIL YOU KNOW" AND THE TRIUMPH
OF THE HORRIBLE GIFT OF FREEDOM

In 1980 C. L. R. James, by now an old man, wrote a new preface to his masterpiece *The Black Jacobins* and explained what had moved him to write the book:

> I was tired of reading and hearing about Africans being persecuted and oppressed in Africa, in the Middle Passage, in the USA and all over the Caribbean. I made up my mind I would write a book in which Africans, or people of African descent, instead of constantly being the objects of other peoples' exploitation and ferocity would themselves be taking action on a grand scale and shaping other people to their own ends.[19]

It is now seventy years since the publication of *The Black Jacobins* and James's motivation remains as relevant as ever. In 2007 as the bicentennial went through its paces James would have read and heard a great deal that would

have continued to spark his anger and tiredness. It would be wonderful if things do start to move in new directions, if slave agency, slave resistance, slave rebellion, and slave creativity start to drive historical memory around Atlantic slavery. Yet 2007 has made it painfully obvious exactly how much remains invested in the myth of the emancipation moment and in a continued vision of black passivity and victimhood. How dangerous and endemic this investment might be, and how it can corrupt the thought of ex-slaves and ex–slave owners alike, are subjects that have been anatomized by a great and ironic imagination. So I will end this book with the warnings that Jorge Luis Borges, a man not usually thought of as a philosopher of slavery and freedom, laconically provided us with.

At the age of thirty-five Borges published his first book of short stories. It carried the sensational title *The Universal History of Iniquity*. The first story in this collection, "The Cruel Redeemer Lazarus Morell," was an episodic meditation upon the subjects of enslavement and emancipation. The first section of the story constitutes a history of the African slave diaspora in one paragraph. It begins in 1517 with Fray Bartolomé de las Casas's suggestion to Charles V of Spain that African slaves be imported to work the gold and silver mines of the Spanish Americas in order to save the indigenous populations from unnecessary suffering. Emancipation and slavery emerge from the beginning as inseparably and ironically linked. This one act, whereby freedom for one set of people is gained at the expense of the enslavement of another, is seen as the mechanism unleashing everything good in Afro-American diasporic culture, from the blues and the beauty of mulatta women, to the Argentinean Tango and the Brazilian cult religion of Candomblé. Lazarus Morell is also seen as a product of Bartolomé las Casas's "remote cause."

Morell was poor white trash from the lower Mississippi Delta who ran a racket that played cruelly with slaves and freedom. Morell and his associates would persuade slaves to escape. They would then, with the slave's connivance, sell the escapee on to new owners; then the slave would escape again, and Morell would advertise the slave as escaped and collect a reward for his capture. The slave and Morell would then share the profits and the slave would enjoy "The Final Liberation," which took a different form from that anticipated by the wretched dupe at the center of Morell's cruel game:

> The runaway expected his freedom. Therefore, the nebulous mulattoes of Lazarus Morell would give a sign (which might have been no more than a wink) and the runaway would be freed from sight, hearing, touch, daylight,

iniquity, time, benefactors, mercy, air, dogs, the universe, hope, sweat — and from himself. A bullet, a low thrust with a blade, a knock on the head, and the turtles and mudfish of the Mississippi would be left to keep the secret among themselves.[20]

In this cruel world, the slave, who keeps investing his belief in the sacred idea of freedom, finds too late that in this world of white power death emerges as the only real form of liberation on offer, and the only life forms that benefit from the gift of freedom are white criminals and the bottom feeders of the Mississippi. Yet this is not the end of Borges's lesson in the cruelty of redemption. The story continues. Morell is betrayed by his associates, and in a desperate final bid to save himself plots a general slave insurrection in New Orleans. This is possible because many slaves have heard of the myth of Morell the liberator, and owing to the fact that the slaves he liberated have never been seen or caught, the myth appears to clothe a truth. In the final paragraph we are told that Morell died of a chest infection before he could put his plan into operation, and the final sentence informs us: "On that day, the 4th of January, slaves on scattered plantations attempted to revolt, but they were put down with no great loss of blood." This bleak little fiction ends by literally enacting the death of the hope of freedom in the slave populations. Freedom is snuffed out before our eyes. The horrible gift of freedom is a fiction that the slave power possesses, and that the slaves are encouraged to invest in, although they can never attain it through their own action. Freedom emerges as something the slave is taught to believe in, but as something altogether too clean and good to be realizable in the complicated and morally infected world created by the white slave power.

What interests Borges in this early parable on the power of the myth of freedom is the opulent blindness with which humans will invest in the idea of liberty, without ever addressing the reality of how freedom can be achieved and lived through in practice in a wicked world that had already invented slavery. The pitiful credulity of the slaves is the raw material that enables Morell's career. The unbridgeable gap between the theory and the practice of freedom in a world where slavery has been realized, and the relation of death to the process of liberation, were themes that continued to interest Borges. He returned to meditate on the precarious nature of freedom late in his career, and this time came at the subject with a leaner aesthetic that no longer required the historical props and the humorous melodrama of Lazarus Morell.

At age seventy the blind Borges wrote a very brief book called *In Praise of*

Darkness, which consisted of five very short, short stories of an intensely meta-physical cast. The last of these stories is called "His End in His Beginning" and precisely develops the concerns he had approached in "The Cruel Redeemer Lazarus Morell" and that Orlando Patterson would analyze at length and with brilliance in *Slavery and Social Death*. Borges, typically, reapproaches these concerns from an unexpected direction. The story is as impossible to summarize as Hamlet's impossibly familiar monologue upon the subject of "that bourne from which no traveller returns," and similarly speculates on the relation between death and freedom. Borges is inevitably in dialogue with Hamlet's lines, but I will try to distill Borges's development of the argument. Borges has certain un-Shakespearian insights into the operations of the human craving for familiarity, no matter how degrading or painful the familiar might be. "His End in his Beginning" is in formal terms a mono-logue, but unlike Hamlet's it exists at a remove; it is a monologue spoken by a disembodied and nameless second-person narrator, who talks to the reader about a certain case, referred to as "he" although it is intimated throughout that "he" is synonymous with "I." The plot is as follows. The central character "he" dies painfully and then falls asleep in the first sentence. He then awakes in the next sentence, to find himself back in the world he had left, though the people in it perceive he is different and turn from him, sensing he is dead. He is then afflicted by indescribably terrible nightmares he cannot remember at all, and his whole life outside dream is lived in terror of the dreams he cannot recall. He then realizes that these dreams are, in fact, his reality and that they exist beyond his memory (a terrifying idea). From this realization he moves to the position that he must leave behind what he thought was the real world, the dear and familiar world, and embrace the new. This move causes him infinite pain; he is in an intensely painful world, which remains beyond his understanding. He has entered a world of perceptual agony: "realms of des-peration and loneliness — appalling peregrinations . . . all horror lay in their newness and their splendour." In the last sentence we learn that this new state of agony, which is endless, is both freedom and heaven.

Borges's meditation completes the work he began in "The Cruel Redeemer Lazarus Morell" and quietly annihilates the complacent mythologies of the emancipation moment. Borges gives a bleak set of mechanisms through which to consider the fictions of the gift of freedom. The state-engendered propa-gandas of abolition focused on selling the reassuring idea that liberty can be an immediate, extravagant, and permanent gift from the slave power to the slave populations. The move from the known degradation of slavery to the

unknown bliss of freedom is presented as an easy one. How that idea was mass marketed is the central concern of this book. The fictions adopted are seen to exist within crudely redemptive parameters that bury eschatology within a set of immovable oppositions.

These oppositions might be summarized in the simple maxim: "The death of slavery is the birth of liberty." Slavery dies, or is slain, suddenly by the forces of good, inevitably manifested as abolition enlightenment. The death is final and quick, an extinction; there is no life after death for slavery in this fantasy world. Slavery is not merely superscribed or erased, but blindingly, immediately, simultaneously replaced by a new world. This new endless state of bliss is positively embodied allegorically in the figures who have so thoroughly populated this book — Liberty, Freedom, Britannia, Columbia, and so on — and is embodied in historical fiction in the equally familiar "heroes of abolition." Slavery and the emancipation moment are locked within a Christian tale of redemption, the belief, so casually obliterated by Borges, that when you die you are set free and enter a world of endless and unchanging happiness. Borges's story says no to this redemptive fairy tale and the fascism of its sentimentality. Borges has a different message and suggests that the movement from slavery into freedom involves agonistic struggle. Slavery ends not through a gesture or the gift of a magic piece of paper but through painful opposition. As Amílcar Cabral knew, the fight for freedom is not as difficult as life after the attainment of freedom. If a person who has known only one kind of life, consisting of disempowerment and suffering under slavery, is suddenly thrown into a new world of completely different rules, behaviors, and appearances, a world called "emancipation," this is unlikely to be an experience of simple joy, but a process that will induce extreme suffering or even madness. The new land of freedom will be a new world of pain.

The cruelest irony lies in the fact that both the victims and the perpetrators won't even realize that this is the case, because they are so locked into their old myths of death as rebirth, of transmigration as transmogrification, of suffering converting seamlessly to apotheosis. But, Borges insists, slavery does not leave the slave, or the ex-slaver, in heaven; it leaves them in a shifted, but not entirely new political and social space that they are not equipped to deal with. In these circumstances there is massive psychological and political pressure on both sides to regress, wherever the new system makes regression possible. This process was recently explored as a filmic parable in Lars von Trier's bleakly brilliant *Manderlay*. Anyone wishing for a photomontage crash course in what the horrible gift of freedom meant to America in real terms should

watch the masterly final credit sequence to this film.[21] The extent to which no society properly prepared for, or was equipped to deal with, the realities of emancipation is thoroughly reflected in the social conditions of the Atlantic diaspora today. In Britain it is particularly the case that white culture lacked the vision and the courage, and now lacks the opportunity, to be sympathetic to the agonizing processes of rebirth that define true emancipation. Britain's and North America's cultural institutions invested so completely, and for so long, in the horrible gift of freedom that we shut ourselves and our cultures out from that new and intensely painful world, which Borges's protagonist and certain black diasporic ex-slave populations have entered. The horrible gift of freedom was the fiction we invented and then embraced in order to enable our own self-delusion. And so what we are left with are emotional and ideological regression to the familiar dynamics of the Atlantic slave systems. The black ghettoes of Baltimore, Washington, D.C., and Boston, the favellas of Rio, Brazilia, and São Paulo, the gun culture of Moss Side and Hackney, the abuse of Rodney King and the death of Stephen Lawrence — these are an inadequate shorthand for a list with no end. This book has revealed how the patterns of cultural investment invented in 1807 to express the gift of freedom were still largely followed in 2007, and this lack of ability, or desire, to reapproach the memorial construction of slavery constitutes a vast moral failing. White British and American cultures have continued to invest in the blinding fiction. There is still an unflagging commitment to the story that a set of morally-pure-named-white-persons gave freedom to an enormous and nameless mass of black slaves. As Frantz Fanon warned us, certain inevitable developments result from such an ideological investment. Encased to different degrees in psychosis and paranoia, ex-slaves and ex-slave owners are doomed to revisit, and to reinhabit, the old paternalistic power structures established by colonial slave societies. The infection is now in the marrow, and the horrible gift of freedom remains as triumphantly pervasive a myth as ever. It appears unlikely that we will ever rid our cultures of the moral pollution and aesthetic contamination it generates.

NOTES

Chapter One. "The Horrible Gift of Freedom": An Odd Title?

The epigraphs to this chapter are drawn from Lewis, *The Essential C. S. Lewis*, 498–99, and Hyde, *The Gift*, 5, 23.

1. I use the terms *freedom* and *liberty* synonymously in this book and take my lead in this from Thomas Hobbes, who marries the words in his famous analysis "Of the Liberty of Subjects," which opens: "Liberty or Freedome signifieth (properly) the absence of Opposition." See Hobbes, *Leviathan*, 145.

2. "Two Concepts of Liberty" was first published in Berlin, *Four Essays on Liberty*. "From Hope and Fear Set Free" was first published in Berlin, *Concepts and Categories*.

3. As far as I know David Brion Davis coined the term *emancipation moment* when he first set out the evolution of organized attempts on the part of ex–slaving nations to normalize emancipation as "a ritualised moment of rebirth that ensured a degree of social continuity and of subservience on the part of the freedman." See Davis, *The Emancipation Moment*, 18. This lecture is a brilliantly compressed and deeply imaginative analysis and remains the most probing discussion of the rhetorical limits and methods of abolition narratives of emancipation.

4. The epigraph to this section is drawn from Hyde, *The Gift*, 44. For Rousseau's uncompromising idealization of independence and his celebration of the quest for freedom at any cost, see Berlin, "The Apotheosis of the Romantic Will," 561–63.

5. For the meticulous plotting and cultural reinvention of these emancipation moments, see Oldfield, *"Chords of Freedom."*

6. Hyde, *The Gift*, xvi. Hyde provides an excellent short bibliography of the few key works in the field. Apart from Hyde's own work, the other valuable speculative text remains Mauss, "Essai sur le don," 30–186. The essay appeared in English in single book form as *The Gift: Forms and Functions of Exchange in Archaic Societies*, trans. Ian Cunnison (New York: Norton, 1967). Hyde is centrally concerned to elaborate a theory relating artistic and aesthetic endeavor to the functioning of the gift, yet the first half of his book, which considers the relation of the gift to modern processes of industrialization and commodification, has great relevance to the co-opting of freedom as a type of commodified gift within emancipation ceremonies.

7. Hyde's only sustained consideration of the transformation of humans into commodities in the context of gift exchange concerns the treatment of women in the context of marriage. See *The Gift*, 93–108.

8. For the detailed discussion of this print in relation to the imagery established by the Society for Effecting the Abolition of the Slave Trade for describing the gift of freedom, see pp. 54 and 70 below.

9. Hyde, *The Gift*, 43.

10. Hyde, *The Gift*, 69.

11. Hyde, *The Gift*, 42. Hyde reproduces this image as a distillation of the idea of the "threshold gift."

12. See my discussion of the passionate intervention of Toyin Agbetu, pp. 297–306 below.

13. For the detailed analysis of this gesture and its genesis in classical manumission ceremony, see pp. 62–89 below.

14. Hyde, *The Gift*, 41.

15. Van Gennep's theory of liminality offers an intriguing counter to the somewhat cruder adaptation of the concept in the context of hybridity by Homi Bhabha. See *The Location of Culture*, 112–20, 225–26, 251–22. Ashcroft, Griffiths, and Tiffin, *Key Concepts in Post-Colonial Studies*, 116–21.

16. For Fanon on the gift of freedom, see pp. 18–29 below.

17. The epigraph to this section is drawn from *The Havamal, with Selections from other Poems in the Edda*, quoted in Mauss, *The Gift*, xiv.

18. For the use of this gift in subsequent abolition ceremony, see pp. 97–98, 102–3, and 106 below.

19. Mauss, *The Gift*, 22–45.

20. Mellor, *British Imperial Trusteeship, 1783–1850*, 68–69. The cultural impact of the payment is considered from a variety of angles in Oldfield, *"Chords of Freedom,"* 90, 144, 151–53. For the silence over the subsequent investment of the redemption payments, see the hard-hitting Sherwood, *After Abolition*, 16–19.

21. See Honour, *The Image of the Black*, 4:1, 150–52; Oldfield, *"Chords of Freedom,"* 23.

22. Evans-Pritchard, "Introduction," to Mauss, *The Gift*, ix.

23. Brown, *Moral Capital*, 209–59, 451–62.

24. I follow Brown's lead in taking John Kane's definition of "moral capital" as authoritative: "Political scientist John Kane has defined moral capital as moral prestige — whether of an individual, organization or cause — in useful service"; quoted in Brown, *Moral Capital*, 456.

25. For the remarkably low cost of slaves in today's global market, see Bales, *Disposable People*. Also visit the website of Anti-Slavery International.

26. Mauss, *The Gift*, 63.

27. Evans-Pritchard, "Introduction," to Mauss, *The Gift*, vi.

28. The epigraph to this section is drawn from Fanon, *Peau noire masques blancs*, 27. "Le nègre doit, qu'il le veuille ou non, endosser la livrée que lui a faite le blanc." My translation. In the French there is a pun on *livrée/livre*, the latter meaning "to give up," "to surrender," "to give up the goods." This makes black servility seem all the more absolute.

29. Davis's *The Problem of Slavery in the Age of Revolution* remains the most precise map of the shifting intellectual and moral landscapes thrown up by the slavery debates. His discussion (pp. 403–68) of the interpretation and practical outfall of the 1807 bill sets out the conflictual nature of responses and the confusions within English society that the bill generated. On the intellectual and theological inter-

relationship of abolition and the American War of Independence, see Brown, *Moral Capital*, 155–209.

30. The original document "An Act for the Abolition of the Slave Trade," 47 Geo. III, c. 36, is kept in the Parliamentary Archives HL/PO/PU/1/1807/47G3sln60, and consists of an animal skin parchment 0.72 meters wide and 5.92 meters long. The act is given a full-page color illustration in Farrell, Unwin, and Walvin, *The British Slave Trade*, 321. The full text, taken from Statutes at Large, LXI, pp. 140–148, can be found at http//www.pdavis.nl/Legis_06.htm.

31. For detailed analysis of these fetishistic encounters, see pp. 301 and 343–44 below.

32. Sherwood, *Britain and the Slave Trade*.

33. For missionaries in the context of emancipation rhetoric, see Oldfield, *"Chords of Freedom,"* 153–56.

34. The major paternalistic proslavery publications to emerge in the late eighteenth and early nineteenth centuries are concisely summarized in Brown, *Moral Capital*, 33–36, 365–84.

35. Drescher, *Capitalism and Antislavery*, 84–85, 124, 138, 142–49, 200, 252–54; Walvin, "The Public Campaign in England Against Slavery, 1787–1834," 67–68; Fladeland, *Abolitionists and Working Class Problems*, 98, 104; Taylor, *The Decline of British Radicalism, 1847–1860*, 179–83.

36. Even here, however, we need to be on our guard, for the optimistic fictions of eighteenth- and nineteenth-century emancipation rhetorics have been recirculated in revisionist popular history in the jaw-breakingly crude prose cartoons and anecdotes of the crowd-pleasing Niall Ferguson. See p. 106 below.

37. Dubois, "The Enslaved Enlightenment," 1–14.

38. Bernier, *African American Visual Arts*, 36.

39. For a survey of the most persuasive recent scholarship devoted to correcting celebratory takes on colonialism in the context of Atlantic slavery, see pp. 356–63 below.

40. *Peau noire masques blanc*, 51: "Il y a une trentaine d'années, un Noir de plus beau teint, en plein coït avec une blonde «incendiaire», au moment de l'orgasme s'écria: «Vive Schoelcher!» . . . Schoelcher es celui qui a fait adopter par la IIIe République le décret d'abolition de l'esclavage." The standard translation of Charles Lam Markmann gives "un Noir de plus beau teint" as "a coal Black nigger" (*Black Skin White Masks* [London: Pluto Press, 1986], 63) but Fanon's writing is more subtle and leaves it open to the reader to decide which shade of black is the most beautiful, while "Noir" does not translate automatically as "Nigger," and can just mean "black" or even "swarthy skinned."

41. Quoted in Anstey, *The Atlantic Slave Trade and British Abolition, 1760–1810*, 381.

42. For a detailed analysis of the genesis and subsequent generation of this visual device, see pp. 58–78 below.

43. See Macey, *Frantz Fanon*, 42; Haudrère and Vergès, *De L'Esclave au citoyen*, 142.

44. The most thorough account of Schoelcher's activities as the political architect of French slave abolition is Schmidt, *Victor Schoelcher et l'abolition de l'esclavage*.

45. For Schoelcher, the colonies, and race theory, see Cohen, *The French Encounter with Africans*, 198–270. For Schoelcher's dominance of French memorial art in the context of slavery, see Honour, *The Image of the Black*, 4:1, pp. 268–72 and for Schoelcher in commemorative philately, see pp. 224–35 below.

46. Fanon, *The Wretched of the Earth*, 40.

47. Fanon, *Peau noire masques blancs*, 178, translated and quoted in Macey, *Frantz Fanon*, 10.

48. The epigraph to this section is drawn from Fanon, *Peau noire masques blancs*, 187: "La densité de l'Histoire ne détermine aucun de mes actes. Je suis mon proper fondement. Et c'est en dépassant la donnée historique, instrumentale, que j'introduis le cycle de ma liberté. Le malheur de l'homme de couleur est d'avoir été esclavagisé."

49. Hegel casts his spell upon a variety of major intellectuals working on Atlantic slavery from different disciplines and with different political agendas. The two most forceful applications of Hegel within diaspora studies are Davies in his "Epilogue" to *The Problem of Slavery in the Age of Revolution, 1770–1823*, 557–64, where the relationship of Toussaint L'Ouverture and Napoleon is examined in the context of the master/slave dialectic; and Gilroy, *The Black Atlantic*, 51–53, 60–61, where he applies the master/slave dialectic to Frederick Douglass's account of his battle with the slave master Covey in the *Narrative of the Life of Frederick Douglass*.

50. Hegel in fact envisaged "freedom" finally as a nationalistic force, a spirit of the nation, or *Volksgeist*, which would drive world history to evolve "the spirit of its own freedom." This aspect of Hegel's thought is set out with admirable clarity by Gombrich in his essay "In Search of Cultural History," reprinted in *Ideals and Idols*, 28–34. On p. 30 he translates and quotes the key passage from the *Philosophy of World History*: "World history represents . . . the evolution of the awareness of the spirit of its own freedom. . . . In history such a principle becomes the determination of the spirit — a peculiar national spirit (*ein besondere Volksgeist*). It is here that it expresses concretely all the aspects of its consciousness and will, its total reality."

51. Hegel, *Philosophy of World History*, 88–102.

52. Hegel was finally if confusedly "outed" as even for his times a particularly bigoted "cultural racist" in an overly long and chaotically organized article, which also makes attempts to link Hegel's response to Africa with developments in Haiti. See Susan Buck-Morss, *Critical Inquiry*, 821–65. Published by University of Chicago Press, Stable URL: http://www.jstor.org/stable/1344332.

53. Sitwell, "Gold Coast Customs," 257–58.

54. Sitwell used a historical footnote on only one other occasion, to her poem "The Centaurs and Centauresses Jodelling Song," 114.

55. Sitwell, *Collected Poems*, 272.

56. See especially the comical black caricatures in "Notebook of a Return to the Native Land," in Césaire, *Collected Poetry*, 623, 76–79; René Depestre, "Epiphanies of the Voodoo Gods: A Voodoo Mystery Poem," 93–95.

57. "L'expérience vécue du Noir," in *Peau noir*, 87–99.

58. "Le Nègre et Hegel," *Peau noire masques blancs*, 175–80. Fanon's take on Hegel,

strangely, has attracted almost no commentary from postcolonial theorists or from Fanonian specialists. Fanon's dialogue with Hegel is written off in two sentences in Macey, *Frantz Fanon*, 162. In Macey's curt analysis Fanon is seen to read Hegel through the abstract filters of Alexander Kojève and Jean Hyppolite. As Macey reads it, Fanon merely finds this version of Hegel not fit for his radical colonial purposes.

59. Hegel, *The Phenomenology of Mind*, 233.

60. Fanon, *Peau noire masques blancs*, 178:

Historiquement, le nègre plongé dans l'inessantialité de la servitude, a été libéré par le maître. Il n'a pas soutenu la lutte pour la liberté. D'esclave, le nègre a fait irruption dans la lice où se trouvaient le maîtres. Pareil à ces domestiques a qui une fois l'an on permet de danser au salon, le nègre cherche un support. Le nègre n'es pas devenu un maître. Quand il n'y a plus d'esclaves, il n'y a pas de maîtres.

61. Césaire, *Collected Poetry*, 86.

62. Fanon, *Peau noire masques blancs*, 178:

Un jour un bon maître blanc qui avait de l'influence a dit à ses copains: «Soyons gentils avec les nègres» Alors les maîtres blancs, en rouspétant, car c'était quand même dur, ont décidé d'élever les hommes-machines-bêtes au rang supreme d'hommes. *Nulle terre française ne doit plus porter d'esclaves.* Le bouleversement a atteint le Noir de l'extérieur. Le Noir a été agi. Des valeurs qui n'ont pas pris naissance de son action, des valeurs qui ne résultent pas de la montée systolique de son sang, sont venues danser leur ronde colorée autour de lui.

63. Fanon, *Peau noire masques blancs*, 178–79:

La libération des esclaves noirs détermina des psychoses et des mortes subites. Dans une vie, on n'apprend pas deux fois cette même novelle. Le Noir s'est contenté de remercier le Blanc, et la prevue la plus brutale de ce fait se trouve dans le nombre imposant de statues disséminées en France et aux colonies, représéntant la France blanche caressant la chevelure crépue de ce brave nègre dont on vient de brizer les chaînes. «Dis merci à monsieur», dit la mère à son fils … mais nous savons que souvent le petit garçon rêve de crier quelque autre mot — plus retentissant.

64. Fanon, *Peau noire masques blancs*, 179: "Quand il arrive au nègre de regarder le Blanc farouchement, le Blanc lui dit: «Mon frère, il n'y a pas de différence entre nous.» Pourtant le nègre *sait* qu'il y a une différence. Il la *souhaite*. Il voudrait que le Blanc lui dise tout à coup: «Sale nègre»"

65. Fanon, *Peau noire masques blancs*, 179: "L'ancien esclave exie qu'on lui conteste son humanité, il souhaite une lutte, une bagarre. Mais trop tard."

66. Fanon, *Peau noire masques blancs*, 180:

«*The twelve million black voices*» ont geuele contre le rideau du ciel. Le rideau traversé de part en part, les empreintes dentales bien en place, lo-gées dans son ventre d'interdiction, est tombé tel un balaton crevé. Sur le champ de bataille, limité aux quatre coins par des vingtaines de nègres pendus par les testicules, se dress peu à peu un monument qui promet

d'être grandiose. Et au sommet de ce monument, j'aperçois dêjá un Blanc et un Nègre *qui se donnent la main.*

67. Gillo Pontecorvo, Dir., *Burn!,* a.k.a. *Queimada!* (France/Italy, Alberto Grimaldi, 1968), 132 mins.

68. The finest analysis of the film in the context of slavery and cinema is Davis, *Slaves on Screen,* 41–55.

69. Brando took on the part of Sir William for a minimal fee, and acted alongside a cast of a few minor and a mass of unknown actors. The blacks were played by people with no acting experience at all. Brando had titanic conflicts with Pontecorvo, and maintained to the end of his days that the film contained his most significant and finest performance. See Davis, *Slaves on Screen,* 47–48.

70. Franco Solinas, *Burn!,* screenplay, mins. 115–16.

71. The epigraph to this section is drawn from de Mello, *Estatutos do Homem,* 44–45: "Artigo Final / Fica Proibido o uso da palavra liberdade / A qual será suprimida do dicionários / E do pântano enganoso das bocas. / A partir deste istante / A liberdade será algo vivo e transparente / Como um fogo ou um rio, / Ou como a semente do trigo, / E a sua morada será sempre / O coração do homem." My translation.

72. Lewis, *The Essential C. S. Lewis,* 489.

Chapter Two. The Arts and Craft of Freedom: Picturing Liberty and the Free Slave

The epigraphs to this chapter are in part drawn from Nevison, *England's Voice of Freedom* (Locke, 95; Burke, 128–29).

1. *Green's Characters from Uncle Tom's Cabin,* pasteboard toy, J. K. Green, London, 1853, New York Public Library, Theatre Collections.

2. "The Antiquity of Freedom," in *Poems of William Cullen Bryant,* 187.

3. See pp. 44–49 below.

4. Davis, *Emancipation Moment,* 16–17.

5. Finley, *Ancient Slavery and Modern Ideology.* Although Finley did not have access to much of the more important primary source material that has since come to light, he brilliantly sets out the conflicting and politically biased history of the interpretation of the demise of the Roman slave systems prior to the final collapse of the empire. His wry sense of humor makes a potentially dry subject continually funny.

6. See Wiedemann, "The Regularity of Manumission in Rome," 162–75. For contemporary classical accounts with all primary sources translated into English, see the brilliant anthology Wiedemann, *Greek and Roman Slavery,* Greek (pp. 45–49), Roman (pp. 50–56, 70–77), Christian (pp. 244–46); Palmer, "The Cultural Significance of Roman Manumission," http://userwww.sfsu.edu/~epf/1996/manumssn .html#035.

7. The first serious study of primary source manumission documents and objects in ancient Greece was Calderini, *La manomissione e la condizion dei liberti in Grecia.* See also Buckland, *The Roman Law of Slavery;* Duff, *Freedmen in the Early Roman*

Empire. For social life and manumission in the ancient world, see Wiedemann, *Greece and Rome*, 27–28; Pomeroy, *Goddesses, Whores, Wives and Slaves*, 194–97; Hughes, *Greek and Roman Slavery*, 21–30; Vogt, *Ancient Slavery*, 103–22. Vogt also includes a useful survey of major humanist interpretations of ancient slavery together with an explanation of their relative limitations on pp. 188–211.

8. For the bibliography of ancient slavery, see the ridiculously massive Haaga, *Bibliographie zur Erforschung der antiken Sklaverei im 19. und 20. Jahrhundert*; Bellen and Heinen, *Bibliographie zur antiken Sklaverei*. The best brief overviews I have read are Finley, of which pp. 18–149 are particularly valuable in giving a series of key insights into the neglected subject of Greek slavery; Vogt, *Ancient Slavery*, 170–219, and "bibliographical supplement" (pp. 211–19). See also Palmer, "Cultural Significance." For a skeptical approach to the tendencies of Vogt and the vast and ongoing Mainz ancient slavery project to idealize aspects of classical slavery, see Finley, *Ancient Slavery*, 18–19, 55–60, 94, 107.

9. M. I. Finley remains the most level-headed and informed scholar to have attempted specific comparisons between Roman slavery and that of the plantation systems of North America. It is clear from his work that the debates and confused discussions over the demise of the Roman slave systems find no parallel in the Atlantic diaspora. See in particular his chapter in *Ancient Slavery*, "The Decline of Ancient Slavery," pp. 123–49.

10. Dionysius of Halicarnassus, *Ancient History of Rome*, 4, 24, quoted in Wiedemann, *Greek and Roman Slavery*, 71.

11. For statuary and illustrations of statues showing this imagery, see Honour, *The Image of the Black*, 4:1, 77, 81, 84, 97–105, 154–55, 165, 225–27, 245–51, 255–57, 261–77; for the Brazilian imagery, see Wood, "Creative Confusions," 245–71; see also pp. 19–21, 222–23, and 234–35, below.

12. Reproduced and very briefly discussed in Wiedemann, *Slavery*, 28, 36. For texts describing the ceremony of manumission with the rod (*vindicta*), see Wiedemann, *Greek and Roman Slavery*, 24, 27–29, 50, 231–32.

13. Cicero, *Topica*, 2, 10, quoted in Palmer, "Cultural Significance," fn. 6.

14. Paulus, *apud* Festus translation from Gardner and Wiedemann, *The Roman Household*, 50.

15. *Brewer's Dictionary of Phrase and Fable*, entry "Cap of Liberty," 193.

16. For Cesare Repa's use of the liberty cap icon, see Giornale Nuovo, "The Genius of Salvator Rosa," online at www.spamula.net/blog/i40/rosa3.jpg.

17. Wrigley, *The Politics of Appearances*, 142–43.

18. The best comparative study of the liberty cap movement between France and America and of the absorption of Dupre's famous image of Liberty is Korshak, "The Liberty Cap," 53–69.

19. The most minute discussion of the complicated cultural evolution of the *bonnet rouge* is Wrigley, *The Politics of Appearances*, 136–68. The popular imagery featuring the liberty cap and the cultural historical background relating to its exploitation is most fully covered in Hunt, "The Political Psychology of Revolutionary Caricatures," 33–40; and for analysis of the liberty cap in individual entries for plates in this

catalogue, see pp. 178–82, 199, 203–4, 208–9, 227. The other readily available visual archive is Darnton and Roche, *Revolution in Print*, which illustrates the remarkable variety of graphic contexts in which the icon was used and includes fine discussions of its exploitation in specific contexts.

20. Male and female busts, stipple engravings on copper both entitled *Moi Libre Aussi* made in 1792 by Jean-Louis Darcis, Paris, Bibliothèque Nationale, Cabinet des Estampes, Collection Hennin, t. 129, nos. 11353, 11354. The engravings relate to and are probably copied from the heads of the sculptured pair of figures by Simon-Louis Boizot entitled *Moi égale à toi, moi Libre aussi*, Musée du noveau Monde, 83–4–2. Honour, *The Image of the Black*, 82–84, 200 nn. 202, 206, 207, states that there was a plethora of popular and technically crude prints flooding France at this date that showed blacks, and particularly black women, as equals. One particularly powerful example had the black woman wearing a perfectly balanced spirit level around her neck to show the equality of all humans when set in the level playing field of the Revolution.

21. Quoted in Honour, *The Image of the Black*, 84; for further examples of French mass propaganda, including card packs and packing boxes showing freed blacks in liberty caps, see p. 318 fn. 207.

22. See *French Caricature*, 180: "On 20 June 1792 the anniversary of the Oath of the Tennis Court and the flight to Varennes the *sans-culottes* of Paris staged a great demonstration or *journée* invading the Palais de Tuilleries. Brandishing pikes and spears and wearing red liberty caps the crowd . . . made its way to the palace where it confronted Louis XVI with cries of 'down with the veto.' The king donned the Phrygian cap of liberty and drank a toast to the health of the nation."

23. Anonymous copper engraving of Louis XVI published in 1792 but constituting a reworked version of an official portrait engraving of 1775, which had been made after a painting by Joseph Boze, court painter to the king. See *French Caricature*, 179 catalogue numbers 64 and 65.

24. See Darnton and Roche, *Revolution in Print*, for Hercules (p. 209); for images of the Bastille heroes beneath the liberty cap (p. 237); for revolutionary playing cards and the cap of liberty (color plate 13).

25. See Honour, *The Image of the Black*, 4:1, 104–6, for Girodet's *Portrait de Jean-Baptiste Bellay*, and 4:2, 7–9 for Benoist's *Portrait d'une négresse*.

26. For an analysis of the politics of color in this poem, see Wood, *Slavery, Empathy and Pornography*, 236–37; and for the full text, Wood, *The Poetry of Slavery*, 233–34.

27. The most succinct summary of these tendencies is to be found in Paulson, "The Severed Head," 55–67; and Paulson, *Representations of Revolution*, 200–215.

28. The two best accounts of Fox's treatment by Gillray during the early stages of the French Revolution are Donald, *The Age of Caricature*, 167–71; and Godfrey, *James Gillray*, 151–57.

29. *Regeneration — Viz. Parliament Reformed a la Francoise*, hand-colored etching March 2, 1795, British Museum, BMC 8264. Discussed and illustrated in Godfrey, *James Gillray*, 103.

30. Godfrey, *James Gillray*, 103. The print has no date but was intended for the deluxe edition of the journal *The Anti-Jacobin*. In 1800, Gillray withdrew from the project and the print was never published.

31. George, *English Political Caricature*, 1:205–17; 2:1–15, and plates 1, 5, 7, 15; Donald, *Age of Caricature*, 142–81; Godfrey, *James Gillray*, 98–105. For the continuation of this treatment of French Liberty in the *bonnet rouge*, see Cruikshank's etching *The Leader of the Parisian Blood Red Republic or the Infernal Fiend*, cat. 405, p. 12.

32. Joseph Collyer, after Henry Moses, *Plate to commemorate the abolition of the Slave Trade*, June 4, 1808. For a detailed discussion of the print, see Wood, "Popular Graphic Images," 138–40.

33. Reilly, *Catalog*, "The American Flag," 1862–4.

34. See Vivien Green Fryd, "Political Compromise in Public Art: Thomas Crawford's Statue of Freedom," online at http://www.people.virginia.edu/~tsawyer/DRBR/fryd/fryd.html.

35. Reilly, *Catalog*, "The Triumph," 1862–15.

36. Reilly, *Catalog*, "Northern Coat of Arms," 1864–36.

37. For Haitian atrocity propaganda, see pp. 168–70 below.

38. Dixon, *The Clansman*, 309–10.

39. For the figure of nobody in popular graphic culture, see George, *English Political Caricature*, 1, 161, and plate 58, "Whose in Fault Nobody."

40. The epigraph to this section is drawn from Chesnutt, *Collected Stories*, 90–91.

41. For reasons of economy I concentrate fairly exclusively upon adaptation of the male version of the seal in this chapter. The adaptive history of the female version in the nineteenth century within the North American context is conveniently plotted by Yellin, *Women and Sisters*, 3–29.

42. Davis, *Emancipation Moment*, 17.

43. The epigraph to this section is drawn from *Complete Works of Shelley* (Oxford: Oxford University Press, 1904), stanza xxxix, p. 369.

44. Quarles's *The Negro in the American Revolution* remains the standard account of the treatment of slaves in the Revolutionary War.

45. Hochschild, *Bury the Chains*, 98–105.

46. Reilly, *Catalog*, 1781–1, *America to Those who wish to Sheathe the Desolating Sword of War.*

47. The most detailed historical commentary on the prints generated by the War of Independence in America is Reilly, *Catalog*, prints for 1766–96; see also Williams, *A Cartoon History of the American Revolution*; and Thomas, *The English Satiric Print, 1600–1632.*

48. See Reilly, *Catalog*, 1819–1, 1821–1, 1825–1, 1827–1, 1832–4, for other examples of "Bobalition" satire during 1808–35.

49. For a detailed account of these interactions, and particularly for the effect of the propaganda on Mirabeau, see Wood, *Blind Memory*, 26–29; also Oldfield, *Popular Politics and British Anti-Slavery.*

50. See letter, April 8, 1789, from Compt d'Agiviller to the director of the Sèvres factory, quoted in Honour, *The Image of the Black in Western Art*, 4:1, 79.

51. Quoted in Honour, The *Image of the Black*, 4:1, 56.

52. Acts 17:26.

53. See Wood, *Radical Satire and Print Culture*, for a detailed discussion of this image and its race implications within British radicalism.

54. See Ferguson, *Subject to Others*, 249–59, for Heyrick and her ambivalent relationship with British abolition.

55. Quoted in Sutherland, "Thackeray as Victorian Racialist," 441.

56. For a detailed account of British graphic responses to America during the Civil War, see Wood, "The Deep South and English Print Satire, 1750–1865," 107–40.

57. *Punch*, November 13, 1858, 196.

58. *Punch*, March 4, 1865, 88.

59. For an excellent account of the event, see Heuman, *"The Killing Time"*; for a summary of the Eyre Affair's effect on the cultural life of Lorimer, see *Colour, Class, and the Victorians*, 178–201; for Carlyle's input, see Workman, "Thomas Carlyle and the Governor Eyre Controversy," 77–102.

60. *Punch*, December 23, 1865, 248.

Chapter Three. Pragmatic Popular Propagations of the Emancipation Moment

The epigraph to this chapter was drawn from Nevinson, *England's Voice of Freedom*, 6–7.

1. Sherwood, *Britain and the Slave Trade after 1807*, 15–26, 180–81, and pp. 13–15 above and 343–44 below.

2. Sherwood, *Britain and the Slave Trade after 1807*, 59–110; Jordan, *The Great Abolition Sham*, 141–56; Turner, "The Limits of Abolition," 319–57; Eltis, "The British Trans-Atlantic Slave Trade after 1807," 1–11; Farrell, "'Contrary to the Principles of Justice, Humanity and Sound Policy,'" 165–71.

3. Hume, *The Student's Hume*, 700–701.

4. For Pitt on slavery, see James, *The Black Jacobins*, 42–43, 108, 175, 220–21; Williams, *Capitalism and Slavery*, 52, 121–23, 146–49. The first extended defense of Pitt's twists and turns on abolition, in dialogue with Williams, is Mellor, *British Imperial Trusteeship*, 47, 50–57, 64–70, 71.

5. Fox on slavery, see pp. 18–20 below.

6. Airy, *A Textbook History of England*, 415–18.

7. Trevelyan, *History of England*, 599.

8. For the disguises now put in place to animadvert the word *slavery*, see Plant, *Sugar and Modern Slavery*; Sutton, *Slavery in Brazil*; Anderson, *Britain's Secret Slaves*; Bales, *Disposable People*.

9. Rose and Newton, *The Cambridge History of the British Empire*, 215.

10. Mellor, *Imperial Trusteeship*, 11–30.

11. Schama, *Rough Crossings*.

12. Schama, *Rough Crossings*, 462–63.

13. For the detailed analysis of this visual legacy, see pp. 53–54 and 70–72.

14. *Anti Slavery Jubilee*, 5.

15. *Anti Slavery Jubilee*, 7.

16. *Anti Slavery Jubilee*, 19.

17. *Anti Slavery Jubilee*, 24.

18. Emerson, *An Address*, 3.

19. To see the construction of this myth in the late nineteenth century in America, see Lecky, *A History of European Morals*. For a brief survey of the American celebration of 1834, see Davis, *The Problem of Slavery in Western Culture*, 24–28.

20. Michael, *The Slave and His Champions*, 21.

21. For representative collections of this material, see Hamilton and Blyth, *Representing Slavery Art*, 193–207; Tibbles, *Transatlantic Slavery Against Human Dignity*, 87–95.

22. Kowaleski, *The British Slave Trade and Public Memory*.

23. The black insistence on sharing the celebratory rhetoric of the emancipation moment is dealt with in some depth in Eudell, *Political Languages of Emancipation*.

24. Du Bois, *The Souls of Black Folk*, 6.

25. Smart, *On This Day*.

26. For the precise replication of this gesture of liberation in official statuary, see figs. 1.5 and 5.20 and the analysis on pp. 20–22, 234–35, and 283 below.

27. For slave dancing in emancipation prints, see pp. 170–81 below.

28. For the fetishization of this gift and its relation to the theory of gift exchange, see pp. 9–13 above.

29. *On This Day*, unpaginated, article "Jan. 1st 'American Slaves Must Be Unchained.'"

30. For Lincoln and the Emancipation Proclamation, see pp. 219–21 below.

31. Quarles, *The Negro and the American Revolution*; Quarles, *The Negro in the Making of America*; and see pp. 166–70 below.

32. Ferguson, *Empire*, 118–19.

33. See Flaubert, *A Sentimental Education*, vii.

34. Mellor, *British Imperial Trusteeship*, 31–173.

35. The epigraphs to this section were drawn from Fox, *The Journal of George Fox*, entry for the year 1654; Hochschild, *Bury the Chains*, 248; Hall, "William Knibb," 317.

36. Quoted in Hochschild, *Bury the Chains*, 348.

37. Quoted in Hochschild, *Bury the Chains*, 348.

38. See pp. 7–9 for the threshold gift, and the gift over the coffin in particular.

39. Brown, *Moral Capital*, 435–43; Oldfield, *Popular Politics and British Antislavery*, 70–91.

40. Clarkson, *History*, 1:9–10.

41. I restrict myself in this chapter primarily to popular texts and prints. This is partly because the wider performative contexts for emancipation rituals in Britain from 1807 to the early twentieth century have been mapped with exemplary scholarship and deep imagination in Oldfield, *"Chords of Freedom."*

42. For Wilberforce's dubious positioning on domestic politics, his support of

Pitt's excessively repressive domestic legislation, and the consequent hatred in which he was held by the entire spectrum of political radicals, see Wood, *Blind Memory*, 293–95; for the manufacture of the Wilberforce myth, see Oldfield, "*Chords of Freedom*," 3–4, 33–49, 56–62, 65–72, 98–107, 131–32.

43. Williams, *A Narrative*, 5.

44. For the conditions of apprenticeship and the confused but muted political responses, see Burn, *Emancipation and Apprenticeship in the British West Indies*; Holt, *The Problem of Freedom*, 60–71; Shelton, "A Modified Crime," 331–45; Marshall, "Apprenticeship and Labour Relations in Four Windward Islands," 23–24.

45. Some propaganda did gain a wider audience. For an excellent contextualizing discussion of the operations of propaganda around the question of apprenticeship, see Diana Paton, introduction to *A Narrative of Events*, xxiii–xlvi.

46. In an accompanying letter sent with his original drawing Ramsay stated that the local Jamaican printers would not be capable of producing the work, noting that his drawing of the scene "could be well worked up in England and at a small expense: done here I think a sad job would be made." Stewart, *Michael Graham Stewart Slavery Collection*, 23.

47. The National Maritime Museum's copy of the print is accompanied by a double-page printed commentary on the event and the participants. The details relating to the participants and subsequent quotations in my text are drawn from this document, which is reprinted in Stewart, *Michael Graham Stewart Slavery Collection*, 23–24.

48. Hollis, "Anti-slavery and British Working Class Radicalism," 297–311.

49. For the continuation of this formula in the context of the Abolition Seal in mainstream British graphic satire, see the discussion of *Punch*, pp. 85–89 above.

50. See pp. 56–57 above.

51. Reilly, *Catalog*, 1861-35. For the association of the slave power with the dragon of Revelation, see pp. 361–62 below.

52. Lemprière, *Classical Dictionary*, 288–89, entry "Hydra."

53. *Revista Illustrada* (May, 26 1888); the print is discussed in *Cadernos Brasileiros 80 anos de abolição*, Number 47, part 3, May–June 1968, pp. 31–32, reproduced 37.

Chapter Four. No-go Areas and the Emancipation Moment: Running-Dancing-Revolting Slaves

1. The epigraph to this section was drawn from Boswell, *Life of Samuel Johnson*, entry 1768, 114.

2. For an imaginative treatment of this syndrome, see the discussion of Borges on pp. 364–68 below.

3. For protean evolution of the slave narrative into a postbellum set of containing orthodoxies, see Davis and Gates, *The Slave's Narrative*; Andrews, *To Tell a Free Story* and his still exemplary bibliography.

4. Carretta, *Olaudah Equiano*. For what remains a fine account of the intellectual and publishing milieu in which Equiano wrote and worked, see Sandiford, *Measuring the Moment*, 17–71, 119–51.

5. See Andrews, *To Tell a True Story*, 265–93, 333–42; Davis and Gates, *The Slave's Narrative*, 326–27; Starling, *The Slave Narrative*.

6. Bolt, *The Anti-Slavery Movement and Reconstruction*; Blight, *Passages to Freedom*; Hudson, *Encyclopaedia of the Underground Railroad*.

7. Neither the greater or lesser Antilles, nor the European slave powers that ran the slave industries on these islands, fostered any significant slave narrative, at least until the introductions of the apprentice systems. See pp. 116–19 above. For the literary context, see Giles, *Transatlantic Insurrections*.

8. For the continuing popularity of Foxe and for his vast influence on American abolition thought and action, see Dimond, *The Psychology of the Methodist Revival*, 133–55; Wolf, *On Freedom's Altar*, 4–7, 62–65, 130–31, 147–48.

9. For English abolitionist cults of martyrdom and their sadomasochistic leanings, see Wood, *Slavery Empathy and Pornography*, 24–86, 398–427; for the American materials, see Walker, *The Trial and Imprisonment of Jonathan Walker at Pensicola Florida*; Brown, "Lovejoy's influence on John Brown," 97–102; Goodell, *Slavery and Anti-Slavery*; Hinton, *John Brown and his men*; Karsner, *John Brown: "Terrible Saint"*; Root, *A Memorial of the Martyred Lovejoy*; Stowe, *The Lives and Deeds of our Self Made Men*; Wolf, *On Freedom's Altar*.

10. For the porous boundaries between the slave narrative and the marketing of "runaway" novels, see Stowe, *Key to Uncle Tom's Cabin*; Hildreth, *The Slave; or, Memoirs of Archie Moore*, 2 vols. (Boston, 1836) republished in single-volume form as *The White Slave; Another Picture of Slave Life in America* (Boston, 1852); Newberry, "Eaten Alive," 61:1, 159–87.

11. For the mass adaptation of *Uncle Tom's Cabin* and abolition in popular culture, see Davis, "Tom Shows," 355–60; Birdoff, *The World's Greatest Hit*; Gardiner, "The Assault upon Uncle Tom," 313–24; Bowlby, "Breakfast in America," 197–212; Wood, *Blind Memory*, 143–214.

12. For a comprehensive analysis of the thoroughness with which abolition texts generally could be absorbed into Anglo-American publishing environments, see the scholarly Meer, *Uncle Tom Mania*.

13. For Jacobs's negotiation of the subjects of lechery and extramarital pregnancy, see Yellin, *Women and Sisters*, 87–96; and for a more general approach to fictional constructions of threatened black female sexuality, see Rogin and Yellin, *The Abolitionist Sisterhood*, 5–8; De Vere Brody, *Impossible Purities*. There has been growing interest in Jacobs's scholarship over the relation of her text to pornography; see Painter, *Southern History Across the Color Line*, 110–17, and the H-Net review of this book, "Jeanette Keith on Nell Irvin Painter, *Southern History Across the Color Line*," published by H-SAWH (July 2002) online at http://www.h-net.msu.edu/reviews/showrev.cgi. For proslavery exploitation of the latent pornography of Jacobs's text, see the fascinating unpublished conference paper by Colette Corrigan, "Anti-Abolition Writes Back: An English Pornographic Parody of Harriet Jacobs' Slave Narrative." The Annual Victorian Conference in Literature and Culture: The Victorians and America, University College Worcester, Worcester, UK, April 28, 2001. For a terrifying insight into how distorted pornographic readings of Jacobs can get, see "Tayari's Blog: Confessions Of A Video Vixen, More Thoughts" where Tayari Jones compares

Karrine Steffans, *Confessions Of A Video Vixen*, with Jacobs, *Incidents*, and a furious exchange results online at http://www.tayarijones.com/blog.

14. For UTC and erotic bondage fantasy, see Wood, *Blind Memory*, 184–85. The connections between black and white sexual exploitation of Atlantic slavery in the context of sexual bondage fantasy remains an under-researched subject; see Wood, *Slavery Empathy and Pornography*, 403–27. See also Burgett, "Obscene Publics: Jesse Sharpless and Harriet Jacobs," *Genders* 27 (1998), online at http://www.Genders.org; and Corrigan, "Transatlantic Slavery and The English Vice," 67–99.

15. Andrews, *To Tell A Free Story*, 205–65; Foster, *Witnessing Slavery*; and for a general discussion of literary canon formation that relates to the slave narrative, see Guillory, *Cultural Capital*.

16. *American Slavery as it is or Testimony of a Thousand Witnesses*, 78.

17. Clarkson, *NEGRO SLAVERY*; Coleridge, *The Table Talk and Omniana of Samuel Taylor Coleridge*, 353–54; Stowe, *Key to Uncle Tom's Cabin*, 239–57; Dickens, *American Notes*, 230–35. For eighteenth-century American slave advertisements, see Windley, *Runaway Slave Advertisements*. See also Smith and Wojtowicz, *Blacks who stole Themselves*, and Morgan, "Colonial South Carolina Runaways," 6:3, 57–79. For Brazilian runaway advertising, see Freyre, *Os Escravo nos Anúncios de Jornais Brasileiros do Século XIX*.

18. Young, *The Texture of Memory: Holocaust Memorials and Meaning*, 126–35.

19. These processes are mapped in the context of popular American graphics; see pp. 55–58 above.

20. Still, *The Underground Railroad*.

21. For radical developments in American publishing in the mid-nineteenth century, see Mott, *A History of American Magazines, 1850–1865*; Tebbel, *Between Covers*; Zboray, "Antebellum Reading and the Ironies of Technological Innovation," 65–82.

22. Still, *The Underground Railroad*, 23.

23. For the operations of this rhetorical tradition in the contexts of Thomas Clarkson, William Wilberforce, and Harriet Martineau, see pp. 91–99 and 112–15 above and pp. 199–213, 324–30, and 336–53 below.

24. Brown had published *The Black Man* and *The Rising son: or, The antecedents and advancement of the colored race*, but neither of these is exclusively devoted to the celebration of black slave agency through escape.

25. For the role of memorial photographs and the Vigilance Committee, see Still, *The Underground Railroad*, 153, 171, 284, 713.

26. Still, *The Underground Railroad*, 281–82.

27. Still, *The Underground Railroad*, 282.

28. For Christ and his "Eastern" approach to eye symbolism, see Miller and Miller, *Black's Bible Dictionary*, 181, article "eye."

29. Still, *The Underground Railroad*, 283–84.

30. Still, *The Underground Railroad*, 283.

31. For the celebration of Henry "Box" Brown, see Wolff, "Passing Beyond the Middle Passage," 37:1, 23–43; Gara, "The Professional Fugitive in the Abolition Movement," 48:2, 196–204; Wood, *Blind Memory*, 104–17.

32. Blackett, *Building an Antislavery Wall*, 159–60; Ripley, *The Black Abolitionist Papers*, 5:1, 174–75 n.

33. For the popular visual imagery, see Wood, *Blind Memory*, 103–17.

34. Brown, *Narrative of the Life of Henry Box Brown, Written by Himself*, 1–3, 47–48.

35. Blackett, *Building an Antislavery Wall*, 159.

36. Still, *The Underground Railroad*, 82.

37. Still, *The Underground Railroad*, 81.

38. Still, *The Underground Railroad*, 81.

39. Still, *The Underground Railroad*, 81.

40. Still, *The Underground Railroad*, 83.

41. Still, *The Underground Railroad*, 84.

42. Still, *The Underground Railroad*, 4.

43. Still, *The Underground Railroad*, 46.

44. Still, *The Underground Railroad*, 46.

45. Still, *The Underground Railroad*, 47.

46. Still, *The Underground Railroad*, 48.

47. The plantation songs provide one way of glimpsing the remarkable and long-standing potency of this myth within the slave cultures. See Fisher, *Negro Slave Songs in the United States*; Wood, *The Poetry of Slavery*, 399–404.

48. The idea of hell as a lake of fire and brimstone comes from the biblical book of Revelation, chapters 19 and 20. For hell and the evolution of a metaphorics of fire, see *Black's Bible Dictionary*, 593, article "Punishment."

49. Still, *The Underground Railroad*, 55.

50. Still, *The Underground Railroad*, 55.

51. Still, *The Underground Railroad*, 609.

52. Browning, "An Epistle containing the strange medical experience of Karshish the Arab physician," 117–22.

53. Still, *The Underground Railroad*, 150.

54. Still, *The Underground Railroad*, 152.

55. The "Wonderful Tar Baby Story" first became widely available to white American audiences with the massive popularity of Harris, *Uncle Remus*. Yet Harris's tales were adapted in every particular from black plantation folklore, and Still would almost certainly have come across one of the multiple versions of this story.

56. See n. 48 above.

57. Still, *The Underground Railroad*, 152.

58. Still, *The Underground Railroad*, 152.

59. Still, *The Underground Railroad*, 374.

60. For Powers and American neoclassical revival, see Fine, *The Afro-American Artist*, 38–39; for contemporary accounts verging on the pornographic, see Yellin, *Women and Sisters*, 110–12, and for the *Punch* caricature, 119–22.

61. Still, *The Underground Railroad*, 375–76.

62. See Gattrell, *The Hanging Tree*.

63. Barrell, *Imagining the King's Death*.

64. Wood, *Radical Satire and Print Culture, 1790–1822*, 97–155.

65. Andrews, *To Tell a Free Story*, 47–51.

66. The role of Gray in the production of the text of *The Confessions of Nat Turner* has recently become the center of intense academic speculation. The extant scholarship and current state of play are ably summed up in Almendinger, "The Construction of *The Confessions of Nat Turner*," 24–45. Almendinger concludes that Turner's account emerges largely intact, yet along with the rest of the scholarship that looks at this text does not focus on the fact that the *Confessions* is, in formal terms, a straightforward contribution to the gallows confession pamphlet literatures.

67. For the publishing background to the *Confessions* and for the literary exploitations of the Tuner insurrection across America, see Tragle, *The Southampton Slave Revolt of 1831*; see also Greenberg, *Nat Turner*.

68. For Dessalines's cruelty and the slaughter of the whites in the concluding stages of the San Domingo revolution in le Cap, see James, *The Black Jacobins*, 233–34, 291–92.

69. A full bibliographic transcription of the *Authentic and Impartial Narrative* (1831) is in Tragle, *Southampton Slave Revolt*, 281–300.

70. Tragle, *Southampton Slave Revolt*, 310.

71. For Dred in the popular marketplace, see Meer, *Uncle Tom Mania*, 225–51; Hamilton, "*Dred*," 257–77; Grüner, "Stowe's *Dred*," 1–37.

72. For this print in its general graphic context, see Wood, "Popular Graphic Images of Slavery and Emancipation in Nineteenth Century England," 138–51; the print is discussed on p. 150.

73. For the confused operation of such imagery in the publicity surrounding the 2007 bicentennial of the slave trade act, see pp. 204–5 below.

74. For the reproduction of this material, see Tragle, *Southampton Slave Revolt*, 159.

75. For the context for the production of Rainsford's book, see Thomas, *The Image of the Black*, 4:1, 94–95.

76. It is relevant that certain literary responses at this period were far more positive and daring in their preparedness to present the black violence as justified. See, for example, Whitchurch, *Hispaniola*, and Wood, *Poetry of Slavery*, 154–55, 168–80; Wood, *Slavery, Empathy, and Pornography*, 232–34.

77. The classic proslavery account for the planter lobby in England was Edwards, *An Historical Account of the Black Empire of Hayti*; the most extreme and popular atrocity literature in translation was *Account by the planter Deputies of San Domingo before the French National Assembly at the beginning of November 1791* (London, 1792); *An Historical Account of the French Colony of San Domingo: Comprehending . . . a Narrative of the calamities which have desolated the island ever since 1789 with some reflections on their causes and probable consequences and a detail of the British Army in that Island to the end of 1794* (London, 1794). For the whole span of responses to San Domingo, see Geggus, *Slavery, War, and Revolution*, 79–132, 360–72, 387–91; for the incorporation of the Revolution into Negrophobe stereotypes in the political rhetoric

of Burke and Cobbett, see Wood, *Slavery, Empathy, and Pornography*, 155–63; for American responses, see Hickey, "America's response to the Slave Revolt in Haiti," 361–79.

78. The historical model in this context is the monumental Morgan, *Slave Counterpoint*; for slaves and visual culture, see Fine, *The Afro-American Artist*, 9–37; Barringer, Forrester, and Martinez-Ruiz, *Art and Emancipation in Jamaica*; Berniere, *African American Visual Arts*, 17–55; for "Dave the Potter" and slave ceramics, see pp. 357–63 below.

79. Slave dancing during the middle passage is a lamentably under-researched subject. There are some sporadic and disinterested references in Rediker, *The Slave Ship*, 19, 61, 164, 170, 237–38, 260, 267, 325, 332. The subject is briefly considered in Edward Thorpe's confrontational and rambunctiously written *Black Dance*, 8–12.

80. Lambert, *House of Commons Sessional Papers of the Eighteenth Century*, 85, 87. This and other accounts of the male slaves dancing in a "sulky" fashion are quoted in Rediker, *The Slave Ship*, 332.

81. Rediker, *The Slave Ship*, 237–38.

82. For the emotional range of African dance, see Thorpe, *Black Dance*, 13–31.

83. Gréhan, *France Maritime* (Paris, 1855), unpaginated plate.

84. For evolution of Jim Crow and black-face dancing, see Toll, *Blacking Up*, 40–52; Meer, *Uncle Tom Mania*, 51–73; Straussbaugh, *Black Like You*, 1–57.

85. Thorpe, *Black Dance*, 13–14.

86. For representative examples, see Thorpe, *Black Dance*, 46–109; Honour, *The Image of the Black*, 4:2, 63, 65, 72–74, 138–40, 213.

87. The best introduction to the whole field is McConahie, *Melodramatic Formations*; see also Meer, *Uncle Tom Mania*, 44–45, 63–64, 84–88, 105–6, 122–27.

88. For the early history of black dance and its relation to slavery, see Thorpe, *Black Dance*, a valuable cultural history that shows how blacks managed to evade their stereotypification within Euro-American dance cultures.

89. George Cruikshank, illustrations to Harriet Beecher Stowe, *Uncle Tom's Cabin* (London, 1852), plate opposite page 324 captioned "He appeared among them with a bundle of papers in his hand, containing a certificate of freedom to everyone in the place," plate opposite page 26 captioned "'Ain't she a peart young'un?' Said Tom, holding her from him to take a full length view."

90. Morgan, *Slave Counterpoint*, 416, 418–20, 524, 532, 581–88, 592–93, 644. Morgan introduces his sensitive discussion of slave dance in the Chesapeake and Low Country with the honest declaration: "Unfortunately little can be discerned about Lowcountry dancing styles" (p. 584). In this context it should be pointed out that the visual archive generated in Brazil is very rich. The records that Debret left in his meticulous sketch books of slave dances are detailed and numerous. See Bandeira and Corrêa do Lago, *Debret e o Brasil Obra Completa*, 129, 165–67, 629.

91. The variant readings are summarized in Morgan, *Slave Counterpoint*, 587 fn. 47, 588. There is also a detailed discussion of the hybrid nature of the dancers in the painting: Babatunde Lawal, "Reclaiming the Past: Yoruba Elements in African

American Arts," in Falola and Childs, *The Yoruba Diaspora in the Atlantic World*, 293–97.

92. Morgan, *Slave Counterpoint*, 590.

Chapter Five. Stamping Out the Memory of Slavery: The 2007 Commemoratives and Philatelic Approaches to Bondage and Freedom

The epigraphs to this chapter were drawn from Williams, *The Postage Stamp*, 191, and Scott, *European Stamp Design*.

1. For the full range of products marketed by the Royal Mail around the 2007 abolition stamps, and for issue statistics, see "Royal Mail Stamps, Past Stamp Issues, 2007 Abolition of the Slave Trade" at http://www.royalmail.com/portal/stamps/content1.

2. The only extended analysis of stamp production for and in the French and English colonies is Scott, *European Stamp Design*, 72–86. Scott also discusses Ireland in his chapter "Post Colonial Identity Stamps of the Irish Free State and Republic," 86–95. There is a brief allusion to stamps from the British Caribbean connected to emancipation anniversaries in Oldfield, *"Chords of Freedom,"* 164–65.

3. For the semiotic complexity of stamps and their basis in nationalistic politics, see Scott, *European Stamp Design*, 6–15. Scott's remains the only extended study to think about the ambiguities of stamps in terms of how they convey information, yet his overly rigid reliance on Charles Sanders Peirce's theory of signs limits the terms of the discussion. For stamps as a development of *emblemata*, see Elkins, *The Domain of Images*, 197–200.

4. For the great formal complexity of stamped and mailed envelopes, see Elkins, *Domain*, 236–38; Svarc, *Stamps and Stamp Collecting*, 60–85. The extent to which stamp design production and distribution are now in thrall to the massive globalized collectors' market has greatly increased in the past twenty years due to the development of international auction and trading sites on the Internet. www.Delcampe.com gives instant access to this unending network of auction sites and sellers.

5. For customized FDCs generated around the abolition stamps, see the discussion of the productions of Norvic Philatelics, pp. 208–11 below.

6. There is little sophisticated work on the semiotic interpretation of stamps and their relation to nationalist and imperial agendas. The best historical surveys of British stamp production are Finlay, *An Illustrated History of Stamp Design*; Rose, *Royal Mail Stamps*; Scott, *European Stamp Design*, 17–23.

7. For the dominance of the heads of reigning monarchs in British philately, see Scott, *European Stamp Design*, 8–9, 17–19.

8. *Stanley Gibbons Great Britain Concise Stamp Catalogue 1999 edition*, 2–21.

9. The major sets were: *Gibbons*, pp. 55–56, "Investiture of Prince of Wales"; p. 96, "Royal Silver Wedding"; p. 99, "Royal Wedding Princess Anne Capt. Mark Phillips"; p. 111, "Silver Jubilee"; p. 123, "80th Birthday of HM the Queen Mother"; p. 127, "Royal Wedding Charles and Diana"; p. 146, "60th Birthday of Queen Elizabeth II";

p. 148, "Royal Wedding, Prince Andrew and Sarah Ferguson"; p. 168, "90th Birthday of HM the Queen Mother"; p. 210, "400th Anniversary of Death of Henry VIII"; p. 215, "Royal Golden Wedding."

10. *Gibbons*, p. 216, cat. nos. 1338–42.

11. *Gibbons*, p. 56, cat. nos. 272, 273.

12. For a sophisticated discussion of the commemorative in relation to National Politics, see the discussion of French stamps celebrating the bicentennial of the French Revolution in Scott, *European Stamp Design*, 33–38; see also Découvertes and Scott, "National Icons," 215–33.

13. The millennium has seen the number of commemoratives expand to an unmanageable degree. The millennium itself generated a vast number of special issues, including the forty-eight separate special commemoratives in the Royal Mail Millennium Collection. This in turn led to a deluxe box-set two-volume study of the stamps, *The Essential Royal Mail Millennium Collection* (Post Office, Royal Mail, London, 1999).

14. It might be noted that the Jewish Holocaust, or Shoah, has also generated a large number of commemorative stamp issues, and that these, like stamps on slavery, have not attracted critical or theoretical attention. They do not, for example, feature in the otherwise excellent Young, *Holocaust Memorials and Memory*.

15. *Gibbons*, p. 33, cat. no. 112.

16. *Gibbons*, p. 39, cat. no. 147.

17. For the proximity of the imagery of this stamp to prints produced in Britain in 1833 and 1838 to mark emancipation, see pp. 93–100 and 116–19 above.

18. *Gibbons*, p. 47, cat. nos. 194, 195.

19. For the Goamans' remarkable and highly politicized designs, see Scott, "The Art of Design," 30–33; Scott, "The Work of Sylvia and Michael Goaman," chapter 5, part 2 of *European Stamp Design*, 76–86.

20. *Gibbons*, pp. 50–51, cat. no. 225.

21. *Gibbons*, p. 51, cat. no. 228.

22. Wills and Knobil, *Images of the Carnival*; Hall, "Legacies of Anglo-Caribbean Culture," 179–94.

23. *Gibbons*, p. 51, cat. no. 229.

24. *Gibbons*, pp. 103–4, cat. nos. 453–56.

25. *Gibbons*, p. 129, cat. no. 656.

26. *Gibbons*, p. 220, cat. nos. 1368–71.

27. *Gibbons*, p. 220, "special first day of issue post marks."

28. Wilberforce had in fact been included in the accompanying publicity for a 1984 Christian Heritage commemorative booklet of stamps in 1984. The six regular first-class stamps have the queen's head on them. On the left is a pane, with a black border and peach-colored background. Inset on the design is a black-and-white portrait head of Wilberforce, and partially set over this is a black-and-white reproduction of an eighteenth-century slave-sale notice. Beneath the images is the text "William Wilberforce is best known for his campaign against the slave trade which he saw abolished in his lifetime." His image was only ephemeral and not part of the genuine stamp.

29. See Carretta, *The Letters of Ignatius Sancho*; King and Walvin, *Ignatius Sancho*; Carretta, *Olaudah Equiano*. For Equiano's mass exposure around the Birmingham exhibition in 2007, see the web publicity relating to the Equiano society and the Equiano project online at http://www.itzcaribbean.com/equiano_society_uk.php.

30. For the incorporation of Zumbi into Brazilian stamps, and of Toussaint into Haitian and Dahomeyan stamps, see pp. 238–42 and 250, figs. 5.33–5.37, and plate 10 below.

31. For the reproduction of instruments of slave torture, see Clarkson, *History*, i, 375.

32. For a hard-headed series of slavery commemoratives focused on the economics of Atlantic slavery, see the discussion of the St. Lucia stamps on pp. 253–54 below.

33. For the ruthless economics of the 2007 act, see pp. 14–15 above and pp. 343–44 below.

34. www.info@wilberforce2007.co.uk.

35. For engraving techniques and the description of skin tone in relation to engravings of Equiano and Henry Bibb, see Wood, *Blind Memory*, 130–32.

36. Brown, *Moral Capital*, 416, 422–24, 447–49; Farrell, "Contrary to the Principles of Justice, Humanity and Sound Policy," 141–72, and 318–19 for a reproduction of and discussion of a major petition delivered to Parliament.

37. For the text of the poem and cultural analysis, see Wood, *The Poetry of Slavery*, 110–16.

38. Wood, *The Poetry of Slavery*, 114.

39. Wood, *The Poetry of Slavery*, 114.

40. Clarkson, *The History of the Rise, Progress, and Accomplishment of the Abolition of the Slave Trade*, 268–71; Wood, *Blind Memory*, 27–29. For the multiple adaptations and parodies of the image in 2007, see pp. 264–92 below.

41. There have been several accounts of the genesis of the *Brookes* image and of its impact in revolutionary France. The most recent, which draws heavily and rather exclusively on the work of Marcus Wood and John Oldfield, is Rediker, *The Slave Ship*, 329–31.

42. The marketing of the bicentenary via the Royal Mail and the Royal Mint has been a neglected but fascinating process. The actual stamps used in daily circulation for a few months are only the tip of a philatelic iceberg, which cannot be covered here due to space constraints. Suffice it to say there were postcards, posters, and an enormous variety of elaborate and often surprising first day cover issues for collectors. The materials I deal with here are the mainstream productions of the Royal Mail, designed for purchase by the general public. These are the 50 pence stamp devoted to Clarkson and featuring the *Brookes*; the first day cover Royal Mail envelope featuring the stamps beneath the *Brookes*; and the "Abolition of the Slave Trade" presentation pack, featuring the *Brookes*. For the marketing of these, see the Royal Mail official website at www.royalmail.com/stamps/slavetradeaboliton. An authoritative account of the design and distribution of these materials, and an illustrated account of all postmarks issued across Great Britain on FDCs of the abolition bicentennial stamps, is the Norvic Philatelics website at www.norphil.co.uk/catalog/slavery.

43. "Volume of Bound Manuscripts Documents Relating to the Case of the ship Zong 1783. Entirely in Granville Sharp's Hand," National Maritime Museum, sec. 6 Rec/9; Shyllon, *Black Slaves in Britain*, 184–99.

44. The image is analyzed and reproduced in *Captive Passage*, 100.

45. *Letters of Ignatius Sancho*; Ellis, "Ignatius Sancho's Letters," 199–217; Brown, *Moral Capital*, 286–87.

46. Carretta, *Sancho Letters*, 73–74.

47. For the politics of representation in the depiction of African American and native American bodies in tobacco trade advertising of the eighteenth century, see Molineux, "Pleasures of the Smoke," 327–76.

48. *Olaudah Equiano: The Interesting*; for Equiano's combative relationship with establishment abolition and with the Sierra Leone recolonization scheme, see Brown, *Moral Capital*, 284, 293–96.

49. There is not space here to provide in-depth analysis of the entire set. They are reproduced with commentary in a table in the specialist philatelic website: www .norphil.co.uk/catalog/slavery.

50. For a detailed analysis of the design of the seal and its motto and the charting of its mass adaptations, see Hamilton and Blyth, *Representing Slavery Art*, 193–99.

51. For analysis of the old museum set up at Hull, see Wood, *Blind Memory*, 294–97; Oldfield, "*Chords of Freedom*," 70–73, 122–23.

52. www.bletchleycovers.com.

53. *Stampex, the newsletter of Britain's secret little post office* no. 10 (Spring 2007): 3.

54. Benjamin, "One Way Street," 478.

55. "Sierra Leone, 1833–1933."

56. See pp. 5–6 and 63–75 above for the body of eighteenth- and nineteenth-century imagery this stamp developed out of.

57. For Chulalongkorn the Great, known as Rama V, and his liberation mural, see Noobanjong, *Power, Identity, and the Rise of Modern Architecture*, 170–71. Rama V is also shown in military uniform standing before the liberation mural on the 100 baht note.

58. See pp. 123–25, 223, 234, and 344–45 above. For the Count Rio Branco imagery and its Brazilian contexts, see Wood, "Creative Confusions," 41:3–4, 245–71.

59. Each stamp carries the central inscription "Gold Coast Ghana Independence March 6th 1957." The denominations and titles are as follows: ½ d, Position of Gold Coast (map printed in red showing the Gold Coast in bronze); 1 d, Christiansborg Castle (side view of the castle printed in indigo); 1 ½ d, Emblem of Joint Provincial Council (with three chain links beneath printed in green); 3 d, Manganese Mine (train tracks running on a curve into distant landscape, printed in magenta); 6 d, Cocoa Farmer (farmer harvesting cocoa pods with a machete, printed black with orange background carrying decorative border of cocoa pods); 1 shilling, Breaking Cocoa Pods (two women, one seated beating pods with a club, one standing with a basket of pods on her head, printed black with orange background); 2 shilling, Trooping the Colour (three soldiers with the Union Jack, the central one holding the flag is white, a military band in the background, printed in black against a pink

background); 5 shilling, Surfboats (two canoes coming in through surf, printed in deep violet against indigo background); 10 shilling, Forest (forest printed in black, queen's head in olive green).

60. The most balanced analysis of Ghanaian independence ceremonies in 2007 and of the invasive influence of the British Arts Council hijacking and misrepresenting the official Ghanaian coverage of the events is Herbstein, "Silences" and *Reflections in a Broken Mirror*. For detailed analysis of this material and references, see pp. 309–11 and 352 below.

61. For the historical background referred to here, see van Dantzig, *Forts and Castles of Ghana*, 31–32, 52, 72, 87.

62. The tensions between Ghanaians and African Americans over the construction and commodification of the slave castles is analyzed in Osei-Tutu, "Ghana 'Slave Castles.'"

63. See Jones, "Art of Africa"; de Witte, "Money and Death."

64. For American fetishization of Lincoln and the signing of the Emancipation Proclamation, see pp. 220–23 below.

65. See pp. 62–89.

66. Douglass, glass albumen print, c. 1870, 22.

67. For the continued philatelic patronization of black males in the context of slavery and civil rights in the States, see the discussion of Martin Luther King Jr., pp. 59–61 above.

68. For the background to Dulac's designs for de Gaulle and the British government, see Scott, *European Stamp Design*, 72–75.

69. For Fanon's satire on Schoelcher, see pp. 18–29 above.

70. Delpeck and Maurin, *Toussaint l'Ouverture*, 305.

71. For celebratory cultural commentary on this stamp, see "Tous les hommes nascent égaux," in *L'Écho de la Timbrologie la Tribune des Philatelistes* no. 1707 (April 1998): 30–33. The edition of the journal carried a spectacular front page with a blown-up image of the stamp, floating above the abolition law and the title "Esclavage, abolition célébrée par un timbre."

72. For positive images of Toussaint and other black revolutionaries, see pp. 231–32 and 238–42 below.

73. The back of the certificate is inscribed: "Cet encart ilustré et oblitéré sure soie, dédié à VICTOR SHOELCHER pour le 150e Anniversaire de l'Abolition de l'esclavage est le No. 254 d'une collection philatélique consacrée aux CELEBRITÉS DE FRANCE. Tirage de 700 exemplaires."

74. Both the passage from Larousse and the Revolutionary Proclamation by Dessalines were appended by Césaire to his ecstatic poem "Mémorial de Louis Delgrès." For the original French texts and English translation, see *Aimé Césaire*, 330–37.

75. *Aimé Césaire*, 46–49.

76. *Aimé Césaire*, 332–33; it is impossible to translate the passage, which runs as follows: "et je chante Delgrès qui aux ramparts s'entête / trois jours arpentant la bleue hauteur du rêve / projeté hors du someil du peuple / trois jours soutenant de la grêle contexture de ses bras / notre ciel de pollen écrasé."

77. The inscription runs "France 0.53 € Mémoires de l'esclavage et de son abolition La Poste 2007. Timbre créator Nicolas Vial; metteur en page atelier Didier Thimonier, héliogravure."

78. For the Vasselot image, see Honour, *The Image of the Black*, 4:1, fig. And for further discussions of commemorative sculpture devoted to Schoelcher, see pp. 269, 270, 329 fn. 109, 343 fn. 32, and figs. 171 and 172.

79. For a detailed discussion of Fanon on the emancipation moment and the colonial statues of Martinique, see pp. 19–22 above.

80. For the relative neglect of the Senegalese trade, see Searing, *West African Slavery*, 1–15.

81. For Chambon's plate, and a detailed discussion of its philatelic adaptation, see pp. 258–59 below.

82. James, *The Black Jacobins*, 296–97.

83. Equestrian portrait, *Toussaint l'Ouverture*, n.d., Bibliothèque Nationale. The image is reproduced in Aravamudan, *Tropicopolitans*, 304.

84. For the specific claims of Toussaint's Beninese origin, see Paultre P. Desrosiers, "On Toussaint from Desrosiers," online at www.hartford-hwp.com/archives/43a/373 .html, posted June 2, 2003, which states that Toussaint's "father's name was the Gaxu Ginou or Genu, Chief of staff of the armed forces and head of intelligence services in under Detchada, the seventh king of Adanhunsa of the Dynasty of Alada of the Agasuvi. He was captured probably when Dossou Agadja, fifth king of the kingdom of Danxome conquered the kingdom of Alada/Arada in 1724 and sold as slave along with his wife Assiba (from Savalou, meaning born on a Sunday) and made the journey to Saint Domingue. He arrived in Cap François between 1730–1740.

"Toussaint was apparently the direct descendent of Adjahuto or Kokpon, the first king and founder of the Aja/fon dynasty of Alada of the Agasuvi. Since his father the Gaxu Ginou or Genu may have been the son or grandson of Kokpon. It is believed that the remarkable Toussaint l'Ouverture, precursor of the independence of Haiti was himself a Fá Seer a traditional healer who went under the strong name of Fá tó Gbà tò (He who has the ears of the Fá to conquer a country)."

85. The stamp is reproduced and briefly discussed in *Captive Passage*, 113.

86. Valtierra, *Peter Claver*.

87. For Claver's treatment of slaves, see Fleuriot, *Saint Pierre Claver*.

88. Kalenberg, "Figari, Pedro"; Castillo, "The Development of a Style," *XXIII Biennal Internacional de Sao Paolo*, December 8, 1996, online at http://www1.uol.com .br/bienal/23bienal/especial/iefi.htm#Nome.

89. See p. 220–22 above.

90. Anton de Kom is a badly neglected figure. In many ways he was a father of postcolonial theory; his seminal study, *Wij slaven van Suriname*, was published in a heavily censored form in 1934, and only appeared in an uncensored Dutch edition in 1971. An English translation, *We Slaves of Surinam* (London: Palgrave Macmillan, 1987), has begun to attract interest.

91. Patrocinio's centenary was marked by a number of significant cultural productions in Brazil. See Orico, *O Tigre da Abolição edição*.

92. For Patrocinio's multifaceted contribution to the Brazilian abolition movement, see Conrad, *The Destruction of Brazilian Slavery 1850–1888*, 137–49, 164–65, 216–24.

93. The years of military government or dictatorship stretched from 1964 to 1984; the celebration of black resistance and black culture was a constant element of opposition. See Fausto, *A Concise History of Brazil*, 280–337.

94. The best illustrated account of his masterworks remains Graciela and Hans Mann, *The 12 Prophets of Aleijadinho*.

95. The reading of Aleijadinho as political satirist first emerged in the mid-1940s: "If I rightly interpret his work it was and remains the expression of social revolt and of the Brazilian native and mestizo wish for independence from white European masters and exploiters of slave labour." Freyre, *Brazil*, 156–57.

96. For the socioeconomic background and for a straightforward account of the remarkable abolitionist activism of 1884 in Ceará and the Amazonas, see Conrad, *The Destruction of Brazilian Slavery, 1850–1888*, 175–82, 186–93.

97. For the evolution of Zumbi in historiography, see Southey, *The History of Brazil*; of the three Brazilian editions the most carefully annotated is Southey, *Historia do Brazil*; the best summary of the extant historiography on Palmares and Zumbi in English is Anderson, "The *Quilombo* of Palmares," 545–65; the best short account of the Zumbi myth in Brazilian publications is Diegues and Rocha, *Palmares Mito e Romance da Utopia Brasileira*.

98. Oldfield, "*Chords of Freedom*," 164–65.

99. The reviews are quoted in Wood, *Blind Memory*, 48–49.

100. For a discussion of Williams in this context, see pp. 342–43 below. For a summary of the current state of debate over Williams's thesis, see Brown, *Moral Capital*, 12 fn. 9; for a full historiographical review, see 12–15, 26–27.

101. The text in translation is printed in Honour, *The Image of the Black*, 53. The original French text is reproduced on p. 312 fn. 88.

102. See discussion pp. 66–68 above, and fig. 5.51.

103. For the history of the design and for the technical details regarding this stamp, see www.bps.gov.bb.

104. See pp. 250–55 and fig. 2.23 above.

105. Goya, "The Colossus"; Gassier, Lochenal, and Wilson, *Goya*, 214–15.

106. For the genesis of these stamps and the association of the figure in the statue with Bussa, see the anonymous illustrated pamphlet *Barbadoes 200th Anniversary of the Abolition of the Slave Trade from Africa* (Bridgetown: Barbados Philatelic Bureau, 2007).

Chapter Six. Supine in Perpetuity:
The *Description* of the *Brookes* in 2007

1. All of these crucial visual elements are analyzed in detail in Wood, *Blind Memory*, 16–36, 80–95, 218–30, 263–69.

2. I refer to the image as *Description* throughout the rest of this chapter.

3. Kay, "Missing Faces," 21. Despite the opportunistic use of imagery, the article is

a timely and very well argued piece of polemic insisting that Scotland address its role in Atlantic slavery and the slave trade.

4. See pp. 343–52 below.

5. For the analysis of the iconography of this exhibition, see Wood, "Packaging Liberty," 203–23. For the slave yoke, the model of the *Brookes*, and the *Description*, see pp. 272–75, 278–79.

6. For how and why this image became so popular, and for its myriad reappropriations, see "Che in the Sky with Rifles," 196–206.

7. Ferens Art Gallery Hull, www.hullcc.gov.uk. The website states: "Neil Mac-Gregor, Director of the British Museum, said: 'La Bouche du Roi is a key acquisition for the British Museum collection and will form the centrepiece of a program to mark the 200th anniversary of the Parliamentary abolition of the transatlantic slave trade. I am delighted that we are able to tour it to our partner venues across the country, thanks to the generosity of Arts Council England and the Dorset Foundation. It is important that this powerful work can be seen by as many people as possible in the UK, starting with the launch venue in Hull.'"

8. Hazoumé, selected by Curator Zoe Whiteley for the V & A's *Uncomfortable Truths*, made a powerful sculpture. This was a vast snake consuming its own tail. It was set up in the museum's courtyard garden, and was made out of Hazoumé's signature plastic gasoline cans, and had a twenty-foot diameter. This sculpture worked because unlike *La Bouche du Roi* it was not slavishly tied down to parodic dialogue with a more powerful original, but constituted a far more open symbol, which could mean very different things to different people.

9. This detail and other subsequent reproductions of *La Bouche* are taken from the official British Museum publicity publications: *La Bouche du Roi, an Artwork by Romuald Hazoumé* (London, The British Museum, sponsored through the National Lottery, via The Arts Council of Great Britain, 2007); *Resistance and Remembrance, 1807–2007* (The British Museum, Royal African Society, Rendezvous for Victory, 2007). There was of course a lot of a certain sort of remembrance, but nothing connected with resistance, in these publications.

10. The work was on a myriad of websites for museums and newspapers, but the following galleries were to display it between 2007 and 2009, and each had web pages devoted to it: March 22–May 13, British Museum, www.thebritishmuseum.ac.uk/tradeandidentity; June 2–July 15, Ferrens Art Gallery Hull, www.hullcc.gov.uk; August 4–September 2, Merseyside Maritime Museum, Liverpool, www.merseyside martimemuseum.org.uk/hazoume; September 15–October 28, Bristol City Museums and Art Gallery, www.bristol.gov.uk/museums; November 10, 2007–February 2, 2008, Laing Art Gallery, Tyne and Wear Museums, Newcastle, www.twmuseums .org.uk/lang; December 5, 2008–March 1, 2009, Horniman Museum, London, www .horniman.ac.uk. It is a foregone conclusion that it will go straight back to the British Museum in March 2009 and into storage, and will probably never reemerge.

11. Kevin Bales, "Slavery Today," Purcell Room, South Bank Centre, Thursday, March 22, 2007, 7:00–9:00 p.m. Quotations are taken from a filmed version of the discussion between Bales and Sealey that followed the lecture.

12. Material adapted from film recording of Sealey and Bales in dialogue, Purcell

Room, South Bank Centre, March 22, 2007, 8:03–8:07 p.m. This exchange is recorded in full in the forthcoming documentary *The Horrible Gift of Freedom* (Marcus Wood and Richard Misek, Bigslugsister Productions, 2010).

13. See Oldfield, "*Chords of Freedom,*" 78–80.

14. Paul Hope, *Jam Packed Berth Space*, mixed media on paper, 1998–2007.

15. Golliwogs are of course embedded within the folk culture of Anglo-America. Historically their birthplace is seen to lie in the 1890s in Florence Upton's illustrated children's books, but that is a convenient fiction, and these black male dolls in reality go back much farther and are caught up in the history of Jim Crow, minstrelsy, and those very early race satires on black male vanity and overdressing. One thing about the golliwog, however, is that it constitutes a genuine example of black grotesque; for *Webster's Dictionary* the golliwog is "a grotesque black doll, or a grotesque person." The Carol Thatcher "golli-gate" scandal played its way out across the British media in the first two weeks of February 2009. Some of the more responsible feature articles in the quality press are as follows: Lola Shoneyin, "A Mocking Parody of My Difference," *The Times*, February 6, 2009, "Times 2," 2–3; David Mathews, "Carol's no racist: she's just been left behind by a better Britain," *Evening Standard*, February 6, 2009, 15; John Henley, "Golliwog Controversy. From bedtime story to ugly insult: how Victorian caricature became a racist slur," *The Guardian*, February 6, 2009, 16–17; Hannah Pool, "I'll tell you why a small doll causes such a big fuss," *The Guardian*, February 6, 2009, 17; anon., "Profile the Golliwog. Rag-doll causing a stir in the playroom," *The Sunday Times*, February 8, 2009, 23; Dominic Lawson, "Carol the Pope and selective anti-racism," *The Sunday Times*, "Comment," February 8, 2008, 20.

16. "As a brand it was a terrific success, everyone knew the Robertson's Gollywog guaranteed a quality jam or marmalade. I know because my Uncle Bert worked there for forty years and went annually to buy their oranges from Seville. . . . Then as a summer job I took my place in the conveyer belt in the factory placing a paper cut out of the little chap in the top of each passing jar." Joan Bakewell, "I can barely type the word Golliwog, but the Pope beats Carol for outrage," *The Times*, February 6, 2009, "Times 2," 3.

17. Hope was a detective sergeant in the Met. He carried out motorway patrols and surveillance in the 1990s.

18. *Description of a Slave Ship* (London: Printed by James Phillips, George Yard, Lombard Street, 1789). This is the large single-sheet wood-engraving and letterpress version of the London Abolition Committee rendering of the *Brookes*. It devotes almost precisely half of its space to the image and half to the detailed accompanying text. This was the mass-produced version; the wood-engraved images of the slave decks could be set in the same form as the text, and printed with one pull on a large flat bed press like any other street broadside or poster.

19. For the use of human feces in *La Bouche*, see Charlotte Higgins, "Ship shape artwork recalls slave's ordeal," *The Guardian*, March 22, 2007. This aspect of the work is completely bypassed in all the official museum publicity put out in London, Hull, Liverpool, Newcastle, and Bristol.

20. For a detailed discussion of the work, including its relation to the "Wonderful

Tar Baby Story" of Joel Chandler Harris, see Wood, *High Tar Babies* and the film by Richard Misek, *High Tar Babies* (DVD, 14 mins., Bigslugsister Productions, 2002).

21. As far as I can gather from conversations with Ronnie Mosebach, the Project's education officer, the following works ironizing the image of the *Brookes* were produced collaboratively during February and March 2007: *Southwark As* Brookes *(Slave Ship)* [anonymous collaboration, photocopy, photomontage]; *Britain as* Brookes *(Slave Ship)* [anonymous collaboration, photocopy, photomontage]; *Buckingham-upon-Brookes* [anonymous collaboration, photocopy, photomontage]; *Parliament-upon-Brookes* [anonymous collaboration, photocopy, photomontage], reproduced here as figure 6.10. The work *Identity* was produced as part of the same project, during the same timeframe, by the Ghanaian student Earnest Gyasi, reproduced here as figure 6.11.

22. *Art and Emancipation in Jamaica* exhibition catalogue.

23. For the African contexts for the houseboat, see Bilby, "More Than Met the Eye," 121–33.

24. For the commemoration of these canoes in independence commemorative stamps of Africa, see pp. 217–18 below.

25. For the symbolic functions of water in relation to ancestor worship, see *Art and Emancipation*, 480.

26. See pp. 266–67 above.

27. Transcript of filmed interview with John Phillips, London Print Studio, 11:30 a.m.–1:00 p.m., Thursday, November 22, 2007. [Hereafter cited as Phillips, Interview, 11/22/2007.] Full DVD versions of the interview are held in the library of The London Print Studio.

28. *Chambers Dictionary*: "happening *n.* an event, occurrence, a partly improvised performance, often outdoors, usually demanding audience participation."

29. "The Print that Turned the World," exhibition, London Print Studio, 45 Harrow Road, London, W10, October 5 to November 10, 2007.

30. Transcript, Phillips, Interview, 11/22/2007.

31. Transcript, Phillips, Interview, 11/22/2007.

32. *The Bloody Writing is Forever Torn*, August 8–12, 2007, Accra and El Mina Ghana. See pp. 309–10 below.

33. *The Bloody Writing is Forever Torn*, "Session IV Textual Representations and Ambiguities," question period. Mini DVD recording of the entire conference sessions, including this exchange, is held at the Omahundro Institute of Early American History and Culture.

34. Bazzi, *The Artist's Methods and Materials*, 49, Table IX, Carbons.

35. See Barbieri, *Madagascar*, plates 11, 13, 14, 25.

Chapter Seven. The Horrible Gift of Freedom and the 1807/2007 Bicentennial

The epigraphs to this chapter were drawn from transcription from interview, *Ms. Dynamite, In Search of Nanny Maroon*. Directed by Krishner Covender, 56 mins.

First broadcast Sunday, March 25, 2007, BBC 2 [hereafter cited as McClean-Daley, *Nanny Maroon*]; Swift, *The Drapier's Letters (1723)*, letter 4.

1. Young, "The Truth in Chains," 16–17. See also Hornsey, *The British Slave Trade*, xi–xiii.

2. For the manner in which this truism is borne out in the dull hagiography of William Hague and Melvyn Bragg, see pp. 341–44 below.

3. Agbetu's intervention was recorded live on Radio 4, and on BBC 2, on March 27, 2007, between 12:22 and 12:35 p.m. He then gained limited subsequent media coverage. See Toyin Agbetu, "My Protest was Born of Anger not Madness," *The Guardian*, March 28, 2007, and "Protest at slavery service," *The Independent*, March 28, 2007.

4. Toyin Agbetu in conversation with Stephanie Merrit, *Observer Sunday Review*, December 16, 2007, 11. There are conflicting accounts. See, for example, David Smith's eyewitness account, *The Guardian Unlimited*, March 27, 2007: "Finally, outside the building, Mr. Agbetu was not bundled away as might be expected. Instead, he gave an impromptu press conference. 'I had always planned to make this demonstration,' he said. 'The Queen has to say sorry. It was Elizabeth I. She commanded John Hawkins to take his ship. The monarch and the government and the church are all in there patting themselves on the back.'"

5. For extreme blog reactions, see pp. 307–8 below.

6. The best online site that has links to all other relevant websites, and that has generated and collected together much of the most violent debate around Agbetu's intervention is http://newportcity.blogspot.com/2007/03/toyin-agbetu-who-do-you-think-you-are.html.

7. David Smith, *The Guardian Unlimited*, March 27, 2007: "In the pews, Mr. Blair watched with dismay as if already preparing a speech about this 'regrettable incident.' Mr. Brown, whose eyes had been sleepy, was jolted awake."

8. See, for example, *Riches From Freetown*, Radio 4 Sunday Feature, first broadcast 9:30 a.m., March 25, 2007.

9. Kwamei Kwei-Armah, "From Ian to Kwame — why slavery made me change my name," *The Observer*, March 25, 2007, "News" 18.

10. Transcription of dialogue from prologue to *"Set All Free": National Commemoration Service to mark the Bicentenary of the Abolition of the Slave Trade Act*, BBC 1, 11:30 a.m.–1:00 p.m., Tuesday, March 27, 2007.

11. Prologue, *"Set All Free."*

12. For Bragg's encounter with the document, see pp. 343–44 below.

13. For Mansfield's canny vacillation over the issue of slavery in England, and his ownership of his cousin's bastard slave girl whom he "emancipated" in his will, see Chater, "Black People in England," 72 and 288–89.

14. Prologue, *"Set All Free."*

15. Prologue, *"Set All Free."*

16. Transcription of script of prepared voice-over read by Nicholas Witchell as part of the radio broadcast coverage of *"Set All Free": The Westminster Service National Commemoration Service to Mark the Bicentenary of the Abolition of the Slave Trade Act*, BBC Radio 4, 11:56 a.m.–1:00 p.m., Tuesday, March 27, 2007.

17. Witchell, *"Set All Free."*

18. Transcription of recitation by Lady Davson of Wilberforce's first antislavery speech performed as part of the radio broadcast coverage of *"Set All Free": The Westminster Service National Commemoration Service to Mark the Bicentenary of the Abolition of the Slave Trade Act*, BBC Radio 4, 11:56 a.m.–1:00 p.m., Tuesday, March 27, 2007.

19. Witchell, *"Set All Free."*

20. See Wood, *The Poetry of Slavery*, 399–400, 403.

21. Witchell, *"Set All Free."*

22. See the media response to Brown's decision to send Amos to the European Union Africa Summit Convention held in Lisbon.

23. Transcription of Rowan Williams, reading prepared script of his "Address" as part of the radio broadcast coverage of *"Set All Free": The Westminster Service National Commemoration Service to Mark the Bicentenary of the Abolition of the Slave Trade Act*, BBC Radio 4, 11:56 a.m.–1:00 p.m., Tuesday, March 27, 2007.

24. Williams, "Address," *"Set All Free."*

25. "Kwame Kwei-Armah has been dubbed the black David Hare": Paul Taylor, "Not listening with prejudice," *The Guardian*, January 23, 2008.

26. Transcription of John Hall, reading from prepared text of "Confession and Absolution" as part of the radio broadcast coverage of *"Set All Free": The Westminster Service National Commemoration Service to Mark the Bicentenary of the Abolition of the Slave Trade Act*, BBC Radio 4, 11:56 a.m.–1:00 p.m., Tuesday, March 27, 2007.

27. I was given this information by an ex-detective inspector from Special Branch, who was present at the event and who described Agbetu's fortuitous survival as a "definite result" for the police. See Paul Hope, filmed interview, Imperial War Museum, Monday, January 14, 2007, on DVD in London Print Studio.

28. Transcription of Nicholas Witchell improvised voice-over, and Toyin Agbetu improvised speech, part of the radio broadcast coverage of *"Set All Free": The Westminster Service National Commemoration Service to Mark the Bicentenary of the Abolition of the Slave Trade Act*, BBC Radio 4, 11:56 a.m.–1:00 p.m., Tuesday, March 27, 2007.

29. Hope, interview, January 14, 2007.

30. Toyin Agbetu, "My Protest," *The Guardian*, March 28, 2007.

31. "The Devil's Kitchen," "An Open Letter to Toyin Agbetu" posted by "Martin," http://devilskitchen.me.uk/2007/03/open-letter-to-toyin-agbetu.html.

32. These blogs are all generated in response to "An Open Letter to Toyin Agbetu" and can be found at http://devilskitchen.me.uk/2007/03/open-letter-to-toyin-agbetu.html.

33. Most of the pie had been cut up and distributed as early as October 13, 2006, and apart from some crumbs all the big funding went to very predictable, very safe projects sited in "heritage institutions" (for which, read major urban museums and galleries) often in order to alter or revamp existing space and collections. See the detailed account online at www.hlf.org.uk/.../B1EFD886-E350-41CA-8FFC35C8B 4CAE304/3926/OverviewofHLFand2007BicentenaryNovember2006.pdf.

The salient facts are these:

> Projects funded by HLF. We have made over 40 awards with a total value of over £10 million to projects that are related to the bicentenary of the abolition of the slave trade and the slave trade generally. £10,920 to the Anti Slavery Arch Group in Gloucestershire to restore the Arch, which was built in the 1830s to commemorate the struggle against the trans-Atlantic slave trade. £92,000 to Anti-Slavery International to conserve and catalogue over 600 abolitionist tracts and pamphlets. £1.5 million to establish the National Centre for the Understanding of Trans-Atlantic Slavery in Liverpool. £800,500 to Wilberforce House Museum in Hull. £281,000 to the National Maritime Museum to purchase the Michael Graham-Stewart Slavery Collection. £653,000 to Birmingham Museum and Art Gallery in partnership with the Equiano Society to create an exhibition and education programme. £50,000 to Tyne and Wear Museums for an exhibition showcasing objects; photographs, paintings and documents from TWM's collections related to the transatlantic slave trade.

34. For the British Council in Ghana "as a propaganda agency of the British Foreign and Commonwealth Office," see Manu Herbstein, "Silences," Powerpoint presentation delivered at the conference *The Bloody Writing Is Forever Torn*, Elmina Beach Resort, Friday, August 10, Session VIII, Round Table on Slavery and Abolition in Ghana, 5:30–8:30 p.m. Herbstein analyzed *The British Council/Foreign & Commonwealth Office Memorandum of Understanding*. Herbstein summarizes the main points of the lengthy text in the following bullet points:

- Integral part of the UK's overall diplomatic effort
- Secretary of State answerable to Parliament for policies, operations and performance of the Council
- Secretary of State may nominate two Board members
- Secretary of State must approve appointment of Director-General
- Enhance United Kingdom's reputation in the world as a valued partner
- Increase impact of and respect for British policies and values overseas
- Promote export of British educational and cultural goods and services
- FCO provides strategic guidance to the Council
- Strategic objectives, priorities compatible with policies, priorities of FCO
- Partly funded by a grant-in-aid from the FCO

For the full text, see Herbstein, "Silences," window 13. See also Manu Herbstein, "Reflections in a Shattered Glass," *African Writing online, many literatures one voice*, December–January 2008, online at www.african-writing.com.

35. Herbstein, "Silences," Powerpoint presentation. Herbstein has since essentialized some main points of his presentation into the online article "Reflections in a Shattered Glass." This short piece has gained in clarity and economy but lacks some elements of the emotional immediacy and much of the detail from the earlier conference Powerpoint, which I have consequently continued to quote from when necessary.

36. All facts and quotations relating to the British in Ghana and Prescott's charm offensive are taken from Herbstein, "Reflections in a Shattered Glass."

37. For this and a whole slew of official government publications relating to 2007, see http://www.culture.gov.uk/reference_library/media_releases/2464.aspx.

38. For Wilberforce's determination to correct the public's morals and the hatred that the English radicals directed toward him because of this, see William Cobbett's sustained assault on Wilberforce in *The Political Register*, 40:1 (1821) 1–39; 40:3 (1821) 147–86; 47:9 (1823) 513–62; 48:10 (1823) 577–94; 48:11 (1823) 641–94. For Hazlitt's attacks on Wilberforce, see *The Complete Works of William Hazlitt in Twenty One Volumes*, 11:149–51. For a consideration of the inheritance of Wilberforce, see Hull and Wood, *Blind Memory*, 293–95; Oldfield, "*Chords of Freedom*," 59–72, 98–99, 103–6.

39. Patrick Wintour, "Blair fights shy of full apology for slave trade," *The Guardian*, November 27, 2006.

40. Charles Moore, "Blair's Sorry Apology for Slavery," *Daily Telegraph*, December 2, 2006.

41. Major articles and letter pages devoted to the issue in the broadsheet press were as follows: Patrick Wintour, "Blair fights shy of full apology for slave trade," *The Guardian*, November 27, 2006; Paul Valley, "Are apologies for historical events worthwhile or just empty gestures?" *The Independent*, November 28, 2006, 33; Jonathan Petre, "Blair's deep sorrow for slavery 'is not enough.' Critics say that Britain must pay a heavy price for its past," *The Daily Telegraph*, November 28, 2006, 7, and "Editorial Comment: Everywhere in Chains," 23, and "Letters to the Editor: Britain should say sorry, but be thanked for ending the trade," 23; John Walsh, "Do we really need to be told by Tony Blair that the slave trade wasn't a terribly good idea?" *The Independent*, November 28, 2006, 7; Miles Kington, "Slavery the Ashes and other sorry international affairs," *The Independent*, November 28, 2006; Peter Brookes, half-page caricature entitled "Slave Trade Sorrow," *The Times*, November 28, 2006, 17; "Letters and Emails: Sorry seems to be the hardest word," *The Guardian*, November 29, 2006, 33; Thomas Sutcliffe, "Slavery isn't just a 'black' subject," *The Independent*, March 9, 2007, 5; "Letters and Emails: Slavery, abolition and apologies," *The Guardian*, March 24, 2007, 32; Nicholas Lezard, "Nut-jobs, fruitcakes, axe-grinders, and drum-bangers," *The Independent*, March 25, 2007, 19; Jonathan Wynn-Jones, "Archbishop attacks Blair's 'unforgiving materialistic' Britain," *The Sunday Telegraph*, "News," 5; Gaby Hinsliff, "Blair told to apologise for the slave trade; expressing Britain's 'profound regret' is not enough Archbishop of the West Indies says," *The Observer*, March 25, 2007, 4; Yasmin Alibhai-Brown, "It's understanding we need not apologies. How can Tony Blair say sorry for slavery when he will never apologise for Iraq?" *The Independent*, March 26, 2007, 31; David Ward, "Archbishop of York urges PM to apologise for slavery," March 26, 2007, 15; "Letters and Emails: The Legacy of slavery in the Modern World," *The Guardian*, March 31, 2007, 33.

42. Trade Roots (BBC Radio 4), Presenter: Michael Buerk, Producer: Tony Phillips, Dates: March 26, 27, 28, 2007, Time: 11:00 a.m.

43. The world's leading economic historian of slavery David Richardson explained the financial nuts and bolts. Richardson was also instrumental in heading Britain's only serious contribution to thinking through the fiftieth anniversary of Ghanaian

independence in the context of Anglo-African slave trading. He was instrumental in bringing key Ghanaian and Beninese intellectuals and statesmen to Britain, and fronted the only serious British presence at the groundbreaking conference *The Bloody Writing is Forever Torn*, in El Mina in August 2007.

44. *In Search of Wilberforce*, presented by Moira Stuart, documentary, 58 mins., BBC2, March 16, 2007, 9:00 p.m. See David Smith. "Abolition's forgotten heroes," *The Observer*, March 4, 2007, for a carping response foregrounding Stuart's emotionalism.

45. For the prevalence of this myth, and for quotation of the few historical documents referring directly to Nanny, see Hart, *Slaves Who Abolished Slavery*, vol. 2: *Blacks in Rebellion*, 60–83.

46. Transcription of dialogue from McLean-Daley, *Nanny Maroon*.

47. Transcription of dialogue from McLean-Daley, *Nanny Maroon*.

48. For the detailed analysis of this material, see pp. 68–85 and 91–120 above.

49. *Trade and Empire Remembering Slavery* exhibition, June 16, 2007–April 27, 2008, Whitworth Art Gallery, Manchester; *Slavery and the Natural World*, Natural History Museum. There were various one-day symposia from October to December 2007. Museum publicity stated: "The Slavery and the Natural World programme is a series of events giving a unique perspective on the slave trade through the plants and people using the natural history collection. The Natural History Museum looks after millions of specimens, books, and artworks. Some of these reveal aspects of the transatlantic slave trade." Email circulation, December 4, 2007, quoting text from www.nhm.ec.uk/access.

50. For the Lottery Heritage Fund award, see p. 398 above.

51. There is an elaborate celebratory website giving a virtual guide to the museum, "London Sugar and Slavery," museum press package. The site states that the gallery was enabled by a Heritage Lottery Fund grant of 506,500 pounds. See www.museum indocklands.org.uk.

52. For a wonderful account of Wedderburn at work in London's radical underground, see McCalman, "Anti-Slavery and Ultra-radicalism," 99–117; McCalman, *The Horrors of Slavery*.

53. There was a similar, but even weaker parodic impulse operative in much of the work that big art institutions commissioned Yinka Shonibare to make. His fun and games with the costumes of the English aristocracy are finally imprisoned within the semiotic nexus of the source, and his imitations never move out from the shadow of the white slave power that inspired them. See Shonibare's contributions to *Scratch the Surface*, National Gallery, July 20–November 4, 2007, and to *Uncomfortable Truths, The shadow of slave trading on contemporary art and design*, Victoria and Albert Museum, February 20–June 17. Shonibare's piece, *Sir Foster Cunliffe Playing*, was exhibited in the museum at Level 2, Gallery 52.

54. Transcription of brass plaque inset in the center of the Buxton table, permanent exhibit, entrance to the "Sugar and Slavery" Gallery, Docklands Museum, London.

55. For a flamboyant and reverential official website dedicated to the Lincoln ink-

wells and their institutionalization, go to http://www.thelincolnmuseum.org/new/publications/1843.html. There are in fact two emancipation inkwells; the Smithsonian claims to own another that Lincoln used in 1862 to draw up first ideas on the Emancipation Proclamation. For context and illustrations, see Division of Social History, Political History, National Museum of American History, Smithsonian Institution, Behring Center, http://www.civilwar.si.edu/lincoln_inkwell.html. Princess Isabella's gold-, pearl-, and diamond-encrusted pen is still on display in a glass case, in the room dedicated to her and the passage of the Golden Law, in the Royal Palace in Petropolis.

56. For a magisterial discussion of British imperial trade in relation to the slave trade, see Eltis, *Economic Growth*.

57. For trade goods advertising, see Molineux, "Pleasures of the Smoke," 327–76; Scott, "The Waddesdon Trade Cards," 91–100; Berg and Clifford, "Selling Consumption in the Eighteenth Century."

58. Clarkson, *History*, 1:373.

59. For the original oil painting, see *Transatlantic Slavery Against Human Dignity* exhibition catalogue, 88.

60. Clarkson, *History*, 2:13.

61. The best account of the historical evolution and cultural significance of Kente is Ross, *Wrapped in Pride*, exhibition catalogue, 76–159.

62. For Nkrumah's propagandistic celebration of Kente, see *Wrapped in Pride*, 164–68; for Clinton and Kente, 175–76; for W. E. B. Du Bois and Muhammad Ali and Kente, 148–49 and 164. It is noticeable that only the beautiful and relaxed Ali wore the cloth properly, over his naked flesh; Clinton and Du Bois wrapped the cloth over Western suits.

63. For Clarkson's exploitation of slavery torture implements and his creative combination of image and words in this context, see Wood, *Blind Memory*, 228–30; and Wood, "Packaging Liberty," 203–24.

64. Hochschild, *Bury the Chains*, 127, 154–55; for the rope, see *The British Slave Trade*, 312–13.

65. Clarkson, *History*, 1:400; for further discussion of the contents of Clarkson's chest, see *The British Slave Trade*, 312–13.

66. For a competent overview of the "nursery" theory, and the reality, see Rediker, *The Slave Ship*, 218, 239–47, 253–62, 320–25, 325–26, 348.

67. A particularly intense account is to be found in Snelgrave, *A New Account*, 103–6, 165–68; for the use of violence and terror to control slave ships and the conduct of captains, see the compilation of primary and secondary sources in Rediker, *The Slave Ship*, 39–40, 217–21, 204–5, 238, 251.

68. The significance of the object was acknowledged by Wilberforce House in Hull, whose rearranged slavery galleries contain a replica of the chest.

69. For a discussion of the African slave yoke and the politics of display, see my discussion in *Blind Memory*, 223–25.

70. For media treatments of the event, see Esther Addley and Hugh Mair, "Marching to London to hear a single word . . . sorry," *The Guardian*, March 24, 2007,

12; Arifa Akbar, "Wilberforce family marks abolition of Slavery" *The Independent*, March 2, 2007, 7.

71. Blair had at this point rendered the whole thing meaningless, because he had already slipped in a full apology. In a press conference with the president of Ghana on March 14, he had replied to a reporter who asked, "What's so hard about saying sorry for slavery?" with the words, "Well actually I have said it. We are sorry and I say it again now."

72. "Funding was a mixture of H.L.F. D.C.M.S. (Department of Culture Media and Sport) and Yorkshire Forward." Vanessa Salter in interview with Marcus Wood, Wilberforce House Museum, 10:00–11:00 a.m., May 21, 2007. A DVD copy of the full interview is available from the Library, Wilberforce House Museum. All quotations and factual statements relating to the refurbishment and layout of the new slavery galleries in the following discussion are taken from this interview, unless otherwise stated.

73. See pp. 308–11 above and footnotes.

74. The display label reads: "Iron Age Slave Chain From Llyn Cerrig Bach, Anglesey (1000 BC–100 AD). This ancient neck shackle was found in 1943. It once restrained at least five captive slaves each loop secured around the neck of an individual. . . . This trade in slaves was happening before the invasion of Britain by the Roman army in AD 43."

75. In April 2009 it was announced that Bragg was no longer to be producer of flagship arts program *The South Bank Show*, and he was retired as arts controller of Independent Television UK.

76. This is the passage as performed with a thick Caribbean (I think Jamaican not Trinidadian) accent by a hired actor in the *In Our Time* broadcast. In fact, Williams's original assessment of Wilberforce taken in full is far less hostile, and parts of it are positively complimentary. Yet the balanced views of Williams did not, it appears, fit into Bragg's propaganda agenda. For the record the full passage continues:

> He relied for success on aristocratic patronage, parliamentary diplomacy and private influence with men in office. He was a lobbyist and it was a common saying that his vote could be safely predicted for it was certain to be opposed to his speech. "Generally" said Tierney "his phraseology is designed to suit either party; and if, now and then, he loses the balance of his argument and bends a little to one side, he quickly recovers himself and deviates as much in an opposite direction as will make a fair division of his speech on both sides of the question." But he was a persuasive and eloquent speaker, with a melodious voice which earned him the sobriquet of "the Nightingale of the House." Above all he had the reputation of being otherworld-minded, and it is certain that his reputation for saintliness and his disinterestedness in the cause were powerful factors in Pitt's prodding that he should lead the Parliamentary crusade. (Williams, *Capitalism and Slavery*, 181.)

77. See pp. 90–96 above.

78. The scholarship and economic evidence relating to this widescale abuse of the letter of the law has been most succinctly compressed in Sherwood, *Abolition*, 8–25; for the various pieces of legislation, see her "Appendix 1," 178–85.

79. See pp. 13–15 for an analysis of what the cynical and pragmatic terms of the act really were.

80. For the film's financing and its corrupt marketing, see Herbstein, "Reflections in a Shattered Glass": "The movie *Amazing Grace* was made by Walden Media. Walden Media is owned by Philip Anschutz. . . . He is worth at least five billion U.S. dollars. . . . He is a strong supporter of George W. Bush and the Republican Party, opposes gay and lesbian rights and supports the teaching of 'intelligent design' in American schools. Anschutz controls some six thousand movie screens in the U.S. (nearly one-fifth of the total) and determines what may or may not be shown on them. . . . The BBC has described him as a 'corporate vulture.' He is a strong supporter of conservative Christian causes."

81. The inaccuracy and distortions were pointed out in a ruthlessly truthful review by historian Peter Linebaugh, who specializes in eighteenth-century naval history, entitled *"Whitewashing the Slave Trade*: An Amazing Disgrace," www.counter punch.org February 28, 2007. For the travestying of Clarkson, see the Thomas Clarkson Society, "Ten Reasons why the portrayal of Thomas Clarkson in the film 'Amazing Grace' should not be seen as historically accurate," online at www.thomas clarkson.org.

82. For N'Dour's lack of experience, see *One Voice Changed the Lives of Millions: Amazing Grace, an Unforgettable True Story* (DVD, Momentum Pictures, 2008) special features, "The Making of Amazing Grace": "the part of Equiano was N'Dour's first performance as an actor, a Grammy award winning musician N'Dour is one of Africa's foremost artists, the intricate rhythms of N'Dour's African music became an inspiration for composer David Arnold."

83. For a lengthy discussion of the operations of empathetic theory in the context of British eighteenth-century abolition propaganda, see Wood, *Slavery, Empathy, and Pornography*, 24–93.

84. For an analysis of this line in context, see Wood, *Slavery, Empathy, and Pornography*, 85.

85. Not one of the reviews in the quality press had any problems with the film's politics, or the quality of the acting or camera work; only the structure using flashback seemed to annoy the reviewer. See Philip French, "How Just William Won, Michael Apsted's biopic of Wilberforce is done with great style, unlike those Spartans in Speedos," *Observer Review*, March 25, 2007; Jenny McCartney, "Bling and Bloodlust," *Sunday Telegraph*, March 25, 2007, "Arts and Entertainment," 19–20; Nicholas Barber, "A lesson for us all," *Independent on Sunday*, March 25, 2007. Lee Jasper quoted in James Langton and Chris Hastings, "200 years on, slave film turns Wilberforce into America's hero," *Sunday Telegraph*, February 25, 2007, "News" 18.

86. There is a long tradition of Wilberforce worship among the extreme religious right in America. The prefatory apparatus to William Wilberforce, *A Practical View*

of Christianity (Peabody, Mass.: Hendrickson Christian Classics, 2006) provides a succinct crash course to this development. Charles Colson's introduction is particularly chilling.

87. James Langton and Chris Hastings, "200 years on, slave film turns Wilberforce into America's hero," *Sunday Telegraph*, February 25, 2007, "News," 18.

Conclusion

1. Dodgson, *The Complete Works of Lewis Carroll*, 172.

2. This work has been inaugurated in the context of eighteenth-century plantation slavery by Philip Morgan's magnificent and almost endlessly patient *Slave Counterpoint*. See pp. 177–80 above. Morgan is not, however, and to our great loss, concerned with the interpretation of visual arts.

3. See pp. 26–32, 48–50, and 176 above.

4. Brazil has been leading this type of work since the mid-twentieth century. The work of Pierre Verger, Roger Bastide, and Jão Gilberto Reiss is exemplary. North America has also seen the publication of an increasing number of micro histories attempting to put together slave life in specific slaveholding communities.

5. See particularly the groundbreaking edited collections Falola and Childs, *The Yoruba Diaspora in the Atlantic World*; Falola and Afolabi, *African Minorities in the New World*; Ogundiran and Falola, *Archaeology of Atlantic Africa and the African Diaspora*.

6. Bernier, *African American Visual Arts*, 17–55.

7. The epigraph to this section was drawn from Benjamin, "One Way Street," 267.

8. Dave's art is keenly collected, and as the prices of his pots rise, he generates expanding critical and catalogue literatures. See http://www.davetheslave.info/index.html; http://www.americanantiquities.com/features/bob%20brooke.html; http://www.usca.edu/aasc/davepotter.htm; Horne, *Crossroads of Clay*; Julie Singer, "Art as Resistance: The Truth about Dave the Potter," http://www.postpicasso.com/lounge/arttherapy_may02.asp; Camilla Fox, "Unearthing Resistance: African American Cultural Artefacts in the Antebellum Period," in *U.S. Studies Online: The BAAS Postgraduate Journal* at http://www.baas.ac.uk/resources/usstudiesonline; *Pottery, Poetry and Politics Surrounding the Enslaved African American Potter, Dave* (McKissick Museum, University of South Carolina, 2000).

9. For hypotheses as to the conditions in which Dave may have worked and the best reconstruction of his biography, see Todd, *Carolina Clay*; and for a highly theorized account of Dave's multiple hybridities, in relation to his use of language, see Chaney, *Fugitive Vision Slave*, 187–203. I am grateful to Michael for first introducing me to Dave the Potter's work and the fascinating world of slave ceramics.

10. For the satiric elements of African praise-poems, see Gleason, *Leaf and Bone*, xxii–xxxii. The roots of Dave's language in folkloric, biblical, and oral African rhetorical traditions have been neglected in interpretations to date. For the most up-to-

date listing and transcription of all Dave's known inscriptions, see Todd, *Carolina Clay*, 230–52.

11. Benjamin, "Old Toys," 99.

12. Dave's works, and the inscriptions recovered to date, are collected in Koverman, *I Made This Jar*, exhibition catalogue, 90–91. The chronology of the inscriptions I have assembled are as follows: Ladies & gentlemens shoes / Sell all you can & nothing you'll loose, January 29, 1840; Dave belongs to Mr. Miles / Wher the oven bakes & the pot biles, July 31, 1840; I wonder where is all my relations / Friendship to all — and every nation, August 16, 1857; Making this jar: I had all thoughts / Lads & gentlemen: never out walks, January 30, 1858; The forth of July is surely come / to blow the fife — and beat the drum, July 4, 1859; I saw a leopard & a lion's face / then I felt, the need of grace, August 7, 1860.

13. The scriptures abound with figures of speech equating the potter's art with God's acts of creation: "Shall the clay say to him that fashioneth it, What makest thou? Or thy work?" (Isaiah 45:9); "Then I went down to the potter's house, and behold he wrought a work on the wheels. And the vessel that he made of clay was marred in the hands of the potter; and so he made it again another vessel, as seemed good to the potter to make it. The word of the Lord came to me saying, Oh house of Israel I cannot do with you as this potter. And behold as the clay is in the potter's hand, so are ye in my hand, O house of Israel" (Jeremiah 18:3–6).

14. See pp. 82–83 above.

15. For the association of the Beast with slavery in Anglo-American abolition, see Wood, *Slavery, Empathy, and Pornography*, 189 and footnotes; for American graphic satires, see pp. 121–22 above.

16. Joel Chandler Harris's *Tales of Uncle Remus* brought the slave's metaphoric association of large carnivores with the slave power to a global audience.

17. Lewis, *The Essential C. S. Lewis*, 48–49.

18. *The Essential C. S. Lewis*, 489.

19. James, *The Black Jacobins*, xv.

20. Borges, *Collected Fictions*, 10.

21. *Manderlay: A Case of Mistaken Identity*, feature film, written and directed Lars von Trier (Zentropa Entertainments, APS and Danish Film Institute, 2005, released as DVD Metrodome MTD6269, 2006).

BIBLIOGRAPHY

Museums, Libraries, and Manuscript and Special Collections

Bibliothèque Nationale, Paris, Cabinet des Estampes, *Collection Hennin*, t. 129, nos. 11353, 11354, and Qb1 20 juin 1792 [M101224].

British Museum, London, Department of Prints and Drawings, *Collection of Political and Personal Satires*.

House of Commons, London, *Parliamentary Archives*, HL/PO/ PU/1/1807/47G3sln60, "An Act for the Abolition of the Slave Trade," 47 Geo. III, c. 36.

Library of Congress, Washington, D.C., *American Political Prints, 1766–1876, Collections in the Library of Congress*.

National Maritime Museum, Greenwich, *Art and Artefacts in the Collections Representing Slavery, Volume of Bound Manuscript-Documents Relating to the Case of the ship Zong 1783. Entirely in Granville Sharp's Hand*, sec. 6 Rec/9.

New York Public Library, Theatre Collections, *Green's Characters from Uncle Tom's Cabin*, pasteboard toy, 1865.

Slavery Exhibitions and Museum Displays

Birmingham Museums and Art Gallery in Association with the Equiano Society, *Equiano*, September 29, 2007–January 13, 2008.

British Museum London, *La Bouche du Roi: An Artwork by Romuald Hazoumé*, March 22–May 13, 2007.

Gallery 198, Brixton, London, *Blind Memories: The Role of Visual Representation in the Formation of Collective Memories of the Slave Trade*, September 27–November 29, 2007.

Hull City Museums and Galleries, Wilberforce House Museum, Permanent, Slavery Galleries.

Hunterian Museum, Royal College of Surgeons, London, *A Visible Difference, Skin, Race and Identity, 1720–1820*, July 3–December 21, 2007.

Museum in Docklands, London, "London, Sugar and Slavery," permanent galleries.

National Gallery London, *Scratch the Surface: An Exhibition Marking the Bicentenary of the Abolition of the Slave Trade*, exhibition, July 20–November 4, 2007.

Natural History Museum, London, *Slavery and the Natural World*, June 2007.

Phillips, John. *The Print That Turned the World*, exhibition, London Print Studio, 45 Harrow Road, London, W10, October 5–November 10, 2007.

Resistance and Remembrance, 1807–2007, exhibition, The British Museum, Royal African Society, Rendezvous for Victory, 2007.

Whitworth Art Gallery, Manchester, *Trade and Empire Remembering Slavery*, exhibition, June 16, 2007–April 27, 2008.

Films, Broadcasts, and DVDs

Amazing Grace. London, Momentum Pictures, 2008. DVD.
Covender, Krishner, dir. *Ms. Dynamite: In Search of Nanny Maroon*. Documentary, 56 mins. First broadcast March 25, 2007, BBC 2.
Herbstein, Manu. "Silences." Powerpoint presentation delivered at the conference *The Bloody Writing Is Forever Torn*, Elmina Beach Resort, August 10, Session 8, Round Table on Slavery and Abolition in Ghana, 5:30–8:30 p.m. Full text on DVD in the "The Bloody Writing is Forever Torn," archive, the Omohundro Institute, University of Virginia.
Phillips, Tony, producer, with Michael Buerk, presenter. *Trade Roots*. Three-part documentary. First broadcast 11:00 a.m., March 26, 27, and 28, 2007, BBC Radio 4.
Pontecorvo, Gillo, dir. *Burn!*; aka *Queimada!* France/Italy: Alberto Grimaldi, 1968. Feature Film.
Riches From Freetown, Sunday Feature. First broadcast September 30, March 25, 2007, BBC Radio 4.
"Set All Free": National Commemoration Service to Mark the Bicentenary of the Abolition of the Slave Trade Act. Live broadcast, 11:30 a.m.–1:00 p.m., March 27, 2007, BBC 1.
"Set All Free": The Westminster Service National Commemoration Service to Mark the Bicentenary of the Abolition of the Slave Trade Act. Live broadcast, 11:56 a.m.–1:00 p.m., March 27, 2007, BBC Radio 4.
Stuart, Moira, presenter. *In Search of Wilberforce*. Documentary, 58 mins. Broadcast 9:00 p.m., March 16, 2007, BBC 2.
von Trier, Lars, writer and dir. *Manderlay: A Case of Mistaken Identity*, 2006. DVD.
Wood, Marcus. Filmed interview with John Phillips, London Print Studio, November 22, 2007. DVD in the archives of London Print Studio.
———. Filmed interview with Paul Hope, Imperial War Museum, January 14, 2007. On DVD in the archives of London Print Studio.
———. *The Great Blacks in Wax*. Baltimore, Bigslugsister Co, 2005. DVD.

Primary Materials

Account by the Planter Deputies of San Domingo before the French National Assembly at the beginning of November 1791. London, 1792.
Agbetu, Toyin. "In Conversation with Stephanie Merrit." *Observer Sunday Review*, December 16, 2007, 11.
———. "My Protest was Born of Anger not Madness." *The Guardian*, March 28, 2007.
American Slavery As It Is or Testimony of a Thousand Witnesses. New York, 1839.
Anti Slavery Jubilee August 1st 1884 Meeting of the British and Foreign Anti-Slavery Society in the Guildhall of the City of London. London, 1884.

Bandeira, Julio, ed. *Debret e o Brasil Obra Completa*. Rio di Janeiro: Capivara, 2007.

Benjamin, Walter. "One Way Street." In *Walter Benjamin, Selected Writings*, vol. 1: *1913–26*, edited by Marcus Bullock and Michael W. Jennings, 444–89. Cambridge, Mass.: Harvard University Press, 1996.

Berlin, Isaiah. "Two Concepts of Liberty." In *Four Essays on Liberty*, 191–243. London and New York: Oxford University Press, 1969.

Berlin, Isaiah. "From Hope and Fear Set Free." In *Concepts and Categories: Philosophical Essays*, 91–119. London: Hogarth, 1978.

———. *The Proper Study of Mankind is Man: An Anthology of Essays*. Edited by Henry Hardy and Roger Hausheer. London: Farrar, Straus and Giroux, 2007.

Borges, Jorge Luis. *Collected Fictions*. Translated by Andrew Hurley. London: Penguin, 1999.

Boswell, James. *Life of Samuel Johnson*. London, 1768.

Bradford, Sarah H. *Scenes in the Life of Harriet Tubman*. Auburn, N.Y.: W. J. Moses, 1869.

Brown, Henry "Box." *Narrative of the Life of Henry Box Brown, Written by Himself*. Manchester, 1851.

Brown, William Wells. *The Black Man: His Antecedents, His Genius and His Achievements*. Savannah, Ga., 1863.

———. *The Rising Son; or, The Antecedents and Advancement of the Colored Race*. Boston, 1874.

Browning, Robert. *Poems of Robert Browning*. Oxford: Oxford University Press, 1910.

Bryant, William Cullen. "The Antiquity of Freedom." In *Poems of William Cullen Bryant*, 186–88. Oxford: Oxford University Press, 1914.

Césaire, Aimé. *Aimé Césaire Collected Poetry*. Translated by Clayton Eshleman and Annette Smith. Los Angeles: University of California Press, 1983.

Chesnutt, Charles W. *Collected Stories of Charles W. Chesnutt*. Edited by William Andrews. London: Penguin/Mentor, 1992.

Clarkson, Thomas. *The History of the Rise, Progress, and Accomplishment of the Abolition of the Slave Trade by the British Parliament*. London, 1808. Reprint, Teddington: Techno Library, 2006.

———. *NEGRO SLAVERY. Argument, That the Colonial Slaves are better off than the British Peasantry, ANSWERED FROM THE ROYAL JAMAICA GAZETTE*. London, 1824.

Cobbett, William. *The Political Register*. London, 1821–23.

Coleridge, Samuel Taylor. *The Table Talk and Omniana of Samuel Taylor Coleridge*. Oxford: Oxford University Press, 1917.

Depestre, René. "Epiphanies of the Voodoo Gods: A Voodoo Mystery Poem." In *The Negritude Poets: An Anthology of Translations from the French*, edited by Ellen Conroy Kennedy, 93–115. New York: Thunder Mouth, 1989.

Dickens, Charles. *American Notes*. Oxford: Oxford University Press, 1987.

Dixon, Thomas, Jr. *The Clansman: An Historical Account of the Klu Klux Klan*. Norborne, Mo.: Salon Publishing, 1904.

Dodgson, Charles Lutwidge. *The Complete Works of Lewis Carroll*. New York: Nonesuch, 1939.

Douglass, Frederick. *Narrative of the Life of Frederick Douglass, an American Slave.* 1845. Reprint, New York: Doubleday & Co., 1963.

Du Bois, W. E. B. *The Souls of Black Folk.* New York, 1903.

Edwards, Bryan. *An Historical Account of the Black Empire of Hayti.* London, 1805.

Emerson, Ralph Waldo. *An Address in the Courthouse in Concord, Massachusetts, on 1st of August 1844 on the Anniversarie of the Emancipation of Negroes in the British West Indies.* Boston, 1844.

Equiano, Olaudah. *Olaudah Equiano: The Interesting Narrative and other Writings.* Edited by Vincent Caretta. London and New York: Penguin, 1998.

Fanon, Frantz. *Peau noire masques blancs.* Paris: Editions du Seuil, 1952.

———. *The Wretched of the Earth.* 1961. Reprint, Harmondsworth: Penguin, 1967.

Fisher, Mark Miles. *Negro Slave Songs in the United States.* New York: Citadel, 1990.

Fox, George. *The Journal of George Fox.* London, 1654.

Gleason, Judith. *Leaf and Bone: African Praise Poems.* London: Penguin, 1994.

Harris, Joel Chandler. *Uncle Remus: His Songs and Sayings.* New York, 1880.

The Havamal, with Selections from Other Poems in the Edda. Cambridge: Cambridge University Press, 1923.

Hazlitt, William. *The Complete Works of William Hazlitt in Twenty One Volumes.* Edited by P. P. Howe. London: J. M. Dent, 1931.

Hegel, G. W. F. *The Phenomenology of Mind.* Translated by J. B. Baillie. London: Allen and Unwin, 1949.

———. *Philosophy of World History.* Translated by J. Sibree. Mineola, N.Y.: Dover Philosophical Classics, 1956.

Hildreth, Richard. *The Slave; or, Memoirs of Archie Moore.* 2 vols. Boston, 1836.

———. *The White Slave; Another Picture of Slave Life in America.* Boston, 1852.

An Historical Account of the French Colony of San Domingo: Comprehending... a Narrative of the calamities which have desolated the island ever since 1789 with some reflections on their causes and probable consequences and a detail of the British Army in that Island to the end of 1794. London, 1794.

Hobbes, Thomas. *Leviathan.* Edited by Richard Tuck. 1651. Reprint, Cambridge: Cambridge University Press, 1991.

James, C. L. R. *The Black Jacobins.* 1938. Reprint, London: Penguin, 1980.

Jefferson, Thomas. *Writings.* Edited by Merrill D. Peterson. New York: Library of America, 1984.

Kwei-Armah, Kwamei. "From Ian to Kwamei — Why Slavery Made Me Change My Name." *The Observer,* March 25, 2007.

Lambert, Sheila, ed. "Testimony of Trotter." In *House of Commons Sessional Papers of the Eighteenth Century,* 85, 87. Wilmington: Scholarly Resources, 1975.

Lawal, Babatunde. "Reclaiming the Past: Yoruba Elements in African American Arts." In *The Yoruba Diaspora in the Atlantic World,* edited by Toyin Falola and Matt D. Childs, 291–315. Bloomington: Indiana University Press, 2004.

Lemprière, J., *Classical Dictionary of Proper Names Mentioned in Ancient Authors.* 1788. Reprint edition revised by F. A. Wright. London: Routledge and Kegan Paul, 1951.

Lewis, C. S. *The Essential C. S. Lewis.* Edited by Lyle W. Dorsett. New York: Collier/McMillan, 1988.

Mello, Thiago de. *Estatutos do Homem.* Manaus: Editora Valer, 2001.

Miller, Madeleine S., and J. Miller. *Black's Bible Dictionary.* London: Adam and Charles Black, 1973.

Noobanjong, Koompong. *Power, Identity, and the Rise of Modern Architecture: From Siam to Thailand.* Dissertation.com, October 2003.

Norvic Philatelics website. www.norphil.co.uk/catalog/slavery.

Punch, or the London Charivari.

Revista Illustrada. Rio di Janeiro, 1873–88.

Ripley, C. Peter, ed. *The Black Abolitionist Papers.* 5 vols. Chapel Hill: University of North Carolina Press, 1985.

Royal Mail Stamps, Past Stamp Issues, 2007 Abolition of the Slave Trade. http://www.royalmail.com/portal/stamps/content1.

Sancho, Ignatius. *The Letters of Ignatius Sancho, An African.* Edited by Vincent Caretta. London and New York: Penguin, 1998.

Sitwell, Edith. *The Collected Poems of Edith Sitwell.* London: Duckworth, 1931.

Stowe, Harriet Beecher. *Key to Uncle Tom's Cabin; Facts and Documents upon Which the Story Is Founded.* Boston, 1853.

———. *The Lives and Deeds of Our Self Made Men.* Boston, 1872.

Swift, Jonathan. *The Drapier's Letters.* London, 1723.

Walker, Jonathan. *The Trial and Imprisonment of Jonathan Walker at Pensicola Florida, for Aiding Slaves to escape from Bondage.* Boston, 1846.

Wedderburn, Robert. *The Horrors of Slavery and Other Writings by Robert Wedderburn.* Edited and with an introduction by Iain McCalman. Edinburgh: Edinburgh University Press, 1991.

Whitchurch, Samuel. *Hispaniola.* London, 1804.

Wilberforce, William. *A Practical View of Christianity.* Edited and with an introduction by Charles Colson. Peabody, Mass.: Hendrickson Christian Classics, 2006.

Windley, A., comp. and ed. *Runaway Slave Advertisements: A Documentary History from the 1730s until 1790.* 4 vols. London: Greenwood, 1983.

Williams, Eric. *Capitalism and Slavery.* 1944. Reprint, New York: Perigee, 1980.

Williams, James. *A Narrative of the Events since the first of August, 1834 by James Williams an Apprenticed Labourer in Jamaica.* Edited and with introduction by Diana Paton. Durham, N.C.: Duke University Press, 2001.

Secondary Materials

Airy, Osmond. *A Textbook History of England.* London, 1898.

Almendinger, David F., Jr. "The Construction of *The Confessions of Nat Turner.*" In *Nat Turner: A Slave Rebellion in History and Memory,* edited by Kenneth S. Greenberg, 24–45. New York: Oxford University Press, 2003.

Alpers, Edward A. "Mozambique and 'Mozambiques': Slave Trade and Diaspora

on a Global Scale." In *Slave Routes and Oral Tradition in Southeastern Africa*, edited by Benigna Zimba, Edward A. Alpers, and Allen F. Isaacman, 39–61. Maputo: Filsom Entertainment, Lda., 2005.

Anderson, Bridget. *Britain's Secret Slaves: An Investigation into the Plight of Overseas Domestic Workers*. London: Anti-Slavery International, 1993.

Anderson, Robert Nelson. "The *Quilombo* of Palmares: A New Overview of a Maroon State in Seventeenth-Century Brazil." *Journal of Latin American Studies* 28, no. 3 (1996): 545–65.

Andrews, William. *To Tell a Free Story: The First Century of Afro American Autobiography, 1760–1865*. Urbana: University of Illinois Press, 1986.

Anstey, Roger. *The Atlantic Slave Trade and British Abolition, 1760–1810*. Atlantic Highlands, N.J.: Humanities, 1975.

Aravamudan, Srinivas. *Tropicopolitans, Colonialism and Agency, 1688–1804*. Durham, N.C.: Duke University Press, 1999.

Ashcroft, Bill, Gareth Griffiths, and Helen Tiffin, eds. *Key Concepts in Post-Colonial Studies*. London and New York: Routledge, 1998.

Bales, Kevin. *Disposable People: New Slavery in the Global Economy*. Berkeley: University of California Press, 1999.

Barbadoes 200th Anniversary of the Abolition of the Slave Trade from Africa. Bridgetown: Barbados Philatelic Bureau, 2007.

Barbieri, Gian Paolo. *Madagascar*. London: Harvill, 1995.

Barrell, John. *Imagining the King's Death: Figurative Treason and Fantasies of Regicide, 1793–1796*. Oxford: Oxford University Press, 2000.

Barringer, Tim, Gillian Forrester, and Barbaro Martinez Ruiz, eds. *Art and Emancipation in Jamaica: Isaac Mendes Belisario and his Worlds*. New Haven: Yale Centre for British Art in Association with Yale University Press, 2007.

Bazzi, Maria. *The Artist's Methods and Materials*. London: John Murray, 1965.

Bellen, Heinz Heinen. *Bibliographie zur antiken Sklaverei: Forschungen zur antiken Sklaverei*. 2 vols. Stuttgart: Franz Steiner Verlag, 2003.

Bernier, Celeste Marie. *African American Visual Arts*. Edinburgh: Edinburgh University Press, 2008.

Bhabha, Homi. *The Location of Culture*. London and New York: Routledge, 1994.

Birdoff, Harry. *The World's Greatest Hit: Uncle Tom's Cabin*. New York: S. F. Vanni, 1947.

Blackett, R. J. M. *Building an Antislavery Wall: Black Americans in the Atlantic Abolitionist Movement, 1830–1860*. Ithaca: Cornell University Press, 1983.

Blight, David, ed. *Passages to Freedom: The Underground Railroad in History and Memory*. Washington, D.C.: Smithsonian Books, 2004.

Bloch, Marc. "Comment et pourquoi finit l'esclavage antique." In *Slavery in Classical Antiquity*, edited by M. I. Finleyson, 204–29. Cambridge: Heffer, 1968.

Bolt, Christine. *The Anti-Slavery Movement and Reconstruction: A Study of Anglo-American Cooperation, 1833–1877*. London: Oxford University Press, 1969.

Bowlby, Rachael. "Breakfast in America — *Uncle Tom's* Cultural Histories."

In *Nation and Narration*, edited by Homi K. Bhabha, 197–212. London: Routledge, 1990.

Brown, Christopher L. *Moral Capital: Foundations of British Abolitionism.* Chapel Hill: University of North Carolina Press, 2006.

Brown, Justus N. "Lovejoy's Influence on John Brown." *Magazine of History* 23 September–October 1916, 97–102.

Buckland, W. W. *The Roman Law of Slavery.* Cambridge: Cambridge University Press, 1908.

Burgett, Bruce. "Obscene Publics: Jesse Sharpless and Harriet Jacobs." *Genders* 27 (1998). http://www.genders.org/g27/g27_obscene.html. Accessed March 12, 2009.

Burn, W. L. *Emancipation and Apprenticeship in the British West Indies.* London: Jonathan Cape, 1937.

Cadernos Brasileiros 80 anos de abolição, no. 47, part 3, May–June 1968.

Calderini, A. *La manomissione e la condizion dei liberti in Grecia.* Milan, 1908.

The Cambridge History of the British Empire. Edited by J. Holland Rose, A. P. Newton, and E. A. Benians. Vol. 2. Cambridge: Cambridge University Press, 1940.

Captive Passage: The Transatlantic Slave Trade and the Making of the Americas. Newport, Va.: Smithsonian Institution, 2002. [Exhibition catalogue.]

Castillo, Jorge. "The Development of a Style." *XXIII Biennal Internacional de São Paolo*, December 8, 1996. http://www1.uol.com.br/bienal/23bienal/especial/iefi.htm#Nome.

Chaney, Michael A. *Fugitive Vision: Slave Image and Black Identity in Antebellum Narrative.* Bloomington: University of Indiana Press, 2008.

Chater, Kathy. "Black People in England." In Farrell, Walvin, and Unwin, *The British Slave Trade*, 272–89.

Cohen, William B. *The French Encounter with Africans: White Response to Blacks, 1530–1880.* London: Bloomington, 1980.

Conrad, Robert. *The Destruction of Brazilian Slavery, 1850–1888.* Berkeley: University of California Press, 1972.

Corrigan, Colette. "Anti-Abolition Writes Back: An English Pornographic Parody of Harriet Jacobs' Slave Narrative." Paper presented at *The Annual Victorian Conference in Literature and Culture: The Victorians and America, University College Worcester.* Worcester, UK, April 28, 2001.

———. "Transatlantic Slavery and The English Vice." In *International Exposure: Perspectives on Modern European Pornography, 1800–2000*, edited by Lisa Z. Sigel, 67–99. New Brunswick, N.J.: Rutgers University Press, 2005.

Cox, Camilla. "Unearthing Resistance: African American Cultural Artefacts in the Antebellum Period." *U.S. Studies Online: The BAAS Postgraduate Journal* 8 (Spring 2006). http://www.baas.ac.uk/resources/usstudiesonline/article.asp?us=8&id=26. Accessed March 12, 2009.

Darnton, Robert, and Daniel Roche, eds. *Revolution in Print: The Press in France, 1775–1800.* Berkeley: University of California Press, 1989.

Davis, Charles T., and Henry Louis Gates Jr., eds. *The Slave's Narrative.* New York: Oxford University Press, 1985.

Davis, David Brion. *"'The Emancipation Moment,' 22nd Annual Robert Forten-baugh Memorial Lecture."* Gettysburg: Gettysburg College Press, 1983.

———. *The Problem of Slavery in the Age of Revolution, 1770–1823.* 1975. Reprint, Oxford: Oxford University Press, 1999.

———. *The Problem of Slavery in Western Culture.* New York: Oxford University Press, 1966.

Davis, Frank. "Tom Shows." *Scribner's Magazine* 67 (1927): 355–60.

Davis, Natalie Zemon. *Slaves on Screen: Film and Historical Vision.* New York: Vintage, 2000.

Description of a Slave Ship. London: James Phillips, George Yard, Lombard Street, 1789.

Desrosiers, Paultre P. "On Toussaint from Desrosiers." www.hartford-hwp.com/archives/43a/373.html.

De Vere Brody, Jennifer. *Impossible Purities: Blackness, Femininity and Victorian Culture.* Durham, N.C.: Duke University Press, 1998.

Devil's Kitchen. "An Open Letter to Toyin Agbetu." Blog posted by "Martin." http://devilskitchen.me.uk/2007/03/open-letter-to-toyin-agbetu.html. Accessed March 12, 2009.

Diegues, Carlos, and Evararardo Rocha. *Palmares Mito e Romance da Utopia Brasileira.* Rio de Janeiro: Rio Funda Editora, 1989.

Dimond, Sidney G. *The Psychology of the Methodist Revival.* London, 1926.

Donald, Diana. *The Age of Caricature: Satirical Prints in the Reign of George III.* New Haven: Yale University Press, 1996.

Drescher, Seymour. *Capitalism and Antislavery: British Mobilisation in Comparative Perspective.* Oxford and New York: Oxford University Press, 1987.

Dubois, Laurent. "The Enslaved Enlightenment." *Social History* 31, no. 1 (February 2006): 1–14.

Duff, A. M. *Freedmen in the Early Roman Empire.* Oxford: Oxford University Press, 1928.

Elkins, James. *The Domain of Images.* Ithaca: Cornell University Press, 1999.

Ellis, Markman. "Ignatius Sancho's Letters: Sentimental Libertinism and the Politics of Form." In *Genius in Bondage: Literature of the Early Black Atlantic,* edited by Vincent Carretta and Phillip Gould, 199–217. Lexington: University of Kentucky Press, 2001.

Eltis, David. "The British Trans-Atlantic Slave Trade after 1807." *Maritime History* 4 (1974): 1–11.

The Essential Royal Mail Millennium Collection. 2 vols. London: Post Office, Royal Mail, 1999.

Eudell, Demetrius L. *Political Languages of Emancipation in the British Caribbean and the U.S. South.* Chapel Hill: University of North Carolina Press, 2002.

Falola, Toyin, and Niyi Afolabi, eds. *African Minorities in the New World.* New York: Routledge, 2008.

Falola, Toyin, and Matt D. Childs, eds. *The Yoruba Diaspora in the Atlantic World*. Bloomington: Indiana University Press, 2004.

Farrell, Stephen. "'Contrary to the Principles of Justice, Humanity and Sound Policy': The Slave Trade Parliamentary Politics and the Abolition Act, 1807." In Farrell, Walvin, and Unwin, *The British Slave Trade*, 165–71.

Farrell, Stephen, James Walvin, and Melanie Unwin, eds. *The British Slave Trade: Abolition, Parliament and People*. Edinburgh: Edinburgh University Press, for the Parliamentary History Yearbook Trust, 2007.

Fausto, Boris. *A Concise History of Brazil*. Cambridge: Cambridge University Press, 1999.

Ferguson, Moira. *Subject to Others: British Writers and Colonial Slavery, 1670–1834*. New York: Routledge, 1992.

Ferguson, Niall. *Empire: How Britain Made the Modern World*. London: Allen Lane/Penguin, 2003.

Fine, Elsa Honing. *The Afro-American Artist*. New York: Holt Rinehart and Winston, 1973.

Finlay, William. *An Illustrated History of Stamp Design*. London: Peter Lowe, 1974.

Finley, M. I. *Ancient Slavery and Modern Ideology*. London: Chatto and Windus, 1980.

———, ed. *Slavery in Classical Antiquity*. Cambridge: Heffer, 1968.

Fladeland, Betty. *Abolitionists and Working Class Problems in the Age of Industrialisation*. Baton Rouge: Louisiana State University Press, 1984.

Flaubert, Gustave. *A Sentimental Education*. Translated by Douglas Parmée. New York: Oxford University Press, 2000.

Fleuriot, P. B. G. *Saint Pierre Claver, Apôtre des nègres*. Rev. ed. Paris, 1888.

Foster, Frances Smith. *Witnessing Slavery: The Development of Ante-Bellum Slave Narratives*. Westport, Conn.: Greenwood, 1979.

Frantisek, Svarc. *Stamps and Stamp Collecting*. London: Caxton Editions, 1998.

Freyre, Gilberto. *Brazil: An Interpretation*. New York: Alfred Knopf, 1945.

———. *Os Escravo nos Anúncios de Jornais Brasileiros do Século XIX*. 2nd ed. São Paulo: Companhia Editoria Nacional, 1979.

Fryd, Vivien Green. *"Political Compromise in Public Art: Thomas Crawford's Statue of Freedom."* http://www.people.virginia.edu/~tsawyer/DRBR/fryd/fryd.html.

Gara, Larry. "The Professional Fugitive in the Abolition Movement." *Wisconsin Magazine of History* 48, no. 2 (1965): 196–204.

Gardiner, Jane. "The Assault upon Uncle Tom: Attempts of Pro-slavery Activists to Answer *Uncle Tom*, 1852–1860." *Southern Humanities Review* 12 (1978): 313–24.

Gardner, J. F., and T. H. Wiedemann. *The Roman Household*. London and New York: Routledge, 1991.

Gassier, Pierre, Juliet Lachenal, and François Wilson. *Goya: Life and Work*. Cologne: Taschen, 1994.

Gattrell, V. A. C. *The Hanging Tree: Execution and the English People, 1770–1868.* Oxford: Oxford University Press, 1996.

Geggus, David. *Slavery, War, and Revolution: The British Occupation of San Domingue, 1793–98.* Oxford: Clarendon, 1983.

George, M. Dorothy. *English Political Caricature: A Study in Opinion and Propaganda.* 2 vols. Oxford: Oxford University Press, 1959.

Giles, Paul. *Transatlantic Insurrections: British Culture and the Formation of American Literature, 1730–1860.* Philadelphia: University of Pennsylvania Press, 2001.

Gilroy, Paul. *The Black Atlantic: Modernity and Double Consciousness.* London: Verso, 1992.

Godfrey, Richard. *James Gillray: The Art of Caricature.* London: Tate Publishing, 2001.

Gombrich, E. H. "In Search of Cultural History." In *Ideals and Idols: Essays on Values in History and in Art*, 24–60. Oxford: Phaidon, 1979.

Goodell, William. *Slavery and Anti-Slavery: A History of the Great Struggle in Both Hemispheres.* New York, 1855.

Graham Stewart, Michael. *Michael Graham Stewart Slavery Collection.* London: National Maritime Museum, 2001. [Autumn 2001 museum catalogue.]

Grüner, Mark Randall. "Stowe's *Dred*: Literary Domesticity and the Law of Slavery." *Prospects* 20 (1995): 1–37.

Guillory, John. *Cultural Capital: The Problem of Literary Canon Formation.* Chicago: University of Chicago Press, 1993.

Hall, Catherine. "William Knibb and the Constitution of the New Black Subject." In *Empire and Others: British Encounters with Indigenous Peoples, 1600–1850*, edited by Martin Daunton and Rick Halpern, 303–24. Philadelphia: University of Philadelphia Press, 1999.

Hall, Stuart. "Legacies of Anglo-Caribbean Culture: A Diasporic Perspective." In Barringer, Forrester, and Ruiz, *Art and Emancipation in Jamaica*, 179–94.

Hamilton, Cynthia. "*Dred*: Intemperate Slavery." *Journal of American Studies* 34 (2000): 257–77.

Hamilton, Douglas, and Robert J. Blyth, eds. *Representing Slavery: Art, Artefacts and Archives in the Collections of the National Maritime Museum.* London: Lund Humphries, 2007.

Harries, Patrick. "Making Mozbiekers: History, Memory, and the African Diaspora at the Cape." In *Slave Routes and Oral Tradition in Southeastern Africa*, edited by Benigna Zimba, Edward A. Alpers, and Allen F. Isaacman, 91–123. Maputo: Filsom Entertainment, Lda., 2005.

Hart, Richard. *Slaves Who Abolished Slavery.* Vol. 2, *Blacks in Rebellion.* Kingston, Jamaica: University of the West Indies Press, 1985.

Haudrère, Phillipe, and Françoise Vergès *De L'Esclave au citoyen.* Paris: Gallimard, 1998.

Herbstein, Manu. "Reflections in a Shattered Glass." *African Writing Online, Many Literatures Once Voice*, December–January 2008. http://www.african-writing.com/hol/manuherbstein.htm. Accessed March 12, 2009.

Heuman, Gad. *"The Killing Time": The Morant Bay Rebellion in Jamaica*. London: Macmillan, 1994.

Hickey, Donald R. "America's Response to the Slave Revolt in Haiti." *Journal of the Early Republic* 2 (1982): 361–79.

Hinton, Richard J. *John Brown and His Men with Some Account of the Roads They Travelled to Reach Harper's Ferry*. New York: American Reformer's Series, 1894.

Hochschild, Adam. *Bury the Chains: The British Struggle to Abolish Slavery*. London: Macmillan, 2005.

Hollis, Patricia. "Anti-slavery and British Working Class Radicalism in the Years of Reform." In *Anti-slavery Religion and Reform: Essays in Memory of Roger Anstey*, edited by Christine Bolt and Seymour Drescher, 297–311. Folkestone: Archon, 1980.

Holt, Thomas. *The Problem of Freedom: Race, Labour and Politics in Jamaica and Britain, 1832–1928*. Baltimore: Johns Hopkins University Press, 1992.

Honour, Hugh. *The Image of the Black in Western Art*. Parts 4:1 and 4:2. Cambridge, Mass.: Harvard University Press, 1987.

Hudson, J. Blaine. *Encyclopaedia of the Underground Railroad*. Jefferson, N.C.: McFarland, 2006.

Hughes, Kenneth. *Greek and Roman Slavery*. London: George Allen, 1975.

Hume, David. *The Student's Hume: A History of England*. London, 1875.

Hunt, Lynn. "The Political Psychology of Revolutionary Caricatures." In *French Caricature and the French Revolution, 1789–1799*, 33–40. Berkeley: Grunewald Center for the Graphic Arts and University of California Press, 1989. [Exhibition catalogue.]

Hyde, Lewis. *The Gift: Imagination and the Erotic Life of Property*. London: Vintage, 1999.

James, C. L. R. *The Black Jacobins: Toussaint l'Ouverture and the San Domingo Revolution*. 1938. Reprint, London: Penguin, 1980.

Jones, A. H. M. "Slavery in the Ancient World." *The Economic History Review*, 2nd ser., 9 (1956): 185–99.

Jones, Jonathan. "Art of Africa." *The Guardian*, December 28, 2005.

Jordan, Michael. *The Great Abolition Sham: The True Story of the End of the British Slave Trade*. London: Stroud, 2005.

Kalenberg, Angel. "Figari, Pedro." In *Encyclopedia of Latin American and Caribbean Art*, edited by Jane Turner. New York: Oxford University Press, 2000.

Karsner, David. *John Brown: "Terrible Saint."* New York: Dodd, Mead, 1934.

Kay, Jackie. "Missing Faces." *Saturday Guardian Review*, March 24, 2007.

Keith, Jeanette. "Jeanette Keith on Nell Irvin Painter, *Southern History Across the Color Line*." H-SAWH, July 2002. http://www.h-net.msu.edu/reviews/showrev.cgi.

King, Reynann, and James Walvin, eds. *Ignatius Sancho, an African Man of Letters*. London: National Portrait Gallery, 1997.

Kom, Anton de. *We Slaves of Surinam*. London: Palgrave Macmillan, 1987.

Korshak, Yvonne. "The Liberty Cap as a Revolutionary Symbol in America and France." *Smithsonian Studies in American Art* 1, no. 2 (Autumn 1987): 53–69.

La Bouche du Roi, an Artwork by Romuald Hazoumé. Publicity handout. London: The British Museum, sponsored through the National Lottery, via The Arts Council of Great Britain, 2007.

Lecky, E. H. *A History of European Morals from Augustus to Charlemagne.* New York, 1890.

Lewis, C. S. *The Essential C. S. Lewis.* Edited by Lyle W. Dorsett. London and New York: Collier/Macmillan, 1988.

Lorimer, Douglass. *Colour, Class, and the Victorians.* Leicester: Leicester University Press, 1978.

Macey, David. *Frantz Fanon: A Life.* London: Granta, 2000.

Mann, Graciela, and Hans Mann. *The 12 Prophets of Aleijadinho.* Austin: University of Texas Press, 1967.

Marshall, W. K. "Apprenticeship and Labour Relations in Four Windward Islands." In *Abolition and its Aftermath: The Historical Context, 1790–1916,* edited by David Richardson, 203–24. London: Frank Cass, 1985.

Mauss, Marcel. "Essai sur le don: Forme et raison de l'échange dans les sociétés archaïques." *L'Année Sociologique* 1 (1923–24): 30–186.

———. *The Gift: Forms and Functions of Exchange in Archaic Societies.* Translated by Ian Cunnison. New York: Norton, 1967.

McCalman, Iain. "Anti-Slavery and Ultra-radicalism in Early Nineteenth Century England: The Case of Robert Wedderburn." *Slavery and Abolition* 7, no. 2 (1986): 99–117.

McConahie, Bruce A. *Melodramatic Formations: American Theatre and Society, 1820–1970.* Iowa City: University of Iowa Press, 1992.

Meer, Sarah. *Uncle Tom Mania: Slavery Minstrelsy and Transatlantic Culture in the 1850s.* Athens: University of Georgia Press, 2005.

Mellor, G. R. *British Imperial Trusteeship, 1783–1850.* London: Faber and Faber, 1951.

Michael, C. D. *The Slave and His Champions.* London: S. W. Partridge, 1915.

Molineux, Catherine. "Pleasures of the Smoke: 'Black Virginians' in Georgian London's Tobacco Shops." *William and Mary Quarterly* 64, no. 2 (April 2007): 327–76.

Morgan, Philip D. *Slave Counterpoint: Black Culture in the Eighteenth-Century Chesapeake & Low Country.* Chapel Hill: University of North Carolina Press, 1998.

———. "Colonial South Carolina Runaways: Their Significance for Slave Culture." *Slavery and Abolition* 6, no. 3 (1985): 57–79.

Mott, Franck Luther. *A History of American Magazines, 1850–1865.* Cambridge Mass.: Harvard University Press, 1938.

Nevinson, Henry W. *England's Voice of Freedom: An Anthology of Liberty.* London: Victor Gollancz, 1929.

Newberry, Michael. "Eaten Alive: Slavery and Celebrity in Ante-bellum America." *English Literary History* 61, no. 1 (1994): 159–87.

Nuovo, Giornale. "*The Genius of Salvator Rosa.*" www.spamula.net/blog/i40/rosa3.jpg. Accessed March 13, 2009.

Ogundiran, Akinwumi, and Toyin Falola, eds. *Archaeology of Atlantic Africa and the African Diaspora*. Bloomington: Indiana University Press, 2007.

Oldfield, J. R. *"Chords of Freedom": Commemoration, Ritual, and British Transatlantic Slavery*. Manchester: Manchester University Press, 2007.

———. *Popular Politics and British Anti-Slavery: The Mobilisation of Public Opinion Against the Slave Trade, 1787–1807*. Manchester: Manchester University Press, 1995.

Orico, Osvaldo. *O Tigre da Abolição edicião comemorátiva do centenário José do Patrocinio*. Rio: Gráfica Olímpica, 1953.

Osei-Tutu, Brempong. "Ghana 'Slave Castles,' Tourism and the Social Memory of the Atlantic Slave Trade." In Ogundiran and Falola, *Archaeology of Atlantic Africa*, 59–78.

Painter, Nell Irvin. *Southern History Across the Color Line*. Gender and American Culture Series. Chapel Hill: University of North Carolina Press, 2002.

Paulson, Ronald. *Representations of Revolution*. New Haven: Yale University Press, 1987.

———. "The Severed Head: The Impact of French Revolutionary Caricatures on England." In *French Caricature and the French Revolution, 1789–1799*, 55–67. Berkeley: Grunewald Center for the Graphic Arts and University of California Press, 1989. [Exhibition catalogue.]

Plant, Roger. *Sugar and Modern Slavery: A Tale of Two Countries*. London: Z Books, 1987.

Pomeroy, Sarah B. *Goddesses, Whores, Wives and Slaves: Women in Classical Antiquity*. London: Pimlico, 1994.

Pottery, Poetry and Politics Surrounding the Enslaved African American Potter, Dave. Columbia, S.C.: McKissick Museum, University of South Carolina, 2000. [Exhibition catalogue.]

Pritzker, Barry. *Mathew Brady*. North Dighton, Mass.: JG Press, 2004.

"Projects Funded by the Heritage Lottery Fund 1807." www.hlf.org.uk/.../B1EFD 886-E350-41CA-8FFC35C8B4CAE304/3926/OverviewofHLFand2007 BicentenaryNovember2006.pdf.

Quarles, Benjamin. *The Negro in the American Revolution*. Chapel Hill: University of North Carolina Press, 1961.

———. *The Negro in the Making of America*. New York: Oxford University Press, 1969.

Rediker, Marcus. *The Slave Ship: A Human History*. New York: Penguin/Viking, 2007.

Reilly, Bernard F., Jr. *American Political Prints, 1766–1876: A Catalog of the Collections in the Library of Congress*. Boston: G. K. Hall, 1991.

Richardson, David. "The Slave Trade, Sugar and British Economic Growth, 1748–1776." *Journal of Interdisciplinary History* 17, no. 4 (1987): 739–69.

Rogin, Ruth, and Jean Fagan Yellin. "Introduction." In *The Abolitionist Sisterhood: Women's Political Culture in Ante-bellum America*, edited by Jean Fagin Yellin and John C. Van Horne, 1–19. Ithaca: Cornell University Press, in collaboration with the Library Company of Philadelphia, 1994.

Root, David. *A Memorial of the Martyred Lovejoy. A Sermon Delivered in Dover, N. H.* N.p., n.d.

Rose, Stuart. *Royal Mail Stamps: A Survey of British Stamp Design.* London: Phaidon, 1980.

Ross, Doran H., ed. *Wrapped in Pride: Ghanaian Kente and African American Identity.* UCLA Fowler Museum of Cultural History Textile Series No. 2. Los Angeles: UCLA FMCH Textile Series, 1998. [Exhibition catalogue.]

Royal Mail official website. www.royalmail.com/stamps/slavetradeaboliton.

Sandiford, Keith. *Measuring the Moment: Strategies of Protest in Eighteenth-century Afro-English Writing.* New York: Associated Universities Press, 1988.

Schama, Simon. *Rough Crossings: Britain, the Slaves, and the American Revolution.* London: BBC Books, 2005.

Schmidt, Nelly. *Victor Schoelcher et l'abolition de l'esclavage.* Paris: Fayard, 1994.

Scott, David. "The Art of Design: The Postage Stamps of Michael and Sylvia Goaman." *Gibbons Stamp Monthly,* September 1992, 30–33.

———. *European Stamp Design: A Semiotic Approach to Designing Messages.* London: Academy Editions, 1995.

———. "National Icons, the Semiotics of the French Stamp." *French Cultural Studies* 3 (1992): 215–33.

Searing, James F. *West African Slavery and Atlantic Commerce: The Senegal River Valley, 1700–1860.* New York: Cambridge University Press, 1993.

Shelton, Robert S. "A Modified Crime: The Apprenticeship System in St. Kitts." *Slavery and Abolition* 16, no. 3 (1995): 331–45.

Sherwood, Marika. *After Abolition: Britain and the Slave Trade since 1807.* London: I. B. Tauris, 2007.

Shyllon, F. O. *Black Slaves in Britain.* New York: Oxford University Press, 1974.

Smart, Ted, ed. *On This Day: The History of the World in 366 Days, a Day by Day Collection of over 8000 Events.* London: Octopus Publishing, 1992.

Smith, Billy G., and Richard Wojtowicz. *Blacks who stole Themselves: Advertisements for Runaways in the Pennsylvania Gazette, 1728–90.* Philadelphia: University of Pennsylvania Press, 1989.

Snelgrave, William. *A New Account of Some Parts of Guinea and the Slave Trade.* London, 1794. Reprint, London: Frank Cass, 1971.

Sola, Óscar. *Che: Images of a Revolutionary.* London: Pluto, 1997.

Southey, Robert. *The History of Brazil.* 3 vols. London, 1817–19.

Stampex, the Newsletter of Britain's Secret Little Post Office, no. 10 (Spring 2007): 3.

Stanley Gibbons Great Britain Concise Stamp Catalogue. 1999 ed. London: Stanley Gibbons Ltd., 1999.

Starling, Marion Wilson. *The Slave Narrative: Its Place in American History.* Boston: G. K. Hall, 1982.

Still, William. *The Underground Railroad.* Philadelphia: Porter and Coates, 1872.

Straussbaugh, John. *Black Like You: Blackface, Whiteface, Insult and Imitation in American Popular Culture.* New York: Penguin, 2006.

Sutherland, John. "Thackeray as Victorian Racialist." *Essays in Criticism* 20, no. 4 (October 1970): 441–45.

Sutton, Alison. *Slavery in Brazil: A Link in the Chain of Modernization*. London: Anti-Slavery International, 1994.

Taylor, Miles. *The Decline of British Radicalism, 1847–1860*. Oxford: Clarendon, 1995.

Tebbel, John. *Between Covers: The Rise and Transformation of Book Publishing in America*. New York: Oxford University Press, 1987.

Thomas, Peter D. G. *The English Satiric Print, 1600–1632*. Cambridge: Chadwyck Healey, 1986.

Thorpe, Edward. *Black Dance*. London: Chatto and Windus, 1989.

Tibbles, Anthony, ed. *Transatlantic Slavery Against Human Dignity*. London: HMSO, 1994.

Todd, Leonard. *Carolina Clay: The Life and Legend of the Slave Potter Dave*. New York: Norton, 2008.

Toll, Robert. *Blacking Up: The Minstrel Show in Nineteenth Century America*. New York: Oxford University Press, 1974.

"Tous les hommes nascent égaux." *L'Écho de la Timbrologie la Tribune des Philatelistes*, no. 1707 (April 1998): 30–33.

Tragle, Henry Irving. *The Southampton Slave Revolt of 1831: A Compilation of Source Material*. Amherst: University of Massachusetts Press, 1971.

Trevelyan, G. M. *History of England*. London, 1926.

Turner, Michael J. "The Limits of Abolition: Government, Saints and the 'Africa Question,' c. 1780–1830." *English Historical Review* 112 (1997): 319–57.

Valtierra, Angel, SJ. *Peter Claver: Saint of the Slaves*. Westminster, Md.: Newman, 1960.

Van Dantzig, Albert. *Forts and Castles of Ghana*. Accra: Sedco, 1980.

Van Gennep, Arnold. *The Rights of Passage*. London: Routledge, 2004.

Vogt, Joseph. *Ancient Slavery and the Ideal of Man*. Translated by Thomas Wiedemann. Oxford: Blackwell, 1974.

Wallace, Elizabeth Kowaleski. *The British Slave: The Trade and Public Memory*. New York: Columbia University Press, 2006.

Walvin, James. "The Public Campaign in England Against Slavery 1787–1834." In *The Abolition of the Atlantic Slave Trade*, edited by D. Eltis and J Walvin, 63–82. Madison: University of Wisconsin Press, 1981.

Westermann, W. L. "Slavery and the Elements of Freedom in Ancient Greece." *Quarterly of the Bulletin of Polish Institute of Arts and Sciences in America*, January 1943, 1–16. Reprinted in Finley, *Slavery in Classical Antiquity*, 17–32.

Wiedemann, Thomas. *Greece and Rome: New Surveys in the Classics Slavery*. Oxford: Oxford University Press, Published for the Classical Association, 1997.

———. *Greek and Roman Slavery*. Baltimore: Johns Hopkins University Press, 1981.

———. "The Regularity of Manumission in Rome." *Critical Quarterly* 35 (1985): 162–75.

Williams, Eric. *Capitalism and Slavery*. 1943. Reprint, New York: G. B. Putnam, 1980.

Williams, Gwyn. *A Cartoon History of the American Revolution*. London: London Editions, 1977.

Williams, L. N., and M. Williams. *The Postage Stamp: Its History and Recognition*. London: Penguin, 1956.

Wills, Leslée, and Marcel Knobil. *Images of the Carnival*. London: Creative and Commercial Publications, 1996.

Wolf, Hazel Catherine. *On Freedom's Altar: The Martyr Complex in the Abolition Movement*. Madison: University of Wisconsin Press, 1952.

Wolff, Cynthia Griffin. "Passing Beyond the Middle Passage: Henry 'Box' Brown's Translations of Slavery." *Massachusetts Review* 37, no. 1 (1996): 23–43.

Wood, Marcus. *Blind Memory: Visual Representations of Slavery in England and America*. New York: Routledge, 2000.

———. "Creative Confusions: Angelo Agostini, Brazilian Slavery, and the Rhetoric of Freedom." *Patterns of Prejudice* 41, nos. 3–4 (2007): 245–71.

———. "The Deep South and English Print Satire, 1750–1865." In *Britain and the American South from Colonialism to Rock and Roll*, edited by Joseph Ward, 107–40. Jackson: University Press of Mississippi, 2003.

———. *The Poetry of Slavery: An Anglo American Anthology*. Oxford: Oxford University Press, 2003.

———. "Popular Graphic Images of Slavery and Emancipation in Nineteenth Century England." In Hamilton and Blyth, *Representing Slavery*, 138–51.

———. *Radical Satire and Print Culture*. Oxford: Oxford University Press, 1994.

———. *Slavery, Empathy, and Pornography*. Oxford: Oxford University Press, 2002.

Workman, Gillian. "Thomas Carlyle and the Governor Eyre Controversy: An Account with some New Material." *Victorian Studies* 18 (1974): 77–102.

Wrigley, Richard. *The Politics of Appearances: Representations of Dress in Revolutionary France*. Oxford and New York: Berg Publishers, 2002.

Yellin, Jean Fagin. *Women and Sisters: The Anti-Slavery Feminists in American Culture*. New Haven: Yale University Press, 1989.

Young, James. *The Texture of Memory: Holocaust Memorials and Meaning*. New Haven: Yale University Press, 1983.

Young, Lola. "The Truth in Chains: Two Centuries after Britain Began to Dismantle the Slave Trade the Whole Issue Is Still Beset by Myths, Half-truths and Ignorance." *The Guardian*, March 15, 2007, G2, 16–17.

Zboray, Ronald. "Antebellum Reading and the Ironies of Technological Innovation." *American Quarterly* 40 (1988): 65–82.

INDEX

RACE IN THE ATLANTIC WORLD, 1700–1900

The Hanging of Angélique:
The Untold Story of Canadian Slavery and the Burning of Old Montréal
by Afua Cooper

Christian Ritual and the Creation of British Slave Societies, 1650–1780
by Nicholas M. Beasley

African American Life in the Georgia Lowcountry:
The Atlantic World and the Gullah Geechee
Edited by Philip Morgan

The Horrible Gift of Freedom:
Atlantic Slavery and the Representation of Emancipation
by Marcus Wood